MEDIEVAL ART

MARILYN STOKSTAD

MEDIEVAL ART

SECOND EDITION

All rights reserved. Printed in Canada. No part of this publication may be reproduced or transmitted in any form or by any means, electronic or mechanical, including photocopy, recording, or any information storage and retrieval system, without permission in writing from the publisher.

Copyright © 2004 by Marilyn Stokstad

Published in the United States of America by Westview Press, 5500 Central Avenue, Boulder, Colorado 80301-2877, and in the United Kingdom by Westview Press, 12 Hid's Copse Road, Cumnor Hill, Oxford OX2 9JJ.

Find us on the world wide web at www.westviewpress.com

Westview Press books are available at special discounts for bulk purchases in the United States by corporations, institutions, and other organizations. For more information, please contact the Special Markets Department at the Perseus Books Group, 11 Cambridge Center, Cambridge, MA 02142, or call (617) 252-5298, (800) 255-1514 or email specialmarkets@perseusbooks.com.

Text design by Brent Wilcox Set in 11-point Adobe Garamond by the Perseus Books Group

Library of Congress Cataloging-in-Publication Data Stokstad, Marilyn, 1929–

Medieval art / Marilyn Stokstad.—2nd ed.

p. cm.

Includes bibliographical references and index.

ISBN 0-8133-4114-0 (pbk.: alk. paper)—ISBN 0-8133-3681-3 (hardcover: alk. paper)

1. Art, Medieval—History. I. Title.

N5970.S75 2004

709'.02-dc21

2003006643

The paper used in this publication meets the requirements of the American National Standard for Permanence of Paper for Printed Library Materials Z39.48-1984.

10 9 8 7 6 5 4 3 2 1

Printed in Canada

CONTENTS

	Preface	xi
1	AN INTRODUCTION TO MEDIEVAL ART The True Cross, 1 BOX: The Idea of the Middle Ages, 3	1
	Christianity and the Early Christian Church, 3 BOX: The Christian Story and Liturgical Cycles, 4	
	Traditional Roman Art, 6 BOX: From Idealism and Realism to Abstraction, 8	
	Official Art Under Constantine, 9	
	Constantine and the Christians, 10	
	Theodosius and Official Art in the Later Fourth Century, 11	
2	THE EARLY CHRISTIAN PERIOD	13
	Jewish and Christian Art Before Constantine, 14	
	Christian Art in the Age of Constantine, 21 BOX: Types and Typology, 22	
	Architecture, 23 BOX: The Christian Basilica: Sta. Sabina, 24	
	The Fifth Century, 32 BOX: Galla Placidia, 33	
	Rome in the Fifth Century, 34	
	Fifth-Century Architecture and Decoration Outside Rome, 38	

3		The First Golden Age	45
		Architecture, 48 BOX: The Dome, 51 BOX: Neoplatonism and the Aesthetics of Light, 54	
		Byzantine Mosaics, 58 BOX: <i>Monasticism</i> , 65	
		Jewish Mosaics, 65	
		Ivories and Manuscripts, 67	
		Icons and Iconoclasm, 72	
4		EARLY MEDIEVAL ART IN THE WEST	75
		A Brief History, 78 BOX: Barbarian Imagery, 78	
		The Art of the Goths and Langobards, 79 BOX: Visigothic Scholar, 80	
		The Art of the Merovingian Franks, 82	
		The Art of the Vendels and Vikings, 86 BOX: Viking Westward Exploration, 88	
		Art in the British Isles, 89 BOX: Anglo-Saxon Riddles, 92	
5		CAROLINGIAN ART	101
		BOX: The Value of Art, 103	
		Carolingian Architecture, 103	
		Carolingian Painting and Sculpture, 109	
		Later Carolingian Art, 114 BOX: How to Make Ink, 119 BOX: Monks, Canons, and Lay Abbots, 120	
6		RIVALS FROM THE EAST Byzantine and Islamic Art	127
,		The Middle Byzantine Period, 867–1204, 129	
		The Middle Byzantine Church 133	

BOX: The Hierarchy of Angels, 137

Byzantine Art Outside the Empire, 139

Byzantine Art in the West, 140

The Byzantine Contribution to the Art of the West, 141

Islamic Art, 143

Architecture, 144

The Decorative Arts, 146

The Norman Kingdom in Sicily: A Unique Case Study, 148

BOX: A Royal Palace, 153

BOX: The Imperial Ideal: Early Medieval Reactions to Ancient Rome, 154

7 | ART AT THE MILLENNIUM

The Imperial Tradition Continues

155

Asturian and Mozarabic Art in Spain, 157

Mozarabic Art in Northern Spain, 158

BOX: Mozarabic and Mudejar Art, 158

The Lombard-Catalan Style in Italy, France, and Catalonia (Catalunya), 161 BOX: Masonry Construction, 163

The Congregation of Cluny, 166

The Art of Scandinavia and the British Isles, 168

BOX: Timber Construction Techniques, 169

BOX: Anglo-Saxon Painting, 172

The Art of the Ottonian Empire, 173

Ottonian Church Treasures, 180

Ottonian Architecture and Bronze Sculpture, 182

BOX: Bronze Casting, 187

8 | ROMANESQUE ART

191

BOX: The European Economy in the Twelfth Century, 192

Secular Architecture, 193

The Empire and the Papacy, 194

Catalonia (Catalunya), 201

The "Pilgrimage Style" in Languedoc and Northern Spain, 202 BOX: Romanesque Aesthetics, 204

	Burgundy, 208	
	The Cistercians, 216 BOX: Cistercian Building, 218	
	Western France (Aquitaine), 219	
	Normandy and England, 222 BOX: On the Diverse Arts, 225	
9	ORIGINS OF GOTHIC ART The "Year 1200" Style	227
	The First Gothic Churches, 229 BOX: The Term "Gothic," 229 BOX: How We Refer to Cathedrals, 233	
	Stained Glass, 234	
	Early Gothic Sculpture, 236 BOX: How to Make a Stained-Glass Window, 237	
	The New Gothic Cathedrals, 240 BOX: Flying Buttresses, 244	
	English Gothic Art, 247	
	Books for Women, 250	
	Art of the "Year 1200," 251	
	The Spread of Early Gothic Art, 256	
10	MATURE GOTHIC ART	259
	The Cathedral of Chartres, 261	
	The Architecture of Cathedrals, 264 BOX: <i>The Seven-Spire Church</i> , 274	
	Architectural Sculpture, 275 BOX: Villard de Honnecourt, 283 BOX: Roman de la Rose (Romance of the Rose), 284	
	Gothic Art in England, 285	
	Gothic Art in the Empire: Germany and Italy, 290 BOX: Franciscans and Dominicans, 295	
	The Art of the French Court and the Rayonnant Style, 296	
	Approaches to Gothic Art, 300	

BOX: The Royal Ideal: The Gothic Reaction to the Romanesque, 302

ΙI	RAYONNANT GOTHIC AND ITS REVERBERATIONS	303
	The Later Rayonnant Style, 304 BOX: Guillaume de Machaut, 307	
	England and the Decorated Style, 310 BOX: The Elaboration of the Ribbed Vault, 312 BOX: Mabel of Bury St. Edmonds, 318	
	Gothic Art in German Lands, 319	
	The Synagogue, 322	
	Catalonia (Catalunya), 324	
	Gothic Art in Italy, 325	
	Fourteenth-Century Italian Painting, 329	
	The Character of Gothic Art, 334	
12	LATE GOTHIC ART	335
	The End of the Middle Ages, 352	
	Timeline: Europe in the Middle Ages	355
	Glossary	365
	Selected Readings	379
	Photo Credits	389
	Index	395

PREFACE

Like those Celtic saints who confidently set sail for parts unknown on ships of millstones or cabbage leaves, I once accepted a strange mission and a challenge—to write a survey of over a thousand years in the history of western art and architecture, from ancient Rome to the modern age of exploration. The Celtic sailor-saints, beset by flying fish, giant cats, and deep-sea monsters, made their way to new lands, to the very mouth of Hell, to the Blessed Isles, and back home again to tell their stories. This book, subject to a closer scrutiny than those ancient tales, suggests an intellectual voyage no less challenging and certainly just as enlightening.

Medieval Art, like most books by college professors, began as a set of lecture notes that changed over the years in response to the interests of students and the critiques of colleagues. My purpose in writing Medieval Art then as now was to introduce the reader, the museum visitor, and the student to extraordinarily complex and beautiful art and architecture. The diverse arts of painting (from tiny manuscript illustrations to huge stained glass windows), architecture, and sculpture are presented within the religious, political, and intellectual framework of lands as varied as France and Denmark, Spain and Germany—countries that did not even exist as political entities in the Middle Ages. Over a thousand years of art had to be summarized within the constraints of a limited number of pages and illustrations.

Medieval Art includes the art and building of what is now Western Europe from the second to the fifteenth centuries. Although to Renaissance scholars the Middle Ages was a single dark period, a vast black hole in the triumphant development of western philosophy and science from the Greeks and Romans to their own enlightened days, the period is in fact extremely diverse. What do the painters of catacomb images have in common with artists of the imperial Byzantine court, or indeed with stone carvers in Ireland or builders of Gothic cathedrals? One would first say: a devotion to and sponsorship by the Christian church, whether the Latin church led by the Pope in Rome or the Orthodox church led by the Patriarch in Constantinople. However, one should note that religious art has survived, while secular art and architecture has largely vanished. Christianity, of course, was subject to constant interpretation and development, and the impact of non-Christian cultures influenced the form, if not the content, of the art.

The great cultures of Eastern Europe, of the Orthodox Church, of Judaism, and of Islam have been given far less attention that they deserve. These great arts, worthy of independent studies, have been presented primarily as sources of influence and inspiration

for the art of the West. Late Medieval art has also been given a more cursory treatment than I would wish. This material, however, has been included in books on northern Renaissance art or, in the case of Italian art, as a prelude to the Renaissance. In a limited and highly selective text many favorite monuments—be they cathedrals or jewels—have been omitted. I have often chosen my own favorites to discuss and illustrate. When possible I have used works now in American museums, hoping to encourage the study of local collections. The reader will also note the inclusion of some less traditional work. This probably stems from my interest in the art of northern Europe, an interest that led me, as a student, back in time from the paintings of Edvard Munch to the art of the Vikings. I have continued to follow those Viking hordes, exploring coasts and rivers of Western Europe, thus giving this book a slightly peninsular and insular focus. The inclusion of Scandinavian, British, or Spanish art may sometimes be at the expense of a more traditional focus on France, Italy, and Germany. Even the added attention paid to the so-called cloister crafts or decorative arts might be attributed by the fanciful reader to my admiration for the brilliant, sparkling, and exquisite work of northern goldsmiths.

The book has gone through many transformations, and the present text bears little resemblance to the one read by colleagues many years ago. The original project—to summarize and define the styles found in over a thousand years of art and architecture—was twice abandoned, but finally, with the encouragement of family and friends and the enthusiastic support of Cass Canfield Jr., creator of the Icon Editions, the book was finally completed. When the Icon Editions became part of Westview Press, Sarah Warner took over the vital managing role of Senior Editor for this new edition of *Medieval Art*.

In the beginning, before there was a first edition of Medieval Art, three medievalists worked very hard with me on the project: the late Franklin Ludden and the ever-optimistic William Clark and Ann Zielinski. My heartfelt thanks to them and to all those other friends and colleagues, some of whom know parts of the original manuscript only too well and others who offered advice, criticism, and encouragement. Among the many who have tried to save me from egregious error are Santiago Alcolea, Peter Barnet, Janetta Benton, Sara Blick, Jonathan Bloom, Robert Bork, Katherine Reynolds Brown, Walter Cahn, Robert Calkins, Annemarie Weyl Carr, Madeline Caviness, John Clark, Robert Cohon, Walter Denny, William Diebold, Jerrilynn Dodds, Lois Drewer, Marvin Eisenberg, James D'Emilio, Helen Evans, Ilene Forsyth, Paula Gerson, Dorothy Gillerman, Dorothy Glass, Stephen Goddard, Oleg Grabar, Cynthia Hahn, M. F. Hearn, Ruth Kolarik, Charles Little, Janice Mann, Serafin Moralejo, Karl Morrison, Lawrence Nees, Judith Oliver, Virginia Raguin, Paul Rehak, Richard Ring, Lucy Freeman Sandler, Elizabeth Sears, Pamela Sheingorn, Mary Shepard, David Simon, Anne Ruddoff Stanton, Roger Stalley, Neil Stratford, Thomas Sullivan, Elizabeth Valdez del Alamo, Amy Vandersal, Otto Karl Werckmeister, John Williams, William Wixom, and John Younger. Graduate Research and teaching assistants who have helped me include Ted Meadows, Martha Mundes, Donald Sloan, and Jill Vessely. Reed Anderson revised the bibliography for this new edition. The words of others still ring in my ears: Harold Wethey, Jane Hayward, Thomas Lyman, George Forsyth, Robert Van Nice, Marie-Madeleine Gauthier, Jose Gudiol Ricart, and Juan Ainaud de Lasarte.

Anna Leider and Nancy Dinneen gave me benefit of the intelligent layperson's view, and students at the University of Kansas and Colorado College have read and criticized the text. For help in assembling photographs and checking references I would like to thank vi-

PREFACE xiii

sual resources librarians Sara Jane Pearman, Ruth Philbrick and Monserrat Blanch, and librarians Susan Craig, William Crowe, Richard Clements, and my sister Karen Leider. Thanks, too to the staff members of the Instituto Amattler in Barcelona, the National Gallery in Washington, the Victoria and Albert Museum in London, Dumbarton Oaks in Washington, the American Academy in Rome, and the Kenneth Spencer Research Library in Lawrence, Kansas, where much of this book was written and rewritten. The Kress Department of History of Art at the University of Kansas, where I have been privileged to be the Judith Harris Murphy Professor of the History of Art, and the Endowment Association of the University of Kansas assisted me as I prepared the Manuscript.

Special thanks go to my editor at Westview Press, Sarah Warner, and her able assistants Jessica McConlogue, Lisa Molinelli and Jim Ahern (who took on the arduous task of assembling the illustrations and permissions), copy editor Norman MacAfee in New York, Senior Project Editor Rebecca Marks, designer Brent Wilcox, proofreader Alexandra Eddy, Philip Schwartzberg for his work on the maps, and researcher Reed Anderson. They truly know what it means to labor in the vineyards.

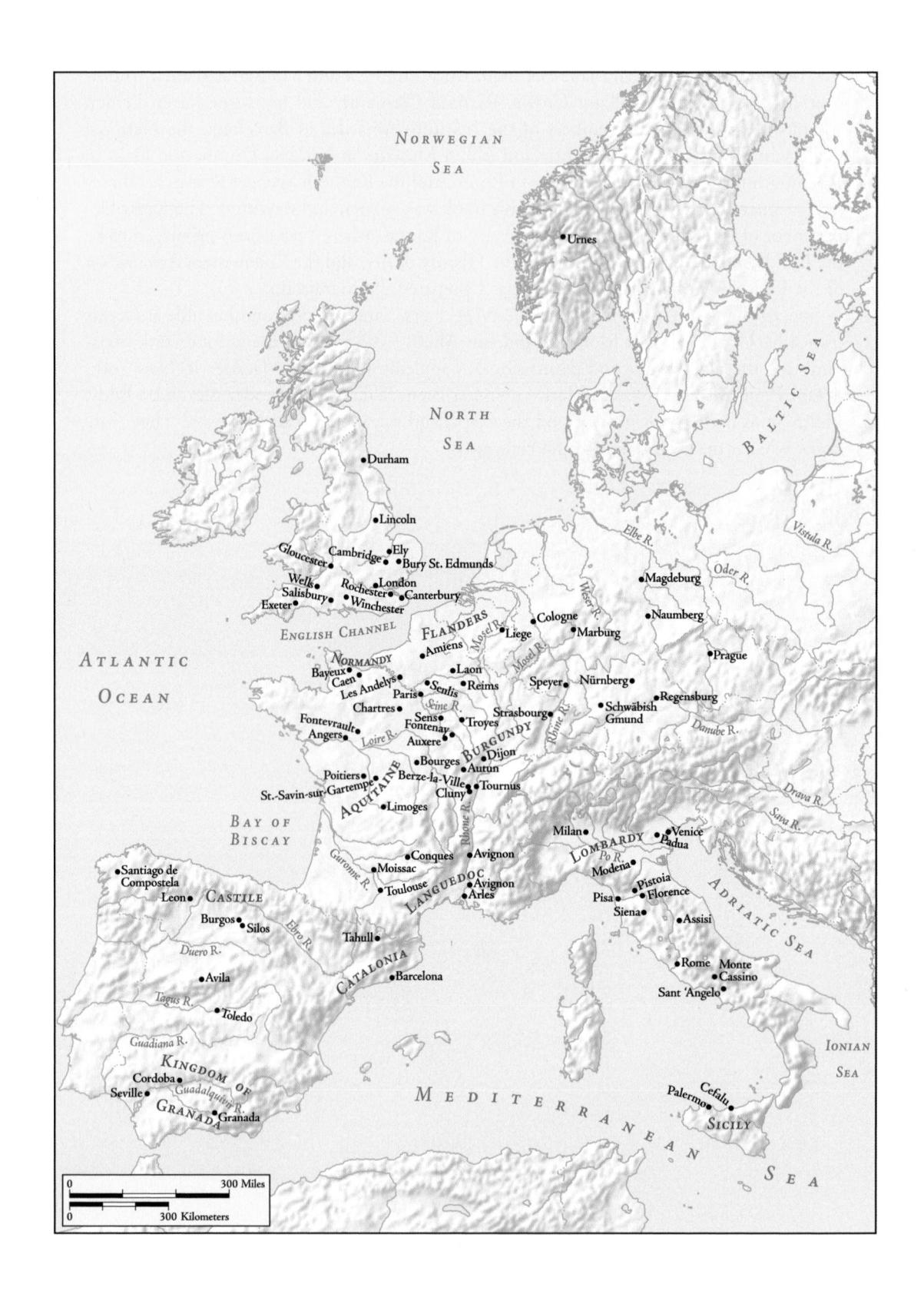

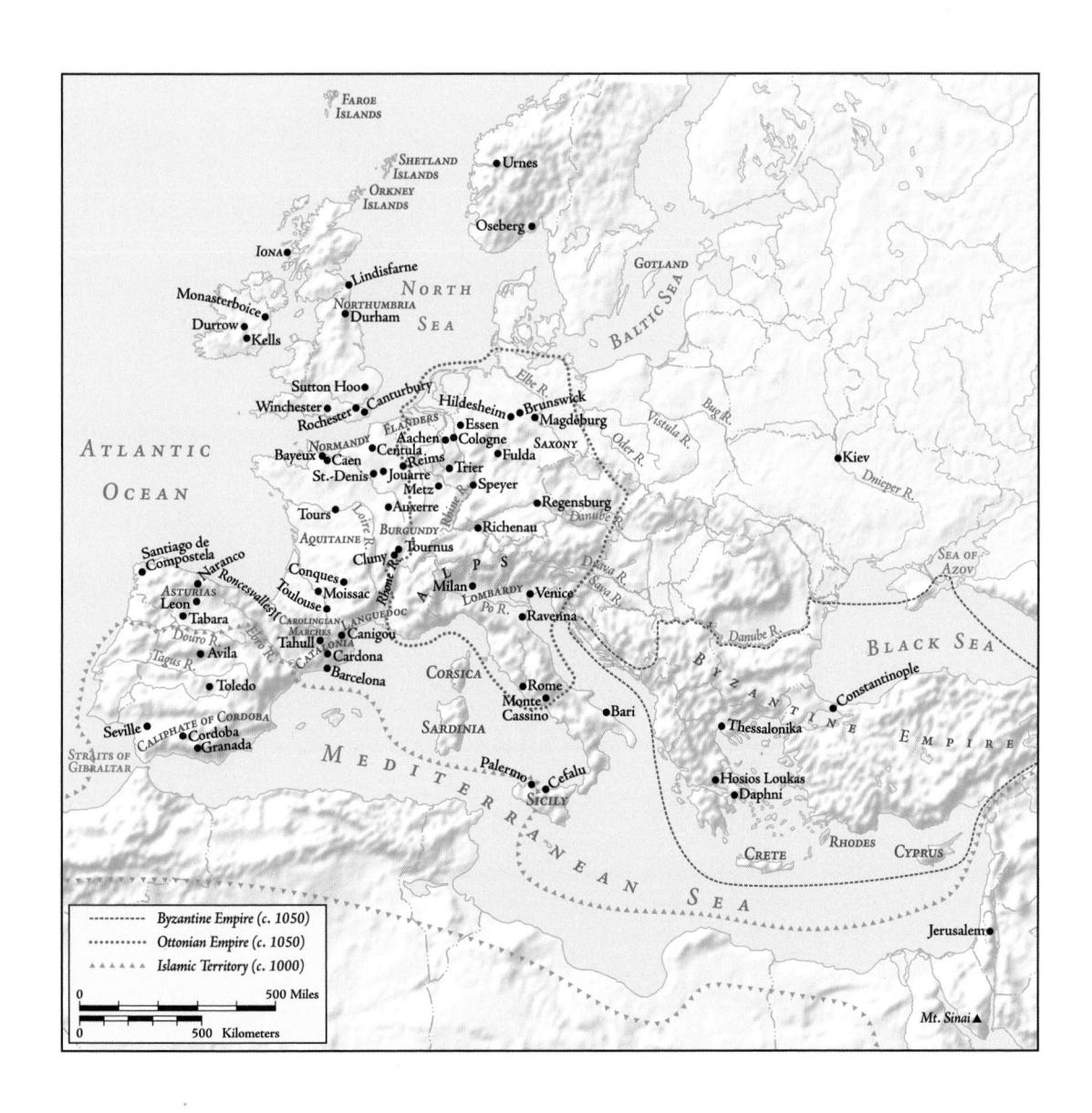

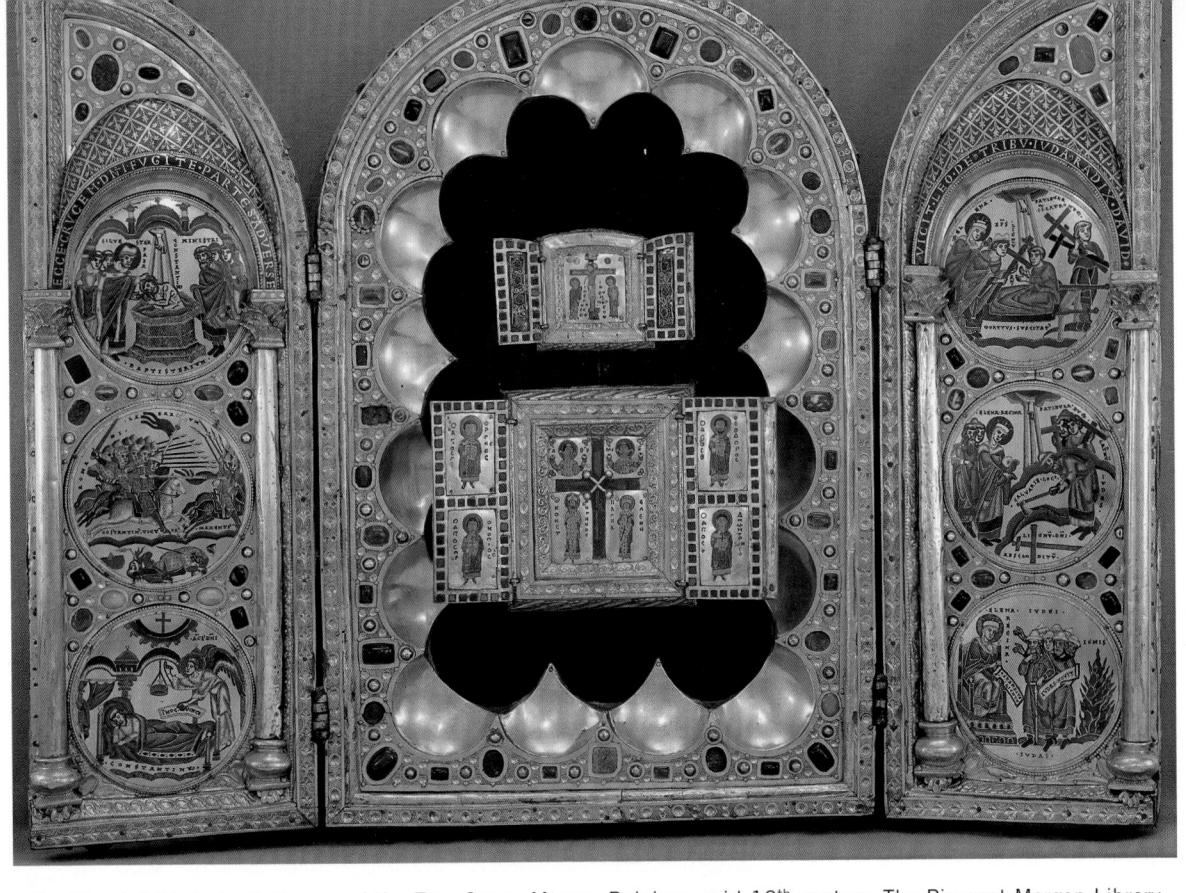

1.1 Stavelot Triptych, Reliquary of the True Cross, Mosan, Belgium, mid-12th century, The Pierpont Morgan Library.

CHAPTER

AN INTRODUCTION TO MEDIEVAL ART

THE TRUE CROSS

strange but hauntingly beautiful object greets visitors to the Pierpont Morgan Library in New York [1.1]. Drawn by the glitter of gold and jewels, we move closer and discover that we are looking at a three-part winged shrine, a triptych. The piece displays and protects two small enameled triptychs, which in style and technique are quite different from it. The label information—that this is the Stavelot Triptych made in the Mosan region of Belgium in the twelfth century—fails to satisfy our curiosity. The glowing colorful figures in their golden world have lured us back into the Middle Ages where works of art often frustrate our modern desire for information. We do not know who the artists were or even the location

of the workshops where they mastered their craft. We do not know with certainty who ordered the work or provided the semi-precious stones, the enamels, and the relics assembled here. We have theories, suppositions—guesses, if you will—combined with some hard evidence from the works of art themselves and from a few documents. The study of history, literature, philosophy, religion, and folklore, as well as other works of art may help us to understand. Of one thing we are sure, the makers of the Stavelot Triptych believed that they had enshrined relics associated with Christ, including the Cross on which he was crucified. In contrast to the large triptych, the two small reliquaries exemplify the art of the Eastern, Byzantine Church.

Originally the Mosan artists placed them on a golden field enriched with semi-precious stones. (The velvet background seen today is modern.) In the wings, the Mosan artists added their own enamels to tell the story of the True Cross as it was known in the Middle Ages.

In the enamel medallions on the wings, the Mosan artists capture the drama of the legends and miracles of the Cross. According to the collection of saints' lives written by the thirteenth-century bishop of Genoa Jacob of Voragine, the Golden Legend, Constantine, during the night before fighting his rival Maxentius for control of the Roman Empire, dreamed he saw the Cross of Christ in the sky. Angels told him that the sign of the Cross would ensure victory. Constantine ordered his troops to place the cross-monogram of Christ (Chi Rho) on their shields. In the ensuing battle at the Milvian Bridge outside Rome, Constantine

won a decisive victory, killed Maxentius, and entered Rome in triumph. In the last scene, Constantine accepts Christianity and is baptized by Pope Silvester. In fact, Constantine granted toleration to all the unofficial religions in his empire, and he put off Christian baptism until the end of his life, in 337.

In the right-hand wing of the triptych, Empress Helena, Constantine's mother and a Christian, has traveled to Jerusalem seeking the True Cross. In the first scene, she interrogates the Jews. They lead her to Golgotha and dig up the crosses of Jesus and the two thieves who were crucified with him. The True Cross reveals itself when it brings a dead youth back to life. In the medallion, a servant carries off the two false crosses. The empress brought pieces of wood and the nails from the Cross, along with the other relics, back to the imperial court.

The larger of the two Byzantine reliquaries in the central panel houses a fragment of the wood of the True Cross, which on the enamel cover is

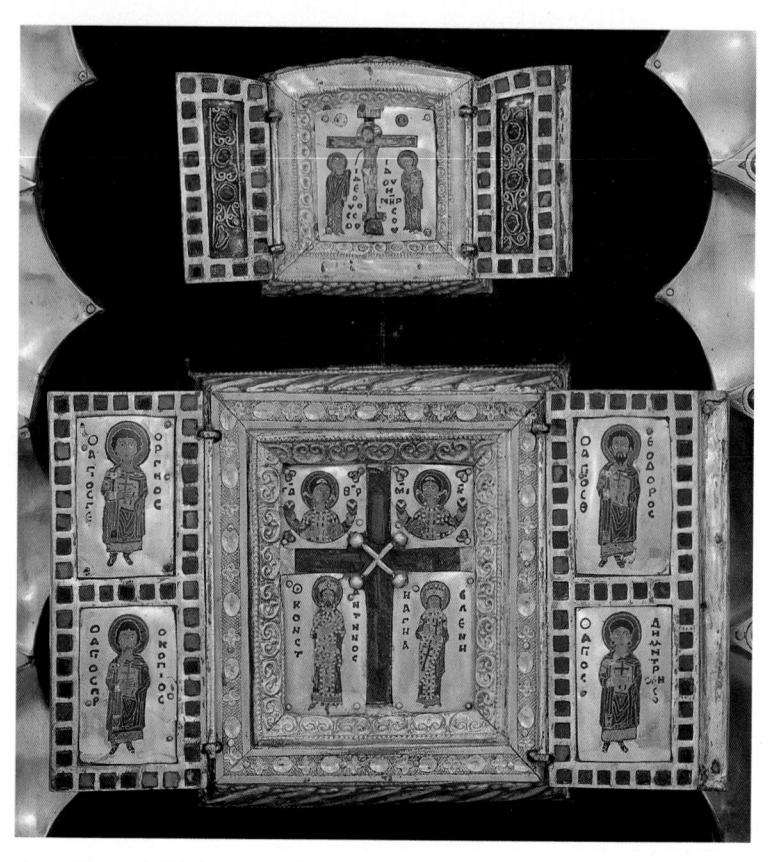

1.2 Stavelot Triptych, detail.

flanked by angels, Eastern saints, and Constantine and Helena [1.2]. The Eastern Orthodox Church revered Constantine and Helena as saints, but Constantine was not considered a saint in the West. The smaller reliquary held relics of the True Cross, the Holy Sepulchre, and the robe of the Virgin Mary, all of which were identified on a strip of parchment. In the enamels, St. Mary and St. John witness Christ's death on the Cross. The twelfth-century text in the arches above the narrative roundels celebrates the Discovery and Exaltation of the Cross. It reads, "Behold the Cross of the Lord. Flee you hostile powers. The Lion of the Tribe of Judah, the Root of David has conquered." The medieval artists succeed in giving the essence of Christian belief tangible form, both in the Western narratives and the static symbolic icons of the Eastern Church.

What else can we learn from these enamels? First, they are technically different, following the

preferences of the Eastern and Western churches. The small rectangular plaques are cloisonné enamel, and the larger medallions are in the champlevé technique. Both use fine colored glass enamel, but in cloisonné the individual cells that divide the colors are formed by tiny gold strips soldered to the surface of the panel, whereas in the champlevé technique, the cells are gouged out of the metal plate. Cloisonné enamel is typical of Byzantine art (the art of the Eastern Orthodox Church), and champlevé enamel is the preferred technique among Western artists. Eastern artists created two-dimensional patterns in translucent jewel-like colors with enamels that reflect light like rubies and emeralds. Mosan artists, working in the champlevé technique, try to suggest rounded, three-dimensional forms in space by using two or more colors in the cells. The two very different enamel techniques represent two very different views of the world.

Medieval art is essentially Christian art, but the Stavelot Triptych focuses our attention on an East-West dichotomy in Christianity, which continues to this day in the Catholic and Orthodox churches. Not only do we see two different enamel techniques but also two different modes of representation. The Eastern Byzantine artists use a symbolic mode: static hieratic compositions in which figures, seemingly almost frozen in place, quietly adore the Cross. In contrast, the Westerners work in a narrative mode, creating lively energetic figures acting out dramatic stories of visions, battles, confrontations, and miracles. Finally, even the conception of Emperor Constantine differs—in the Byzantine Church, he was venerated as a saint; in the Western Catholic Church, he was never canonized, although his mother, Helena, was.

In the twelfth century when the Mosan enamels were made, Abbot Wibald led the imperial Benedictine monastery of Stavelot (1130–1158). The abbot was an important diplomat and adviser to three Holy Roman Emperors—Lothair II, Conrad III, and Frederick Barbarossa. In 1154, Frederick Barbarossa sent him on a mission to Constantinople. The Byzantine Emperor Manuel Komnenus may have given Abbot Wibald the two small

Byzantine reliquaries as a diplomatic gift. The abbot traveled to the Byzantine court again in 1157, and he died in 1158 on the way home. In the period between the abbot's two trips, the Western shrine for the Byzantine reliquaries could have been made in Stavelot. Of the artists who made the triptych, we know nothing.

The Idea of the Middle Ages

The Middle Ages—exuberantly self-confident Renaissance scholars looked back on this period of a thousand years as an interlude. They considered the centuries after the fall of Rome as a dark "middle" age because the period fell between the time of Classical Greece and Rome and the revival of learning in their own day. Today, these centuries appear to us as a brilliant period out of which emerged our own modern world with its rival nations, its different philosophical, political, and economic systems, and its varied forms of art and architecture. The medieval period extends from the fourth-century battle of the Milvian Bridge-when Constantine's troops, bearing the monogram of Christ on their shields, conquered Rome-to the fifteenth-century discovery of the Americas by navigators from Portugal sailing the uncharted ocean with the Cross of the Order of the Knights of Christ on their sails. Thus, two powerful visual images will begin and end our study-the Chi Rho and the Knights' Cross.

CHRISTIANITY AND THE EARLY CHRISTIAN CHURCH

We have been looking at an image made for a triumphant Christian Church. Christianity did not begin as an imperially sponsored religion. In the first century, Octavian, who was made Roman emperor by the Senate with the title Augustus, formed a united empire. Far from Rome, in Palestine, where Herod ruled as Roman governor, a woman called Mary gave birth to a child she named Jesus. The Gospels tell of angelic messengers announcing the coming of the Messiah and wise men traveling to Bethlehem to recognize him

as the Christ, the Son of God. Later his followers declared his birth to be the beginning of a new era, year one of the time of our Lord, Anno Domini, A.D., today more ecumenically referred to as the Common Era, C.E.

At first, few people would have been aware of Jesus of Nazareth, a Jewish carpenter who performed miracles of healing and who claimed to be the Son of God and the Messiah of the Jews. Jesus urged his followers to love all humankind and to consider life on earth merely a preparation for life everlasting in Heaven. By his death on the Cross, Jesus offered himself as a sacrifice to atone for the sins of all humanity. The Christians said that Jesus arose from the tomb and returned to God, his Father in Heaven, but he would return to judge the world and take those people deemed worthy back with him to paradise. This message of faith and hope soon gained followers, especially among the poor.

The central body of Christian belief is contained in the New Testament, which together with the Jewish scriptures, called by the Christians the Old Testament, form the Bible. The New Testament consists of four Gospels (meaning the good news), attributed to Matthew, Mark, Luke, and John. These four Evangelists provide four versions of the life and teachings of Jesus. St. Paul's letters to the new Christian communities (the Epistles) and the Acts of the Apostles record the establishment of Christianity as an organized religion. The New Testament concludes with St. John's Revelation of the end of earthly time in the Apocalypse. The sacred texts of the Jews provided the Christians with the historical context for their belief. Christians saw Old Testament events as prefigurations of Christianity; for example, the deliverance of Jonah from the sea monster became a prototype for the Resurrection of Christ, and the shepherd of the 23rd Psalm could be identified with Christ the Good Shepherd. At the end of the fourth century, St. Jerome edited and translated the Bible into Latin, the vulgar or people's language, and his edition is known as the Vulgate.

The form of Christian worship was at first very simple. When Christ gathered with the apostles

The Christian Story and Liturgical Cycles

Christians use two kinds of time—historical and liturgical. Events in the Life of Christ may be represented as a narrative in historical sequence or grouped and organized according to the order in which they were celebrated by the church. The Western Christian liturgical year is based on Christmas (fixed on December 25th, the Roman solstice) and begins with the first Sunday in Advent, four Sundays before Christmas. A second set of calendrical calculations establishes the date of Easter, which is set by the Jewish Passover, and consequently based on the lunar year. The eastern Christian Orthodox calendar is based on Easter.

Events in the Gospels are usually organized into three "cycles."

The Marian (or Nativity) Cycle: Annunciation, Visitation, Nativity, Annunciation to the Shepherds, Adoration of the Magi, Presentation in the Temple, Massacre of the Innocents, Flight into Egypt, Jesus among the Doctors.

The Public Ministry Cycle: Baptism, Calling of the Apostles, Calling of Matthew, Jesus and the Samaritan Woman, Jesus Walking on the Water (Storm on Galilee), Marriage at Canaan, Raising of Lazarus, Delivery of the Keys to Peter, Transfiguration, Cleansing of the Temple.

The Passion Cycle: Entry into Jerusalem, Last Supper, Washing the Apostles' Feet, Agony in the Garden, Betrayal (Kiss of Judas), Denial of Peter, Trial of Jesus, Pilate Washing His Hands, Flagellation, Crowning with Thorns, Bearing the Cross, Crucifixion, Deposition, Lamentation (Pietà), Entombment, Descent into Limbo (Harrowing of Hell), Resurrection, Marys at the Tomb, Noli Me Tangere (Jesus and Mary Magdalene), Supper at Emmaus, Doubting Thomas, Ascension, Pentecost.

Other themes used in Christian art include: The Last Judgment, or Second Coming.

The Fathers of the Church (Scholars and teachers of the early Church).

The Latin Fathers: St. Jerome, St. Ambrose, St. Augustine, and St. Gregory.

The Greek Fathers: St. John Chrysostom, St. Basil, St. Athanasius, and St. Gregory Nazianzus. Lives and miracles of the Saints.

for the Jewish Feast of the Passover and defined the bread and wine as his own body and blood, he established the sacrament of Holy Communion. "And he took bread, and gave thanks, broke it, and gave unto them, saying, This is my body which is given for you: this do in remembrance of me. Likewise also the cup after supper, saying, This cup is the New Testament in my blood, which is shed for you." (Luke 22:19–20) The new concept of Christian commemoration, added to the original Jewish rite of thanksgiving for divine intervention and salvation, has remained the core of Christian worship.

At first the Christians gathered in the homes of members of the congregation to reenact the Last Supper by taking a full meal together. Twenty-five officially Christian houses (tituli) are known to have existed in Rome, and there must have been many more. The communal meal became formalized into a ritual (the Mass, or Eucharistic rite) performed by a priest, in which bread and wine miraculously became the flesh and blood of Christ (transubstantiation). Eventually, the supper table became an altar; and the house where the Last Supper was reenacted became known as the House of the Lord—Domus Dei, the Church.

As a more elaborate service developed in the fourth century, elements of Jewish worship-reading from sacred books, collective prayer, and song were incorporated into the Christian ritual. The service was divided into two parts—one open to all, and a second part reserved for initiates. In the public part of the service—the liturgy of the Word—the clergy and people invoked the saints and praised the Lord with hymns. Then, in the liturgy of the Eucharist, the initiates alone celebrated the Lord's Supper [1.3]. The priest consecrated the bread and wine, asking God to transform the bread and wine into the body and blood of Christ. A complicated ceremony of the breaking of bread and taking of wine followed. The service ended with collective prayers of thanksgiving and a formal dismissal, "Ite, missa est" (Go, you are sent forth), from which the term for the service, the Mass, is derived.

The second important rite in the early Church was the initiation ceremony called baptism. The

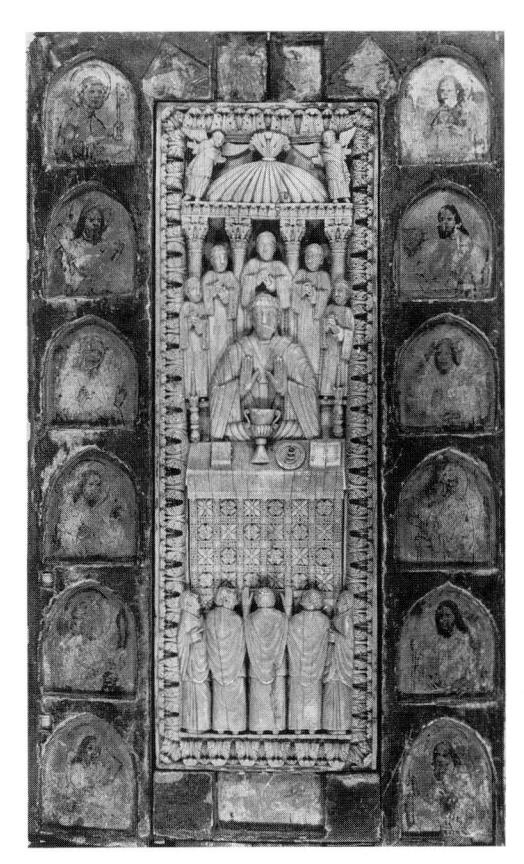

1.3 The Mass. Northern France, c. 875 or Germany, c. 1000. Ivory. Universitätsbibliothek, Frankfurt.

simple washing away of sins and the gift of the Holy Spirit by the laying on of hands mentioned in the New Testament became an elaborate and formal ritual presided over by the head of the Christian community, the bishop. In baptism the initiates "died" and were reborn in Christ. The participation of large numbers of people in the Mass and baptism required special buildings. The ritual death and rebirth suggested the architectural symbolism of the tomb for the baptistery, just as the Lord's Supper could appropriately be taken in a house-church.

In the early years, rival religions influenced the development of Christianity. Many of the religious cults in the Eastern part of the empire evolved around the concept of death and rebirth, for example, the Egyptian cult of Isis and Osiris. The Roman cult of the Earth Mother Demeter and the

Greek cults of Dionysus (Bacchus) or the Great Goddess Cybele were also ecstatic in tone and highly individual in their appeal. These "mystery religions" had elaborate, secret rites in which music, incense, lights, and sacred images created a sense of dramatic urgency among the believers. Christians incorporated some of these elements into their liturgy to enhance the emotional intensity and immediacy of their worship. The idea of powerful secrets open only to the initiate, ensuring eternal life through union with a Man-God-Savior, was powerful indeed.

Monotheistic cults and religions, such as the Neoplatonic One, Zoroastrianism, Mithraism, and Sol Invictus (triumphant sun), also spread through the empire by the third century. The army favored Mithras, and Sol Invictus had a cult associated with the Roman emperors. Even Constantine, for all his support of the Christian cause, continued his devotion to the sun and was baptized only on his deathbed, a common practice among adult men, especially those active in politics and government, who thus avoided the problem of having to live sin-free lives after baptism. The designation of Sunday rather than the Jewish Sabbath (Saturday) as the Christian sacred day and the choice by the Christians of December 25 (both the festival of Sol and the birth of Mithras) to celebrate the birth of Christ suggest the influence of these other beliefs on Christian practice.

As Christianity became a major religion within the Roman Empire, it needed an organized administrative structure and a coherent philosophy. The first it took from the Romans and the second from the Greeks. As a political and economic institution, Christianity adopted the Roman imperial model—provincial governments under a central ruler (bishops, and especially the bishop of Rome, the Pope), a system of taxation (tithes), and even elaborate records and archives. To create a rational system for the justification of intuitive beliefessential in order to appeal to the educated classes—Christians turned to Greek philosophy. However, the Greek belief in man as a rational being contrasted vividly with the Christian acceptance of the power of faith.

St. Augustine (354–430) in the West and St. Gregory of Nazianzus (329–389) in the East sought to adapt elements of Greek Platonic philosophy to Christianity. The Platonic cosmology, later refined by Plotinus and the Neoplatonists, conceived of a Universal Soul that radiated through the universe and animated the world of matter. Human beings participated in both the world of the soul and the world of matter but their ultimate goal was the reunion with the Universal Soul, the One. The educated Greek or Roman could understand the Universal Soul as another way of describing the Christian God.

For more than a thousand years the ideals and precepts of Christianity dominated European thought and its visual expression in art and architecture. At the same time early Christian art can be seen as a phase of Late Roman art, distinguishable as Christian only by its subject matter.

TRADITIONAL ROMAN ART

Roman art is fascinating in itself, but it cannot be treated here with the care and depth it deserves. The examination of a few examples must suffice to establish a context for the earliest Christian art. Typical of Roman imperial art is the Arch of Titus, erected in 81, commemorating the Roman Palestine campaign and conquest of Jerusalem [1.4]. Such tangible records of specific historical events, represented with well-observed detail, are an important contribution by the Romans to the history of art. On the Arch of Titus, the historical situation depicted is as follows: A rebellion in Judea (66-70) ended disastrously for the Jews when the Roman general Titus captured Jerusalem. Titus brought the Ark of the Covenant, the temple lampholder known as the Menorah, and other treasures back to Rome as trophies. He and his troops paraded through the heart of the city to the Temple of Jupiter, the customary triumph awarded a victorious general. Titus later ruled as emperor (79-81) and on his death joined the official state gods of the empire.

Relief sculpture, on the inner faces of the piers of the commemorative arch, depicts the triumphal

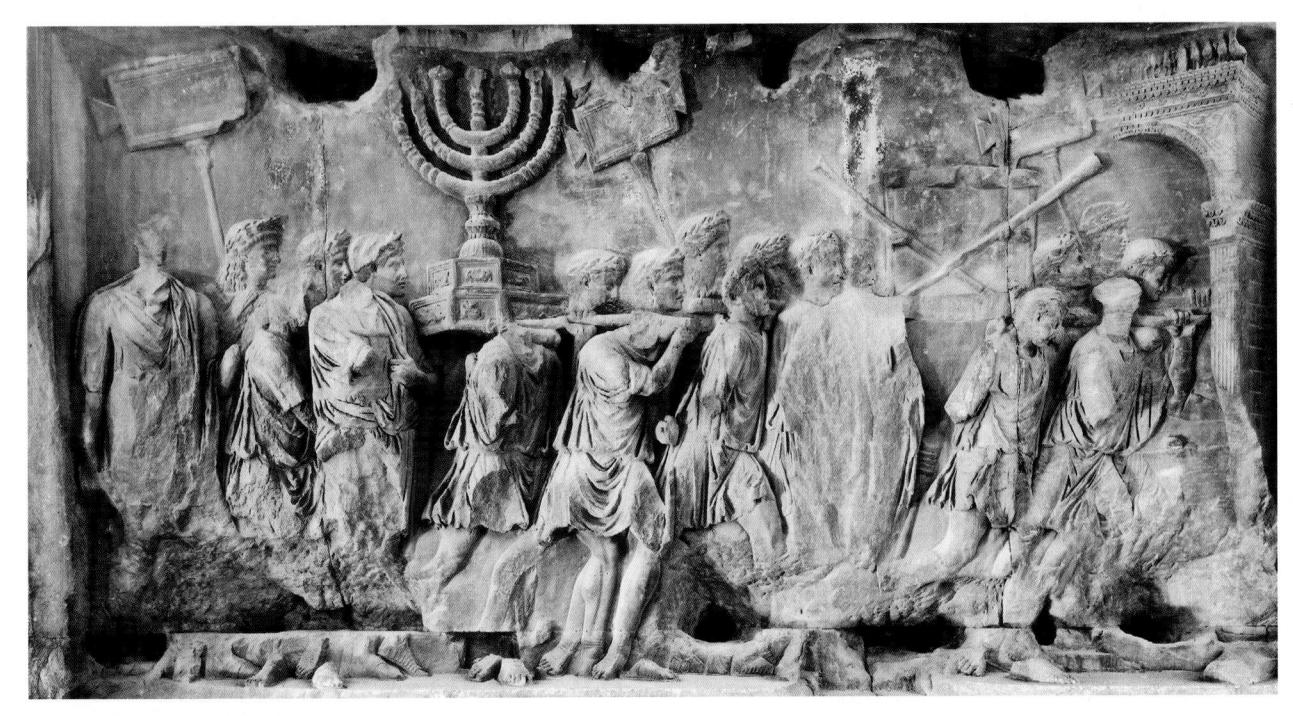

1.4 Spoils from the Temple of Solomon, Jerusalem, relief in the passageway of the Arch of Titus, 81. Rome.

procession. On one side is the emperor, and on the other soldiers march through an arch carrying the spoils from the Temple including the Ark of the Covenant and the menorah. Not only have the artists carefully reproduced marching men and their loot, but they have also achieved a sense of space. By the remarkable device of the curved background plane, they eliminate the cast shadows of the frame and so produce an illusion of atmosphere. The sculptors also varied the height of the relief, carving figures in the foreground in high relief and those farther away progressively lower. The artists have tried to create the illusion of a window through which a spectator looks out on the world.

During the second century, artists continued to depict specific events in a sensible, rational world, but new techniques undermined the subtle realism seen in first-century art. In the Hadrianic reliefs on the Arch of Constantine, the sculptors began to compress space and action by tilting the ground upward and by reducing the architecture or landscape to a few well-chosen elements [1.5]. They modeled the individual figures as subtly as had the sculptors of the Arch of Titus, but to make the

images more visible at a distance, they sharpened outlines by undercutting the edges of the forms to create shadows. Gradually the sculptors began to think in terms of light and shade rather than of solid figures in a defined space, a change in focus that naturally led to a change in style and an increasing abstraction of form.

By the third century, the Roman Empire, and its art, changed. The Christians had been given limited official status in the empire, first by Emperor Septimius Severus in 202, who made it permissible to be a Christian but not to try to convert others, and later by Gallienus (253–268), who made Christianity a "permitted religion" (religio licite). This easy situation changed under Diocletian. In an attempt to bring religious as well as political stability to the empire, in 303 Diocletian issued an edict requiring sacrifices to Jupiter, the Roman gods, and the deified emperors as proof of allegiance. Christians and Jews who worshipped no God but their own were imprisoned and sometimes executed, becoming martyrs for their faith.

Emperor Diocletian reorganized the Roman Empire into workable administrative units by

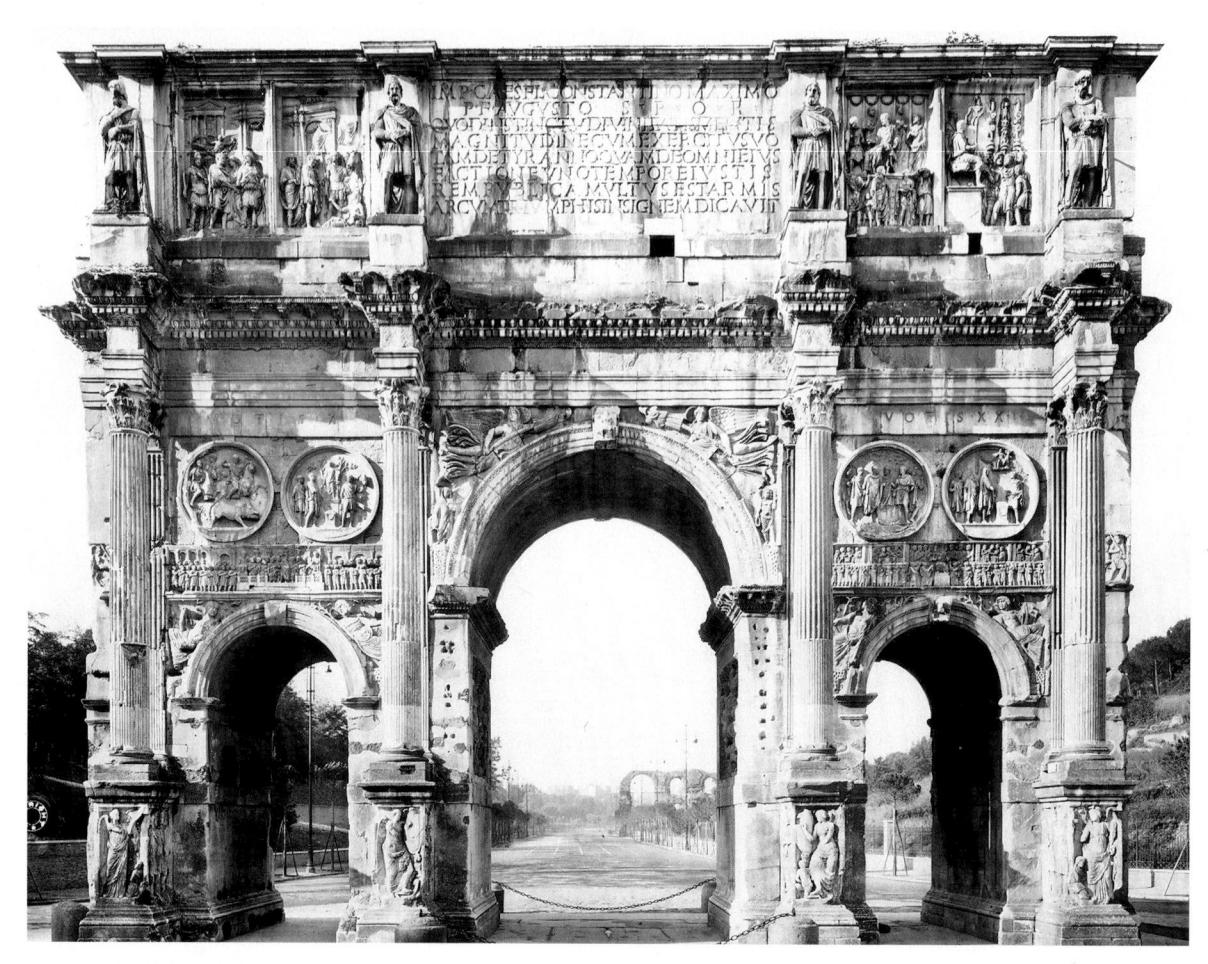

1.5 Arch of Constantine, 312–315. Rome.

From Idealism and Realism to Abstraction

Greek artists observed nature and then tried to create typical but perfect forms—the ideal. They focused on moments of perfect harmony and on the idealized representation of human beings. Roman artists recorded the world of everyday existence, that is, they worked in a realistic or naturalistic style. They interpreted nature with great skill and imagination. They achieved an illusion of material reality in sculpture, painting, and mosaic through subtle modeling, varied textures, and the effects of light.

In contrast to the ideal or realistic art of the ancient classical world, an abstract and expressionistic mode unrelated to visual appearances characterizes medieval art. The change in style began as part of the technical and visual changes seen in the second century. The two styles—realistic and abstract—existed side by side by the end of the third century. Sometimes one, sometimes the other gained ascendance depending on political, social, and economic as well as religious factors. Patrons and artists came to prefer abstract styles as the appropriate means to express the visionary character of their belief. By denying the importance of the material world they also denied the relevance of an art that recorded surface appearances.

An ideal style is often called "classical." Greek and Roman art, whether idealized or realistic in style, is often referred to as classical. But the term "classical" has other meanings. Any peak of achievement has come to be referred to as "classic," hence classic cars, screen classics, or a classic Gothic cathedral.

establishing a four-man rule, known as a tetrarchy. Two emperors (Augusti) each had a junior emperor (Caesar) as an assistant and heir. Diocletian became Augustus of the East, and his old friend Maximian was Augustus of the West. When Diocletian and Maximian retired as planned in 305, the tetrarchy failed, and the empire was again split by contending factions as the Caesars and their heirs fought for supremacy. Constantine (ruled 306/312-337) and Maxentius (ruled 306-312) both claimed the Western Empire. In the bitter struggle that ensued, Constantine defeated Maxentius in 312 [see 1.1]) and re-established a strong central government. Having secured his authority in the West, Constantine sought absolute supremacy in the Eastern Empire as well. The struggle with Licinius lasted until Constantine finally emerged victorious in 324.

OFFICIAL ART UNDER CONSTANTINE

Contemporary sources record that Constantine commissioned many colossal statues of himself and appropriated sculpture made for his predecessors. Portraits served as symbols of the imperial presence. Constantine's portraits radiate heavensent sovereignty through aggrandized, abstracted features [1.6]. The geometric forms of the face, his massive jaw, hawk nose, and distinctive haircut suggest his individual characteristics, while rigid frontality and absolute immobility create a superhuman appearance. Although his deeply set eyes look upward, the regular, repeated arcs of his eyelids and eyebrows seem to deny even this slight sense of movement. These immense staring eyes seem to fix on the spiritual source of the emperor's rule, for Constantine directs his sight upward to the gods acknowledged by his reign, be they Christian or Roman. No longer the portrait of a mortal man, Constantine personifies ordained majesty in eternal communion with the heavens.

A magnificent triple arch erected by the Roman Senate to celebrate his victory over Maxentius recalls Constantine's imperial triumph. As if to assert Constantine's place in the succession of great Roman emperors, the builders incorporated fragments of sculpture from monuments honoring

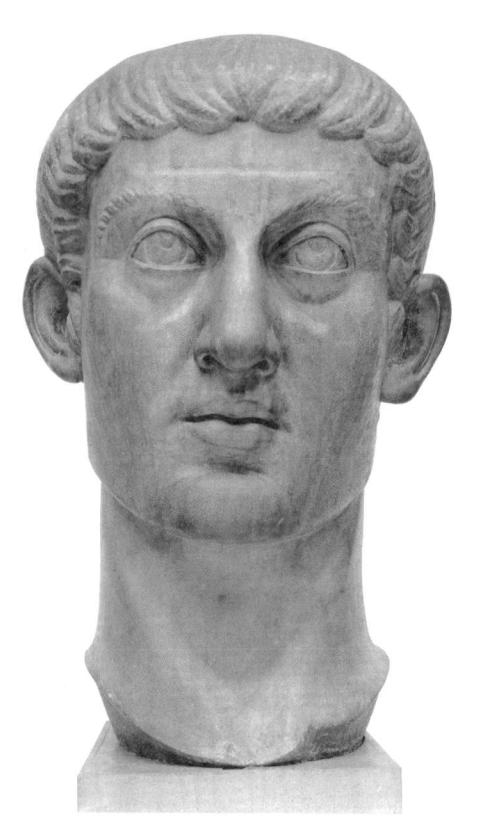

1.6 Head of Constantine, c. 325. Marble. Height 3ft., 1.5in. (95.3 cm). The Metropolitan Museum of Art.

his greatest predecessors—Trajan, Hadrian, and Marcus Aurelius. Figures and reliefs carved especially for the arch break decisively with the Roman realistic style [1.5, lower relief]. Instead of carefully modeling three-dimensional figures and settings, the sculptors outlined forms by drilling a series of holes or continuous grooves to produce deep shadows and strong highlights. At a distance the images are strikingly dramatic, but when seen close at hand, the two-dimensional pattern of drill work tends to destroy the organic unity of forms. This change in technique signaled a change in attitude toward the representation of the material world, as artists sought to create an illusion of substance rather than a tangible form. The complete work of art began to depend on elements that are outside the image—that is, on the effects of light and on the imagination and vision of the spectator. The rational, self-reliant, and anthropocentric classical Greek and Roman world gave way to times requiring a new style, an art focused on intangible concepts expressed through geometric forms abstracted from nature, symbolizing intellectual and spiritual ideals.

On the Arch of Constantine every part of the new reliefs—not only the composition but also the carving of individual figures—reflects the artists' will to depict the emperor as benign yet allpowerful, an imperial presence dispensing wisdom, justice, and alms. Constantine appears at the precise center of the composition, the only figure unconfined by the horizontal registers. His frontal position removes him from the active world, since the frontality isolates him physically and psychologically from his petitioners and retainers, who are consistently rendered as short, dumpy figures with enormous heads. Whether the figures dispense charity or petition for it, their repeated forms and gestures and their round, heavy-jawed heads produce a symmetrical pattern. Four identical galleries house indistinguishable officials, all bestowing the emperor's gifts to similar recipients. Alms giving is represented as a permanent feature of Constantine's rule rather than as a pictorial recollection of a specific act of generosity.

In the Constantinian reliefs, the illusionistic space of earlier Roman art has given way to a flat background aligned parallel to the relief surface. The architecture does not establish any illusion of three-dimensional space, yet we can identify the individual buildings. Crowds are represented by the ancient convention of superimposed registers. Compounding this lack of implied depth is the actual overall flatness of the modeling. A transparent plane seems to press against the figures, cutting off any projection into the spectator's space. Figures are simplified to geometric essentials: Drapery folds are reduced to patterned linearity; legs are like a row of tree stumps. Extensive drill work produces sharp contours and patterns of light and shadow. Finally, the composition is dominated by the strict rectangularity of the panel's shape—a "sovereignty of the frame." If we regard this new symbolic mode not from the point of view of

Roman art but from that of the Middle Ages, it emerges, like most Constantinian art, as an omen for the future.

Roman architects and engineers as well as sculptors and painters provided models. Later Christian builders learned from Roman practicality and efficiency, functional planning, excellent engineering, and creative use of strong, inexpensive materials. Throughout the Middle Ages, great brick and concrete walls and vaults towered over the columns and friezes of temples and basilicas, a constant demonstration of engineering skill to be emulated when Western builders tried again to cover large spaces with vaults. Roman secular basilicas, audience halls, and peristyles provided models for Christian churches. Roman imperial tombs and the Roman Pantheon, rededicated to the Virgin Mary and all the martyrs in 609, reinforced the idea of using centrally planned, domed buildings as martyrs' churches and baptisteries.

CONSTANTINE AND THE CHRISTIANS

As emperor, Constantine immediately began to undo the wrongs that his predecessors had visited upon the Christians. First he issued a decree whereby Christians would be tolerated and their confiscated property restored, then he recognized Christianity as a lawful religion. In a crucial pronouncement known as the Edict of Milan, issued in 313 in concert with the Eastern ruler, Licinius, Constantine formalized his earlier decrees. The text of the edict, a model of religious toleration, allowed not only to Christians but to the adherents of every other religion the choice of following whatever form of worship they pleased.

Giving religious freedom to both Christians and pagans should have assured the empire internal peace. But if Constantine expected the Christians to unite behind his government as a pious, harmonious people, he was disappointed. Christian theologians attacked each other with the same vigor that they directed toward unbelievers. A critical problem in the fourth century was the very definition of the nature of Christ. To most Christians the

indivisible equality of Christ's human and divine nature was essential. All the time he lived and died on the Cross as a man, Jesus remained the divine Son of God. Nevertheless Arius (d. 336), a Libyan priest in Alexandria, Egypt, argued that the Father, Son, and Holy Spirit were not one substance and that Christ, being a creation of the Father, was not identical with God. The Arian position was challenged by Athanasius (d. 373), who claimed that the three persons of the Trinity were of one substance. In 325 Constantine called a church council at Nicaea in an effort to establish a uniform Christian doctrine for the empire. The council accepted the Trinitarianism of Athanasius as the basis for the Nicaean Creed and declared Arius' doctrine heretical. Nevertheless, Arianism continued to flourish and to plague the Christian world.

As Persians and others living outside the frontiers challenged the Roman Empire, Constantine, ever the pragmatist, decided to move from Rome to a new headquarters nearer the troublesome East. After his defeat of Licinius in 324, he chose a superbly defensible site, Byzantium, a Greek port on the Bosporus at the eastern end of the Mediterranean. There, in 330, he dedicated a magnificent imperial residence. The city was called Constantinople, the city of Constantine, and throughout the empire it came to be considered the New Rome (see Chapter 3).

Until his death in 337, Constantine commissioned works of art and architecture for his new city, for he recognized the propaganda value of great public works. Pervading these monuments is an ecumenical spirit that reflects the emperor's calculated willingness to be all things to all people, and the universal toleration explicitly stated in the Edict of Milan. For his forum in Constantinople, he ordered a colossal statue of himself-a fulllength portrait incorporating objects revered by his people. Now lost, it was said to have combined Jewish, Christian, and pagan elements in a monument that enabled every citizen to regard Constantine as the defender of his or her own faith. A bronze figure of Apollo was turned into an image of Constantine by replacing the pagan god's head with a portrait of the emperor. Crowning the imperial brow was a diadem, which had in it one of the Crucifixion nails discovered by St. Helena. The base of the statue was believed to contain a marvelous collection of sacred objects: for Jews, an adz used by Noah to build the Ark and the rock from which Moses struck water in the desert; for Christians, crumbs from the loaves of bread with which Christ miraculously satisfied five thousand faithful, fragments from the crosses of the two thieves whom the Romans crucified with Jesus, and the jar of spices and ointment used by the Holy Women to prepare Christ's body for the tomb; for tradition-loving Roman citizens, the standard that had been carried to Rome from Troy by its mythical founder Aeneas. The monument typified Constantine's cosmopolitan, syncretic vision.

THEODOSIUS AND OFFICIAL ART IN THE LATER FOURTH CENTURY

The Pax Romana envisioned by Constantine faded with his passing. Not until the accession of Theodosius I in 379 were decisive steps taken to stabilize the empire. With external threats more ominous than ever, Theodosius determined to unify his subjects through religion. In a series of momentous edicts, he proclaimed Christianity for the first time to be the sole religion of the empire. By the time he died in 395, Theodosius had irrevocably transformed the Roman Empire into a thoroughly Christian state.

Theodosius, while condemning paganism, did not repudiate the imperial glorification of the emperor that paganism fostered. Official art in the second half of the fourth century continued to portray the emperor as a superhuman being. His artists intensified the formal principles developed earlier in the century—abstraction of natural forms, insistent frontality, rigid symmetry, and hieratic scale. In a stark and uncompromisingly symbolic manner they depicted the emperor as an omnipotent, divinely inspired sovereign.

A silver plate (missorium) made in 388 to mark the tenth anniversary of Theodosius' accession por-

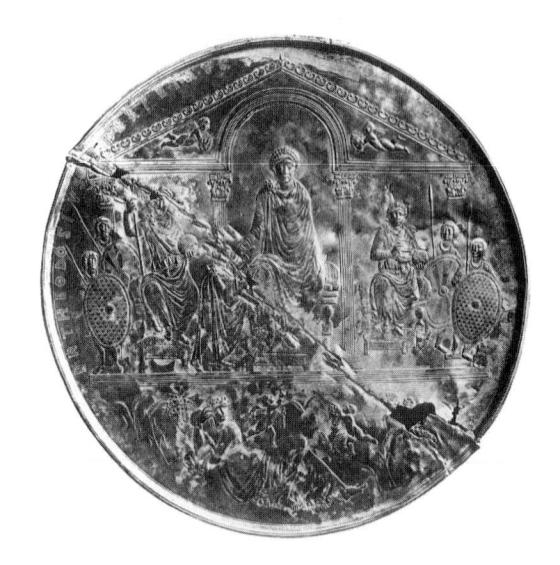

1.7 *Missorium* of Theodosius, found in Estremadura, Spain, 388. Diameter, 29 1/8in (74cm), silver. Academy of History, Madrid.

trays the emperor looming over an official to whom he presents a commission [1.7]. The artist has made hierarchic distinctions visible and explicit.

The emperor—rigid, frontal, and twice the size of any other man-is flanked by his co-rulers, his nephew Valentinian (d. 392) and his son Arcadius. They hold scepter and orb, and haloes circle their heads to indicate imperial majesty. The guards are smaller still and shown in the more informal threequarter view. The emperor's achievements and the prosperity of his reign are symbolized by a personification of Earth, who reclines at his feet, bearing the cornucopia of abundance and surrounded by plants and putti bearing offerings. Theodosius is majestically enthroned in a symbolic palace, an arched lintel and gable that also serve to isolate him and emphasize his position. The material vestiges of the classical heritage—idealized faces, personifications, and architectural forms—appear

in a space made immeasurable and irrational by the flatness of the relief. Bodies disappear beneath stiff ceremonial robes or behind decorative shield patterns, while mask-like boyish faces with stylized hair and jeweled headdresses seem to exist only to frame immense staring eyes. Not surprisingly, the style of such secular imperial work provided a fitting model for Christian artists when they began to represent Jesus as the Divine King with a court of apostles and saints.

Theodosius, like Constantine, made Constantinople his capital. Meanwhile, the city of Rome suffered political and economic decline although the city remained the administrative center of the Western Church (Alexandria, Antioch, and Jerusalem, as well as Constantinople were also major centers). To meet the threat posed by peoples such as the Goths, the government in the West moved northward first to Milan, which flourished under its great bishop, St. Ambrose, and then, at the beginning of the fifth century, to the safer retreat of Ravenna on the Adriatic coast (see Chapter 3). In 410 the Visigothic chieftain Alaric lay siege to Rome and finally entered its gates. The fall of Rome sent shock waves through the empire.

The idea of Roman unity and imperial grandeur, as expressed in Roman architecture and sculpture, remained an ideal and a model throughout the Middle Ages. Roman buildings, even in ruins, helped to keep alive the concept of international dominion, a concept adopted by the Christian Church and emulated time and again by later political leaders. Imperial capital cities—Constantinople in the East and Rome in the West—became Christian capitals. As the emperor and his family became patrons of Christian art, imperial Roman art became Christian art. Ultimately the Christian Church supplanted the Roman Empire as the unifying force in the Western world.

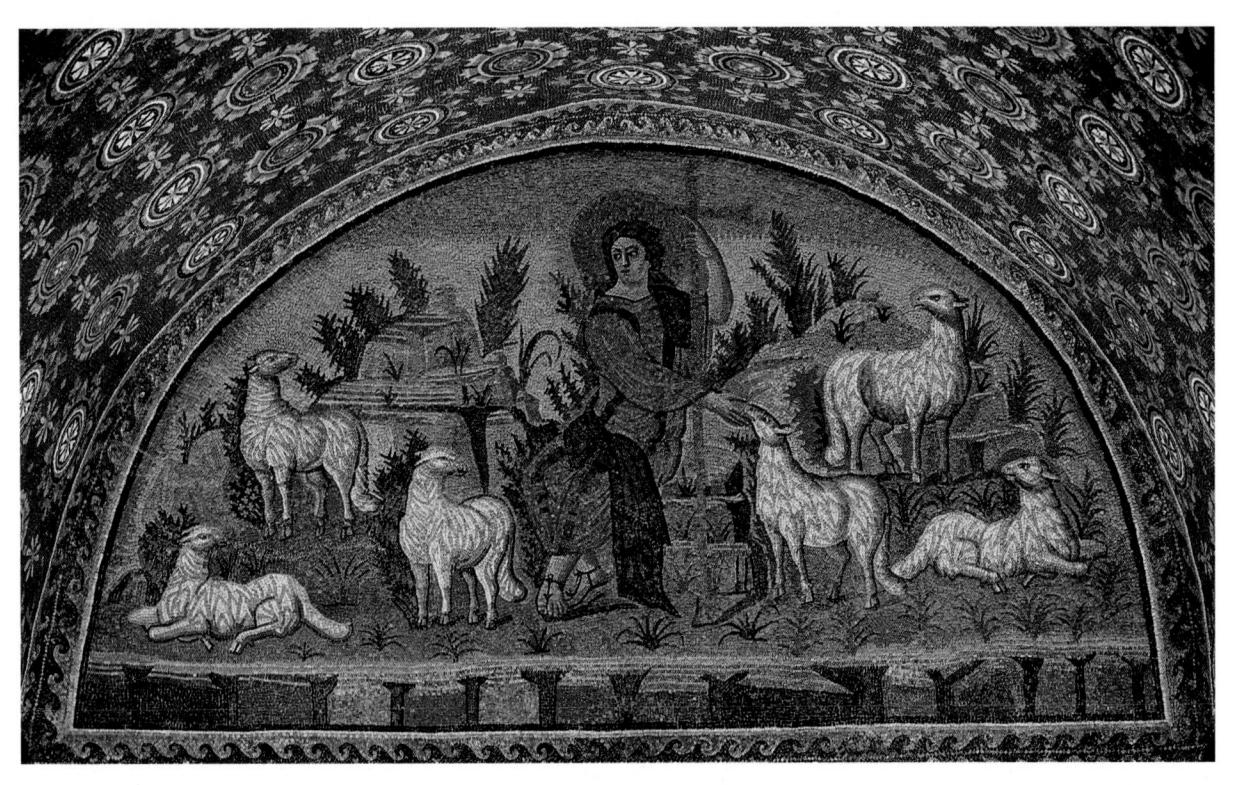

2.1 The Good Shepherd. Lunette mosaic over the entrance to the Mausoleum of Galla Placidia. 425-450. Ravenna.

CHAPTER

THE EARLY CHRISTIAN PERIOD

beautiful landscape, a handsome young shepherd, a flock of gentle sheep—even an urban dweller with no personal experience of country life can feel the sense of peace and security pervading the image placed over the door into the so-called Mausoleum of Galla Placidia [2.1]. The artists have tried to portray ideas and feelings rather than events. They communicate through symbols and metaphors, and they depend on the spectator to understand their meaning. The curly-headed youthful Christ reflects a type established centuries earlier for Apollo, the healer, and adopted by Alexander the Great to express his association with the divine sun. Christ sits in a mountain landscape and turns to comfort a lamb.

Everyone could interpret the image of the Good Shepherd according to his or her own tradition: A pagan could see the god Hermes or the shepherd Orpheus, and a Jew, the Good Shepherd of the Psalms; the Christian knew that the image symbolized Christ and the parable of the lost sheep (Luke 15:3–7). Churchmen might argue passionately over the nature of Christ, but artists followed the words recorded by St. John: "I am the Good Shepherd, the Good Shepherd lays down his life for the Sheep. . . " (John 10:11–16).

As the viewer's eyes wander over the mosaic surface, they are drawn to the glittering gold of Christ's robes and the imperial purple of his mantle. This is no ordinary shepherd but Christ, the

supreme ruler. The symmetry of the composition focuses attention on the golden cross. Christ's twisting movement and right arm also lead the eyes not only to the lamb but also to the tall, stemmed cross. The imperial staff joined to the Christian cross replaces the Constantinian Chi Rho monogram as the imperial standard and the symbol of the combined earthly and heavenly empires. The golden cross proclaims Christ's victory over death. That victory brings the hope of salvation for all faithful believers.

As they gaze at the lunette, the spectators are sheltered by a vault as splendid as any secular palace. A deep blue mosaic is spangled with stars—or are they flowers? The sumptuous pattern creates a twofold effect—it becomes the starry vault of heaven and recalls the flowering meadows of Paradise. The image of the Good Shepherd appeared in every medium—in paintings and mosaics, gold glass, and sculpture. It is found in tombs, catacombs, and baptisteries. What better image for the believers than Christ with his promise of new life?

JEWISH AND CHRISTIAN ART BEFORE CONSTANTINE

Social factors worked against the creation of significant Jewish and Christian art in the second and third centuries. Christians and Jews emphatically disassociated themselves from official Roman reli-

gious practices, including the veneration of images of many gods. Both religions expressed serious reservations about the representation of divinity. Sometimes the Biblical prohibition against graven images was interpreted as referring only to three-dimensional images, and sometimes representational arts of all kinds were forbidden. Among the earliest Christians the austerity of actual poverty as well as the denial of worldly goods as irrelevant, if not downright evil, also played a part in the rejection of art by some communities. Nevertheless, a vibrant artistic tradition existed in some Jewish communities and soon developed among the Christians as well.

The study of early Jewish and Christian art depends on chance survivals and especially on funerary art. In the twentieth century, remarkable religious art of many faiths came to light in Dura-Europos, a Roman city on the Euphrates River in Mesopotamia, which was destroyed in 256. Buried in the hastily erected city wall were a Jewish synagogue and a Christian house-church. Archaeologists also found temples dedicated to Zeus, Bel, Mithras, and many other gods. The Jewish community at Dura-Europos remodeled a private house into a large and splendidly decorated synagogue [2.2]. The hall with the niche for the Torah (the first five books of the Old Testament) was painted with scenes from the life of Isaac, Jacob, and Moses. Within decorative frames dividing the

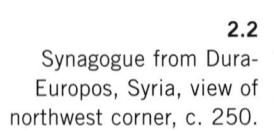

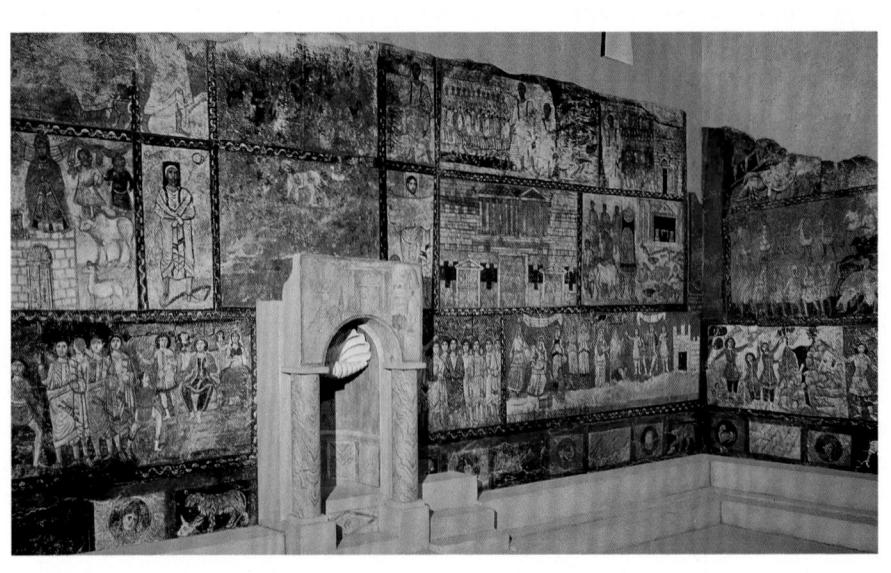

walls into rectangular panels, the stories unfold with quiet dignity. The painters worked in an abstract style that reduced the forms of people, animals, and architecture to simplified geometric shapes with strong outlines and flat, bright colors. The frontal figures engage the viewers' attention by looking out with huge staring eyes. The painters follow a visual convention known as hieratic scale in which size depends on importance rather than on relationships in space. Either a sharply rising plane or superimposed registers indicate distance. This abstract and decorative style, known throughout the Near East and Egypt, seems appropriate for the representation of anti-material religious beliefs. If painting of such clarity and vigor flourished in a border city like Dura-Europos, then surely a fully developed Jewish pictorial tradition must have been widespread.

The Christians also remodeled a house. Their house-church is an ordinary, modest home with rooms arranged around a courtyard. Except for one room, the baptistery, which had a rectangular font set in a niche framed by columns at one end of the hall, none of the rooms had any special architectural features. The date 231 was scratched in the plaster of one of the walls.

Paintings in the baptistery depict the fall of man and salvation through Christ, a recurrent theme in Christian art [2.3]. Behind the font the artist drew figures of Adam and Eve and the Good Shepherd, and on the side walls he depicted Christ's miracles and the Holy Women at the Tomb. The paintings are mere sketches with crude figures scattered irregularly over a light, neutral background. The painter ignored the physical beauty of human beings and their world in the attempt to communicate an important message. The Good Shepherd combined with Adam and Eve reminded the newly baptized Christians of their sins and at the same time the promise of salvation affirmed by St. Paul in a letter to the Corinthians: "For just as in Adam

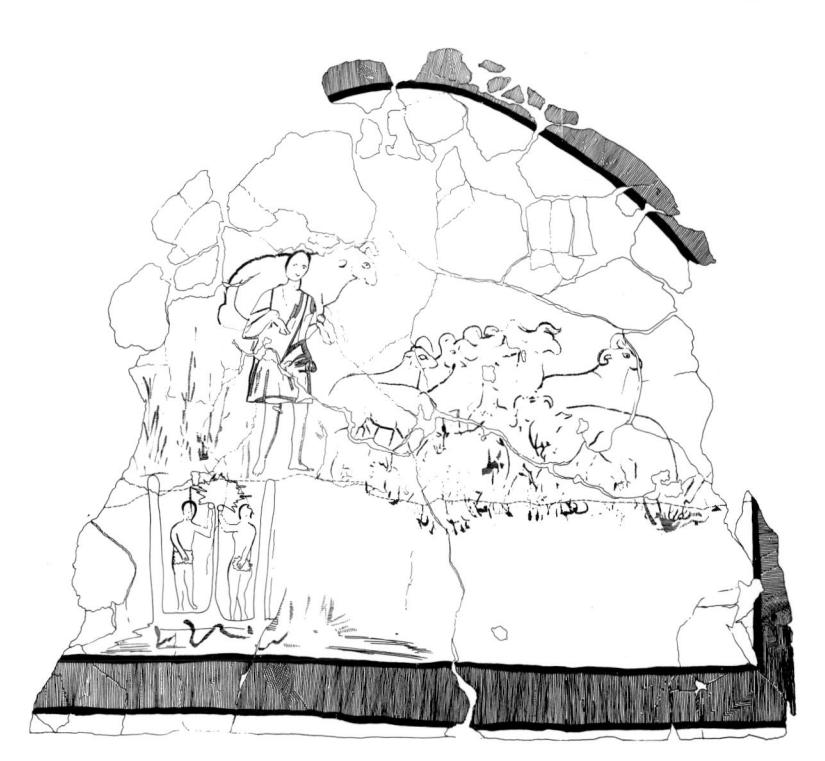

2.3 The Good Shepherd, baptistery in the Christian House, Dura-Europos, before 256. Drawing by Henry Pearson. The Yale University Art Gallery.

all die, so in Christ shall all be made to live" (I Cor. 15:22). Even this earliest Christian art is an art of stories and allegories intended to state and reinforce Christian doctrine.

In Rome, funerary art provides evidence for Jewish and Early Christian art. Paintings and some sculpture are found in the underground cemeteries known as catacombs. Catacombs consisted of narrow streetlike tunnels with niches in the walls (loculi) to hold the dead. Chambers (cubicula) provided additional space for loculi and for simple funeral rites. With increasing demand for space, a catacomb became a complex maze of passages and chambers on many levels, a veritable necropolis, or city of the dead. Catacombs were not secret places (an idea spread by nineteenth-century Romantic writers). Commemorative services and funeral banquets took place openly in large halls and churches built above ground in the cemeteries.

Pictures appropriate for the beliefs of the owners covered the walls of the catacomb chambers. Jewish catacombs might have the Ark of the

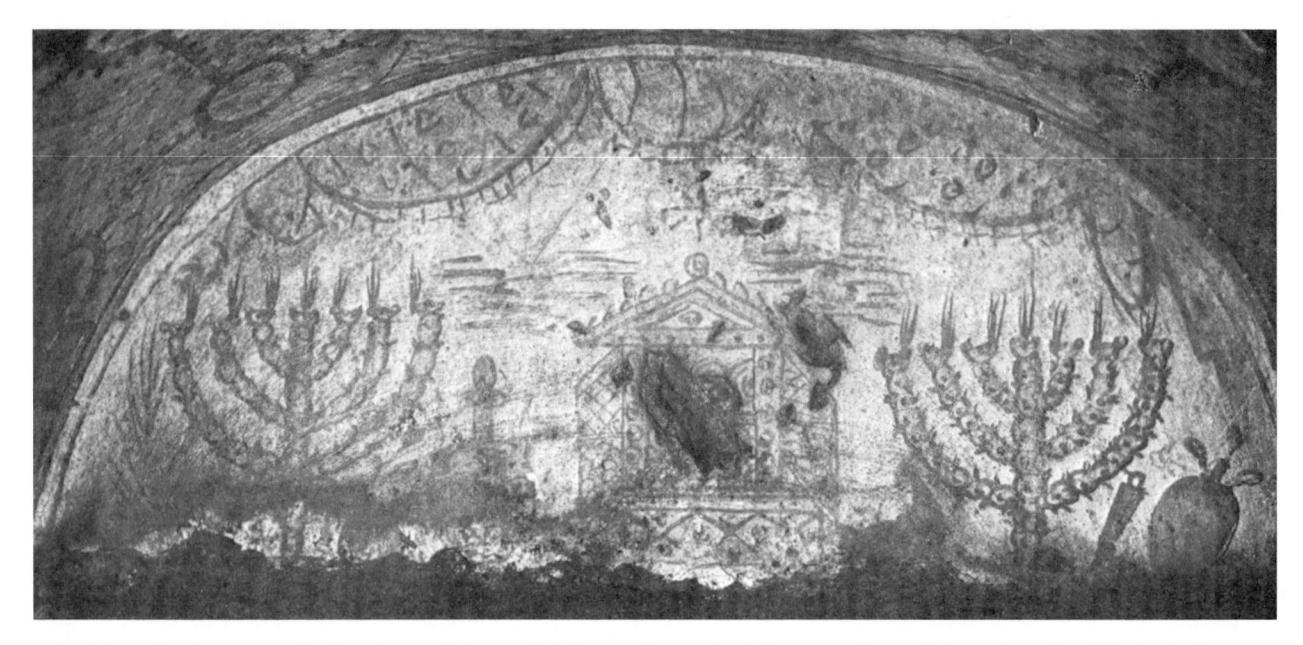

2.4 Ark of the Covenant, flanked by candelabra. Painting at the back of the arcosolium. Catacomb in the Villa Torlonia, 3^{rd} – 4^{th} century. Rome.

Covenant, the menorah, and other symbols painted on the walls [2.4]. Traditional Romans might decorate walls with the vines of Bacchus, or with Orpheus or Hermes.

In the decoration of the underground chambers, the painters worked in the current illusionistic style, modeling forms with loose, fluid brushwork and subtle colors. Although the final effect of illusionistic painting is one of spontaneous ease, the technique actually required great control, care in execution, and thoughtful composition. In the hands of lesser artists, it could all too easily become sketchy shorthand, as is apparent in the painting of the baptistery at Dura-Europos and in many catacombs. The distinction between imperial and popular art is all too often one of quality and in the case of Christian or Jewish art, one of iconography—that is, subject matter and its interpretation. The abstract quality inherent in Roman illusionism, developed in late imperial art and characteristic of Near Eastern art (such as the Dura Synagogue paintings) became an effective instrument for the expression of a new antimaterialistic vision of the world.

Sometimes only the context identifies the work as Christian. As we have seen, a shepherd in a land-

scape could be Christ but might be Orpheus or Hermes. A harvest scene with putti did not necessarily convey the image of the vineyard of the Lord and the wine of the Eucharist but might also be interpreted as the wine of Bacchus. A fisherman, a flock of sheep, an anchor, a praying soul (hands upraised and known as an orant), a shepherd, or a seated philosopher—none of these figures has overtly Christian meaning. Yet when they are found in a clearly Christian context they can be identified with the Fisher of Souls, the Good Shepherd, Christ the teacher, the congregation of faithful Christians, and symbols of hope and prayer.

The Catacomb of Priscilla has some of the finest surviving Early Christian painting. The Cubiculum of the Veiled Lady illustrates the typical arrangement of the paintings and the adaptation of themes by the Christians [2.5]. Black, red, and green lines divided the creamy white ceiling into symmetrical fields. Four lunettes surround a central medallion and create a shape that suggests the canopy of the heavens with a vision of paradise through a central opening. This central medallion frames the Good Shepherd, an idealized youth effortlessly bearing a sheep on his shoulders and standing in a landscape

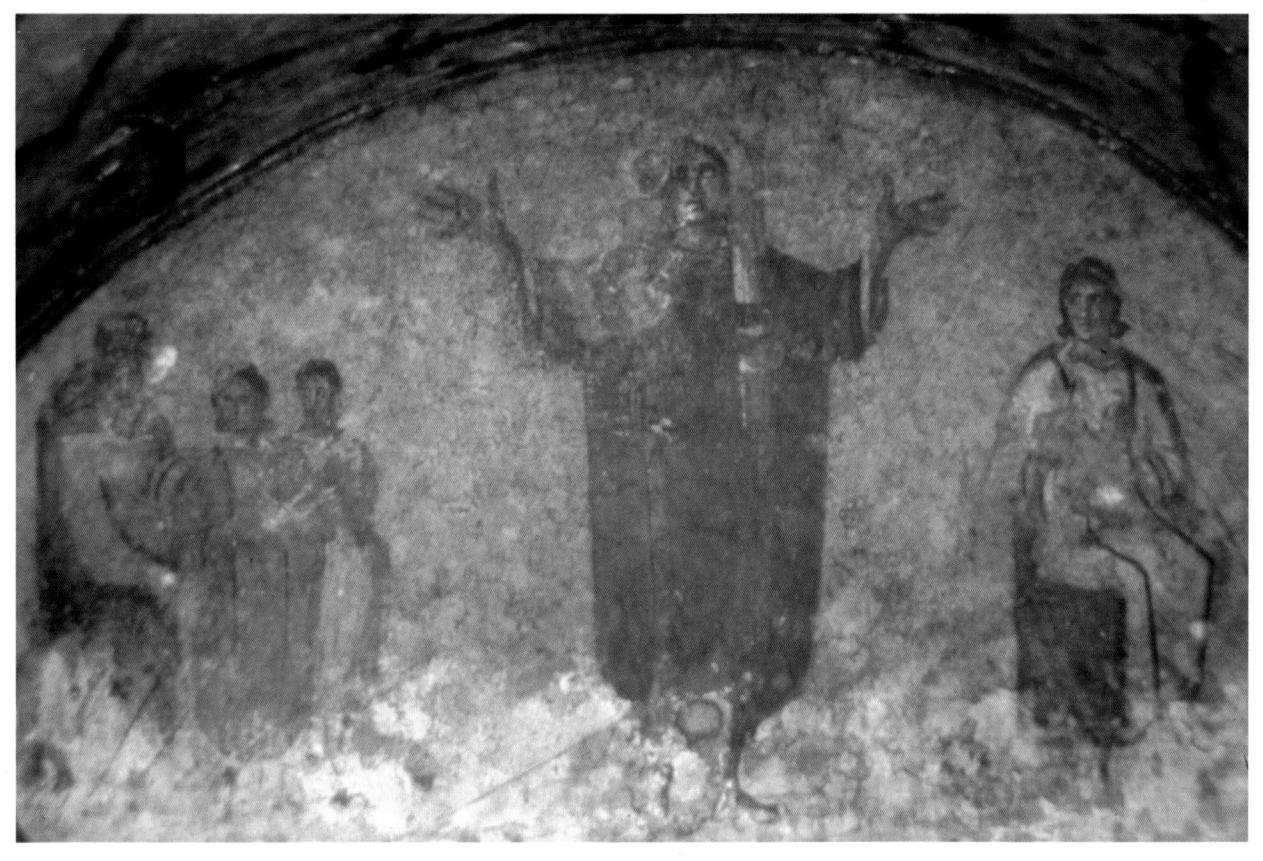

2.5 Teacher and Pupils, Orant, and Woman and Child, wall painting in a lunette. Cubiculum of the Veiled Lady, Catacomb of Priscilla, 3rd century. Rome.

between two more sheep. Doves stand among flowers, and leaves fill the lunettes on the ceiling and rectangular panels on the walls. The artist has copied the typical secular wall decoration of foliage, birds, and flowers set in fanciful painted architectural frames found in fine Roman houses; however, in the context of the catacomb the painting suggests the Christian soul in the gardens of paradise.

The Catacomb of Priscilla is a veritable painting gallery filled with images of salvation [2.6]. The artist could have been inspired by Jewish and Christian prayers, which enumerated examples of God's intervention on behalf of His people. "Deliver, O Lord, the soul of thy servant as thou didst deliver Noah in the flood . . . Isaac from the sacrificing hand of his father . . . Daniel from the lion's den . . . the three children from the fiery furnace. . . . "

The Hebrew youths condemned to the fiery furnace (Daniel 3), wearing the Persian dress associated with Mithras or Zoroaster, stand with their hands raised in the ancient gesture of prayer as the flames whip around them. The figures are merely green shapes touched by yellow; hands, faces, and flames are sketched in with a few strokes of red and orange. Yet, in spite of the simplification of the forms and the economy of the brushwork, the story and its message would have been clear to Jews and Christians alike. The presence of the Holy Spirit, in the form of a dove bearing foliage that could be either the palm of victory or the olive branch of peace, indicates that the flames were powerless to harm the believers. The mood of the catacomb paintings remains hopeful and even joyous. Believers waited confidently for the release of death, for salvation, and for the eternal bliss of paradise.

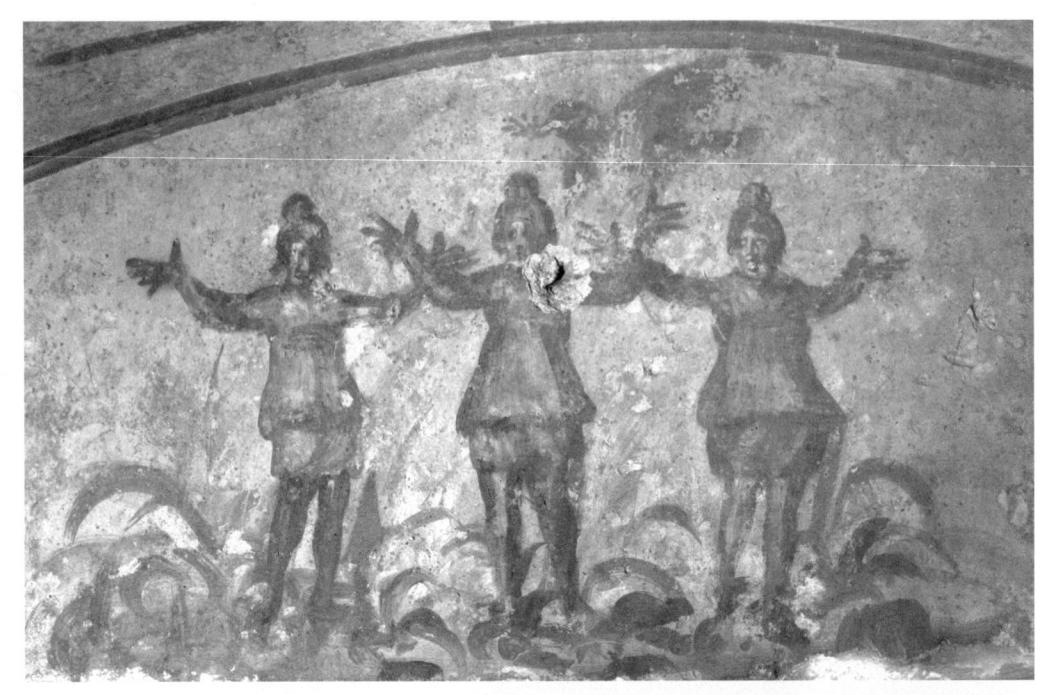

2.6 Three Children in the Furnace, Catacomb of Priscilla, 3rd century. Rome.

Single images, as well as narratives, conveyed Christian messages. The palm was an emblem of victory whether given to a victorious athlete or to a Christian martyr (one who died for his faith) who triumphed over death as an "athlete of God." A dove indicated the presence of the Holy Spirit. The anchor became a symbol of hope. The cross, however, was usually disguised as the mast of Jonah's ship, a T-shaped (tau) cross, or an Egyptian looped cross (the ankh, symbol of life). Only in the fourth century, after Constantine's vision and Empress Helena's discovery of the True Cross, did the cross become the principal Christian symbol.

At first, the most common and important early Christian symbol was the fish. The fish had many meanings. It signified Christ, for the word "fish," as a cryptogram on the Greek word *ichthus*, spelled out the first letters of the phrase "Jesus Christ, Son of God, Savior." Christ had called on his disciples to be "fishers of men," and thus the fish stood for the Christian soul swimming in the water of baptism, to be caught and saved by the Fisher of Souls. Christ fed the multitude with fish (baptism) and loaves (the Eucharist). In such ways

2.7 Mother and Child, Catacomb of Priscilla, $3^{\rm rd}$ century. Rome.

did the Christians give multiple interpretations to apparently simple subjects.

Some images seem perfectly clear even today. In the Catacomb of Priscilla, the nurturing theme of mother and child has been interpreted as the earliest representation of Mary and Jesus [2.7]. The man pointing to a star may be the Prophet Isaiah
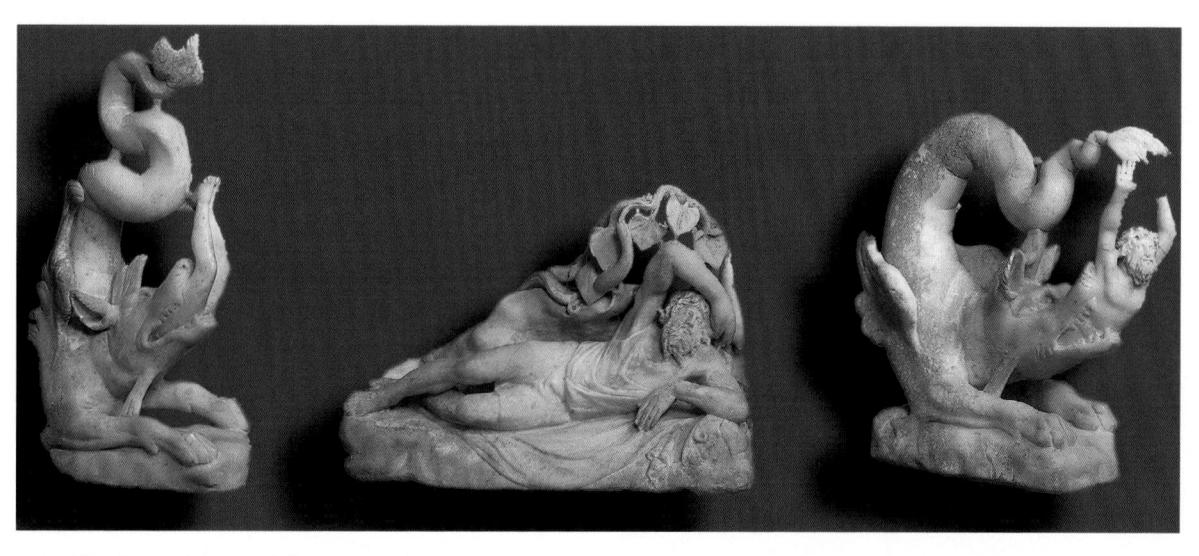

2.8 The Story of Jonah, 3rd century. Asia Minor. Marble 12–21in. high (30.5–53.3cm). The Cleveland Museum of Art.

foretelling the birth of Christ (Isa. 7:14) or the priest-diviner Balaam (Numbers 24:17), who prophesied, "A star shall come out of Jacob, and a scepter shall rise out of Israel." A skillful artist has captured the image of a squirming child and protective mother. The reduction of illusionistic modeling to flashes of color touched with brilliant highlights suggests the dematerialization of form typical of late Roman art.

In Early Christian sculpture, like painting, subjects are often ambiguous. The carvers adapted pagan and Old Testament themes for their new Christian patrons. The Jonah story, for example, is told in a remarkable series of statuettes now in the Cleveland Museum of Art [2.8]. Freestanding sculpture from the Early Christian period is rare, and these figures illustrate the difficulty of assigning a date and place of origin for many works of art. Scholars now suggest that they are the product of a workshop active in the third quarter of the third century somewhere in Asia Minor where classical Hellenistic influence remained strong. Even the function of the figures is unclear. Who ordered them, and why? They could have come from a tomb or a baptistery. They might have been fountain ornaments in a private Christian home. In two of the statuettes, the sea monster swallows and spews forth Jonah with a vigor that recalls the

intricate compositions of Hellenistic Greek sculpture. A third statue illustrates Jonah reclining under a vine like the classical shepherd Endymion. The Cleveland group also includes a Good Shepherd, a praying Jonah, and six portrait busts. The figures are highly finished, and the details of head, hair, and anatomy are skillfully treated. The sculptor had clearly not lost contact with his classical heritage and could, when called upon, create remarkably expressive idealized figures.

Christian sculpture in the round was rare in the third century, but mosaic—the monumental and expensive medium that was to become one of the glories of Early Christian and Byzantine art—is even more unusual. One of the earliest Christian mosaics known today was found in the Mausoleum of the Julii in the cemetery under St. Peter's Basilica in Rome and is dated to the end of the third century [2.9]. Like so much Early Christian art, the mosaic at first appears to have a pagan subject: the vineyard of Bacchus and a charioteer. Like Helios crossing the sky in his chariot, the man has beams of light streaming from his head. The walls of the mausoleum, however, were painted with Jonah, the Fisher of Souls, and the Good Shepherd. Consequently, in the mosaic the vine symbolizes the Eucharistic wine, making the charioteer none other than Christ ascending to Heaven. The

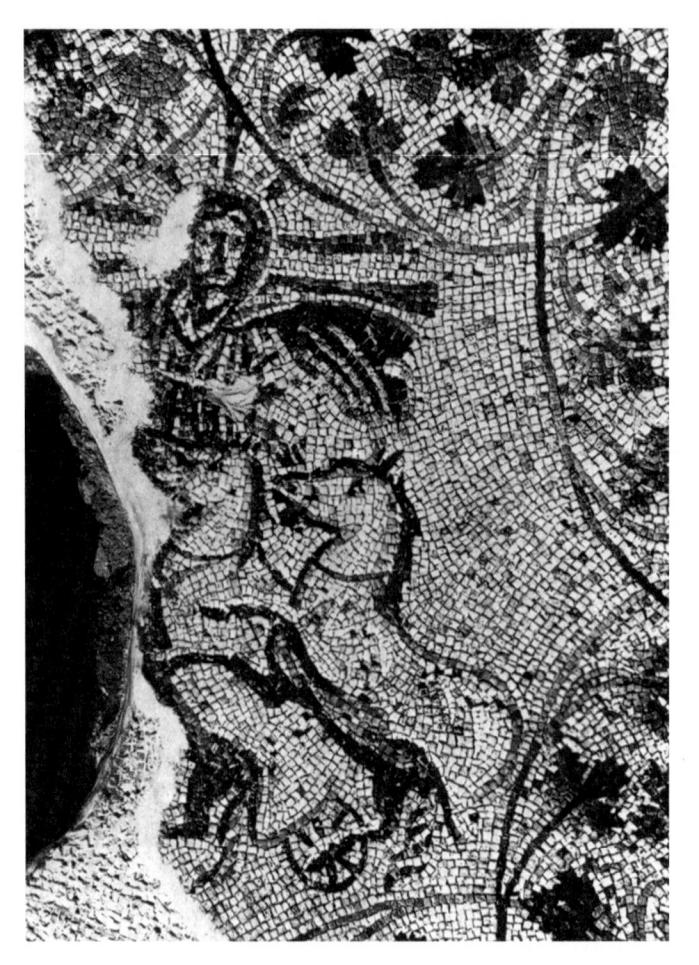

2.9 Christ/Helios. Mausoleum of the Julii, 3^{rd} century. Mosaic, 78×64 in. (198.1 x 162.6cm). Vatican.

image of the charioteer has a long history in art. In the Near East he symbolized astral bodies and the cosmic power of the ruler. In pagan Rome the heavenly charioteer carried a deceased emperor into the heavens at the moment of apotheosis. The charioteer could also represent the Victorious Sun, Sol Invictus. The triumphant visual equation of Christ as Light of the World with Helios and cosmic power, and Christ's Resurrection with an imperial apotheosis, indicates the growing strength and confidence of the Christian community. In this mausoleum, at least, the Christian owners and the artist adopted the most imposing imperial symbolism for their image of Christ.

If Christ/Helios appears brilliantly simplified, the effect is due in part to mosaic as the medium.

Mosaic lends itself to simplification and abstraction, for repeated geometric patterns, such as the vine leaves, are easy to set, and they produce handsome decorative effects. A skilled artist working with small tesserae of many shades can imitate the illusionistic effects of painting, and Roman mosaicists had learned to reproduce natural forms, usually in strong colors against a light background. But in the modeling of the charioteer's cloak and tunic or in the horses, for example, shadows and highlights are exaggerated and repeated so that they begin to form independent patterns, almost like drill work in sculpture. Through repetition and misunderstanding, techniques that began as rapid, easy ways to achieve an illusionistic effect eventually led to a new style. When this abstract mode also served to express a new definition of reality—when abstract form and spiritual content coincided—a new medieval style emerged.

Christian art flourished when people from a level of society accustomed by wealth and education to patronize the arts began to enter the Church in large numbers. These cultured Romans commissioned painting and sculpture in the current local style, changing only the interpretation of the subject matter. The development of a style is not a self-conscious act. The earliest artists working for Jewish and Christian patrons represented new subjects, but obviously it did not occur to anyone that they should create a new style in order to do so appropriately. The Late Antique style current throughout the Roman Empire, combined with increasingly strong influence from the Near East and the north—the people outside the borders of the empire-gradually produced an art in which the physical appearance of material objects and their spatial relationships were unimportant. Artists denied the physical world and conveyed the essence of the scene through expressive glances and gestures. Late Roman art had become abstract and expressionistic in style before it became Christian in content, but artists working for Christians enhanced and consciously developed these tendencies until painting, sculpture, and mosaic approached the ideal described by the philosopher Plotinus, "an appropriate receptacle . . . seeming like a mirror to catch an image of [the Soul]."

CHRISTIAN ART IN THE AGE OF CONSTANTINE

A reluctance to raise the visual arts to a position of prominence persisted among many Christians. Nevertheless, the practical value of art as an instrument of instruction and the desire for monumental commemoration encouraged the creation of images and buildings that might otherwise have been considered too worldly, too ostentatious, and too reminiscent of pagan idolatry. Sculpture in the round was particularly vulnerable to the charge of idol worship. Except for portrait busts or small figures of the Good Shepherd, Christianity encouraged figurative sculpture only on sarcophagi.

When the Roman prefect Junius Bassus died on August 25, 359, at the age of 42 years and two months, he held one of the two highest official

positions in the city government. Aristocratic, wealthy, and politically powerful, he was baptized on his deathbed. All funerals were ceremonial moments for the family, and the sarcophagus becomes a central focal point, replacing the deceased and emphasizing family ties and aspirations. Junius Bassus was interred in a splendid sarcophagus displaying a complex narrative program [2.10].

The sarcophagus of Junius Bassus was carved on three sides as if it was intended to stand in a mausoleum or in a garden cemetery. Instead the family placed it as near as possible to the tomb of St. Peter in the Vatican. The patrons and carvers of the sarcophagus seem to have been concerned with two themes—the guarantee of salvation and the triumph of the Roman Christian Church. Ten scenes from the Old and New Testaments occupy two horizontal registers and are set forth as if in tabernacles, framed by freestanding ornamental columns supporting an architrave of alternating shells and gables. The sculpture is the work of an iconogra-

2.10 Sarcophagus of Junius Bassus, Rome, c. 359. Marble, approximately 4 x 8ft. (1.22 x 2.44m). Vatican.

Types and Typology

In Christian art and thought Typology refers to the foreshadowing of persons and events in the New Testament by events in the Old Testament. The word "type" comes from a Greek word meaning figure or example. Christ himself used Jonah's three days in the belly of the sea monster as an example—the type—of his own resurrection. Moses and the brazen serpent prefigure the crucifixion; Abraham's preparation to sacrifice his son Isaac, prefigures God's sacrifice of His son, Jesus.

Typology was never a fixed system of correspondences, and individual scholars, patrons, and artists devised increasingly complex systems in the eleventh and twelfth centuries. In enamels that are now assembled as an altarpiece (see Ch. 9) Nicholas of Verdun divided the Old Testament types into events occurring before and after Moses received the Law. Nicholas set up a three-part system in which the New Testament antitype was flanked by Old Testament types; for example, on the theme of betrayal, the Pre-law type is Cain slaying his brother Abel; the New Testament antitype is the Kiss of Judas, the betrayal of Christ; the Post-law type is Joab slaying Abner, whom King David had granted safe conduct.

In another system medieval scholars recognized four levels of interpretation: the literal, the allegorical, the moral (tropological), and the spiritual (the consideration of divine reality or anagogical interpretation).

pher or master sculptor who knew the conventions of the Passion cycle so well that he felt free to use traditional images and to improvise new ones. He may have invented the image of Christ enthroned in majesty above the personified heavens, an image traditionally associated with Jupiter. To combine the image with "the handing down of the law" (tradio legis), the moment when Christ designates Sts. Peter and Paul as his successors, was ingenious. Next to this image is the martyrdom of Peter (a rare image thought to have been used first in the apse mosaic of St. Peter's). Below is the Entry into Jerusalem, which begins the Passion cycle.

At the right Christ stands in front of Pontius Pilate, who, washing his hands, initiates the sacrifice that will lead to Salvation. All around are Old Testament prefigurations (types)—Adam and Eve, whose sin made necessary the sacrifice of Christ, Abraham and Isaac, Daniel and the lions (a togaclad figure replaces the original nude), and Job and his wife. Peter and Paul, the first saints in the Canon of the Mass, frame the image of Christ with their own martyrdoms. The emphasis on these saints affirms the second major theme on the sarcophagus—the triumph of the Roman Catholic Church through the local saints, Peter and Paul.

Architectural elements break up the surface into evenly measured units. The evenly disposed columns, gables, and entablature impose a sym-

metrical composition. Stage-like settings and figures completely fill the neutral background, and tiny trees and buildings further suppress the illusion of measurable space. The figures are short, muscular actors who move beneath form-revealing drapery, and their gestures are both dramatic and convincing. The conflict between the human images and their unreal, stagelike environment testifies to the lingering appeal that classical forms still held for wealthy Christian Romans.

The sarcophagus of Junius Bassus had an imperial size and proportions. Typical of Christian sarcophagi is the Passion Sarcophagus [2.11] from the Catacomb of Domitilla. Here symbol and narrative have been harmoniously merged. Again a few figures suggest a larger story, that is, each panel functions like an abstract emblem. Christ is arrested and brought before Pilate, who by his symbolic washing of hands leaves the Lord's fate to the will of the multitude. At the left a Roman soldier mockingly crowns Christ with a wreath of thorns, and then Simon of Cyrene seeks to lighten Jesus' burden by carrying the Cross, an act indicating the obligation of every Christian metaphorically to bear the Cross after Christ. The Crucifixion and Resurrection are implied, not represented. In the central panel, doves, symbols of peace and purity, perch on the arms of the Cross while overhead hangs the laurel-wreathed Chi Rho seen by Con-

2.11 Passion Sarcophagus, Catacomb of Domitilla, second half of 4th century. Rome.

stantine and thus understandable as an allusion to the triumph of the Church. However, the most striking innovation, combining symbol and narrative as never before, is the inclusion of the two sleeping figures. Sent to guard Jesus' tomb, they are the soldiers who watched in vain, unaware of the miracle of the Resurrection. Their presence reminds us that the Chi Rho stands not only for Christ's monogram and Constantine's victory, but also for Christ's own victory over death—the moment when the Lord triumphantly rose from the sealed tomb. With Jesus appearing not in human guise but under the sign of His Holy Name, we enter the symbolic world of the Middle Ages.

ARCHITECTURE

The modest buildings and houses adequate for the simple Early Christian service became inappropriate once Constantine recognized Christianity as one of the state religions. Christian architects had new problems to solve. The ever-present symbolic focus of Christianity demanded that the Church signify both the house of God and the tomb of Christ. The building had to be majestic, worthy of the Ruler of Heaven. Furthermore, this heavenly mansion on earth had to house the entire Christian community. In their efforts to create an imposing architecture, Early Christian builders rejected Roman temples and turned to the civil basilica and the tomb for inspiration.

Roman secular basilicas were large, rectangular halls that served as places for public gatherings, such as law courts, markets, and palace reception rooms. A basilica could be a simple hall with a trussed timber roof, or it might be extended by colonnades and aisles. Lower levels with shed roofs over the aisles allow the upper wall of the central aisle to be pierced with windows (the clerestory). In addition, a basilica had one or more semicircular apses projecting beyond the walls. The apse of a civil basilica provided an imposing site for a judge's seat, an emperor's throne, or the *image* of the emperor. In a church it housed the clergy and altar.

In their churches, Christians adapted the basilican form to their own purposes. At the end of the hall a single apse housed the clergy and the altar, while the hall served the congregation. The entrance was placed opposite the apse so that, on entering, the worshipper's attention was immediately focused on the sanctuary. This longitudinal orientation of the building also provided space for processions. Thus, both conceptually and functionally, the basilica fulfilled the congregational needs of the Early Christian Church.

Constantine and his successors built splendid churches to vie with pagan temples and to dignify Christianity as an official religion of the empire. Although he commissioned huge buildings for the Christians and lavished riches on their interiors, Constantine built churches with simple exteriors and placed them in the outskirts of Rome,

The Christian Basilica: Sta. Sabina

Sta. Sabina, Rome. Exterior of apse. 422–432.

The Church of Sta. Sabina in Rome, built between 422 and 432 (and carefully restored in the 1930s) gives us a good idea of the appearance of the Christian basilica. Like the pagan secular basilica, the church consisted of a rectangular hall with a high central nave flanked by lower side aisles. A colonnade divides the nave and aisles. Sta. Sabina's nave had long, tall pro-

portions (length 148 feet or 48 m., width 48 feet or 13.50 m., height 61 feet or 19 m.). Clerestory windows pierced the upper nave wall. Between the nave colonnade and the clerestory, a wall (the triforium) covered the blind space formed by the sloping roofs over the aisles. A raftered roof covered the nave. The nave ended in a semicircular apse covered by a half-dome vault. The juncture of apse and nave wall was called the tri-

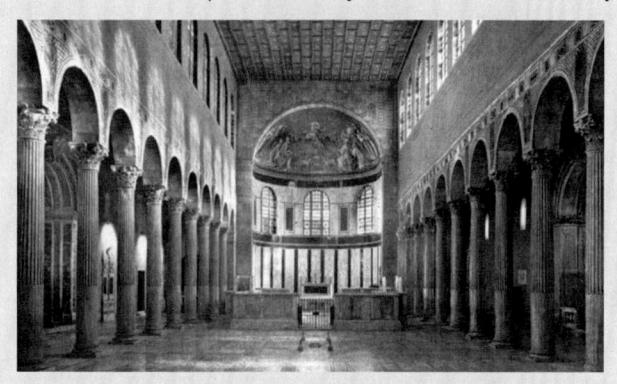

2.13 Sta. Sabina, Interior of nave.

umphal arch. Mural decoration in painting or mosaic covered the apse and triumphal arch, and colorful marbles were used on the triforium, outer wall, and floors.

The church was oriented, with the altar at the east, except in Constantinian churches like St. Peter's. The altar stood at the front of the apse under a canopy supported by four columns (the baldachino or ciborium). In the apse, curving benches for the clergy followed the line of the outer wall. The choir, defined by low walls or the choir screen, stood in the nave in front of the altar.

An entrance porch (narthex) and usually a

colonnaded open courtyard (the atrium) stood in front of the church at the west. The doorway into the nave might be decorated, but generally the exterior of the church was unadorned. Sta. Sabina had carved wooden doors, parts of which have survived. Additional features (not seen in Sta. Sabina) might include galleries over the aisles for women (the matroneum), a crypt under the apse, a separate bell tower, and in Constantine's buildings sometimes cross aisles or a transept. Additional rooms might be added to accommodate special requirements such as the prothesis, where the wine and bread for the Eucharist were prepared and stored, and

the diaconicum, where the deacons kept archives, books, vestments, and other church treasures.

Sta. Sabina, Plan. This is a good example of the small, basilica-plan Christian churches built throughout the city once Christianity became established as the state religion.

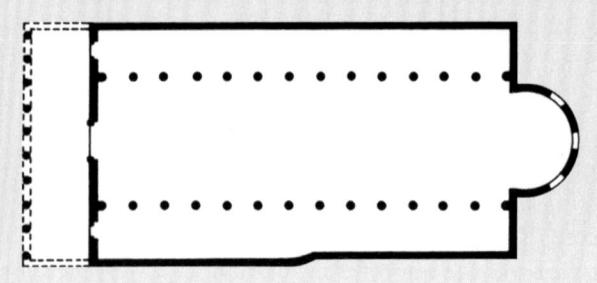

often on imperial property. Of course, cemeteries with their martyrs' shrines lay outside the city walls. The emperor may have wanted to avoid offending the pagan Romans who still held political and economic power. It is estimated that in Constantine's time the city of Rome had a population of almost 800,000 (down from a high of a million or a million and a half) of whom one third were Christians or had Christian sympathies. The wealthy, politically powerful classes remained pagan, with a few exceptions like the prefect Junius Bassus.

The Church of St. John Lateran is Constantine's first imperial Christian building. As early as 312 Constantine donated the Palace of the Laterani and the imperial horseguard to the Christians to serve as a residence for their bishop (the administrative head of the church). The bishop's church, consecrated on November 9, 318, is still the Cathedral of Rome—that is, the church in which the Pope presides as the bishop and has his throne (cathedra). Early descriptions of the Lateran Basilica, originally dedicated to Christ but now to St. John (S. Giovanni in Laterano), enable us to imagine the appearance of the Constantinian church [2.15]. The original building is hidden by Francesco Borromini's seventeenth-century

structure.

The ciborium and altar provided the focal point of the church [see 1.3]. The basilica, entered now from the narrow gable end, was a vast rectangular space divided by four rows of columns into a wide nave flanked by double side aisles. The colonnade and entablature accentuated the longitudinal focus of the nave, directing the viewer's eye to the sanctuary, a ceremonial path illuminated by clerestory windows at the end of the nave. The triumphal arch signified the triumph of Christ about to take place symbolically at the altar. In this sense the arch marked a dividing line between the worldly nave and aisles and the sanctified space in the apse.

Passing through the portals, the worshippers entered a light- and color-filled space. No ex-

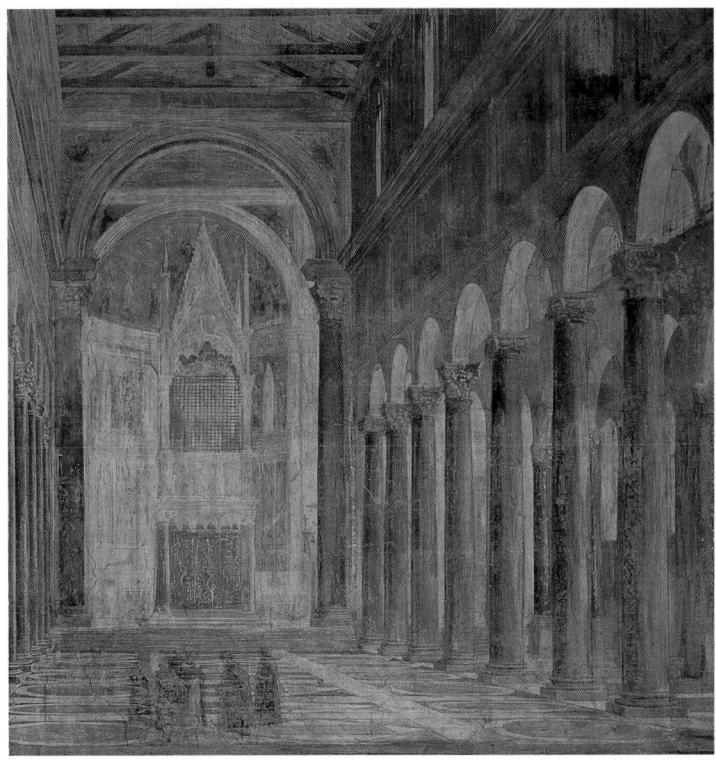

2.15 Interior of the Lateran Basilica before its reconstruction in the $17^{\rm th}$ century. S. Martino ai Monti, Fresco, Rome.

pense was spared on glittering veneers and fine furnishings. Gold foil covered the timber roof, picking up the color of the red, green, and yellow veined marble columns. More than a hundred chandeliers and 60 candlesticks, all of gold and silver, produced a shimmering light that was reflected off seven golden altars and silver statues of Christ and the apostles. Although inspired by the pomp of the imperial court, the magnificence of the church was justified as an attempt to re-create on earth the splendor of the House of the Lord in Paradise.

If the church building had been oriented solely around a congregation assembled to participate in the Mass, the basilica would have provided a model wholly satisfactory to later architects, but the organization and devotional character of Christianity had grown remarkably complex. Just as the Mass had developed from a simple commemorative meal shared in a private home to an

intricate ritual performed within the sanctified space of a church, so too Christian devotions came to encompass the saints and martyrs who sacrificed their lives as witnesses to their faith.

To aid them in their prayers for intercession, Christians wanted to associate themselves with a martyr (from the Greek for "witness"), to possess a relic of the saint, or, if a relic was not available, a strip of linen (called a brandea) animated by a relic. Eventually the inclusion of relics transformed every altar into a symbolic tomb as well as into the sacred table of the Mass. Whereas an altar or a small shrine initially marked a martyr's burial or an especially holy place, when thousands of pilgrims began to visit, buildings known as martyria had to be erected to accommodate the crowds and to protect the relics. Cemeteries became crowded not only with tombs but with facilities for funeral and commemorative banquets and shrines of the martyrs—that is, funeral basilicas and martyria.

Such a complex with a basilica, funeral basilica, and catacomb arose on imperial lands outside Rome around the burial place of St. Agnes (S. Agnese) beside the Via Nomentana [2.16]. A funeral basilica combined the features of a covered cemetery, a banquet hall, and a church where commemorative banquets ended with the celebration of the Mass. Graves filled the building, and tomb slabs paved the floor. To enable the congregation to approach the altar and to pass by the relics in the shrine under the altar, the builders projected the side aisles into an aisle encircling the apse (an ambulatory), making a U-shaped plan. This ambulatory permitted people to walk around the altar, at the same time protecting the relics from the possibility of desecration. Thus, a new type of church developed in response to the practical requirements of the veneration of martyrs and the dead.

Tombs joined basilicas in the expanding repertory of Christian architectural types. The typical pagan mausoleum was a tall chamber, square, polygonal, or circular in plan, and often covered by a dome, symbolic of the Dome of Heaven. The mausoleum of Constantine's daughter (dated some-

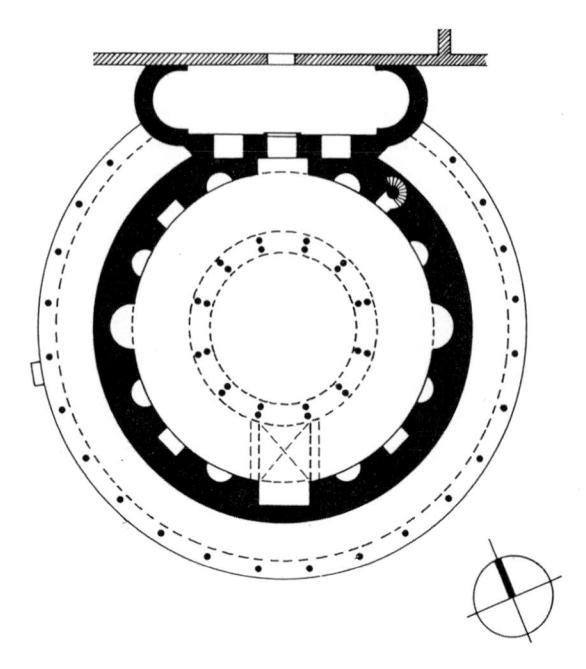

2.16 Plan, Church of Sta. Costanza, c. 350. Rome.

time between the death of Constantine in 337 and of the princess about 351) is a typical circular central domed structure extended with an encircling ambulatory [2.17]. The exterior is unadorned, but inside, twelve pairs of columns support the dome on an arcade and clerestory wall. A barrel vault covers the circular ambulatory. Four niches (one of which includes the entrance and one, the space for Constantina's sarcophagus) suggest the form of a cross. Twelve windows lighting the central space may symbolize the twelve apostles. Today the tomb is the Church of Sta. Costanza, another form of the princess's name.

Constantina was a Christian but the aggressive paganism of her two husbands may have influenced the decoration of her tomb. The decoration of the dome (lost), the ring vault of the aisle, and the niches combined religious and secular themes [2.18]. A host of cupids, libation vessels, assorted birds, foliage, and the ever-present grapevine come together in a celebration that could be interpreted as either Bacchic or Christian. Clearly the artists came from the syncretic milieu of the Constantinian court. The mosaics, with their pagan motifs

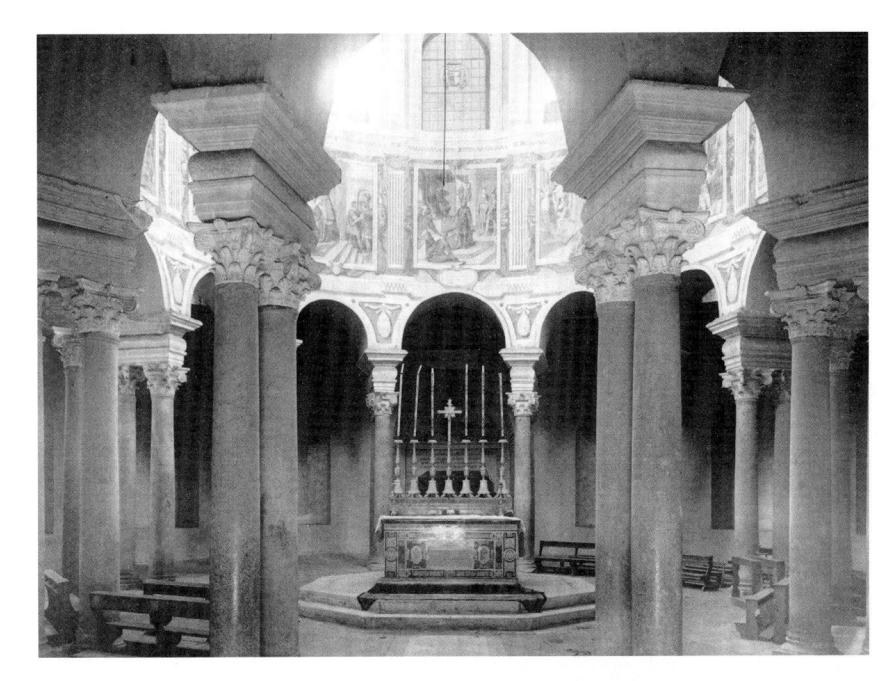

2.17 Interior, Church of Sta. Costanza, c. 350. Rome.

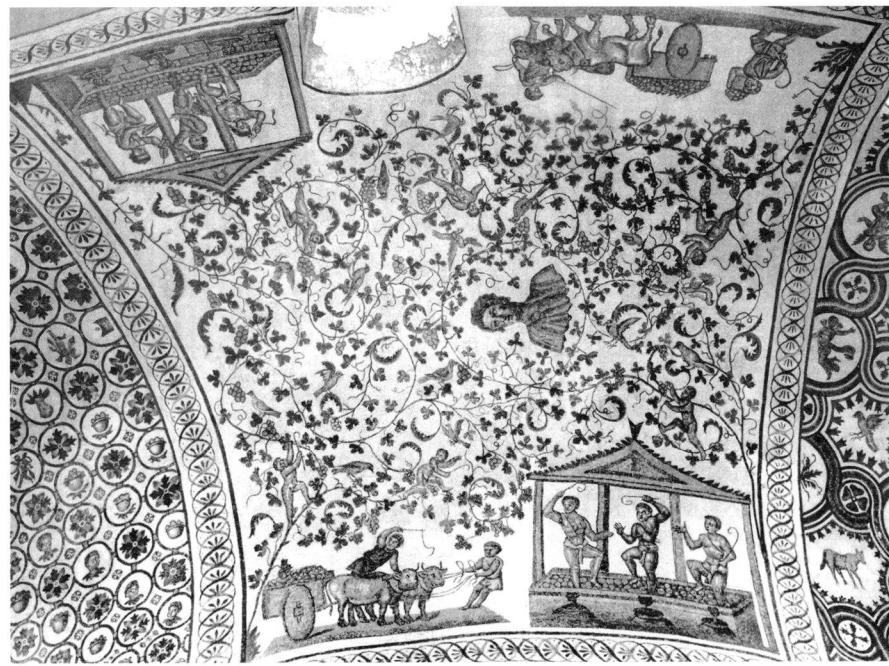

2.18 Vintaging putti, Church of Sta. Costanza, Mosaic in ring vault, c. 350. Rome.

and late Roman style, are related to floor mosaics in both theme and technique and to decorated ceilings in composition. Fully modeled objects and figures are depicted against a light background laced with ornamental frames and foliage. In some panels cupids and nymph-like females fill medallions formed by a continuous circular interlace,

while in two panels putti work enthusiastically in a vineyard. Although Christians had appropriated the popular images of grape vines to allude to the wine of the Eucharist, any overt sign for Christ is absent. The mosaics at Sta. Costanza exemplify the coexistence of Christianity and paganism found in fourth-century Rome.

With characteristic boldness, Constantine ordered his tomb in Constantinople to be part of a complex dedicated to the Holy Apostles. The church had cenotaphs to all the apostles and claimed to house the relics of St. Andrew, the first bishop of Constantinople, and then Sts. Luke and Timothy. Eusebius (c. 270–c. 340), bishop of Caesarea, described the tomb in his *Life of Constantine*. Whether the tomb was built by Constantine or by his son Constantius, whether the tomb was circular or cruciform in plan, whether it was part of or adjacent to the church are questions argued by scholars.

The Church of the Holy Apostles itself was an equal-armed (Greek) cross with a central dome. The altar where Christ's sacrifice was reenacted stood at the crossing, the juncture of the four arms, suggesting that the entire church represented the Cross. So symbolically appropriate was this plan that within the next century builders adapted it for martyria and for churches. Echoes of the scheme resounded throughout the Middle Ages [see St. Mark's, Venice].

The centrally planned building, although symbolically appropriate for a martyrium, had serious functional disadvantages as a church. The building could accommodate relatively fewer people than a basilica; furthermore, if worshippers gathered around instead of in front of the altar, the visual impact of the ceremonies was reduced. The need to accommodate vast crowds of pilgrims and simultaneously give added focus to the altar resulted in a new kind of church, one that achieved a compromise between the mausoleum and the basilica. Architects sought to merge the forms of tomb and hall, and to fuse symbolic meaning and functional structure. Their first efforts appear in two of the most important churches in all of Christendom: the Church of the Holy Sepulchre in Jerusalem and the Basilica of St. Peter in Rome. In both the builders solved the problem of accommodating thousands of pious visitors to the shrines. Both structures combined the martyrium and the congregational basilica in designs whose influence on church architecture would resonate through the Middle Ages. Both have disappeared under later rebuilding.

In Jerusalem, construction of the original building began shortly after Constantine's mother, the

Empress Helena, visited Jerusalem sometime between 325 and 328. As we saw [1.1], she was taken to the hill of Golgotha, where, according to legends, she discovered the True Cross. Over this most sacred of all sites associated with Jesus, Constantine ordered his architects to raise "a basilica more beautiful than any other." The complex included not only a martyrium over the Lord's tomb but also a courtyard sanctuary around Calvary and a basilica dedicated to the Resurrection. The entire complex became the Church of the Holy Sepulchre.

Architects responded to the problems of sheltering three sacred sites by using colonnades and atriums to join a basilica, a traditional mausoleum, and an outdoor shrine with colonnades and atriums [2.19]. To preserve the tomb, the builders cut away the cliff, leaving only the rock

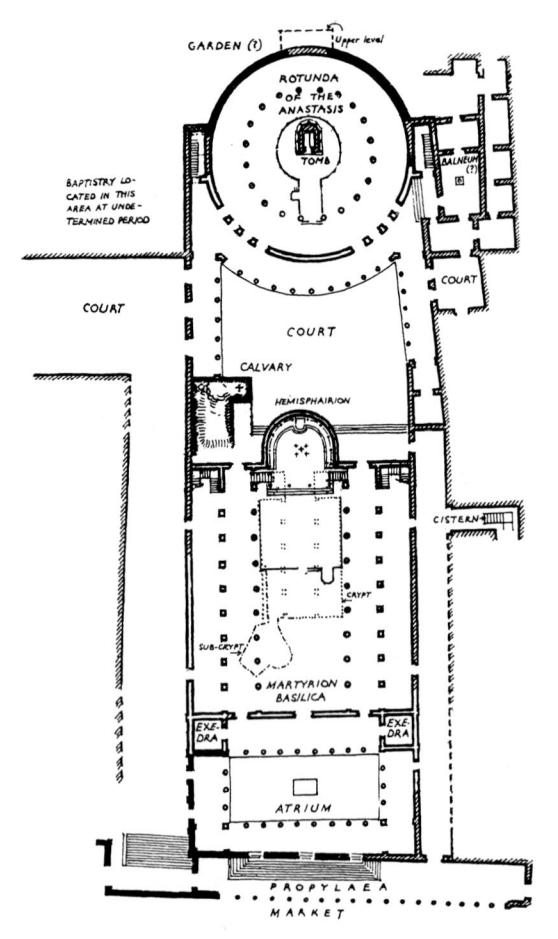

2.19 Conjectural plan, Church of the Holy Sepulchre, mid-4th century. Jerusalem.

surrounding the tomb. Above this cube of stone they raised a canopy or simple pavilion on 12 columns to symbolize the apostles. They connected the Holy Sepulchre to Golgotha with a colonnaded courtyard. (Emperor Theodosius II placed a monumental jeweled cross on Golgotha.) Next a basilica, over the place where Christians believed that St. Helena had found the Cross, provided a setting for the celebration of the Mass. Eusebius, who attended the dedication, tells us that a central nave, flanked by double columned aisles surmounted by galleries, led to a domed apse, nearly adjacent to the Rock of Calvary. An atrium and a monumental gateway separated the basilica from the street.

The diverse architectural elements of the Church of the Holy Sepulchre were united by the liturgy. Pilgrims moved through the basilica to Calvary, then to the Holy Sepulchre, and back again into the basilica—a pious circuit through the most venerable sites in Christendom. Thus the builders managed to accommodate a large congregation while preserving the form of the

martyrium, their method being to erect separate architectural units consolidated not by their structures but by their ceremonial use.

Just before mid-century, in the first of many alterations, a rotunda was built over the tomb of Christ. Known as the Anastasis (from the Greek word meaning "resurrection") Rotunda, the building covered the earlier shrine and surrounded it with an ambulatory aisle (the building may have resembled Constantina's mausoleum in Rome on a larger scale). The builders may have added a second-story gallery to accommodate the crowds of pilgrims, and in the wall above clerestory windows to light the tomb. Exactly what kind of covering—conical roof or

hemispherical dome—rose over the sepulchre remains a mystery. In any case, the imposing rotunda exalted the risen Christ.

Representations of the tomb of Christ in the visual arts vary in details but all show a tomb-like structure [2.20]. An ivory panel (c. 400) represents the Holy Women confronted by an angel at the tomb of Christ, while in the upper right the Savior ascends to Heaven [2.21]. In the representation of the building the sculptor used the familiar features of pagan tombs: a cubical base and a round dome with a tall drum resting on a columnar arcade. Medallion portraits appear in the spandrels of each arch and more sculpture flanks the door. Such an image represented, for all those without personal knowledge of the Holy Land, the idea that the tomb in Jerusalem both recalled and surpassed imperial funeral monuments of ancient Rome.

In the greatest pilgrimage church of the West, the faithful came as pilgrims to Rome and the shrine of St. Peter. Sometime between 317 and 322, Constantine ordered a huge basilica to be

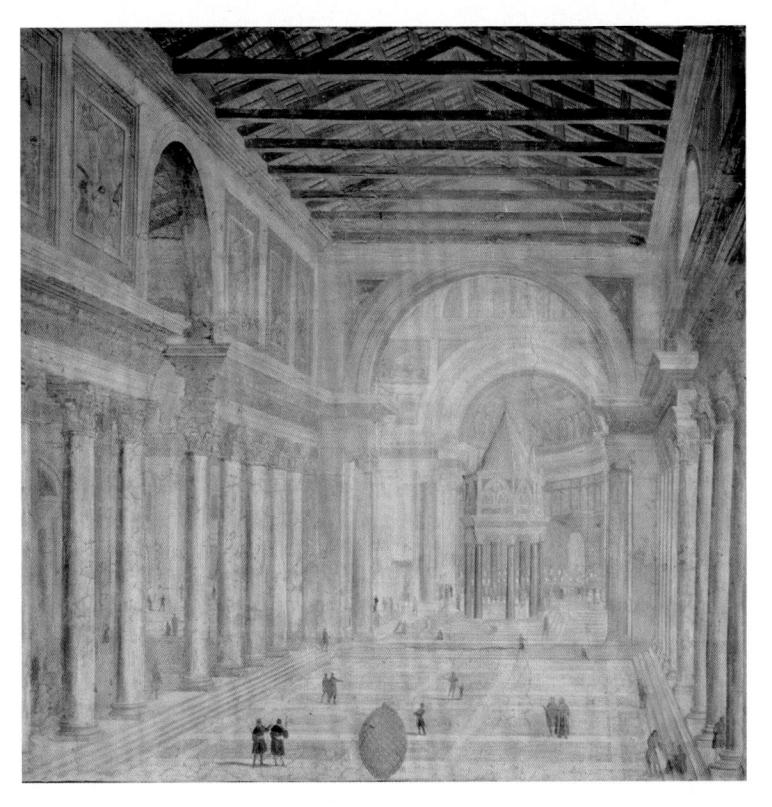

r of Old St. Dotor's befor

Interior, of Old St. Peter's before its reconstruction in the 16th century. S. Martino ai Monti, Fresco. Rome.

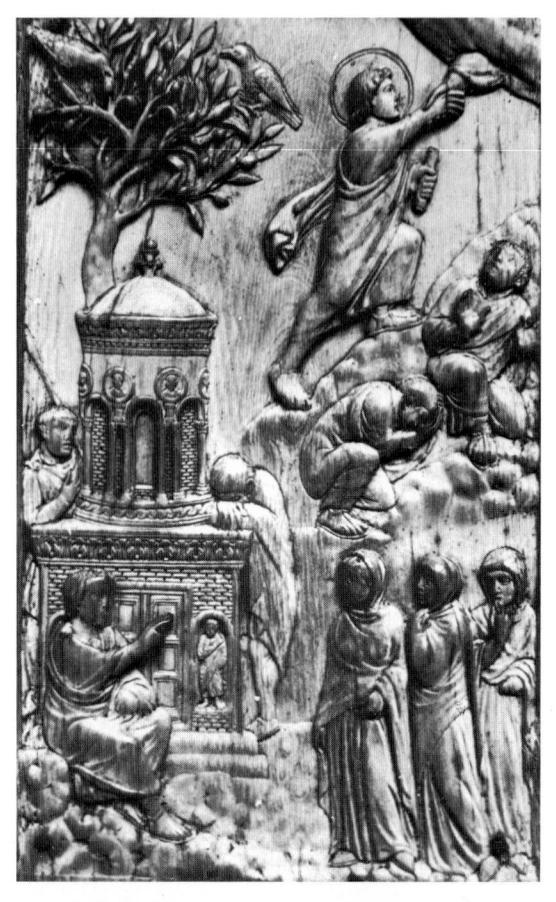

2.21 Holy Women at the Tomb and the Ascension, Church of the Holy Sepulchre, early 5^{th} century. Ivory, 7 $3/8 \times 4 1/2$ in. (18.7 x 11.4cm). Bayerische Staatsbibliothek, Munich.

built on the Vatican hill outside the city walls over the place venerated by the Christian community as the burial place of St. Peter. The church was finished, except for the atrium, and dedicated on November 18, 333.

When construction began, a small secondcentury shrine marked the site believed to be St. Peter's tomb. A "trophy," or symbol of Peter's victory as a martyr, identified the place of burial. The trophy consisted of two niches, one above the other with a stone ledge for offerings between them, flanked by two columns and surmounted by a pediment. This shrine took on great importance when St. Peter's successors as the bishop of Rome (the Pope) claimed authority over their fellow bishops, powers granted by the emperor in 444. Constantine intended that the basilica over the shrine be larger and more splendid in appearance than any other religious building [2.22]. With its many different functions-martyrium, pilgrimage center, funeral basilica, and church for the liturgy, St. Peter's required a new design. (In the sixteenth century, Popes claimed that even this Constantinian church was inadequate and ordered it rebuilt; therefore, the Early Christian church is now known as "Old St. Peter's" to distinguish it from its Renaissance successor.) Constantine established an endowment of 300,000 gold solidi for the church's maintenance.

Modern excavations have revealed the extraordinary topographical obstacles overcome by the Constantinian architects in order to situate the building over the memorial shrine. The vast necropolis with tombs dating from the first to fifth century lay outside Rome in a suburban green zone with luxurious villas and farms. Here had been the circus of Caligula and Nero, where Christians believed St. Peter was executed in 64. To construct the new church over the burial spot, the builders destroyed part of the cemetery.

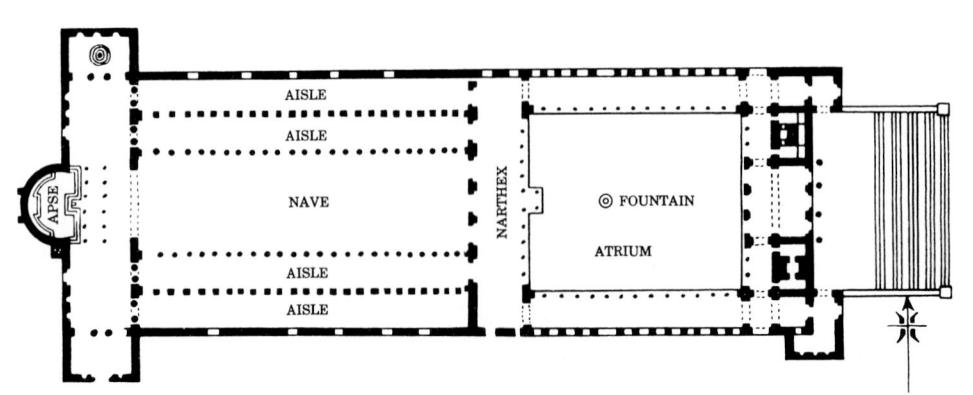

2.22 Old St. Peter's Basilica, Rome, 4th century. Plan total length including atrium about 653ft. (199m).

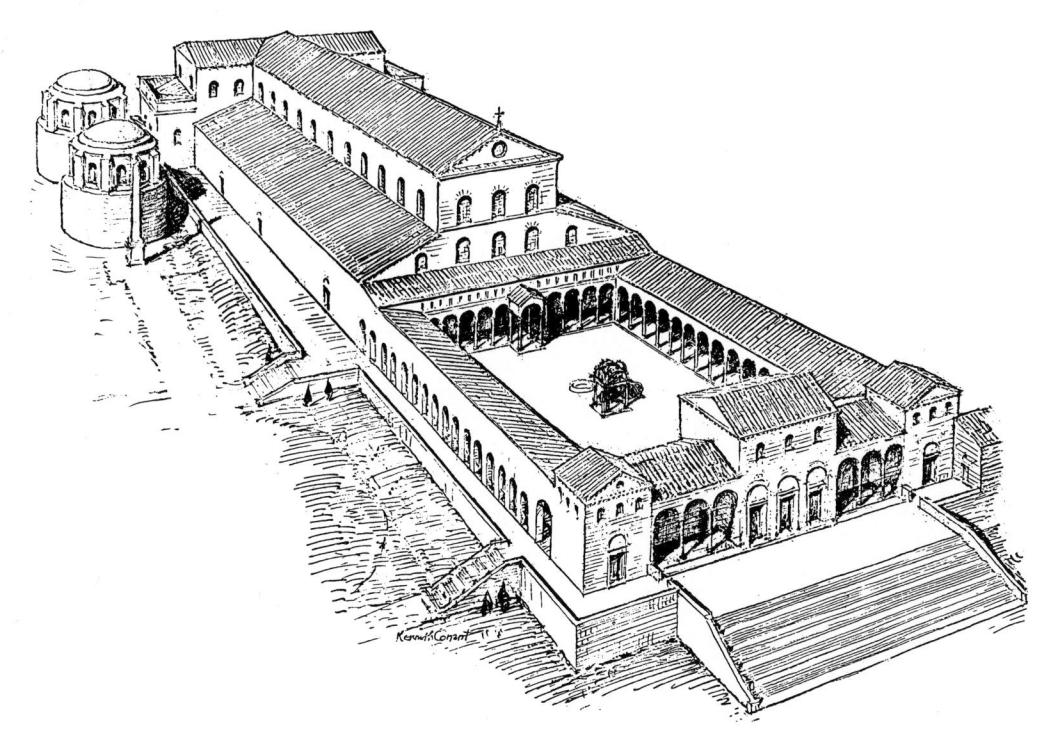

2.23
Exterior drawing of St. Peter's Basilica.

A platform had to be built by cutting and filling the sloping hillside, building up foundations on one side by about 25–30 feet (7.6–9.1m) and excavating the other side by an equal amount. The five-aisled basilica that rose on these foundations was a huge building, a third again larger than the Lateran. It had a total length, including the apse, of 403.33 feet (118.98m) and a width of 215 feet (63.42m) including side aisles. Four rows of 22 columns supported a straight entablature, and clerestory windows pierced the upper wall. A trussed timber roof whose peak (modern scholars have calculated) may have risen as high as 125 feet (37.02m) above the floor made the building taller than many Gothic cathedrals.

Old St. Peter's had been designed so that the second-century shrine would lie just in front of the apse [2.23]. There a baldachino (also called a ciborium), recalling by its shape a rising centralized tomb, provided the focal point for the vista down the long nave. St. Peter's was "occidented" rather than "oriented"; the apse was at the west so that during the celebration of the Mass, the priest faced east, the rising sun of the Resurrection, and the congregation in the nave.

Clearly the space in even a large apse was not sufficient to accommodate both a large clergy and throngs of pilgrims. The architects solved the problem by adding a transept, a continuous transverse hall as wide and high as the nave (some evidence suggests that it may have been lower) and projecting beyond the aisles. Transept and nave together had the form of a tau (T-shaped) cross. This space between the nave and the apse could be used by pilgrims or the clergy, depending on the needs of the moment. The transept, an unprecedented kind of structure, emerged in response to new issues and requirements. Transept and apse provided ample space for the liturgical functions of a church; the nave provided space for the congregation. As we shall find throughout the history of medieval art, changes took place through a process of appropriation and transformation. Once the basilica and the mausoleum had been appropriated, they were transformed to meet the special needs of the Christian community.

Constantine's St. Peter's has been lost, swept away to make space for Michelangelo's dome, but the magnificent scale and appearance of the church can be visualized at St. Paul's Outside the Walls. Piranesi recorded the appearance of the building in

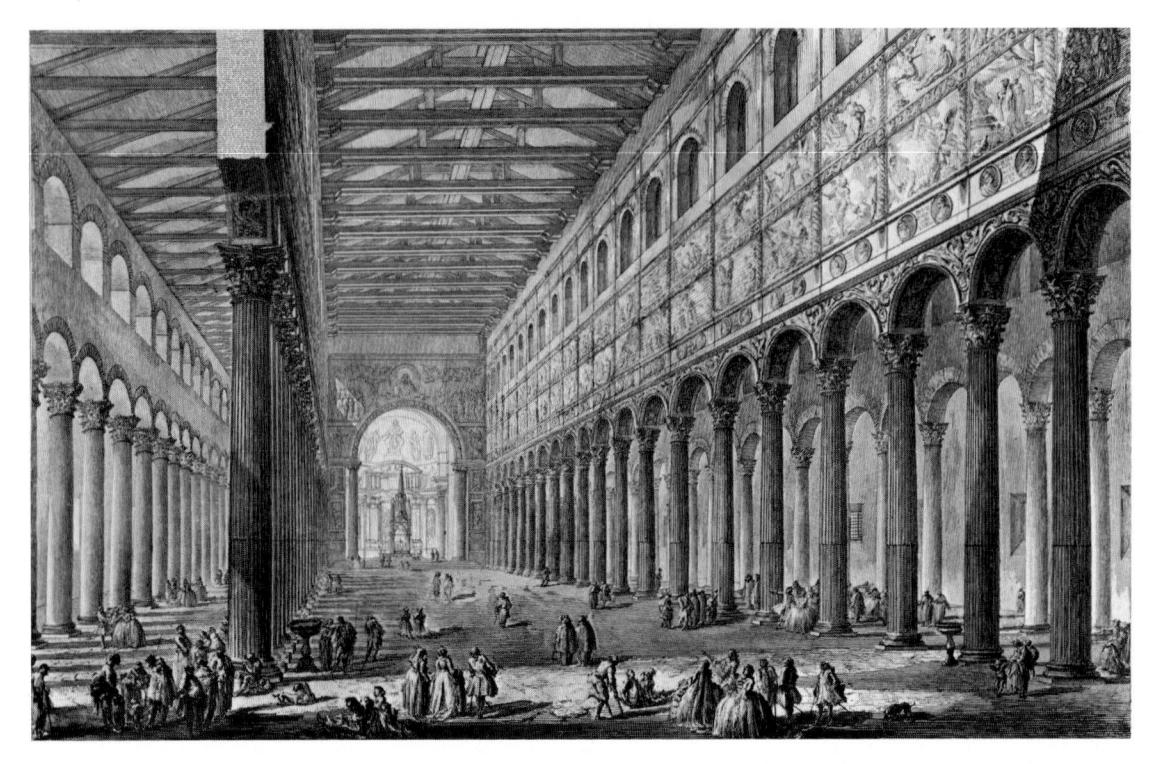

2.24 Interior of the Church of St. Paul Outside the Walls in the 18th century. Etching, 1749. G. B. Piranesi.

the eighteenth century [2.24] before a fire in 1823 destroyed much of it (but left the sanctuary and right wall standing). In the spring of 384 or 386, Theodosius I began a basilica, which copied old St. Peter's. It was finished about 400. The builders made a few changes from St. Peter's: They oriented the plan, placing the altar at the east; the transept was as high as the nave and projected only slightly beyond the line of the walls; and the nave colonnade supported arches, not entablatures. Ample supplies of expensive materials were available from disused pagan temples. Columns came from pagan buildings, but new capitals were carved for the church. The mosaics and painted decorations of the church were part of the restoration work carried on by Pope Leo I (440-461) with the financial help of the Empress Galla Placidia.

THE FIFTH CENTURY

Rome remained the spiritual center of the Western Empire and the home of the Pope, but the city lost its political power after Constantine moved the imperial capital to his New Rome, Constantinople (see Chapter 3). Later in the fourth century Milan developed into the administrative and commercial capital of the Western Empire. St. Ambrose (340–397), who became bishop of Milan in 373/374, transformed that city, for a short time, into the foremost ecclesiastical center of the West. The sack of Rome by the Goths in 410 and Vandals in 455 shocked the world.

At the beginning of the fifth century, Honorius, emperor of the west, moved the capital again, this time to Ravenna, a port on the Adriatic Sea. In Rome, in the course of the fifth century, the Popes grew ever more powerful under the leadership of Sixtus III (432–440) and Leo I (440–461). But by the end of the century the population of the city had fallen to about 100,000; Christianity was the only permitted religion; and the Pope was the de facto ruler of the city.

Even Ravenna was not a safe haven for the Western government, and at the end of the century the Arian Goths captured the city. Theodoric the Great, king of the Ostrogoths, made Ravenna his

Galla Placidia

Galla Placidia—daughter, sister, wife, mother, and grandmother of kings and emperors and Augusta herself—led the kind of life only imagined today by romantic novelists. The princess was born in Constantinople about 388/89 to Theodosius I the Great and his wife Galla. She was sent to Milan (the seat of government in the west) to be educated by St. Ambrose in 394. When Theodosius died in 395, the divided empire was ruled by her half-brothers Honorius in the west (395–423) and Arcadius in the east (395–408).

During the fourth century the Goths and other barbarian peoples moved into the Roman Empire. Galla Placidia had the misfortune to be living in Rome at the time that the Visigothic King Alaric laid siege and sacked the city, 408–410. (At the time Honorius and the Pope were both living safely in Ravenna). Carried off as a hostage, she moved with the Visigoths through Italy, southern Gaul, and into Spain. In 414 she married the Visigothic King Athaulf. Within a year she had a son; the baby died; her husband was murdered; and her own existence became precarious. Finally the Goths allowed Galla Placidia to return to the Romans. In 417 Honorius forced her to marry his general, Constantius.

Galla Placidia had a daughter, Justa Grata Honoria, and then in 419 a son, Valentinian. Honorius, having no heir, appointed Constantius his co-ruler and his sister Augusta in 421. When Constantius died a few months later, Galla Placidia was suspected of abetting conspiracy. She fled with her children to Constantinople, where Theodosius II had ruled since the death of Arcadius.

When Honorius died in 423 still without an heir, Theodosius should have ruled both East and West, but the Roman Senate elected a new emperor. Theodosius II declared Valentinian to be the rightful ruler, made Galla Placidia Augusta (Empress of the West), and sent his army to defeat and execute the usurper. Galla Placidia assumed the regency for her six-year-old son, who was proclaimed Emperor as Valentinian III and crowned in Rome on October 23, 425. The story does not end happily with this victory, however, for both the Huns and the Vandals continued to threaten the slowly disintegrating empire. Galla Placidia found an implacable and clever rival in the general Aetius, who was in league with the Huns. When Valentinian came of age in 437, Aetius made his move, and in 438 Galla Placidia had to retire from active politics.

Galla Placidia's influence continued as a staunch defender of the Pope and as a patron of the arts. In Rome, she added mosaic decorations to the Church of St. Paul's Outside the Walls, and in Ravenna she built churches including the Church of the Holy Cross (Sta. Croce). Attached to Sta. Croce's narthex, she built a chapel dedicated to St. Lawrence. Galla Placidia may have intended the building to be her mausoleum, but she died in Rome on November 27, 450. Her burial place is unknown. As a postscript to her life, we must note that Valentinian murdered Aetius in 454 and was himself murdered by Aetius' allies in 455. In 455 the Vandals occupied and looted Rome, and in 476 the empire in the West came to an end.

capital and ruled there from 497 until his death in 526, nominally as vice-regent for the Byzantine emperor, but in fact as an independent king.

The Eastern Roman Empire, meanwhile, was ruled from Constantinople, where Arcadius and his son Theodosius II (b. 401, ruled 408–450) created an effective bureaucracy and stable government. They ushered in a period of internal civil peace and prosperity, although Persians and the Goths remained a threat and the Huns had to be bought off with large amounts of gold. The Eastern Church, however, was not at peace, for debates over the nature of Christ and the role of the Virgin Mary in-

tensified. Heresies spread throughout the East. Nestorianism denied Mary the title "Mother of God" (*Theotokos*, or God-bearer) by claiming that while Jesus' divine nature came from the God the Father, the Virgin bore him solely as a human. In 431 a church council at Ephesus attempted to settle the controversy and decreed that Christ had two distinct natures, human and divine, inseparably joined in his one person. Another heresy developed out of a reaction to Nestorianism. Monophysitism, or belief in a single nature, held that Jesus was wholly divine. The Council of Chalcedon in 451 attempted to destroy Monophysitism, but as

before, the bishops' decisions only clarified theological issues, doing little to end the strife. Syria and Egypt remained bastions of Monophysitism, and as the century progressed the controversy persisted. The Coptic church is still Monophysite.

The historical overview of the fifth century reveals the empire beset by dangers from within and from without. The West remained spiritually unified under the Pope but fragmented by military invasions. Meanwhile the East, although politically unified under the emperor at Constantinople, found itself rent by religious wars. As if to escape the turmoil of their own time, people looked nostalgically back at the fourth century when architects and artists evolved new forms befitting the special requirements of Christianity. The fifth century, particularly in Rome and Constantinople, became an era of consolidation and retrospection, while in outlying regions artists adapted Roman Christian art to suit local needs.

ROME IN THE FIFTH CENTURY

In Rome especially during the reign of Pope Sixtus III, the purest form of the classical revival flourished. Although partly the product of the Pope's

own refined taste, the invocation of ancient Rome also lent an aura of stability and grandeur to Christian art. Christian artists underplayed the materialistic aspects of pagan classicism, as though they sensed that a style proper to one kind of image might be incongruous when applied to another. The result, however, was that the classical revival simply appeared in a more veiled manner in work such as the ivory representing the Ascension and the Holy Women at Christ's Tomb seen earlier [see 2.18]. The image is based on the apocryphal (unauthorized) Gospel of James rather than the brief account of the Ascension in Acts 1:9-12. Compared to the Passion Sarcophagus [see 2.11], the figures have more natural proportions, and they move dramatically within an illusionistic environment. Legs and feet extend beyond the frame to thrust the figures forward into the viewer's space. Space within the frame is also indicated, for the figures are foreshortened, and the lumpy hillside provides a continuous landscape setting. Christ triumphantly strides up to grasp the hand of God, represented in an art that remains richly evocative of ancient Rome.

This classical heritage appears in ever-changing guises [2.25]. In an ivory with a Crucifixion scene, probably carved in Rome about 420–430, the

The Crucifixion and the suicide of Judas, Rome or southern Gaul, 420-30. Ivory, 3 x 4in. (7.6 x 10.2cm). The British Museum, London.

proportions of the figures have become stocky, the heads large, and the musculature stylized. At the left, a tree, instead of gracefully receding through a gradual lowering of the height of relief, as in the Ascension ivory, stands isolated against a flat ground—so much so that it describes not a real space but a symbolic one.

The classical heritage surfaces, however, here in the narrative concept. At the right, the Roman centurion Longinus shields his eyes in reference to the miracle of his sight. On the other side of the cross stand Mary and either St. John or-because the figure is bearded—Joseph of Arimathaea, the pious Christian who would later place the body of the Savior in his own tomb. In the tree above, a bird feeds its young, a reference to the eternal life promised by Christ. In contrast to these positive images of salvation, Judas swings lifelessly from the tree as telltale silver coins spill out of a bag at his feet. By representing two separate moments with a single frame, instead of dividing events by columns or other confining devices, the artist imitated the tradition of continuous narrative used in imperial Roman reliefs. The portrayal of the protagonists also establishes the dramatic element. The erect posture, open eyes, and idealized anatomy of Christ on the Cross characterize his sacrifice as triumphant. The letters above his head read REX IUD, "King of the Jews." The heroic image of Christ contrasts with Judas, whose body dangles limply from the tree. This concern for narration and drama belongs to the ancient tradition of Roman realism.

The most monumental evidence of the classical revival appears in Roman churches. Churches had been spared during the fifth-century pillaging of Rome, thanks in part to the Goths' and Vandals' own Arian Christianity. The heretics' presence in Rome, however briefly, provided another reason for the assertion of pontifical authority. The Popes had not only claimed primacy over the patriarchs of Constantinople but also had to prove that their condemnation of Arianism was binding throughout the empire. The building of churches like Sta. Sabina on the Aventine Hill (see Box: *The Christian Basilica of Sta. Sabina*) and Sta. Maria Maggiore on the

Esquiline and the decoration of the basilicas of St. Peter and St. Paul outside the Walls became important projects for Popes Sixtus III and Leo the Great, who enjoyed the support of the imperial family.

The decoration of the majestic basilica of Sta. Maria Maggiore [2.26] became Pope Sixtus' single most important project. New research suggests that the church had been begun about 30 years before Sixtus' reign and that it had an unusual plan. Like the funeral basilicas of the fourth century, the side aisles of the nave continued around the apse to form an ambulatory. An Ionic colonnade, continuous with the nave colonnade, defined the sanctuary. The builders faithfully copied classical architecture, so the columns carry an entablature whose frieze is ornamented with a classical foliage scroll. Pilasters divide the upper wall into panels framing mosaics under clerestory windows. The building has been altered many times over the centuries, and photographs do not do it justice. The splendid ceiling we see today was given by Ferdinand and Isabella of Spain and is covered with gold brought from the Americas.

Early Christian mosaics survive in small panels on the triforium wall of the nave and the triumphal arch. The nave mosaics have the oldest surviving narrative cycle from Christian Rome. They illustrate the Old Testament stories of Abraham, Jacob, Moses, and Joshua, but the Old Testament patriarchs are also interpreted as prefigurations of Christ. Although late antique in style, the dramatic imagery of the narratives may have been inspired by Jewish illustrated manuscripts. Uniquely Christian is the emphasis on allegorical and miraculous happenings [2.27].

The rebellion of the Jews against Moses focuses on God's intervention to save Moses. Having wandered through the desert seeking the Promised Land, the people began to lose faith in their leaders. As interpreted in the mosaics, when the spies returned from Canaan with their report, the rebellious people angrily stoned Moses, Joshua, and Caleb. Just as the Old Testament describes (Numbers 13:25–31 and 14:10), the people throw stones at the men to no avail. In the center of the composition the stones literally bounce off "the glory of

2.26 19th Century reconstruction drawing of nave, Church of Sta. Maria Maggiore, 432–440. Ceiling after 1492. Rome.

2.27
Rebellion Against Moses, Church of Sta.
Maria Maggiore, 432–440. Mosaic
in the nave. Rome.

the Lord" that surrounds Moses and his lieutenants. The indescribable presence of God is represented by His hand above and the mandorla, an almond-shaped aureole of light.

The Roman illusionistic style lingers on in the solid modeling of the figures and in their energetic gestures, in the landscape background of rolling hills and blue sky, and in the perspective rendering of the city walls and tabernacle. On the other hand, strong outlines encompassing shoulders, arms, and much of the architecture tend to flatten the forms. The artists carefully graduate the colors to suggest rounded forms; at the same time they introduce space-denying gold tesserae. Their use of gold marks a shift from the classical Roman style to the intentional immateriality of medieval art.

In the New Testament mosaics of the triumphal arch, the symbolic mode grows noticeably stronger [2.28]. The figures have lost that lively mobility of gesture that gave dramatic force to the nave mosaics. Instead, they stand erect and immobile. Since their heads nearly touch the top of each register, they block any illusionistic view into the background. This hieratic presentation suits the location on the triumphal arch and the message contained in the subject matter. Underlying the New Testament images is the reminder of the decrees of the Council of Ephesus. The mosaics proclaim both natures of Christ—his eternal divinity and his humanity. The role of Mary as Theotokos, the Mother of God, and her lofty position as Queen of Heaven and receptacle of divinity are emphasized by her enthronement, her regal costume, and the attentive presence of guardian angels. Moreover, Jesus appears not as a baby in his mother's lap, as in the early catacomb paintings [see 2.7], but as a miniature adult. The youthful Savior sits isolated on a throne and reigns as King of Heaven with his angelic court. The Magi approach bearing gifts; they appear as Zoroastrian priests and symbolize the Gentiles. At the crest of the arch, all the implicit references to Christ's divinity converge upon a single symbol: In a medallion flanked by Sts. Peter and Paul and the emblems of the four Evangelists, an imperial throne supports a cross, a crown, and the apocalyptic lamb-all three together symbolizing Christ's triumphant Second Coming. Beyond the arch, the original apse mosaic had an image of the Virgin, as Queen of Heaven. Thus, at the visual climax of the church, she was raised to an exalted state suitable only for the Theotokos.

Through the affirmation of Mary as Theotokos in the Church of Sta. Maria Maggiore, Pope Sixtus

2.28
Infancy of Christ, Church of Sta.
Maria Maggiore, 432–440. Mosaic
on the triumphal arch. Rome.

refuted Nestorianism and defended the Roman prerogatives. His successor, Leo the Great, made a similar claim for absolute authority at mid-century when the Council of Chalcedon met to condemn Monophysitism. Pope Leo supported his claim by glorifying St. Peter and St. Paul in a campaign of church decoration. The Pope's efforts can only be imagined, for little remains of the work completed during his pontificate. Drawings, watercolors, and prints made before the destruction show the paintings ordered for St. Peter's, St. Paul's, and the Lateran basilica by Pope Leo.

In contrast to its austere exterior, the interior decoration of St. Peter's was light and colorful, shimmering with polished marble and mosaic. The columns with Corinthian capitals were spolia (spoils taken from pagan buildings). In figural imagery, the artists and patrons were both followers and innovators. Since an image of the emperor had been placed in the apse of a basilican civil court, it followed that an image of Christ, the King of Kings, should be located in the apse of a basilican church. But the apse mosaic also has a new theme—the dramatic moment when Jesus singled out St. Peter-and consequently the bishopric of Rome-to be the foundation of the Christian Church. The traditio legis, or the handing down of the law, had its most monumental expression here. In the transept, illustrations of the life of St. Peter attested to his importance as the chosen Apostle. In the nave, Pope Leo commissioned a double row of Old and New Testament scenes and, below them, resting on the architrave, roundels with portraits of all his predecessors, beginning with St. Peter. The Popes form a symbolic progression down the nave to the apse, where Christ ordains their illustrious founder.

Pope Leo with the backing of Empress Galla Placidia also ordered the decoration of the Basilica of St. Paul Outside the Walls. In paying homage to the two founders of Christian Rome by enriching their churches, Pope Leo gave moving testimony to the divinely prescribed heritage of the Roman bishops, whose mortal remains lay under the great funeral church, and to the primacy of Rome as the apostolic See.

FIFTH-CENTURY ARCHITECTURE AND DECORATION OUTSIDE ROME

Patrons and their architects outside Rome adapted traditional architecture and visual arts to regional traditions. In response to local materials and methods of construction, as well as to slightly differing ceremonial practices, patrons might order builders to add towers or elaborate the atrium courtyard and narthex or entrance porch to the familiar basilica. They might rethink the design of the transept area or add galleries over the aisles. Because of the requirements of the Eastern Orthodox rite, they might add rooms to the narthex or the apse where the clergy prepared and stored the consecrated Host (the prothesis) and housed the archives, treasury, and clerical vestments (diaconicon, or sacristy).

In Ravenna, Galla Placidia embarked on a building campaign while ruling as regent (425-437) for her young son Valentinian III. One of her first buildings was the Church of Sta. Croce, now partly destroyed but known for the small mausoleum and martyr's chapel that adjoined its narthex [2.29]. The cruciform chapels stood at each end of the narthex; the one at the right was probably dedicated to St. Lawrence. The present-day appearance of the chapel is deceptive, for the ground level of Ravenna has risen, reducing the building's tall proportions. For the building the architects adopted the cross plan in which the four wings abut the sides of a higher central block [see the Church of the Holy Apostles, 2.16]. Blind arcades strengthen and enliven these outer walls, and alabaster panels fill the narrow windows. The arms are capped by pediments and tiled roofs. Even the fabric of the mausoleum—not stone or thin Roman bricks but thick bricks with narrow mortar joints-denotes the participation of craftsmen from northern Italy.

On the interior the original vertical proportions of the chapel are apparent [2.30]. Rising over the lower, barrel-vaulted arms and giving the effect of a soaring space within the tiny building, the tall crossing bay is covered by a pendentive dome. An atmosphere of luxury pervades the dark interior. The lower walls are veneered in veined marble; and ornamental and figurative mosaics glisten on the

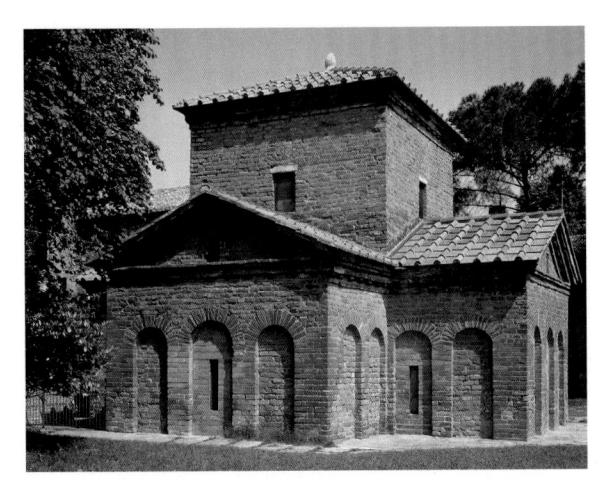

2.29 Exterior Mausoleum of Galla Placidia, c. 425. Rayenna.

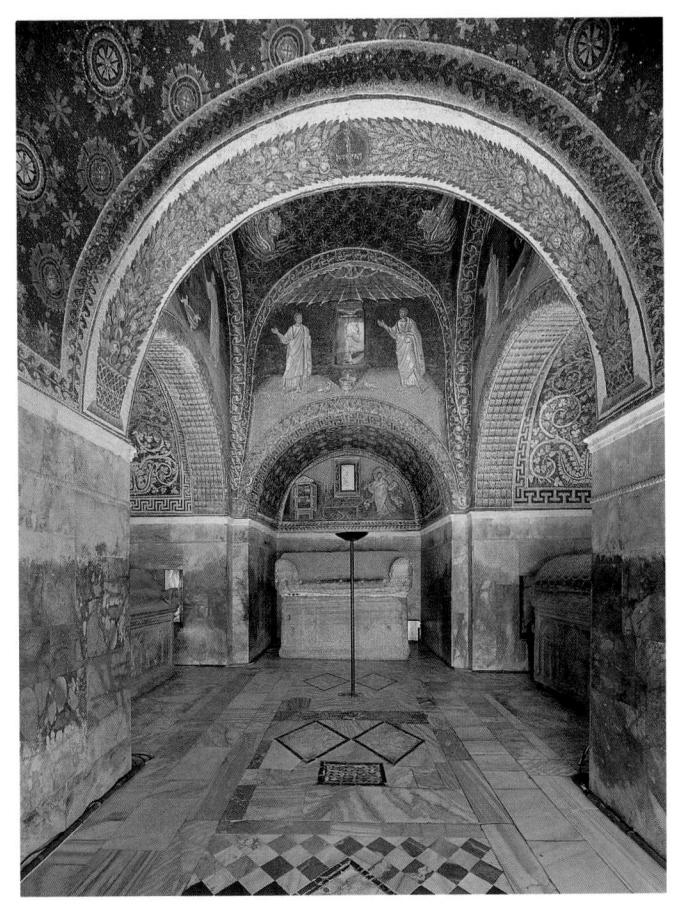

2.30 Interior, Mausoleum of Galla Placidia, Ravenna, c. 425–450.

walls and vaults. White and gold stars or flowers turn the blue vaults into a vision of paradise while the dome of Heaven covers the crossing. This allusion to the celestial realm accords with the iconographic program of the mosaics, since each of the four lunettes at the terminals of the cross arms contains a scene that alludes to salvation through Christ: the Good Shepherd [2.1], stags symbolizing Christian souls drinking the waters of paradise, and the martyr St. Lawrence (d. 258).

In the mosaic depicting St. Lawrence, the saint strides eagerly forward to his martyrdom on a flaming grill. (The Romans executed Lawrence for refusing to turn over the Church's money.) The Word of the Lord is symbolized by the four Gospels resting on the shelves of the cupboard at the left. Read together, the elements of the composition represent two possible vehicles of deliverance available to the pious Christian. The gridiron on

which the saint was tortured and the Cross he carries signify redemption through the intercession of martyred saints. The images do not, then, unfold in narrative fashion, as do those in Roman churches, but rather stand as separate emblems to be contemplated.

The central crossing rises above the barrel vaults of the four arms. Silhouetted against the blue of the walls are pairs of apostles [2.31]. They gesture upward, acclaiming the Cross in the star-studded blue and gold sky. The four mystical creatures described by Ezekiel appear in clouds. In the center of the dome, positioned in relation to the door, a golden cross symbolizes the divinity of Christ, in contrast to Christ as the Good Shepherd in the lunette below. Here, the idea of the Second Coming is bound up in the divine light of the golden cross. In Neoplatonic fashion, the decorative program moves from earthly references in the lunettes

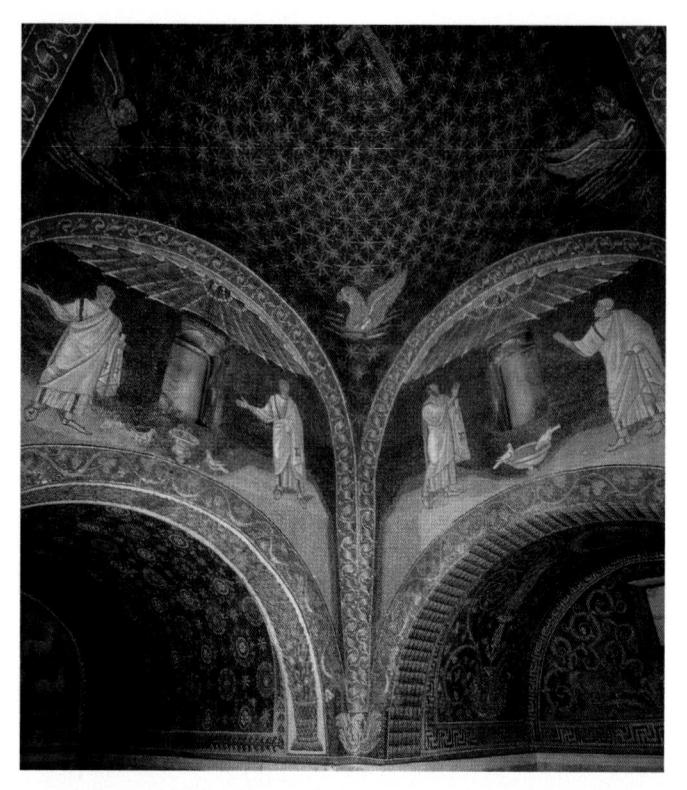

2.31 Mausoleum of Galla Placidia. Central crossing rising over the barrel vaults.

upward to the visions of the Divine One in the crown of the dome.

The mystical focus of the chapel's decorative scheme affected the style of the mosaics. Material forms become linear designs. As vigorous and lively as St. Lawrence appears, the underlying musculature necessary to activate his striding posture is denied, since the flying drapery falls unnaturally in a series of abstract patterns indicating movement but not the body. Moreover, the visual isolation of the book cabinet, the gridiron, and the saint against a flat, blue ground and the rendering of each of these elements from a different point of view confound any attempt to establish a natural three-dimensional space. The tradition of spatial illusionism inherited from antiquity has once again given way before the spiritual priorities of Christian art.

This pictorial emphasis on salvation through Christ and his saints reappears in the nearby Baptistery of the Orthodox [2.32]. Not unexpectedly, the program refers specifically to the role of baptism in

Ezekiel and St. John

As I looked, a stormy wind came out of the north: a great cloud with brightness around it and fire flashing forth continually, and in the middle of the fire, something like gleaming amber. In the middle of it was something like four living creatures. This was their appearance: they were of human form. Each had four faces, and each of them had four wings. (Ezekiel 1:4–6)

As for the appearance of their faces: the four had the face of a human being, the face of a lion on the right side, the face of an ox on the left side, and the face of an eagle... (Ezekiel 1:10)

At once I was in the spirit, and there in heaven stood a throne, with one seated on the throne! And the one seated there looks like jasper and carnelian, and around the throne is a rainbow that looks like an emerald. Around the throne are twenty-four thrones, and seated on the thrones are twenty-four elders, dressed in white robes, with golden crowns on their heads. Coming from the throne are flashes of lightning, and rumblings and peals of thunder, and in front of the throne burn seven flaming torches, which are the seven spirits of God; and in front of the throne there is something like a sea of glass, like crystal.

Around the throne, and on each side of the throne, are four living creatures, full of eyes in front and behind: the first living creature like a lion, the second living creature like an ox, the third living creature with a face like a human face, and the fourth living creature like a flying eagle. And the four living creatures, each of them with six wings, are full of eyes all around and inside. Day and night without ceasing they sing,

"Holy, holy, holy, the Lord God the Almighty, who was and is and is to come." (Revelation 4:2–8)

From The Holy Bible, *The New Revised Standard Version (NRSV)* (Grand Rapids, MI: 1984).

The creatures came to symbolize the writers of the Gospels: St. Matthew, the man; St. Mark, the lion; St. Luke, the ox; and St. John, the eagle. redemption. The sacrament of baptism, we recall, symbolized not only the cleansing of the soul but also the death of the sinful self and the initiate's rebirth in Christ. The implicit association with death and spiritual resurrection caused patrons to build baptisteries in the form taken by pagan mausolea and Christian martyria. Patrons also transformed the circular or square plan into an octagon, for in the context of Early Christian numerology, eight was the number of regeneration. On the eighth day after creation the world began, and Jesus arose from the dead on the eighth day of the Passion Cycle. The Baptistery of the Orthodox, built early in the fifth century, is a large octagonal building near the cathedral. The bishop baptized neophytes by immersion once a year at Easter. The building had to accommodate crowds of people and a font built like a bath. About 450-460 Bishop Neon replaced the original wooden ceiling with a dome and commissioned an elaborate program of mosaic and stucco decoration.

Simply stated, baptism is the first step in the divine scheme of salvation, which began when Christ appeared as the Messiah prophesied in the Old Testament and accepted the purifying waters of the Jordan from St. John the Baptist. The expression of this doctrine on the walls and dome of the Baptistery of the Orthodox is the most complex iconographical program we have yet seen [2.33]. The program begins with the frames around the lower niches, which are inscribed with passages from the Psalms and Gospels that relate to baptism. At the window level, the stucco figures represent the Hebrew prophets who foretold the coming of a Messiah. In the three concentric rings of the dome mosaic, four altars, each of which supports a Gospel book, alternate with draped thrones standing under baldachinos. The thrones symbolize the Second Coming of Christ (Hetoimasia). Next the twelve apostles processing around the dome offer the wreathed crowns that are the prize of their martyrdom. In the center of the dome John baptizes Christ with water from the Jordan River. The baptism of Christ reminded the initiates that, by accepting the sacrament, they

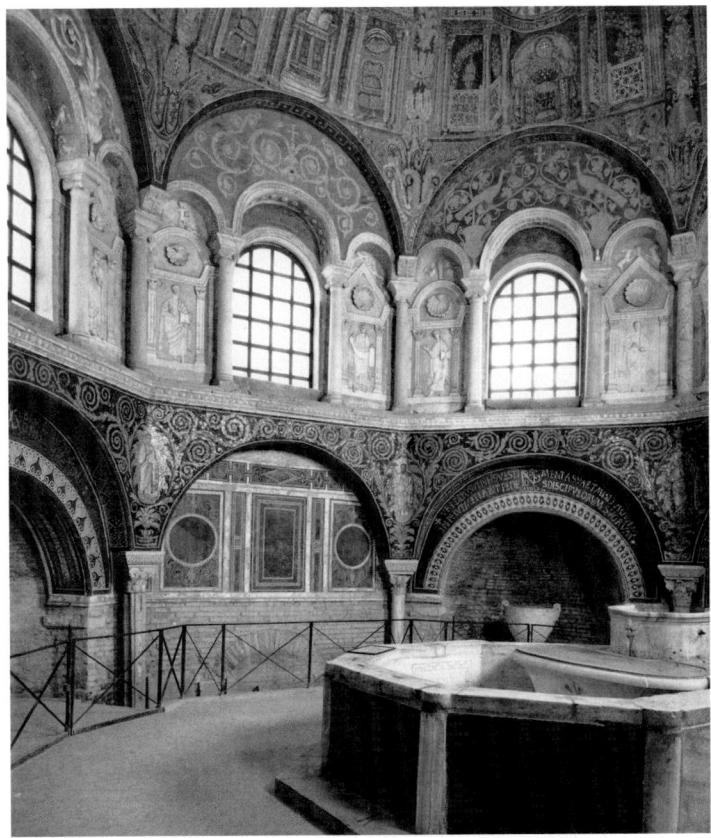

2.32 Baptistery of the Orthodox, late 4th century, remodeled mid-5th century. Stucco sculpture; mosaic. Interior diameter, 36ft. 10in. x 37ft. 7in. (11.2 x 11.5m). Ravenna.

repeated a moment in Christ's life on earth that would assure them a place with him in paradise.

The style of the Orthodox Baptistery mosaics rejects the realities of the visible world, the better to concentrate on the mysteries of salvation through baptism. Vestiges of antique illusionism do appear-for example, in the architectural and landscape settings—and the classical world is even more specifically recalled by the river god who personifies the Jordan. The baptism, however, takes place against a golden Heaven, not a blue sky. The ambiguity between a three-dimensional rendering and an abstract presentation continues in the middle zone. The apostles' solid forms cast dark shadows as they step across light-green grass, but their garments fall into repeated layers of schematic folds, while the colors alternate with precise regularity between gold and white tesserae. Below the

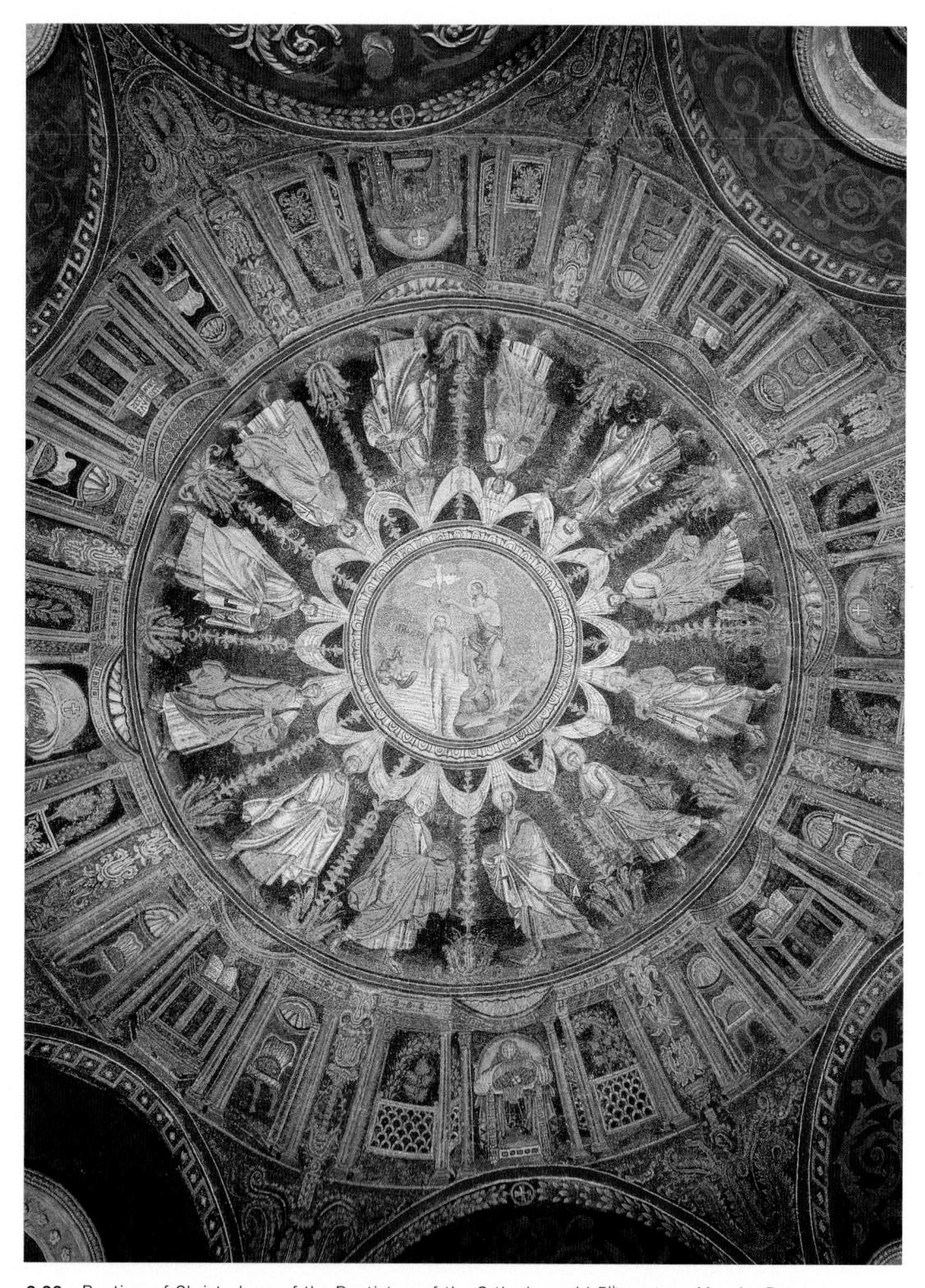

 $\textbf{2.33} \quad \text{Baptism of Christ, dome of the Baptistery of the Orthodox, mid-} \\ \textbf{5}^{\text{th}} \text{ century. Mosaic. Ravenna.}$

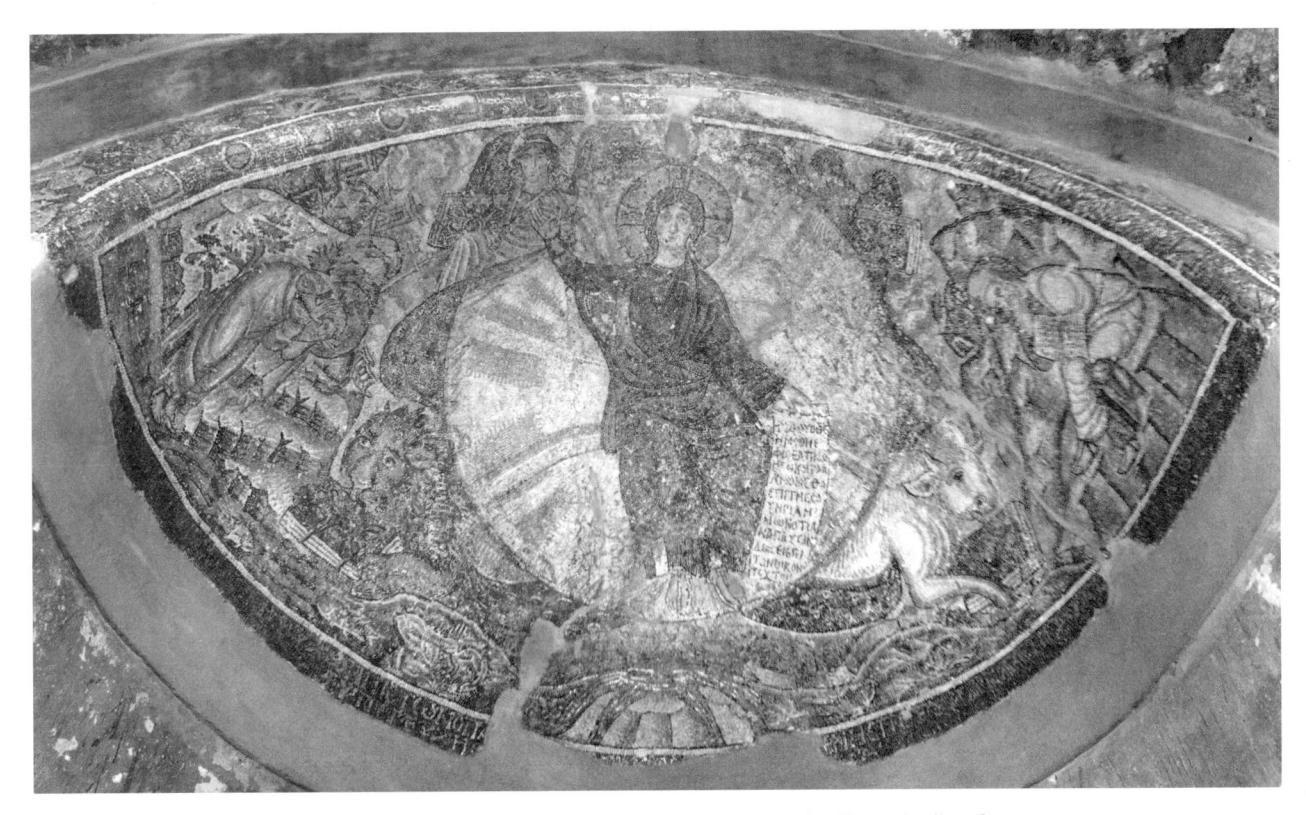

2.34 Christ in Glory, the Vision of Ezekiel, Hosios David, c. 470. Apse mosaic. Thessalonika, Greece.

apostles, porticoes, niches, and garden walls constructed of shimmering gold tesserae suggest the garden of Paradise and the preparation for the Second Coming of Christ.

Like Ravenna, Thessalonika in Greece was a former Roman imperial city that became an important Christian capital. In an oratory, or small chapel, attached to the monastery of the Latemos, now the Church of Hosios David [2.34], apocalypse imagery fills the apse. The apse mosaic, dated either at the end of the fifth or early in the sixth century, combines the vision of Ezekiel with a theophany (in a theophany, for a moment God becomes visible, in contrast to the incarnation in which the union of human and divine is permanent). The Lord, represented in human form, emanates from a radiant glory. This youthful, blessing Savior sits on the crest of a rainbow within an aureole of light. A lion, an ox, an eagle, and a man with eye-studded wings emerge from behind the glory. Below, at Christ's feet, the four rivers of paradise stream down from a hilltop. Ancient tradition held that four sacred rivers in paradise issued from a single rock and these rivers symbolized the four Gospels that flow from Christ. An inscription at the bottom of the mosaic explains that Jesus is the "spring of living water" at which the faithful quench their spiritual thirst. An old man sits at each side. The man at the left, raising his hands to his face as if blinded by the light of the Word, is surely Ezekiel, the Hebrew prophet whose vision of the four winged creatures (see Box: Ezekiel and St. John) came to be interpreted, when they appear holding books, as a prefiguration of the authors of the four Gospels: Matthew, Mark, Luke, and John. The man meditating on the right has been identified as St. John the Evangelist to whom God revealed a vision of glory and the Second Coming.

The artists inserted the mosaic tesserae with such calculated irregularity that no form seems to be stably affixed to the curving surface. The celestial apparition is removed from all contact with the tangible, mundane world below, and the whole apse glitters as the little cubes of color catch the light. In the individual figures, an illusion of real substance is achieved through a careful gradation of hues. At the same time, the use of heavy contours and internal patterns—for example, in the draperies—effectively denies their physical weight. Nor is there any definable illusionistic space, although hints of architectural and landscape backgrounds rise behind the heads of Ezekiel and St. John. Ultimately, the shining glory of the Lord in Heaven dominates the entire composition.

By the end of the fifth century, the vestiges of classical realism still present in early catacomb painting had nearly disappeared. For Christians the Lord took on human form in order to redeem the sinful world. At the same time he remained God. The art that gave visual testimony to this concept had to be firmly dissociated from the ephemeral substance of earthly existence. The pictorial themes and architectural designs that evolved during the third, fourth, and fifth centuries resulted in a great and innovative art created out of the heritage of ancient Mediterranean civilization.

The political success of Christianity brought with it the inducement to create huge buildings befitting the Church's role as an official state religion. The simple domestic house of worship had

to become the visible embodiment of the entire Christian community, a civic as well as religious center. Architects responded to this challenge by successfully transforming two totally different ancient architectural types—the basilica and the tomb—into complex, richly symbolic designs. The desire to adorn buildings proved irresistible, while the instructional value of paintings, mosaics, and sculpture further justified the impulse to embellish interiors. Moreover, since the church was above all the house of the Lord, the tomb of Christ or a saint, and an evocation of Paradise, it deserved the most elaborate and serious enrichment. The resulting decorative programs provide a striking demonstration of the change from a realistic to an abstract style.

In the course of the first centuries after Christ, Mediterranean society underwent a complete spiritual reorientation, and this revolution required the development of a new aesthetic for its effective expression. Ultimately, several styles evolved throughout Christendom, but all shared a common body of subject matter and an anti-realistic, anti-materialistic style. The medieval artist seemed determined to reproduce a visionary world in which the angels were as real as human beings and, because they were closer to the One, even more worthy of artistic representation.

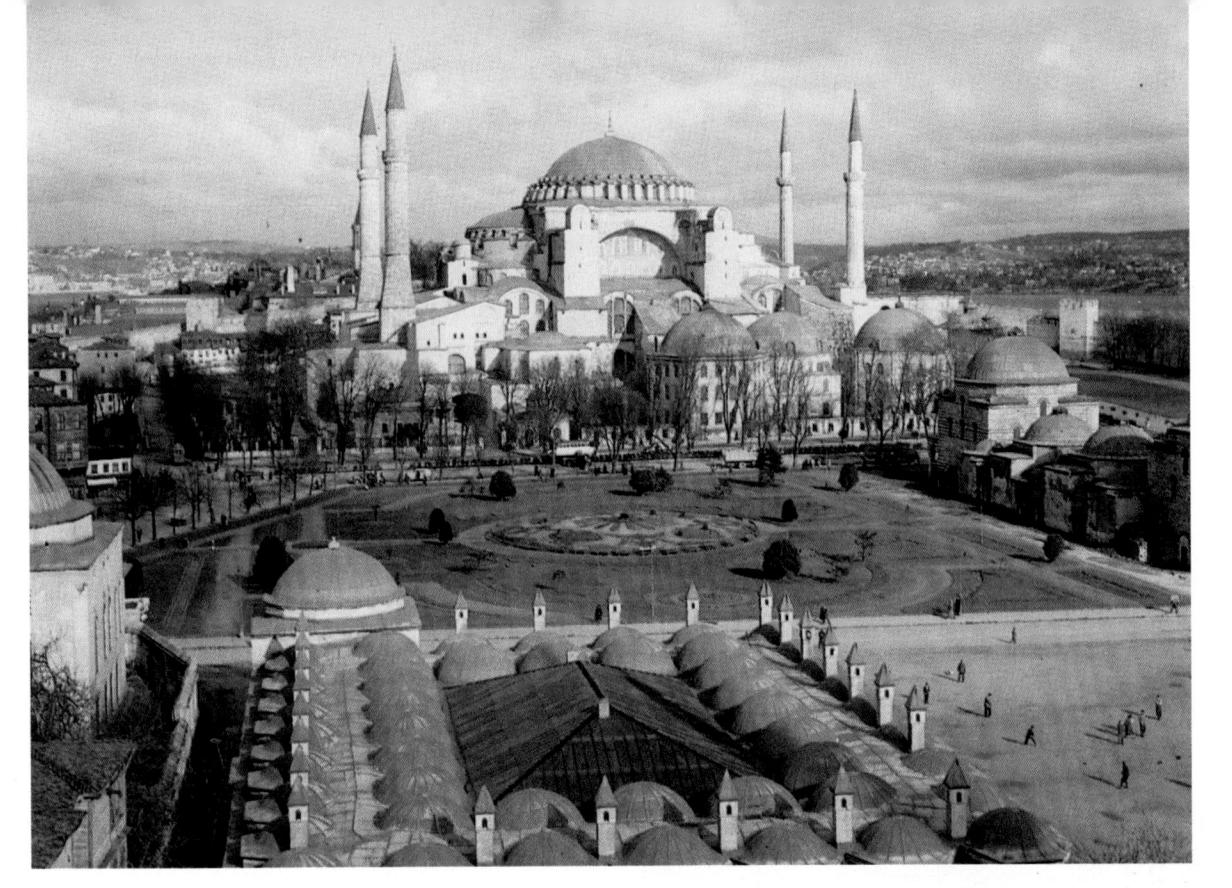

3.1 The Church of Hagia Sophia, Constantinople, modern Istanbul. The original church 532–537; dome rebuilt after 558; minarets added after Turkish conquest.

CHAPTEI

THE EARLY BYZANTINE PERIOD

The First Golden Age

hen Constantine moved the government of the Roman Empire to the Greek port of Byzantium, he could hardly have imagined that one day the city would give its Greek name to an entire civilization. Constantine made his city the new Rome and called it Constantinople, the City of Constantine. Constantinople/Byzantium (now Istanbul) has a perfect strategic location on a narrow peninsula protected by the waters of the Bosphorus and the bay called the Golden Horn [3.1]. The city commanded the overland trade routes between Europe and the East, as well as the shipping lanes leading to and from the Black Sea and the Mediterranean. When in 395 the Roman Empire split into Eastern

and Western parts, Constantinople flourished as the Eastern capital. The political power, military strength, and economic prosperity of Constantinople generated more than mere physical growth. From the accession of Theodosius II in 408 until the end of the sixth century, the city was the nucleus of a brilliant civilization. Later generations admiringly saw the period as a Golden Age and named the civilization Byzantine.

Constantine laid out his beautiful metropolis with colonnaded avenues, open squares, and splendid public buildings. The governmental center, with the emperor's palace, the senate, and the forum, was near the former Greek acropolis at the eastern end of the peninsula. Later the palace church dedicated

to Holy Wisdom (Hagia Sophia) faced the palace across a square. Beside the palace stood a racecourse (Hippodrome) with its loggia, a place where the emperor and the court made official appearances. Defensive walls protected the city from land attacks and the navy guarded the waterways.

The great age of Byzantine architecture began with a military project in the fifth century—the building of a new city wall [3.2]. Early in his reign

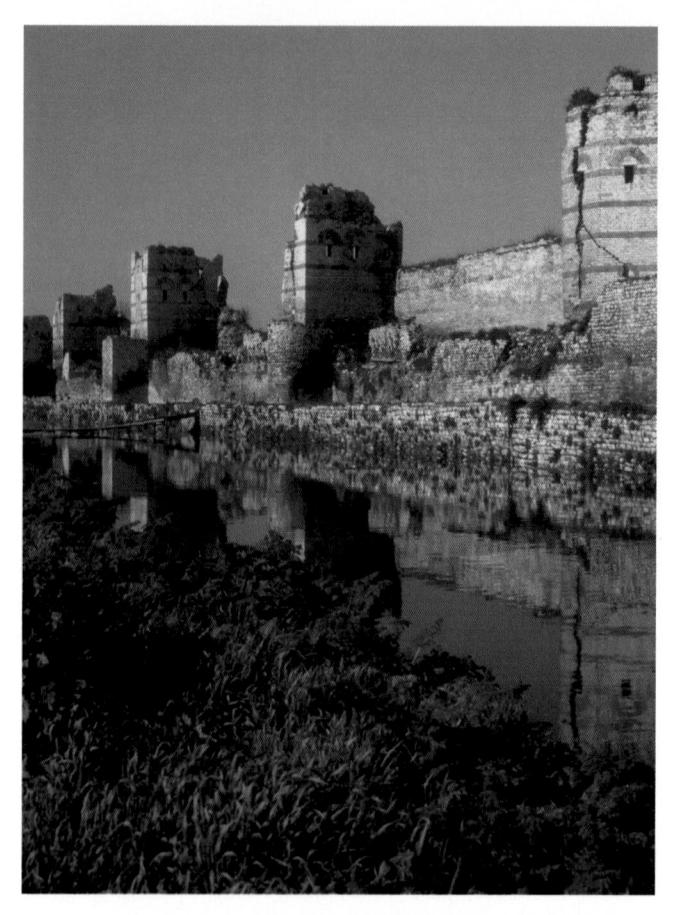

3.2 Land walls of Constantinople, built by Theodosius II, 412–413.

(408–450), Theodosius II expanded the city by constructing a second wall about a mile beyond the fourth-century defenses. The new fortifications were necessary in order to secure the city from the barbarians in the west and Persians in the east. These Theodosian defenses—double walls and a moat—provided the city with effective protection for more than a thousand years. They held back in-

vaders until 1453, when elite troops of the Turkish sultan, using cannon for which no fifth-century builder could have prepared, finally broke through the fortifications.

That the ramparts stood firm for a millennium was due to the inventiveness of the imperial engineers. (Their work provided a model for builders of fortifications throughout the Middle Ages.) Sea walls and the navy defended the city against attacks from the sea, and the Golden Horn (the harbor) could be closed to ships by drawing a giant iron chain across its entrance. Danger lay on the land side of the peninsula, and here the engineers created a whole defensive system rather than a single wall. This system, four and a half miles long and about 180 feet (54.9m) wide, was composed of alternating walls and terraces and a moat. An enemy first encountered a 60-foot (18.3m) stone-lined moat, reinforced with additional earth embankments, then a terrace and a massive towered wall. A second terrace led to a mighty inner wall, 36 feet (11m) high and 16 feet (4.9m) thick. These inner fortifications commanded and protected the outer. The inner wall was strengthened by battlements, fortified gates, and 96 huge towers, which stood 80 feet (24.4m) high. The towers projected beyond the wall and served as firing platforms. The defenders could unleash a raking crossfire against intruders along any part of the wall. Finally, since every tower was physically independent of its neighbor, the enemy had to try to take them one by one.

The only inherent weaknesses in the walls were the gateways leading into the city, but to reduce this liability the defenders flanked each of the openings with a pair of towers. The principal entrance was the so-called Golden Gate, an impressive structure covered with marble revetment and closed with gilded bronze doors. The outer gate opened only into a courtyard in front of the main gate. This space was surrounded by walls and towers so that an invading party, breaching the outer defenses, would find itself trapped under a barrage of fire from soldiers in the inner towers.

The builders of the Theodosian walls adopted an ancient eastern Mediterranean masonry system in which alternating courses of stones and bricks

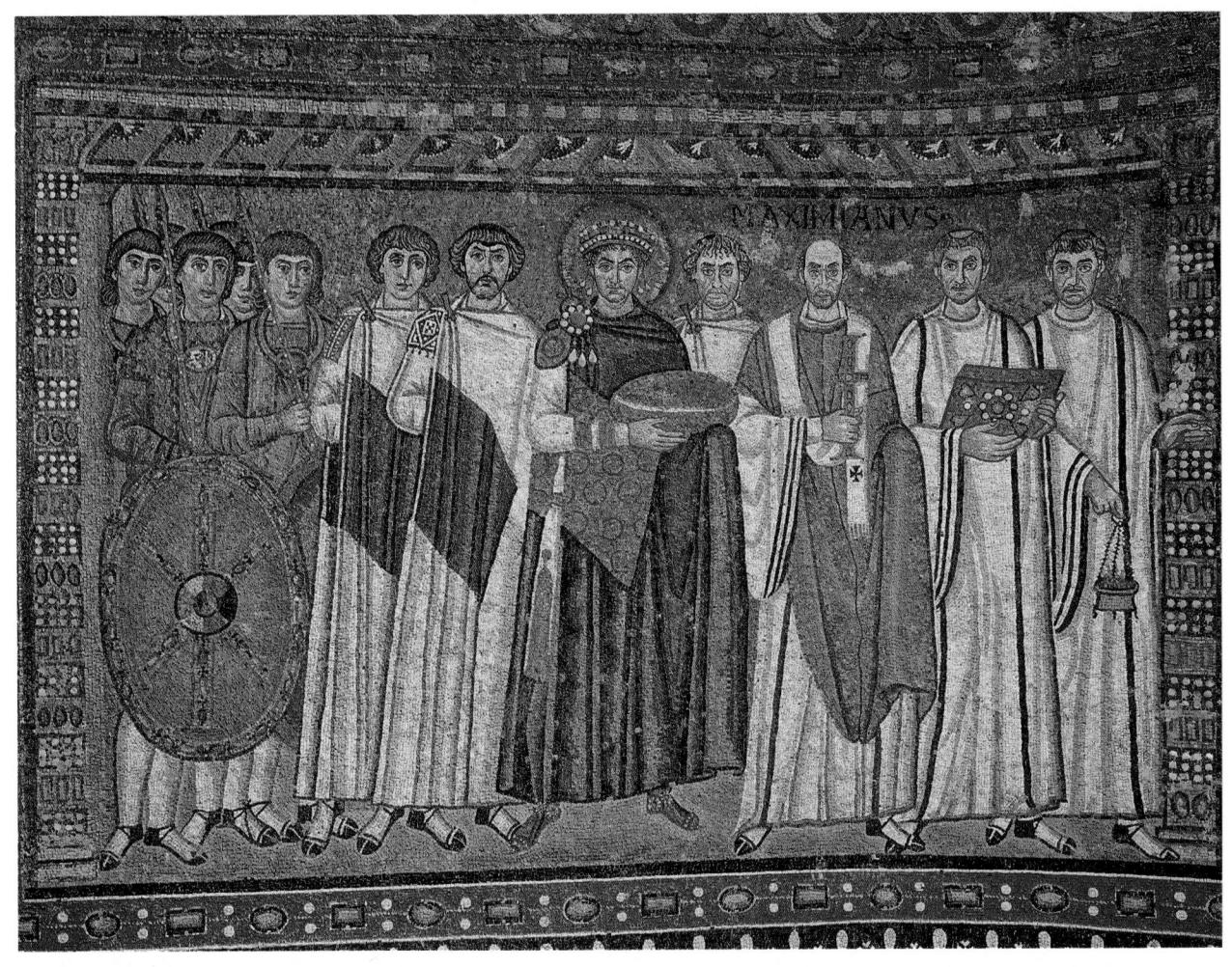

3.3 Emperor Justinian and his attendants, mosaic on north wall of the apse, Church of San Vitale, c. 547. 8ft. 8in. x 12ft. (2.64 x 3.65m). Ravenna.

faced a solid core of concrete and rubble. In the tower rooms thin bricks set in thick mortar formed light, strong vaults. Here engineers and masons gained practical experience, which was to stand them in good stead when the emperors ordered them to build elaborate churches and palaces.

In the sixth century, Justinian (ruled 527–565), a man as remarkable in his own way as Constantine, ruled the Eastern Empire [3.3]. With the help of brilliant advisers he achieved the imperial goal of a revitalized, unified Empire. His closest adviser may have been his strong-minded wife, Theodora. Justinian appointed the generals Belisarius and Narses to turn back barbarian threats and

win new territories for the empire. Justinian called upon John of Cappadocia, an administrative genius, to help reorganize the government, revise its tax structure, and set up an efficient civil service. He ordered the scholar Tribonianus to sort out the complex, contradictory, and often unjust laws and to direct the writing of a new code, or "body of civil law" (corpus jurus civilis), now known as the Justinianic Code. Byzantine law became the basis of many modern legal systems in the West.

of many modern legal systems in the West.

With an exceptionally fine bureaucracy to administer clear and just laws, Justinian would seem, in the words of his biographer, Procopius, to have "wedded the whole state to a life of prosperity," but

in reality Justinian's reign was neither as prosperous nor as benevolent as Procopius would have us believe. Constantinople had its poor and sick, its immigrants as well as artisans and merchants. The revised taxation system permitted the emperor to increase assessments until taxes became an intolerable burden on the populace. Meanwhile, the Monophysites, a formidable sect in the Eastern Empire, grew ever more discontent with Justinian's orthodoxy. And like all medieval cities Constantinople suffered fires, plagues, and urban discontent.

In 532 the citizenry rose up against Justinian in the Nika rebellion, so called from the rioters' cheer of Nika (Victory). Within a few days the insurgents destroyed half the city, including the old Church of Hagia Sophia. Justinian panicked and his ministers begged him to flee. Theodora alone stood firm, saying that she preferred death as the empress to flight and life as a fugitive. "Purple," she is reported to have said, referring to the imperial color, "makes a fine shroud." Taking courage from the empress, Justinian remained in Constantinople and, with the aid of Belisarius, put down the rebellion. The rebuilding of the city and of the churches began at once. So did a campaign of reconquest throughout the Mediterranean. Justinian extended the empire as far as Spain, recaptured Italy from the Goths, and made Ravenna his western capital.

Justinian tried to unify the empire further by enforcing the pronouncements of the fifth-century church councils of Ephesus and Chalcedon. Of the five great patriarchies, Rome, under the Pope, became the spiritual capital of Christendom, while at the same time the patriarch of Constantinople became the senior bishop in the east. The patriarchies of Antioch, Alexandria, and Jerusalem gradually lost power. Like Constantine and Theodosius before him, Justinian convened church councils in an attempt to reconcile the quarreling Christian factions. Although the Second Council of Constantinople (553) was only marginally successful, the emperor emerged as the political head of the Church. Such an exercise of temporal and religious authority is called "caesaropapism." The term is especially applicable to

Justinian, a secular emperor who nevertheless ruled as a sacred monarch, living in a sacred palace, and surrounded by elaborate rituals.

ARCHITECTURE

Secure from barbarians and Persians behind the Theodosian walls, and in full control of the city after the Nika rebellion, Justinian embarked on a building campaign that not only changed the city but demonstrated his generosity throughout the state. The court historian Procopius devoted an entire book, On Buildings, to Justinian's works. According to Procopius, the emperor sponsored more secular architecture than he did religious building; however, the secular buildings have been destroyed or remodeled. Churches, on the other hand, were often preserved out of respect for tradition; consequently, the accomplishments of Byzantine architects can be viewed today primarily in religious buildings. Hagia Sophia as well as churches in the western capital of Ravenna attest to the brilliance of the Byzantine court and the lasting achievement of its artists.

The Nika rebellion had left the city center in ruins. No sooner had Justinian subdued the rebellious citizens in 532 than he set out to erect a new Church of Hagia Sophia [3.4]. Construction progressed so rapidly that the project was completed in the short space of five years—clear testimony to the emperor's overriding concern for the project. Surely Justinian's personal interest spurred the builders on to create one of the most original monuments in the history of architecture, a church that fulfilled all the aesthetic, symbolic, and functional needs of the Byzantine Church. Hagia Sophia was known simply as "the Great Church."

That the finest structure in the long history of Byzantine architecture was created at the very outset of Justinian's reign rather than after generations of experimentation may seem remarkable, but Justinian was a patron of unusual energy and sophistication. Only a daring and discerning patron would have been inspired to select as architects two theoretical scientists who had never confronted the problems of erecting an actual building. An-

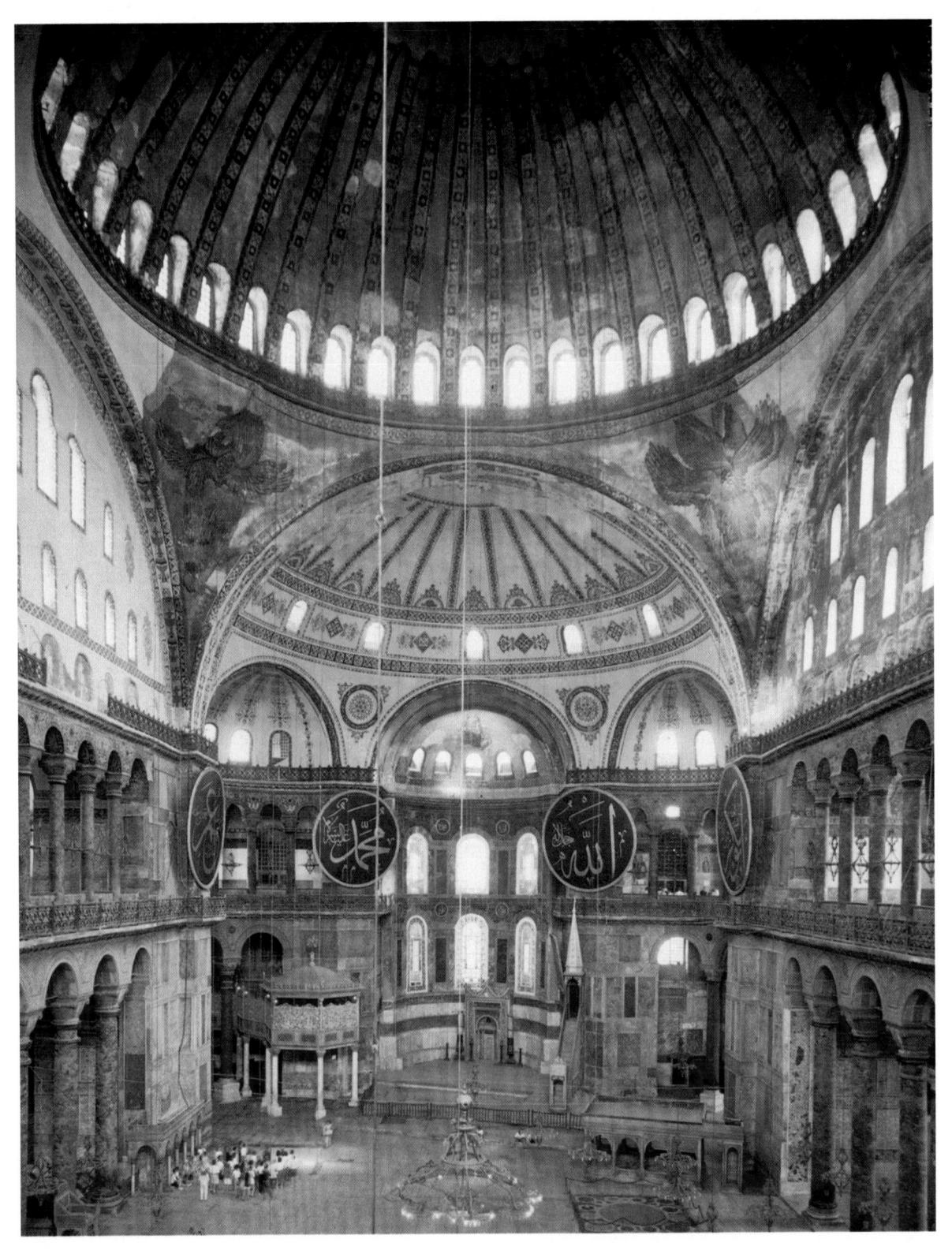

3.4 The Church of Hagia Sophia, (modern Istanbul) 532-537. Constantinople.

themius of Tralles, a Greek mathematician, specialized in geometry and optics. To complement Anthemius' abstract talents, Justinian chose Isidorus of Miletus, a professor of physics at the universities of Alexandria and Constantinople, who was an academic expert in the mechanics of thrust and support and the author of a scholarly commentary on vaulting. In his extraordinary perceptiveness, the emperor foresaw that the Church of Hagia Sophia, in order to rise as the perfect embodiment of imperial power and Christian aspirations, had to be designed by men whose theoretical knowledge could transcend the limits of contemporary architectural practice.

Justinian's architects succeeded magnificently. They captured the spiritual and ceremonial needs of the Orthodox Church by integrating the longitudinal and centralized schemes of early Christian buildings in a manner inconceivable to Constantinian architects [3.5]. Fourth- and fifth-century architects simply built basilicas and rotundas next to each other and linked them by colonnades, as we have seen at the Holy Sepulchre in Jerusalem. The extraordinary Byzantine achievement was to consolidate the basilican plan and elevation with the central domed martyrium into one logical and indivisible whole. The inspiration to fuse the disparate types seems to have come from the liturgical and symbolic requirements of Byzantine ritual. In the Byzantine rite, the Gospel and the Host remained in or near the sanctuary. (In the Middle Byzantine period, about which we have more information [see Chapter 6], the Eucharistic proces-

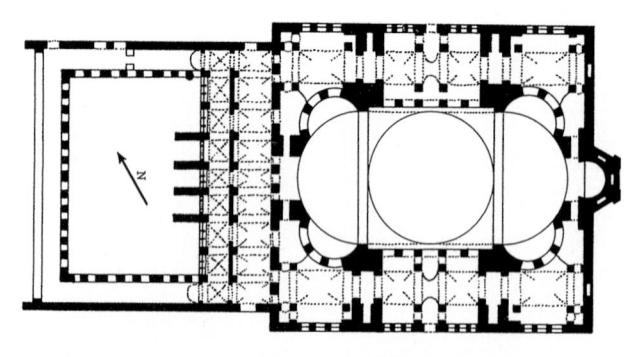

3.5 Plan, Hagia Sophia. Body of building, 226ft. 7in. x 244ft. x 8in. (69.1 x 74.6m).

sion no longer followed the longitudinal direction of the nave but formed a circuit moving around the apse and its adjoining rooms—the diaconicon and the prothesis—into the nave, and back again.) In order to make the structure at one with ceremony, Byzantine architects turned to the dome, the hemispherical symbol of the canopy of Heaven. Indeed, the very word "Byzantine" today conjures up visions of rising domes and vaults covered with shimmering mosaics. The dome is a shape that encourages the eye to circle upward, seeking the crown of the vault. In marked contrast to the driving horizontal movement down the nave to the apse in a basilica, the movement in a domed building revolves around a central vertical axis. One can even draw a striking parallel between the two structural types and their characteristic decorations. In architectural terms, the basilica is to the narrative scheme what the dome is to the symbolic image, in that the first suggests an active succession of events while the second induces a static contemplative state.

In order to vault the enormous spaces demanded by the imperial ceremonies, Justinian's builders gave the dome on pendentives its definitive form. Pendentives had appeared as early as the second century, and we have seen a pendentive dome over the central crossing in Galla Placidia's chapel, but the Byzantine architects were the first to make extensive use of the forms. Moreover, they reduced the weight on the load-bearing walls by substituting a brick and mortar construction, similar to that found in the towers of the land walls, for the traditional stone or concrete fabric. In so doing, the architects could build very large domes and half-domes, and support them with fewer and lighter piers and abutments.

Such was the structural and visual adaptability of the dome on pendentives that it could be applied to several different plans—domed basilicas, domed octagons, and domed Greek-cross churches. Even the number of domes employed remained variable, so that in the course of the sixth century two major types of domed architecture evolved. In one, a single dome covered a central area usually expanded by aisles and galleries. In an-

The Dome

A dome, like the vault, is an extension of the arch (imagine an arch pivoted on its axis). Just like an arch, the dome exerts a dynamic thrust outward with the greatest movement occurring at the curving haunch. The steeper the profile of the dome, the less outward thrust it exerts and the more stable the structure becomes. A pendentive is a spherical triangular section of masonry that makes a structural transition from the square of the bay to the circular rim of the dome. The walls, piers, and pendentives carry the sheer weight of the dome while the thrust is countered by galleries and half-domes abutting the dome. Since the dome needs continuous support at the rim, sometimes it is literally tied with chains or timbers. One of the most spectacular domes on pendentives is that of Hagia Sophia [3.6 and 3.7].

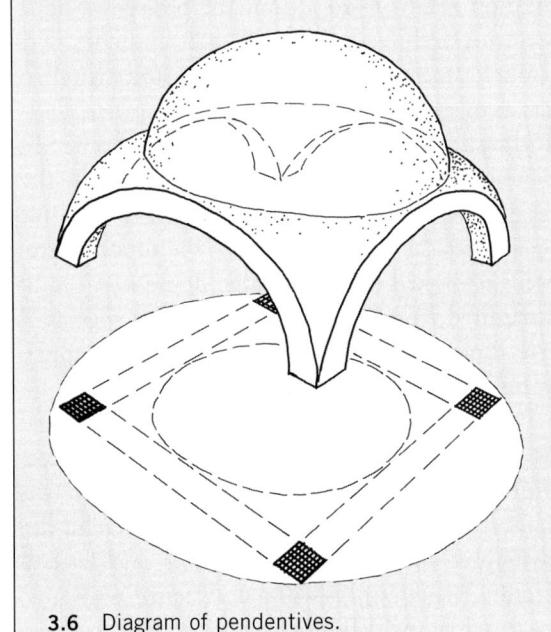

3.7 Hagia Sophia, interior of dome. Height of dome 184ft. (56.1m).

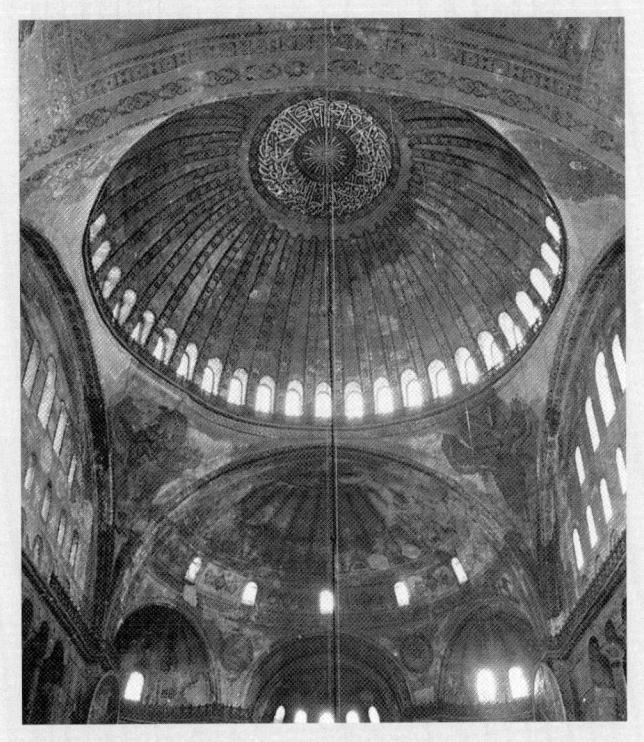

other, several domes covered the nave and transept or the arms of a Greek cross (seen in the Church of the Holy Apostles). Although the multidomed building had a wider and more lasting influence than did buildings roofed with only one dome, it was the single-domed church, developed by Justinian's architects and perfected at Hagia Sophia under his special patronage, that generated the most imaginative aesthetic and structural forms. The designers converted the dome on pendentives into a canopy that not only covered an extensive space and mirrored the circular path of the Eucharistic ceremony but also served to integrate the

forms and spaces of the entire fabric into an indissoluble whole.

The greatness of Anthemius and Isidorus lay in their ability to reconcile the inherent conflict in Christian church architecture between the desire for a symbolic, upward-soaring space and the need for a directional focus on the altar. From afar, Hagia Sophia commands the whole skyline of Constantinople. If we block out the four minarets—those slender towers added by the Muslim Turks—Hagia Sophia ascends from an earth-hugging mass into a man-made mountain. The dome that crowns the upward-surging exterior also dominates the inte-

rior. Through a series of large niches (exedrae) and half domes rising to the main dome, the architects infused the inevitable horizontal movement from entrance to altar with a dramatic upward sweep of 180 feet (54.9 meters), a unique integration of the basilica and the central-domed building.

In theory (not in actual construction), the architects began with the gigantic dome, measuring 100 Byzantine feet in diameter (102 feet or 31.1 meters), supported on four enormous piers and pendentives. Then, in order to expand the church's longitudinal dimensions while accentuating the all-important rising effect of the central canopy, the architects added half domes at the eastern and western sides (creating a vaulted nave). These half domes were in turn supported by conch-covered niches. The sanctuary with an apse at the east, an atrium and double narthex at the west, and vaulted side aisles on the north and south further extended the basilica-like plan. Galleries extended over the aisles and narthex. Nevertheless, the dome remained the unifying, form-giving element in the design, drawing together sanctuary and nave into a centralized space known in Byzantine architecture as the naos (Greek, meaning "interior"). Anthemius and Isidorus defined the longitudinal space of the nave primarily with circular shapes: from the relatively low level of the narthex, the rising movement leads the eye from vaulted aisle to conch to half dome to dome and on down again to the altar. This slow rising and falling movement was originally even more fluid and continuous than it appears today, since the original dome had a shallower curve than the present one. The architects defied gravity by building a dome so low in curvature that it exerted a powerful outward thrust, and then by piercing its rim with windows.

Building techniques could not match the architects' bold imagination. They used narrow bricks and very thick mortar, building so rapidly that the mortar did not have time to set properly. In 558, part of the dome collapsed. The builders replaced it with a ribbed dome 20 feet (6.1m) higher than the first, but this second, steeper dome was balanced precariously, and it required extensive repairs—in 989, when the western section fell, and again in

1346, when the eastern half had to be strengthened. (The dome has survived recent earthquakes.) Apart from the decorations added after 1453 by the Turkish conquerors of Constantinople, the vault still retains its sixth-century appearance.

The central dome, even with its steeper profile, is an amazing achievement. The brick and mortar structure seems to levitate, as if it were truly the visionary Dome of Heaven [see 3.8]. This floating sensation results from a dramatic passage of light. Byzantine architects designed their churches with as much attention to illumination and visual effects as to structural or functional necessities. Forty windows pierce the entire rim of the dome. By opening the circumference of the dome to the sky, the architects created a luminous aureole that dematerializes the real substance of the support. Procopius remarked that the golden dome seems to be "suspended from Heaven." Even today spectators share Procopius' amazement at the dome's apparent hovering suspension.

The wonder of Hagia Sophia's physical fabric was more than equaled by the spectacle of its decoration, for Byzantine planners understood the architectural interior as an arena for a splendid display of precious materials, vivid colors, and patterns of light. Hagia Sophia's dome glistened with gold mosaic while the columns were of purple porphyry and green marble. A lustrous veneer of green, white, yellow, and purple marble covered the walls, and the windows transmitted light through panes of colored glass. The columns and architrave of the sanctuary screen were sheathed in silver and hung with red silk. Against such a background, the effects of the constantly shifting shafts of illumination must have elevated worshippers to a state of spiritual exaltation in which they felt themselves truly to be in the presence of the divine. Justinian was devoutly moved by the magnificence of his new church. Upon entering Hagia Sophia for the dedication on Christmas day, 537, he is said to have exclaimed, "Solomon, I have surpassed thee!"

Hagia Sophia, as the palace church, was a testament of unending praise to the emperor as well as to God, and Justinian took full advantage of the symbolic possibilities of the liturgical ceremony

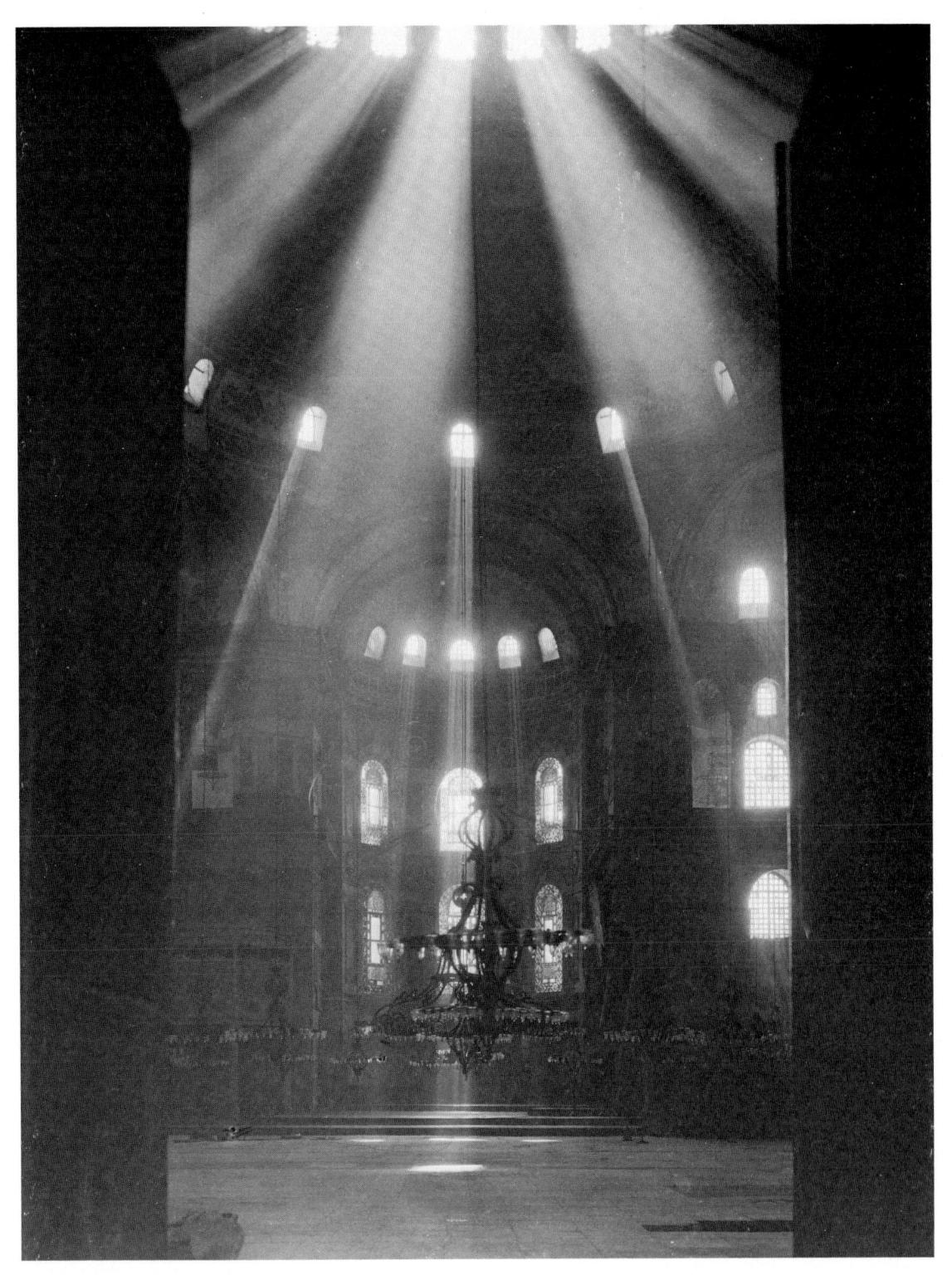

3.8 Interior, Hagia Sophia.

Neoplatonism and the Aesthetics of Light

The theoretical formulations underlying Neoplatonic aesthetics derived from the third-century Greek philosopher Plotinus, whose writings, *The Enneads*, were familiar to the Byzantine world through the interpretations of his fifth-century disciple Proclus. Plotinus developed a cosmology of creation and divinity based on a hierarchical order. At the pinnacle of the hierarchy is the incomprehensible One, a unity perfect in truth, beauty, and goodness. Through a process known as emanation, the One is reflected in Divine Reason, an intelligence then made manifest in the Universal Soul, which in turn animates the material world. Matter lies at the bottom of Plotinus' scale. Since the One is the only reality, all else being an ever weakened reflection of unknowable perfection, material things have no existence except as they are given spiritual life by the Universal Soul. Earthly objects and beings appear as faint echoes of the One.

Although humans belong to the world of matter, they also participate in higher realms because they have intellect. Each person, theoretically, can achieve a mystical union with the One through meditation. Contemplation of beauty in the visual arts assists this union. In the words of the philosophers, then, art becomes a mirror to catch an image of the Universal Soul. The artist must try to represent the essence of the thing depicted rather than superficial, outward appearances. Only by capturing this essence can art transmit the knowledge of infinite beauty to humanity's imperfect intelligence.

None of these metaphysical speculations would have influenced Byzantine imagery had not Neoplatonism found adherents among Christian thinkers. In the late fifth century, the anonymous Greek theologian known as Dionysius the Pseudo-Areopagite, reinterpreted Plotinus' theories in Christian terms. The Pseudo-Dionysius saw the One of Plotinus as the Christian God. He justified the use of images as a step toward mystical communion with the Divine. Like Plotinus, the Pseudo-Dionysius believed that light and the colors that transmit light play an essential part in the contemplative process. As the immaterial element in material things, light links the world of matter with the higher realm of the spirit. Neoplatonic aesthetics required that art glow with light and color in order to make the perfect beauty of the invisible world intelligible and visible to the ordinary person.

Hypatius of Ephesus, writing in the mid-6th century, justified decorating churches as a means to inspire piety in the congregation. He wrote: "We, too, permit material adornment in the sanctuaries, not because God considers gold and silver, silken vestments and vessels encrusted with gems to be precious and holy, but because we allow every order of the faithful to be guided in a suitable manner and to be led up to the Godhead, inasmuch as some men are guided even by such things towards the intelligible beauty, and from the abundant light of the sanctuaries to the intelligible and immaterial light."

enacted within its walls. Indeed, the Eucharistic service is telling evidence of the Byzantine emperor's caesaropapism, for among laymen only Justinian had the privilege of participating directly in the lengthy and elaborate ritual. The solemnities were partially screened from the congregation by railings and curtains. The ceremony began with a double entrance as the patriarch and his clergy moved into the sanctuary and the emperor arrived with his court. The courtiers watching from the aisles and the empress and ladies from the galleries saw only a series of processions moving out from and into the sanctuary: the Great Entrance, a procession of the clergy bringing the

bread and wine from the prothesis to the altar, the appearance of the emperor and patriarch to exchange the kiss of peace, and finally the emperor's entrance to receive communion. Justinian had a special relationship to God and the Church; he was an equal of the patriarch. Throughout the ceremony the emperor and the patriarch were sheltered by the "Dome of Heaven," where as an eighth-century patriarch wrote, "The church is an earthly heaven in which the super-celestial God dwells and walks about."

Hagia Sophia was never copied by Christian builders, although it inspired Islamic mosques after the Turks captured the city. Neither its un-
usual structure nor its perfect fusion of architecture and symbolic ritual suited a church where the emperor was not in attendance. Nor, given the high cost of such perfection, could an imperial patron again risk bankrupting the empire for his personal glorification of God. Nevertheless, Hagia Sophia set a standard of architectural excellence throughout the Byzantine world.

Although Hagia Sophia was the architectural marvel of Byzantium's Golden Age, its design was too sophisticated and too closely allied with the ceremony of the imperial court to remain a workable model for other buildings. To satisfy symbolic and devotional needs, Byzantine planners turned to such multidomed buildings as the Church of the Holy Apostles. By the sixth century, the Constantinian Church of the Holy Apostles needed repair, and in 536 Justinian rebuilt the martyrium and vaulted its Greek cross form with five domes [3.9]. The new church, dedicated in 550, was so easily imitated and so well suited to the needs of the Eastern Orthodox Church that it became a model for later Byzantine architecture.

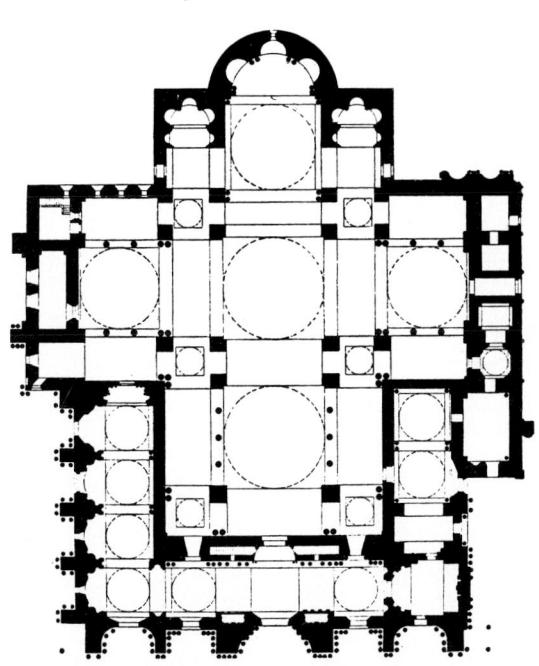

3.9 Typical multidomed Greek-cross plan (Church of St. Mark, Venice), inspired by the 6th-century Church of the Holy Apostles, Constantinople (destroyed 1469).

Although the sixth-century church was razed in 1469 to make room for the Turkish conquerors' mosque, we can reconstruct its appearance from Procopius' description and from churches inspired by the plan, such as St. Mark's in Venice. The emperor's architects chose not to alter significantly the symbolic Greek-cross plan, but they transformed the roofing system by building a central dome over the crossing, surrounded by four lower domes over the arms of the cross. Furthermore, they inserted a ring of windows around the rim of the main dome, thereby creating an emphatic vertical accent by flooding the crossing with light. The upward-surging spaces inside the church reflected the ancient symbolism of the martyrium. Moreover, the renovated church was easy to build, because of its modular composition of repeating units, each one of which was a square surmounted by a dome on pendentives. The very simplicity of the design facilitated both imitation and endless variation.

A view of St. Mark's Church in Venice enables us to compare the relative success of single-domed and multidomed buildings [6.19]. The single, though expanded, dome of Hagia Sophia creates a sense of flowing, interpenetrating spaces. In contrast, the spatial development of the multidomed church is the product of individual units. This breakup of spaces seems unsatisfactory if measured against Hagia Sophia, since the very repetition of the dome reduces and diffuses its dramatic effect. Also, the series of vertical axes in a multidomed structure creates a conflict with the horizontal movement of space down the long arm of the nave. This negative comparison is unjustified, however, because the single-domed church evolved out of the special needs of the imperial court. When we consider the multidomed building as an independent architectural conception, its organization of spaces merges as a rich and complex scheme of unending fascination.

In spite of the challenging possibilities offered by domed buildings, the traditional basilica with its trussed roof continued to be popular. In Ravenna, the capital of the Byzantine Empire in the West after 540, builders adopted aspects of the Byzantine aesthetics even while they perpetuated the venerable

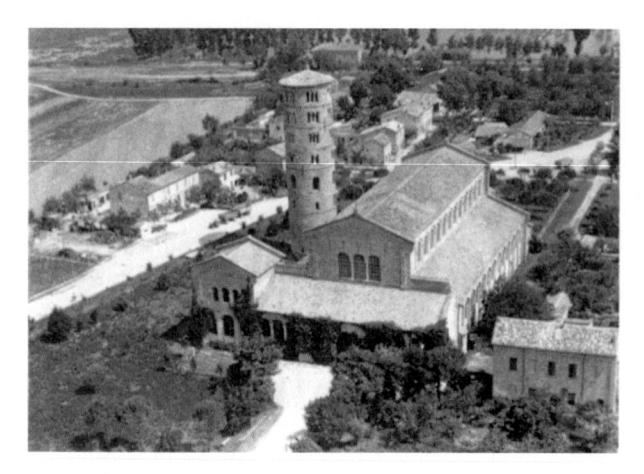

3.10 Exterior, Church of S. Apollinare in Classe, the former sea port of Ravenna (Classis), 533–549.

Western tradition of the basilican hall. The Church of S. Apollinare Nuovo, originally the Arian cathedral dedicated to Christ, was built at the end of the fifth century by the Arian Gothic ruler Theodoric (493–526) as his palace church [3.10]. In the sixth century, the victorious Byzantine conquerors rededicated the basilica to St. Martin. (Later the relics of St. Apollinaris—the first bishop of Ravenna—were transferred to the church, which became the "new" Church of St. Apollinaris—S. Apollinare Nuovo.)

The relics of St. Apollinaris originally lay in a church in Ravenna's seaport, Classe. The church was built by a Byzantine official, Julianus Argentarius, and completed in 549. Both S. Apollinare in Classe (532/536-544) and S. Apollinare Nuovo are three-aisled basilicas, but they differ from Roman basilicas in their proportions and other details. The naves are wider and shorter than in typical Roman basilicas. Side rooms flanking the apse reflect the architects' Eastern heritage, although these rooms may have served simply as chapels rather than as the Byzantine diaconicon and prothesis. Furthermore, the apse has an Eastern form, polygonal on the exterior and semicircular on the interior. (The apse at S. Apollinare Nuovo was destroyed by an earthquake.) Large windows in the outer walls flood the aisles and lower part of the nave with light, which emphasizes the lateral extension of the space [3.11]. Thus the directional emphasis so characteristic of the Western basilica gives way to a feeling of expansiveness in the Ravennate type.

The finest surviving church in Ravenna, the Church of S. Vitale, was founded by Bishop Ecclesius (521–532) while that city was still the capital of the Ostrogothic Empire [3.12]. Probably soon after 540, when Justinian's armies under Belisarius

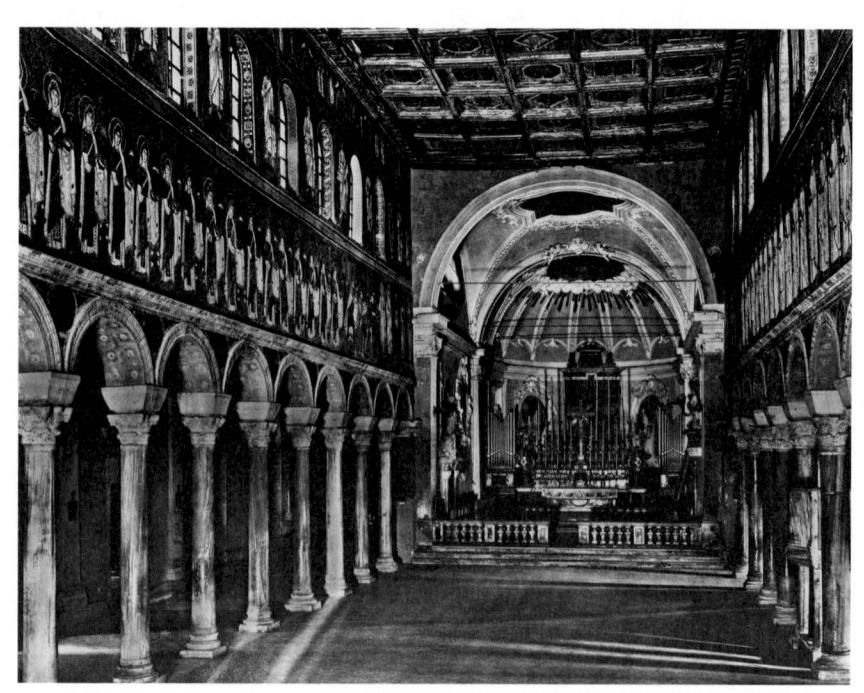

3.11 Nave, Church of S. Apollinare Nuovo, 6th century, Ravenna.

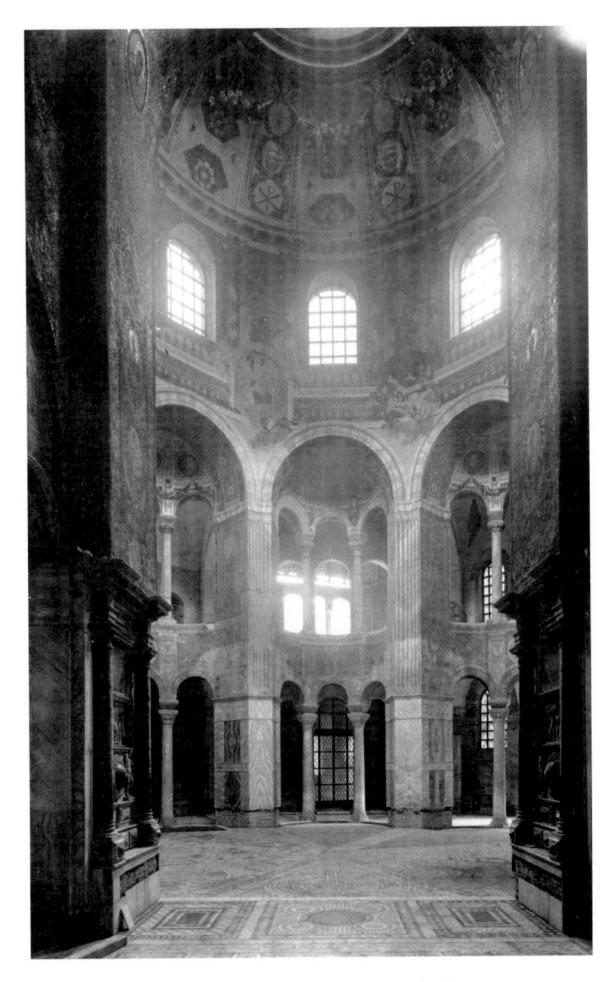

3.12 Interior, Church of S. Vitale, 548, Ravenna.

recaptured Ravenna and again turned the Adriatic port town into the Western Byzantine capital, Julianus Argentarius gave 26,000 gold solidi for the present church's construction. On May 17, 548, the Orthodox Archbishop Maximianus (546–556) dedicated the church to the city's patron St. Vitalis, who had been martyred on the site. The Church of S. Vitale had a central octagonal plan, perhaps inspired by the Constantinian Golden Octagon in Antioch or by martyria. The designers gave the familiar plan new complexity and sophistication.

At S. Vitale, the central domed octagon is surrounded by an ambulatory and gallery [3.13]. The eight piers that support the dome also define the galleried niches, which seem to press out from this central core. A rectangular choir, apse, and flanking rooms project from the eastern face. Even so,

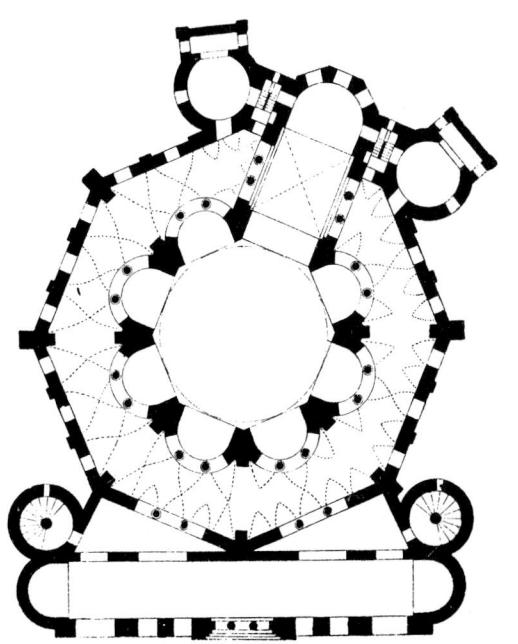

3.13 Church of S. Vitale. Plan. Diameter about 111ft. (33.8m).

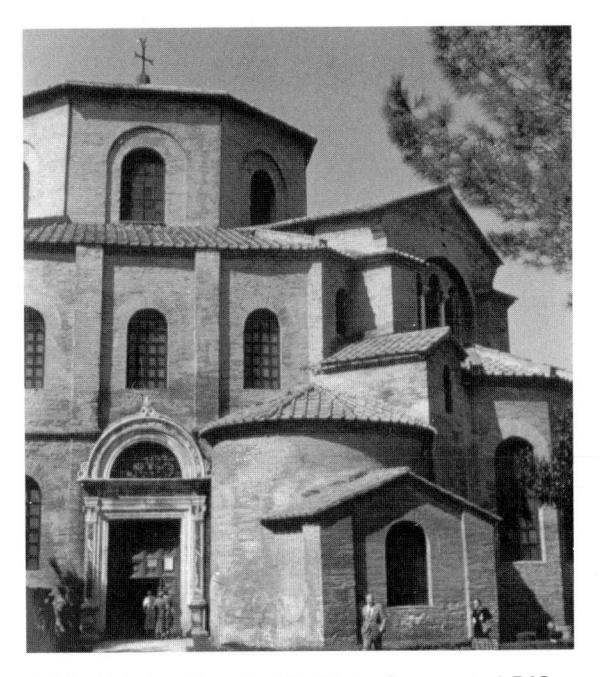

3.14 Exterior, Church of S. Vitale. Consecrated 548.

an exterior view of the building discloses a clarity uncommon in Constantinopolitan buildings but characteristic of the West [3.14]. The apse, the choir, and the gallery roofs all ascend to the roof over the dome in a series of distinct yet interlocking polygonal forms. Such a lucid disposition of

exterior shapes contrasts with the complexity of spaces within the church.

The church was connected to the palace by a shallow narthex placed at an angle to the main axis. A stair tower at each end of the narthex led to the gallery (one tower was later made into a bell tower). The offset narthex created two entirely different vistas for the worshipper, and neither view carries the eye directly to the sanctuary. This spatial ambiguity extends throughout the building, since the semicircular exedrae, opened as they are by arcades at two levels, cause space to seem to flow unbroken between the naos and the outer aisles. The arcades create identical semicircular figures and rise into half-domed niches. The architects provided additional structural stability to the slender columns by inserting downwardtapered impost blocks between the column capitals and the arcade above, thereby concentrating the weight at the center of the column. A lighter wall was made possible by constructing the dome of ceramic tubes and mortar, a device first used in ancient Rome. The steep dome and its attenuated supporting structures created an effect of rising space. (The church became part of a Benedictine monastery in the eighteenth century. The dome and upper walls were frescoed with a scene of the glory of St. Vitalis and St. Bernard.) In the worshipper's experience of the building even today, such verticality helps to bind all the parts into a single, soaring whole. As light pours in from the large windows of the ambulatory, galleries, and dome, it forms a halo of illumination around the tall central core. In its own way S. Vitale is as remarkable a building as Hagia Sophia.

BYZANTINE MOSAICS

In the churches built to honor the Sts. Apollinaris and Vitalis, the most noticeable features are the mosaics. The Ravenna mosaic cycles give us precious information about the lavish programs that once decorated the churches built under imperial patronage in Constantinople and elsewhere. They reveal that artists combined high standards of craftsmanship with an extraordinary spirit of innovation. Byzantine

mosaicists had to create sumptuous interiors worthy of both the imperial and the heavenly courts. To achieve this awesome goal, artists augmented naturally colored stones with glass tesserae, and because glass could be manufactured in almost any hue, the variety and intensity of colors could be increased. For the gold so vital to Byzantine sensibilities, dazzling tesserae were created by encasing a layer of gold leaf in clear glass. Ultimately, artists and patrons came to prefer color schemes composed of brilliant gold, deep blue, green, and purple, all enhanced by touches of red, yellow, and white. With these imperial colors they turned each wall into a light-refracting plane. Craftsmen spaced tesserae widely and often colored the exposed plaster bed with red, thereby achieving a rich yet subdued background color. The mosaicists also tilted the tesserae at irregular angles to heighten the play of glittering reflections from candles and lamps. Finally, Byzantine designers created mosaics that seemed truly to float over walls and vaults, as if with a separate reality independent of the supporting structural framework. No longer were images conceived of as windows opening into the world of matter. On the contrary, a Byzantine mosaic aimed to transcend matter and capture the intangible world of the spirit.

Justinian's artists worked within a well-formulated aesthetic theory, grounded in the Greek philosophy of Neoplatonism. By the sixth century, the Neoplatonic ideal had so pervaded the Eastern Empire that it became the intellectual basis for the entire scheme of pictorial arts. Neoplatonism emphasized a hierarchical order of the universe; thus, in devising the iconographical program, the most sacred figures were placed in the upper zones, and the earthly scenes in the lower registers. Byzantine artists and viewers, in effect, agreed to a series of conventions that is, an artistic language that communicated unseeable mystic reality. The most important artistic convention evolved from the Neoplatonic theories of light and vision. Since all objects, Plotinus contended, interrelate and interpenetrate as they share in the oneness of Divine Reason, they are, ideally, transparent. To eliminate matter and attempt to evoke the diaphanous nature of material presences, the artist concentrated on light and color, while

ignoring aspects of darkness and shadow—those features, in other words, that lent three-dimensionality to forms. With the image thus separated from mundane appearances, the viewer could meditate on art not with the physical but with the "inner eye." In so doing, the viewer intuitively grasped the reflections of beauty and perfect goodness emanating from the One through the Universal Soul.

Byzantine artists employed another device to deny traditional illusionism. They rendered objects in reverse perspective, that is, the lines diverge from each other as they recede, and objects appear to tip up and grow larger in the distance. In the mosaic of Theodora's court in S. Vitale, for example, the fountain is drawn in reverse perspective [3.15]. Two factors, both grounded in Neoplatonic philosophy, are responsible for the use of this method of representing space. First, the object had to be presented as completely as possible in order to permit the viewer's eyes to wander over its surface. Second, the zone between the observer and the work of art is the active space. The spectator did not look through the wall to the image but was confronted by it. Any space depicted had to extend forward, toward the

3.15 Detail of [3.18] Theodora's court, mosaic in Church of S. Vitale.

viewer, not backward beyond the wall. The artists accepted the notion that material objects exist in space, but they inverted the "illusionism" of the setting to imply that things project forward into the atmosphere between the image and the observer. In short, they abandoned the Roman idea that the picture is a window on the world.

Byzantine artists had to satisfy both societal and imperial needs. The Eastern emperors wanted to rule in the glorious tradition of imperial Rome. Assisted by the educated taste of the court advisers, they encouraged a revival of classical culture, ceremonial etiquette, and art. In reconciling the earthy realism of ancient art with the spiritual goals of Neoplatonism and Christianity, sixth-century artists developed the first truly medieval style. In order to capture the intangible reflection of divinity or supreme power, be it Christ or the emperor, court artists adapted a hieratic, abstract style. Thus two different but equally respected modes of perception—naturalistic illusionism and hieratic abstraction—underlie the Byzantine style.

The shift from illusionistic vision to thoroughly abstract imagery is nowhere more evident than in the mosaics covering the interiors of Byzantine churches. This is not surprising since religious art was regarded as an aid to meditation and had to be rendered so that the worshipper could suspend belief in sensory experience, the better to partake of the spiritual world. For this purpose, the static, timeless quality of an image took precedence over any narrative element. Furthermore, if the required emphasis on light and color permitted an intellectual ascent to immaterial beauty, it also served to glorify Church and state by creating a brilliant environment for the celebration of the Mass. Hagia Sophia must have offered the most splendid setting of all. Unfortunately, the church's original decorations have been damaged or destroyed, but in Ravenna, despite changing political fortunes and religious controversies, sixth-century mosaics survive in remarkable numbers.

At S. Apollinare Nuovo, the mosaics show a conscious effort to reject narrative development in favor of abstract, hieratic imagery [3.16]. The panels above the clerestory windows, part of the Arian dec-

3.16 Holy Women at the Tomb, Church of S. Apollinare Nuovo, before 526. Mosaic on upper wall of nave. Ravenna.

oration of the church, and probably completed before Theodoric's death in 526, form the earliest surviving mosaic cycle illustrating the miracles and the Passion of Christ (appropriately since the church was dedicated to Christ). Strong contours and bright, flat colors make the images easily visible from the nave floor. That the sixth-century mosaicists carefully considered the worshipper's relationship to the artwork is further demonstrated by the simplification of the design. Gone are the genre details and the profusion of small figures that gave many earlier mosaics an anecdotal character. Instead, the Arian artists have reduced the number and enlarged the size of the remaining figures. Still, making the image visible to the spectator was not the only motivation behind the artist's simplified design. The individual image is no longer understood as part of a lively narrative, but rather as an eternal symbol. When looking at the picture, the worshipper had to grasp its symbolic content in order to see and understand the reflection of divinity mystically present in the material substance of the mosaic.

The designers ordered each composition symmetrically and eliminated all landscape and architectural details, except for the few elements essential to the identification of the subject. Thus, a rock and some green lines establish the garden site of Christ's tomb. These vestiges of nature appear against a glimmering golden background rather than against the blue sky found, for example, in the Good Shepherd lunette in the nearby oratory [see 2.1]. The use of gold at S. Apollinare Nuovo disassociates the scene from a tangible environment and forces the viewer to focus attention on the dominant, central sepulchre. Unlike the Early Christian ivory that represented the same moment [see 2.22], the Byzantine mosaic only suggests a story. In the ivory sculpture, sleeping soldiers and the confrontation between the Holy Women

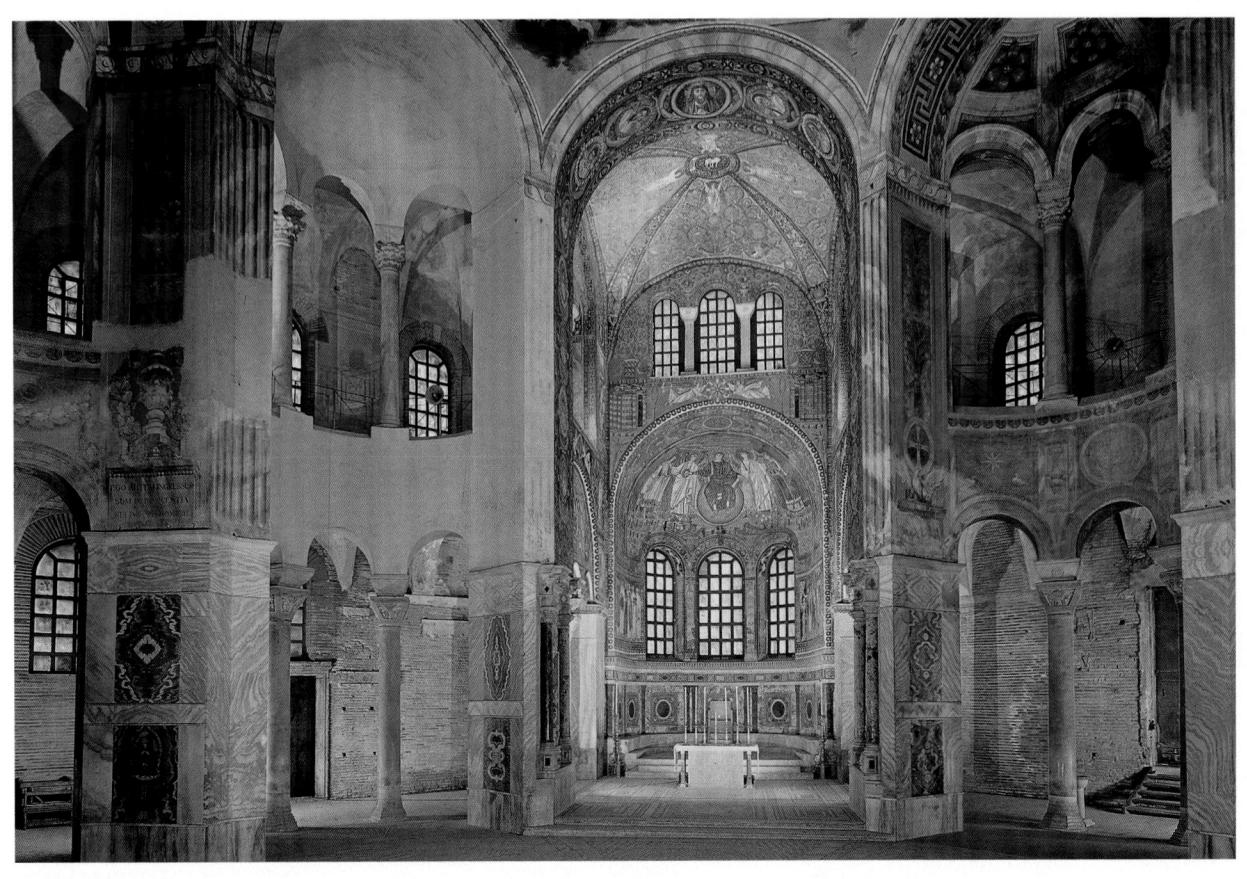

3.17 Sanctuary of the Church of S. Vitale, before 548. Ravenna.

and the angel lend drama to the depiction of a specific moment. Here the soldiers have disappeared. The divine messenger and the pious witnesses, rigid in posture and staring outward, simply gesture toward the tomb between them, where the open door reveals the raised lid of the empty sarcophagus. By means of this pictorial abbreviation, the artists present, not the temporal narrative of Christ's ascent from the tomb, but the miracle of the Resurrection.

Although created for the decoration of an Arian church, the scenes from the life of Christ showed no heretical views, and the later Orthodox conquerors left them untouched. Below the clerestory windows, however, Theodoric's Arian artists had placed a procession of men and women and views of the palace and seaport of Ravenna. The Byzantines transformed these secular figures to a gathering of saints. On the left side of the nave, the three Magi lead a procession of female martyrs toward the

Virgin and Child. On the right, male martyrs leave the palace to follow St. Martin, the new patron of the church, to the enthroned Christ. The figures repeat the verticality and regular rhythm of the nave columns and enhance the directional movement toward the sanctuary. Barely distinguished from one another in physiognomy, and in no way individualized by dress or gesture, the toga-clad men become patterns—white shapes overlaid with blue and green lines. The S. Apollinare Nuovo martyrs cast no shadows; they stand in an aureole of bright yellow tesserae. The Ravenna mosaicists have willfully inverted the natural order of the material world as they exclude the material world from pictorial representation.

In the Church of S. Vitale, we find a more highly developed version of these ideas. The mosaics of the sanctuary survive, still surrounded by elegant columns, carved capitals, intricate moldings,

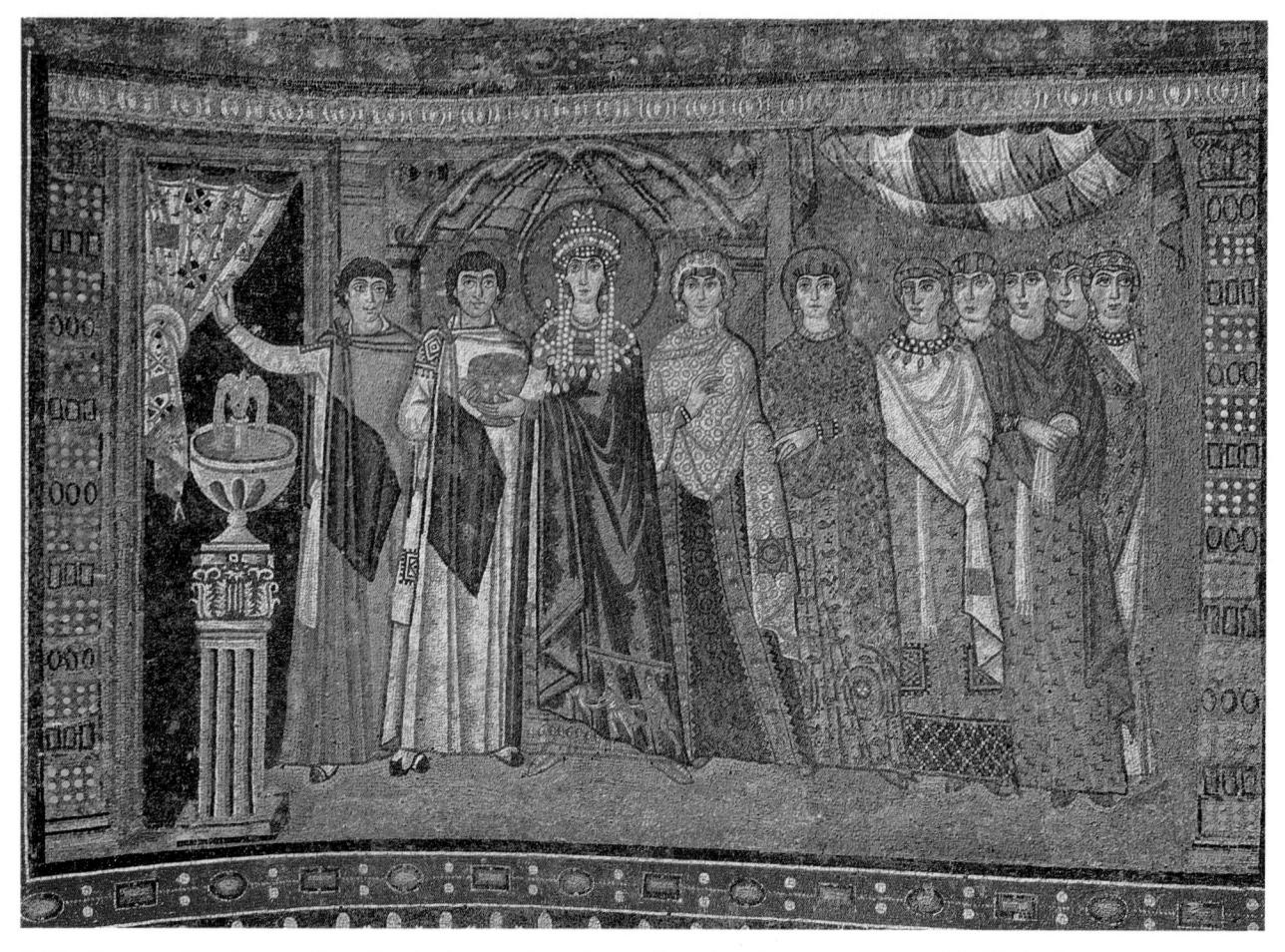

3.18 Empress Theodora and her attendants, mosaic on the south wall of the apse, Church of S. Vitale. Ravenna.

and a rich encrustation of marble veneer imported from the imperial quarries near Constantinople [3.17]. Sheer splendor, however, is only one aspect of the decorative program, for in the hallowed space of the apse, the artists finally rejected continuous narration in favor of symbolic images related to the function of the sanctuary.

In the apse, Christ sits enthroned on a celestial orb and offers a crown of martyrdom to St. Vitalis, at the same time that he accepts a model of the church from Bishop Ecclesius, its founder. On the wall below, Justinian rules the material world as Christ's vicar. The emperor, attended by courtiers and Archbishop Maximian, holds his gift to the church, a Eucharistic plate (paten) [see 3.3]. Across the sanctuary, but represented as if in the narthex, Empress Theodora with her guards and ladies com-

plements Justinian's action by offering a chalice [3.18]. Although neither Justinian nor Theodora ever visited Ravenna, they participate eternally in the celebration of Mass at the altar. Theodora died of cancer in June 548, shortly after the dedication of the church.

In the lunettes of the choir, just in front of the apse, Old Testament scenes refer to the sacrifice of Christ. The patriarch Abraham entertains three angels, symbols of the Trinity, with round loaves incised with crosses, prefigurations of the Host. At the right, the hand of God reaches out to stop Abraham's obedient sacrifice of his son Isaac, an event symbolizing the Crucifixion of Christ. As if to make explicit the analogy between the Old and the New Testaments—between the sacrifice of Isaac and of Jesus—two angels hovering above the

lunette support a cross wreathed by a victor's laurel.

The dedicatory mosaics of Justinian and Theodora provide an instance of the union of styles found in the best Byzantine art of the period. Pictorial abstraction has made the imperial presences a timeless reflection of the celestial order. Justinian, Theodora, and their entourage stand in a yellow glow rather than shadows, a spacedenying device appropriate to their ethereal bodies. Indeed, the men's garments, like those at S. Apollinare Nuovo, are arranged as flat white rectangles articulated by tubular folds and interrupted by patterns of black lines. Meanwhile, the multicolored, bejeweled robes and headdresses of the female figures and soldiers create an even more dazzling effect. In contrast, all the faces—especially those of the imperial couple and their closest attendants-are rendered as lifelike portraits, thereby evoking the Roman tradition of realism. The images may have been based on official portraits made in Constantinople and sent to Ravenna to be copied. Ultimately, the combination of two distinct pictorial

modes in the S. Vitale dedicatory panels suggests that at the very moment the mosaicists sought to represent the exalted nature of emperor and empress, they also wanted to leave future generations in no doubt about the monarchs' identity.

In the Theodora mosaic many individual elements recall the classical heritage—the shell-like niche denoting prestige, the fluted pedestal and fountain, the open door, and the knotted draperies of the natural world. But since Theodora and her companions neither stand in a rational space nor have material substance, the architecture and the curtains cannot function, as they had in the Greco-

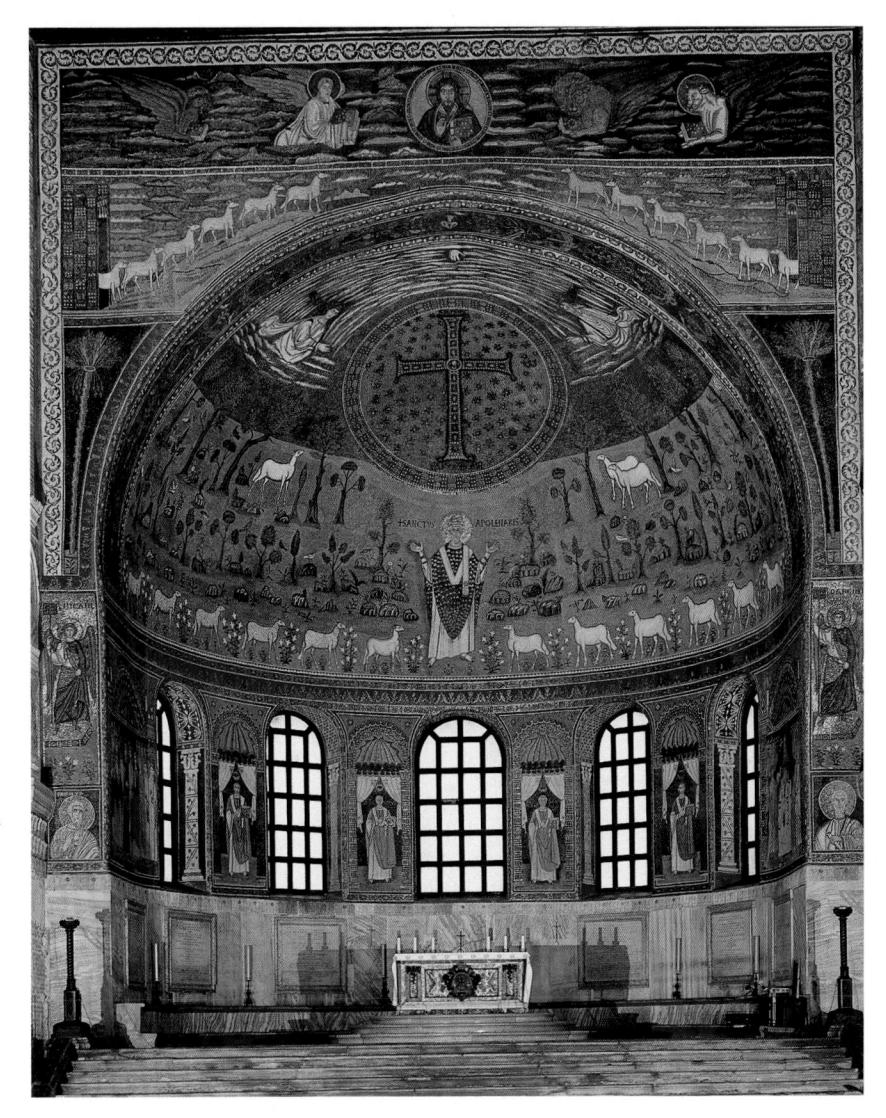

3.19 The Transfiguration, Church of S. Apollinare in Classe, 549. Mosaic. Ravenna.

Roman world, as space-creating elements. Instead, they simply allude to a bygone visual tradition.

The substitution of symbolic images for narrative or visual realism, so pervasive at S. Vitale, reaches a climax in the two great apse mosaics, in the Church of S. Apollinare in Classe [3.19] and the Monastery of St. Catherine at the foot of Mount Sinai, where Moses received the Ten Commandments [3.20]. Although geographically distant, both works probably reflect aspects of the court style in Constantinople in the second half of the sixth century. Both depict the Transfiguration of Christ—the moment, that is, when Jesus tem-

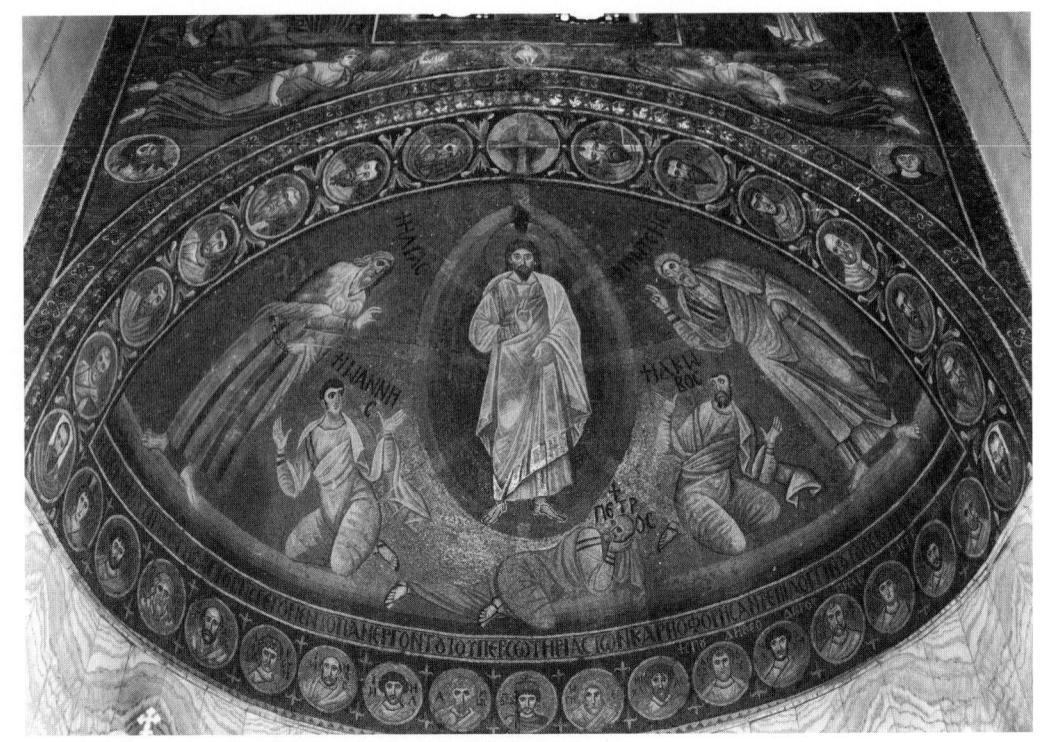

3.20 The Transfiguration, Monastery Church of St. Catherine, 560–565. Mosaic. Mount Sinai, Egypt.

porarily shed his earthly, human form and appeared to Sts. Peter, James, and John as the shining divinity (Matthew 17:13, Mark 9:1–13). The imagery reinforced the established church's emphasis on the human and divine nature of Christ. As the voice of God said, "This is my beloved Son," the Savior appeared flanked by Moses and Elijah.

In the mosaic that fills the apse of S. Apollinare in Classe the Transfiguration is combined with the Glorification of the Cross. The themes are depicted almost entirely through symbols. A jeweled cross floats in a blue, star-spangled sky as Christ appears in the center as a tiny, pearl-framed face. The hand of God extends toward the cross. Halflength figures of Moses and Elijah emerge from the clouds, but the apostles who witnessed the miracle are shown as three sheep. Below the cross St. Apollinaris, whose relics originally lay under the altar, acts as intercessor for his congregation, depicted as a flock of sheep. As a martyr he raises his hands in prayer, recalling Christ's triumph over death on the Cross. A preparatory drawing (sinopia) discovered under this lowest zone shows the original scheme to have been a cross flanked by plants, birds, and baskets of grapes, all traditional emblems of paradise. In the final version, the landscape of paradise becomes a meadow filled with bushes, trees, flowers, and rocks. These landscape elements are symmetrically arranged, each transformed into an isolated and independent decorative unit. As a result, the garden has undergone an astonishing metamorphosis. By rejecting an illusionistic rendering of solid figures in a deep natural landscape in favor of a mystical vision, the mosaicists captured the timeless quality of a divine miracle.

A fortified monastery of St. Catherine with a church dedicated to Mary, mother of God, was built at Justinian's command between the death of Theodora in 548 and the emperor's own death in 565. The monastery had been the site of pilgrimages to the Burning Bush since the fourth century. In the apse of the church, monumental human figures depict the Transfiguration. In contrast to Ravenna, the Sinai artists eliminate everything belonging to the natural world and fill in the conch with glittering, gold glass tesserae. The prophets and apostles seem

Monasticism

Monasticism began in the East. By the third century some devout Christians began to question the value of the materialistic life they experienced in the great cities of the empire. Some people withdrew from association even with their fellow Christians. In Egypt, about 285, St. Anthony (c. 251–356) moved into the desert to become a hermit in order to live an entirely spiritual life. Others followed his example, and by 315 they established the first religious community (monastery). Some organization proved to be necessary for communal life, and in 370 St. Basil (330–379) drew up the first monastic rule. Monks and nuns were to lead an ascetic life of poverty, chastity, and obedient service to God through prayer and manual work.

In the sixth century, St. Benedict of Nursia (480–543) drew up a set of rules for the monks of Monte Cassino in Italy. He adapted the austere ideals of St. Basil to the realities of life in the West. Although still based on the ideals of poverty, chastity, and obedience, the Benedictine Rule focused on an active life of work and prayer. Opus Dei, or the Divine Office (daily public prayer at regular intervals), formed the center of monastic life. St. Benedict's sister, St. Scholastica, established a community for women based on her brother's Rule. Monks and nuns educated children, cared for the poor and sick, and assisted travelers. Copying texts and making books became one of their most important duties. The Benedictine Rule became the basis for Western monasticism and is still followed in many communities today.

to levitate in a golden Heaven, barely touching the green and yellow bands at the base of the conch that signify the earth. Even the figures' active, exaggerated gestures, and their three-dimensional forms so carefully described by close-fitting garments, serve here to accentuate the abstract design.

JEWISH MOSAICS

In the Jewish synagogues of Galilee and Judea, carpet-like decorations, consisting of symbols and narratives in a simplified formal style, were used in the major halls. Few examples of the art have survived since the tolerance for images in Judaism lasted only to the middle of the sixth century, and after that many pavements were destroyed. The earthquake that destroyed the Beth Alpha Synagogue in Galilee preserved the floor mosaic under debris [3.21]. The theme of the mosaic is the origin and fulfillment of God's covenant with His people. At the entrance an inscription tells us that the artists Marianos and his son Anaias made the mosaic during the reign of the Emperor Justin (518–527).

Decorative borders divide the floor into panels. The images within the panels are highly stylized and follow the ancient convention of representing figures full face with profile legs and feet. At the

entrance, a panel illustrates the story of the sacrifice, or more properly the "binding," of Isaac [3.22]. The sacrifice of Isaac signified perfect obedience and therefore God's promise (the Covenant). In the center of the room, signs of the zodiac and personifications of the seasons circle the sun, Helios. The zodiac describes human time but also the cosmic spheres existing since creation. At first the prominent place of Helios, the seasons, and the zodiac may be surprising, until one recalls the importance of the movements of the heavenly bodies in determining the cycle of Jewish festivals. The sun becomes a symbol of the order of the universe, as do the recurring seasons and the figure cycle of the zodiac. And finally, in front of the Torah niche is the Ark, flanked by the roaring lions of Judah, the menorah, palm frond (lulav), citron (etrog), incense shovel, and ram's horn (shofar). These symbols and the Ark recall the promise of a messiah and the rebuilding of the temple. These earthly things lead the devout to the Ark and the revealed law. In short, the iconography of the floor moves from promise to fulfillment.

The rich Jewish imagery soon disappeared before the onslaught of puritanical forces, just as the Orthodox Christian art would be ravaged by the iconoclasts. Jewish communities suffered earlier. In

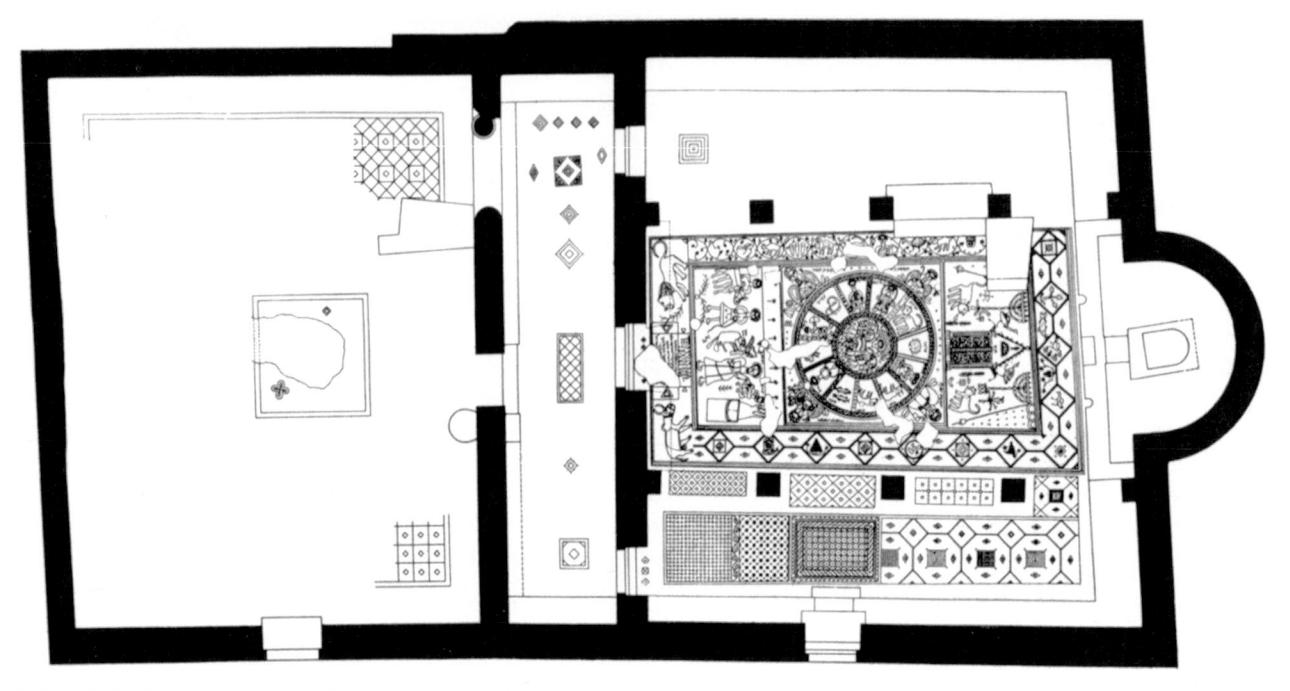

3.21 Beth Alpha Synagogue. Plan showing mosaic pavement. c. 518.

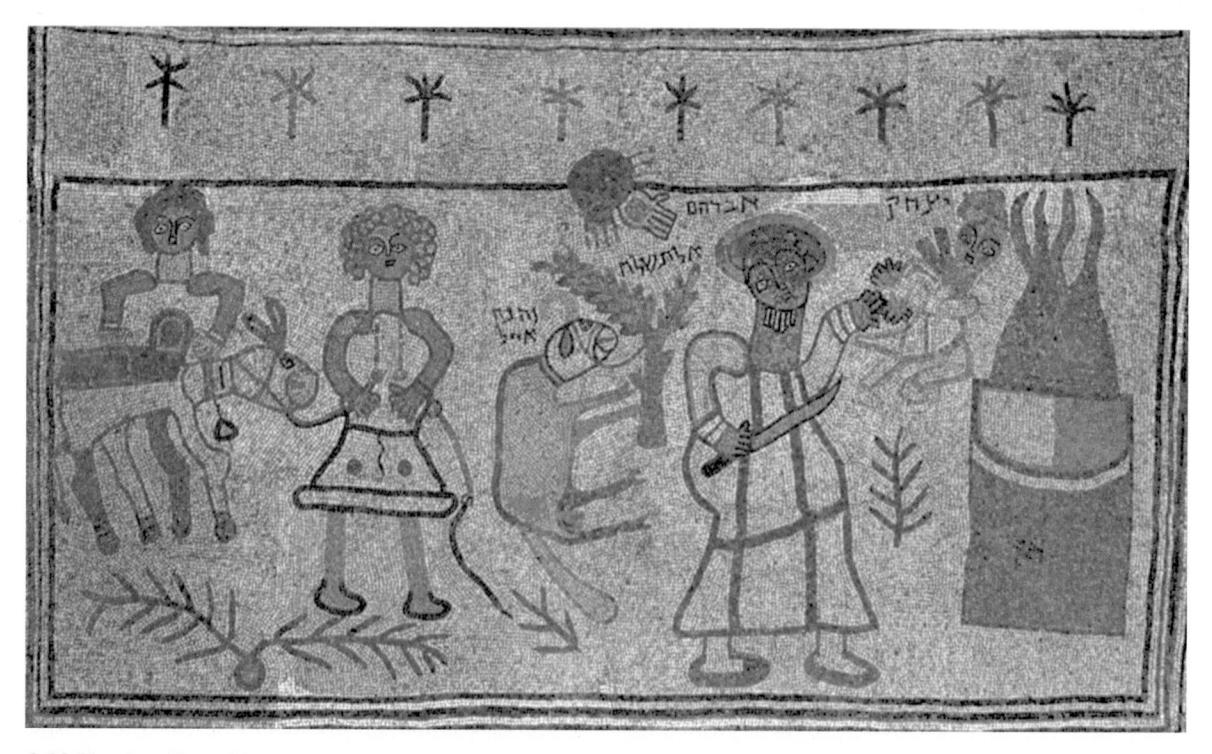

3.22 The Sacrifice of Isaac, Beth Alpha Synagogue, c. 518, mosaic pavement (detail). Galilee.

545 Justinian banned the building of synagogues. Then in the seventh century, Arabs under the banner of Islam conquered the Near East. In 638 Jerusalem fell to Islam, and in 661 Damascus became the capital of the new Umayyad Dynasty.

IVORIES AND MANUSCRIPTS

When we turn from architecture and monumental decoration to the sumptuary arts, we are at once reminded that objects and images fashioned from precious materials delighted the wealthy, cultivated, intellectual elite. Goldsmiths worked and lived in the imperial palace and even enjoyed favored seating at festivals and in the hippodrome. Artists excelled in working with ivory, silver, gold, and semiprecious stones. Panel painting and manuscript illuminations, too, took on a jeweled, highly wrought character, although some paintings also reflect the style of large-scale mosaic cycles.

Ivory sculpture illustrates the debt of the Byzantine artists to their classical heritage; however, not unexpectedly, classical forms are imbued with symbolic content. Superb examples of this Byzantine classicizing style are two ivories made in Constantinople: one of the archangel Michael [3.23] and another of an emperor, probably Justinian. In churches throughout the East, ivory diptychs (panels joined in pairs) served as memorial tablets, on which were inscribed the names of people for whom prayers were to be said during the Mass. On one such panel, St. Michael appears as a divine messenger holding an imperial orb with a cross. His youthful face conforms to a classical ideal, and his well-proportioned figure is revealed by clinging tunic and pallium. The archangel seems more like a young Greek hero or a Roman orator than an invisible messenger of God.

The Byzantine sculptor's debt to classical art is nowhere more striking than in this relief; nevertheless, features of the panel disclose its Byzantine character. The architectural framework, for example, does not create a rational space; St. Michael's feet rest on the back steps of a staircase that recedes from the pedestals and columns in the foreground, while

3.23 St. Michael, early 6^{th} century. Ivory diptych, right leaf, $16\ 7/8\ x\ 5\ 5/8$ in. (42.9 x 14.3cm). The British Museum, London.

his arms and wings project in front of the columns, bringing the upper part of his body into the foremost plane. This spatial ambiguity between figure and setting denies the careful realism of the individual details. The Byzantine artist has suspended the physical world's laws of optics and gravity, and, in the process, created a fitting environment for a Heaven-sent messenger. The Greek inscription reads, "Receive these gifts, and having learned the cause. . . . "The quality of the sculpture suggests that the ivory was made in the imperial workshop, and the right-hand leaf of the diptych might have had a representation of the emperor and a continuation of the inscription.

In the fifth and sixth centuries, complex imperial ivories, composed of several panels, were made. Four of the five panels of such a relief makes up the so-called Barberini ivory [3.24]. An idealized emperor clad in Roman armor sits astride a rearing horse. The image may echo the towering equestrian statue of Justinian once set up on a column in Constantinople. In the ivory, antique emblems mingle comfortably with religious allusions in

that mixture of pagan and Christian iconography familiar in Constantinian art. A personification of earth supports Justinian's foot, while a winged Victory bearing a palm cheers the emperor on. To the left (and originally to the right as well), a general offers a statue of Victory bearing a wreath. Still another flying Victory, surrounded by tribute-bearing representatives of the subjugated territories, reaches up to Justinian from the center of the lower frieze. The full, rounded modeling and the complex poses of conquered Persians and barbarians and wild animals suggest that the sculptor turned to Roman battle scenes for inspiration. The emperor himself, although seated on a rearing horse, appears as an ideal, superhuman ruler. His impassive, masklike face seems to look beyond the earthly realm. So

3.24 The Emperor Victorious: the Barberini ivory, 6th century. The Louvre, Paris.

that the source of Justinian's authority does not go unnoticed, Christ blesses him from the heavens above (represented by a sphere engraved with sun, moon, and stars). In a thoroughgoing combination of pagan and Christian motifs, two winged angels holding the celestial image are indistinguishable from classical Victories.

The late Roman style seems to have lingered tenaciously into the sixth century in Byzantine painting as well as ivory carving [3.25]. Manuscript illumination can be studied only through isolated examples. An encyclopedia of medicinal herbs compiled in the first century by the Greek physician Dioscorides, and known as the *Materia Medica*, has survived in a sixth-century copy made in Constantinople for the Princess Anicia Juliana

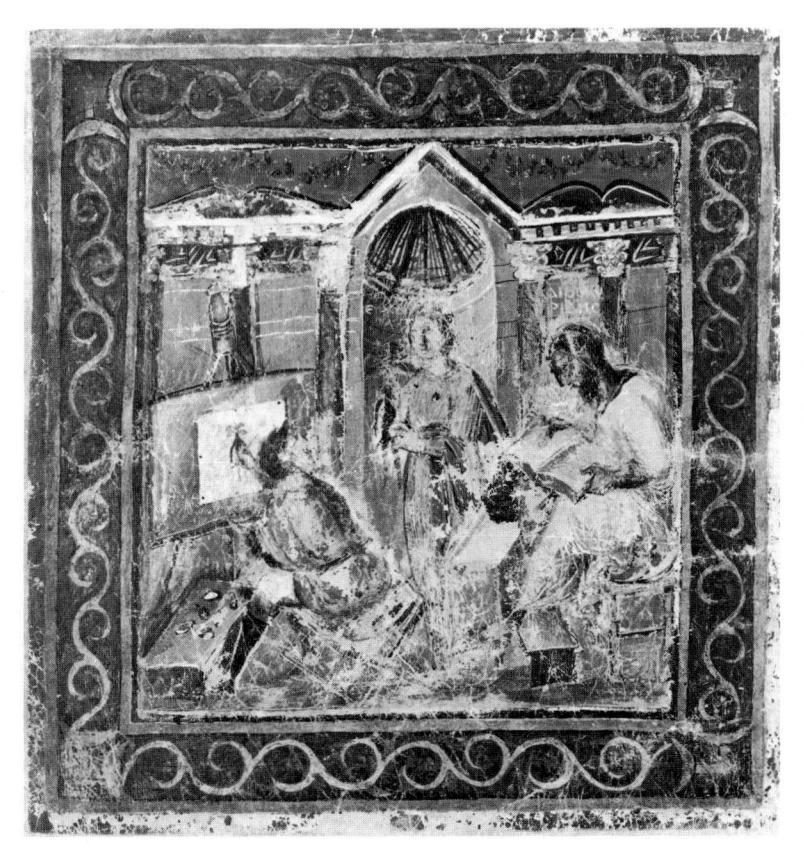

3.25
Portrait of the author at work with an assistant, and Inspiration, Dioscorides, *Materia Medica*, Constantinople, 512. 15 x 13in. (38.1 x 33cm). Österreichischen Nationalbibliothek, Vienna.

(it is now in Vienna and therefore is known as the Vienna Dioscorides). Since in a scientific treatise the illustrations were intended to clarify the text, not merely to ornament it, the artists naturally copied the late Roman painting style along with the text. The illustrations demonstrate a careful observation of nature.

The scene with Dioscorides and his assistant at work not only follows the established tradition of including a portrait of the author of the book but makes abundantly clear the artist's intention to record nature faithfully. Dioscorides is represented as a scholar seated with an open book on his lap. He is inspired by Epinoia, the Power of Thought, who holds a mandrake root. An assistant studies the plant as he records it on a large sheet of vellum fastened to his easel. (In the first century, long papyrus rolls began to be replaced by codices made up of individual leaves, as in a modern book. By the fourth century, the codex had become the usual form of a book.) Such realistic details contrast with the ideal-

ized background of colonnade and niche. The complex poses of the figures, the refined modeling in light and dark tones, and the perspective rendering of the setting suggest that the Vienna Dioscorides is a skillful rendering of its classical model.

The antique pictorial style also influenced the illustration of religious texts with Christian subjects. Artists who worked in the imperial workshops for the production of books (scriptoria) created luxurious manuscripts worthy of their patrons. First, they dyed the light-colored vellum a deep purple, the color reserved for the use of the imperial court. Then the scribes wrote out the texts in silver or gold. Finally the painters illustrated the narrative, often turning to classical sources as they worked.

One of the most sumptuous manuscripts to survive from the sixth century is part of the Book of Genesis, now in the National Library in Vienna, and consequently known as the Vienna Genesis [3.26]. Twenty-four folios survive, each page with a half-page illustration. The artists did not fully

3.26
Rebecca at the Well,
Vienna Genesis,
Constantinople, sixth
century. Purple vellum,
13 1/4 x 9 7/8in.
(33.7 x 25.1cm).
Österreichischen
Nationalbibliothek,
Vienna.

adapt to the modern codex arrangement, for they often illustrated the events as a continuous narrative as they would in a scroll. In the story of Rebecca (Genesis 24), the heroine, carrying a jug on her shoulder, journeys out of the walled city and down to a stream. A lightly draped classical nymph leaning on a jar appears as a personification of water. The narrative then turns to the right where Rebecca appears again, charitably offering water to Eliezar and his camels. This shift in pictorial direction suggests that the illuminator was self-consciously following the scroll format. The figures themselves are equally reminiscent of an earlier, classical style. Even though the flat purple ground removes the scene from the material world, the individual figures are full-bodied and seem to move easily and naturally in their limited space.

Not all Byzantine manuscripts were imperial purple codices. Many were made for private patrons and for churches and monasteries in the provinces. Such a book is a Gospel copied in 586 by a calligrapher named Rabbula at the Monastery of St. John in Zagba, Syria [3.27 and 3.28]. Here the artists worked in brilliant colors on the natural light vellum, using a sketchy illusionistic painting

technique for the background although they retained strong outline drawings for the well-modeled figures. The accurate proportions, expressive poses and gestures, and illusionistic setting suggest that they, too, used classical models.

Some of the full-page paintings in the codex may have been inspired by monumental apse decorations in the churches of the Holy Land. The scene of Christ's Ascension is combined with apocalyptic imagery described by Ezekiel (see Box: Ezekiel and St. John). The depiction of the four beasts emerging with eye-studded wings from wheels of fire follows the scriptural source. As he is borne heavenward in a mandorla by the creatures and angels, Christ raises his hand in blessing and steps forward like an ancient orator. Below the celestial apparition, angels direct the apostles' wondering gaze to the miracle of the Ascension. Yet, the focus of attention also falls on the Virgin. The Mother of the Lord does not share in the apostles' excitement. Instead, she stretches out her arms like an orant, as if praying for the faithful who will come before her Son on the Day of Judgment, on that awesome day already alluded to in Ezekiel's vision.

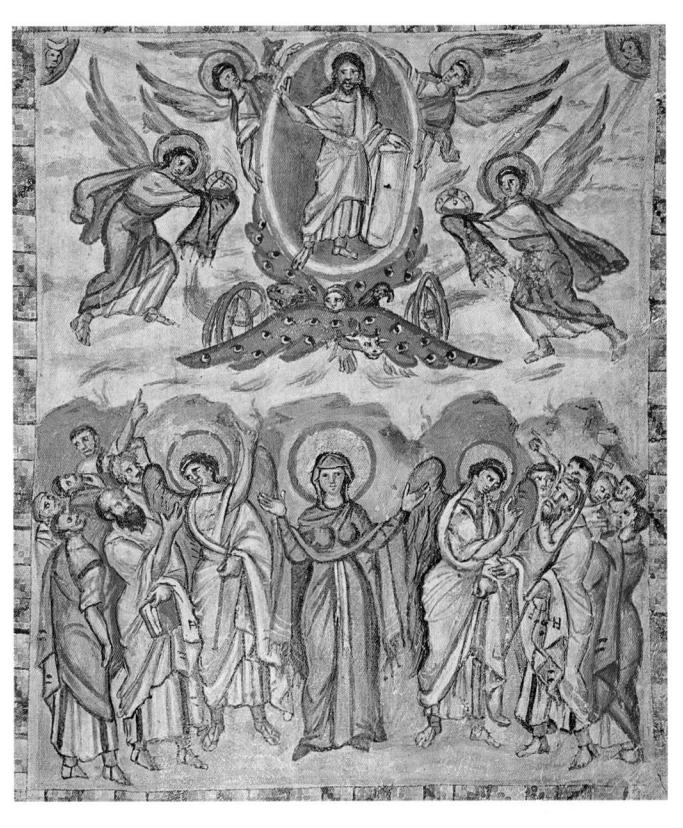

3.27 The Ascension, Rabbula Gospels, Zagba, Syria, c. 586. 13 1/4 x 10 1/2in. (33.7 x 26.7cm). Biblioteca Medicea Laurenziana, Florence.

3.28 Crucifixion and Holy Women at the Tomb, Rabbula Gospels, Zagba, Syria, c. 586. 13 1/4ft. x 10 1/2in. (33.7 x 26.7cm). Biblioteca Medicea Laurenziana, Florence.

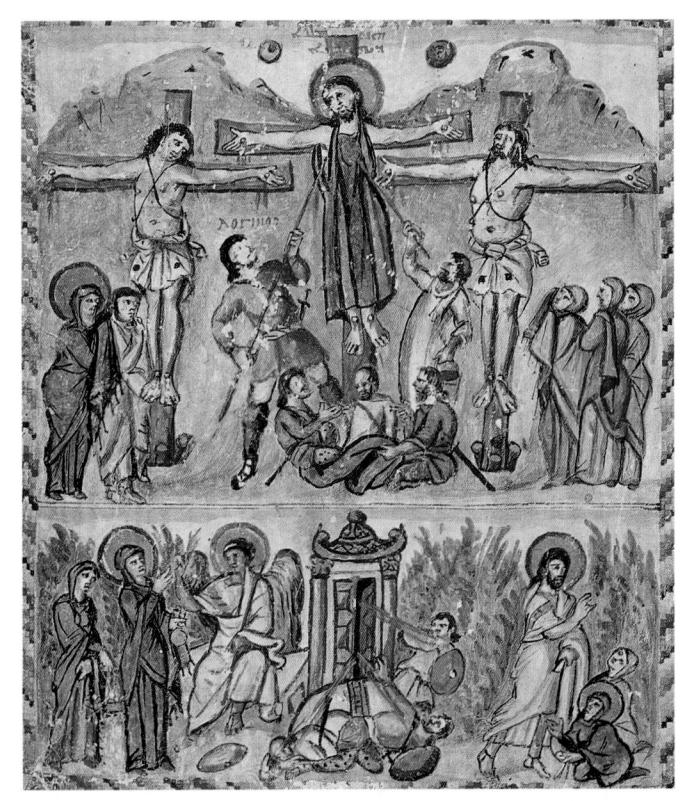

In another illustration, the many episodes at the end of the Passion cycle have been organized into a symmetrical composition in two registers (perhaps inspired by the apse at Golgotha). Christ is a mature, regal figure represented as alive and triumphant on the Cross. He wears a colobium, or long, sleeveless, purple robe, in the modest and dignified tradition of the Byzantine Church. Good and bad thieves, the centurion Longinus and Stephaton with the sponge, the mourning Virgin, St. John, and the Holy Women surround the Savior. Below the Cross, indifferent Romans fulfill the prophecy (Matthew 27:35) by casting dice for Jesus' clothes. In the lower register the artist depicted later episodes: the Holy Women at the empty, guarded tomb and the appearance of Jesus to the two Marys to reaffirm His Resurrection (Matthew 28:9-10). In contrast to the Arian mosaics in Ravenna, this wealth of narrative detail gave historical validity to Christ's sacrifice and presented in visual terms the Orthodox answer to the heretical Monophysites, who, believing the Lord to be totally divine, denied the reality and the necessity of the Crucifixion.

ICONS AND ICONOCLASM

The very heresy that the artists of the Rabbula Gospels may have sought to counter indirectly caused one of the greatest traumas of Byzantine civilization. If Christ was an exclusively divine manifestation, the Monophysites argued, then no anthropomorphic form could describe him. Pictures that attempted to represent the godhead were blasphemous. This position, also advocated by those Christians who upheld the Old Testament ban on imagery, diametrically opposed the popular use of art as an aid to instruction and meditation. In the sixth and seventh centuries, the condemnation of religious images increasingly focused on icons—hence the designation of the resulting crisis as iconoclasm, or "image-breaking."

Icons (Greek: eikon, image) were small portraits of Christ, the Virgin, or the saints, designed, like the pagan imperial portraits, to serve as proxies for the divine presences. In order to avert charges of idolatry, theologians carefully pointed out that in

venerating an icon one paid respect not to the image but to the person depicted. Thus, St. Basil explained that "the honor rendered to the image passes to the prototype." By this process the icon provided a channel of communication between the worshipper and the divinity.

An important distinction between icons and secular portraits was that the original Christian images were believed to have been fabricated under miraculous circumstances, often without human intervention. The column of the flagellation, for example, bore traces of Christ's form, and the Mandyleon of Edessa, believed to have been given to King Abgar by Christ himself, had the face of Christ on a cloth. The Empress Eudokia, wife of Theodosius II, discovered a portrait of the Virgin Mary painted from life by St. Luke, or so it was believed. Because of these supernatural origins, the faithful often credited the icon itself with marvelous powers. At the time of Persian invasions, in 626 and 717, icons of Christ and the Virgin were taken to the gates of Constantinople and were believed to have saved the city.

Naturally, the number of miraculously wrought images was limited. Consequently, ordinary mortals began to copy the sacred icons, in the hope that even a facsimile of the holy form would in some way partake of its sanctity. Monasteries became important centers for the manufacture and sale of these reproductions because they kept most of the existent icons in protective custody. Icons could be fashioned in mosaic, ivory, or precious metals, but the monks preferred painted images, using either encaustic (colored wax) or tempera on wood panels, which enabled them to avoid that three-dimensional likeness so uncomfortably reminiscent of pagan idols.

Very few icons survived the victory of the iconoclasts in the eighth century. The movement resulted in the destruction of countless works of art. In the Monastery of St. Catherine, however, far away in the deserts of the Sinai Peninsula, an unusually large collection of icons has been preserved. Among the earliest is a sixth-century encaustic image of the Virgin and Child [3.29]. The Byzantine preference for abstract form determines the severely frontal

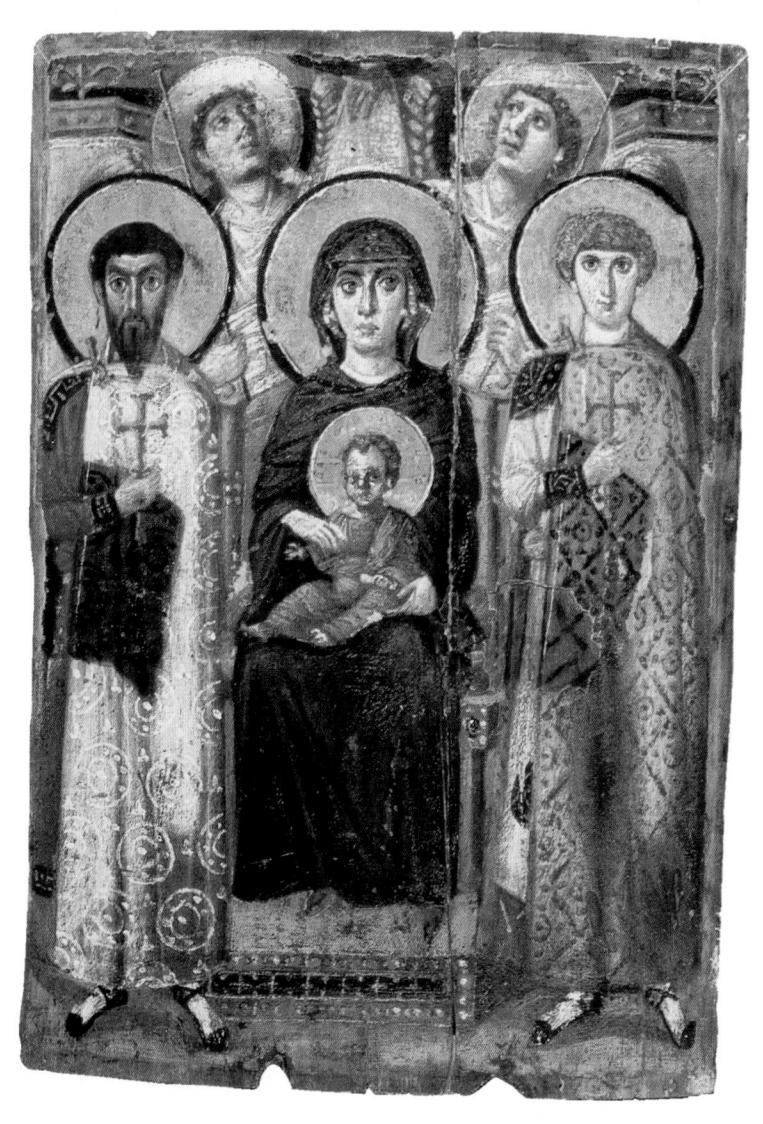

3.29 Icon of the Virgin and Child with saints and angels. Encaustic painting, 27 x 19 6/16in. (68.6 x 49.2cm). Constantinople, 6th century. Monastery of St. Catherine, Mount Sinai, Egypt.

figures of the enthroned Virgin and Child and the attendant saints. The Virgin herself becomes a throne for the Christ Child through her hieratic posture, while rich brocades transform the bodies of St. Theodore and St. George into flat, attenuated and equally architectonic designs. Moreover, the ovoid shape of the faces of Mary and the saints, along with the repetition and the sheer size of the heavy halos, also reduces their tangibility. Nevertheless, the two angels behind the throne, and to

some extent the Infant himself, seem inspired by classical art, revealing yet again the two stylistic worlds that constitute the universe of Byzantine art. The saints stare directly into the viewer's eyes seemingly to communicate and intensify the devotional experience, but the Virgin disconcerts by looking to the right. "The eyes encourage deep thoughts," wrote the poet Agathies in the sixth century.

By the eighth century, the opposition to icons had grown formidable. Because the images were

taken into private homes for domestic use, it was feared, with some justification, that their power and holiness would be abused. The powers sometimes attributed to such icons did seem dangerously close to magic. In 726 Emperor Leo III, a passionate iconoclast, removed all religious pictures from the palace and issued a decree prohibiting the making or the veneration of icons. Leo's successor, Constantine V (741–775), held even more extreme views and persecuted those who continued to venerate icons. Thoughtful theologians rose to the defense of images, at the great risk to their personal safety. St. John of Damascus contended that if "God created man in His own image" (Genesis 1:27), and further chose to make His divinity visible through the Incarnation of Christ, then representations of the human form had to be permissible, for they reflected the perfect truth and beauty of God. Despite St. John's efforts, however, iconoclasm remained the imperial policy until the accession of Empress Irene.

In 787 the Empress convened a second Church Council of Nicaea, which affirmed the power and importance of images. Nevertheless, the controversy erupted once more in 813, iconoclasm having been reintroduced by the newly crowned Emperor Leo V. A council in 815 condemned icons, and, not until 28 years later under the leadership of Empress Theodora did another council officially restore the cult of images. On March 11, 843, a great new liturgical feast—the Feast of Orthodoxy—was solemnly inaugurated and icons restored to Hagia Sophia. Iconoclasm may have troubled the Byzantine East, but it never became official policy again.

The Iconoclastic interlude resulted in irreparable losses, since the ban against pictures

spread to any image that contained human figures, thereby condemning to destruction mosaics, sculpture, and other paintings as well. As a result, what little Constantinopolitan art survives tends to be purely abstract or decorative. Great non-figurative pictorial traditions, however, also existed in northern Europe and the Near East, and soon began to enrich the artistic vocabulary of the Christian world.

Byzantine art served both the Church and the empire. By perfecting a centralized, dome-covered architecture, Byzantine architects effectively fulfilled the needs of the court and captured the essence of the Eastern liturgy. Elements of Byzantine religious architecture survive in the buildings of the Orthodox Church to this day. While theologians and philosophers expounded a philosophy of art, the artists represented the Christian story and message in pictorial terms, using the human figure as the vehicle for communication. They perfected techniques of composition and craft—from monumental wall decoration to miniature work in ivory carving, manuscript painting, and enamel. The artists preserved and transmitted both the classical idealism of Greece and Rome and the abstract art of the Near East, combining these impulses to form a visionary and transcendental style. In style, theme, and technique, Byzantine artists were prepared to fulfill the imperial ideals. Patronage of the arts by the emperor as well as by the Church continued the ancient ideal of imperial largesse. The Byzantine court and its artists—while attempting to create the splendors of Heaven in earthly terms for mortal eyes—established a standard of excellence and opulence, which the barons and prelates of the medieval West could only envy.

EARLY MEDIEVAL ART IN THE WEST

he people whose incursions irrevocably altered the history of the Roman and Byzantine Empires were not nomadic bands of warriors, nor were they "barbarians" in the modern sense of the word. The "barbarians" had an ancient cultural heritage and a highly developed artistic tradition. They were hunters, shepherds, and farmers with a tribal social/political organization, an oral history, and complex ritual activities. Without a written history or literature until they joined the Romans, they left the record of their achievement in their arts and material culture. They had achieved a high level of technical accomplishment by the second millennium B.C.E., in the period known as the European Bronze Age. They engaged

4.1 Iron Age, La Tène III, mid-1st century B.C.E. Iron blade with copper alloy hilt and scabbard. Length 19 3/4in. (50cm). The Metropolitan Museum of Art.

in those crafts most common to migratory cultures: pottery, textiles, and woodworking, and they excelled in fashioning metals into jewelry, armor, and tools [4.1].

Among the most important of the many different groups were the Celts in western Europe and the Germanic peoples living around the Baltic Sea. Between the eighth and the sixth centuries B.C.E., the widespread adoption of iron for weapons and tools advanced agricultural productivity, a development that led, in turn, to a higher standard of security and living. As their population increased, people moved toward the Mediterranean and the Black Seas in search of yet more land. Through migration and trade, a very creative group, the La

Tène Celts (as they are now called, after a site in Switzerland where extensive remains have been found), came into contact with Mediterranean art and culture. As a result, La Tène craftsmen invented a brilliant artistic style that combined classical palmette and vine patterns with their native geometric decoration.

A bronze mirror illustrates the La Tène artist's ability to turn a functional object into a spirited work of art [4.2]. The engraved surface of taut linear motifs and cross-hatched shapes, compass-drawn circles, and expanding crescents called peltae form a symmetrical lyre-like pattern infused with energy. The sculptured handle ends in a cat-like face with red glass eyes. This penchant for surprise and disguise and for structures not apparent to the casual observer is typical of La Tène art. So powerful was this imaginative Celtic style that it survived in the British Isles well into the Christian era.

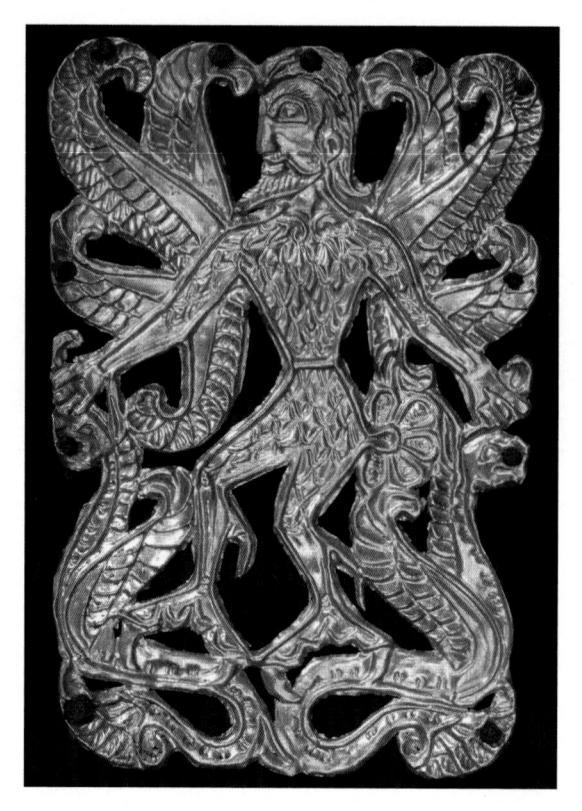

4.3 Scythian Birdman, 4th century, gold, Gorniatskoye. Institute of Archeology, National Ukranian Academy of Sciences, Khiev.

While the La Tène Celts still controlled most of Europe, the Scythian horsemen began to move westward across the Ukrainian plains. By the fifth century B.C., they established themselves north of the Black Sea, where they frequently encountered Greek traders and artisans. They created a style based on animal forms and imaginary creatures such as the golden birdman [4.3] that once decorated a horseman's quiver. The figure has multiple wings and clawed feet and controls a pair of winged serpentine creatures. With long pointed beard, knotted hair, and feathered body, he becomes as fearsome a creature as the mounted archer whose arrows he protected.

Still another animal style, dominated by ferocious birds and sinuous, serpentine beasts that weave through intricate interlaces, emerged from the imagination of Scandinavian craftsmen [4.4]. The decoration on a Vendel harness mount consists of ribbon animals, drawn and cut on the

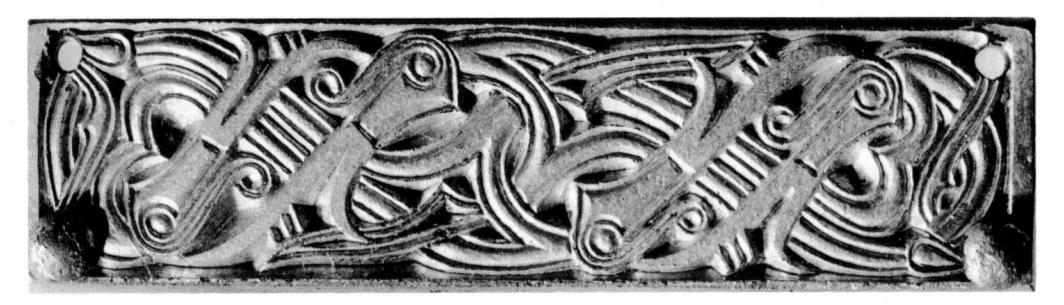

4.4 Harness mount with animal ornament, Vallstenarum, Gotland, Sweden, 6^{th} or 7^{th} century. Gilt bronze, $4\ 1/2\ x\ 1\ 1/8$ in. ($11.4\ x\ 2.9$ cm). Statens Historika Museum, Stockholm.

surface rather than modeled. The pattern develops as a triangular mirror image based on imaginary diagonals. Large heads with circular eyes, heavy "eyebrows," pointed "chins," and long jaws affixed to the ends of ribbons in the interlace transform each band into a serpent. The Scandinavian artists usually represented complete animals. No matter how complex the interlace becomes, or how freely the dragon seems to dissolve into a coiling contour, the creature's head, body, and limbs all share in the pattern's formation. The fanciful Norse dragon is like no beast that ever stalked.

The Goths, Germanic tribesmen who settled in former Scythian territories in the second and third centuries and then moved west across Europe displacing the Celts—and ultimately the Romans—added yet another kind of ornament to this non-classical repertory of forms [4.5]. They enriched their jewelry and weapons with colored stones mounted within strips of gold. The style has been called a polychrome or gem style. The Gepids, living in the Danube basin, produced typical fibulae in the gem style. Fibulae (safety pins), generally made in pairs, fastened cloaks and other garments. By the fifth and sixth centuries, fibulae had become very elaborate. A head plate, covering the spring, was joined by an arched bow to a foot plate that concealed the catch. Fibulae were usually worn with the head plate down.

At first the artists simply polished the stones into cabochon forms and set them in symmetrical geometric patterns. Later artists became master

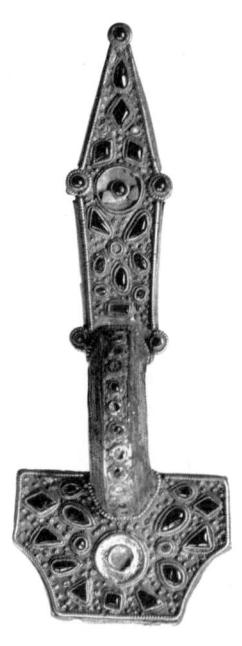

4.5 Fibulae, gold lead over silver core with almandine, mother-of-pearl, or enamel; length 6 1/4in. (15.9cm). Gepidic, 5th century. Szilágy-Somlyó, Hungary. The Metropolitan Museum of Art.

gem cutters. They employed geometric shapes such as lozenges, stepped patterns, and circles, into which they sometimes inserted animals and birds. Ultimately, the artists achieved a truly polychromatic effect by combining gold with blue and green stones, pieces of ivory or bone, and red garnets. In sum, artists beyond the Alps at the beginning of the Christian era used several separate although occasionally interdependent motifs and styles: geometric forms and spirals, fantastic animals, and colored stones or gems.

A BRIEF HISTORY

Even as the Roman Empire reached the apogee of its power and grandeur, the ever restless outsiders began to cross imperial frontiers, lured there by the attractiveness of Roman civilization—its relative security, its cultivated land, and its stable life. At first they claimed only territories that had not originally belonged to Rome. The Romans, after all, had extended their empire across Celtic lands to the Rhine and Danube Rivers. The Romans often turned the indigenous population into foederatii, allies or federates, and charged them with the defense of the newly established borders. The people in return received military aid and lands, as well as the privilege of associating with the mighty empire. Eventually the Roman army was largely composed of Germanic troops. Most of the men who fought for Constantine in 312 were Germans.

The transplanting of Mediterranean art and architecture beyond imperial borders by the Roman conquerors and settlers introduced the indigenous populations to a new repertory of visual forms and materials. Imperial architects, following on the heels of victorious battalions, introduced masonry construction to a people accustomed to building in wood. Moreover, Roman sculpture, paintings, and mosaics displayed a classical simplicity and a formal regularity that must have seemed strange to the people who based their art on the sheer energy of nature as expressed by the animal world and in geometric forms such as spirals and interlaces.

Christianity did not at first provide a unifying force. Unfortunately for the stability of the Roman Empire, in 345 the Goths abandoned their old gods for heretical Arian Christianity. Other tribes followed their lead. In the eyes of Rome and Byzantium, therefore, many barbarians had simply renounced paganism for heresy.

Increasing violence marked the fifth century as the tempo of migration accelerated under new pressure from the Huns, who swept into Europe from Central Asia. They forced the Goths to cross Rome's Danube frontier. The eastern Goths, or Ostrogoths, established a kingdom in northern Italy, while the Visigoths, or western Goths, led by

Barbarian Imagery

The Celtic and Germanic artists' and patrons' love of abstraction and patterns was conceptually akin to the dematerializing tendencies of Early Christian and Byzantine art; however, their abstract style stemmed from vastly different spiritual sources. Even after they accepted Christianity, these people did not forget their ancestors' veneration of the forces of nature and creation-of the life-giving power of the sun, of the earth as a fertile mother goddess, and of the physical strength and energy of wild animals. They continued to use solar disks, trefoils, swastikas, and spirals-motifs that had been inspired by their forebears' pantheistic religion. The spiral winding in and out of itself remained a sign of the ever-recurring seasons, a life cycle encompassing death and regeneration. The soaring eagle with an upturned head and disk-like body remained an ancient reference to the sun, and the slithering serpent represented evil, darkness, and death. Hawks, boars, stags-the strongest and most ferocious beasts in the animal kingdom—once employed as tribal totems, became personal insignia. When the time came to transfer allegiance to the Christian god and to fashion objects whose themes did not offend the new spiritual masters, artists simply adapted the primal motifs to a changed context. In so doing, they laid the foundation for that extraordinary fusion of Northern, Eastern, and Mediterranean styles, which resulted in Western medieval art.

Alaric (B. C. 370–410), captured and sacked Rome itself before moving on into France (see Box: Galla Placidia). Other Germanic tribes, which had already pushed the Celts to the western fringes of the continent, were themselves displaced. The Burgundians settled in Switzerland and eastern France; and the Franks occupied Germany, France, and Belgium. Meanwhile the Vandals (whose name has come to mean senseless destruction—vandalism) swept through France and Spain, crossed over into Africa, where they established a kingdom around Carthage. In 455 they returned to sack Rome.

On the move again under their ruthless leader Attila—known to Christians as the "scourge of God"—the Huns raided western Europe. Before he died in 453, Attila devastated parts of France and Germany. The Visigoths escaped to Spain and other displaced Germanic tribes migrated to Italy. In 476 the last Western Roman emperor was deposed, and the Ostrogoth Odovacar (B. C. 433–493, also spelled Odoacer) ruled Italy under the nominal authority of the Eastern emperor in Constantinople. His successor, Theodoric the Great (B. C. 454–526, vice-regent of the Western empire from 497), established his court in Ravenna and made the former Roman city an Arian stronghold.

Meanwhile in 496 Clovis (ruled 481–511), the king of the Franks, accepted Roman Christianity on behalf of all his people. His wife, Clotilda, a Burgundian princess, was already a Christian. Across the Channel, the British outposts of the Roman Empire were left undefended in 408/409 by the recall of the imperial troops. The Picts and Scots breached the old Roman walls in the north, and the Angles, Saxons, and Jutes crossed the seas to settle southeastern Britain. The Celts finally took refuge along the western coast of Europe.

Bewildering as this migration period seems, Europe as we know it began to take shape out of this confusion. One more major political shift occurred in the sixth century, when Justinian reconquered some of the Mediterranean territories for the Byzantine Empire. Yet such victories proved to be ephemeral, for the pagan Langobards (later called Lombards) invaded Italy in 568 and settled in northern Italy, thereafter called Lombardy. Nevertheless during the next century almost everyone accepted Christianity and acknowledged the spiritual authority of the Pope in Rome.

THE ART OF THE GOTHS AND LANGOBARDS

While Theodoric's architects sought to emulate and adapt Christianized classical forms, as we have seen in the mosaic decorations in the royal Church of the Savior (rededicated as S. Apollinare Nuovo) at Ravenna [see 3.11], the Visigoths, who had moved

from Italy to southern France and on into the Iberian Peninsula, continued their pagan heritage in fine weapons and jewelry. In a magnificent pair of eagle brooches [4.6] that combine polychrome and animal styles, the artist rendered the bird in flight with outspread wings and tail, and profile head with curved beak and large round eyes. The fibulae also display a rich assortment of gems. Besides the red garnets interspersed with blue and green stones, the circles that represent the eagles' bodies have cabochon (polished but unfaceted) crystals at the center. Round amethysts in a meerschaum frame form the eyes. Pendant jewels originally hung from the birds' tails, accentuating the lavish polychrome effect. The eagle remained one of the more popular motifs in Western art, owing in part to its significance as an ancient sun symbol, a symbol of imperial Rome, and later as the emblem of St. John.

The Visigothic ruler King Reccared converted from Arianism to Roman Christianity in 587. He

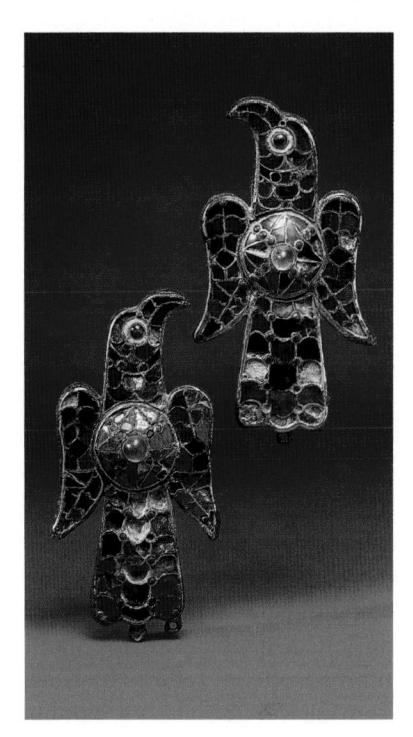

4.6 Eagle-shaped fibulae, Spain, 6th century. Gilt, bronze, crystal, garnets, and other gems. Height 5 5/8in. (14.3cm). The Walters Art Museum.

Visigothic Scholar

St. Isidore (560–636), who became the Bishop of Seville in 599, exemplifies the extraordinary scholarly energy of the Visigothic clergy. St. Isidore attempted to preserve all human knowledge, which he collected and organized into a huge encyclopedia. He called his work *Etymologies* because he attempted to explain things by analyzing words and names and tracing their histories. Many of his derivations are quite fantastic, and Isidore clearly loved to record a fabulous story. Nevertheless, so comprehensive and learned was his study that it became the most frequently consulted source book for the next three hundred years. Carolingian scholars based their work on his. Every great library had a copy of *Etymologies*, and it continued to be used as a reference book throughout the Middle Ages.

St. Isidore also wrote on church history, doctrine, and liturgy, including the Mozarabic liturgy. He wrote a history of the world beginning with the Creation and ending with his own time (615). His *History of the Goths, Vandals, and Suevi* is an invaluable resource today. Not surprisingly, St. Isidore is the patron saint of historians—and art historians.

and his successors consciously copied imperial ceremonies. Justinian had presented votive crowns to Hagia Sophia-that is, crowns designed to hang over the altar in testament to the emperor's piety and ecclesiastical authority—so the Visigothic monarchs also ordered jeweled crowns and crosses as royal offerings [4.7]. A crown, given by King Recceswinth (ruled 649-672), is the most magnificent example of these donations. In a wide band of gold, three rows of 30 large polished sapphires alternate with pearls over an openwork surface punched with palm-like motifs. The narrow strips girding the upper and lower edges are decorated with interlaced tangent circles, a late Roman design often called "Constantinian." From the base of the crown hang inlaid letters spelling out the Latin phrase "Reccesvinthis rex offeret" (offered by King Recceswinth). From each letter hangs a sapphire and a pearl. Four golden chains of pierced, heart-shaped palmettes suspend the crown from an exquisite floral terminal of gold and rock crystal. The jeweler enhanced the borders of these palmettes with granulation, a process whereby beads of gold are fixed to

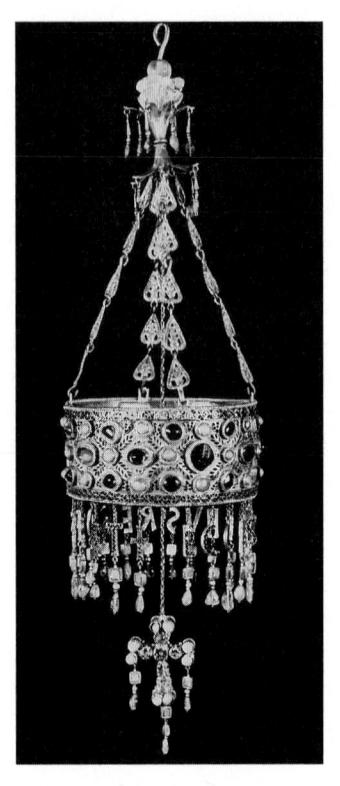

4.7 Receswinth Crown. Toledo, 653–672. Museo Arqueológico Nacional, Madrid.

the golden ground. The formal setting of precious stones and pearls within the gold frame recalls Byzantine design, while the exquisite craftsmanship harks back to traditional barbarian metalwork. The crown marks both the end of the classical tradition and the beginning of a new Western style.

Artists in Italy did not enjoy the relatively peaceful existence permitted their Visigothic counterparts. The violence that marked the Langobards' invasion of 568 continued unabated even after the conquerors had settled the region. Paul the Deacon, an eighth-century scholar whose *History of the Langobard People* recounts their wanderings, described with horror the devastation wrought by the armies: "The churches have been reduced to rubble and the priests murdered; the cities have become deserts and the people destroyed. Where once were the homes of people, today is the domain of wild beasts."

At the beginning of the seventh century, the kingdom, ruled by Queen Theodelinda and her

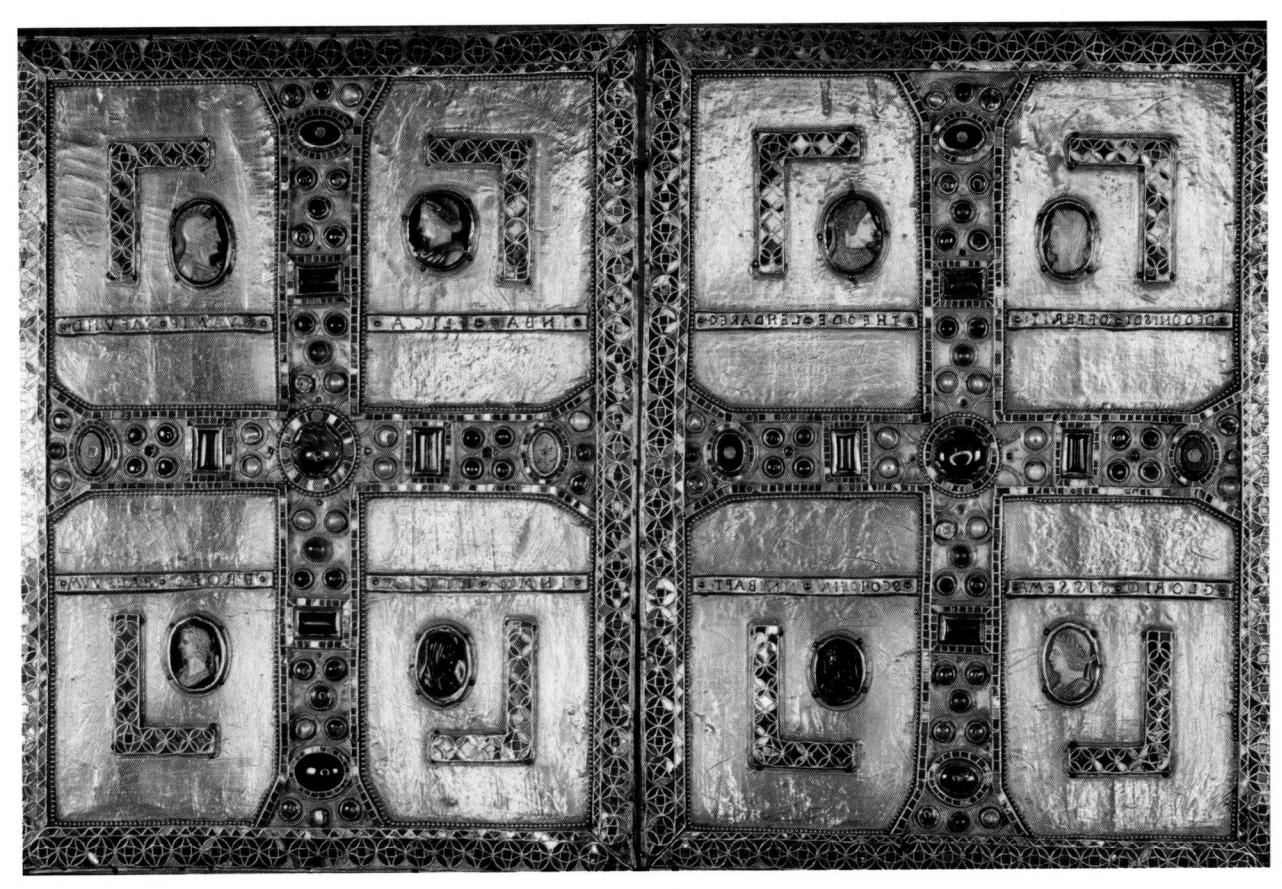

4.8 Cover of the Gospels of Theodelinda. Basilica of St. John the Baptist, Monza, Italy. Gold, gems, and pearls on a wood base. 13 2/5in. (34cm) high, 6th–7th century. Museo del Duomo, Monza.

consort, King Agilulf, had become a microcosm of the religious beliefs dividing the Western world. Although the majority of the Langobards were Arian Christians, some had remained pagan. The queen herself was a loyal follower of Pope Gregory the Great and the Roman church; nevertheless, she permitted rival Celtic monks to establish a monastery at Bobbio. St. Columban (c. 543-615) founded this monastery, which not only served as a link between the Celtic and the Langobard peoples but became one of the foremost centers of scholarship and book production in the early Middle Ages. Books made splendid gifts of state. In 616 Queen Theodelinda presented Pope Gregory with a gold and jeweled case, or cover, which combines the formal symmetry of classical art with the refined metalworking skills traditional among her barbarian Langobard ancestors [4.8]. Like the

Goths, the Langobard rulers sought to emulate the art of Rome and Byzantium.

The Langobards attained the height of their power during the reign of King Luitprand (ruled 712–744), who restored and endowed churches, monasteries, and palaces. So skilled were the masons that the term "Lombard" was adopted in the Middle Ages to designate the building technique used throughout northern Italy. While few of Luitprand's projects still stand, the skills developed by his masons became forever part of the local tradition, with the result that the Lombard masters profoundly influenced the formation of the Romanesque style.

Luitprand commissioned many buildings for Cividale del Friuli, in the political and religious heart of his kingdom. Of those that survive, the Oratory of Sta. Maria in Valle, known as the Tem-

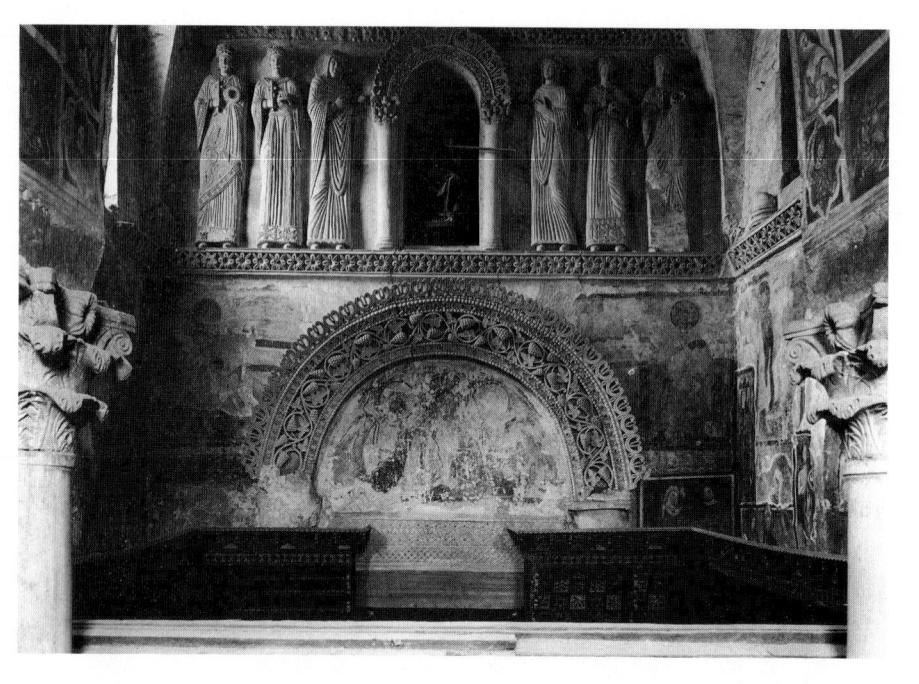

Sta. Maria-in-Valle, Cividale, Italy, 8th century. Stucco, relief sculpture.

pietto, or little temple, is the most remarkable for its splendid interior display of six over-life-sized stucco figures [4.9]. The decoration of the entrance wall echoes the Byzantine style. Indeed, the standing female saints and the ornamental moldings may even have been carved by itinerant Eastern artists rather than local craftsmen. In either case, the floral patterns across the wall re-create Byzantine designs in a somewhat stylized fashion. The figures—five crowned saints in richly embroidered cloaks and one dressed in a nun's habitshow their Byzantine ancestry. Static in pose, elongated in proportion, with small heads on slender bodies, the Cividale women could be granddaughters of the Empress Theodora and her retinue in the mosaic in San Vitale. Here the sculptor has intensified the regularity of the faces and the parallel lines that indicate the garment folds. Nevertheless, in the context of eighth-century Italy, this conservative version of the Byzantine style remains unique in its bold three-dimensional modeling.

The creative potential underlying Sta. Maria in Valle was never to be realized, because the Langobard kingdom did not endure long after Luitprand's death. Although he had maintained relatively cordial relations with the Franks, later

Langobard rulers were not so astute. In 751 the Langobards conquered Rome, but this action forced the Pope to appeal to the Franks for aid. The two armies battled for control of Italy until 774, when the Franks, under Charlemagne (see Chapter 5), decisively defeated the Langobards and ushered in a new phase of medieval art.

THE ART OF THE MEROVINGIAN FRANKS

During the fifth and sixth centuries, the Salian Franks of the Merovingian dynasty—so called after their semi-legendary founder, Merovech—occupied Gaul and successfully vanquished or incorporated all others into their kingdom. If we are to believe the unsympathetic account of Bishop Gregory of Tours (d. 594), the Merovingians achieved these victories because, although they had adopted Christianity, they remained ruthless and greedy.

The Franks had converted to Christianity (496) during the reign of Clovis partly through the efforts of Queen Clotilda. According to legend, in the midst of battle, the king called on the Christian God for help, and his troops immediately carried the day. Thus Clovis, like Constantine,

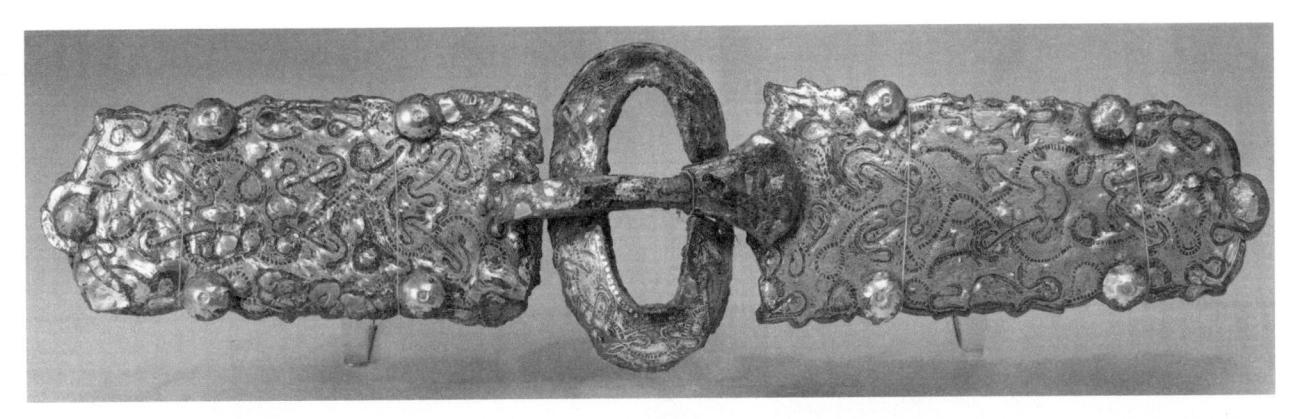

4.10 A massive Burgundian buckle and belt plate in iron overlaid with silver and decorated with interlace partially gilded, the bosses covered with gold. 13 3/4in. (35cm): The Walters Art Museum.

adopted Christianity in order to ensure military victory. The conversion immediately put the Franks on the side of the Roman Church. In the process of successfully defending the papacy in the eighth century, the Franks emerged as the prevailing military force in continental Europe.

Understandably, early Frankish art reflects its Germanic tribal origins, with jewelry and weapons in both the polychrome and animal styles being the principal objects. The magnificent Burgundian belt buckle decorated with silver and interlacing serpents is typical [4.10]. The craftsmen had ample opportunity to study the art of other migratory people, partly as a result of trade and the exchange of gifts, but primarily because hoards of precious jewelry and armor constantly circulated throughout Europe as booty taken and given by people forever at war with one another.

The skills of the metalworkers soon were employed in the service of Christianity. Frankish artists copying the objects and themes favored by Rome and Byzantium satisfied their patrons' love of brilliant display and their own taste for abstract design. A medallion with Christ holding the Bible, placed above the arc of the heavens, flanked by alpha and omega (the first and last letters of the Greek alphabet, therefore signifying "the beginning and the end") and mysterious heads (the winds?), suggests that the Christian artists had adapted the early polychromatic gem style [4.11]. Like the Byzantine reliquaries of the Stavelot Trip-

tych [see 1.1, 1.2], the image is cloisonné enamel. Since the colored glass forms a brilliant, nearly luminous surface, the artist could work with dazzling colors and glittering surfaces without incurring the expense of precious stones. Furthermore, the medium lends itself to the abstract style preferred by the Franks. In early Western enamels, forms are simplified and colors limited to emerald green, dark and light blues, red, yellow, and white.

When the Merovingians began to build churches, they necessarily adopted late Roman architectural

4.11 Medallion with bust of Christ, Frankish, second half of 8th century. Cloisonné enamel on copper. Diameter about 2in. (5.1cm). The Cleveland Museum of Art.

4.12 Crypt of St. Paul, Abbey of Notre-Dame, 7th century. Left: Sarcophagus of Agilbert; right: Sarcophagus of Theodochilde. Jouarre.

techniques and structural forms. Gregory of Tours wrote of large and lavishly decorated basilicas and baptisteries such as the Church of St. Martin at Tours, erected in 466–470 to house the relics of the fourth-century apostle to Gaul. The Merovingians added towers to the horizontal basilican hall and, according to Gregory of Tours, decorated their churches with paintings, marble panels, and rich ornaments.

Interesting masonry walls, columns, and capitals can be seen in the Crypt of St. Paul, Jouarre, in France [4.12]. In 630 Celtic missionaries had established a monastery at Jouarre in northern France. About 50 years later, the bishop of Paris,

Agilbert, erected a church on the site, intending the foundation to serve as his family's mausoleum. The crypt dedicated to the fourth-century saint known as Paul the Hermit survived untouched during later restorations. The Frankish architects used indigenous structural techniques in patterned masonry walls, and they pilfered columns from local Gallo-Roman buildings. To fit these shafts, they imported capitals from workshops in southern Aquitaine, where marble carvers still used classical compositions and techniques.

Capitals that so carefully adapt Roman designs lead us to presume a Late Antique Style in other sculpture. Such expectations are confirmed by the reliefs on the sarcophagus of St. Theodochilde (d. 662), the sister of Bishop Agilbert and the first abbess of Jouarre [seen at the right in 4.12]. Only a firsthand knowledge of Mediterranean art could have inspired the vine scroll with leaves and grapes adorning the cover and the rows of scallop shells and the precise letters of the inscription decorating the side of the marble tomb. The austere simplicity of the design, with its delicate carving and finely adjusted proportions, suggests contact with Byzantine art.

Merovingian monasteries such as Jouarre were missionary outposts and educational establishments. An important duty of the monks was to copy books, since missionaries needed the Bible and the writings of the Church Fathers. From the seventh century onward, the writing and decoration of manuscripts was a flourishing enterprise in Merovingian scriptoria. The natural desire of an expert scribe to glorify the text with art caused words and letters themselves to be so elaborated that words often took on the semblance of jewelry. It was but a step from decorated words to the addition of pictures. Inspired by Early Christian and Byzantine manuscripts, Frankish illuminators inserted author portraits at the beginning of the Gospels and frequently turned concordances of the four Gospels (canon tables), cross pages, and the introductory words of the text (incipits) into fullpage designs.

Scribes delighted in adopting traditional motifs for their manuscripts, just as craftsmen employed the decorative patterns invented for swords and fibulae to adorn church treasures. One popular conceit was derived from the Roman practice of converting birds and fish into readable letters. Knowledge of this custom was surely acquired through the Celtic monasteries that developed close contacts with Italy. Nowhere did a Merovingian artist more beautifully interpret the animal alphabet than in the Sacramentary of Gelasius, probably made in a monastery at Corbie about 750 [4.13]. Named for the fifth-century Pope Gelasius, the Sacramentary is a liturgical service book containing the celebrant's part of the Mass. Each section has a decorated opening. The second section begins with a portal, followed by a cross that introduces the words "Incipit liber secundus" (Here begins Book Two). Roundels inhabited by animals form the arms of the cross, and the Lamb of God appears instead of a human at the center. The lamb was an up-to-date feature, since Pope Sergius (687-701) had introduced the Agnus Dei into the Mass only 50 years earlier. Two birds hovering below the alpha and the omega nibble at the pendent letters, and the last words on the page are made up entirely of small fish and birds. These creatures, although at first glance rendered in natural proportions, are ingeniously composed of compass-drawn arcs. Their distinctive Merovingian eyes—round and white with a black dot exactly in the center for the pupil—repeat the circular motif. The cross, the roundels, the foliate motifs are laid out with geometric precision, for the traditional love of ornament still dominates the Merovingian style.

4.13 Sacramentary of Gelasius, France, mid- 8^{th} century. Manuscript illumination, $10\ 1/4\ x\ 6\ 7/8in$. (26 x 17.3cm). Vatican Library.

THE ART OF THE VENDELS AND VIKINGS

Trade contacts and raiding expeditions brought Mediterranean art and culture to Scandinavia. Byzantine and Near Eastern vessels and coins are found in northern graves, for booty was buried with the owner. Despite such encounters, the Scandinavian artists in the early Middle Ages remained independent of the rest of Europe. The artists and designers never lost their love of abstract animal forms. Indeed, Scandinavia, where people continued to worship pagan deities until the tenth and eleventh centuries, was the last stronghold of the animal style.

Norse jewelers, like their Germanic cousins, adopted and transformed simple Roman "safety pins" into magnificent fibulae [4.14]. Instead of using polychrome garnet inlays and cloisonné enamel, however, the northern artists covered the surface of their jewelry with chip-carving, a faceting technique derived from wood carving and designed to catch and refract light. Intricate animal and anthropomorphic forms crouch, crawl, and snarl their way over the objects. Scandinavian craftsmen invented fantastic birds and beasts by exaggerating and recombining elements until natural shapes metamorphosed into symbols of sheer energy. Yet, for all the complexity of the concept, the integral parts of the creatures can usually be distinguished.

In the Gummersmark Brooch the rectangular head plate is divided into two sections by an animal seen from above, whose head lies in the center of a bird-head border. His beaded spine bisects a symmetrical arrangement of ribs, pear-shaped hips, shoulder joints, and slender legs and paws. At the top of the foot plate a pair of profile heads link up with elongated quadrupeds, whose snapping tongues spiral out to define the bottom of the plate. Human figures emerge between the beaded volutes of the foot plate and again below the chip-carved coils on the head piece. The artist has reduced anatomical parts to generalized shapes and compressed them into physically contorted but artistically elegant pat-

4.14 Gummersmark Brooch, Gummersmark, Denmark, 6th century. Silver gilt. Height, 5 3/4in. (14.6cm) Nationalmuseet, Copenhagen.

terns. Only a pointed oval eye, an oblong nose, and a down-turned mouth describe the head, while the roll that represents hair rests directly on top of the shoulders, and a single ornamented band indicates clothing. Although each man and animal is a complete being, each also interlocks with its neighbor in order to establish the form of the fibula.

At the end of the sixth century and through the seventh century, the sinuous Vendel style dominated Scandinavian art [see 4.4]. The royal burial mounds excavated at Vendel and Valsgarde in Sweden have yielded treasures so distinctive in aesthetic sensibility that archaeologists have named both the period (600–800) and the style "Vendel." Vendel chieftains were interred in ships and fully equipped with horses, hounds, weapons, and supplies necessary for their final trip across the seas to Valhalla, the hall of heroes and gods. Cast-bronze mounts decorated shields, swords, and helmets. In

dramatic contrast to the comparatively static Visigothic solar eagles [4.6], the Vendel hawk moves in sweeping curves [4.15]. Wings curl around the body contrasting with the angular leg and claw. Crayfish designs decorate the spreading tail. The head with enormous eyebrows and long curving beak resembles the serpents we have already seen. Vendel art began to have an impact on the rest of Europe at the end of the eighth century when Viking explorations and invasions shook the foundations of the settled world.

At the end of the eighth century, the seafarers, fishermen, and traders who lived along the coasts of Denmark, Norway, and Sweden suddenly took to the sea as explorers and pirates [4.16]. Whether moving as small warrior bands with two or three boats, or in flotillas of 350 ships, the Vikings—named for the *viks*, or bays along the Norwegian coast—terrorized Europe. The shallow draft of

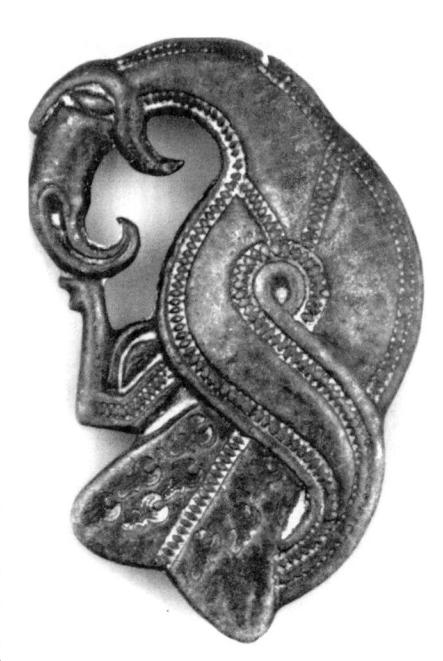

4.15Fibula in the shape of a bird of prey. Copper alloy; 2 3/8in. (6cm). Scandinavian, about 600. The Metropolitan Museum of Art.

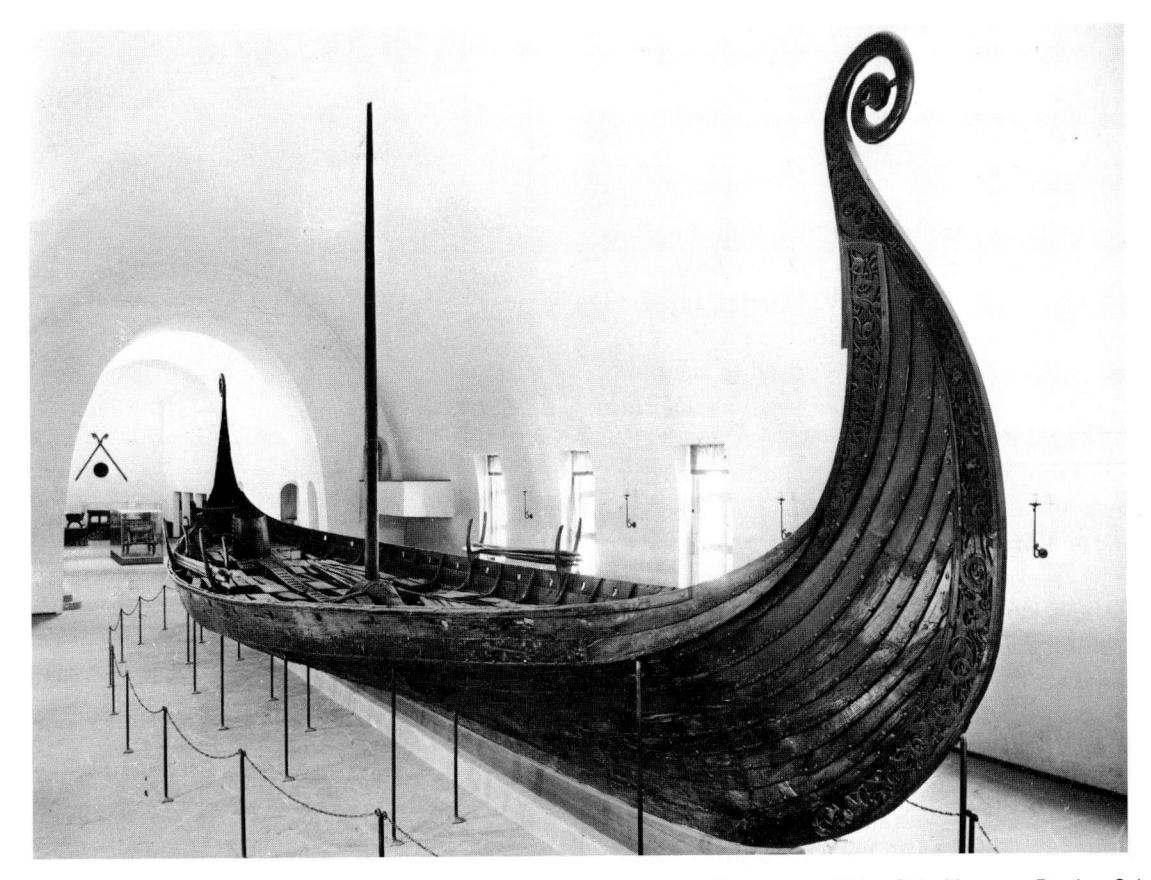

4.16 The Oseberg ship, Norway, c. 800. 71ft. (21.6m) long, 16 1/2ft. (5m) across. Viking Ship Museum, Bygdoy, Oslo.

Viking Westward Exploration

According to the ninth-century Anglo-Saxon Chronicle, in 793, "fiery dragons were seen flying in the air. A great famine followed ... and a little after that ... the Heathen [Vikings] miserably destroyed God's church in Lindisfarne...." Alcuin, learning of the disaster at Lindisfarne from the safety of Charlemagne's court, believed the Vikings to be instruments of God's wrath and cited Jeremiah 1:14: "Then the Lord said unto me, Out of the north an evil shall break forth upon all the inhabitants of the land." By 800, when Charlemagne was crowned emperor in Rome, the Vikings were raiding the coast of Northumbria. They rounded Scotland to destroy St. Columba's monastery on Iona, ravaged the Isle of Man, attacked Wales and Ireland, and reached the coast of France. They settled in Scotland, northern England, and Ireland, and in the second half of the ninth century they began to extend their territories. Not only did Olaf the White found the Kingdom of Dublin in 851, but also in 860 his compatriots discovered and colonized Iceland. Little more than a hundred years later, the Vikings sailed on to Greenland, and about 1000 Leif Eriksson reached the North American continent. A Viking settlement has been found at L'Anse-aux-Meadows in Newfoundland.

their longboats enabled them to sail up the rivers of Europe into the heart of the Continent. No town or monastery was safe. Vikings appeared along the French coast in 814 and on the River Seine in 820. Not until the very end of the ninth century did Carolingian armies begin to hold fast against this threat. Nevertheless, in 911, Charles the Simple was forced to cede the northern coast of France to the Viking Hrolf, or Rollo, who became Duke of Normandy, the land of the Northmen.

The excavation of a mound at Oseberg, on the Oslofjord, unearthed a remarkable ship burial. Although robbers had made off with precious materials, the wooden vessel and its equipment survived. The ship contained the bodies of two women and all the provisions necessary for life in the next world. The burial took place in 834, although the ship itself had been constructed in 815–820. It was a royal barge beautifully carved and designed for the calm waters of the fjord. The

ship's extraordinarily elegant proportions, technically perfect to reduce water resistance, with strong yet flexible oak construction, had been developed by the Vikings over centuries of seafaring experience.

In symbolic terms, the Vikings conceived of a ship as a huge sea serpent, the rising spirals of the prow and stern representing the creature's head and tail. Such a dragon-like shape was no doubt intended to frighten off other monsters, for similar beasts were carved on houses, tent poles, sleighs, and wagons. Carvings of interlaced, silhouetted animals run along the prow and stern in a design that harks back to the Vendel style of earlier Swedish royal tombs [4.17]. The ninth-century craftsmen, however, introduced a contrast of textures and forms absent in Vendel work. The serpent heads in the Oseberg reliefs move down the

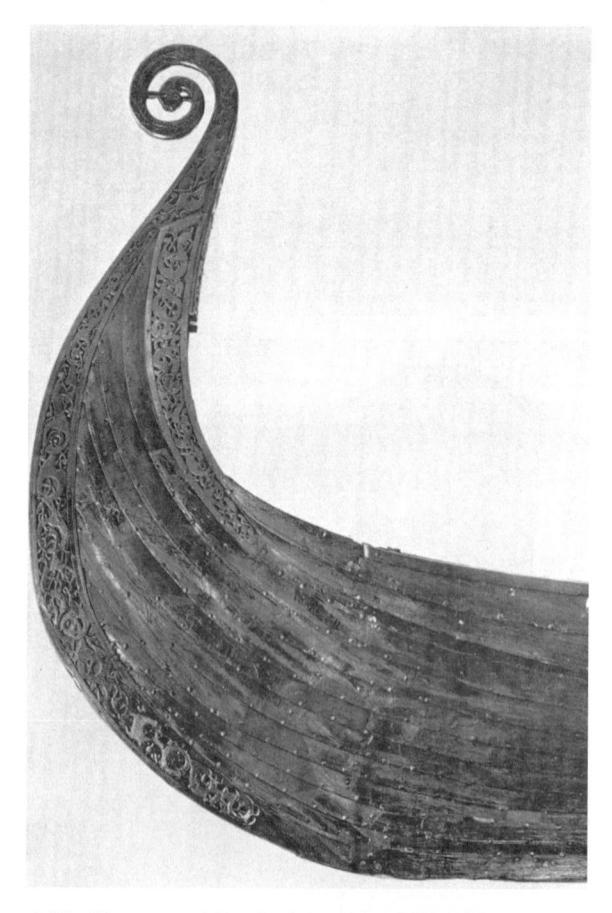

4.17 The prow of the Oseberg ship. 815–820. University Museum of Cultural Heritage, Oslo.

center of the panel, while relatively broad bodies with hatched surfaces provide a visual foundation for an interlace of thin, curving tails and legs, thus adding variety to the refined Vendel serpents. The "gripping beast," as this motif is called, became a hallmark of Viking animal ornament. These strange creatures appear in wood and metal work in Scandinavia and the British Isles.

The Scandinavians remained pagan well into the tenth century. Odin presided over the Viking pantheon of gods from Valhalla, the Hall of the Slain. To this hallowed place the Valkyries, Odin's messengers and cup bearers, carried warriors who had died in battle. The Vikings believed that the world would end one day in a catastrophic upheaval, the apocalyptic Ragnarok. Then a new earth would arise. The conversion of Scandinavia came slowly. In the tenth century, Gorm the Old united Denmark, and his son Harald Bluetooth (ruled c. 945–985) accepted Christianity for himself and his people in 960.

ART IN THE BRITISH ISLES

The Jutes, Angles, and Saxons introduced continental styles into the art of the islands. In the fifth century they pushed aside the Celts (Britons) and replaced the Romans as rulers of that part of the British Isles to which the Angles gave their name— England. Their Scandinavian ancestry also left its imprint on the objects found at one of the most important archeological sites in Britain—the cemetery of Sutton Hoo. In 1938 and 1939 archaeologists excavating a burial mound near the east coast of England uncovered the vestiges of a ship 86 feet long. Earlier than the Oseberg ship, yet similar in form, the Sutton Hoo vessel still held its rich grave goods. Indeed, the notion of a ship as a vehicle for transporting royal dead to the great beyond is one of the oldest themes in Scandinavian lore. The Sutton Hoo site yielded no human bones but new evidence indicates that a body had been there but had completely disintegrated. The king could have been Raedwald (d. 624/625) or one of the last pagan kings of East Anglia. Evidence of coins and the style of the grave goods indicates a date of about 625.

As in the case of the Vendel and Viking graves, the Sutton Hoo boat contained both treasures and practical equipment, the better to establish the credentials of the deceased and give him provisions for the next world. What differentiates the Anglo-Saxon mound from Vendel and Viking tombs is the rich variety of the grave goods. Not only Norse influences but also Celtic and Continental styles determined the design of the king's weapons, his jewelry, and even his cooking utensils.

A pair of hinged shoulder clasps may be true royal regalia. Their form is based on Roman parade armor, and highly visible red and gold had become the color of royalty (like purple in the Byzantine court). The shoulder clasps resemble Jutish and Continental polychrome-style jewelry [4.18]. In the rectangular fields, stepped-pattern compartments are alternately filled with garnets over diapered foil and with blue millefiori or "thousand flowers" enamels. (The enamels are produced by fusing rods of different-colored glass, miniaturizing it by drawing the glass out like taffy, and then slicing off thin cross-sections to set within the field.) The formal stepped cells, garnets, and checkers dominate the central composition, but in the outer borders the Anglo-Saxon artist paid tribute to the northern love of animals. Framing the large rectangles, S-shaped serpents incised in gold and formed of garnets contort their slithering forms in order to snap back at their own bodies. Each curved end of the clasp is decorated with a pair of boars, which are accurately represented from their tusks to their curling tails. The boars could be a personal emblem. These boars seem transparent as they intersect on the same twodimensional plane to create a flat, symmetrical pattern.

A gold belt buckle of Anglo-Saxon workmanship attests to the strong stylistic connections between the craftsmen and their Scandinavian cousins [4.19]. Three circular bosses and two hawk heads in profile [compare 4.15] punctuate a crawling mass of serpents and dragons, all rendered in the two-dimensional Vendel mode. Crocodileheaded beasts chew on their neighbors and their slender legs interlock with pairs of snakes. Two

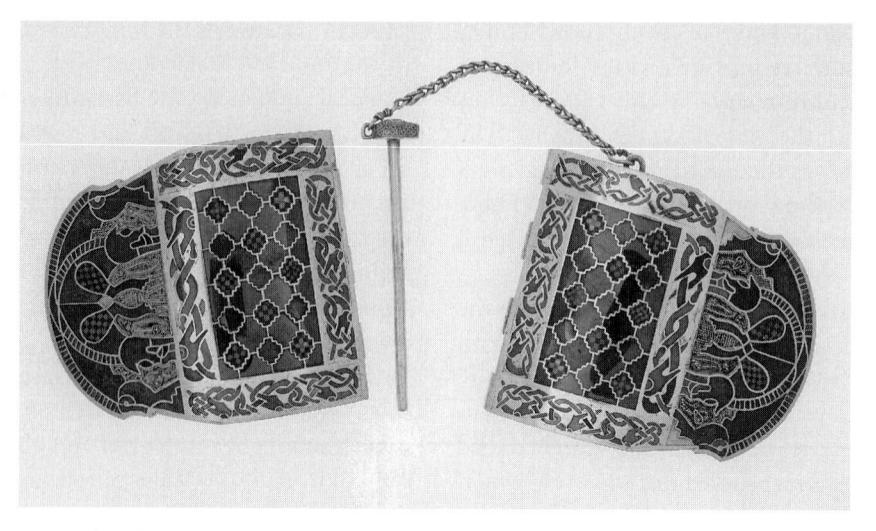

4.18 Shoulder clasp from Sutton Hoo. Southern England, c. 625. The British Museum, London.

4.19 Buckle, Sutton Hoo, England, c. 625. Gold, 5in. (12.7cm) long. The British Museum, London.

dragons gnash their teeth as they attack a little dog at the base of the terminal boss.

The Anglo-Saxon traders (or raiders) also acquired Christian art in the form of Celtic hanging bowls, Byzantine silver bowls, and Merovingian coins (minted before 613). The influx of such spoils as these into Britain slowly created a new artistic climate, in which the descendants of the continental invaders, inspired by new themes and ceremonial requirements, ultimately developed a great northern Christian art.

Surprisingly, Christianity reached the islands early. The conversion of two tribes, the Picts in northern Scotland and the Celtic Scots in Ireland and southern Scotland, began in the fourth century. In 397, St. Ninian established a church in Scotland, and a generation later St. Patrick began his mission in Ireland. Although the Pope nominally ruled the church from Rome, the relative isolation of the islands allowed distinctive liturgical practices to evolve—for example, a different calendar of feasts and saints and an administrative system based on individual monas-

4.20 The Cathach, opening of Psalm 53. Complete page, $7 \ 4/5 \ x \ 5 \ 1/10$ in. (20 x 13cm). Late 6^{th} or early 7^{th} century.

teries. The Celtic preference for locating monastic centers in inaccessible regions nurtured this local autonomy. As described by the eighth-century Anglo-Saxon historian Bede, the monks lived "among craggy and distant mountains, which looked more like lurking places for robbers and retreats for wild beasts, than habitations for men."

Despite the Celtic monks' preference for remote surroundings, their monasteries became centers of learning and of book production. The earliest manuscript to survive is the sixth-century or very early seventh-century fragment of a Psalter called the Cathach, or "champion," of St. Columba [4.20]. Written in capital letters (known as majuscule), each psalm begins with an initial letter larger than the rest followed by letters of diminishing size. These letters are ornamented with dots, pothooks, and spirals. According to legend, when St. Columba (c. 521–597) copied the Psalter with-

out the permission of its owner, St. Finnian, Finnian's people declared war over the book. St. Columba won but moved to Iona, an island off the western coast of Scotland, where he founded a monastery in 563. The story serves as a reminder of the high regard in which books were held and of the vital role of the Gospels in missionary activities. From Iona Columba traveled to the mainland, still held by the Picts, where he drove off the Loch Ness Monster by making the sign of the cross. Convinced of the power of the Christian God by this feat, the Picts accepted Christianity.

Although St. Columba's efforts were confined to the British Isles, his successors became missionaries on the Continent. At the end of the sixth century they founded important monasteries at Luxeuil and Jouarre in France, St. Gall in Switzerland, and Bobbio in Italy. Wherever Celtic monasteries appeared, active centers of book production arose and scholarship flourished.

The Celtic monks practiced an idiosyncratic form of Christianity not entirely welcomed by the Roman Church. Pope Gregory the Great, therefore, decided to

deal with the problem at its heart by sending his own missionaries to the British Isles. In 597, St. Augustine arrived in Kent at the court of King Aethelbert. Influenced by his Christian wife, the Frankish Princess Bertha, the monarch accepted Christianity, and St. Augustine established his church and administrative center at Canterbury. By Eastertide in 627, St. Paulinus of York, a follower of St. Augustine, baptized the Northumbrian King Eadwine and all of his court and so completed the conversion of England. Competition between the rival Christian churches began at once. In 635 a group of Celtic monks from Iona led by St. Aidan established a monastery on Lindisfarne, an island off the coast of Northumbria. Celtic Lindisfarne rivaled Canterbury as a religious center. To settle the conflict between the Celtic and the Roman Church, a Church council met at Whitby in 663-664. The council resolved the

4.21 Weyland the Smith and the Adoration of Magi, the Franks Casket, Northumbria, c. 700. Whalebone. The British Museum, London.

issues—the dating of Easter, the cut of the tonsure—in favor of the papal party.

The establishment of Roman supremacy had significant artistic consequences in the seventh century. Stronger British ties to Rome encouraged the flow of Mediterranean painting and sculpture to the north. Between 653 and 685, Benedict Biscop, a scholar and ecclesiastical administrator, made five trips to Rome in the course of his duties. In 671, he returned with books, paintings, reliquaries, and other precious objects for the new Anglo-Saxon abbeys at Monkwearmouth and Jarrow. Such imports enabled Anglo-Saxon artists to draw on the rich store of Roman and Byzantine narrative and symbolic imagery when they needed to tell the stories of their new religion or cast the legends and myths of the north in visual form.

The Franks Casket, a small box made of whale-bone and usually dated about 700, exemplifies the complex visual heritage of northern England [4.21]. (The name refers to a former owner, Sir Augustus Franks, not to the Frankish people.) Scenes from Roman history and legend, Scandinavian mythology, and the Christian story decorate the four sides and top of the box. Framing each figurative panel, runic inscriptions—the twig-like letters used by the northern people—comment on the action. In a rid-

Anglo-Saxon Riddles

The Anglo-Saxons loved riddles. Written in runes, they are difficult to translate.

The riddle on the Franks Casket: The flood carried the fish on to the mountain coast. The ocean was fierce when he swam on to the sand.

The answer: Whalebone

A typical riddle (already popular in Roman times): A creature walked into a room filled with wise men. It had one eye and two ears, one neck and twelve hundred heads, two hands, arms and shoulders, one back and belly, and two feet. What is it?

The answer: A one-eyed garlic seller.

An Anglo-Saxon moralizing riddle: My garments are bright, red and gleaming. I fool the foolish and urge fools on foolish journeys, but sometimes I send them in useful directions. I do not know why those whose minds I have stolen praise my wicked ways. Woe unto them if they do not refrain from folly.

The answer: Wine

For more Anglo-Saxon riddles in modern English translations see John Porter, *Anglo-Saxon Riddles*, Hockwold cum Wilton, Norfolk, England, 1995.

dle, they tell of a terrible storm and a stranded whale, from which the craftsman acquired bone to make the box. The wealth of detail, no less than these explanatory texts, points up one consistent characteristic of the representational arts in this period: However divergent the stylistic and iconographic sources, vivid storytelling with an educational message was the primary concern of the artists.

Themes of wealth, booty, and gift giving cover the box. On the front, the sculptor depicted the Adoration of the Magi, juxtaposed, curiously enough, with events from the life of the Norse hero Weyland the Smith. Crippled and forced against his will to work for a king, Weyland murdered the king's sons and turned their heads into drinking vessels. As if this were not adequate revenge, Weyland also raped the king's daughter, and then he and his brother Egil flew to freedom on magic wings fashioned from goose feathers. (George Henderson has suggested that, perhaps in the imagination of this still half-pagan world, human sacrifice and skull-cups equated with Christ's sacrifice and the chalice of Eucharistic wine.) The casket's sculptor chose to illustrate the tale by showing Weyland at his anvil making a skull-cup while the princess and her maid look on. At the left, Egil catches geese to make wings.

Juxtaposed to this violent tale is the Christian scene of the Magi. The three gift-giving wise men, identified by the runes "MFXI" (MAGI), follow a rosette-shaped star to the Virgin and Child, bearing gifts of gold, incense, and myrrh. The enthroned Infant and his mother could have been modeled on a Byzantine icon or illustrated book. At the same time, the way in which Jesus' head also serves as the Virgin's body recalls the northerners' fondness for interpenetrating and changing shapes. More pagan elements include Oden's triple knot behind the magi, and—on other panels—Egil and his wife defending their home, and a still unexplained group of Norn-like figures. The artist also included scenes from Roman history—Titus' sack of Jerusalem, and Romulus and Remus nursed by a wolf.

Such diverse sources also appear on the stone crosses of northern England, Scotland, and Ireland. Contrary to present usage, these large, stone slabs

4.22 Cross of Muiredach, early 10th century. Height about 18ft. (5.5m). Monasterboice, Ireland.

and freestanding crosses did not necessarily designate a gravesite. They could define the boundaries of a monastery, or commemorate events and individuals, or mark a consecrated spot for the outdoor celebration of the Mass. In addition, the crosses, like those at Monasterboice in Ireland [4.22], were carved with scenes from the scriptures and the lives of the saints, and served as educational tools. The sculptors must have known Byzantine and Roman art of the kind brought north by Benedict Biscop, but the underlying concept of a column-like cross situated in the open air belongs to the barbarian tradition. The crosses suggest a Christian adaptation of the monolithic sky pillars and sword temples erected by the pagan peoples.

The high crosses of Ireland add "wheels of glory." A wheel joins the four arms to create a motif variously interpreted as a stylization of the braces on wooden processional crosses, a three-dimensional version of engraved, compass-traced crosses, or a reference to an ancient sun symbol. Whatever its origin, the wheel cross became the characteristic Celtic form.

When the Picts began to carve crosses, they left the boulders and stone slabs in their natural form and added engraved crosses and symbols. The Papil Stone from Shetland, dating from the late seventh or early eighth century, has a compass-drawn cross flanked by figures in hooded cloaks carrying crosiers [4.23]. Below stands a lion (the symbol of St. Mark) having the distinctive Pictish emphasis on spiral joints and long curling tongue and tail. At the bottom of the stone, strange bird-headed men holding axes either peck at or hold an object, sometimes identified as a human head, sometimes as the Host. Pictish symbol stones pose fascinating problems of interpretation.

The scribes, faithful to the legacy of pagan styles, although respectful of Mediterranean models, created a distinctive style of painting in their books. (Works produced in Ireland, Scotland, and northern England have so many features in common that the style is called Hiberno-Saxon. "Hibernia" was the ancient name for Ireland.) Luxurious Gospel Books, among the glories of Christian art, document the development of this style.

The Book of Durrow was made between 664 and 675, in Iona or Northumbria. An Evangelist's emblem precedes each Gospel. The lion introduces the Gospel of John (following an early convention that reverses the usual symbols of Mark and John). The beast is far more ferocious than his Pictish cousin and strides forward framed by interlaces whose colors [4.24] change from red to yellow to green, and red stippling (seen in the Cathach) enriches interlacing ribbons. Stippling also covers the lion's head, and red and green diamond shapes resembling enamel inlay form his fur. Typical Pictish bands in yellow mark the muscles, tail, eye, and claws.

The man, symbol of St. Matthew, recalls even more emphatically the art of the enamel workers [4.25]. His body is a solid block of pattern resembling the millefiori inlay of the Sutton Hoo clasps. Only his head and tiny feet add a human element. Although his head with its staring eyes and simple arcs for nose, brows, and mouth seems more pattern than human face, the artist has observed the monks' appearance. St. Matthew wears his hair cut in the fashion of the Celtic church with high shaved forehead and straight cut hair hanging behind his ears. The cut of the tonsure was one of the many points

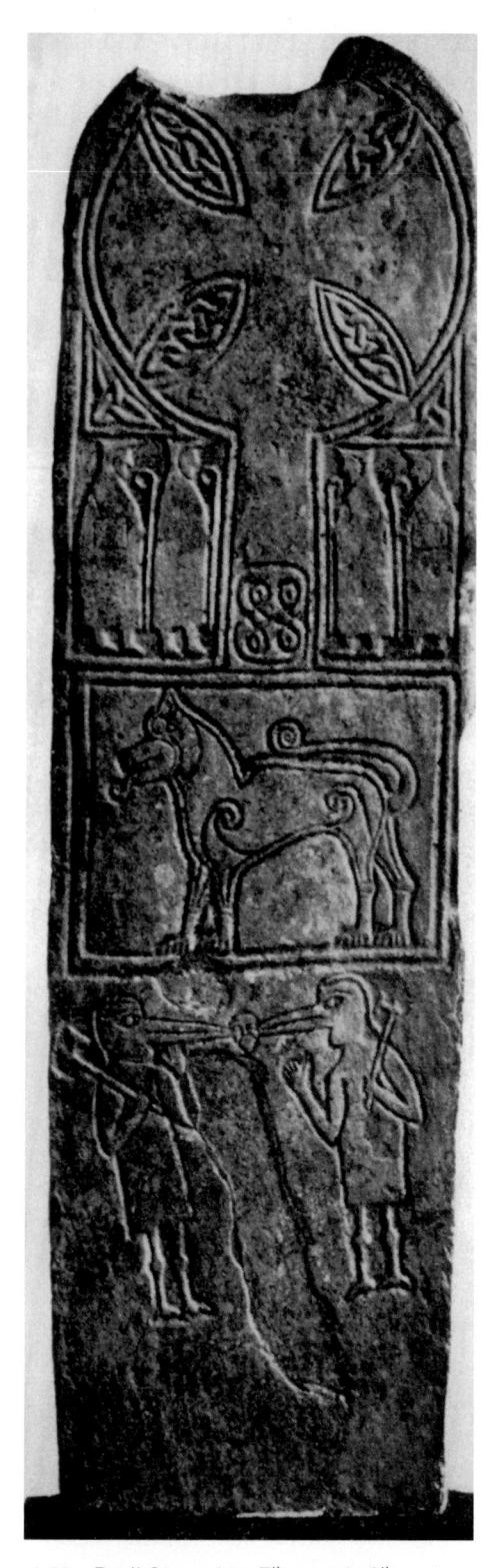

4.23 Papil Stone, late 7^{th} or early 8^{th} century, Shetland. National Museum of Scotland.

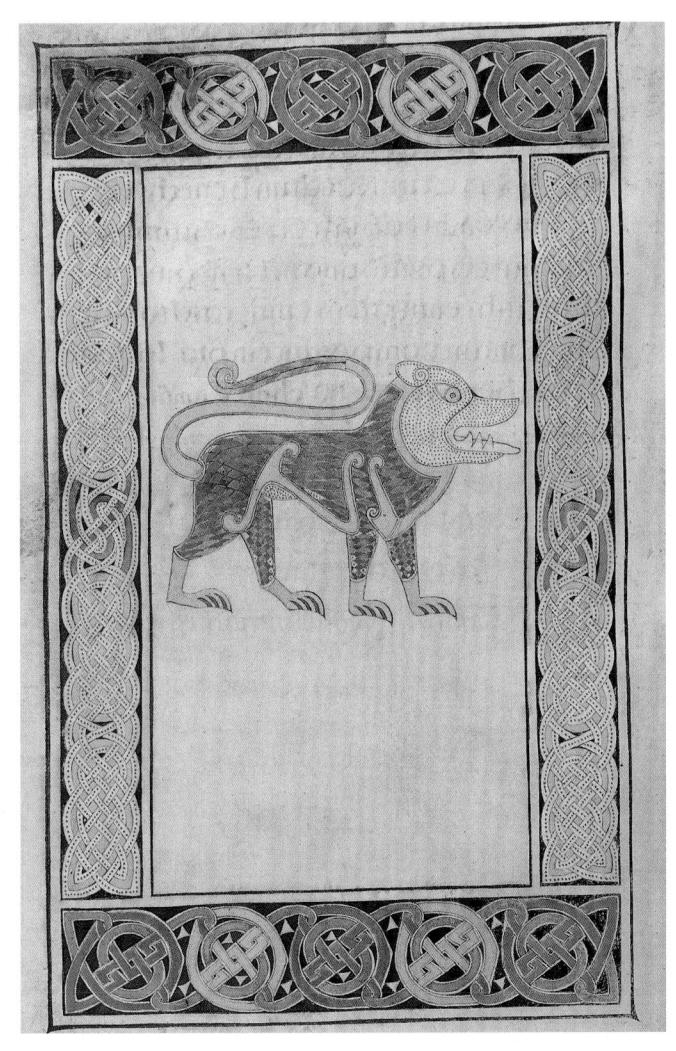

4.24 Lion of John. Book of Durrow. Probably northern England, second half of the 7th century. The Board of Trinity College, Dublin.

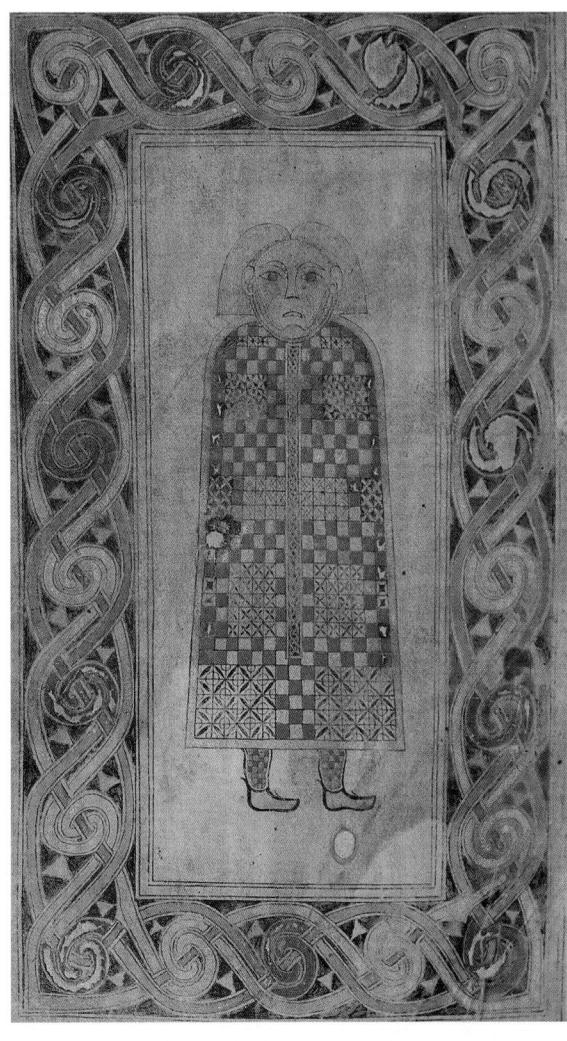

4.25 Man of Matthew, Book of Durrow. Probably northern England, second half of 7th century. The Board of Trinity College, Dublin.

of difference between the Celtic and Roman Churches resolved at the Synod of Whitby.

The tradition of fine goldsmithing continued in works for the Church. With generations of craftsmen behind him, the artist of the eighth-century Ardagh Chalice [4.26] was understandably adept at fashioning liturgical vessels. Such metalwork required no representational elements and therefore allowed free rein to the artist's inherent love of intricate abstract patterns. The clean, unbroken lines of the chalice and its smooth silver surface, inscribed with the apos-

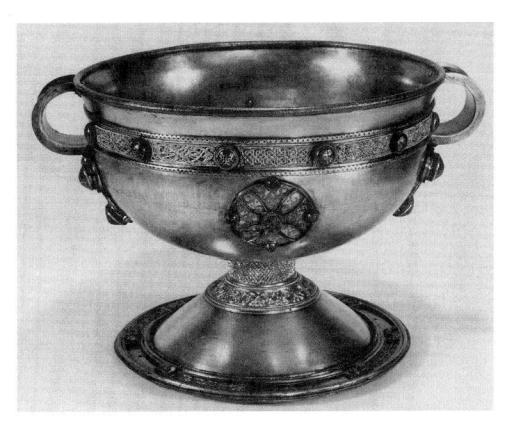

4.26 Ardagh Chalice. c. 800. National Museum of Ireland, Dublin.

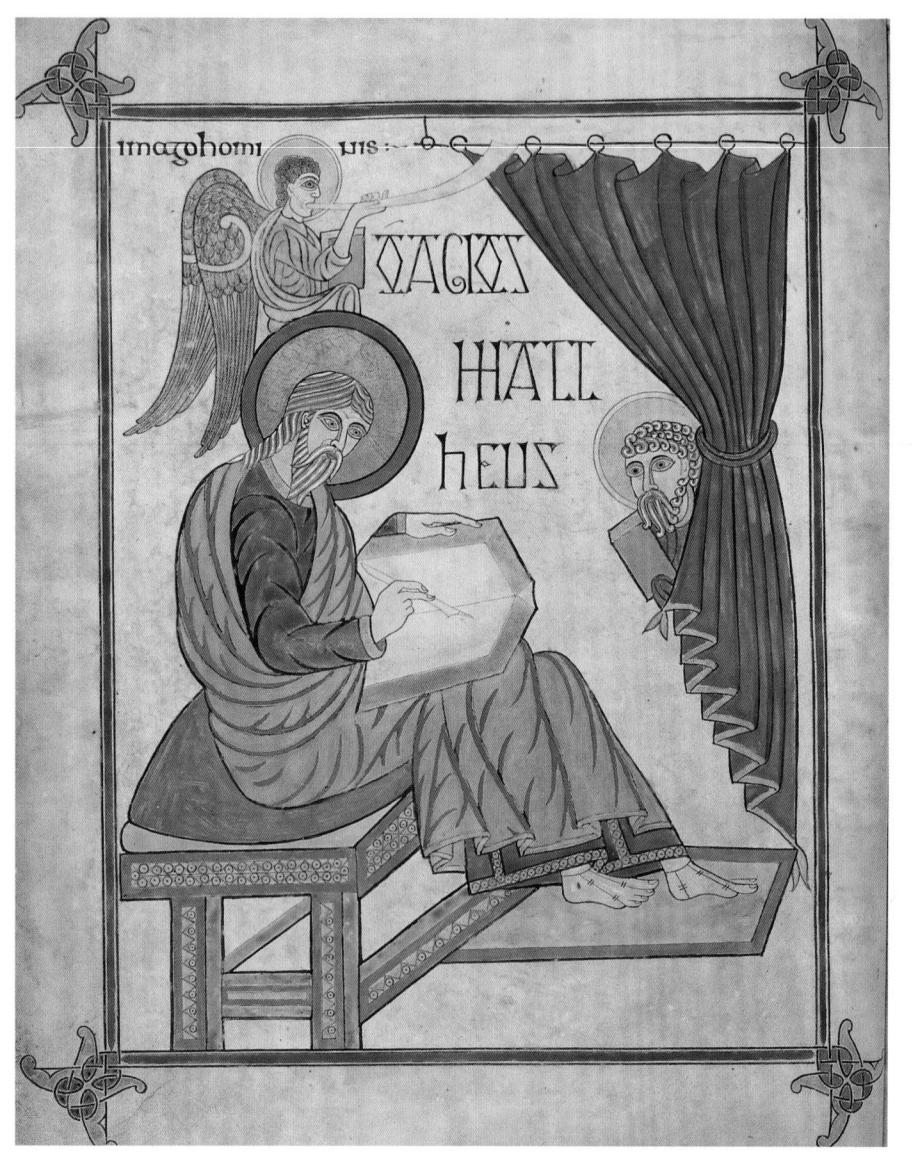

4.27 St. Matthew, Lindisfarne Gospels, Lindisfarne, Northumbria, early 8^{th} century. Manuscript illumination, $13\ 1/2\ x\ 9\ 3/4$ in. $(34.2\ x\ 24.8$ cm). The British Library, London.

tles' names, are enhanced by a subtle application of gold and enamel ornament. The artists did not permit their skill to overwhelm the massive, simple contours of the vessel, and they limited filigree and enamel to panels around the circumference of the chalice and on the handles. In some filigree panels, the master formed a thread out of twisted wires and then ran a beaded strand over it, while in others he hammered a beaded wire flat and soldered a second thin ribbon on top, thereby generating a string of

tiny circles framed by a notched border in low relief. With such remarkable displays of technical virtuosity, the artists sought to honor their God. They created equally remarkable illustrated books to place with the chalice on the altar.

In the Lindisfarne Gospels and the Book of Kells decorative invention reaches its height. In the colophon, or end notes, the Lindisfarne Gospels provides us with an unusual record of the history of a medieval book. In the tenth century, Aldred, then prior of Lindisfarne, documented the efforts of his predecessors. He wrote that the book was written and drawn by Eadfrith, bishop of Lindisfarne (698-721) in honor of St. Cuthbert (d. 689), the founder of the community. Ethelwald bound the book, which was adorned with ornaments of gold and jewels by Billfrith, and glossed in English by himself, Aldred. The Lindisfarne Gospels has lost its jeweled cover, but the text is almost complete, with prefaces, canon tables, and commentaries. Each Gospel is preceded by the author's portrait and a cruciform carpet page.

For the image of the evangelist Matthew [4.27], Eadfrith adopted a Byzantine author portrait [4.28], probably using a Bible brought to Northumbria from Italy. St. Matthew closely resembles the portrait of the scribe Ezra from the Codex Amiatinus, one of three giant Bibles copied by Northumbrian scribes about 700. The two figures are similar in posture, hand positions, and even chairs and footstools. The differences are also significant. While the Ezra painter captured his model's illu-

The scribe Ezra, Codex Amiatinus, Northumbria, early 8th century. Manuscript illumination. Biblioteca Medicea Laurenziana, Florence.

sionistic modeling and perspective drawing in the furniture, the artist of St. Matthew emphasized twodimensional linear patterns. He must have copied the Greek inscription, "Hagios Mattheus," from his model, but he returned to Latin, "Imago hominis" (the image of man), when he added Matthew's symbol, an angel, hovering over the author's head. Ultimately the two images are so different in conception that it has been suggested that the Lindisfarne artist may have been copying a flatter and more linear model than the Cassiodoran Bible. The northern artist maintains the flat colorful patterns to which he was accustomed. What better way for the artist to signal his indifference to naturalistic representation than by completely eliminating the legs of the stool, so that the solid footrest becomes a levitating rug.

The artist's inherently abstract aesthetic assumes full command in the cross carpet page [4.29]. Here, with stunning complexity yet total control, the painter displays an extensive repertory of

motifs, as if the painted page were really a bejeweled plaque spread with golden filigree and enameled interlace. Within the spiral and trumpet patterns derived from earlier insular art, the illuminator set pairs of hounds who snap at long necked birds, traditionally symbolizing the immortal soul. This tangle of creatures remains subservient to the cross, filling the arms with twisting quadrupeds whose ribbon-like bodies

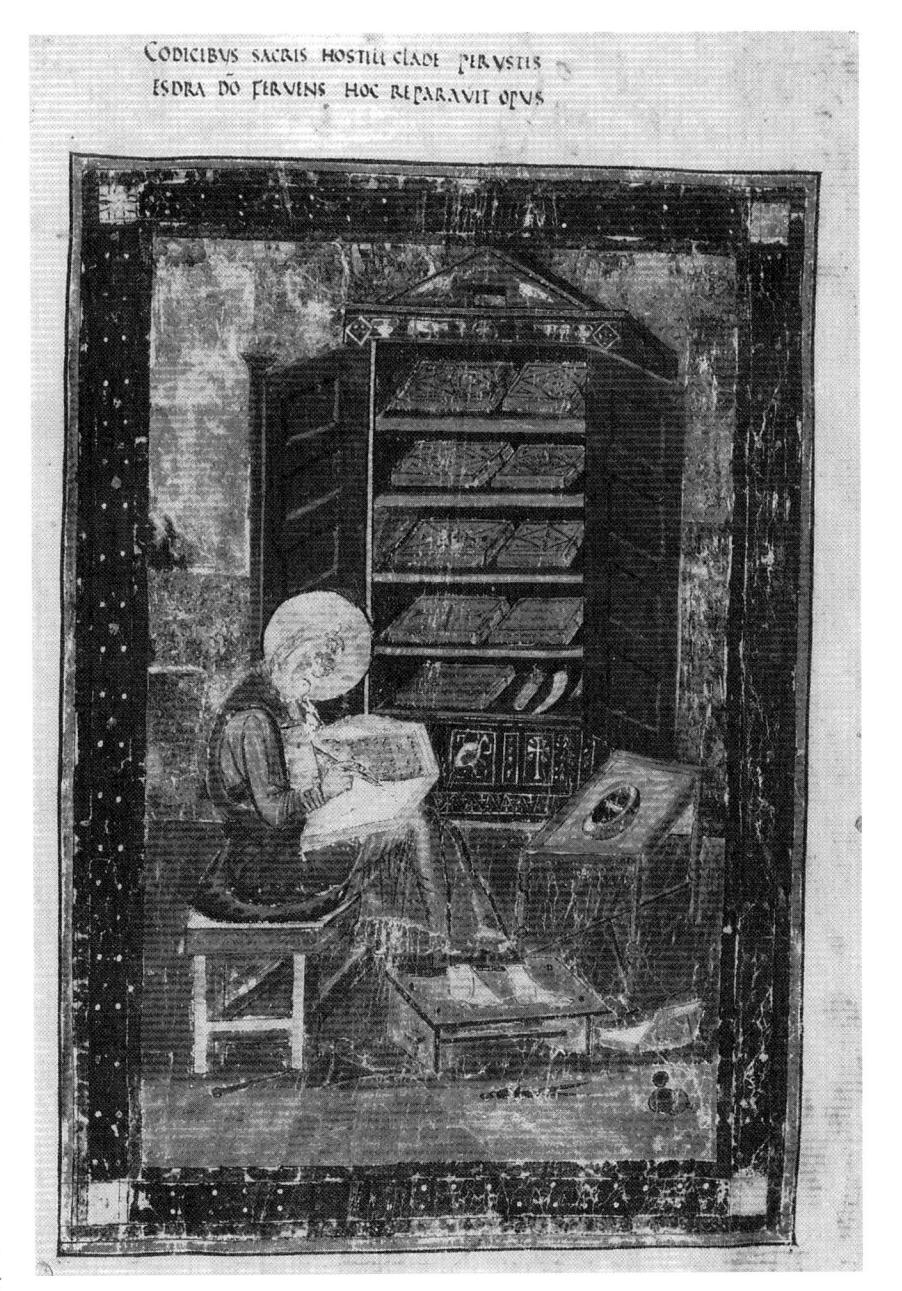

and interlacing legs surround small, white-framed crosses. Since this inner ornament is as dense as the knots of birds and dogs, the cross and the field appear to be a single surface. The artist, in other words, like the Scandinavian and Anglo-Saxon goldsmiths, denied the concept of foreground and background and substituted pure geometry—a method revealed by the still visible ruler lines and compass pinpricks. A series of

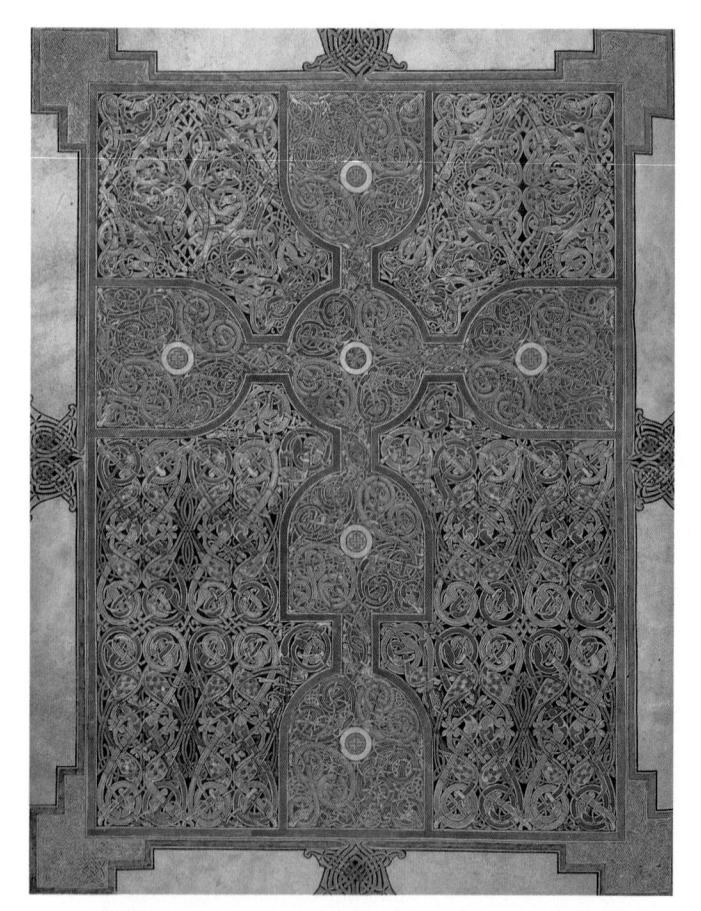

4.29 Carpet page preceding Matthew's gospel. Lindisfarne Gospels. Lindisfarne, early 8th century. The British Library, London.

parallel and diagonal lines and circles orders the layout of the page, and once this underlying logic is perceived, the potentially frantic and wild energy of the elements falls into satisfying rhythms, moving with the precision of clockwork. The Lindisfarne Gospels, the work of a scholarly monk captivated by complex visual abstractions, marks the classic moment of the style, a moment when intellectual control and decorative lavishness are held in perfect balance.

The Book of Kells is larger and even more richly illuminated than the Lindisfarne Gospels. "The chief relic of the Western world," as the Book of Kells was described as early as the eleventh century, was begun by Connachtach, a scribe and the abbot of Iona. When he died in the Viking attacks of 802, the fleeing monks carried the unfinished book to the Irish monastery of Kells, where at least four

other artists and a number of assistants finished it. The Chi Rho monogram is perhaps the most celebrated of the illuminations [4.30]. The three Greek letters, XPI, both represent the sacred monogram of Christ and introduce the text of the Nativity story: "Christi autem generatio" ("Now the birth of Jesus Christ took place in this way."—Matthew 1:18). So elaborate is the ornament that only three words could fit on the page.

The Book of Kells is distinguished by the sheer variety of its design components. The painter subdivided letters into panels filled with interlaced animals, snakes, spirals and knots, then filled the spaces between the letters with equally complex ornamental fields. Despite this profusion of ornament, every line can be traced as a single thread, and the individual parts of every beast are easily discovered. The Kells illuminator also used human figures as shapes in the overall pattern; for exam-

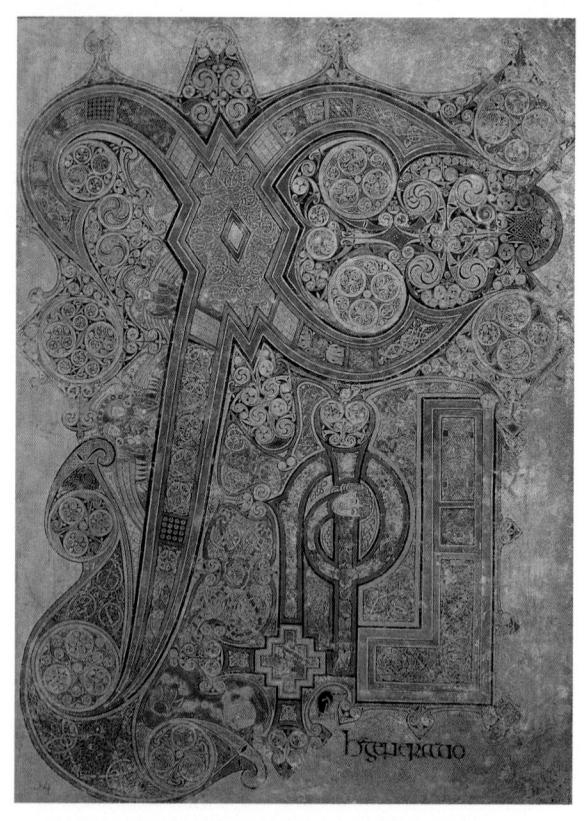

4.30 Monogram of Christ, Book of Kells, Iona and Kells, late 8^{th} or early 9^{th} century. $13 \times 9 \, 1/2$ in. $(33 \times 24.1$ cm). Trinity College Library, Dublin.

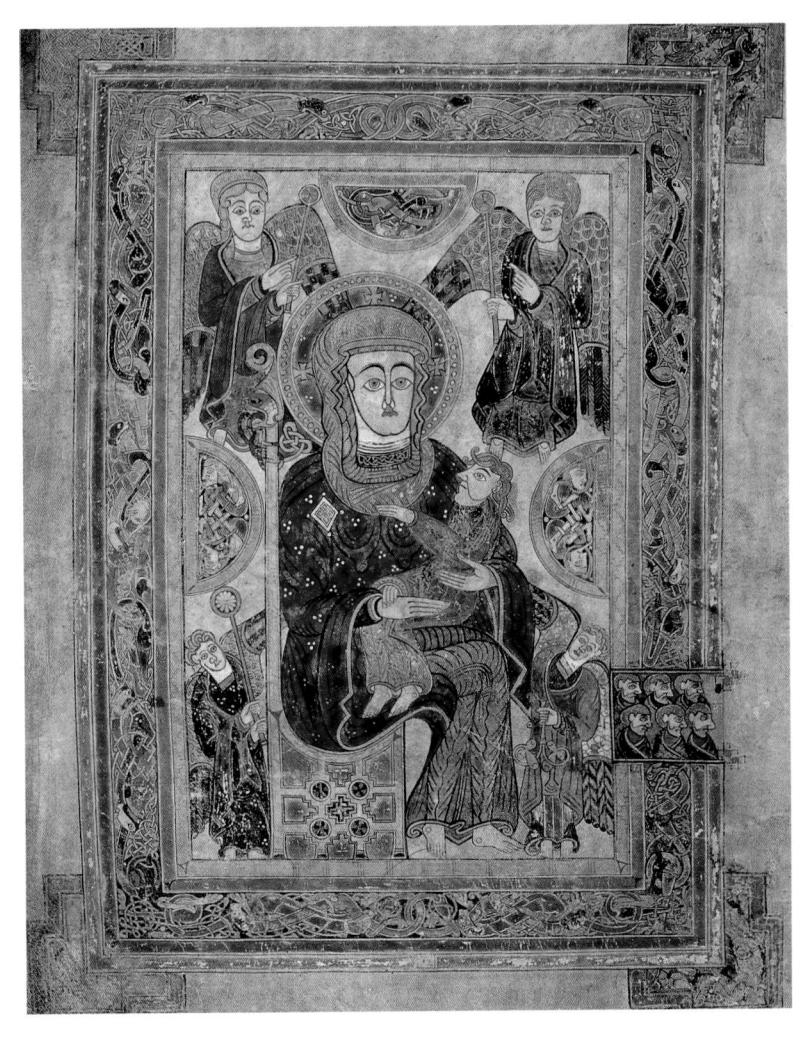

4.31 Virgin and Child. Illustration in the Book of Kells. 13 x 9 1/2in. (33 x 24.1cm). Late 8th or 9th centuries. Trinity College Library, Dublin.

ple, a male head terminates the under curve of the rho and at the same time it "dots" the iota. Angels spring from the downward stroke of the Chi.

In the midst of these abstractions the artist inserted astute pictorial observation and commentary. Near the bottom of the page, just above and to the left of the word "generatio," he painted an otter holding a fish in its jaws. Has this image symbolic meaning, or is it merely observation of the natural world? To the right of the Chi's tail, two cats pounce on a pair of mice as the tiny rodents nibble a Eucharistic wafer. Is this scene an allegory on good and evil with noble cats and demonic rats? Or does it simply record the monastery's cats at work?

The Kells painters may have seen Byzantine icons like the ones Benedict Biscop brought from

Rome, or perhaps they looked at illustrated books. Only Mediterranean models would account for the painting of the Virgin and Child with their broadly draped mantle folds, hieratic immobility, and truly monumental, almost hypnotically impressive, faces [4.31]. The Virgin's inlaid throne suggests the classical world, but it occupies no space and it sprouts interlace and animal heads. The illuminators seem to reaffirm their Celtic ancestry, not merely by an abundance of geometric and animal decoration irrepressibly bursting forth in the border and intruding as half discs on the images, but in the drawing and ambiguous disposition of the figures. They achieve the colorful heraldic character of monarchs in a deck of playing cards.

The Goths, Franks, Norse, Celts, Anglo-Saxons, and others brought to medieval art an abiding preference for dynamic, abstract art. By means of color and line the artists sought to create, or to capture, the energy of forms in motion. The artists' love of light and color in the form of gold and jewels or enamel, the complexity of engraved, painted, or filigree interlaces, the creative representation of imaginary beasts and birds, and the astonishing metamorphoses of geometric patterns into zoomorphic forms gives early medieval art its distinctive character. When these people came into contact with the art of the Greco-Roman Mediterranean world, they adopted individual motifs, including recognizable human figures and occasionally static architectonic compositions. They rejected the Mediterranean

artists' attempts to represent carefully observed surface reality and modeling in light and color. The ancient classical artist sought to bring clarity and stability to nature; the "barbarian" sought to re-create its complexity and shifting diversity.

The rich and varied art of the Celtic and Germanic peoples entered into the mainstream of Western art. The technical virtuosity and fertile imagination of the artists enabled them to produce works of awe-inspiring beauty and vitality. No more fitting summary exists than that of Gerald of Wales (Giraldus Cambrensis), writing in the twelfth-century about a Gospel book with "intricacies, so delicate and subtle, so exact and compact, so full of knots and links, with colours so fresh and vivid, that you might say that all this was the work of an angel, and not of a man."

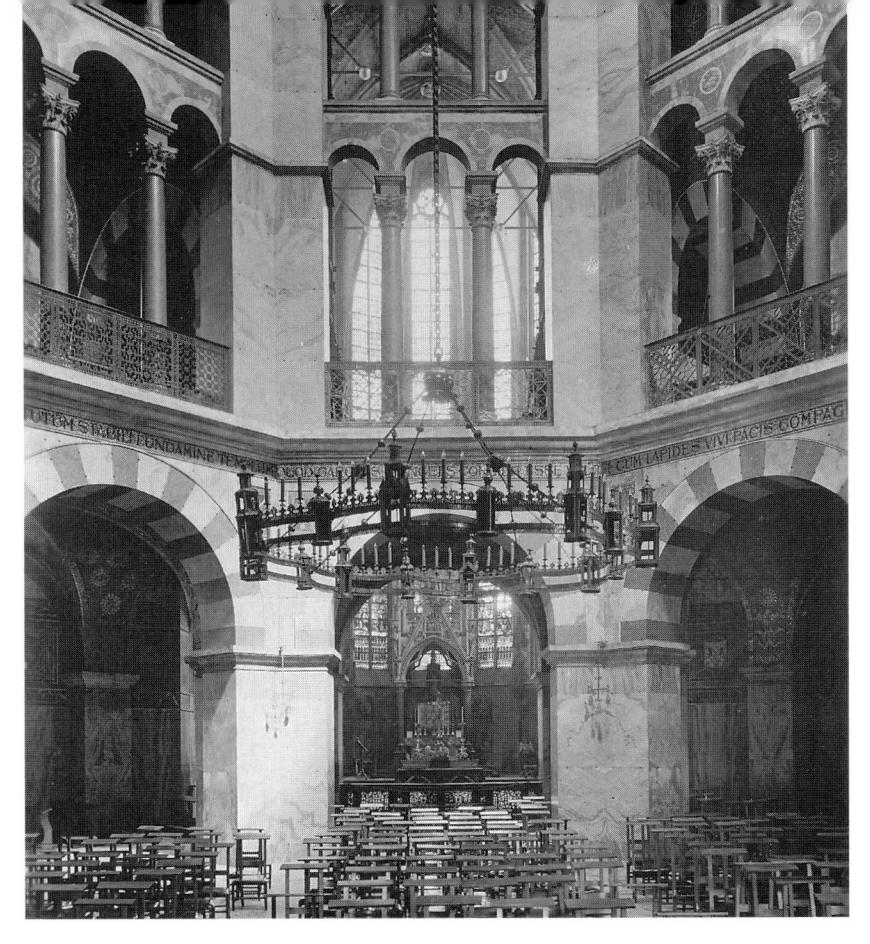

5.1 Palace chapel of Charlemagne, Aachen. View from center of floor up to gallery. c. 790–805.

CHAPTE

CAROLINGIAN ART

In the year 800, at the high altar of St. Peter's basilica in Rome, Pope Leo III crowned the Frankish King Charles as Emperor of the Romans. When Charles the Great, better known as Charlemagne, accepted the crown from the Pope, he assumed the role of heir to the Roman Christian Empire of Constantine. The coronation strengthened both the church and the state. The Pope declared his right to crown the ruler, and he received military assistance in exchange. The new emperor could claim divine sanction for his acts and by this means gain moral superiority over his foes. The new Christian-Roman Empire, however, did not extend over Constantine's vast domain, since the Byzantines ruled the Eastern portion

from Constantinople. Furthermore, Charlemagne, with his interest and authority focused on the lands of the Franks and Langobards (France, western Germany, and northern Italy), moved the political center of western Europe from Rome to Aachen [5.1] in what is now northwest Germany, bordering on the Netherlands and Belgium and not far from the French border. Still, the dream of a unified, all-embracing European empire captured contemporary imagination.

How did a Frankish king, descended from Merovingian warlords, become the emperor of western Europe? Charlemagne's unrivaled position had its roots in the instability of the Merovingian dynasty after the death of Clovis in 511. The successors of that great sixth-century leader, challenged by intriguing, aggressive enemies and further immobilized by their own sloth and incompetence, turned over more and more administrative duties to court officials. Consequently, the official known as the mayor of the palace assumed responsibility for the day-to-day management of the kingdom, its finances, and its army. By the time a man named Pepin rose to the office at 697, the mayor of the palace was the virtual ruler of France, and the office had become a hereditary position. In 717, the succession passed to Pepin's illegitimate son, Charles Martel, called The Hammer (d. 741). Charles not only brought the Merovingian nobility under his sway, but, by defeating the invading Muslim forces at the battle of Tours in 732, he also made western Europe safe for Christianity.

Charles Martel's son, Pepin the Short, overthrew the last of the Merovingians in 751. To obtain sanction for his act, Pepin called upon the Pope, and in return for political assistance Pope Stephen II anointed Pepin as king of the Franks in 754 at the Abbey of St. Denis in France. This act initiated the close association between the Frankish monarchs and Rome and also emphasized the importance of the Abbey of St. Denis. When Pepin died in 768, his sons, Carloman and Charles, divided the kingdom, but Carloman died in 771, leaving Charles—Charlemagne—the sole ruler of the Franks.

Charlemagne (768-814) deserved to be called "the Great." He was exceptionally skilled as a warrior and an administrator, and he proved to be a remarkably intelligent ruler. He gathered around him the most learned people of western Europe, and within a few short years he transformed his court at Aachen into one of the foremost intellectual centers of the Middle Ages. Alcuin of York (c. 730-804), a great Anglo-Saxon scholar, led Charlemagne's educational efforts emphasizing not merely literacy but good grammar, accurate texts, and extensive libraries. Carolingian scribes created a clear readable script based on Roman letter forms, which was used throughout the empire. Paul the Deacon, the historian of the Langobards, came from Italy; Theodulf, a Visigothic theologian and poet from Spain, joined the court circle as bishop of Orleans. Einhard (d. 840), a scholar and artist from Fulda [see 5.4], was a pupil of Alcuin and succeeded his master as the "minister of culture" in Aachen. In his *Life of Charlemagne*, Einhard gives us a vivid description of the Carolingian court. Charles was likened to the Old Testament kings David and Solomon, the patriarch Joseph, and the Roman Caesar.

To cement relations with the papacy, in 789, Charlemagne ordered that the Roman liturgy rather than the native Gallican service be used in all churches-an astute move designed to unify the people through their worship services. Charlemagne also supported a revitalized Benedictine monasticism, promulgated by another former member of the court, St. Benedict of Aniane (d. 821). Charlemagne transformed the Church into an administrative arm of his empire by appointing his children, relatives, and friends to positions of ecclesiastical authority, from which vantage they organized an elite civil service to rule the far-flung territories. Drogo (bishop, the archbishop of Metz), along with Ebbo (bishop of Reims), and Angilbert (a son-in-law and lay abbot of Centula) carried the culture of the court throughout the empire.

Side by side with the ecclesiastical administration was the equally well-organized secular government. Charlemagne established a unified monetary system for the empire, the silver penny. He laid the foundations for the medieval state by formalizing the ancient barbarian tradition of loyalties and oaths. He divided the empire into counties, ruled by loyal officials, the counts, who had followers of their own. Such a system created a ready supply of soldiers for the emperor's military campaigns. The booty from these campaigns gave the victors the enormous wealth needed to support their building programs and patronage of the arts. Charlemagne personally led at least 53 expeditions, and because he always fought in the name of Christianity, it can be said that he, like Constantine before him, used religion to enhance his political goals.

Following his father's precedent, Charlemagne defended Rome against the Langobards and finally destroyed their kingdom in 774. He waged successful wars against the pagan Saxons in northeastern Germany and the nomadic Avars from the

The Value of Art

St. Gregory the Great (Pope, 590-604), writing to the iconoclastic Bishop Serenus of Marseille, argued that images had an educational value in the church as long as they were used to "instruct the minds of the ignorant" and not adored for their own sake. He wrote, "To adore images is one thing: to teach with their help what should be adored is another. What Scripture is to the educated, images are to the ignorant, who see through them what they must accept; they read in them what they cannot read in books." (Epistle 13, translated by Davis-Weyer, Early Medieval Art, 300-1150) The Pope's letter was often quoted in the arguments over the value of art.

The debate over the presence of images in the church broke out anew in the ninth century at the end of the iconoclastic controversy. In response to what the Carolingians learned about the position of the Eastern Church, Bishop Theodulf of Orleans, as spokesman for Charlemagne's court, wrote a lengthy and impassioned reply—"The Carolingian Books" (Libri Carolini). Theodulf distinguished between things made by God, such as the relics of saints, and things made by artists, which were not in themselves holy. Those who made images were craftsmen who learned their trade like anyone else. Art had its principal use as an educational tool in the church and its value depended on the quality of materials and workmanship. Both images and words could tell stories, but the image remained inferior to the word. This point of view represents a common attitude toward art and artists during the Middle Ages.

Hungarian plain (and incidentally acquiring an enormous amount of gold and silver). Around the borders of his realm Charlemagne established special frontier districts known as the Marches (German: Mark, boundary district) governed by powerful warriors. The most famous was the Spanish March. Here Charlemagne, accompanied by his vassal Count Roland of Brittany, fought against the Moors (as Muslims in Spain were called). The death of Count Roland during the massacre of the emperor's rear guard in 778 provided the inspiration for the later epic poem, The Song of Roland. In this masterpiece of French medieval literature, Charlemagne and his knights exemplify the heroic ideal of Christian chivalry.

Charlemagne's seal read "renovatio Romani imperii" (the revival of the Roman Empire). Whatever the political and religious ramifications of the Frankish dream, it also generated a respect for classical art and learning in its Early Christian guise to such an extent that the period is often referred to as the Carolingian Renaissance.

CAROLINGIAN ARCHITECTURE

During the last 20 years of his reign, from about 794, Charlemagne maintained a fixed capital at Aachen. Not only did the city have a geographically advantageous location, it also boasted vast game preserves and natural hot springs, where the emperor could indulge his fondness for riding, hunting, and swimming. Consequently, although he had other residences, it was at Aachen that Charlemagne built a palace complex with a judicial hall and chapel for the imperial court. As models for this endeavor the emperor turned to the imperial cities he knew—Rome and Ravenna.

Charlemagne's architects, led by Odo of Metz, designed the Aachen complex on a classical grid plan, typical of Roman frontier towns [5.2] and [5.3]. Buildings housing the law court, the guards' barracks, and the administrative offices were crossed by two major axes, one running east-west and the other extending from north to south, with a monumental gateway at the point of intersection. The gateway opened into a large forum in the center of which Charlemagne placed an equestrian statue of Theodoric the Great (see Chapter 4), which he brought from Ravenna. Dominating the Aachen complex were Charlemagne's palace chapel on one side of the forum and his residence and audience hall on the other. The audience hall was a large, two-story structure with apses on three sides and a stair tower on the fourth. The imperial re-

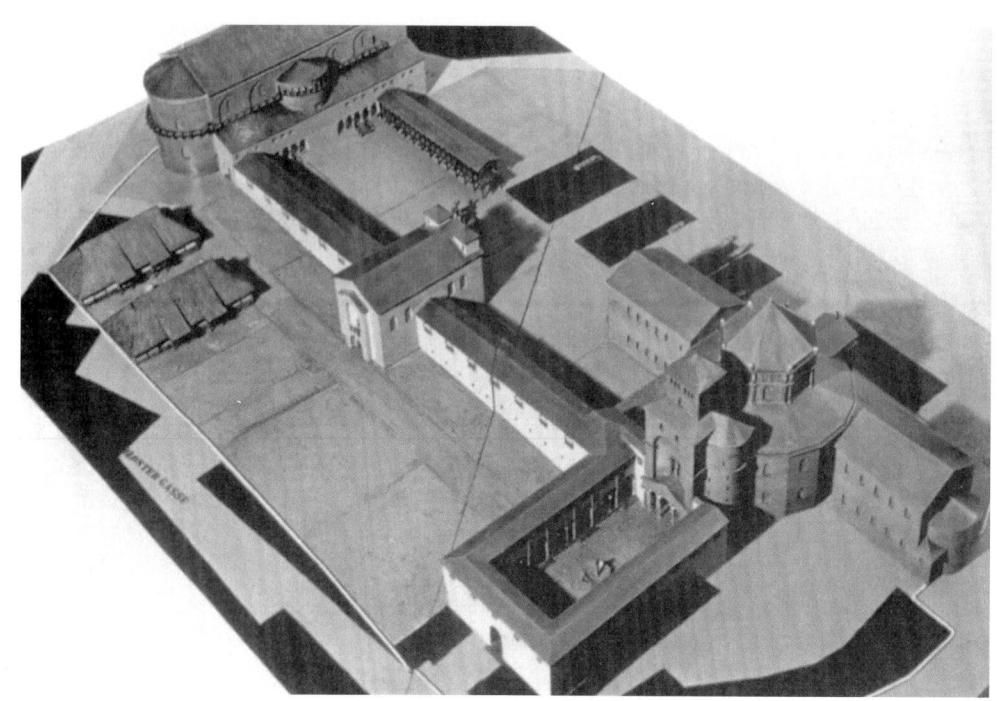

5.2 Aachen, palace and chapel, 789-808: model of complex chapel with westwork and atrium, lower right.

ception chamber was on the second floor. A contemporary description tells that it was hung with colored pictured fabrics. From the hall, Charlemagne could proceed directly to the palace chapel by means of a covered, two-storied portico that formed the main north-south avenue.

The construction of the Palatine or Palace Chapel began about 792, shortly after Pope Hadrian I granted Charlemagne permission to take materials from ancient buildings in Rome and Ravenna. The building was completed by 805, when Pope Leo III consecrated the church to the Savior and the Virgin. An atrium surrounded by porticoes, large enough to contain 7,000 people, preceded the entrance to the chapel. This entryway is a special Carolingian structure, formed out of a public portal on the ground floor and a private room (later used as a throne room) and a reliquary chapel above. From the gallery the emperor could participate in the religious services in the chapel or perhaps make official appearances from an exterior balcony to the crowds in the atrium below, just as his imperial predecessors in Rome and Byzantium had done. With the three sections joined by flanking cylindrical stair towers, the Aachen entrance

tower became the prototype for an architectural feature known as the westwork.

The chapel proper was a 16-sided structure having an octagon as the interior core [5.3]—a centralized conception that admirably fulfilled the building's symbolic and practical functions as a royal house of worship, a martyrium church for Charlemagne's collection of relics, a parish church for members of the court, and, finally, the imperial mausoleum. In designing the Aachen chapel on a central plan, Odo of Metz surely recalled Roman and Byzantine imperial mausolea such as Sta. Costanza in Rome as well as buildings like Constantine's Golden Octagon in Antioch and Justinian's Church of S. Vitale in Ravenna. Even so, the traditional association between the earlier churches and the Carolingian chapel should not be overstated, for the severe and massive forms of the Palatine Chapel at Aachen are a far cry from the complex shapes and flowing spaces of buildings like S. Vitale.

The most distinctive features of the imperial chapel at Aachen—and the building's greatest contribution to the emerging architectural aesthetic of western Europe—are its emphatic verticality and

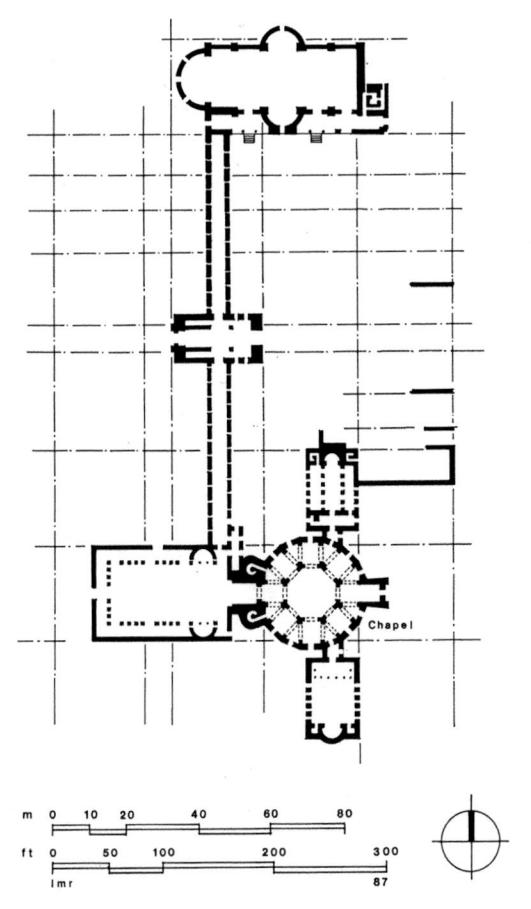

5.3 Aachen, the Palace, and the Palatine Chapel, 792-805. Plan.

its clear definition of the component parts. At ground level the portal opens into an ambulatory divided into alternating rectangular and triangular bays ingeniously designed to fit into the spaces created by the inner octagon and the outer wall. In the second story, the room in the entrance tower leads into a gallery that, like the ambulatory below, leads around the octagon to the sanctuary at the chapel's opposite side. The gallery, too, is articulated by bays of even more precise rectangular and triangular shapes, each bay being separated from the next by a diaphragm arch—that is, a transverse arch carrying a thin upper wall that supports the roof. The core of the chapel receives its octagonal form from eight massive piers and eight plain, wide arches. Above a molding defining this lower story these same masonry piers soar up to support high arches forming the base of the cupola. By thus doubling the height of the gallery arches, the builders generated a powerful vertical pull at the center of the chapel, a rising sensation that once culminated in a mosaic that represented Christ and the 24 elders of the Apocalypse. (The mosaic decorations in the Palatine Chapel, along with many of the moldings and arches, underwent extensive restoration after the church became a cathedral in 1821.) The dome is not a hemisphere on pendentives, as in Byzantine architecture, but rather it is a cloister vault—a construction that results in a cupola of eight segments precisely echoing the octagonal shape of the chapel's core.

The architects respected the eight-sided character of the inner core and reaffirmed the octagon's function as a structural support. Unlike Eastern buildings, such as S. Vitale or Hagia Sophia, where the central zone seems to expand into the curving space of half-domes and conches, the Carolingian church is enclosed by flat walls. The ground floor at Aachen is articulated not by elegant columns, as at S. Vitale, but by heavy piers, each angled to mark off a facet of the octagon. A sharply projecting cornice between the upper and lower stories and richly worked bronze railings forming barricades at the gallery level and the lintels above the gallery arcade further accentuate the idea of walls. The columns within the tall upper arches, which lend so much verticality to the church, also screen the opening and thereby add to the mural effect. By means of such devices, Charlemagne's builders rejected the open, flowing unity of Byzantine church designs and chose instead to define each architectural unit in terms of its inherent structural character.

When a basilican church was to be built, naturally the architects turned to Italy. In the Abbey Church of Fulda, built to house the relics of St. Boniface, apostle to the Germans, the builders adopted special features of St. Peter's Church in Rome with unusual fidelity [5.4]. St. Boniface himself had supervised the building of the original Fulda church between 744 and 751. Dedicated to the Savior, this church was a simple rectangular structure, terminating in an eastern apse. In the

790s, a campaign to enlarge the building resulted in an aisled basilica, again with an apse and crypt for the saint's remains at the eastern end. In 802 Abbot Ratger (802-817) evidently decided that the relics of St. Boniface should have as splendid a setting as the tomb of St. Peter's in Rome. The building was to be as nearly identical to the Constantinian church as differing construction methods, the influence of local style, and the already existent basilica would allow. Abbot Ratger's men added a western transept and apse in order to duplicate St. Peter's tau-cross plan and orientation. The abbot even requested that the dimensions of St. Peter's be sent from Rome, with the result that, when completed, the Abbey Church of Fulda was the largest of all northern churches. Three years after the Fulda abbey church was consecrated in 819, monks, again following the model of St. Peter's, built a new cloister on the east instead of the south side. This atrium, however, fronted the earlier semicircular apse, because they had left the eastern apse of the original church untouched. (The church no longer exists, since it was rebuilt at the beginning of the eighteenth century.)

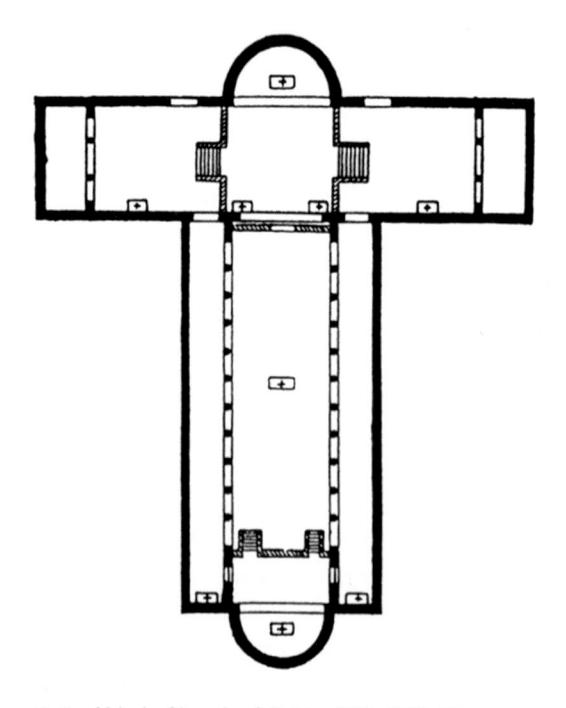

5.4 Abbely Church of Fulda, 802-819. Plan.

Buildings such as the Abbey Church of Fulda demonstrate that Carolingian planners never produced slavish copies of Constantinian monuments, even when they claimed to be doing so. Consequently, it is more accurate to describe the Carolingian revival of Early Christian architecture as a reinterpretation of the older forms—a reinterpretation that integrated classical designs with the northern requirements and so laid the foundation for later medieval structures.

The originality of Charlemagne's architects stands out most clearly in those churches that were not designed as overt imitations of Roman buildings. The Abbey of St.-Riquier at Centula in northern France attests to the inventive character of Carolingian architecture [5.5]. Built by Angilbert, its lay abbot, between about 790 and 799, Centula illustrates the Carolingian builders' interest in geometric planning. Excavations reveal that a cloister joined three churches in a roughly triangular layout. Perhaps this three-sided figure gave visual presence to the three-part, indivisible Trinity to which the monastery was dedicated. Carolingian architects seem to combine their ancestors' delight in geometric designs with the Christian interpretation of architecture as symbolic form—an interpretation already encountered in cross-plan churches and eight-sided baptisteries. The church consecrated to the Virgin and the Apostles also demonstrates the architects' concern for symbolism. Modern excavations have shown that this chapel was a 12-sided structure, surrounded by an aisle that housed 12 altars—one for each of the apostles.

St. Riquier, the major church at Centula, illustrates an innovative Carolingian church design that was to have a long life in Germanic countries. The silhouette of St. Riquier was remarkable for the verticality produced by the tall crossing towers (towers over the juncture of transept and nave) with flanking stair turrets rising from both the eastern and western ends. The towers were composed of round or square drums (the evidence is not clear) supporting three stages of open arcades surmounted by spires. These structures must have been built of timber, perhaps around a central mast. The desire for soaring heights seems to have far outweighed

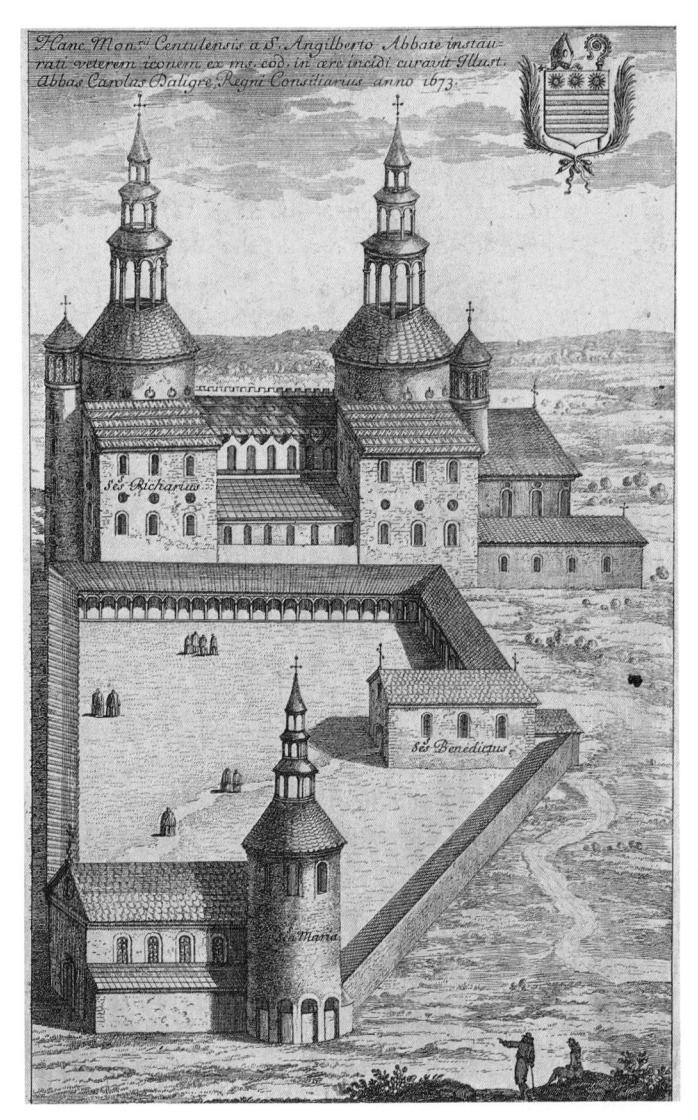

5.5 Abbey Church of St. Riquier, Monastery of Centula, France, dedicated in 799. Engraving, dated 1612, copy of an 11th century drawing.

the need for the kind of permanence afforded by masonry construction. St. Riquier was essentially a timber-roofed basilica with an eastern transept and apse in the Early Christian manner to which a second transverse hall and towers were added at the west. The final building double ended and symmetrically balanced east and west.

The western complex, called a "tower" by the Carolingians, is now known as a "westwork." The westwork was a monumental entrance complex with an upper chapel designed to create additional

space for altars or a choir. It could have a private room for emperor or king, as we have seen at Aachen. Westworks served as reliquary chapels and even as independent parish churches for laymen when the church served a monastic community. Although precedents for the westwork exist in other Carolingian churches, St. Riquier provides the first fully developed example of what was to become a characteristic element in medieval German architecture. Towers and westworks mark a building as important.

Chapels in Carolingian westworks could not house the growing number of relics arriving in France and Germany. In gratitude to Pepin and Charlemagne, the popes had allowed Frankish churchmen to extract relics from Roman catacombs for their own churches. Altars dedicated to the martyrs began to fill the naves as well as the chapels of Carolingian churches. When pilgrims began to visit the shrines, new interior arrangements were required to create additional space. At the same time, in order to accommodate an increasingly large clergy, architects found it necessary to expand the overall size of the sanctuary. Inspired by the early Christian martyrs' churches in Rome, builders found a way to provide for both the relics and the people who came to venerate them. Underneath the sanctuary they built substructures, or crypts, accessible from the main level of the church. Because crypts had to support the weight of the church above, the builders relied on Roman masonry con-

struction techniques of groin and barrel vaults.

The Carolingian monastery, however, was far more than a pilgrimage station. It was designed to be a religious center where people sworn to obedience and poverty lived in a self-sufficient community according to the rule of St. Benedict and worshipped together in a regular sequence of church services, the Divine Office. Just as services in the church formed the heart of the community's spiritual life, so the cloister and scriptorium, where the monks and nuns studied and created books, became the nucleus of its

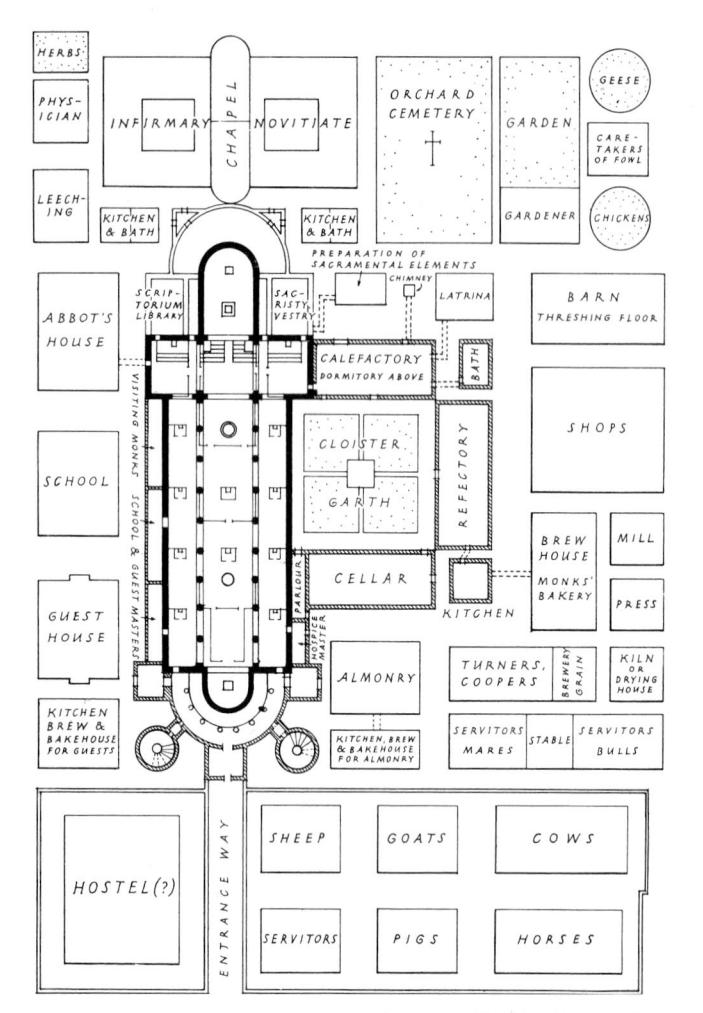

material and intellectual activities. The Monastery of St. Gall, Switzerland, preserves in its library the plan for an ideal monastery [5.6], probably made by Abbot Haito of Reichenau. The plan was sent to Abbot Gozbert of St. Gall (816–830), who was planning to rebuild his monastery.

The St. Gall plan reflects the orderly planning already noted in Aachen [5.7]. A church on the axis, flanked on one side by administrative buildings—the abbot's residence, the school, the hospice for distinguished guests—and on the other side by the open, arcaded cloister and the monks' lodgings, formed the architectural and spiritual core of the complex. The church had places for 112 monks. Off the cloister, the dormitory had 77 beds (but only nine seats are indicated in the adjoining latrine!). Six visitors could be accommodated with beds and seats in the refectory. The monks entered the church from the cloister or from the dormitory by means of stairs directly into the choir. They ate in the refectory and wrote or copied books in the scriptorium. The planners surrounded this inner core with auxiliary structures: kitchen, bakery, brew house, baths and latrines, shops, stables, barns, gardens, and living quarters for lay brothers. The novitiate and the infirmary, separated by an oblong chapel, lay just east of the main church and immediately north of the cemetery.

5.6 Plan for an ideal monastery, early 9th century. Simplified drawing of original plan on parchment. Monastery Library of St. Gall, Switzerland.

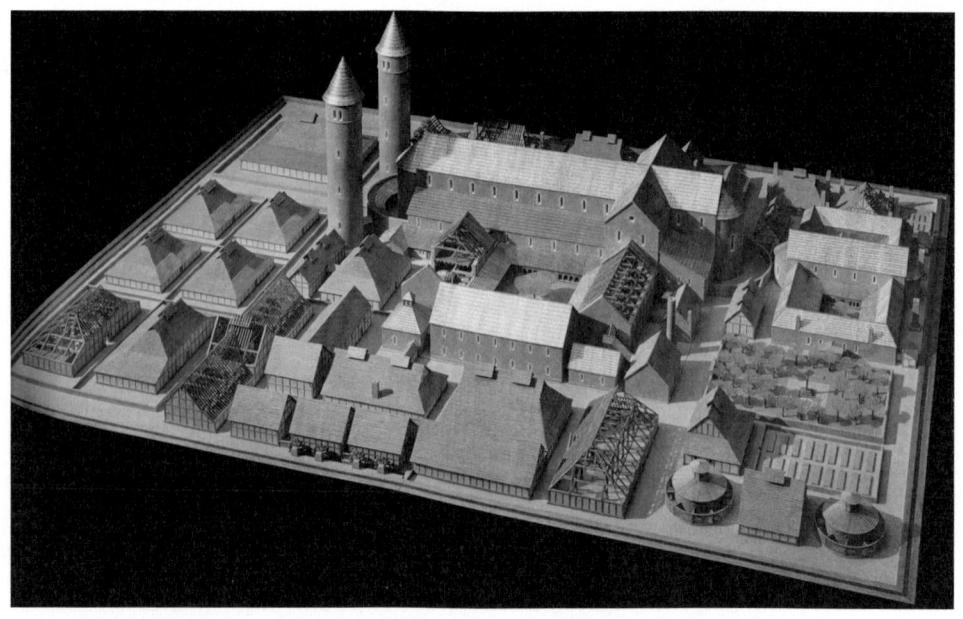

5.7 Hypothetical reconstruction of the ideal monastery for Saint Gall.

The ideal church itself was an aisled basilica with an eastern transept and an apse at both the east and west. This doubling of apses, first seen at Fulda, provided space for additional altars. A crypt lay under the eastern apse to accommodate relics, and more altars filled the nave and aisles. The western apse made an impressive western entrance impractical, and except at the times of great processions, doors from the cloister or living quarters were used by the monks. The St. Gall plan is logical and functional from the point of view of its intended users, the monks whose lives revolved around the church and cloister. The buildings peripheral to the needs of the community are located farthest from the cloister, and the dwellings of the many serfs who would be needed to till the surrounding fields are not represented in the plan at all. Visitors approaching the monastery would be confronted by pigsties, sheep pens, and stables, not by a monumental church. A pair of slender cylindrical towers flanking the western apse indicated the location of the church for the community.

Carolingian architects probably used surveying techniques based on a geometric conception of architecture inherited from antiquity. The St. Gall plan was organized according to a grid sys-

tem, and the dimensions of the building can be calculated by means of circles, squares, and equilateral triangles. It seems that the St. Gall plan represents an ideal. If actual builders had or used plans, none have survived. The builders laid out plans on the ground using ropes and pegs, and lacked a standard system of measurement. How this worked in practice is still subject to lively scholarly debate.

CAROLINGIAN PAINTING AND SCULPTURE

What little survives of the extensive monumental painting and mosaic cycles executed during the Carolingian period suggests that architectural decoration—like the buildings—had an underlying geometric design. The frescoes in the Chapel of St. Stephen in the crypt of the Church of St. Germain, Auxerre, attest to the Carolingian preference for geometric schemes. One of the lunette frescoes, for example, depicts the martyrdom of St. Stephen, who was stoned to death at the gates of Jerusalem [5.8]. At first sight the painting seems loosely ordered and executed with free, vigorous brushwork, inspired perhaps by Roman Christian

The Stoning of St. Stephen, crypt at St. Germain, Auxerre, mid-9th century.

narrative and decorative art. Closer observation reveals that the artist used a square grid, turned at 45 degrees, to establish the position of the key elements in the composition. This grid determines the position of the figures, the city, the drapery folds, and even the hand of God emerging from the clouds at the right. The out-flung arms of Stephen and his attackers fall along the same diagonal, and this line is laid at a precise right angle to the Lord's extended hand. The two intersecting perpendiculars are echoed in the receding planes of the cityscape at the left. The painting has been subject to the same intellectual control as the palace complex at Aachen or the St. Gall plan.

The clearest picture of the Carolingian "renaissance" emerges not from the monumental arts but from a study of manuscripts, ivory carving, and other "cloister crafts." The production of books had an essential place in both the self-conscious revival of learning and the missionaries' propagation of the Christian faith. Charlemagne's educational program required that texts be correct, uniform and legible. Many scholars believe that the development of a new script, the Carolingian minuscule, is the Carolingian's most significant and lasting achievement. To illustrate and decorate the books, painters turned for inspiration to the illusionism of Rome and Byzantium, as well as to intricate abstract art of Germanic and Celtic northern Europe. The ensuing cross-fertilization, with all its local variations, created a fascinating new style.

The first in a group of books executed for the court is a manuscript written between 781 and 783 by the scribe Godescalc to commemorate the baptism of Charlemagne and Queen Hildegard's son Pepin in Rome. Although usually called the Godescalc Gospels, the text in fact is a lectionary—that is, selections, or pericopes, from the Gospels designed to be read at Mass through the liturgical year. Godescalc, following the custom of Early Christian and Byzantine imperial manuscripts, rendered the letters of the texts in gold against a purple vellum ground. The book also has full-page illustrations, probably by a painter rather than the scribe. Given the revival of classical art urged by Charlemagne, it is interesting to see how

the painter tried to reconcile the balance, symmetry, and naturalism of antique forms with the energetic complexity and geometric abstractions traditionally preferred by Germanic and Celtic artists. In the resolution of the conflict between spatial illusionism and surface design, between three-dimensional modeling and linearism, the Godescalc Gospels mark an early stage in Carolingian painting. Hence, despite the obvious presence of Italian and Byzantine prototypes, characteristics of the indigenous northern manner still dominate.

The youthful Christ recalls the figure of the Virgin in the Mount Sinai icon [see 3.29], particularly in the attenuated proportions of the body, the round face, and large eyes [5.9]. Straight edges and compass-drawn lines underlie the composition, as they did in the Hiberno-Saxon school. Horizontal lines drawn across the entire surface, although primarily to aid the scribe, become fixed guides for the painter's drawing of the throne, footstool, and brick wall. Moreover, Christ's cloak falls downward

5.9 Christ Enthroned. Illustration in the Gospels (Lectionary) of Godescalc. 781–783. 12 5/8 x 8 1/4in. (32.1 x 21cm). Bibliothèque nationale, Paris.

from his left arm in a perfect vertical, the shadows of the cascading folds fanning out in an array of meaningless lines. Such abstract features as these, along with the division of the background into contrasting colored bands, visually ally the inner composition with the scroll and interlace border, thereby reducing the image to two dimensions.

Where the text did not demand the inclusion of human forms, the Godescalc artist rejoiced in the display of decorative patterns. The Fountain of Life [5.10] recalls Early Christian images of the Fountain of Life or the Holy Sepulchre. The arched curve of the roof line reflects a distant illusionistic source, but the columns and the capitals of the little temple are merely elongated rectangles filled with local color and ornamental motifs. The horizontal guides are connected by short diagonals, which transform the implicit spatial recession into an abstract zigzag. In addition, the painter has rendered in strict profile almost all the birds and animals inhabiting the leafy branches indicating landscape, and has disposed them one above the other.

On another level, however, the Fountain of Life page is as symbolic as it is abstract. The fountain's eight columns suggest an octagonal structure, and therefore a baptistery font. Surely the artist intended a reference to Pepin's recent baptism in Rome, a ritual enacted in the Lateran Baptistery the very place where, according to legend, Constantine had been received into the Church. Beyond this significant association with Early Christian Rome, the paradisiacal setting of birds and plants elevates the fountain as the source of the four rivers of paradise, which are in turn equated with the four Gospels. The stag becomes humanity thirsting for salvation (Psalm 42); the peacocks are symbols of immortality. Ultimately, the painting stands as a metaphor for eternal life.

After the completion of the Godescalc Gospels, the imperial style matured rapidly. A Gospel book written for an otherwise unknown woman called "Ada the handmaiden of God" contains superb figure painting [5.11]. In an author portrait at the beginning of his Gospel, St. Mark is enthroned in an architectural setting. The evangelist flings his arms

5.10 Fountain of Life, Godescalc Gospels. Bibliothèque nationale, Paris.

out to display the Gospel in one outstretched hand while he dips the pen held in the other hand. His symbolic lion displays a scroll in the lunette above. Sprays of drapery, which constitute the saint's cloak and tunic and cover his throne, end in angular edges that meander in a jagged pattern over his torso and legs. So dynamic is the artist's conception of volumes in space that we imagine the feline heads decorating the throne as attached to bodies crouched to leap. To this animated field with its brilliant color, the architecture contributes a realistic foil. The columns, capitals, and pedestal seem reasonably functional and suggest a background distinct from the throne. The arched frame forms a theatrical proscenium arch through which we as spectators look into a dramatic presentation. Such a sumptuous manuscript recalls the splendor of Charlemagne's court.

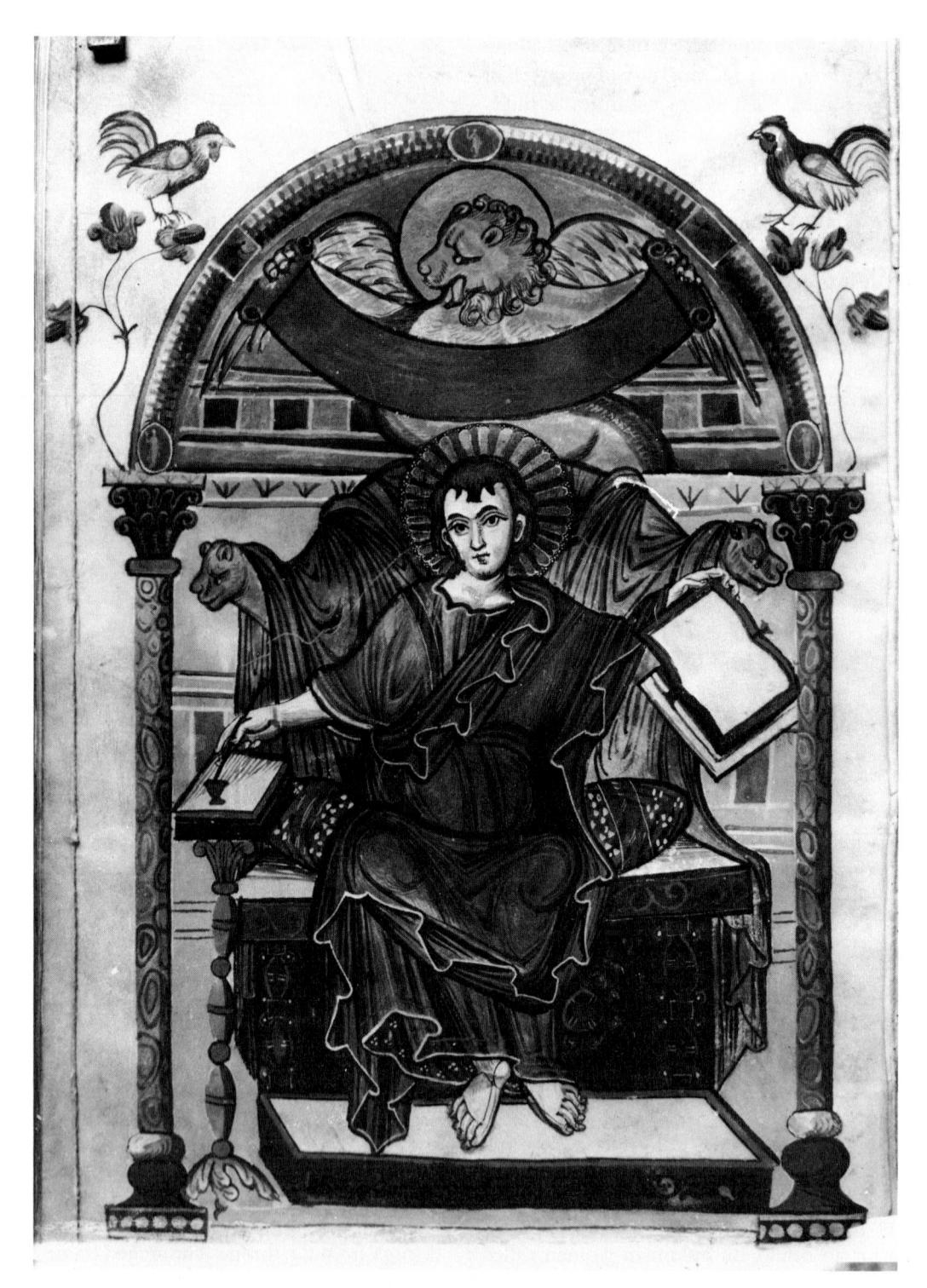

5.11 St. Mark, Ada Gospels, Palace School, Aachen, c. 800. 14 1/2 x 9 5/8in. (36.8 x 24.4cm). Stadtbibliothek, Trier.

5.12 St. John, Coronation Gospels, Palace School, Aachen, early 9th century. Purple vellum, 12 3/4 x 9 7/8in. (32.3 x 25cm). Kunsthistorisches Museum, Vienna.

When Alcuin retired to Tours in 796, Charlemagne's biographer, Einhard, became chief of the palace scriptorium. Under Einhard, Carolingian artists rediscovered the illusionistic painting of imperial Rome as it had been preserved by the Byzantines. Indeed, one or more Greek illuminators may actually have come to Aachen to work. The Greek name "Demetrius Presbyter" appears on the first page of the Gospel of Luke in the Coronation Gospels [5.12]. What part he played in the execution of the manuscript is not known, but the inscription does document the presence of a Greek at the court.

The extraordinary new style that developed out of the revival of ancient Roman art, no less than from the assistance of Eastern-trained artists, is nowhere more striking than in these Coronation Gospels. (When Emperor Otto III opened Charlemagne's tomb, in the year 1000, he found the

Gospel book on his predecessor's knees, and he took it for himself. Thereafter German emperors swore their coronation oaths on this book). Written in gold on purple vellum, the book is dated late in the eighth century or at least before Charlemagne's death in 814. The painter has created portraits of the Evangelists that rival the illusionistic painting of ancient Rome. St. John, a fullbodied, white-robed figure, is seated on a crimsoncushioned golden throne isolated against a hilly landscape. This concentration of solid human forms in an impressionistic landscape suggests antique illusionism. The artist achieved the effect of chiaroscuro modeling by building up forms with a thick application of paint (some of which has flaked off over the centuries). One need only compare the Coronation Gospels' St. John to St. Mark in the Ada Gospels to see the increase in substance and monumentality of the figures. A second comparison, with such Byzantine works as the Rabbula Gospels, reveals the Carolingian painter's source for the lush forest and pale blue sky behind St. John's throne [see 3.27, 3.28]. The wide golden frame is yet another classicizing element, for by creating a picture-window view, it enhances the illusionistic quality of the painting. Nevertheless, the footstool in reverse perspective projects out over the frame into the spectator's space, in accord with Byzantine aesthetic theory.

With Byzantine painting playing such a vital role in manuscript illumination, it is not surprising to find that ivory carving also fell under the influence of Byzantine art. When a Carolingian artist carved ivory reliefs for the cover of a Gospel book at the Abbey of Lorsch, about 810, he must have seen some ivories from Justinian's court [5.13]. (So well did Charlemagne's artists understand their models that this Carolingian book cover was once identified as sixth-century Byzantine work.) The Lorsch cover consists of five panels: the enthroned Virgin and Child, flanked by Zacharias and St. John the Baptist, in the center; a medallion held by hovering angels in the upper section; and the birth of Christ and Annunciation to the Shepherds in the lower panel. The architectural setting of the full-length figures recalls the Byzantine Archangel Michael ivory [see 3.23].

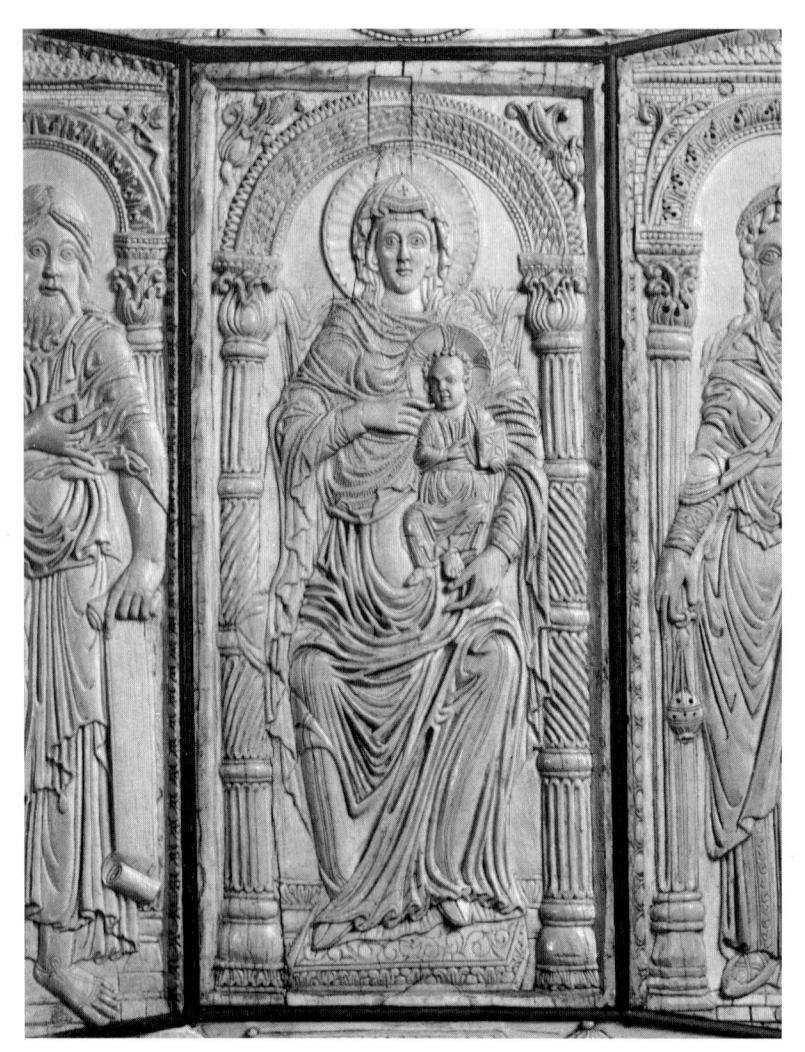

5.13 Virgin and Child with John the Baptist and Zacharias. Book cover of the Lorsch Gospels (back). Nativity and annunciation to the shepherds below. Ivory, 14 7/8 x 10 3/4in. (37.8 x 27.3cm). C. 810. Victoria and Albert Museum, London.

The sculptor of the Lorsch book cover, like the painter of the Ada Gospels, exploited the twodimensional decorative possibilities of line rather than its form-defining function. Although the architectural setting is convincingly rendered, the figures themselves occupy little tangible space. Their corporeal substance is denied by rich ornamental drapery patterns. Looped and hooked folds suggest the roundness of shoulders, thighs, belly, and breasts, but lower legs are hidden by an array of straight sharp lines. The figures seem to disappear behind these linear patterns. The sculptor must have worked from a

model having measurable volumes; however, his attempt to express these volumes by linear means has resulted in a markedly different style. The true classical style, even as translated by the Byzantines, always eluded Charlemagne's artists.

LATER CAROLINGIAN ART

The Carolingian Empire did not last long after the death of the man whose vision created it. Trouble began almost at once, during the reign of the new emperor, Louis the Pious (ruled 814-840), called "pious" because of his interest in the development of monasteries as the spiritual, artistic, and intellectual centers of Carolingian life. Louis had little political or military ability, however, and he could not control his sons, who attempted to secure for themselves as rich a portion of their father's lands as possible. When Louis died, Lothair I inherited the title of emperor, along with the middle section of the empire from the North Sea through Italy. The two younger heirs, Louis the German and Charles the Bald, received, respectively, the eastern and western parts (modern Germany and France). Even if the brothers had lived in peace with each other, Charlemagne's dream of imperial unity was a hopeless cause. The Treaty of Verdun in 843 confirmed the tripartite organization of the empire.

Territorial wars continued until the map of Europe became a jigsaw puzzle of small, interlocking holdings. The moral authority of the Church also suffered under these anarchical conditions. In 882 assassins struck down the Pope himself. So precarious was the political climate that at the end of the century six different popes reigned within a twoyear period.

Adding to the misery of civil wars and the lack of spiritual leadership, the aging Carolingian Empire was threatened from the outside. In the late eighth century the Vikings began their expedi-

tions around Europe. By 881 the Norsemen had destroyed Angilbert's monastery at Centula. Eight years later they leveled Alcuin's abbey at Tours, and in 885-886 they attacked Paris, lifting the siege only when Charles the Fat paid an enormous tribute. As if these incursions from the north were not enough, the Muslims invaded Sicily and then raided the Italian peninsula. They destroyed the famous Benedictine monastery at Monte Cassino in 884 and even attacked Rome. At the close of the ninth century, the savage Magyars swept across Europe from the east and plundered northern Italy. Today we recognize that the Vikings, Muslims, and Magyars had splendid cultural and artistic traditions of their own, but to contemporaries this "dark age" of western Europe seemed terrible indeed. To understand what happened to the Carolingian dynasty, one need only look at the titles of its successive rulers, for such laudatory epithets as Charles the Hammer, Charles the Great, and Louis the Pious gave way in the ninth century to less than flattering nicknames. It is surely a sign of the empire's debilitated state that among the last of the Carolingian monarchs were kings called Charles the Fat, Louis the Stammerer, and Charles the Simple.

When the warring and harassed kingdoms ceased to function, Carolingian art was doomed. It had been a product of imperial patronage and the taste of an educated elite. Nonetheless, for another 50 years, throughout the ninth century, masterpieces continued to be produced. During the reign of Louis the Pious, Reims under Archbishop Ebbo and Metz under Archbishop Drogo, as well as St. Martin's Monastery at Tours, dominated cultural productivity. All three continued on after the Treaty of Verdun-Metz in the kingdom of Lothair, Reims and Tours in that of Charles the Bald. In addition, Charles may have founded a workshop, at the Abbey of St. Denis, where he was titular lay abbot. Since the arts continued to rely on imperial patronage, styles often reflect the individual taste of a patron or the models that happened to be available to the artists.

Louis the Pious appointed Ebbo, who had been the imperial librarian at Aachen, to be Archbishop

of Reims in 816. Shortly thereafter, Ebbo commissioned a Gospel Book for the Abbey of Hautevillers near Reims. The book was made there under the direction of Abbot Peter, probably between 816 and 823 [5.14]. An author portrait precedes each Gospel, followed by an initial page with golden text. The book is one of the great masterpieces of Carolingian art. Although the portrait of St. Mark ultimately derives from sources like the evangelist pages in the Coronation Gospels, in the Ebbo Gospels the classical calm exuded in the early manuscript becomes a vibrating rhythm of brush strokes. Rapid, calligraphic flourishes with an overlay of gold replace illusionistic impasto modeling. The painter focused less on the outward appearance of a man writing than on the inner, spiritual excitement filling the evangelist as he records the Word of God. The consequent expressiveness of face and gestures produces a grotesque result: Mark's head and neck jut awkwardly out of hunched shoulders; his left hand clumsily grasps the book, while the right seeks out the ink bottle. The long diagonal slashes that represent the saint's eyelids lend an almost theatrical character to his inquiring upward glance. Even the furniture serves to accentuate the instability of the composition, for only a single bulging leg supports the lion throne, and the inkstand rests on taffy-like mounts.

The most famous Carolingian manuscript, the Utrecht Psalter [5.15], belongs to this school of painting. In the ink drawings designed to illustrate the Psalms, the scribes captured the linear vitality of the Ebbo Gospels style in a powerful, expressive style—despite the fact that the depiction of buildings and crowds and the integration of picture and text into one field betray a source in antique illuminated manuscripts. The Psalms are metaphorical praises and laments rather than narrative descriptions. Thus, the text of Psalm 88 (89) is a blessing on the kingdom of David and a promise of protection against enemies. God—a youthful Christ in a mandorla—is surrounded by angels and a personified sun and moon. Below on the right hand of God, David, "the anointed one," is enthroned in his palace and receives the gifts of kings who arrive in their ships. On God's left, one sees the evils of the

5.14 St. Mark, Ebbo Gospels, Hautevillers, 816–823. 10 1/4 x 7 3/4in. (26 x 19.7cm). Bibliothèque, Epernay.

world—the destruction of war, the plundering of cities, the individual cruelty of men, and even the Crucifixion of Jesus. The psalmist cries out for God's help: "like the dead who lie in the grave . . . the terrors destroy me: they surround me like water all day long; together they encircle me." Fortresses and palaces, hill, rivers, and the sea provide the setting for the energetic figures of kings, warriors, peasants,

seamen, and prophets. One soul alone (at the upper left) receives a robe and crown of glory from three angels. The unrestrained energy of the drawings typifies the northern medieval spirit. Weightless figures, elegant and delicate, stand on tiptoe, gesturing emphatically. The dynamism accorded serpents in Scandinavia or abstract spirals in Ireland is here transferred to human beings and their activities.

furortuus Homnesfluc NUMQUIDHARABITALI PAUTERSUMECOMINIABO TUSTUOSINDUNISTISUTER QUISINSFPULCHROMISE RIBUSAIUUINIUTIMIA ME: DLATSALMA RICORDIAMIUAM. FIUE EXALIATUSAUTEM HUMILI L oncificistinotosmius RITATEMTUAMINTER ATUSSUMFICONTURBATUS. AME POSUERUNTMEAB DITIONE I MMETRANSIERUNTIRAETU OMINATIONEMSIBI: NUMQUIDCOGNOSCINIUR AL HTHERORISTULCON TRADITUSSUMETNONICRE INTENEBRISMIRABILIA TURBAULRUNIME DIEBAR OCULIMEILANCH TUA HILUSTITIATUAIN CIRCUMDEDERUNTMESICUT ERUNTERALINOPIA : TERRAOBLIUIONIS; AQUATOTADIFCIRCUMDE CLAMAUIADIEDNE TOTA ETICOADTIDNICLAMAUI! DERUNTMESIMUL. DIFEXTANDIADTEMANUS EIMANIORATIOMEAPRAE E LONGASTIAMFAMICUM MEAS ! UINIIITE? ETPROXIMUS TIMOTOSME NUMQUIDMORTUISFACIES UTQUIDDHIREPHLLISORA OSAMISERIA: MIRABILIA AUTMIDICI ILONEMMEAM AUERTIS SUSCITABUNTETCONFITE FACIENTUAMAME: BUNTURTIBL:

5.15 Psalm 88, Utrecht Psalter, Hautevillers or Reims, 816-832. Ink on vellum, approximately 13 x 10in. (33 x 25.4cm). University Library, Utrecht.

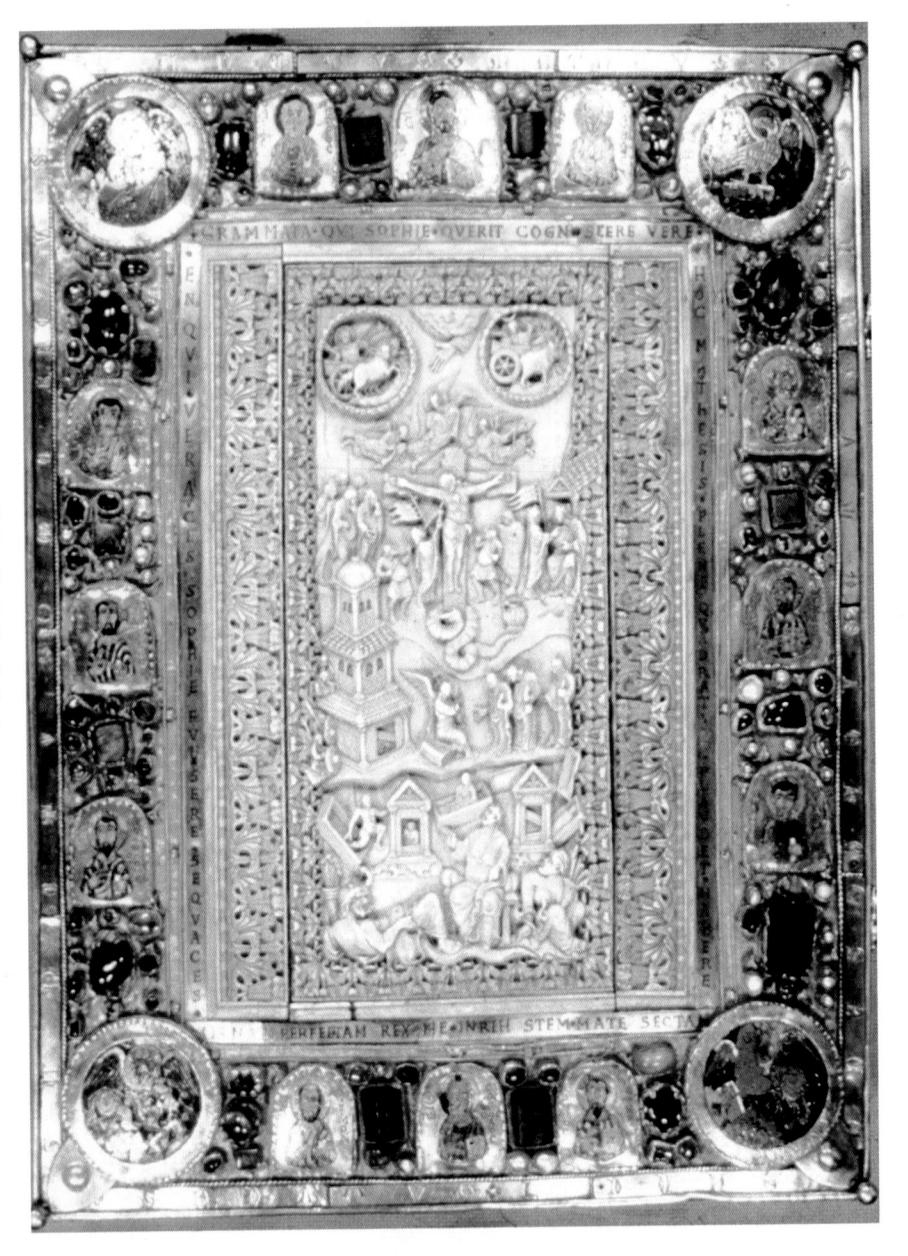

5.16 Cover for the Pericopes of Henry II. Central panel: Crucifixion, c. 870, ivory, 11 x 5in. (27.9 x 12.7cm); frame, c. 1014, enamels, gold, pearls, and gems, height 17 5/8in. (44.8cm). Staatsbibliothek, Munich.

The Utrecht Psalter style also appears in ivory carving. An ivory plaque, which was reset into the cover of the eleventh-century Pericope of Henry II, illustrates the transformation of antique models into a uniquely Carolingian creation [5.16]. The Crucifixion, the Marys at the Tomb, and the Resurrection are disposed in registers within an extended landscape. Despite the clearly Christian subjects, ancient Roman personifications define the time and place. Above the Cross, the sun and moon are personified by Apollo riding in his chariot and Diana guiding her ox cart. In the lower right of the panel, Gea or Gaia (Earth) stares intently up at the crucified Savior, while a reclining river god at the left directs his glance toward the spectator. The carver has drawn heavily on Early Christian sources, too, by including Stephaton, Longinus, the cluster of mourners, and the angel addressing the three Marys (see Rabbula Gospels [3.27] and [3.28]). In addition, the domed, tower-like sepulchre recalls the

How to Make Ink

Carolingian artists could refer to recipe books and technical manuals if they needed help with their projects. The most complete medieval manual to survive is On the Diverse Arts (De diversis artibus), a twelfth century copy of a book by an unknown author who called himself Theophilus (see Box: On the Diverse Arts). The instructions for making such a necessary (and today, ordinary) product as ink gives some insight into the enormous amount of work involved in producing a book. It begins, "When you are going to make ink, cut some pieces of thorn wood in April or in May, before they grow blossoms or leaves. Make little bundles of them and let them lie in the shade for two, three, or four weeks, until they are dried out a little. Then you should have wooden mallets with which you should pound the thorn on another hard piece of wood, until you have completely removed the bark. Put this immediately into a barrel full of water." After steeping for eight days, the water and bark were boiled until the liquid was reduced to a third and had turned black and thick. Then white wine amounting to a third of the volume was added and the boiling continued. The mixture was allowed to settle and the black ink to rise. "Next, take some small, carefully sewn parchment bags with bladders inside, pour the pure ink into them, and hang them in the sun until (the ink) is completely dry. Whenever you want, take some of the dry material, temper it with wine over the fire, add a little green vitriol and write." (Theophilus, On Divers Arts: the foremost medieval treatise on painting, glassmaking and metalwork. Translated from the Latin with introduction and notes by Hawthorne and Stanley Smith.)

An analysis of the ink used in writing the Utrecht Psalter shows it to be composed of the ingredients listed by Theophilus: thornbush bark, white wine, and a little vitriol (atramentum). The color of the ink in the Utrecht Psalter varies from light yellow to reddish brown to almost black, depending on how much water or wine the scribe mixed with the ink.

Painters preferred to use charcoal made from ground grapevine shoots for their blacks rather than the scribes' thornbush bark and wine.

tomb seen in the Ascension ivory [see 2.18]. Yet the slender figures, with their rippling, shape-defining garments, their heads thrusting out from rounded shoulders, and their intensely assertive gestures, are close kin to the actors in the Utrecht Psalter. The undulating ground lines between the zones also suggest Carolingian Reims drawings. In this threedimensional presentation, however, landscape becomes a series of overhanging ledges that create pockets of space around the events. Meanwhile, the architectural elements, although deeply cut in receding planes, sustain a vertical movement over the surface because the tomb and small buildings break through from one area into the next, unifying and energizing the field. Perhaps the most telling sign of the ivory's northern medieval origins is the way the sharply undercut acanthus frame fails to restrain the forms within. Soldiers, lances, coffins, and rooftops all burst out into the rectangular surround, and in so doing give new life to an ancient convention.

In the Sacramentary made for Charlemagne's illegitimate son Drogo-bishop (826-844) and archbishop (844-855) of Metz-the illuminators fitted the entire complex theme into the enlarged opening letters of the text [5.17]. They created a new form, the historiated initial, in which the illustration is actually incorporated into the text. In Te Igitur, the opening words of the canon of the Mass [5.18], the artist arranged the letters in an aesthetic rather than a readable pattern. The letters and their golden foliage serve to illuminate and glorify an already well-known passage. The small figures embedded in the letters extend the meaning of the Mass to incorporate the Old Testament prefigurations of the sacrifice of Christ. In the center Melchisedek, who offered bread and wine to Abraham, appears to celebrate the Eucharist blessed by the hand of God. Abel offers a lamb (the first sacrifice to God) and Abraham holds a ram (the sacrifice and salvation of Isaac). The bulls at the bottom of the T also suggest Old Testament sacrifices. Drogo's artist also rejected the bejeweled or interlaced patterns of his predecessors and chose instead to ornament the initial letters with classical acanthus leaves. In the final analysis, however, the Metz

5.17 Initial "C" with the Ascension of Christ, Drogo Sacramentary, Metz, 844-855. Bibliothèque Nationale, Paris.

5.18 Te igitur. Drogo Sacramentary, Metz, 844-855. Bibliothèque Nationale. Paris.

Monks, Canons, and Lay Abbots

Since early Christian times men and women had withdrawn from worldly life to seek salvation through prayer, living and worshipping according to agreed-upon rules. Monks and nuns in the West favored the Rule of St. Benedict of Nursia. Although Benedictine monks and nuns had as their principal duties services in the church and private prayer, they also maintained active scriptoria (workrooms for scribes) and educational and missionary programs. They supported the arts, which they saw as an expression of the glory of God. In 817 Louis the Pious ordered all monks and nuns in his empire to follow the Benedictine rule. Later, the Congregation of Cluny and the Cistercian Order were important reform movements within the Benedictine Order.

Canons were priests who followed the rather loose set of rules and precepts established by St. Augustine. Like the Benedictines they lived a communal life under the direction of an abbot. Their monasteries were located in cities, and they often served as the clergy of churches or cathedrals. Before the eleventh century, canons could own personal property. Canonesses, too, took vows of chastity and obedience but not of poverty. In the eleventh and twelfth centuries the canons became known as Augustinians.

When laymen began to look with envy at the growing wealth of the church, the situation was open to abuse. Rulers needing to reward a follower might appoint him to be the lay abbot, as Charles the Bald made Count Vivian Abbot of Tours. Such appointments were an open invitation to looting, and unscrupulous lay abbots could easily convert the community's property to their own use.

illuminator remained true to his native tradition, for although the foliage is based on the classical rinceau, it is completely filled with gold, the better to transform this idealized growth into a flat, decorative design.

In the kingdom of Charles the Bald, several monastic centers became major scriptoria. The monastery of St. Martin at Tours had a very active scriptorium, which during the 830s and 840s produced two complete Bibles a year. When Alcuin was abbot (798-804), the scribes specialized in texts to disseminate his edition of the Vulgate, but soon they began to illustrate the Bibles as well. The Grandval Bible has four full-page illustrations [5.19]. The opening illustration for Genesis shows the creation and fall of Adam and Eve. The short, heavy-set bodies, large heads, and staring eyes, the hints of illusionistic landscape, and the use of continuous narration—like an unwinding scroll—recall Early Christian art. The painters were once thought to have used a fifth-century Bible as a model, but they may well have had access to several sources. In the uppermost of four registers God creates Adam and takes a rib to make Eve. He warns the pair but they eat the forbidden fruit and are caught. Adam blames Eve, who in turn blames the serpent. In the bottom register, an angel casts them out into the world, where Adam is seen hoeing and Eve nurses her child while seated in a fragile shelter of sticks. The clarity and directness of the narration is in keeping with the educational mission of Carolingian patrons.

Another form of Tours antique realism can be studied in a Bible presented by the canons of the monastery to Charles the Bald on the occasion of the king's visit at Christmas in 845. The final illustration—the presentation of the Bible to the king—marks one of the earliest medieval depictions of an actual event [5.20]. Charles—enthroned beneath a canopy, flanked by courtiers and guards, and blessed by the hand of God—reaches out to accept the book, today known as the First Bible of Charles the Bald. At the center right stands Vivian, Charles's chamberlain, whom he made Count of Tours in January 845, and lay abbot of the

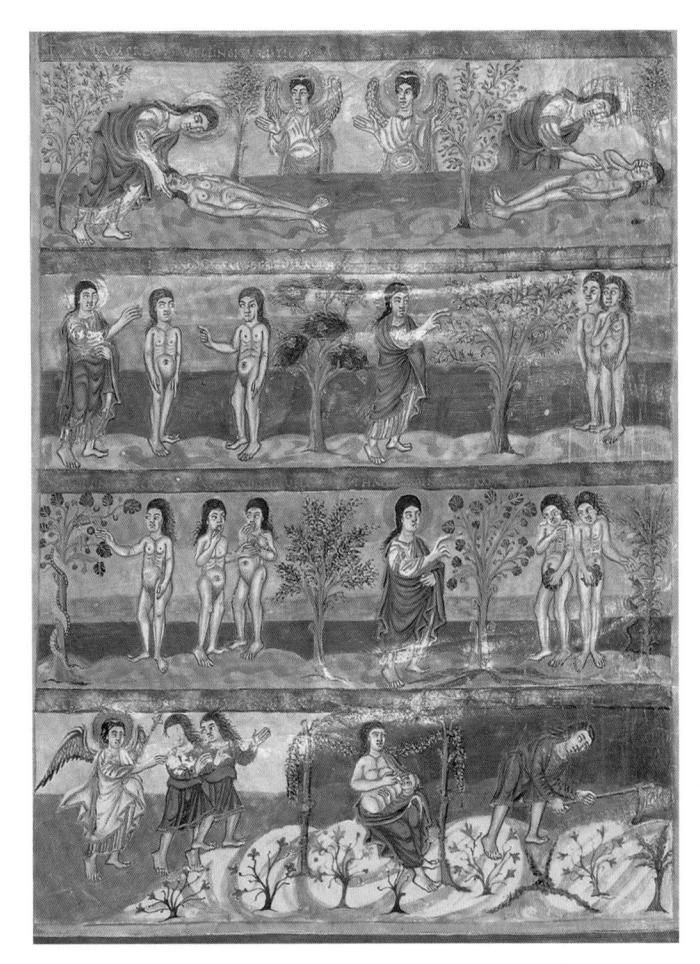

5.19 Scenes from Genesis (1:27-4:1). Illustration in the Grandval Bible. 20 x 14 3/4in. (50.8 x 37.5cm). C. 840. The British Library, London.

monastery just before the end of the year. In the presentation poem Vivian is called a "noble warrior," but six years later the canons called him "treacherous and impious." (The position of lay abbot provided easy access to the treasury!) Count Vivian was killed in Brittany in 851. When the Vikings devastated Tours in 853, many saw it as God's punishment for the lay abbot's transgressions.

The senior canon was Audradus Modicus, a poet and author of the dedicatory poem. He identifies the principal canons by name. At the bottom of the painting, the central figure who raises his hands like an orant must be the acting abbot. We have not encountered a similar attempt at visualiz-

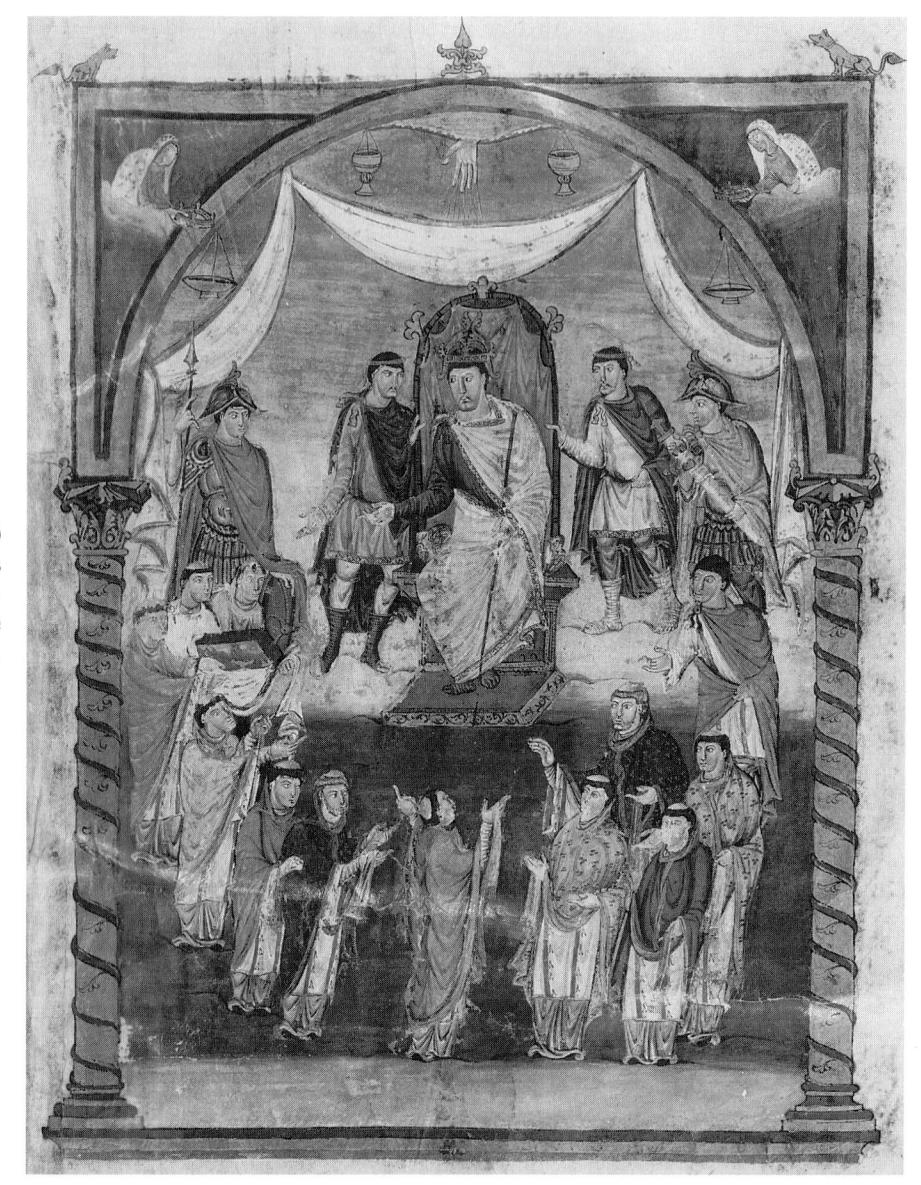

5.20 Bible presented to Charles the Bald. Vivian Bible. Tours, c. 845. Bibliothèque nationale, Paris.

ing a contemporary scene since the commemorative reliefs of imperial Rome. Charles was just 22, and evidently the painter intended the image to be a portrait, because the poet apologizes that mere art cannot do justice to the king's features. The painter placed the participants in a full circle, creating the illusion of a procession. The canons seem to enter, present their gift, and turn to sing psalms to the king. A continuous rhythm of gestures and glances accentuates the circular movement and locks the figures into a chain of relationships. An

aura of physical reality suffuses this dedication page—even the sky glows in softly shaded colors. In addition the painter made his figures more active by infusing their forms with a characteristically northern vitality, a product of elongated proportions, looser brushwork, and, above all, a linear and dynamic treatment of drapery.

The canons used painting and poetry in their attempt to educate and influence the young king. Charles was hailed as a new David and urged to be as great and just and generous as his grandfather

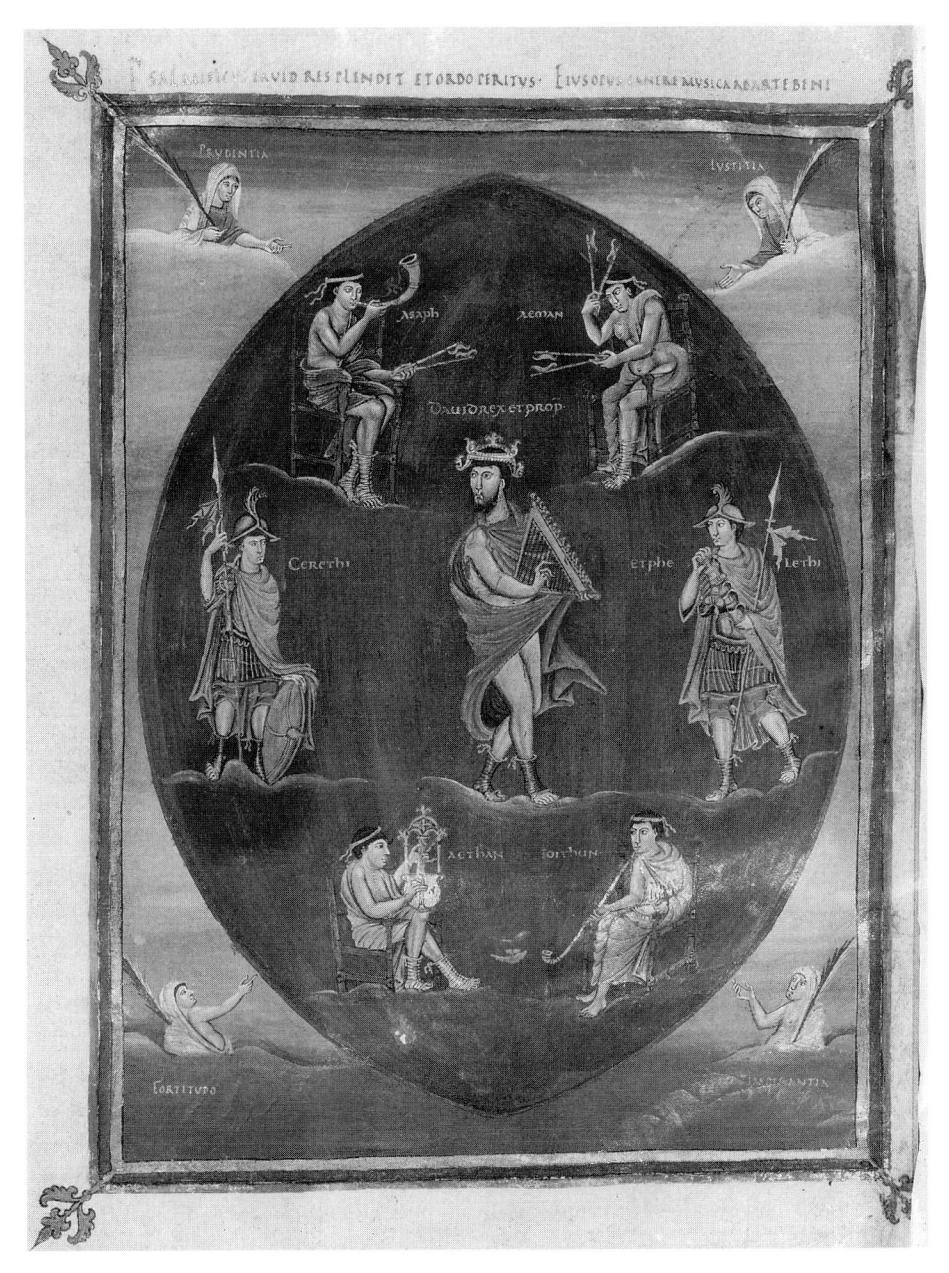

5.21 David Composing Psalms. Vivian Bible. Tours, c. 845. Bibliothèque nationale. Paris.

Charlemagne, who had also been nicknamed David. A painting of the biblical David introduces the Psalms [5.21]. King David, the composer, appears center page, dancing and playing his harp, dressed only in his crown, cloak, and boots. His four musicians, all identified by name, surround him playing their instruments, and his guards—in late Roman armor—stand at each side. The almond-shaped mandorla establishes the setting as an ideal, heavenly realm. Outside this special space are personifications of the virtues-Prudence, Justice, Fortitude, and Temperance. David's nudity is explained not as a Carolingian version of classical heroic nudity, but as an extreme expression of humility, which earned God's favor for David. Here, the canons present David as the model ruler, and an example for Charles to follow. Like David, he must humbly obey God in order to achieve his

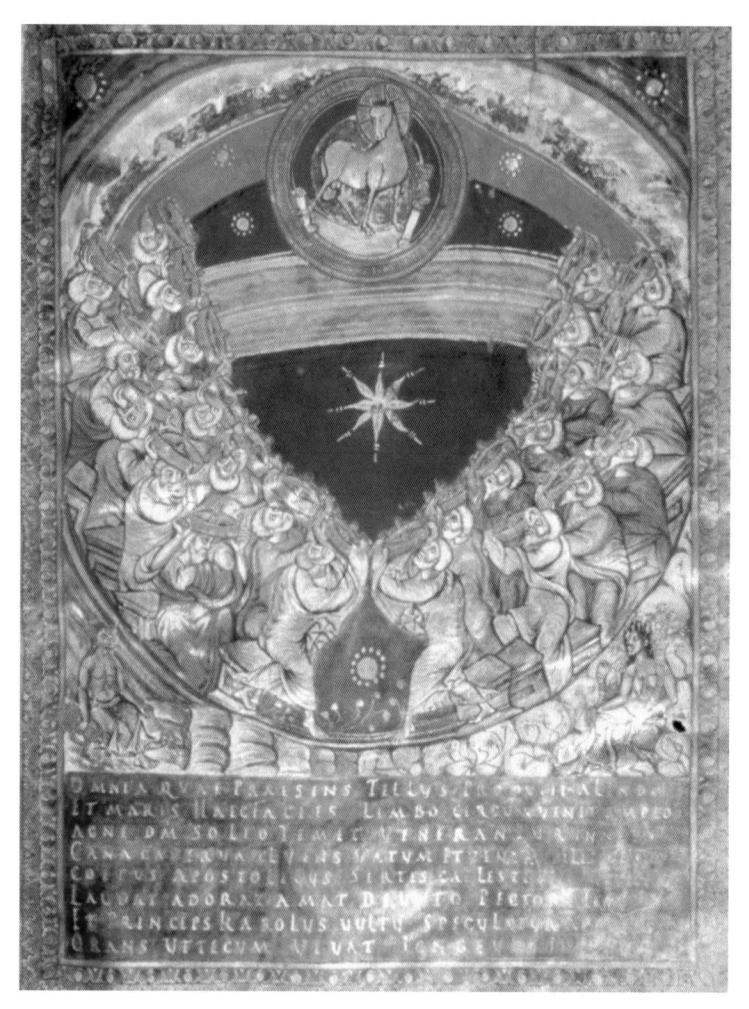

5.22 Adoration of the Lamb of God. Codex Aureus. Court school of Charles the Bald, c. 870. Bayerische Staatsbibliothek, Munich.

earthly goals. If the canons of St. Martin's hoped to capture the king's attention and to educate him, they were to be disappointed. Charles continued to give away church lands to pay off his supporters and was himself lay abbot of St. Denis, one of the most important monasteries of his kingdom.

Charles the Bald, as temporal ruler and lay abbot of St. Denis, was one of the last Carolingian rulers to patronize the arts on a grand scale. The Codex Aureus of St. Emmeran is quite literally a "golden book"—from its bejeweled gold cover to the purple vellum and golden script. Charles not only acknowledges patronage of the book but records his provision of the gold

that makes it truly a Codex Aureus. The brothers Berengar and Liuthard finished the Gospels in 870. In a depiction of the Apocalypse [5.22], which may have been inspired by the dome mosaics of Charlemagne's palace chapel at Aachen, the 24 elders adore the mystic Lamb who stands in a circle of light above a rainbow. The chalice in front of the Lamb recalls Christ's sacrifice and the celebration of the Eucharist. In pictorial terms, the painters conformed to the Byzantine practice of representing the apocalyptic Christ as the Agnus Dei rather than as the human redeemer known in the Western tradition. Within the great starstudded disk of Heaven, the elders twist and turn, rising from their thrones and offering golden crowns to the radiant golden Lamb. The glorious color and gold lend an ecstatic tone to the awesome vision of glory. The painters capture the drama of the scene by adapting the dynamic linearism and spirited movements used by their colleagues at Reims and Metz while retaining the corporeal solidity and illusionistic modeling of their classical models and the earlier court schools.

The covers of these manuscripts match the sumptuous quality of the illuminations within. On the cover of the Lindau Gospels, made about 870, a jewel-encrusted frame surrounds a jewel-bordered cross bearing the triumphant living Christ [5.23]. Weeping per-

sonifications of the sun and moon with fluttering, gesticulating angels fill the upper quadrants of the field. Below, the Virgin, St. John, and two mourners twist in grief around bosses formed of gems and pearls. The small figures with their hunched shoulders, expressive movements, and fluttering draperies contrast with the serene, idealized Christ. In spite of their patrons' pride in emulating Early Christian and Byzantine art, Frankish artists continued to develop the jewelwork and metalwork so beloved by their barbarian ancestors. Delicate arcades on lions' feet support polished gems, and beaded mounts set off pearls from the foliage-encrusted ground. Jewels and pearls attest

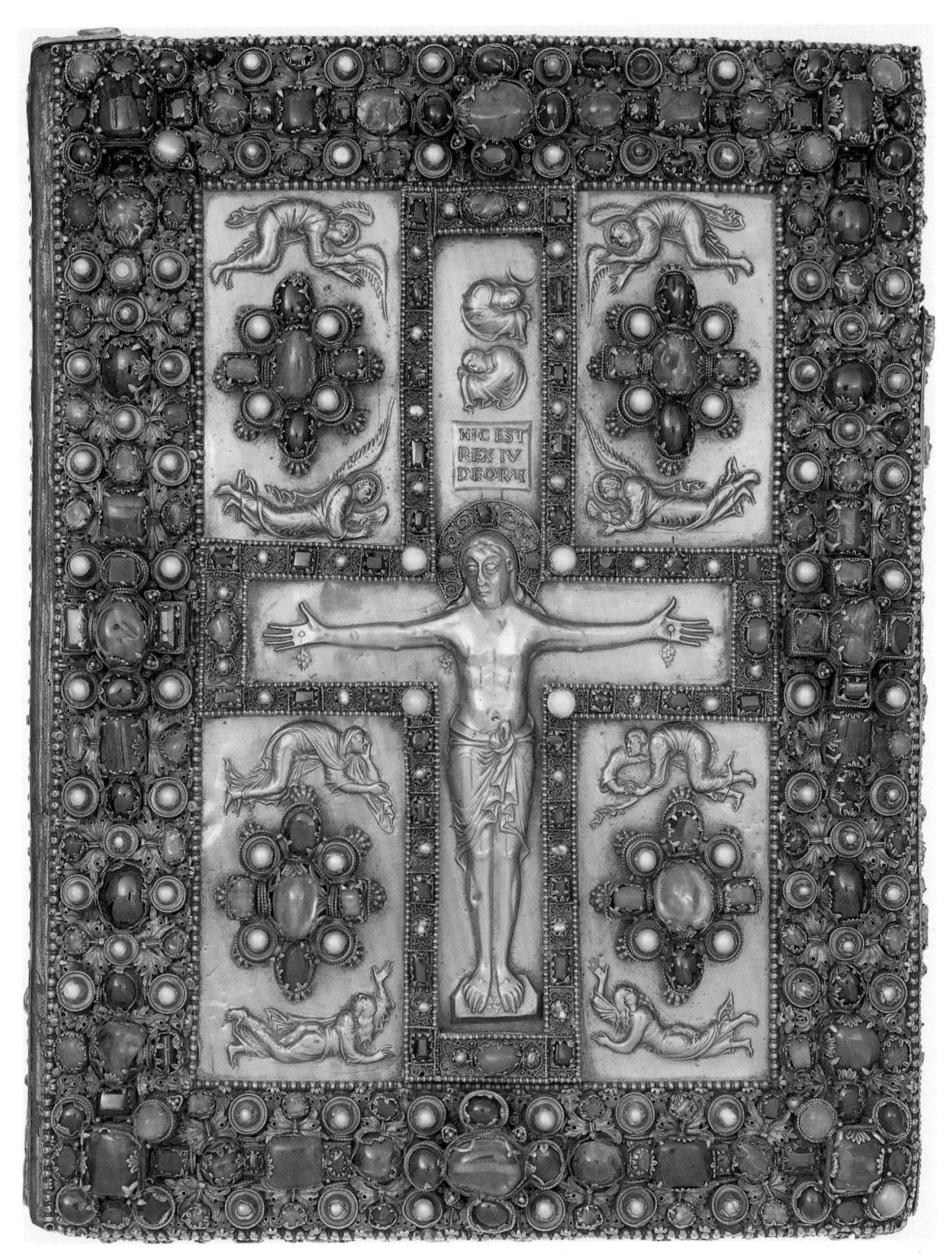

5.23 Christ on the Cross, cover, Lindau Gospels, c. 870, precious stones, pearls, $13\ 3/8\ x\ 10\ 3/8$ in. ($34\ x$ 26.4cm). The Pierpont Morgan Library.

to an almost barbaric delight in the color and quantity of stones. The effectiveness of the Lindau Gospels cover comes from sheer richness and highly skilled craftsmanship as well as from the representation of poignant human images.

In one sense, the term "renaissance" is a misnomer for the Carolingian revival. The arts still flourished during the so-called Dark Ages. The flame of learning had not been extinguished in the tumultuous centuries before Charlemagne. Furthermore, Carolingian art was more than a mere recreation of the classical style. Painters, sculptors, and architects of the later eighth and ninth centuries integrated the antique perception of human forms, of weight and mass, as well as the illusionism and individual motifs of Byzantine work with the highly developed decorative sensibility and the impeccable craftsmanship of Hiberno-Saxon artists. If Carolingian illuminations and relief sculptures sometimes depict events in a visually convincing manner, accurately representing the human body, landscapes, architecture, and the relationship of figures to their environment, it is

because the designers constantly referred to ancient models. What truly motivated Charlemagne's artists was not so much a desire for pictorial naturalism as a desire to perpetuate the pictorial tradition established in Early Christian Rome—a tradition, of course, eagerly emulated in other ways by the emperor himself. The arts provided a splendid and symbolic setting for the Frankish monarch and served to advance his imperial and ecclesiastic ambitions. Given this role, it is understandable that Carolingian art always remained a relatively exclusive enterprise, rarely extending beyond the limits of imperial patronage, whether in the secular court or in the monasteries. It is also understandable that the Carolingian renaissance could not endure beyond the dynasty that created and sustained it. However, the idea of Charlemagne as a Christian hero, together with the idea of a Holy Roman Empire, became one of the great myths of western European civilization—so much so that in 1165 this Frankish warlord, who had fought campaign after campaign to extend his personal empire, was beatified by the Church.
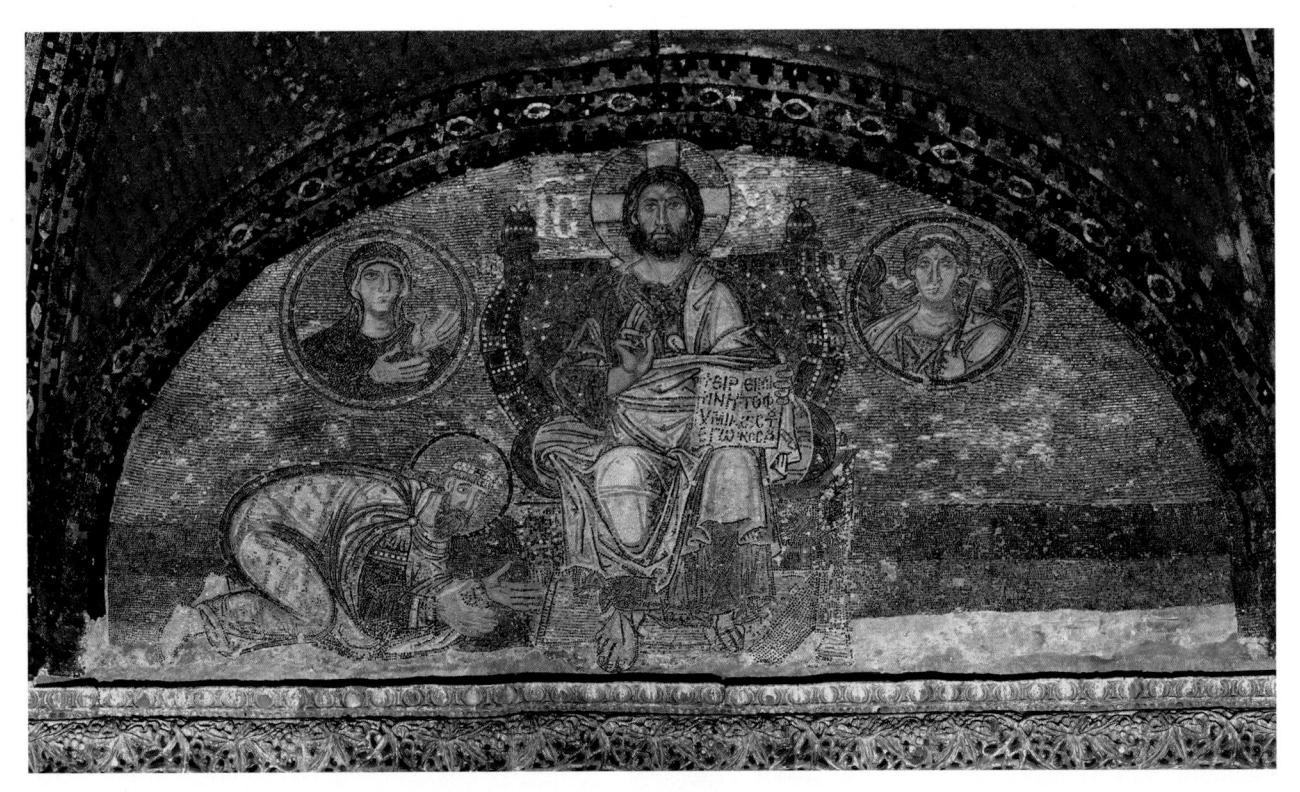

6.1 The Byzantine Emperor Leo VI, the Wise (886–912), paying homage to Christ. Lunette over the principal door of the Church of Hagia Sophia, mosaic, late 9th century. Constantinople (Modern Istanbul).

CHAPTER

6

RIVALS FROM THE EAST

Byzantine and Islamic Art

onstantinople and Baghdad—two legendary centers of wealth and power-estab-✓ lished a standard of luxury and learning barely imagined in western Europe [6.1]. The two rival empires had much in common: belief in a single all-powerful deity whose will was made known to the people and recorded in writing (in the Bible or the Koran), a centralized government supported by a complex bureaucracy and the elite troops of a military machine, a strong and affluent middle class of merchants and artisans who lived in cities and engaged in long-distance trade, an educated eliteheirs of Greco-Roman learning-who excelled in science and medicine, mathematics and engineering, architecture and the visual arts, and had a taste for music, poetry, and luxurious decorative arts. Many people in both cultures had an ambivalent attitude toward the representation of living things, which they sometimes expressed in the outright prohibition of images. Both cultures valued books and fine writing to such an extent that to the Muslims calligraphy was the highest form of art.

Irreconcilable religious differences as well as economic and political competition, however, made conflict between the two powers inevitable. For the Byzantine Christians, Jesus was Christ the annointed one—God and man united in one. To the Muslims, Jesus was human, a prophet in the line of succession from the Jewish prophets to Muhammad, the last and true prophet. Both Christians and Muslims felt a duty to carry the truth as they saw it to others by any means, including war. The

6.2 Hagia Sophia, interior view through doorway. Discs with names of God, Muhammad, and early Caliphs, c. 687. Constantinople.

Byzantines saw their society as a continuation of the glorious and all-powerful Roman Empire, albeit the Christian Roman Empire of Constantine. For their part, the Muslims had risen to power and greatness suddenly, seemingly out of nowhere in the Arabian peninsula. Yet, within a century of Muhammad's death in 629, they were masters of the Iberian Peninsula and had crossed the Pyrenees into France. The two powers seemed destined to

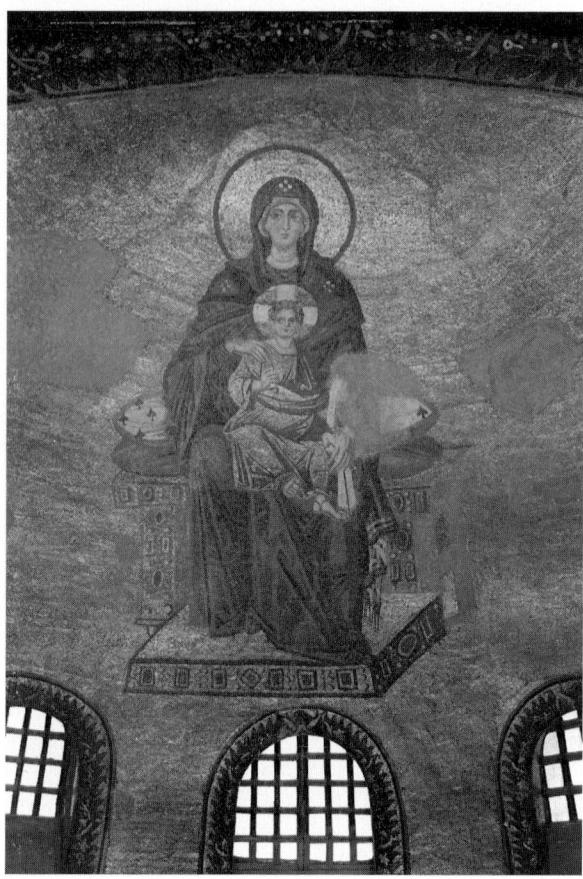

6.3 Hagia Sophia, Virgin and Child, Apse mosaic, c. 867. Constantinople.

confront each other although in the thirteenth century both suffered temporary defeats from outsiders—the Western Crusaders looted Constantinople in 1204 (and held power there until 1261), and the Mongols conquered Baghdad in 1258.

In the period between the eighth and the thirteenth centuries, few people would have foreseen that in the fifteenth century Islam would prevail, and that Byzantine Constantinople would become Turkish Istanbul, where the Church of Hagia Sophia would serve as the conqueror's mosque. A view through the main ceremonial entrance to the church shows a mosaic of the emperor (probably Leo VI) kneeling before Christ [6.1]. Just visible through the open doors are huge discs hung in the nave by the Turks and bearing the names of Allah [6.2]. Between these masterpieces of Turkish calligraphy, the mosaic images of Mary and the Christ Child can be seen enthroned in the golden apse [6.3].

THE MIDDLE BYZANTINE PERIOD, 867-1204

When in 843 the Council of Constantinople ended the iconoclastic controversy, the Byzantine emperors embarked on an ambitious program of restoration, rebuilding, and refurbishing the city's palaces and churches. Constantinople again became a city filled with rich treasures and spectacular buildings. Hagia Sophia received new mosaics in the narthex, galleries, and even the apse. The splendor of the court was supported by the military prowess and administrative skill of many of the emperors and court officials. In the ninth century a wily and ruthless player in the game of palace intrigue, Basil (ruled 867-886), established the Macedonian dynasty (867-1056). Basil and some of his successors, such as Leo VI (ruled 886-912) and Constantine VII (ruled 945-959), patronized the arts as an imperial policy. Mosaics, illuminated manuscripts, and silver, ivory, and enameled treasures testify to the enduring glory of the empire. The period became a second "Golden Age" for Byzantine art.

The creation of art and architecture on a grand scale requires political and economic stability. Although the Macedonian dynasty provided these conditions during the first hundred years of its existence, by the latter part of the tenth century, Muslim armies and marauding bands of Slavs and Vikings threatened the empire. In the Mediterranean area, Muslims landed in Sicily in 827 and completed the conquest of the island by 859. Meanwhile on the empire's northern frontier, Slavs moved across the land and Swedish Vikings sailed down the Russian rivers from the Baltic Sea. In the East the Muslims were halted by Nicephoros II Phocas (ruled 963-969), and the Slavs suffered defeat at the hands of Basil II (ruled 976-1025), henceforth known as the "Bulgar Slayer." Meanwhile, the Viking danger in Russia was reduced when the Vikings began to turn their camps into permanent trade centers and cities. In 989 Vladimir II, Prince of Kiev, accepted Christianity and affirmed his decision by marrying Basil's sister. In Constantinople the Vikings formed the Imperial Guard, effectually reducing the danger from the north.

Troubles multiplied for the empire in the second half of the eleventh century, however. In 1054 the long-standing conflict between Byzantine and Latin Christianity on doctrinal issues resulted in the final separation of the Eastern and Western Churches, with the Pope in Rome and the Patriarch in Constantinople excommunicating each other. In the West the Normans moved into southern Italy and soon turned former Byzantine territory into the Duchy of Apulia. In the East the Muslim threat increased when Seljuk Turks rose to power. Sultan Alp Arslan routed the Byzantine army at Manzikert, in Armenia, in 1071 and then conquered most of Asia Minor.

During this period of crisis a new dynasty came to power through the skill of Alexios Komnenos (ruled 1081-1118) and his son John II (ruled 1118-1143). The Komnenian Period lasted for the next hundred years (1081-1185). In spite of the antagonism between the Roman and Byzantine Churches, Emperor Alexios turned to the West for help against the Muslims. His pleas led Pope Urban II to preach the First Crusade in 1095. For the rest of the Middle Ages westerners mounted crusades against the Muslims in an attempt to control the Holy Land.

The city of Constantinople in the tenth and eleventh centuries was not the city built by Justinian, for many of the capital's most magnificent monuments had been severely damaged during the iconoclastic controversy. After the triumph of the iconodules (lovers of images), the artists of the imperial court restored or replaced the obliterated images in Hagia Sophia. In 867 the Patriarch Photios preached a sermon on the restoration of the images, and the monumental apse mosaic of the enthroned Virgin and Child (Theotokos, Mother of God) must be dated to this time. The massive figures and the idealized faces of Mary and Jesus demonstrate that neither the sensitivity to classical art nor the craft of mosaic had been lost during the period of iconoclasm.

Leo VI continued to refurbish Hagia Sophia. In a mosaic tympanum over the central door in the narthex, he kneels beside Christ as Muslims kneel today [see 6.1]. The mosaic has been interpreted as an act of penance by Leo VI. (Although the Church only sanctioned two marriages, Leo married four times in an effort to produce a son and heir.) In more general terms the scene could represent any emperor ceremonially kneeling before entering the church.

In the mosaic, Christ sits on an imperial throne and holds an open book with the words from the Gospel of St. John, "Peace unto you; I am the light of the world." The position of the emperor is the traditional "proskynesis," one of ceremonial and symbolic humility, recognizing Christ as the King of Kings. The medallions of Mary and the archangel on each side of Christ recall the Annunciation, that is, the moment of the Incarnation. Here at the entrance to the church, God appears in his human form and the emperor bows before him. As the emperor rises and moves into the church he is, metaphorically, surrounded by God's Holy Wisdom.

Like all Byzantine art, the mosaic depicts more than meets the eye. The style evokes the art of the sixth century in the figure of Christ, in the use of medallion portraits for Mary and the archangel, in the three-dimensional modeling, and in the relatively thick-set proportions of the figures. The solidity of the forms, however, is in part the effect of distance. In face, the draperies are represented by brittle, linear patterns of small, sharp, angular folds. Subtle gradations of colors have disappeared, to be replaced by rows of light and dark tesserae. The designer counted on the distance between the image and the beholder to create the illusion of forms modeled in light, since on close inspection the images dissolve into a colorful network of cubes. In later Byzantine art, these devices became such an important part of the stylistic canon that even in small manuscript illuminations, which were meant to be seen at close range, the strongly linear, sharply highlighted manner prevailed.

The artists adopted the vast expanses of gold tesserae as well as the geometric and foliage ornament that had characterized iconoclastic art of the

eighth century. To this abstract mode, they added the classical aspects of Justinianic art (which they could have seen in secular art that had survived iconoclasm) and even knowledge of Greco-Roman sculpture and mosaic. Unlike the ancient Greek and Roman artists, Byzantine masters conceived of their figures as intellectual rather than physical ideals. They followed Plotinus' ideas—that the image has no independent existence, no space of its own within a frame or behind a picture plane. The image, the beholder, and the zone between them share a space articulated by constantly shifting sight rays joining the viewer and image. The viewer is always an active participant in the work of art.

The splendor of Byzantine art has also survived

in extraordinarily rich manuscripts, where painters united religious inspiration with classical forms. This revived classical interest can be seen in the Joshua Roll and the Paris Psalter. In the Joshua Roll [6.4] text and images unwind in a continuous narrative like sculpture on an imperial triumphal column. Fifteen sheets once were fastened together to form a scroll over 35 feet (10.7m) long. In sheet 12, Joshua appears as the commander and as prostrate before the angel (Joshua 5:13–15). Personifications, illusionistic landscape details, figure types, and details of costume all presuppose an intimate knowledge of ancient models. The crowned seated female figure personifying the city of Jericho, for example, derives from Hellenistic sculpture. The scroll format precluded the use of heavy paint or gold, which might crack and flake when rolled. Instead, drawings are lightly tinted with blue and brown washes and, as one scholar notes, the effect is of a "sculptured frieze."

Very different in appearance but just as dependent on classical models are the paintings in the Paris Psalter [6.5], a book of Psalms dated ca. 950. Each of the fourteen full-page illustrations has an independent visual life, almost like an icon. The book is the largest, richest surviving Byzantine psalter. In it antique references abound. David playing the harp could have been copied from a classical image of Orpheus charming the animals. With the muse Melodia behind him, David strums his harp, while the nymph Echo peeps around a stele. In the back-

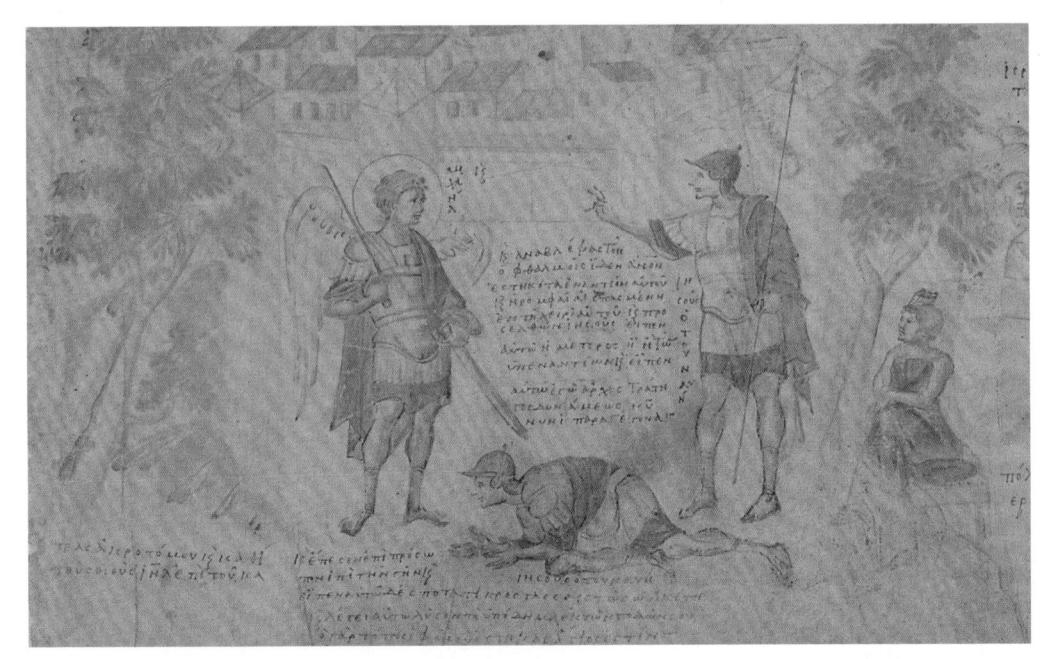

Joshua and the Angel, Joshua Roll, Rome, 10th century. Height. 12 3/4in. (32.4cm). Biblioteca Apostolica Vaticana.

ground, an opening in a rocky, forested landscape reveals the city of Bethlehem, whose personification reclines like an ancient river god in the lower right corner. The painter strictly followed the ancient formulas for achieving realism by modeling his figures in subtly changing tones of light and dark and integrating them within a receding three-dimensional space. Applying the principle of atmospheric perspective, the painter made the farthest trees lighter in color than those in the foreground and reduced the size of the town and rocks. The setting suggests the ancient Roman artists' window view of the world.

David the harpist has both a religious and a political meaning: As a religious figure, David is a "type" of Christ; in the political sense, he is the model for the ideal ruler. The strong classical aspect of the illustrations, with their personifications and antique illusionistic style, suggests that the more secular interpretation might be appropriate. Emperor Constantine VII Porphyrogenesis may have been the patron of the manuscript. A learned writer and patron of the arts, Constantine could have influenced the artist to return to traditional styles and iconography. The addition of scholarly commentaries to the psalms also suggests the interests of the emperor.

With the advent of the Komnenos dynasty in the second half of the eleventh century, Byzantine

6.5 David the harpist, Paris Psalter, Constantinople, 10th century. 14 1/8 x 10 1/4in. (35.9 x 26cm). Bibliothèque nationale, Paris.

art acquired a new vitality as well as elegant refinement. Precious metals, jewels and enamels, silks and ivories, all enhanced the ceremonies of church and court. The art of the Komnenian court is epitomized by an ivory figure of the Virgin probably made in Constantinople [6.6]. The Virgin gestures toward Christ, a type known as the Hodegetria, that is, the Mother of God "showing the way." (The image was based on an icon of the Virgin in the Hodegon Monastery believed to have been painted by St. Luke.) The thin, vertical fluting of the Virgin's drapery and the attenuated lines of her mantle, falling in pressed folds from her left arm, elongate the body and give the Virgin a regal presence. The proportions of Christ seem even taller and more slender than those of the Virgin (the head of Christ is a Western replacement). The carving has reached a level of technical perfection that enabled the sculptor to model details with exquisite precision even while adhering to the Byzantine preference for linear organization. This combination of gentle elegance and severe artistic control is found in almost all Byzantine art of the late eleventh and early twelfth centuries.

Equally elegant, an eleventh-century silver and gold cross recalls the devotion to the True Cross, which had a prominent place in the Byzantine Church [6.7]. This cross would have been carried in liturgical processions and was meant to be seen from either side, as its rich relief decoration attests. Silver panels of stylized vine scrolls cover the iron core. Ten silver gilt medallions with low relief figures are placed at the center of the cross and the ends of the arms. On the horizontal arm, Christ, Mary, and John the Baptist form a composition known as the Deesis (meaning a prayer or entreaty). Above and below them are the archangels Michael and Gabriel. An inscription on the cross offers prayers from the donor, Bishop Leo.

Among the most highly prized luxury items acquired from Byzantium by westerners were cloisonné enamels. Patrons treated these enamels like jewels and reused and reset them in new pieces. In fact, composite objects are often seen in medieval art. Exquisite Byzantine enamels, probably from a crown, were reused in the frame of a Carolingian

6.6 Virgin and Child. Ivory statuette, $11^{\rm th}$ century. Height, 12 3/4in. (32.4cm). The Victoria and Albert Museum, London.

6.7 Processional cross, early 11th century. Silver and silvergilt, 22 5/8 x 17 3/4in. (60 x 45.1cm.). The Metropolitan Museum of Art.

ivory on a German eleventh-century book cover [see 5.16], and two Byzantine reliquaries of the True Cross were reused in the twelfth-century triptych from Stavelot [see 1.1 and 1.2].

The smaller of these triptychs has the Annunciation on the outer wings, which open to reveal the Crucifixion. Inscriptions in blue record Christ's words on the Cross: to Mary, "Behold thy Son," and to John, "Behold thy Mother" (Luke XIX, 26-27). The larger reliquary displays the four Evangelists, the four Byzantine military saints (George, Theodore, Procopius, and Demetrius), and St. Constantine (a saint in the Eastern Church) and St. Helena (a saint in both the Eastern and the Roman Churches) with the archangels Michael and Gabriel. All are identified by inscriptions. Constantine and Helena wear imperial robes, including the ceremonial loros (a strip of cloth of gold embroidered with gems), gold bracelets, red shoes, and large jeweled crowns. The empress also wears an elaborate gold collar like the one Theodora wears in the Ravenna mosaics. The inclusion of Constantine and St. Helena beside the Cross may have been inspired by monumental statues in Constantinople of the emperor and his mother holding and presenting the Cross.

Textiles also provided the brilliant color and aura of luxury desired by the court [6.8]. Purple and red (the dyes made from murex) were the royal colors, purple for its association with porphyry and red because its brilliance called attention to the wearer. Purple was combined with gold; red was often woven into a colorful brocade with blue, green, and yellow. With a few exceptions, the extraordinary silks woven in elaborate colors and patterns in palace workshops and reserved for the exclusive use of the court have so deteriorated over time that they can be best appreciated as we see them represented in paintings or mosaics [see 3.18]. The trade in textiles and the use of silk as gifts in diplomatic missions made silks the carriers of motifs and patterns throughout Europe. A popular design has pearled roundels filled with winged horses, elephants, and fantastic composite creatures

called senmurvs (creatures with an animal's head and paws and a bird's wings and tail). The design was popular during the eleventh and twelfth centuries in both Byzantine and Islamic workshops.

THE MIDDLE BYZANTINE CHURCH

In the ninth and tenth centuries the Eastern Orthodox liturgy became increasingly complex, glorifying both God and His imperial vicar on earth, the emperor. The rituals of the church were hidden from the congregation even more than they were in Justinian's day, as the choir screen grew into a wall hung with icons (the screen is called an iconostasis). From a door in the iconostasis the clergy emerged during the Greater and Lesser Entrances to display the Gospel and the Host. The

Eastern Mediterranean, $11^{\text{th}}\,\text{or}\,\,12^{\text{th}}\,\,\text{century.}$ Silk; weft-faced compound twill (samite) 20 1/8 x 12 3/4in. (52.2 x 32.6cm). Monastery of Sta. Maria de l'Estay, Catalonia, Spain. Cooper-Hewitt, National Design Museum, Smithsonian Institution.

6.9 Diagram of the Greek cross (left) and quincunx (right) showing the arrangement of domes.

congregation, while hearing the Eucharist being celebrated behind the iconostasis, meditated on the icons and looked upward beyond the tiers of images to mosaics or paintings in the vaults where the imposing image of Christ ruled as the Pantokrator, the Ruler of the Universe.

In order to meet the new liturgical requirements and aesthetic preferences, Byzantine architects evolved novel building types based on compact, centralized plans and vertical, rising spaces. Spatial effects were made all the more striking by the reduced size of the churches. Furthermore, a tendency to subdivide spaces and forms and to elaborate details also increased. The architects turned for inspiration to the Greek-cross plan, used in such major churches as the Holy Apostles in Constantinople. The earlier arrangement of a central dome, rising from the midpoint of an equal-armed, barrel-vaulted cross, was changed by covering the cross arms with domes and raising all the domes on window-pierced drums. The domed Greek cross diverged into two distinct, five domed types—the Greek cross and the quincunx [6.9]. In both designs the central domed space remains the focal point of the architectural composition and the iconographic program. The religious architecture of Greece, the Balkans, Ukraine, and Russia in fact, the architecture of the Orthodox Church even today—is a variation on these designs.

The eleventh-century churches in the monasteries of Hosios Loukas and Daphni in Greece illustrate more variations. The Church of the Virgin at Hosios Loukas (c. 1040) [6.10], the "cross-insquare" plan, has a central dome resting on four columns surrounded by four radiating barrel vaults to form a Greek cross. Lower groin vaults between the barrel vaults create a square plan [6.11]. (In the quincunx domes replace the groin-vaulted corner bays). Three tall, projecting apses repeat the verticality of the central space. The compact plan and steeply rising spaces, from groin-vaulted corner bays to barrel vaults to central dome, direct the worshiper's attention upward to the dome, which,

6.10 Hosios Loukas, Greece, Theotokos, c. 1040. Vaults.

6.11 Churches of the monastery of Hosios Loukas. Left: Katholikon. Right: Theotokos. Plan, 11th century.

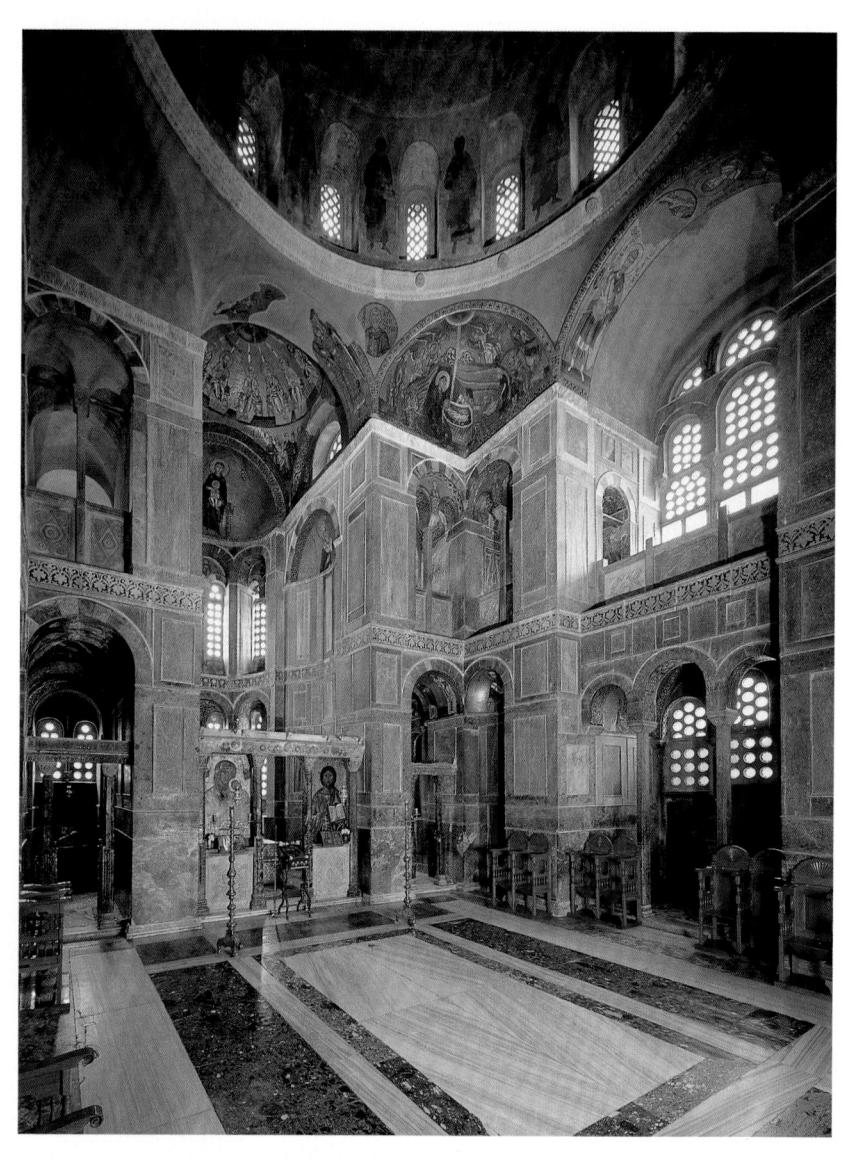

Katholikon of Hosios Loukas, Stiris, Greece, early 12th century. Interior. A marble screen, the templon, separates the nave of the church from the sanctuary.

with its window-pierced drum, becomes the focal point of the church.

The larger Katholikon (c. 1020) dedicated to a local hermit, the Blessed Luke of Stiris, is the principal church at Hosios Loukas [6.12]. Here pendentives and squinches convert the central space into a dome-covered octagon. Barrel vaults cover the arms of a Greek cross; a smaller dome surmounts the eastern bay; and a half dome, the apse. Groin-vaulted aisles and galleries open into the central space (naos) through high narrow arches and arcades. They establish a contrast between their compressed spaces and the open naos. Light filters into the interior

from windows in aisles and galleries and streams directly in from tall windows under the dome. A twostory, groin-vaulted narthex stands across the church's western end. This complex architectural design produces a series of forms and spaces subdivided and compartmentalized, yet simultaneously unified by the central dome.

On the exterior of the churches, the same sense of rising forms is created by the graduated heights of the narrow apses, the walls and roofs disguising the squinches and vaults, and the loftiest of all, the central domes [6.13]. Alternating courses of brick and stone create a rich surface texture. The Greeks

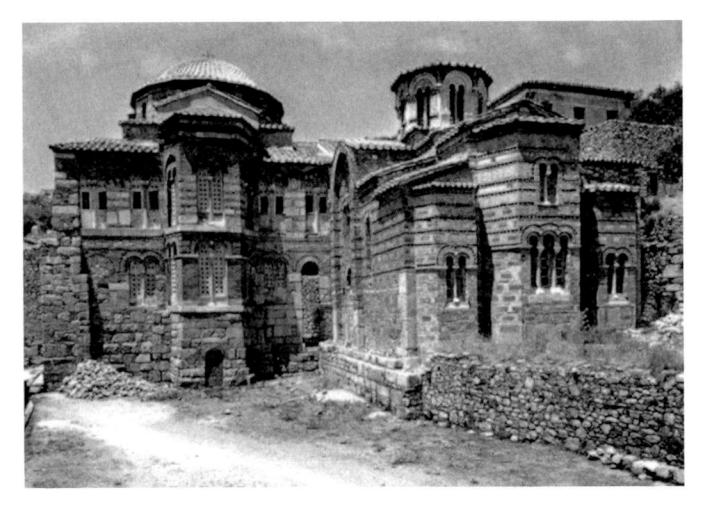

Churches of the monastery of Hosios Loukas, exterior. Katholikon (left); Church of the Virgin Theotokos (right), 11th century.

have transformed what was originally a structural device (bonding bricks) into pure decoration. By setting the bricks both vertically and horizontally to outline the stones, they developed a decorative technique known as cloisonné wall work. A lively, two-dimensional ornament of string courses composed of zigzag, curved, and saw-toothed brick moldings also embellishes the walls.

Just as the exterior walls are reduced to a pattern of stone and brick, so the supporting function of the

interior walls and piers is denied by the marble and mosaic decorations that overspread the surface, illuminated by single, double, and even triple windows. In the decoration of the church, theologians attempted to make the Christian mystery visible. The entire building becomes for them a microcosm of the Christian universe. Following the general principle that the loftier the placement, the greater the honor paid to the image, Byzantine designers placed Christ, the Virgin, and the angels in the domes and highest vaults. The Pantokrator commanded the central dome. At Hosios Loukas his ascension symbolized by the Pentecost appears over the sanctuary—while Mary is portrayed in the slightly lower conch of the apse. The next level—the squinches or pendentives

and the higher vaults-held scenes from the earthly life of Christ, arranged according to the order of festivals in the church calendar. The Annunciation, Nativity [see 6.12], Presentation, and Baptism of Christ fill the four pendentives of the central dome. In the lesser vaults and on the walls were the saints, apostles, and prophets. Finally, the marble-sheathed lower walls and the floor represented the realm of matter. Here the congregation stood to witness the mysteries depicted above them. Artists throughout

The Hierarchy of Angels

Angels are immaterial beings who occupy no space but have the power to act on matter. Since they are minds and spirits without bodies, their presence can only be felt or intuited. God created angels before He created human beings. They form the heavenly choir perpetually singing God's praises; they surround Christ on earth; they act as messengers between God and the world; and they participate in the Second Coming of Christ and the Last Judgment.

In a sermon on the "Celestial Hierarchies," St. Gregory defined nine orders of angels, divided into three groups of three. The highest choir, having the fire and light of Divine Wisdom, consists of Seraphim, Cherubim, and Thrones. Seraphim are depicted as heads with wings of fire; Cherubim, as heads with wings; and Thrones, as winged figures. Angels of the second choir whose function is political—the protection of kings—are called Dominations (depicted with tiaras), Virtues (with palms and laurel crowns), and Powers (with scepters). Finally angels of the third and lowest rank have direct, worldly duties. These angels are Principalities (with crowns), Archangels, and Angels. Three Archangels are identified by name and have specific duties (Michael, the warrior who protected Christian armies and souls from the devil; Gabriel, who carried God's messages to the world; and Raphael, who carried people's prayers back to God). At the lowest level angels act as guardians and messengers. Medieval people believed that every person had a guardian angel acting as guide and protector.

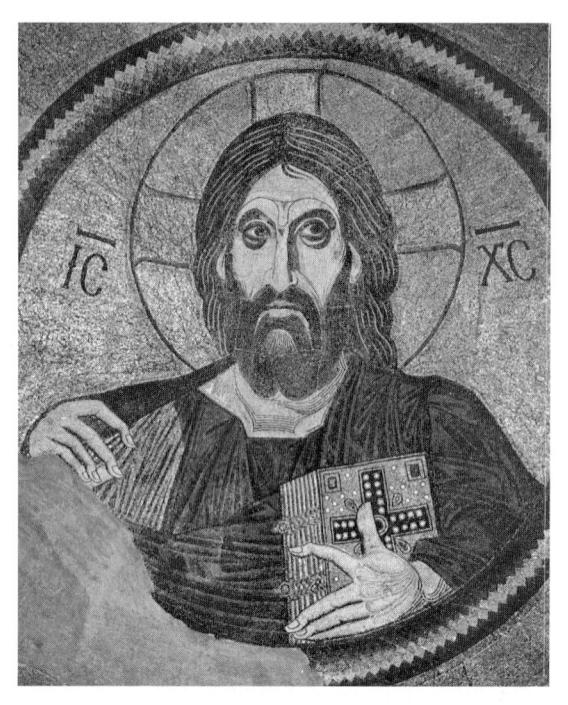

6.14 Christ the Almighty, Church of the Dormition at Daphni, Greece, c. 1100. Dome mosaic.

In order to render the image as a sacred icon within a mystical realm and simultaneously establish a direct relationship with the viewer, artists eliminated all unnecessary details. Consequently, the figures often seem to float in a golden atmosphere. At the same time, to help the worshipper identify with the images, the figures and events had to be easily recognizable and consequently represented with some degree of realism. To resolve these seemingly contradictory aims, artists turned to the art of the past, to Greco-Roman art and the art of the First Golden Age of Byzantium, as they composed their awe-inspiring images.

The mosaic of the Pantokrator at Hosios Loukas fell in an earthquake in 1593; however, the image in the central dome of the Church of the Dormition at Daphni has survived [6.14]. The Pantokrator, for all his striking lifelike power, has dematerialized into a terrifying and condemning

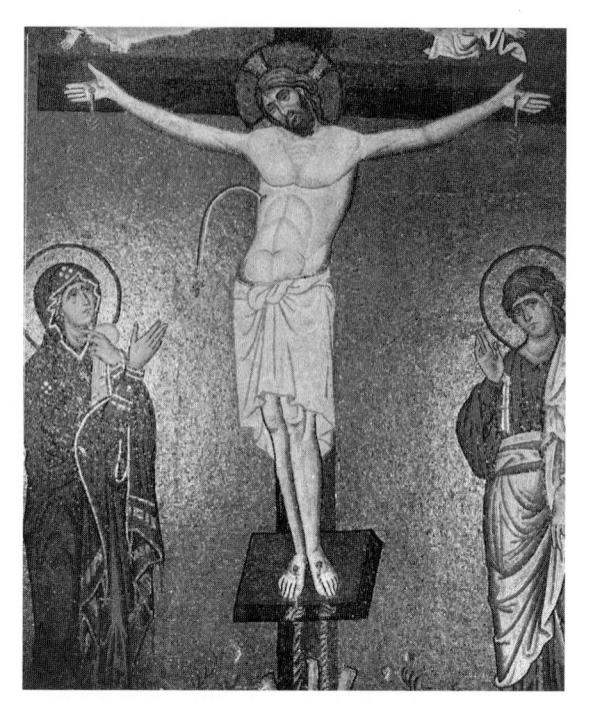

The Crucifixion, Daphni, Greece, c. 1100. Mosaic.

divinity hovering in a vast, golden glory. A system of concentric circles defines the head while the drapery is reduced to a series of parallel lines and acute angles. Consequently the human form emerges as both a naturalistic shape and a geometric design. Thanks to this combination of the real and imaginary, the omnipotent character of the Pantokrator is revealed. His strong hand and his huge, staring eyes are truly intimidating. One feels the threat of damnation passing along charged sight lines into the soul of the sinner standing below.

Like the Pantokrator, the Crucifixion at Daphni expresses the new emotional content of Komnenian art [6.15]. An expanse of gold tesserae isolates Christ, Mary, and St. John (and originally mourning angels) and eliminates every indication of time and place. With none of the detail of earlier representations like the Rabbula Gospels [see 3.28], the scene acquires the timeless concentration of an icon. The mosaic is a symbolic rather than a narrative representation of the crucifixion. The figures are elongated, their bodies and garments rendered

with boldly drawn patterns that only hint at the solidity of the classical models. Christ is represented as the suffering Christ (Christus patiens). In contrast to earlier triumphant representations, here he is naked and dying. His blood streams down toward Adam's skull on Golgotha (a conflation of the legend of the True Cross and John 19:17). The blood and water represent the rites of Eucharist and Baptism. The image is a reminder of the essence of Christianity following Paul's letter to the Corinthians (I Corinthians 15:22): "For as in Adam all die, even so in Christ shall all be made alive."

BYZANTINE ART OUTSIDE THE EMPIRE

In the Middle Byzantine Period, Christianity spread from Constantinople into eastern Europe, where Orthodox Christianity remained the dominant religion into the twenty-first century. The Slavs and the Bulgars had been forcibly converted in the ninth century, and by the tenth century, the Rus', the ancient people that gave their name to Russia, also accepted Orthodox Christianity. Queen Olga had been baptized in Constantinople in 957 and later her grandson, the still pagan Vladimir, Grand Prince of Kiev (982–1015), opened negotiations with the Byzantines. Vladimir's ambassadors to Constantinople, after attending a service in Hagia Sophia, were so overwhelmed by the majesty of the architecture, light, color, incense, and music that they reported back that the angels seemed to join in the service. Vladimir was convinced, and in 988 he and the young Byzantine Emperor Basil II formed an alliance. In 989 Vladimir accepted Christianity and took Basil's sister, Princess Anna, as his wife (he had three wives already and, it was said, 800 concubines!). Anna protested, furious at the prospect of marrying a man she considered a barbarian. Eventually, however, she accepted her fate and left for Kiev accompanied by Orthodox clergy, and possibly artists, in her retinue. Her personal sacrifice changed the course of Ukrainian and Russian art and culture.

Byzantine artists and craftsmen came to Kiev to build churches for the new religion [6.16]. They built the Cathedral of Sviata Sofiia (St. Sophia) in the 1030s, and later moved on to build the Cathe-

dral in Novgorod. Kiev was the seat of the Metropolitan, as the head of the Russian Church was known, under the jurisdiction of the Patriarch of Constantinople. Russian churches adopted the Byzantine centralized plan with multiple domes; however, instead of the small, complex, and broken up spaces, the Kievan churches were large and spacious. With its five aisles and 13 domes (symbolizing, it was said, Christ and the twelve Apostles), the Cathedral of St. Sophia established the pattern for religious architecture in the Russian Orthodox Church. St. Sophia was rebuilt and expanded until it eventually had nine aisles and nine apses [6.17]. Some of the interior decoration in mosaic (begun c. 1037, 1043-1046) and fresco (finished by 1067) survived this later remodeling and both thirteenth-century Mongol and modern destruction.

Needless to say, in a 13-domed building the iconographical scheme became very complex. As usual, the Pantokrator and angels filled the central dome, with the Apostles in the spaces between the windows of the drum. The Evangelists decorated the pendentives, and the Virgin, the apse. On the triumphal arch, three medallions with Christ, the Virgin, and St. John the Baptist form the Deesis, and on lesser domes and walls are scenes from the New Testament and the lives of the saints. Portraits of the family of the patron Yaroslav (1036-1054) can be seen in the nave. The Byzantine artists working for the Rus' made large, highly stylized, emphatically linear, and brilliantly colored mosaics and mural paintings. Bold and dazzling, the effect must have inspired awe among the newly Christianized Kievian Rus'.

The monumental figure of the Virgin dominates the golden space of the apse. As receptacle of Divine Wisdom (Christ), she is equated with the Church. Below her on the apse wall, the mosaic depicts the Communion of the Apostles. Christ is represented twice—as a priest standing at the altar offering bread at the right and wine at the left to the assembled Apostles. This double representation had political as well as religious overtones in this theocratic society. The rulers Vladimir and Yaroslav had imposed Byzantine

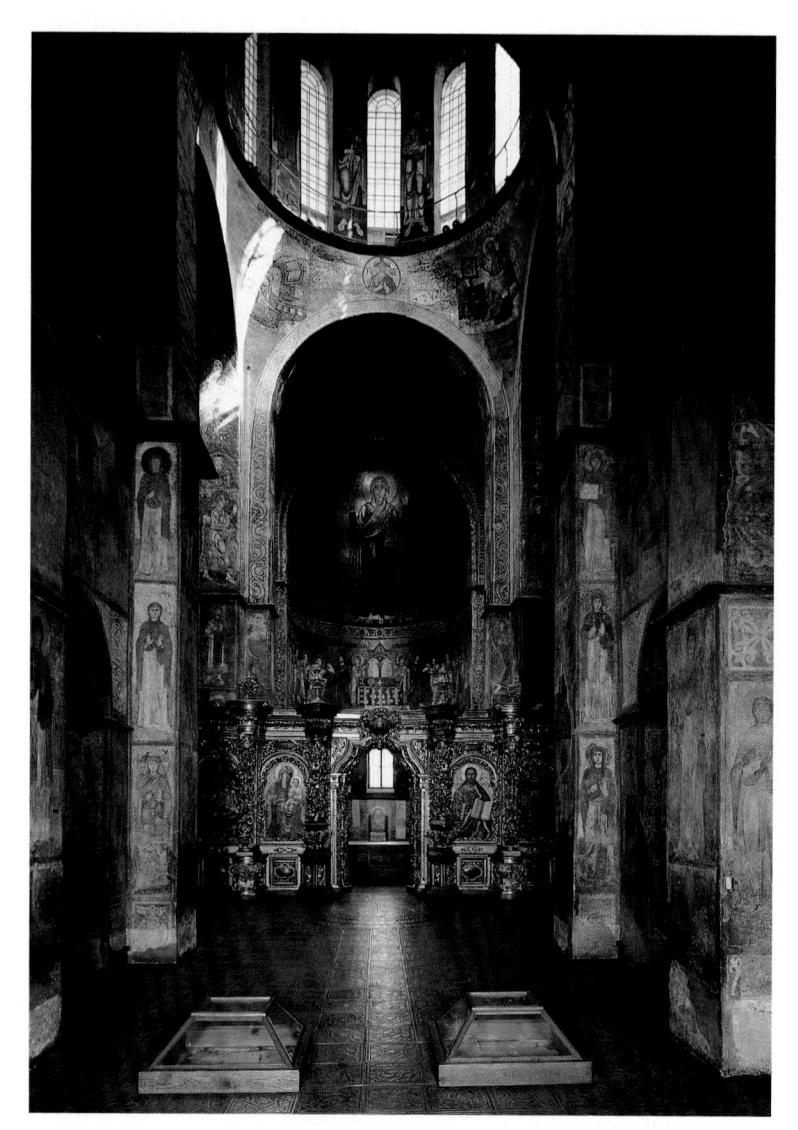

6.16 Interior, Cathedral of St. Sophia, 11th century and later, Kiev.

ceremonies, in both the court and the church, on people only a generation removed from their pagan past. The mosaic emphasizes the role of the new Christian priests, and reaffirmed both religious belief and liturgical practice.

The Orthodox missionaries to the Rus' must have brought icons, and books, as well as crosses, chalices, and other liturgical equipment with them. The new church needed many icons of Christ, the Virgin, and the saints. The earliest surviving icon in Russia is now known as the Virgin of Vladimir [6.18]. Probably made in Constantinople in the twelfth century, the icon was in Kiev by 1131. It was repainted after a fire in the thirteenth century, and today only the faces date from the early period. The Rus' believed the icon to have been painted by St. Luke. The theme of mother and son pressing their faces together is called the Virgin of Compassion. As the center of power shifted from Kiev to Novgorod and Vladimir, so too the icon moved. It was in Vladimir in 1155, and then finally it was taken to Moscow. Recently restored and

now in the Tretyakov Museum in Moscow, a true miracle of the icon may well be its survival into the twenty-first century.

BYZANTINE ART IN THE WEST

Byzantine art came into western Europe through Venice and Sicily. The Republic of Venice had maintained close diplomatic and economic relations with Constantinople and other important

6.17 Cathedral of St. Sophia, Kiev, c. 11th century, as interpreted by Aseyev, V. Volkov, and M. Kresalny,

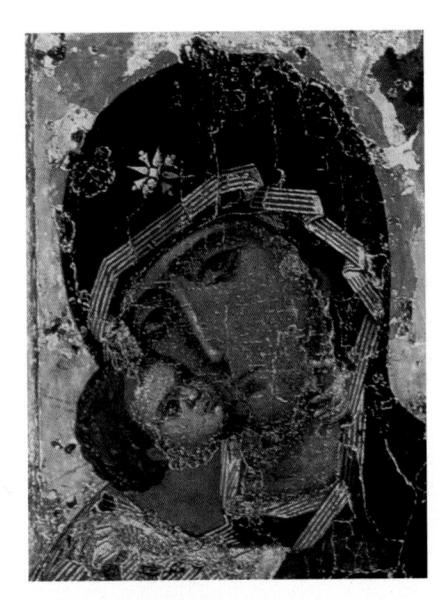

6.18 Virgin of Vladimir, 12th century. Tempera on board, 30 3/4 x 21 1/2in. (78 x 54.6cm). Tretyakov Gallery, Moscow.

cities in the Eastern Empire long after northern Italy had gained independence from Byzantine rule. The prosperity of Venice rested in large measure upon its commerce with the East. When in 1063 the Venetians began to rebuild the church of their patron St. Mark, they copied the Church of the Holy Apostles in Constantinople [see 3.9]. Naturally, they incorporated the changes made during the tenth-century remodeling of that church, a project that had resulted in the raising of the five domes on drums pierced by arched windows. In St. Mark's Church (a cathedral only since 1807), the massive hemispheres of the five great domes and the connecting and abutting barrel vaults produce a space reminiscent of Justinian's buildings [6.19]. Unlike the complex broken views characteristic of many Middle Byzantine churches, St. Mark's repeated vaults and large domes flow one into the next with harmonious grandeur. The mosaics (twelfth century and later) convey the sumptuous effect of the original scheme.

Southern Italy and Sicily also adopted Byzan-

tine art and architecture, but for different reasons. The Byzantines had retaken southern Italy from

the Muslims in the tenth century, but Sicily remained in Muslim hands. Then in the eleventh century the Normans under Count Roger (ruled 1061–1101) invaded, and by the twelfth century they controlled the south (Apulia) and Sicily. Roger II (ruled 1101–1154) was crowned King of Sicily, Apulia, and Calabria in 1130 at Palermo. He established a remarkably tolerant state in which Norman, Muslim, and Byzantine cultural and artistic traditions mingled to form a brilliant and exotic art.

THE BYZANTINE CONTRIBUTION TO THE ART OF THE WEST

Byzantine art exerted a profound and continuing influence on the art of the West. Techniques of painting, mosaic, cloisonné enamel, gold work, and ivory carving were transmitted to the West first by artists and later through handbooks. Byzantine iconography, figure style, and decorative motifs were also adopted by Western artists. At certain key moments in the development of Western art, Byzantine art played an important role. Byzantine models changed the direction of Carolingian painting at the end of the eighth century, and the art and artists who came to the Ottonian court reintroduced Byzantine art to the West at the beginning of the eleventh century. A Burgundian interpretation of the Komnenian manuscript painting style was spread through Europe by the monks of Cluny at the end of the eleventh century. Later, as artists in the Île-de-France were experimenting with the new forms, which we now call Gothic, they had another opportunity to study Byzantine art in the reliquaries brought back by Crusaders.

One of the most significant and enduring contributions to the art of the West was the Byzantine concentration on single religious images in icons. In the design of an icon, the artist had to organize a unified composition around a single idea or a single idea or a single idea. gle figure. To some degree, the development of the full-page manuscript illustration and eventually that of panel painting in the West were inspired by the icon painters.

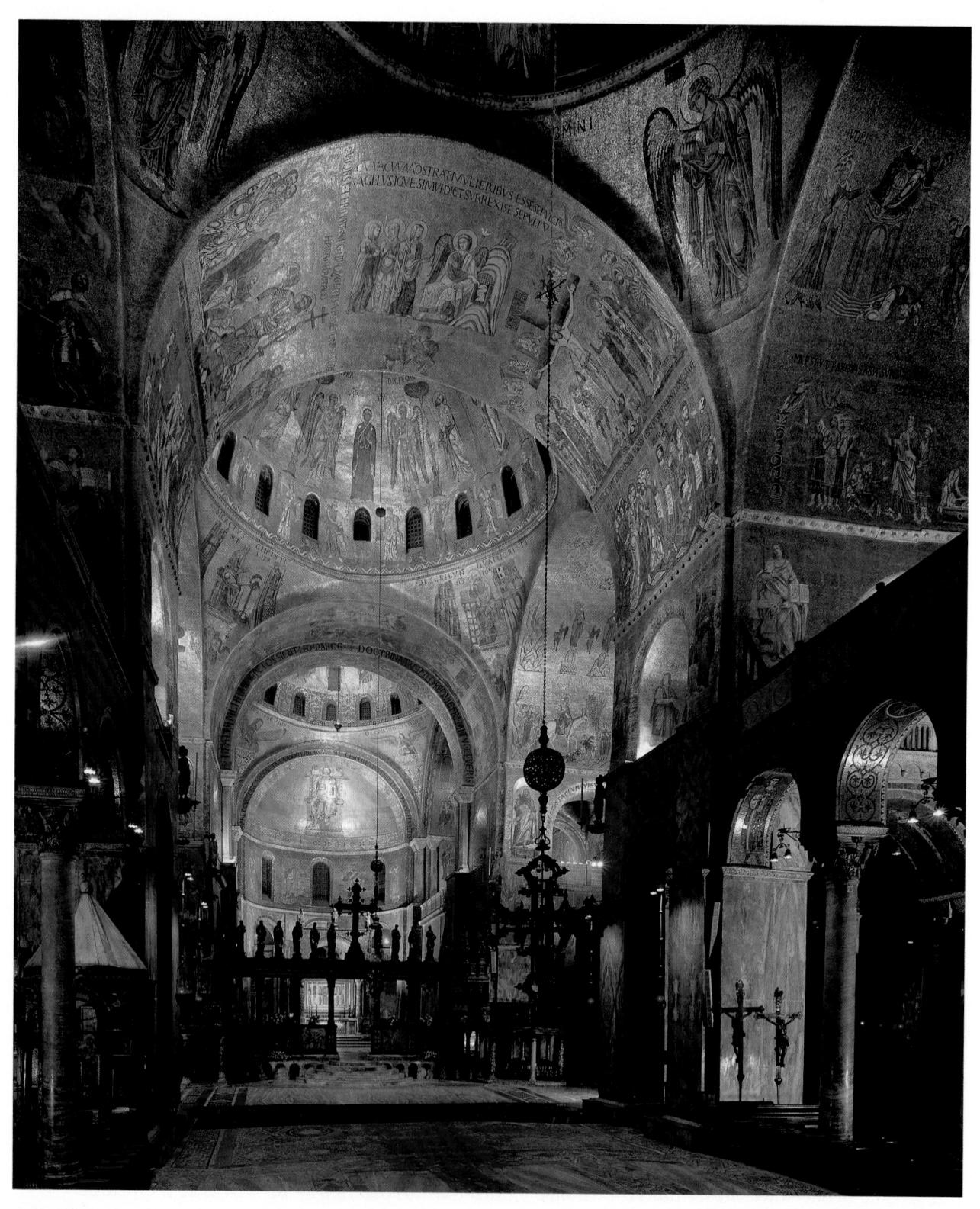

6.19 Cathedral of St. Mark, begun 1063, nave, Venice.

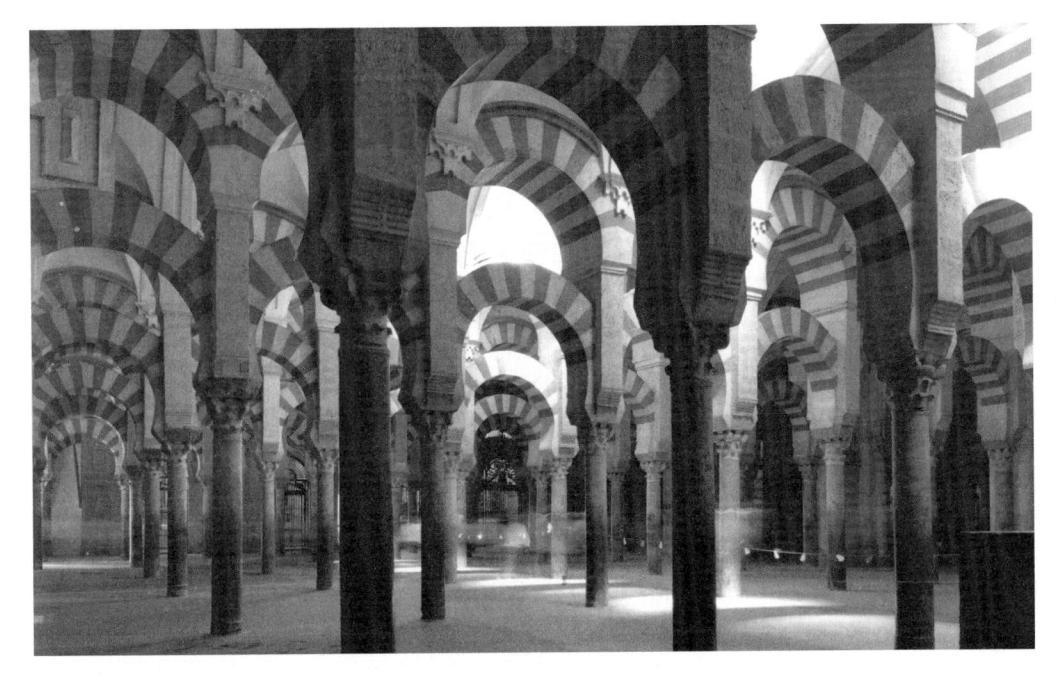

6.20 Great Mosque, Córdoba, begun 785, enlarged in the 9th and 10th centuries.

Constantinople also had the largest collection of ancient Greek sculpture available to the artists of the Middle Ages. The city must have been like a museum, and its artists became the interpreters of the ancient classical heritage for the West. Western artists gradually absorbed more and more of the ancient humanistic style as interpreted by Byzantine artists. The vital message of ancient art, and one not wholly lost in Byzantine art, was an appreciation of the beauty and dignity of the human figure. If in creating human beings God had combined both matter and spirit, then the body should be shown as motivated by an inner will—or so the patrons rationalized. When the artists accepted the challenge of depicting the Word made flesh, they created landscapes and architectural spaces inhabited by spirited figures defined by color and light.

ISLAMIC ART

In the seventh century, a powerful spiritual and political leader, Muhammad (c. 570-632), appeared in Arabia. He founded a new religion, Islam, a word derived from salam, meaning the perfect peace that comes when one's life is surrendered to God. Making no claims to divinity, Muhammad called himself the prophet to whom Allah—God—revealed the truth. These revelations, collected in the Koran, became the sacred scripture of the Muslims.

Islam owed its international success to Caliph Omar, a leader who combined military and political skill with religious fervor. The caliph, meaning "successor," continued to be both a religious and a political leader. Omar embarked on a campaign of conquest: Damascus fell in 635, Jerusalem in 638. Among the great Christian cities of the East, only Constantinople remained in Christian hands. By the time of Omar's death in 644, the Islamic conquests spread from Egypt to Iran. Omar's followers established the Umayyad dynasty, which continued his military and spiritual success. When the Abbasids, who claimed the leadership of the Muslim world through Muhammad's uncle Abbas, toppled the Umayyads in 750, one Umayyad prince, Abd al-Rahman, "the flower of Islam," escaped to Spain.

In 756, Abd al-Rahman established a strong centralized government in Spain with a capital at Córdoba [6.20]. He allowed Christians and Jews to practice their religion by paying a tax for the privilege. They made up most of the city population and the artisan and commercial classes, while

the Muslims controlled the military and political establishment and owned extensive country estates. Abd al-Rahman, although actually an independent ruler, maintained the fiction of Islamic unity by ruling Spain as an emir, or governor. Not until 929 did Abd al-Rahman III proclaim an independent caliphate of Córdoba.

In North Africa, independent states arose in Morocco, Tunisia, and Egypt. The Muslims invaded Sicily in 827, establishing their capital in Palermo by 831. Sicily remained in Muslim hands until the Normans conquered it in the eleventh century. In the East, the Seljuk Turks accepted Islam in 956, and by the eleventh century they virtually ruled the empire. As we have noted, they defeated the Byzantine army in 1071, and they controlled Asia Minor until the rise of the Ottoman Turks in the fourteenth century.

ARCHITECTURE

Like the earliest Christian churches, the Muslim place of prayer, the mosque, took its form from domestic architecture. Muhammad's followers gathered in his house, where he spoke to them from a portico while standing on a low platform. When buildings for religious services became desirable, Muhammad's house provided the model a walled courtyard with an open portico on one side sheltering a raised speaker's platform (minbar). The faithful prayed, facing the holy city of Mecca whose direction was indicated by a wall (qibla) having a niche (mihrab). To this simple scheme later builders added a tower (the minaret), from which the faithful were called to prayer, and a special enclosure in front of the mihrab from which the ruler led communal prayers on Friday.

Muhammad warned his followers against wasting their resources on elaborate building projects, but in this his words were not followed and mosques were built that rivaled the temples and churches of the past. One of the finest surviving early mosques was built in Córdoba, Spain [6.20]. Begun by Abd al-Rahman in 785, and built over a period of two hundred years, the Great Mosque of Córdoba consists of a prayer hall and a courtyard,

to which a minaret was added in the tenth century. The original building rose in only six years (785–791), for the builders saved time and labor by scavenging columns and capitals from Roman and Visigothic buildings. Almost square in plan, the prayer hall had eleven parallel aisles running perpendicular to the qibla wall. Seemingly endless rows of columns, dimly lit from the courtyard, create a sensation of infinite extension into space. In contrast to the focused processional character of a basilica or the rising domes of a Byzantine church, Islamic architecture—and art—achieves its effect through the seemingly endless repetition of equal units, whether columns in a building or geometric motifs in the decorative arts.

Structural necessity led the builders to create remarkable decorative effects. In order to achieve a uniform height for the scavenged columns they had to add impost blocks and then construct additional piers to support the flat timber ceiling. To stabilize these slender shafts the builders linked them with circular horseshoe arches. To adjust the curve of the arches, stone voussoirs alternated with bricks—three or four red brick courses to each stone voussoirproducing a colorful striped pattern. Bricks set at 45-degree angles and forming a zig-zag pattern frame the upper archivolts, and cylinders on the corbels supporting arches produce roll moldings. The alternating voussoirs, the horseshoe arches, zigzag moldings, and rolled corbels all became widely used devices in Islamic and later Christian architecture.

Later rulers enlarged and enriched the Mosque of Córdoba. Between 961 and 968, Hakam II added to the prayer hall, rebuilt the mihrab, and added elaborate vaults and windows in the bays in front of the mihrab to light the qibla wall [6.21]. This new construction presented a challenge to the architects since the original columns and piers were intended to support light wooden roofs, not vaults. The builders achieved a remarkable structural and decorative solution to this problem. Without breaking the rhythm of the repeated columns, they introduced interlacing, polylobed arches to form strong, rigid, screens. They actually created pointed arches, which they disguised under semicircular cusps. Above these interlacing cusped arches, four

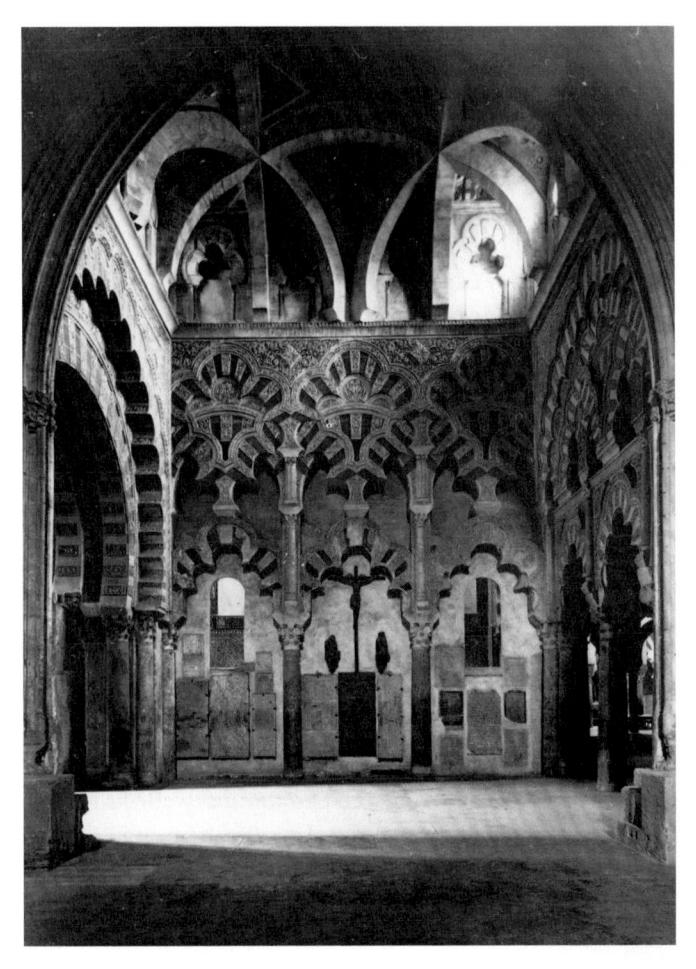

6.21 Great Mosque, Córdoba. Bays in front of the mihrab, 961–968.

pairs of parallel ribs spanned each square bay. The ribs permitted the insertion of windows and supported miniature fluted melon domes and small decorative panels. Originally the surfaces were painted with the interlacing stylized foliage known as arabesques. The architects so completely integrated new forms with the old that innovations seem part of the original builders' intention. Although the building campaign lasted until 988, the Great Mosque retained a remarkable visual unity.

Once established, this form of the mosque underwent little change. The need for econ-

omy, speed in construction, and large size encouraged builders to use adobe, brick, rubble, and wood with only a veneer of stone or stucco even in very important buildings. Columns were replaced by brick piers—sometimes cruciform in cross section; sometimes molded to look like engaged columns when covered with stucco. The pointed horseshoe arch, originating in Iran, and the polylobed arch became standard structural forms by the eleventh and twelfth centuries.

In secular architecture the Muslims also demonstrated their ingenuity. Instead of isolated rural castles, they built walled cities and fortified town residences, often using Byzantine plans and structural techniques. They excelled in the design of monumental fortified gateways with imposing towers and decorated portals [6.22]. These gates with their temptingly large doors were deceptive, for on entering the passage the enemy had to negotiate as many as three right angle turns in a constricted space. This plan made battering rams useless and effectively stopped the charge of the attackers. Openings in the floors of the upper rooms per-

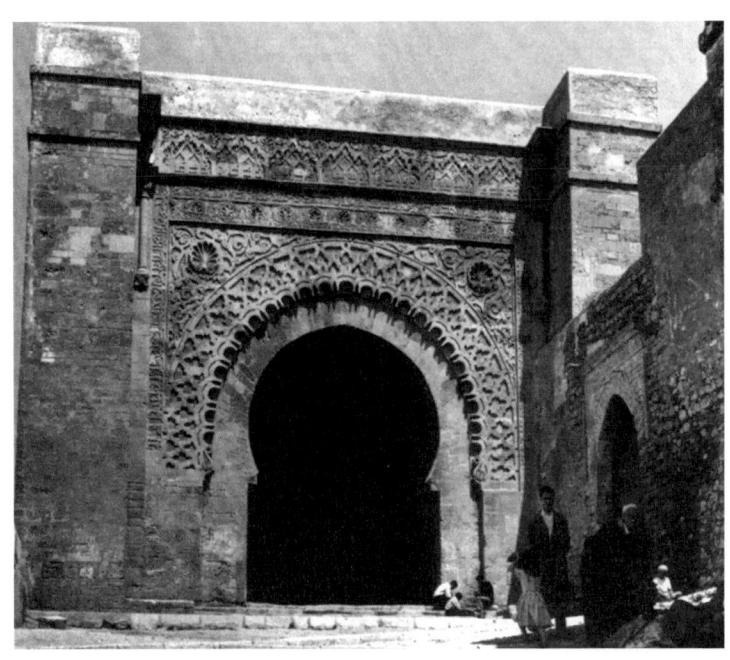

6.22 Oudaia Gate, Almohad, Rabat.

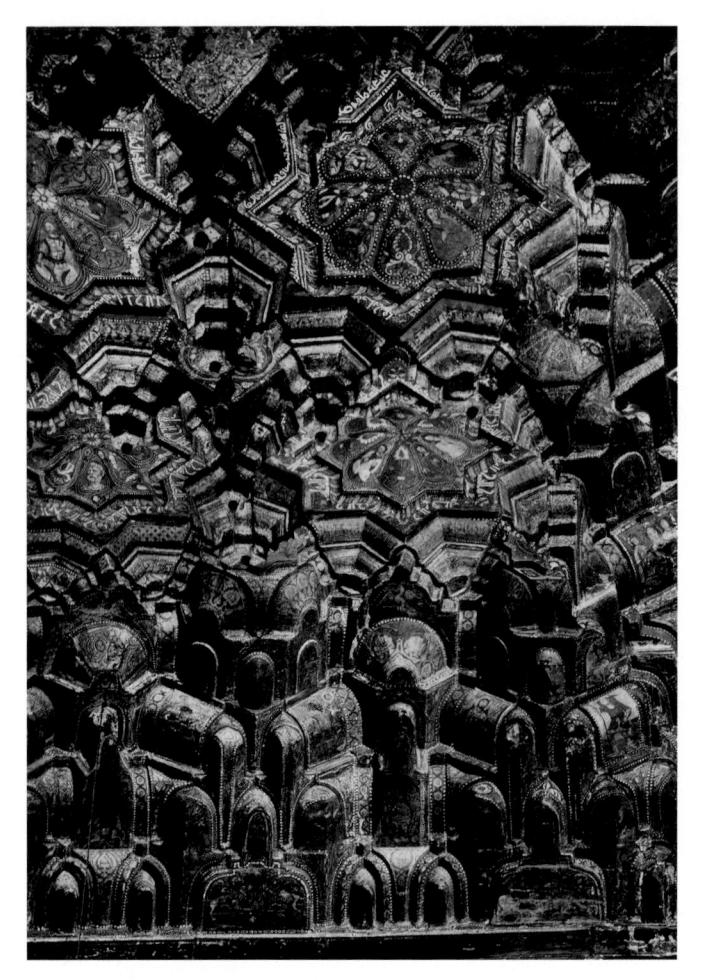

6.23 Cappella Palatina, ceiling of nave, 12th century, wood painted and gilded, Palermo.

mitted defenders to slaughter the trapped invaders almost at will.

A spectacular decorative form invented by Islamic architects in the eleventh and twelfth centuries is the muqarnas, or "stalactite," vault or ceiling [6.23], an ingenious system of corbels and squinches. The vault may be built of masonry or wood and is often purely decorative. Concentric rows of concave cells are corbeled out one above another in an interlocking triple squinch so that the vertical axes of the cells alternate and the upper seem to grow out of the lower. The weight of a muqarnas vault over a square bay does not rest on the corners of the square but on two points along each wall—that is, on the eight points of an octagon inscribed within a square plan. The completed honeycomb-like structure is typically Islamic in its intricate geometric design and its disguise of underlying logic by a dizzying multiplication of forms. Muqarnas could be used structurally in ceilings and vaults and decoratively in marble, plaster, and tile on capitals and wherever architectural decoration was called for.

A wooden muqarnas ceiling covers the Norman Palace Chapel in Palermo. Fatimid artists working for the Normans painted the ceiling with foliate forms, calligraphy, and stylized scenes of court life. Muhammad had promised the faithful eternal bliss in a garden of earthly delights, described in the most sensual, physical terms. Islamic artists lavished attention on secular art and architecture, on material comforts and conveniences, and on worldly display.

THE DECORATIVE ARTS

Muslim artists excelled in the production of luxury objects. They achieved extraordinary effects all the while using inexpensive, impermanent materials brick, wood, clay, and textiles. The transformation of simple materials into objects of delicate beauty, the concentration on the decorative arts, and the elevation of crafts to a position of honor are characteristic of Muslim art.

Fine writing, that is, calligraphy, became a Muslim specialty [6.24]. As the authentic word of Allah, given to Muhammad by the archangel Gabriel, the Koran inspired a superb nonfigural art. No definite prohibition against images is found in the Koran, but a strong iconoclastic party existed in Islam. Nothing in Islam, however, equals the vehemence of Hebrew prohibitions against images (for example, Isaiah 44:9-20). Muslim scribes focused on fine writing with decoration formed by geometric patterns and the abstract floral interlace known as arabesque. Their work influenced all the arts.

Calligraphy played an important role in the decoration of ceramics [6.25]. One of the most remarkable and characteristic achievements of Muslim artisans in the ninth and tenth centuries was the development of ceramics—the conversion of a

6.24 Kufic script, 9^{th} - 10^{th} centuries. Black and gold on vellum, 8 1/2 x 21in. (21.6 x 53.3cm). The Nelson-Atkins Museum of Art.

base material like clay into a work of art. Inspired by Chinese porcelains coming into the Middle East along the trade routes, Muslim artists developed their own distinctive variations. A prohibition against the use of precious metals may have led the patrons to demand a substitute and the potters to invent luster. In luster painted ware, the potters covered a fine white ceramic body with a transparent glaze, and then after firing, painted the decoration of calligraphy, interlaces, foliage, and birds or animals on the surface with metallic glazes. A second firing resulted in a shining metallic surface. Luster painted ware became one of the glories of eleventh- and twelfth-century Muslim art. On an eleventh-century lidded bowl from Syria, decorated with birds, foliage, and calligraphy, the inscription reads "Patience means power; he who is patient is strong. Trust [in God] is what one needs."

Islam required the union of the individual will with a universal, all-pervasive God, achievable through contemplation and the performance of a fixed ritual. Likewise, art expressed Islam through the submergence of individual forms by means of an infinite multiplication of identical elements. This desire for infinite extension in space provides powerful symbolic associations. The geometric basis of forms and ornaments and the subjection of nature to mathematical figures characterizes early Islamic art.

6.25 Lidded Bowl (Pyxis), Syria, second half of the 11th century. Composite body with white slip, glazed and luster-painted. Height 8in. (20.3cm). The Metropolitan Museum of Art.

The decoration of fine metalwork expresses these ideals. Muslim craftsmen perfected techniques of engraving and metal inlay, known today as damascening. Splendid utensils, such as a large silver inlaid brass ewer from Syria [6.26], display

6.26 Inlaid brass ewer, Syria. 1232, Freer Gallery

this sophisticated technique. The silver forms an all-over pattern, sweeping over the body and neck of the vessel, and forming pointed ovoids framing an intricate abstract floral arabesque. The inscriptions tell the viewer that Qasim ibn Ali made the piece in 1232.

No less splendid are Muslim textiles. Patterned silks were produced by both Byzantine and Muslim weavers working around the eastern Mediterranean. Techniques and patterns are so much alike that experts often cannot agree on the place and date of manufacture [see 6.8]. The silk with roundels of elephants, senmurvs, and winged horses has been attributed to both Byzantine and Muslim weavers and dated between the eleventh and twelfth centuries.

The demand for Eastern textiles in western Europe meant that merchants carried silks and brocades across the continent. An inventory from St. Paul's Cathedral, London, made in 1245 lists Eastern silks with eagles, griffins, elephants, lions, trees, and birds. Sphinxes attacked by lions, slim stylized trees, and eight-pointed stars were also worked into patterns or repeated medallions. Such textiles provided Western artists with a veritable encyclopedia of decorative motifs. Silk weavers continued to use the traditional patterns well into the fourteenth century.

Islamic art often seems to present insoluble contrasts, for it may appear to be at the same time rational and anti-rational, earthbound yet otherworldly. Artists did not aim to re-create the appearance of life; instead they based their aesthetic principles on geometry. The expression of the complexity of growth from within, rather than dependence on the observation of external manifestations in nature, characterizes the Islamic use of forms. Intricacy seems to have been appreciated for its own sake. Artists gave their work symmetry without emphasis. The Islamic attitude toward the arts is perhaps best seen in the decorative arts. In the decorative arts, the ornamentation of the forms converts the simple shape or material into something beyond itself, just as the application of luster glaze transforms humble clay into the illusion of shimmering gold.

No attempt has been made here to trace the history and development of Islamic art, for this history deserves a special study. The buildings and objects discussed here, selected because they are of the kind possibly known to Christian artists, can only hint at the riches of a great culture. The struggle between Islam and Christianity both in the Byzantine East and the Latin West continued throughout the Middle Ages. The contact, although sometimes antagonistic, led to valuable cross-fertilization in art.

THE NORMAN KINGDOM IN SICILY: A UNIQUE CASE STUDY

When Roger established his administrative headquarters in Palermo, he was making a political statement, for Palermo had been the Muslim capital of Sicily. Roger succeeded in uniting the diverse population of Normans, Byzantine Greeks, Latins, and Muslims (300 mosques are reported to have existed in Palermo in Roger's time). Unity in diversity led to unprecedented prosperity for the

6.27 Christ the Lord (Pantokrator), cathedral at Cefalù, 12th century. Apse mosaic. Sicily.

next three generations. The Kingdom of Sicily enjoyed a measure of peace, stability, and well-being unknown in the rest of Europe.

At Cefalù on the Mediterranean coast east of Palermo, Roger II founded a church to serve as a dynastic pantheon [6.27]. In 1132 he commissioned mosaics for the church and imported materials and artists from Constantinople. Artists had to adapt the iconographical scheme developed for domed buildings to the apse of a basilica. With the ceremonial and aesthetic focal point in the apse rather than a central dome, the designers moved the image of the Pantokrator to the semi-dome of the apse and the angels to the vault of the sanctuary. Still adhering to the principle that the larger and higher the figures, the greater their sanctity, the mosaicists placed Mary and the archangels under Christ but above rows of apostles-all in superimposed registers on the curving wall.

In decorating the sanctuary, the artists compensated for the large surfaces to be covered and the distance of the images from the spectator by increasing the figure size. They simplified shapes and modeled in broad zones of flat color intensifying the colors of the mosaic. With tonal modeling almost abandoned, faces and draperies became a stylized network of color bands. Extravagant use of gold glass tesserae meant that the radiance of gold spread over architecture and figures alike-from the acanthus capitals of the framing colonnettes to the gold-shot robe of Christ. The final effect is of static figures, whose very stillness creates a serene spirituality. The Cefalù Christ has a kindly dignity, in contrast to the terrifying Pantokrator of Daphni. Even His blessing seems more welcoming, and His open book proclaims in Greek and Latin, "I am the light of the World" (John 8:12).

While Cefalù Cathedral was still under construction, King Roger commissioned a palace and chapel in Palermo [6.28]. The Norman palace has continued in use as the center of government to our own day, housing the Sicilian Parliament. In spite of over 800 years of remodeling to meet new needs, parts of the Norman palace survive.

The Norman chapel was consecrated in 1140, although the craftsmen only finished their work during the reign of William II, the Good (1166-1189). The architecture and decoration of the Palace Chapel captures the spirit of the ecumenical Norman rule. Architecturally it combines

 $\textbf{6.28} \quad \text{Palace Chapel, interior, } 12^{\text{th}} \text{ century, consecrated } 1140, \text{ mosaic } 12^{\text{th}} \text{ century, Palermo. [see ceiling 6.23]}.$

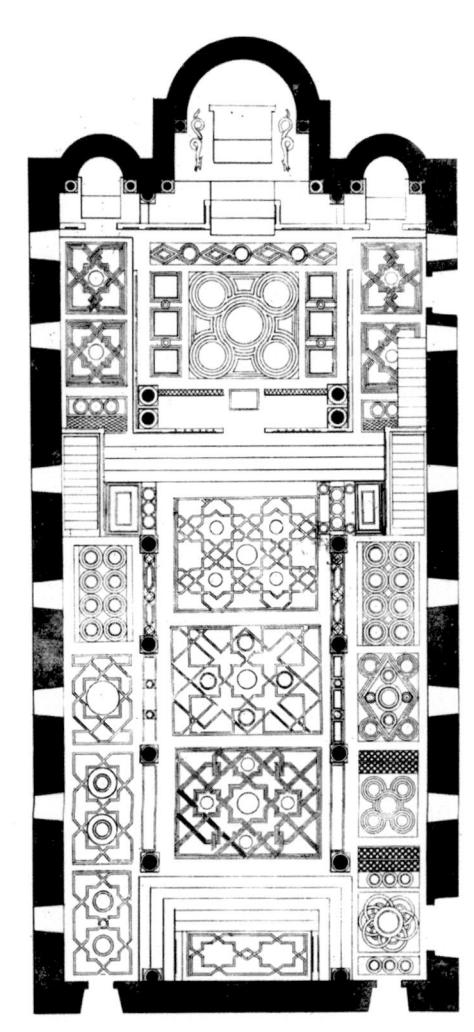

6.29 Palace Chapel, diagram of pavement after Serradifalco, Del duomo di Monreale, Palermo.

a Middle Byzantine domed sanctuary with a Western Latin aisled basilica whose nave is covered by an Islamic wooden muqarnas ceiling. On the walls of these diverse structures are both Byzantine and Western mosaics. Fatimid painting covers the wooden ceiling of the nave, and Roman-style colored stone inlay, the floor.

Recently, William Tronzo has solved some of the mysteries of this unique building. He proposed two distinct and very different building phases, one under Roger II and one under the two Williams. Roger's architects built two distinct, but joined, buildings [6.29]. A Middle Byzantine

church centralized under a dome, having a sanctuary with royal box (a private balcony) at the north, gave the structure a north-south orientation. But to this Byzantine scheme, the builders attached a basilica with an east-west orientation focused on the sanctuary at its east end but also having a platform for the royal throne at the west. This portion of the chapel served as a royal audience hall. The basilica plan, the muqarnas ceiling painted with scenes of court life, and wall hangings woven with colored silk and gold thread were all appropriate for this royal hall.

The chapel stood in the center of the palace, with courtyards to the north and south. A monumental stair led to the public entrance on the southwest. The king had private access from his residence on the north either into chapel or into the royal box where he could privately participate in the Mass. Some evidence suggests that the queen and her ladies also had a private area in an upper room.

In the chapel, the sanctuary mosaics followed the typical Middle Byzantine scheme—the Pantokrator in the dome supported by angels, the four Evangelists in the squinches, and the Feasts of the Church represented on the vaults and walls. The mosaics on the south wall, which King Roger would have faced, emphasized themes of power and glory—Christ's triumphant entry into Jerusalem and his Transfiguration [6.30]. Here a second image of the Pantokrator fills the space under the vault and a complex Nativity scene covers the wall. The two scenes are united by the metaphor of light, for the open book with its message "I am the Light of the World" is joined to the Christ Child. It is placed directly over the huge star, whose beams lead straight to the altar-like manger crib. Emphasizing the theme in words as well as pictures is a poetic inscription; the star leads the world to the divine light, which appears on earth as the newborn child of Mary.

A Western love of narrative detail pervades the scene of the Nativity. All action revolves around Mary and Jesus with Joseph observing pensively from the lower left hand corner. Mary reclines on a large mattress in a cave—a Byzantine conven-

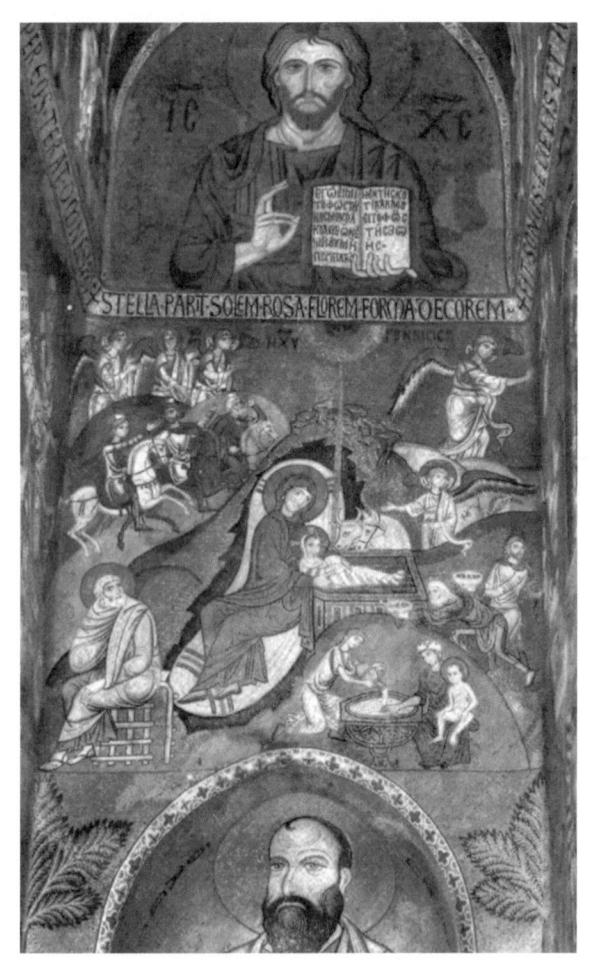

6.30 Palace Chapel, mosaics of east wall of southern transept arm: St. Paul, Nativity, and Pantokrator. Palermo.

tion—and the ox and ass (symbolizing the Jews and Gentiles) adore the child. Below, the two midwives prepare to bathe the baby (Jesus appears for the second time), and the withered hand of the woman who doubted the virginity of Mary is miraculously restored. The three magi gallop through a mountainous landscape led by gesturing angels and the huge star. The magi appear a second time delivering their gifts. Angels in the upper right corner direct the spectator's gaze to the adjoining south wall where the shepherds are tending

flocks of sheep. The sheer exuberance of the figures energizes the surrounding space and draws the viewer into the drama.

This very elaborate mosaic decoration would have been nearly invisible except to people in the south aisle. Tronzo proposes that it played a part in the ritual of homage to the king. The courtiers or ambassadors mounted the stairs from the courtyard and entered the chapel through the door in the south aisle where they turned and walked up the south aisle—at which time the Pantokrator and Nativity mosaics would have been their visual focal point. They turned again to move into the nave, where they would see the king enthroned against the west wall of the chapel. The patterns of the magnificent colored stone floor reinforce the idea of this processional path.

Roger's son William I (ruled 1154-1166) and grandson William II (ruled 1166-1189) turned the royal hall into the nave of the church we see today. They added mosaics in the nave that were Western in style and subject—Old Testament narratives on the clerestory walls and the lives of Sts. Peter and Paul on the aisle walls. They also elaborated the throne and added the church furniture, including a notable sculptured Easter candelabrum. They left untouched the muqarnas ceiling [see 6.22], perhaps because its star patterns suited the theme of heavenly light and the promise of paradise—or perhaps they simply respected Roger's taste—and did not look too closely at the imagery.

The Norman rulers of Sicily brought together the diverse streams in medieval art. Their architecture is both western European and Byzantine. Their mosaics provide a splendid record of late Komnenian art and also illustrate Western interpretations of the style. The muqarnas ceiling of the palace chapel provides evidence of Muslim woodworking and painting. The floors, church furniture, and Easter candlestick exemplify the Romanesque style (see Chapter 8) in southern Italy.

A Royal Palace

Rarely can one experience the ambience of a medieval royal hall. Bare stone walls may suggest the size and arrangement of spaces, but without paintings, textile hangings, and furniture, and without courtiers resplendent in brocades and jewels, the rooms are merely dingy shells. In the Norman palace in Palermo, the mosaics in the vault and on the upper walls of a royal chamber remind us of the exuberant imagery and brilliant color that once surrounded the king and court. According to a letter written during the reign of William II, this room was used for relaxation and receptions.

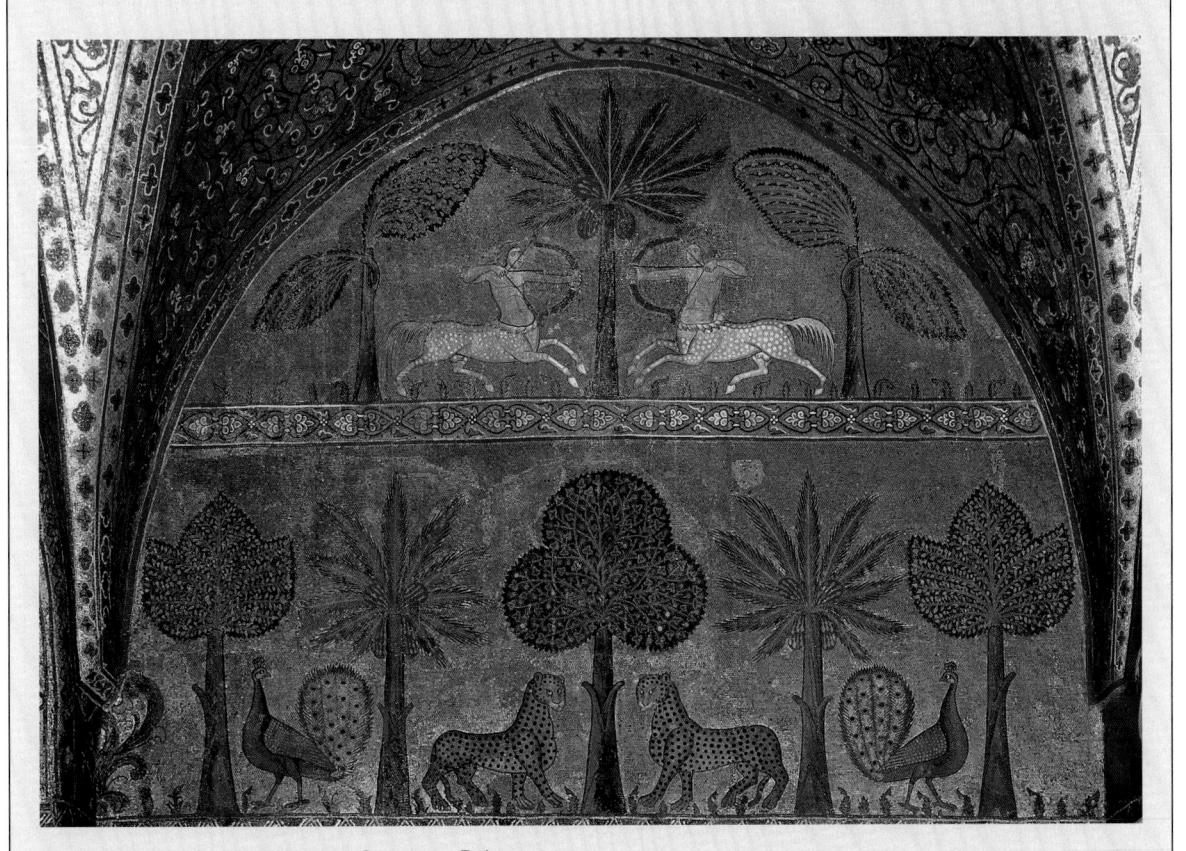

Norman Palace, Norman Stanzam, Palermo.

Like the Palace Chapel, the room was probably built by Roger II but decorated by William I. Centaurs, animals, and trees turn it into an imaginary royal hunting park, literally a paradise (the word "paradise" comes from the Persian word for such a park). The symmetry, simplified geometric forms, and flat bright colors of the figures are all associated with Near Eastern taste. Clipped trees and palms, regal lions, leopards, and peacocks, and hunting centaurs are silhouetted against a gold ground. Symmetrically arranged in confronted pairs, the images seem frozen in time and place. [6.31]

The Imperial Ideal: Early Medieval Reactions to Ancient Rome

All around the Mediterranean Sea- not only in Rome itself but from the provinces of the Near East to the mountains of the Iberian peninsula, even north to the bleak moors of Britain—massive walls and collapsing vaults rising above the ever encroaching wilderness proclaimed the might of the once great Roman empire. The pagan world had come to an inglorious end, to be replaced by a new Christian era, or so many thought. Earlier, the Jewish people had fought the Romans for the right to worship one God; and later, Muslims proclaimed their faith in Allah throughout lands once held by Rome. Christian rulers in Western Europe, who were themselves not far removed from their barbarian pagan ancestors, believed that they could establish a new Rome. Crowned by the Pope, Charlemagne in 800 and later Otto, in 1000, claimed to follow the first Christian emperor Constantine with an imperial authority approved by God.

While Charlemagne and Otto might intend to revive the Empire, the Byzantine emperors thought themselves to be the heirs of Rome. Was not their great city Constantinople the New Rome, established by Constantine? Did not their court ceremony and the liturgy of their worship hark back to the earliest Christian empire? Under Justinian and Theodora's patronage, their great church dedicated to the Holy Wisdom of God, Hagia Sophia, rivaled any ancient imperial building. Constantinople was the seat of classical learning and art, as well as government. At the end of the Middle Ages the city and the Byzantine Empire fell at last to the Muslims and Hagia Sophia became a Muslim prayer hall, a mosque. But during the Middle Ages, the East - first as the Byzantine Empire, and later as part of the Islamic world – stood as a model for luxury arts and splendid architecture, and of lavish enlightened patronage.

The distinctive quality of early medieval art in the West was more than a blend of the imperial styles of ancient Rome and Byzantium. Motivating artists and patrons was a powerful tradition in the visual arts going back to the original Celts as well as the incoming migrating peoples from the north and east. The fertile mix of styles brought an entirely different visual tradition in which geometric patterns and fantastic beasts rather than humans cover small precious intricately worked objects. When they looked at the surviving Roman walls, they imagined them to have been built by giants and magicians. The sophistication of their carpentry is demonstrated by the design and construction of their ocean going ships. By the 9th and 10th centuries Vikings challenged the continental empires, and when Otto was crowned in Rome they were crossing the north Atlantic to North America - their Newfoundland.

Earlier Charles the Great - Charlemagne - had begun a self-conscious revival of Roman culture. Charlemagne himself looked to Theodosius and Constantine, to King David and other Old Testament heroes. From his court at Aachen he ordered monumental masonry architecture, basilican churches, bronze sculpture, mosaics, and mural paintings. Books were to be written in a legible script based on Roman inscriptions, and the desire to communicate visually as well as verbally meant a revival of narrative art with human actors. Charlemagne's empire did not survive, but by the year 1000 another empire had been established in the Germanic lands. Centered first in the Rhineland but soon extending east into today's Germany and also south over the Alps into Italy. In Rome the German imperial palace stood on the Aventine Hill next to the Early Christian Basilica of Sta. Sabina, whose carved wooden doors inspired Abbot Bernward to create doors with Old and New Testament scenes for his church in Hildesheim.

Rome, the city of the Caesars, was replaced by the City of God and the House of the Lord - Paradise - whose glory was suggested by the buildings of the Church. The highest quality art and architecture came to be made for Christian service. The Church became the focus of the people's aspirations and the recipient of their treasure, their energy and skill, their imagination even while Rome survived as an inspiration and perhaps a cautionary tale.

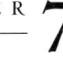

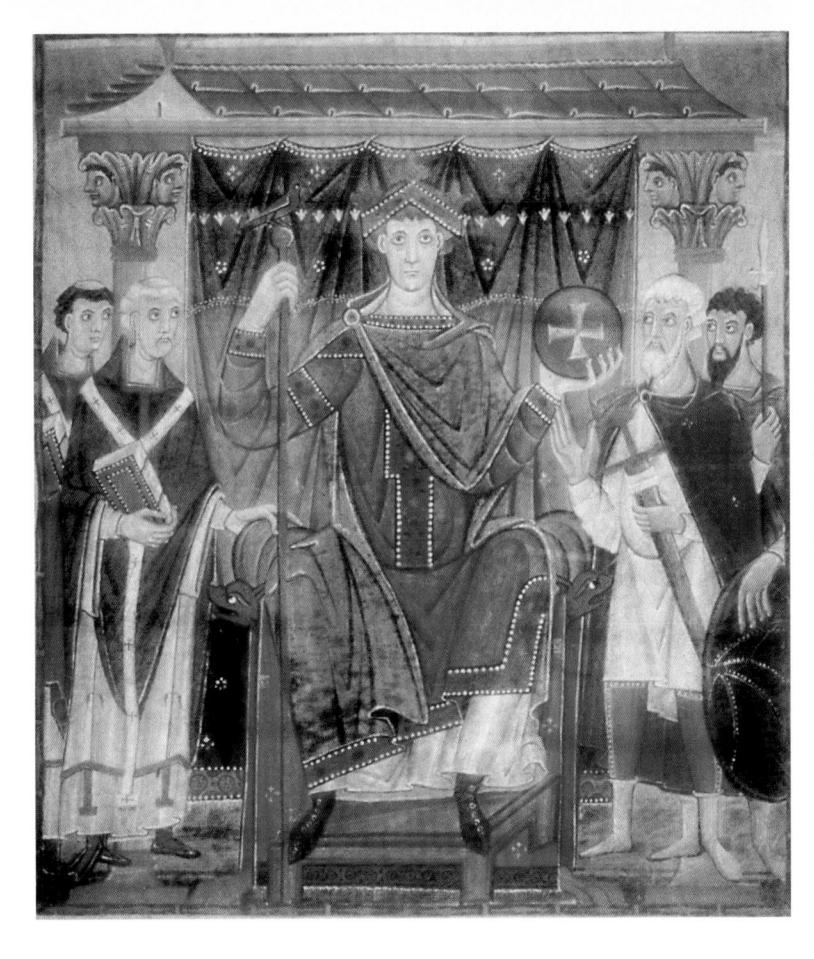

7.1
Otto III between
representations of Church
and State. Gospel of Otto
III. Richenau?, c. 1000.
Vellum, 13 1/8 x 11 1/8in.
(33.4 x 28.3cm). Bayerische
Staatsbibliothek, Munich.

CHAPTER

ART AT THE MILLENNIUM

The Imperial Tradition Continues

mperor Otto III, enthroned between representatives of ecclesiastical and lay authority—Bibles at his left and swords and lances at his right—wears the huge jeweled crown of the empire and holds the eagle-topped staff of command and the cross-inscribed orb symbolizing the Christian world [7.1]. Otto commands the loyalty of the people of the empire he inherited from his father, Otto II, and grandfather, Otto the Great. Dressed in imperial purple and seated in a royal hall in front of a magnificent cloth of honor, Otto recalls in this portrait earlier images of power, such as the Missorium of Theodosius. Like Theodosius, the emperor looms over both elderly advisers and youthful supporters, his importance emphasized by

the painter's use of hieratic scale. Even more than external symbols, the abstract style of the painting—severe, monumental, with simplified contour drawing, schematized forms, and brilliant color and gold—creates an aura of power. Otto was leading a new Christian empire.

The Carolingian Empire had disintegrated in the second half of the ninth century, leaving two rivals competing for world domination—the Orthodox Byzantines and the Muslims [7.2]. By mid-tenth century a revitalized Western Catholic Europe again challenged the East, as religious and political leaders began to gather power and territory, inspired by the dream of re-creating imperial Rome. They stopped the Muslim advance into continental Europe and

tine Empire (c. 1030) Empire (c. 1030) K. or SWEDEN A NG LO DANG PRINCIPALITIES P. of ATLANTIC OTTONIAN POLAND K. of OCEAN EMPIRE FRANCE K, OF K. of LEON MUSLIM PRINCIPALITIES (ALMORAVIDS) FATIMID

7.2 Map of the Empires and spheres of influence c. 1030.

pushed forward the reconquest of the Iberian and Italian Peninsulas. Masons in northern Italy and Catalonia revived masonry building techniques to establish a common architectural style around the Gulf of Lyons. This Lombard-Catalan style spread northward across geographical and political boundaries to form an international masons' style. Meanwhile the Benedictine monks from their center at Monte Cassino, and later the reformed Benedictines at Cluny in Burgundy, created an international monastic state more powerful than the papacy in Rome. At Monte Cassino (founded 529), which had been devastated by the Muslims, the community rebuilt and reached a height of splendor in the eleventh century under Abbot Desiderius (1058-1086). Meanwhile in Burgundy the Cluniac reform, from its beginning in the tenth century, spread rapidly through France, Germany, England, Spain, and Italy to form the Congregation of Cluny, a monastic empire under Abbot Hugh of Semur (1049-1109). In the far north, Anglo-Saxons and Danes fought for the British Isles until Canute the Great (c. 995–1035)

united Scandinavia and the Isles in a short-lived North Sea Empire. In Germany, Otto the Great (936-973) gathered political strength to revive the Carolingian dream of empire. Otto defeated Vikings and Magyars, established secure frontiers, and gained control over Germany and Italy. The Pope in Rome crowned him emperor, a hollow title held by his son and grandson. As movements toward European unity died out, emperors gave way to national kings and feudal lords, great abbots and priors to the pope and his archbishops, and the masons' building style to local and regional art.

Europe in the year 1000 may have been in fact a poor land with people living a precarious existence, but some men in the church and the state determinedly and creatively brought people together and ruled with skill and authority. In the tenth and eleventh centuries, abbots and bishops, kings and emperors supplied the motivation and economic resources to create enduring works of art. The arts and architecture embody their goals and aspirations.

ASTURIAN AND MOZARABIC ART IN SPAIN

When they consolidated their holdings in the Iberian Peninsula, the Muslims made the mistake of leaving two isolated pockets of Christian resistance in the north—the tiny kingdom of Asturias on the Cantabrian coast and the county of Catalonia (Charlemagne's Spanish Marches) in the east. Although the Moors (as the Muslims in Spain came to be known) allowed the Christians to live and worship in peace after paying special taxes, Reconquista—"reconquest"—was the ever-present Christian dream. Reconquista had its spiritual leader in St. James the Greater (Santiago), who was believed to have brought Christianity to the Iberian Peninsula and to have been buried in Galicia after his martyrdom in Ierusalem.

According to medieval Christian belief, in 813 a shepherd led by a miraculous star discovered St. James's tomb. The local bishop, Teodomiro, and King Alfonso II erected a church over the site in the place now called Santiago de Compostela. The tomb of the apostle became a center of pilgrimage, which by the twelfth century rivaled the tomb of St. Peter's in Rome and the Holy Sepulchre in Jerusalem. The badge of the pilgrim to Compostela was the scallop shell, because it was said that St. James miraculously saved a drowning horseman, who rose from the waves covered with scallop shells.

The Christian kingdom of Asturias reached its height of power in the ninth century under Alfonso II (791-842), Ramiro I (842-850), and Alfonso III the Great (866-910). Alfonso II made Oviedo his capital. He built a fortified city and palace complex there, even though his meager economic resources prevented him from replicating Carolingian Aachen or Muslim Córdoba. A second royal complex arose on Naranco, a low mountain outside Oviedo. The present church of Sta. María de Naranco, whose altar was dedicated in 848, originally served as a royal audience hall [7.3]. This change of function from hall to church explains

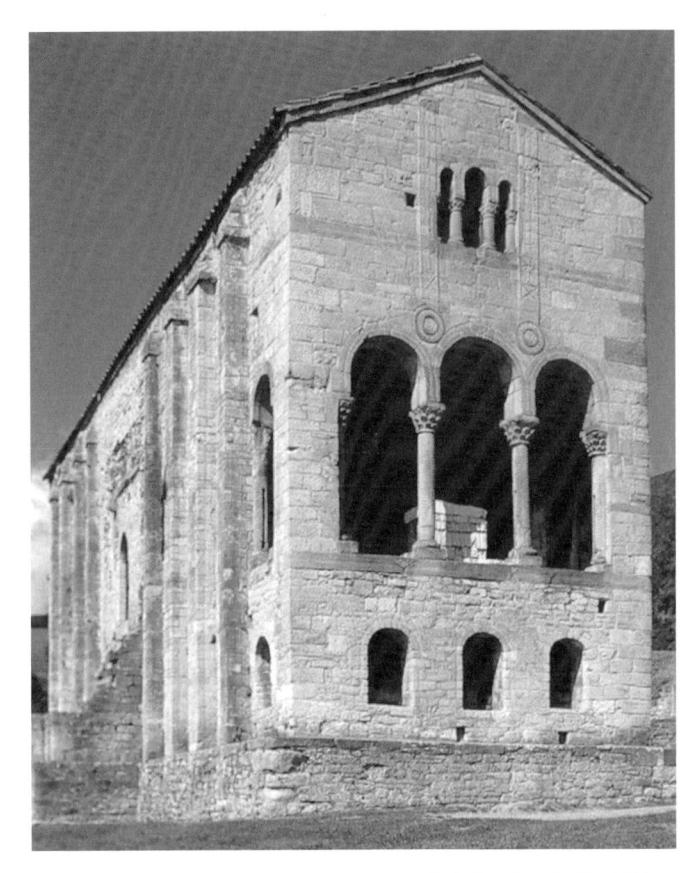

7.3 Church of Sta. María de Naranco. Oviedo, first half of 8th century.

the unusual design, a simple rectangular building divided into three sections at each of its two levels. The upper story, twice as high as the lower, consists of a long hall with a loggia at each end. Central doors pierce all four walls. On the north a double stairway gave access to the entrance vestibule, and on the opposite side, corresponding to the vestibule, there was once another loggia suitable for public appearances by the monarch. The ground floor housed a bath and rooms of unknown use.

The difference between a patron's dreams and an artist's ability, so often seen in medieval art, is apparent here. The patron's will to overcome all obstacles is nowhere more evident than in the architectural projects commissioned by the Asturian kings. Remarkably enough, the masons maintained the technical skills needed to build masonry walls and vaults. Barrel vaults reinforced by transverse arches cover both upper and lower rooms. Exterior strip buttresses reinforce the thin ashlar walls and support the vault of the hall.

Although sculpture at Naranco lacks the finesse of the architecture, its presence reveals the patron's desire for monumental decoration. Bands in low relief punctuate the face of the loggia and terminate in roundels set within the spandrels of the arches, a decorative device known in late Roman architecture. But in the hands of local craftsmen, the spiral columns of the loggias become flaccid and ropelike, denying their supporting and stiffening functions. In a reference to Roman decoration, the flat, spatula-like leaves of the capitals retain a distant resemblance to Corinthian capitals, and the strip buttresses are grooved to suggest pilasters. In spite of the simplicity of the forms, Asturian architecture and sculpture suggest that a wide network of artistic connections existed in the ninth century.

MOZARABIC ART IN NORTHERN SPAIN

Christian warriors rapidly pushed southward into Muslim territory. In 930, they established their headquarters at Burgos in Castile. By 1085, Alfonso VI of Castile captured the former Visigothic and later Muslim stronghold of Toledo, which he made his new capital. The constant interchange between people, even though often unfriendly, created a taste for sophisticated Moorish art among the Christians; furthermore, as Christians from the south moved into conquered lands in León and Castile, they brought with them a knowledge of Moorish arts and crafts. They created a distinctive blend of Christian and Muslim art known as the Mozarabic style, from the Arabic must'arib, Arabicized.

At the beginning of the tenth century, Alfonso the Great invited Christians living under Muslim rule to move north and resettle newly conquered lands in León. One of these refugee groups, a Benedictine community from Córdoba, founded a monastery at Escalada [7.4]. The church, dedicated in 913 to St. Michael, is a typical basilica; however, the Mozarabic builders used the Cór-

Mozarabic and Mudejar Art

Mozarabs were Christians living in Moorish Spain. They adopted some characteristics of Muslim art: in architecture they used horseshoe arches and colorful ceramic tiles (azulejos); in painting and the decorative arts they emphasized colorful abstract patterns. The Beatus manuscripts are typical—the painters use a Muslim style to express Christian content. Even when the Mozarabs moved to lands under Christian rule, they continued this distinctive style. Mozarabic art usually dates from the tenth and eleventh centuries. In Mudejar art, the situation is reversed; here Muslims or Muslim-trained artists are working for Christian or Jewish patrons. Mudejar architecture is characterized by elaborate decorative brickwork, colorful tiles, ribbed vaults, and pointed horseshoe arches. Mudejar art can be found in the fourteenth and fifteenth centuries, especially in the Kingdom of Aragón and in the formerly Muslim lands of southern Spain. Jewish artists in Spain often worked in the Mudejar style [see 11.26].

doban horseshoe arch in both the plan and the elevation of the building. Not only are the nave arcade, the sanctuary screen, and the exterior porch built with horseshoe arches, the three rooms of the tripartite sanctuary are horseshoe in plan. The timber roof permitted a light, open nave; and slender columns support rubble and mortar walls pierced by large clerestory windows.

The present austere appearance of S. Miguel de Escalada results from modern restorations. Originally the interior was painted, hung with rich, patterned textiles, and filled with hanging lamps and patterned screens. The sanctuary screen, hung with curtains, functioned like a Byzantine iconostasis, hiding the altar and officiating priests from view. (The Mozarabic liturgy resembled the Byzantine in its emphasis on the mystery of the sacraments.) Azulejos, the glazed tiles popular in Muslim architectural decoration, may also have been used by the Christian builders on the walls.

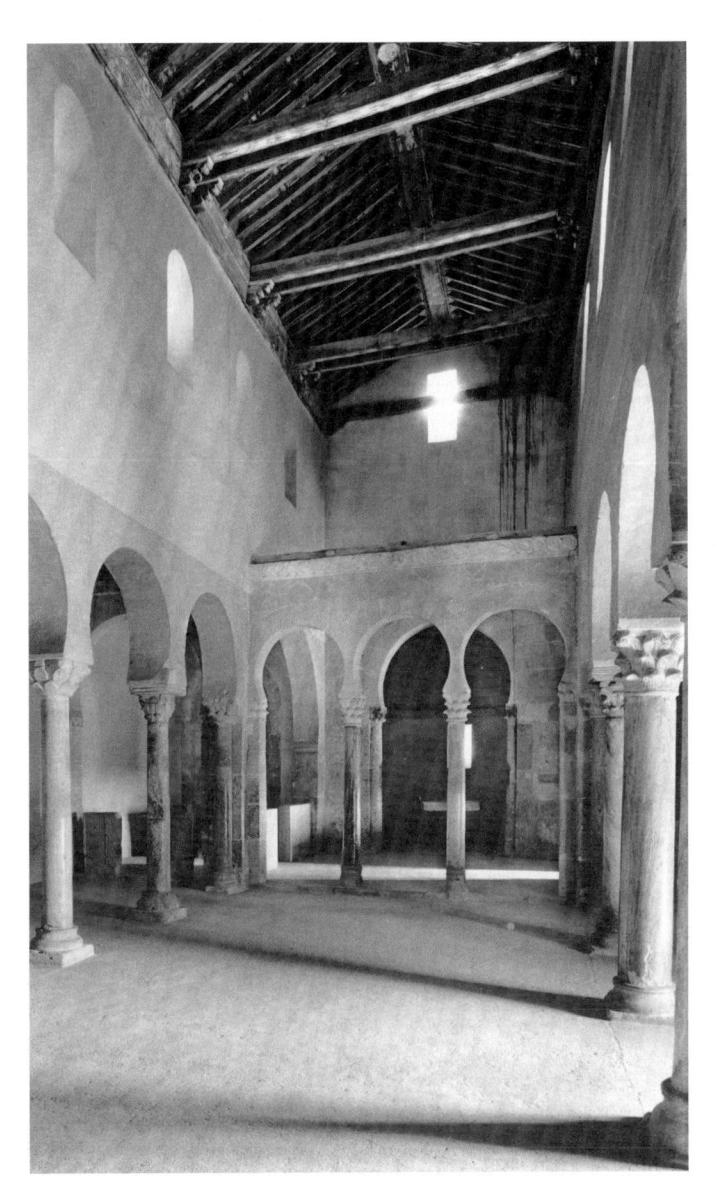

7.4 Interior, S. Miguel de Escalada, circa 913.

The colorful effect of tenth-century structures is recorded in contemporary manuscripts. In the Tábara Apocalypse, Emeterius and Senior represented themselves and their parchment cutter at work in a scriptorium adjacent to a five-story tower [7.5]. Emeterius renders the interior and exterior of the buildings simultaneously, the better to reveal the bustle of activity—the bell ringers, climbing men, and busy scribes—as well as the brilliantly colored tiles affixed to the walls. Emeterius also tells us that the tower was of stone.

The view of the scriptorium at Tábara bears witness to the importance of book production in Mozarabic monasteries. In the tenth and eleventh centuries an extraordinary school of painting arose, centered in the province of León. Mozarabic scribes not only signed their works but also included the names of patrons and painters, the date of completion, and even brief notes, prayers, and appeals for appreciation in endnotes, called colophons. According to its colophon, the Tábara Apocalypse was begun by "the worthy master painter" Maius from Escalade. When Maius died in 968, his student Emeterius completed the book in three months, in era 1008, that is, 970 A.D. (the Spanish calendar ran 38 years ahead of the calendar in use today). Working with Emeterius and other artists at Tábara was a woman named Ende. She is identified as a

7.5 Emeterius and Senior at work, tower of Tábara, Tábara Apocalypse, 970. 14 1/4 x 10 1/8in. (36.2 x 25.7cm). Archivo Histórico Nacional. Madrid.

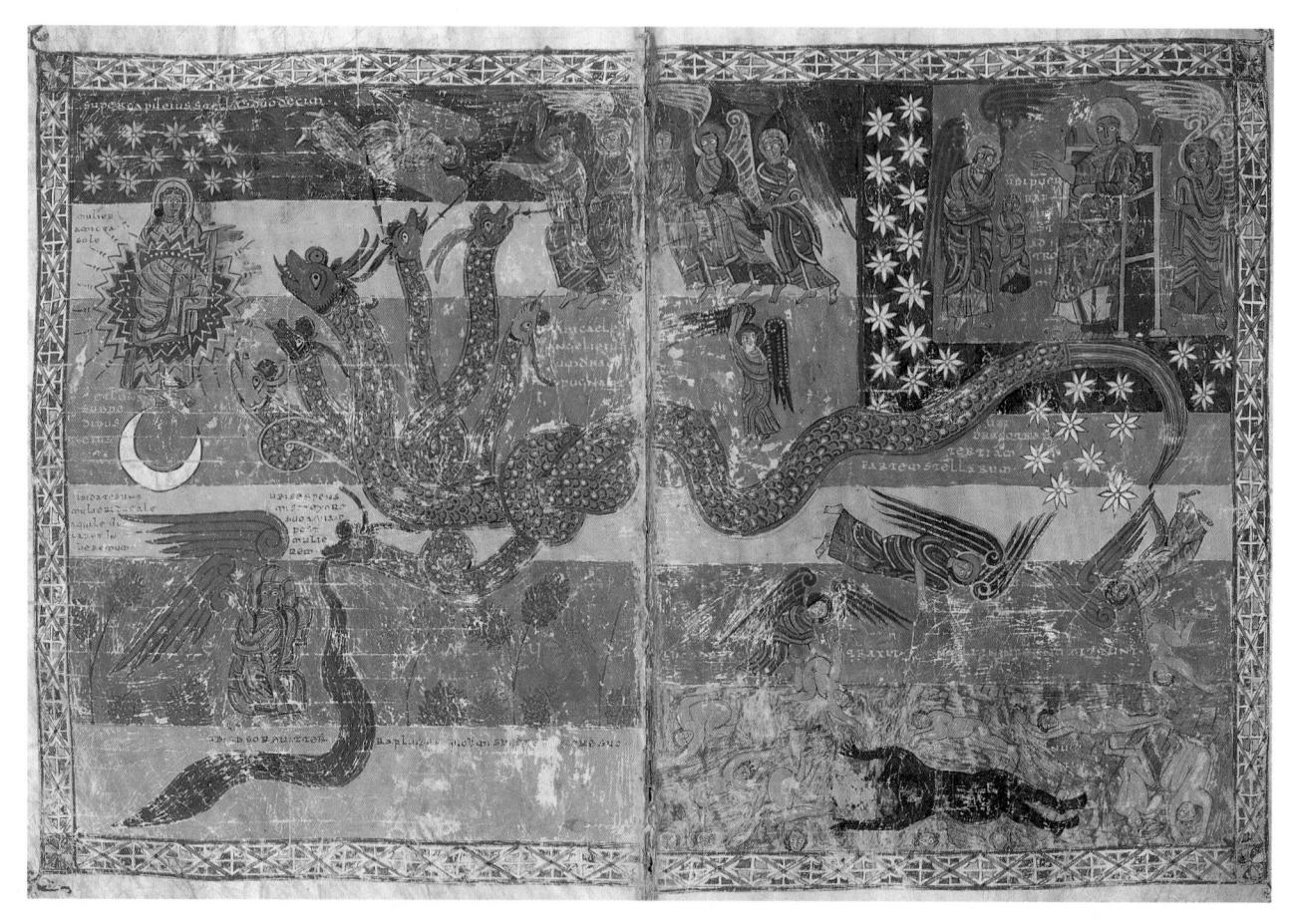

Maius, Woman clothed with the sun escaping from the dragon, Morgan Beatus, c. 940–945, 15 x 11in, (38.1 x 27.9cm). The Pierpont Morgan Library.

"painter and servant of God," one of the first women painters whose name we know. Ende signed no individual paintings; however, according to the colophon of a manuscript now in the Cathedral of Girona, she and Emeterius illuminated the manuscript and finished the work in 975.

Beatus manuscripts are distinctive products of northern Spain. Christians in Spain remained out of the mainstream of western European art. They continued to use the Visigothic liturgy, and they seemed prone to heretical beliefs. In 782, they revived an Early Christian heresy known as Adoptionism—the belief that Christ was born a man and subsequently adopted by God as His Son. The monk Beatus of Liebana (d. 798) dedicated himself to counteracting both the adoptionist heresy

and Islam. His commentaries on the Apocalypse were widely copied and magnificently illustrated.

In the tenth and eleventh centuries, Beatus' commentaries were often combined with St. Jerome's commentary on the Old Testament Book of Daniel (but now referred to as "Beatus manuscripts"). In the imagery of the end of the world destruction, suffering, and final deliverance—and the trials of Daniel, Christians evidently saw a direct analogy with the struggle to preserve the Church from heresy and to free their co-religionists from the Moors. At the monastery of Tábara, Maius finished a copy of Beatus' commentary about 940-945. An allegory of the triumph of the Church over its enemies introduces chapter 12 [7.6]. In the upper left is "a woman clothed with

the sun, and the moon under her feet, and upon her head a crown of twelve stars," an image associated with Mary and the Christ child. She is threatened by "a great red dragon, having seven heads and ten horns, and seven crowns upon his heads. And his tail drew the third part of the stars of heaven, and did cast them to the earth. . . . And there was war in heaven: Michael and his angels fought against the dragon; and the dragon fought his angels, and prevailed not; neither was their place found any more in heaven and the great dragon was cast out, that old serpent, called the Devil. . . . And the serpent cast out of his mouth water as a flood after the woman . . . and the earth helped the woman, and the earth opened her mouth and swallowed up the flood which the dragon cast out of his mouth."

In the hands of a master like Maius, the stylized, ornamental Mozarabic style accentuates the dramatic, nightmarish quality of the text. Such flights of imagination enhance the explicitness of the narration. Maius transformed the background into horizontal bands of brilliant colors and suggested landscape with a few foliage patterns. Curving, brightly hued stripes make up figures that are little more than bundles of drapery. Each face, moreover, dominated by white, staring eyes, is encircled by a colored halo. So thoroughly does the decorative system destroy an illusionistic vision that even the star-covered field of Heaven becomes a frame for frozen activity. In this way, by reducing the momentous, apocalyptic events to exotic abstractions, Maius rendered a pictorial counterpart to the visionary description of the Last Days. Nevertheless, for all its dazzling beauty, Mozarabic painting exists as an elegant and exotic style outside the mainstream of Western European art.

THE LOMBARD-CATALAN STYLE IN ITALY, FRANCE, AND CATALONIA (CATALUNYA)

Meanwhile, in the eastern Pyrenees, the Muslim incursion had been short-lived. Catalonia (Catalunya)— Charlemagne's Spanish March—had close ties to western Europe—politically to the Carolingian dy-

nasty and ecclesiastically to southern France and Italy through the Benedictine Order. The mountains became more bridge than barrier—the backbone, so to speak, of a rugged kingdom lying in both Spain and France. By 840 Catalan rulers replaced the Visigothic liturgy and script with the Roman rite and Carolingian minuscule. In the tenth century, an art and architecture developed under the patronage of the counts of Catalonia, which played an important part in the origin of Europe's mature Romanesque style [7.7].

A powerful Catalan ruler, Count Oliba of Besalu (known as Oliba Cabreto), had traveled in France and Italy. He spent a year in St. Benedict's monastery at Monte Cassino, and on his return he introduced the Benedictine order into Catalonia. His son Bishop Oliba (971-1046) kept up this contact with Monte Cassino, with the reformed Benedictines of Cluny (installed in Catalonia in 962), and with the papal court in Rome. The monk Gerbert of Aurillac exemplifies the continent-wide network of relationships at this time. Gerbert began his career in Aurillac, studied in the monastery at Ripoll in Catalonia (c. 967), moved on to Reims in northern France as head of the cathedral school, became the archbishop of Reims, then the archbishop of Ravenna, joined the Italo-German court of Otto III, and ended his days in Rome as Pope Sylvester II (999-1003).

The travels of rulers and churchmen were only partly responsible for the wide spread of the Lombard-Catalan style. Equally important were the builders themselves, masons who journeyed from project to project. They created an international brotherhood of masons and a common method of building and decoration. Lombard-Catalan architecture is clearly a mason's style, in which the primary concern was for practical, sturdy construction of walls and vaults. The building technique, in other words, determined the style. Wherever they worked, Lombard-Catalan masons built fine masonry using the most readily available materials—in the finest buildings, ashlar blocks or small split stones, but also bricks and even irregular stones or river pebbles. They developed an efficient

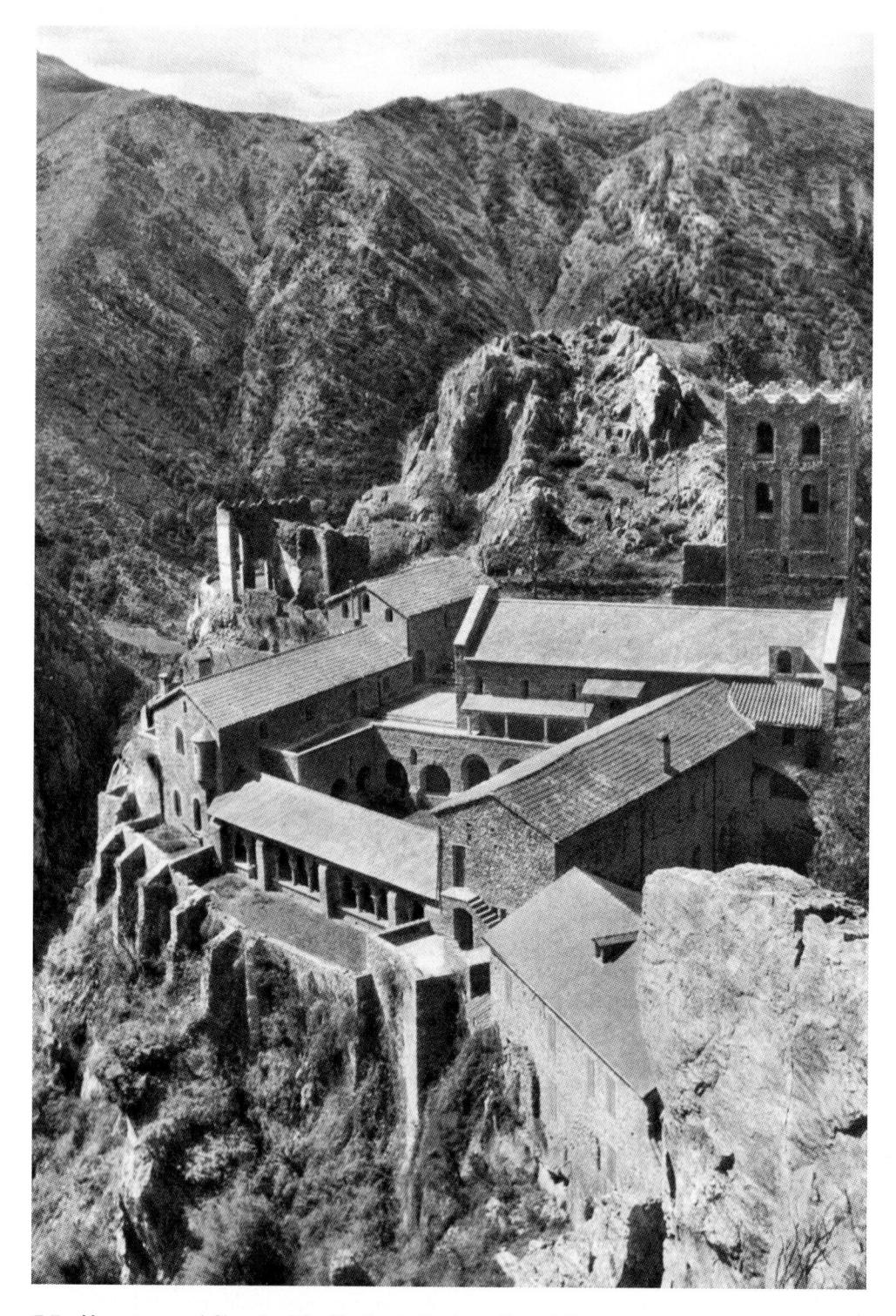

7.7 Monastery and Church of St. Martin-du-Canigou, French Pyrenees, begun 1001.
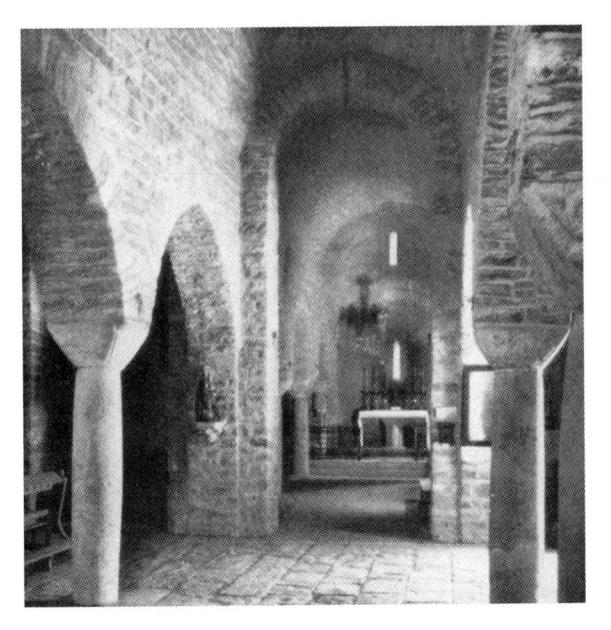

7.8 Church of St. Martin-du-Canigou, Nave, upper church, early 11th century.

technique of raising walls without using costly timber forms by laying up the facing stones set in a very strong mortar simultaneously with a rubble core. The rough masonry was invisible, for the finished walls were stuccoed inside and out. The apse of a church was vaulted, but the nave might be either wooden-roofed (usual in Italy) or vaulted (in Catalonia) [7.8]. To build the vault, the masons constructed a timber centering supported by the thick walls or short, heavy piers or columns. The removal of the centering left a distinctive shelf-like molding at the springing of the vault. On the exterior "Lombard bands" (strip buttresses) and arched corbel tables helped to strengthen the wall, and with their additional weight they buttressed the outward thrust of the vault. The distinctive appearance of buildings in this masonry technique led to an architectural style that appeared in northern Italy, southern France, and Catalonia, in fact in all the lands around the Gulf of Lyons. Although associated with the masons known as magistri comacini from Como in Lombardy, the bestpreserved buildings in this Lombard-Catalan masonry style are in Catalonia.

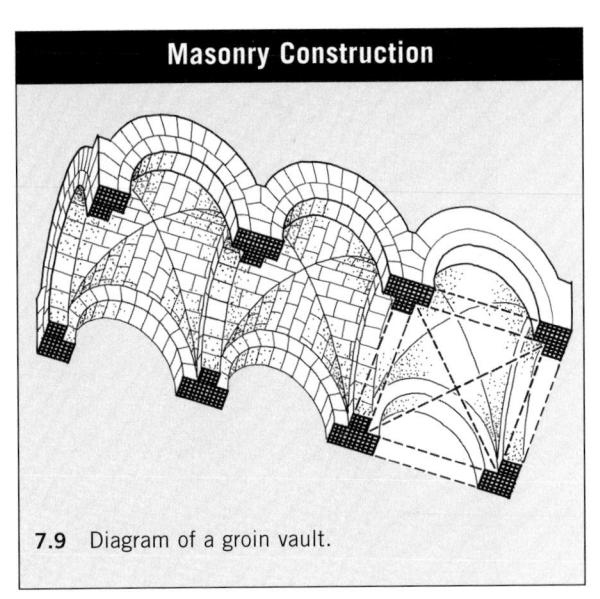

The Benedictine monastic church of St. Martindu-Canigou in the French Pyrenees is a carefully restored edifice begun in 1001 by Count Guiford of Cerdana, another son of Oliba Cabreto. In 1009, Guiford's brother, Abbot Oliba of Ripoll, consecrated the church to St. Martin, St. Michael, and the Virgin. This early structure had both barrel vaults and massive groin vaults on heavy granite columns [7.9]. A few years later the monks added an upper church (large for its time-84 feet (25.6m) long) with a barrel-vaulted nave almost 20 feet (6.1m) high. A transverse arch and compound piers collect the load and concentrate the thrust of the barrel vault and also divide the nave into bays. The masons had little regard for surface ornament or delicate carving; they established unbroken planes sweeping from the upper wall to the springing of the arch and on over the vault. In contrast to the Asturian Church of Sta. María de Naranco, no sculpture articulates the surface.

The same sense of unity, vertical division of space, and an entirely architectonic decorative system determined the exterior design of St. Martin-du-Canigou. The strip buttresses and arches seen in late Roman and Early Christian art in northern Italy (in Ravenna, for example) are joined by arched corbel tables, the additional projecting thickness at the top of the wall sup-

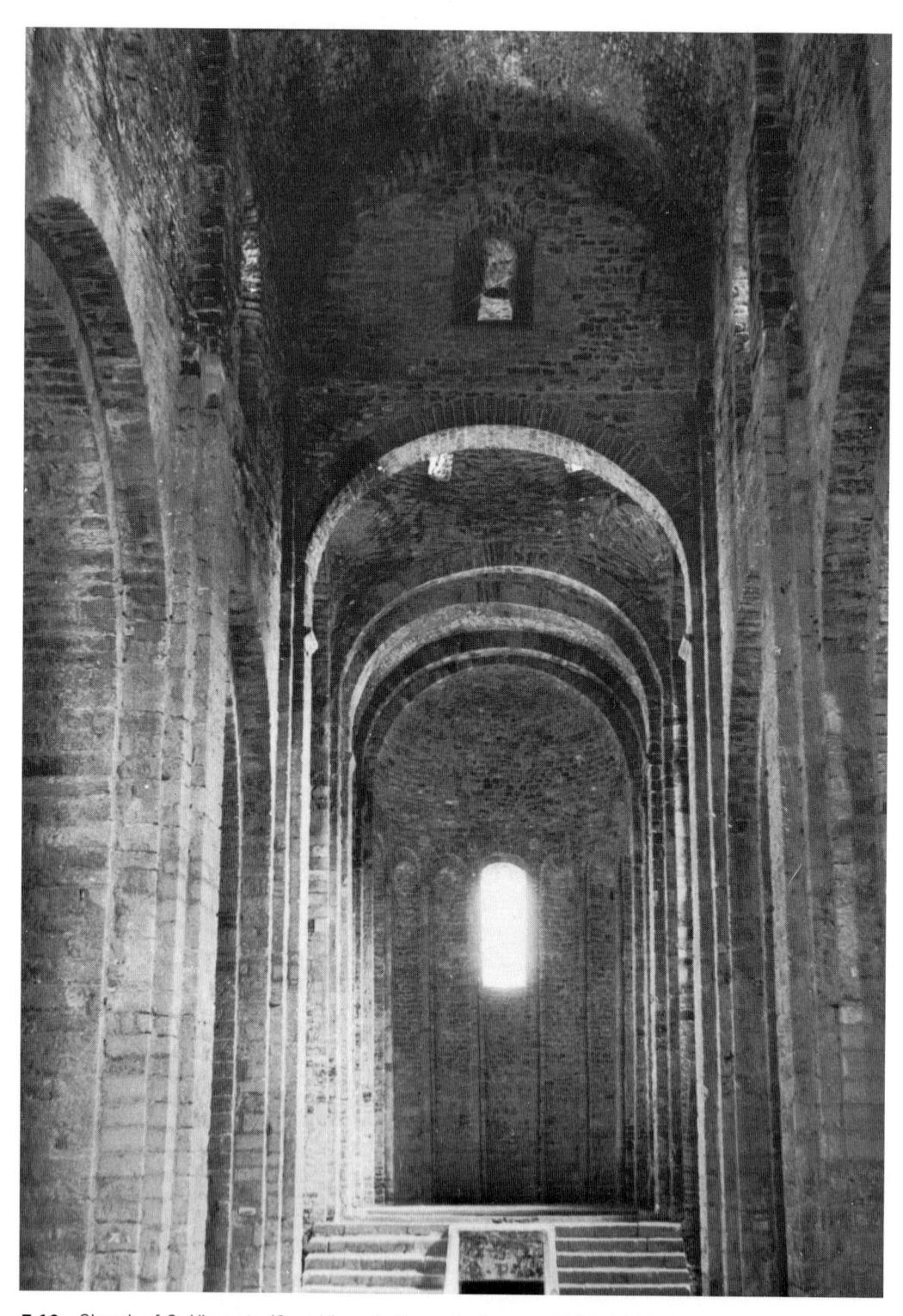

7.10 Church of S. Vincente (Sant Vicenç), Nave, Cardona, c. 1020–1040, Catolonia.

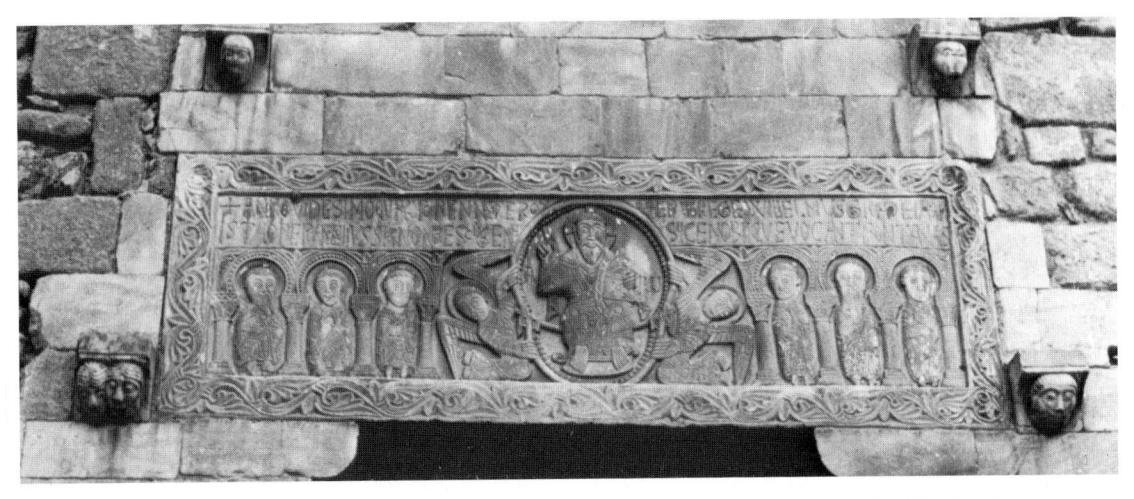

7.11 Christ and the Apostles, Church of St. Genis-des-Fontaines. Marble, approximately 3 x 7ft (.9 x 2.1m). 1020-1021.

ported on arches. Then, instead of covering the outside of the vault with a wooden roof, the masons built up the barrel vault on the exterior in such a way that it formed a sloping stone roof. The tall rectangular bell tower (heavily restored), articulated with strip buttresses and arched corbel tables, continues the massive forms of the church and monastic buildings.

One of the finest examples of the mature Lombard-Catalan style is the Church of S. Vicente (Sant Vicenç) at Cardona, begun about 1020 and consecrated in 1047 [7.10]. The church is vaulted throughout with barrel-vaulted nave and transept, groin-vaulted aisles, and a dome on squinches over the crossing. Three transverse arches in the nave continue down the piers as responds, the visual and structural flow only momentarily broken by the tiny moldings high up at the springing of the arches. The masons at Cardona also added masonry bands supported by responds as a strengthening device on the underside of each arch in the nave arcade. These nave piers mark the first stage in the evolution of the compound pier, a key element in later architecture. Because the transverse arches and compound piers establish a series of vertical bays, the builders achieved a clarification of the structure that lends an architectonic unity to the entire church.

When the masons included sculpture in their buildings, they made it part of the actual structure. In a portal, for example, the lintel and the capitals of the supporting columns might be carved. The eleventh century lintel at St. Genis-des-Fontaines represents this new kind of exterior decoration. Again Apocalyptic themes are used; in this case Christ in Glory is held aloft by angels and flanked by apostles [7.11]. The figures standing in an architectural setting recall Early Christian sarcophagi; however, they have lost any semblance of natural form or space. The Lombard-Catalan sculptor has treated the lintel as a two-dimensional field in need of decoration, not as an open arcade housing tangible beings. Indeed, the Mozarabic horseshoe arches of the arcade actually define the contour of the apostles, for with arms clasped about their bodies and enlarged rounded heads, the men seem designed solely to fill the keyhole shapes of the arches. Unconcerned with three-dimensional effects, the artist seems to imitate a precious silver reliquary or golden altar frontal. The stone surface of the lintel actually glitters as it catches the brilliant Mediterranean light. With such work the Catalan masters initiated a tradition of architectural sculpture that, by the twelfth century, resulted in the application of elaborate carving to the portals and even to the entire façades of churches.

Monastic builders carried this mason's style, with its vaults, architectonic decoration, and rudimentary sculptural programs northward to affiliated monasteries in the territories of the Carolingian Empire. The Benedictine monks of Cluny introduced the style into Burgundy and the Loire Valley, while Lombard builders working for patrons in Germany carried the style and techniques to the imperial buildings in the Rhineland.

THE CONGREGATION OF CLUNY

The Benedictine Congregation of Cluny played a key role in the development and dissemination of high-quality architecture and art. Its center was in Burgundy in the very heart of western Europe. There the fertile lands had been relatively secure from the incursions of Magyars (Hungarians) and Vikings. In 909 William, count of Auvergne and duke of Aquitaine, gave land and a former Roman villa at Cluny to a group of Benedictine monks who wanted a monastery where they could place greater emphasis on the liturgy. With his endowment William waived all his feudal rights and decreed that the abbot of Cluny should be subject only to the Pope. As Cluny grew and established new monasteries, the abbots of Cluny created a centralized monastic government. Cluny became, in effect, an international ecclesiastical empire.

Adhering to the Benedictine ideal "To work is to pray," Cluniac monks emphasized the Divine Service rather than manual labor. Led by scholarly abbots, Cluniac monks became famous for the elaboration and beauty of their liturgical music and art (they spent over ten hours a day in church services). The intellectual level of the congregation also rose rapidly as Cluniac monasteries attracted the brightest youths. Later, Hugh of Semur (abbot from 1049 to 1109, canonized in 1120) enhanced Cluny's temporal power as well. Eventually the monks ruled large agricultural estates worked by lay brothers and serfs. The growth of Cluny in power, prosperity, and numbers (from 70 monks to about 300 during the 60-year abbacy of St. Hugh) inspired significant building campaigns.

Fortunately Cluny had the necessary imaginative, technical, and financial ability to build splendid edifices. The Congregation of Cluny stood foremost among the patrons of learning and the arts in western Europe.

Within 30 years of its foundation, Cluny had outgrown its first simple, barn-like church. In the middle of the tenth century, the monks began a new church, which in 981 they dedicated to Saints Peter and Paul. Because of the destruction and rebuilding on the site, the details of this early architecture remain conjectural [7.12]. Cluny II, as it is called now, evidently was a basilica with a transept and an elongated choir with aisles ending in chapels. The three projecting apses formed a stepped plan (an arrangement known as the echelon or Benedictine plan). At the west end of the church, a pair of towers flanked a two-story narthex, or Galilee porch. The name Galilee was given to this narthex because like the apostles walking through Galilee, during the Easter service the procession of monks stopped in the porch before they entered the church, the symbol of the Heavenly Jerusalem. Laymen may have stood in a second-floor gallery, where they could observe without obstructing the procession.

Only foundations of this early church survive at Cluny, but buildings such as the tenth- and eleventh-century church of St. Philibert at Tournus suggest its structure. St. Philibert's was originally erected to house the relics of St. Valerien, a second-century martyr, but in the ninth century, monks from western France, fleeing Viking attacks, brought the relics of St. Philibert to Tournus. The monks then had to rebuild their church to accommodate the relics of the two saints and the pilgrims coming to venerate them. They placed the shrine of St. Philibert in the center of a crypt, which had an ambulatory leading to the shrine of St. Valerien. In the early eleventh century this arrangement of ambulatory and chapels was repeated above ground in the sanctuary [7.13]. Unlike earlier buildings where the sanctuary was raised over the crypt, at St. Philibert's the sanctuary, nave, and entrance are all on the same ground level.

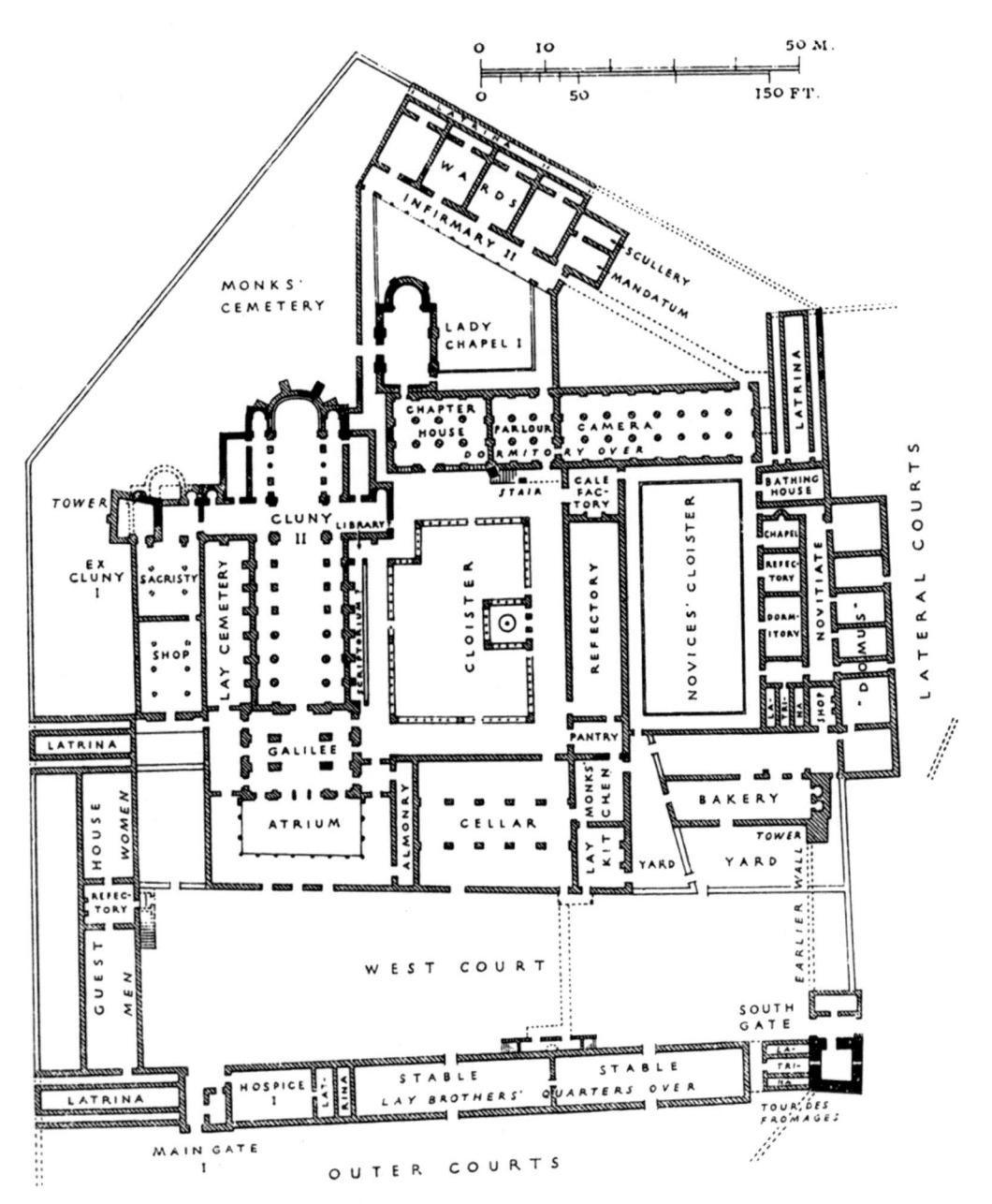

7.12 Cluny: plan of the early monastery (Cluny II), 10th century.

Different vaulting systems throughout the church display an ingenuity that produced a veritable dictionary of tenth- and eleventh-century engineering techniques. In the narthex (at the end of the tenth and beginning of the eleventh centuries), groin vaults cover the center aisle, abutted by transverse barrel vaults over the side aisles [7.14]. The second-

story barrel vault has transverse arches reinforced by tie beams, since quadrant vaults over the aisles are too low to stabilize the high vault. In the nave—as completed in the 1060s—colossal cylindrical piers support diaphragm arches, which in turn hold a series of transverse barrel vaults, each of which buttresses its neighbor [7.15]. Large windows pierce the

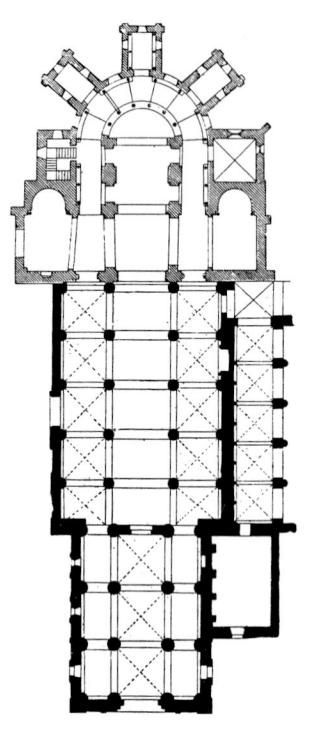

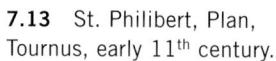

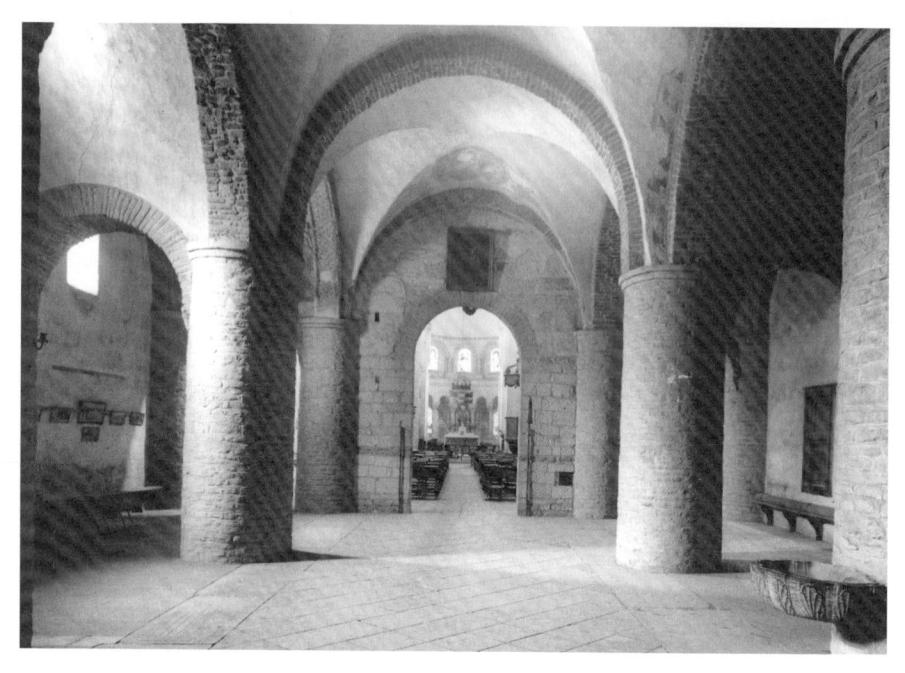

7.14 St. Philibert, Narthex, Tournus, c. 1000.

upper walls. The many subdivisions created by this pier-arch-transverse vault organization distract from the visual continuity of the nave in spite of the continuous floor level from the entrance to the altar. Of course, such suggestions of a building's effect are mere speculations, but medieval builders and patrons must have appreciated the well-lit, nearly fireproof church structure. Burgundy emerges as one of the most creative centers of art and architecture in the eleventh and twelfth centuries.

THE ART OF SCANDINAVIA AND THE BRITISH ISLES

Around the North Sea another empire emerged as the crafty heirs of the Vikings Sven Forkedbeard and his son Knut (known in English as Canute the Great, c. 995-1035), united Denmark, Norway, and the British Isles. The conversion of Scandinavia had come slowly. In the tenth century, Gorm the Old united Denmark, and his

7.15 St. Philibert, Nave, Tournus, 1060s.

Timber Construction Techniques

Wood buildings are perishable, but Norwegian and Swedish country building remained so conservative that seventeenth- and eighteenth-century farmsteads reflect the practices of the Middle Ages. Hence, we know that three types of timber construction prevailed in Scandinavia and the British Isles. In the first, stripped logs notched at the ends to dovetail were stacked horizontally to form a rectangular structure, which was roofed with thatch or sod. (This is the familiar log cabin introduced by Swedish settlers in North America.) A second system—cruck construction—was

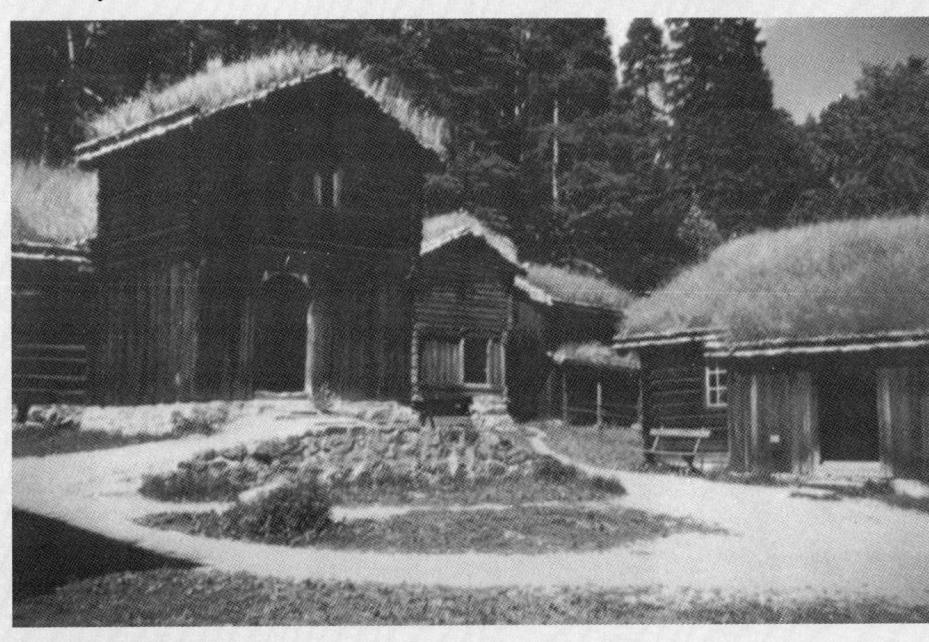

7.16 Farmstead showing traditional building types. Norwegian Folk Museum, Oslo.

widely used in the north as long as extensive forests could provide large, uniform timbers. Trees of equal height with conveniently angled lateral branches were felled, trimmed, and then halved to form pairs of upright posts and roof supports. A series of crucks, joined by horizontal members (sills and plates) created the skeleton of the building, while thatched roofs and wattle and daub walls-that is, wickerwork branches roughly filled with clay, rubble, and plaster—made the dwelling or shelter reasonably snug. In the third method, logs were set vertically into a sill (the horizontal beam) and squared off on the inside. This system was perfected in later Norwegian stave churches.

son Harald Bluetooth accepted Christianity in 960. The Norwegians did not adopt Christianity until 1015, during the reign of St. Olaf. Again the Benedictine monks provided a bridge to European civilization just as they had in the Carolingian Empire. Churches and secular halls were built of wood in time-honored construction techniques. Sometimes they were elaborately

Imaginary animals continued to dominate the northern imagination. In the eleventh century, the Great Beast still battled serpents, monsters, and lizard-bodied birds, but in a process of syncretism, much like the Early Christian adaptation of Roman pagan themes, mighty beasts became associated with the Savior. On the church at Urnes in Norway, enormous dragons cross above the door of the church, two smaller animals and a pair of snakes curl down to bite them [7.17]. The creatures' energy seems directed against the great beast on the left jamb, who defiantly chomps on a monster, or, in symbolic terms, fights off the forces of evil and darkness crawling over and around the church. This art has been given the name Urnes style, since

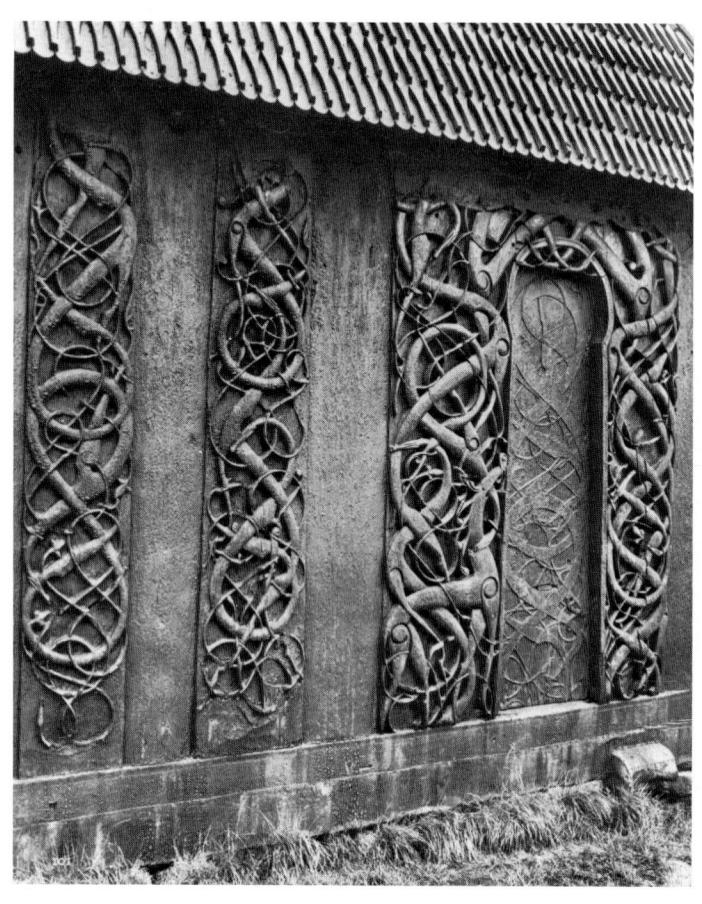

7.17 Stave church, Urnes. Carved portal and wall planks. 11th century.

the finest examples appear in wood carvings of c. 1050-1070 that were incorporated into the twelfth-century church. The beauty of the Urnes style in Scandinavia, no less than in the British Isles, where it was transported, lies in its aesthetic control—the elegance of drawing and the harmonious balance of thick and thin elements arranged in a series of figure-eight patterns, like the carpet pages in Hiberno-Saxon manuscripts but with far greater freedom and vitality.

After the Viking invasions of the British Isles, Danes ruled the north and east in a region known as the Danelaw, while Anglo-Saxons continued to control the south and west. The glory of Anglo-Saxon art lies not in architecture or sculpture but in manuscripts. St. Dunstan's revival of Benedictine monasticism brought the insular monasteries

into close contact with the Continent. St. Ethelwold, Bishop of Winchester (963-984), established a scriptorium in Winchester, the Anglo-Saxon capital. The painters, profoundly affected by Carolingian art but at the same time the heirs of the strikingly different Hiberno-Saxon pictorial tradition, created two kinds of illustrated manuscripts: those with fully painted illumina-tions and those with colored drawings based on the Utrecht Psalter style. The New Minster Charter exemplifies the first type and shows that combination of Hiberno-Saxon and Carolingian art that marks the Winchester style [7.18]. These illuminations are characterized by exuberant use of curling acanthus foliage and expressive drawing, perhaps inspired by Carolingian art.

In 966 King Edgar granted a charter to St. Ethelwold's abbey (minster) at Winchester. St.

Ethelwold commissioned a luxurious copy of the charter to be displayed on the altar as thanks to the king and a testament to the importance of the Benedictines in England. Written in gold, the New Minster Charter rivaled Carolingian imperial manuscripts. In the dedication, King Edgar presents the charter to Christ, who is enthroned in a mandorla supported by angels. St. Mary and St. Peter parrons of the abbey look on The and St. Peter, patrons of the abbey, look on. The composition recalls presentation scenes in Car-olingian painting, but the figure of King Edgar is an original Anglo-Saxon creation. He twists and his head turns back over his shoulder in order to simultaneously look up at Christ and confront the spectator. The other figures, while not subject to such contortions, also move energetically, creating animated draperies pulled tightly across the thighs but ending in crinkly edges or flying folds.

Acanthus leaves winding around golden trellises

frame the images. The variegated curling leaves seem to grow from a stem located in the center of each side. In contrast to Carolingian artists, who filled golden letters with acanthus shoots or enclosed the foliage within a geometric border, Anglo-Saxon illuminators followed their Hiberno-Saxon predecessors and let the ornament burst out beyond the frame. Ultimately foliage and trellis frames dominated the page.

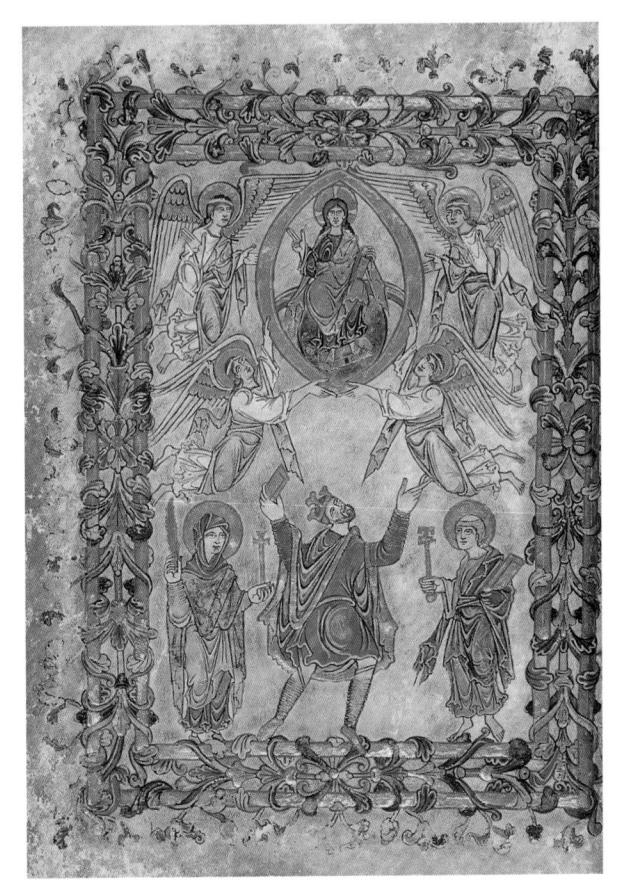

7.18 King Edgar presenting the charter to Christ, New Minister Charter, Winchester, 966. The British Library.

Magnificent frames for full-page illustrations characterize the finest manuscript of the Winchester group, the Benedictional of St. Ethelwold [7.19]. (A benedictional is a prayer book used by the bishop during Mass.) The book was made at Winchester about 980 and signed by the scribe Godoman. The foliage that crept beyond the trellis in the New Minster Charter here commands the entire decorative system. Gold, double-banded trellises support a luxuriant growth of acanthus foliage and four outsized rosettes. As the leaves wind around the frame or each other, they seem permeated with energy. More important, however, is the fact that figures also move into and over the frame. Three women in the right border face the angel seated on Christ's empty tomb, while at the left the Roman soldiers gaze awestruck at the miracle of the Resurrection. The frame, whose enclosing function is already challenged if not destroyed by foliage, becomes a mere foil for actors in a religious drama, as the actors in turn become visual adjuncts to the border rosettes. In the best tradition of Hiberno-Saxon decoration, Godoman and his assistants combine the frame, text, and narrative into a single ornamental composition.

The visually dynamic appearance of the Benedictional owes much to its calligraphic drawing. Indeed, artists in the British Isles had always shown unusual skill in drawing. Faster and cheaper than painting and gilding, drawing suited active monastic scriptoria that were not sustained by an imperial court. Also, books had to be produced rapidly in the tenth and eleventh centuries, for the libraries devastated by Viking raids had to be replenished. This preference for drawing was reinforced when the Utrecht Psalter was brought to

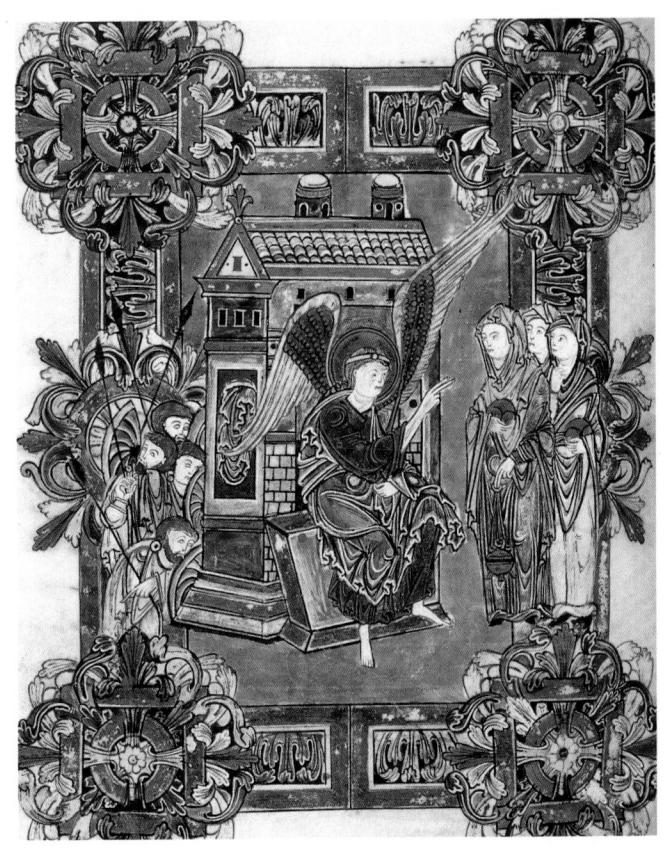

7.19 The Marys at the Tomb, Benedictional of St. Ethelwold, Winchester, c. 980. The British Library.

Anglo-Saxon Painting

An unfinished page in the Benedictional provides an opportunity to study the tenth-century Anglo-Saxon artist's method. The illuminator first rendered the outlines in red, and then filled them in with broad areas of color, over which he applied both light and dark tones. Godoman drew with quick, staccato strokes, especially when representing drapery and foliage. He created heads, with their broad low brows, square jaws, and jutting necks, like those of the Reims school, although the stockiness of his figures bears more relation to the Metz type. Unlike that of the Carolingian models, his drapery becomes so elaborate and excited that the bodies almost disappear. Through the swirling pattern of rippling drapery with fluttering, ragged edges, even a rather static figure gains a nervous energy. When the undulating lines of clouds, hills, or water are added to the scene, individual elements and sometimes the very narrative are virtually lost.

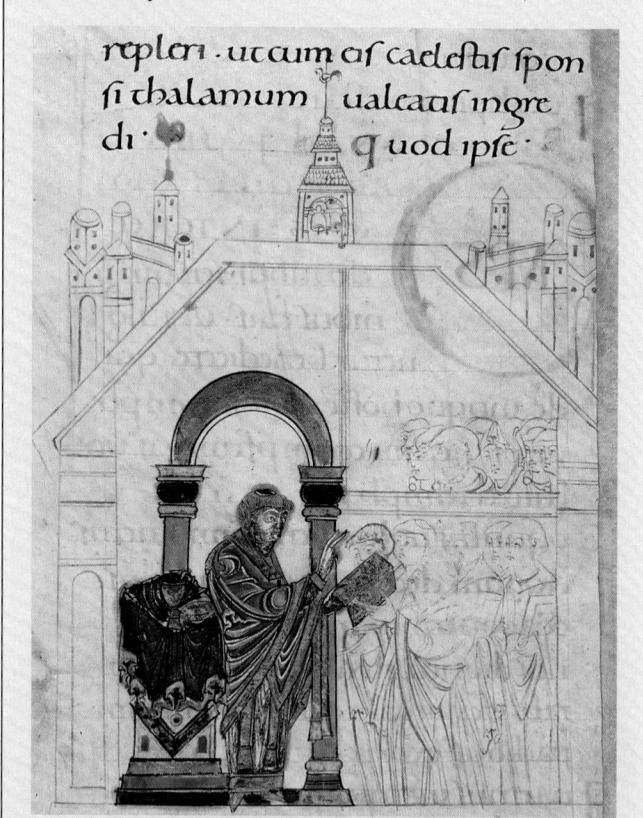

Bishop Blessing the Congregation. The British Library.

Canterbury about 1000, and a copy was made in colors. How and why the manuscript came to England remains a mystery.

The Anglo-Saxon version of Carolingian drawing as well as the Anglo-Saxon artist's narrative skills is impressively displayed in the Liber Vitae of New Minster (a list of benefactors, for whom prayers were to be said, kept on the altar) [7.21]. In the upper register of a highly theatrical version of the Last Judgment, a spirited St. Peter welcomes the blessed into paradise. Below, assisted by an angel holding the book of good deeds, Peter fights for a soul by smashing the devil's face with his huge keys. An angel triumphantly locks the gate against an enormous demon that pulls the damned by their hair into the gaping mouth of hell. The interest in human reactions, the delight in pictorial detail, and the cavalier arrangement of figures for the sake of dramatic confrontation become characteristic features of English art.

King Canute commissioned the Liber Vitae in 1020 for the Minster at Winchester. On the dedication page, the king and queen, patrons of the abbey, place a cross on its altar while Benedictine monks observe the scene from an arcade below [7.22]. As in King Edgar's charter, Christ, the Virgin, and St. Peter bless the donation; however, the rulers now flank the altar and receive crowns from Heaven-sent angels. The charter becomes a political document symbolizing the blessing of the monarchy by the Church. The frontispiece also shows the first signs of a stylistic transformation that was to take place in Anglo-Saxon art about the middle of the eleventh century. The symmetrical, architectonic composition, and the quiet figures drawn with relatively firm, regular lines herald the coming Romanesque style.

When Canute's sons could not hold the new empire together, the Anglo-Saxons and then the Normans took over England, leaving Scandinavia to go its own way. In spite of political conflicts, the lands ringing the North Sea became an integrated cultural province. As a result, art historians sometimes cannot determine where a style or a work of art originated. Indeed, English and Scandinavian

7.21 Heaven and Hell, Liber Vitae of New Minister, Winchester, 1020. The British Library.

art in this period reflects the constant presence of one people on another's soil.

North Sea art and architecture demonstrate again that pattern of religious and artistic confrontation, which so often occurred as Christianity supplanted pagan belief. At first, only the content of art changed. Just as Christ once appeared in the guise of the Good Shepherd, so Christians in the North might identify the Savior with the Great Beast. The eventual appropriation of Christian iconography, with its didactic narratives acted out by human figures in architectural or landscape settings, forced artists to abandon the animal style that had held sway in the North since prehistory.

Yet these artists never ceased to communicate the sheer energy of the forces of nature, for they continued to express their ideas through intricate patterns and abstractions rather than through personifications or literal representations. The result was a revitalized northern Christian art.

THE ART OF THE OTTONIAN EMPIRE

At the beginning of the tenth century, in 919, the German dukes assembled according to ancient custom and elected one of their number, Henry the Fowler, duke of Saxony, to be their leader, the king. Henry's son, grandson, and great grandson-all

7.22 Patrons of the minister, Liber Vitae of New Minister, 1020. The British Library.

named Otto-ruled for the rest of the century (936-1002). Consequently, the historical period and its art and architecture are known as "Ottonian."

Otto I, "the Great," chose to be crowned at Aachen, and so proclaimed himself the heir of Charlemagne. Like Charlemagne he turned his attention south, to Italy. He added northern Italy to his kingdom by marrying the widowed Lombard Queen Adelaide. Then, at the invitation of the Pope, he moved on to Rome as defender of papal lands. In 962 Otto the Great achieved his dream of reestablishing Charlemagne's Christian Roman Empire when Pope John XII crowned him emperor in Rome.

The addition of Italian territories to the Saxon kingdom presented a problem. In this age of personal rule, a king could not reside on one side of the Alps and expect to control his subjects on the

other side without extraordinary help. Otto, like Charlemagne, turned to his family and to the church for support. He filled important posts with his relatives; for example, his younger brother Bruno (d. 965) served as his chancellor, as the archbishop of Cologne, and as the duke of Lorraine. Other relatives held the archbishoprics of Trier and Mainz, and women in the family ruled as powerful abbesses. Nevertheless, Otto had to fight dissident family members in southern Germany, Vikings in the North, and the Magyars in the East. Magdeburg, founded as a monastery in 937, which Otto made an archbishopric in 968, became an important outpost on Otto's eastern front. In an ivory carving, Otto presents the Cathedral of Magdeburg to Christ and St. Peter [7.23]. He is supported by St. Maurice, whose relics he brought to Magdeburg from Burgundy in 960. Eventually the Magyars settled along the Danube in today's Hungary, and by 1000 they adopted Christianity under King Stephen and Queen Gisela, Otto's granddaughter.

Ever the politician, Otto the Great looked with interest at the wealth and prestige of Byzantium. The Byzantine court continued to set the standard for pomp and luxury among Western rulers, and Byzantine gold, enamel, ivory, and textiles served as models of taste and craftsmanship. Twice Otto sent an ambassador to the Byzantine court, but the missions met with little success, for the Germans and the Byzantines despised each other. Nevertheless, Byzantine luxury goods must have appealed to the Germans, for Ambassador Luitprand was caught trying to smuggle silk fabrics back to the West. Eventually Otto the Great arranged a marriage between a Byzantine princess and his son. In 972 Princess Theophanu arrived at the German court with works of art in her dowry and artists in her retinue. Although she had been an insignificant person at home, she became a powerful force in Ottonian politics and art.

The year after Otto and Theophanu married, Otto the Great died, and the young couple ruled the empire (973–983). When Otto II died in 983, he was buried in the atrium of the Church of St. Peter in Rome and the three-year-old Otto III was

7.23 Otto I Presenting Magdeburg Cathedral to Christ, the Magdeburg Ivories, c. 962-73. Ivory, 5 x 4 1/2in. (12.7 x 11.4cm). The Metropolitan Museum of Art.

crowned king of the Germans. Otto's grandmother and mother-the Lombard Adelaide and the Byzantine Theophanu—governed as regents. Otto III (983-1002) began his personal rule in 996 at the age of 16, when he was crowned emperor in Rome [see 7.1]. Italy absorbed his attention, and in this he was encouraged by his tutor, Gerbert of Aurillac. In 999 Gerbert became Pope, taking Sylvester as his papal name, thereby identifying himself with the Pope who had baptized Constantine. Always conscious of the importance of symbolism, in the year 1000 Otto opened Charlemagne's tomb in Aachen. While venerating the imperial relics, he removed Charlemagne's pectoral cross and Gospels (The Coronation Gospels) for his own use.

Ottonian artists created a new imperial style by combining and reinterpreting elements of Roman, Germanic, Byzantine, and Carolingian art. Acceding to their well-traveled patrons' demands, artists copied ancient monuments, whether pagan (the column of Trajan in Rome), Jewish (the menorah as they knew it from the Arch of Titus), or Christian (the stories of Christ and the saints that they saw on the walls of early Christian churches). Noting that Roman artists had depicted both historical events and allegories with human actors in a spatial environment, they, too, developed a powerful narrative and symbolic art using human figures. At the same time the artists' preference for schematization of natural forms and the intensity of their expression derives from their northern heritage. The patrons' love of gold and jewels and the artisans' great skill in every kind of metal and lapidary work are also part of this Germanic tradition. A love of opulence is as Byzantine as it is Germanic, and contemporary Byzantine art also profoundly influenced Ottonian artists. The presence of a Byzantine princess, Byzantine art objects, and perhaps even Byzantine artists in the Ottonian court

7.24 Christ in Glory, Lorsch Gospels, Aachen (Carolingian palace school), early 9th century. Vellum, 14 1/2 x 10 1/2in. (36.8 x 26.7cm). Bathyaneum, Alba Julia, Romania.

had an impact on the style. Byzantine art must have provided models for imperial and religious iconography, for systems of drawing the human figure, for the depiction of space, and even for details of costume and ornament. Finally, Carolingian art often acted as an imaginative filter for the Byzantine style.

The tragic destruction of works of art by fires and wars complicates the study of Ottonian art. Fortunately, illuminated manuscripts—splendid books adorned with gold, gems, and ivory-and other church treasures have survived to provide visual evidence of Ottonian art. Both secular and ecclesiastical courts were centers of patronage, and regional styles appeared in Cologne, Trier, Reichenau, Hildesheim, and Regensburg.

Two images of Christ-one from the Carolingian Lorsch Gospels [7.24] and one from the Ottonian Gero Gospels [7.25]—provide an excellent introduction to Ottonian painting. The one is

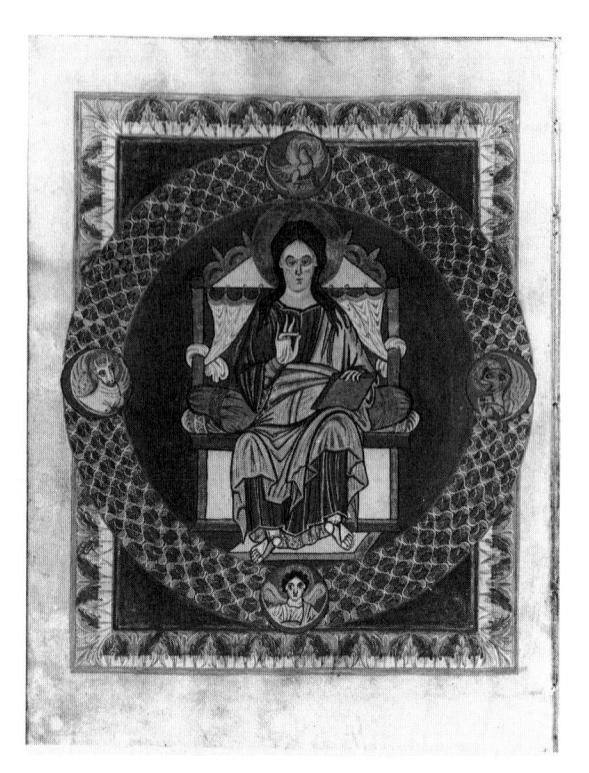

7.25 Christ in Glory, Gero Codex, Cologne or Reichenau, 965-970. Vellum, approximately 11 3/4 x 8 3/4in. (29.8 x 22.2 cm). Hessischelandesbibliothek, Darmstadt.

clearly a copy of the other. A comparison of the paintings of Christ in Majesty illustrates both the debt and the originality of the Ottonian artist. The painter simplified and clarified the image and focused attention on a broader and more massive figure of Christ by eliminating the angels, inscriptions, and outer frames and by simplifying the ornamental motifs. All the elements—the repeated rectangles of frame and throne interlocked with the circles of the mandorla, halo, medallions, and even Christ's round face and enlarged eyes—focus attention on Christ's blessing hand. The compact and concentrated image seems pressed into a series of thin overlapping planes in which the lingering illusionism of the Carolingian model is abandoned. This urge to clarify and control the forms extends into the drawing itself, for the calligraphic quality of Carolingian drawing has given way to clear, simplified outlines filled with bright flat colors, and the once illusionistic modeling of forms

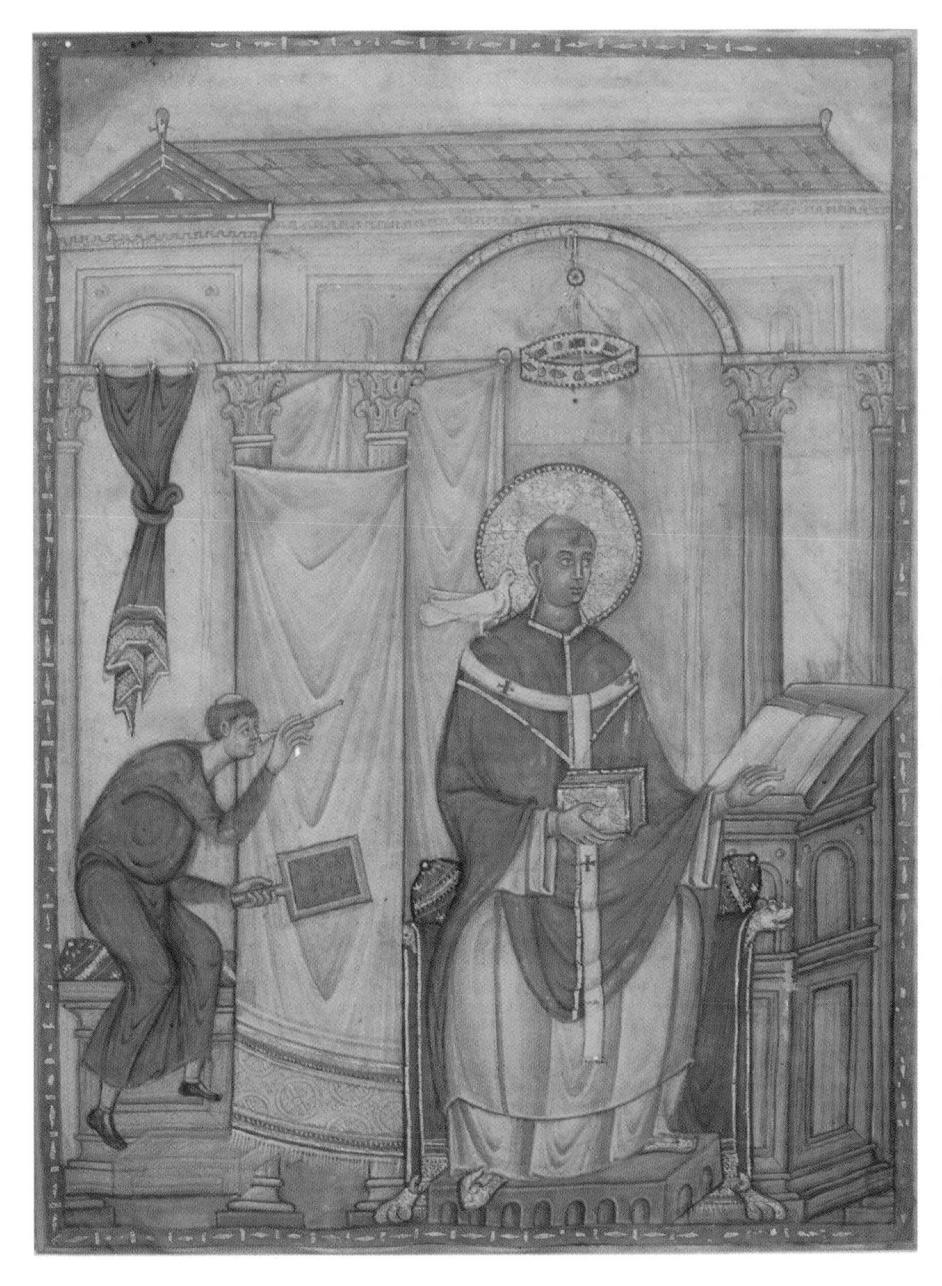

7.26 Pope Gregory the Great. Frontispiece to Gregory's Letters, Gregory Master, 983-984. Trier Stadtbibliothek.

has been turned into repeated linear patterns. Ottonian artists created a style that is more severe and more ornamental than their models. (Scholars do not agree on the location of the scriptorium responsible for the Gero Codex. Some say Trier; others, Reichenau, with a date of about 965-970.)

Archbishop Egbert of Trier (977-993), who had served as Otto II's chancellor, made his abbey of St. Maximin a center of scholarship and spiritual

renewal. In 983-984, he gave his cathedral a copy of the letters of St. Gregory (the Registrum Gregorii) illustrated by one of the most brilliant painters in the early Ottonian period [7.26]. This anonymous artist is known as the Gregory Master (active 972-c. 1000). In the cosmopolitan atmosphere of the bishop's court, he evidently had access to Early Christian as well as Carolingian and Byzantine models, for he developed a sophisti-

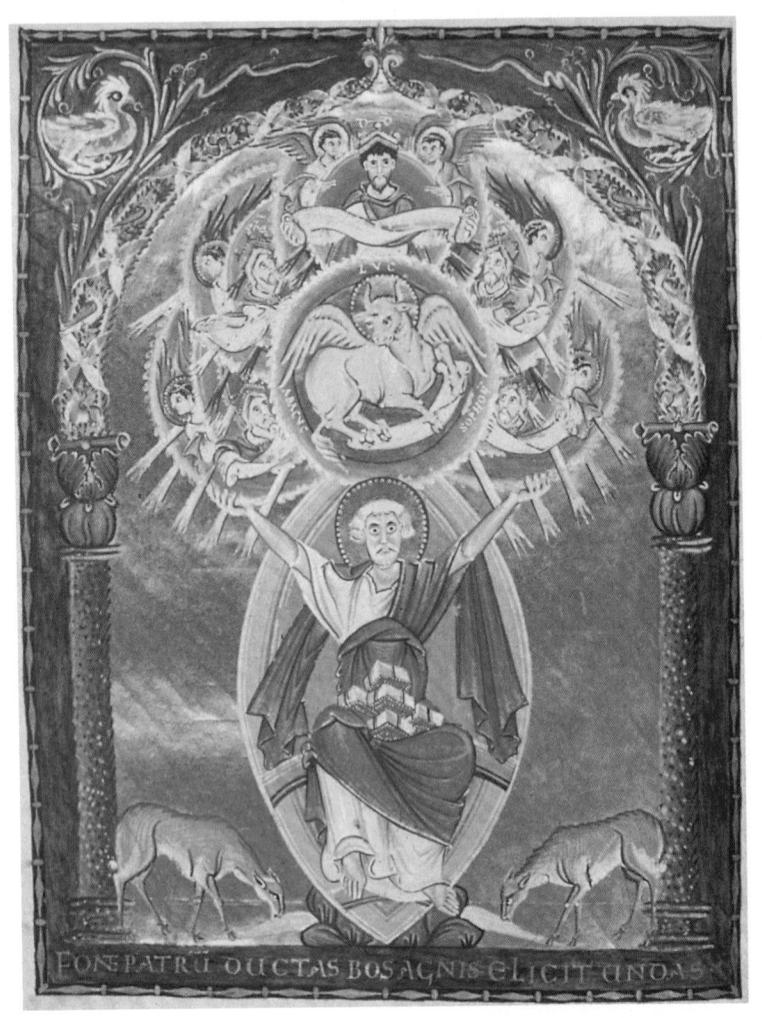

7.27 St. Luke, Gospels of Otto III, Reichenau?, c. 1000. Vellum, 13 1/8 x 11 1/8in. (33.3 x 28.3cm). Bayerische Staatsbibliothek, Munich.

cated, classicizing style. In a portrait of St. Gregory, he represents the learned Pope at work, inspired by the Dove of the Holy Spirit, who whispers in his ear. St. Gregory towers over his secretary who spies on him through the curtains. Gregory sits on a golden throne under a votive crown, like the Visigothic crown of Recceswinth. In contrast, the curious secretary has become a comic figure, as knotty and twisted as the curtain above him.

In the Pope's study the painter has reduced the architectural forms to a series of thin, superimposed layers. In simultaneous yet shifting views, we see the interior and exterior of the building and its gable as well as its side wall. At the bottom of the

page, columns, bases, throne, footstool, feet, and drapery are all worked into a carefully calculated, two-dimensional, rectilinear pattern. The Gregory Master has turned perspective systems to nonsense in a dramatic denial of the material world. The unreal, floating quality becomes particularly apparent in the secretary, who neither sits, stands, nor crouches but hovers over his bench. Yet the Gregory Master remains the most classicizing of Ottonian painters. In the sensitive treatment of idealized faces and the delicate, subtly modeled flesh and drapery, luminous colors and refined drawing, the Gregory Master found the possibility for personal expression even within the hieratic forms of Ottonian painting.

A very different mood suffuses the manuscripts made for Otto III [7.1]. The religious reforms stimulated by the Benedictine monks of the Abbey of Gorze inspired an art in which a sense of barely suppressed inner turbulence bursts forth in dramatic gestures and often a wild-eyed frenzy. The author portraits in the Gospels of Otto III (998-1001) display a striking originality [7.27]. Instead of depicting an evangelist intent on his writing, the artist represented a man in ecstasy to whom the full mystery of his religion is revealed by heavenly messengers. St. Luke sits on a rainbow enclosed by a mandorla, the writings of

the prophets in his lap and his inspiration suggested by circles of heavenly fire, from which emerge King David and the Old Testament prophets, the symbolic ox, and six angels. St. Luke flings out his arms, supporting the vision above him and drawing its power into himself. At his feet flows the River of Life, nourishing the lambs—that is, the Christian community. The inscription across the lower edge of the frame reads, "From the fount of the [Old Testament] fathers the ox brings forth water for the lambs." A festooned arch supported on porphyry columns frames the page, but its architectural quality is denied by flickering brushwork and an imaginative combination of

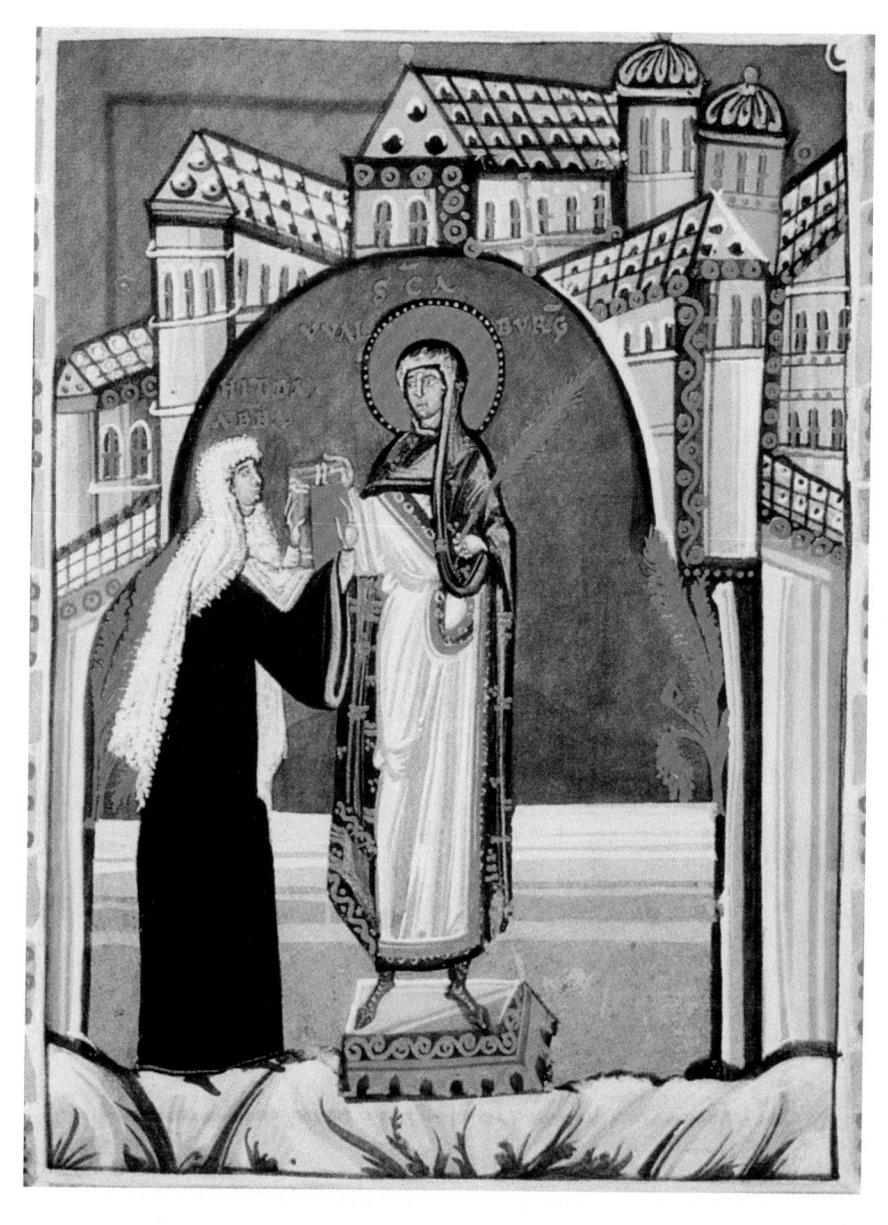

7.28 Presentation page with Abbess Hitda and Saint Walpurga Hitda Gospels. Early 11th century. Ink and colors of vellum, 11 3/8 x 5 5/8in. (29 x 14.2cm). Hessische Landesund-HochschulBibliothek, Darmstadt, Germany.

plants, birds, and ribbons. The painter has eliminated the lingering classicism of the Gregory Master, as a comparison of the heads of St. Luke and Pope Gregory shows. St. Luke nearly explodes in the emotion of the moment, but the artist seems to remain aloof, drawing clear, hard, and controlled outlines and filling them with brilliant and unnatural colors.

The charged emotional content and sumptuous painting in the Gospels of Otto III continues in the justly famous early eleventh-century Gospels of

Abbess Hitda (d. 1042). The abbess, wearing a long white veil, presents the book to St. Walburga, patron saint of the convent in Meschede, near Cologne [7.28]. Her power as abbess is indicated by her size; she equals the height of St. Walburga. Buildings that in the hands of the painter become a stack of architectural details framing the figures indicate the convent she rules. The Abbess, too, is a symbol of her position, not a portrait. The book is filled with unusual paintings that suggest it was intended for private devotions.

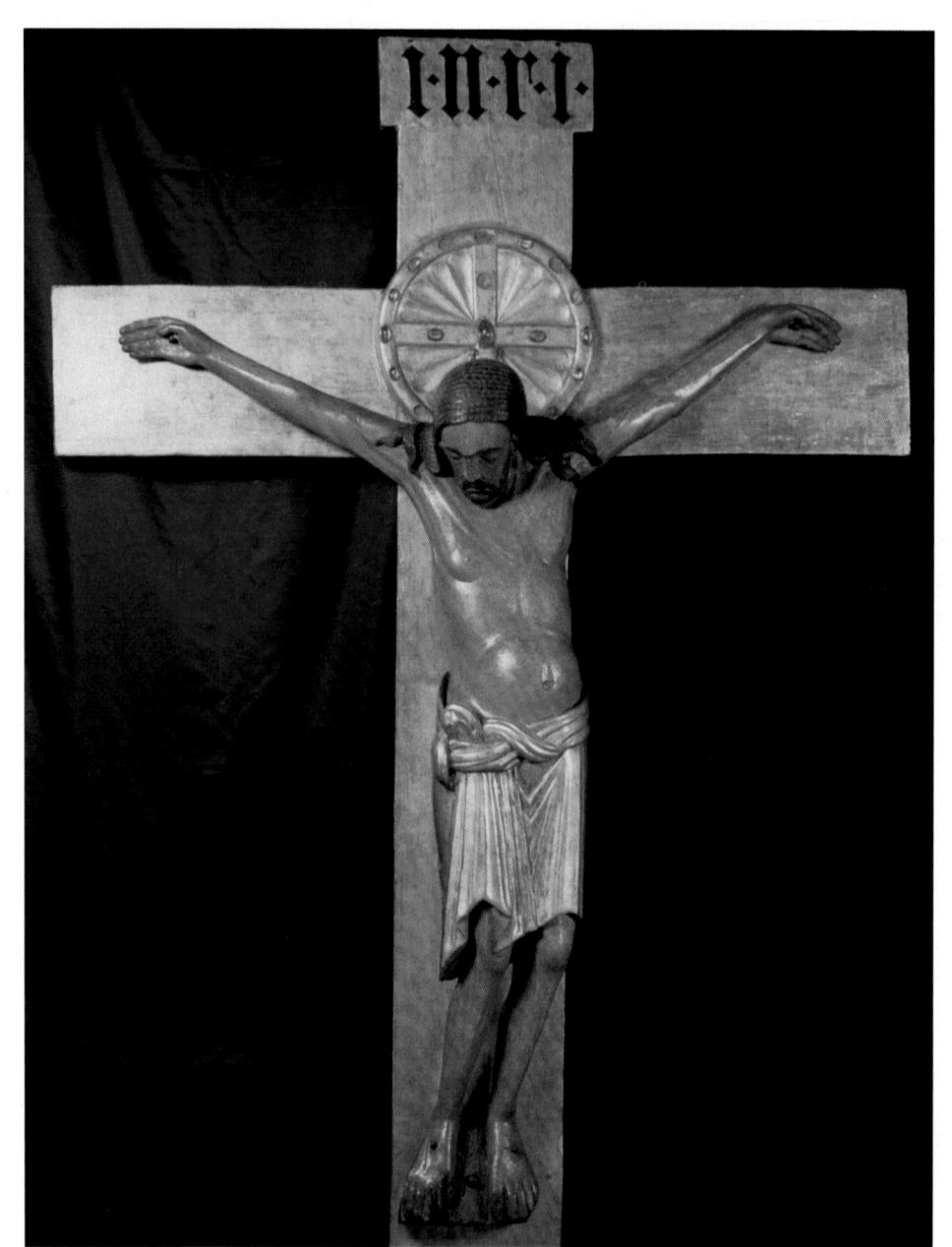

7.29 Gero Crucifix, Cologne Cathedral, Germany, c. 970. Painted and gilded wood, height of figure 6ft. 2in. (1.87 m).

OTTONIAN CHURCH TREASURES

Intense emotional content as well as monumentality and formal clarity characterized sculpture in Cologne. An over-life-sized, polychrome wood sculpture of the crucified Christ, presented to Cologne Cathedral about 975 by Archbishop Gero (969-976), exemplifies these qualities [7.29]. Functioning as both sculpture and reliquary, the

figure held the Host in a cavity in the head; thus the wooden image, in the minds of the devout Christians, literally held the body of Christ. Not a symbolic sacrificial Lamb of God, not a Byzantine emperor alive and crowned in front of a cross, not even a young hero, as in some Early Christian or Carolingian images, but a tortured martyr hangs in front of the worshipper. Archbishop Gero had traveled to Constantinople to escort Theophanu

back to the Ottonian court, so he had seen Byzantine art first hand and must have known the new theme of the suffering Christ. To the solemnity and grandeur of the image, Gero's sculptor has added a new emotional intensity, inducing in the worshipper feelings of pity as well as awe. The humility and sacrifice of Christ on the cross rather than the triumph of the Resurrection suffuses this huge, gaunt figure—invoking a pain and sorrow that the abstraction of the musculature and the geometry of the golden drapery cannot dispel.

If religious fervor distinguished earlier Ottonian art, learned sophistication, material splendor, and technical refinement characterize later work, especially in Regensburg, a city that rose to importance at the beginning of the eleventh century, during the reign (1002-1024) of Henry II and Queen Kunigunde. Otto III left no heir at his early death in 1002, and the empire passed by election to his cousin Henry, Duke of Bavaria. Henry and Kunigunde abandoned the grandiose schemes of the Ottos and devoted themselves to Germany. They enriched churches, patronized the arts, supported monastic reform, and became such efficient and pious rulers that both were canonized—Henry in 1146 and Kunigunde in 1200. They were buried in Bamberg, in the cathedral they had endowed.

Regensburg artists had important Carolingian models available to them. The Abbey of St. Emmeram housed the imperial regalia of the Carolingian house, including reliquaries and manuscripts. Goldsmiths worked beside painters and scribes to create an art that joined refinement and material splendor to surround the Word of God. When Henry II ordered a book of pericopes for Bamberg Cathedral, before his coronation as emperor in 1012, he must have given the goldsmiths items from his imperial treasury to incorporate into the cover [see 5.16]. The artist literally combined rather than reproduced elements from different sources: a Carolingian ivory from Metz, surrounded by Byzantine and Ottonian enamels. The round-headed Byzantine cloisonné enamels of prophets and apostles alternate with large rectangular stones surrounded by smaller gems and pearls. The jewels are set on a gold ground on arcades of pearled wire to raise them from the ground in order that the light will enhance their luster. Enamel roundels with the four evangelists, perhaps made locally in Regensburg or imported from Trier, fill the corners, and a niello inscription on the inner frame names Henry II as the donor. Just as in painting, strict frames within frames visually bind and control the heterogeneous elements. Each part is exquisite—the whole is magnificent.

Although the incorporation of ancient and ex-

otic treasures into a new work associated it with older empires and thus gave it added context, Ottonian jewelers had no need to borrow Carolingian ivories. Skillful carvers worked in their shops. An artist of unusual imagination and skill carved the image of the Doubting Thomas [7.30]. The inscription carved on the ivory comes from the Gospel of John (20:27) when Christ commands Thomas to touch the wound in his side and to believe. Only in this way can Thomas trust his eyes and believe in the bodily Resurrection. With remarkable sensitivity, the sculptor abandoned Ottonian hieratic scale and literally elevated the risen Christ on an octagonal pedestal. Capturing an unusual moment, the sculpture shows St. Thomas from the back, looking upward at Christ, his head dramatically and accurately foreshortened. The intensity of the gaze establishes a psychological as well as physical interdependence, as the heavy muscular figures with their enormous hands and feet seem to interlock. The juxtaposition of the hands—the searching finger and clutching fist of St. Thomas and the passive grace of Christ-capture the spirit of the whole in a detail. Yet for all the psychological potency of the moment, the artist also escapes into an Ottonian love of ornamental display. Christ and St. Thomas both wear patterned cloaks, perhaps the rich Eastern silks so admired by the Ottonian courtiers. The contrast between the monumental figures and this decoration reinforces the tension between surface and form, solid and space, created by the compression of huge figures into a shallow round-headed niche and wide acanthus-filled frame. Scholars disagree on the place and date of this and other ivories of

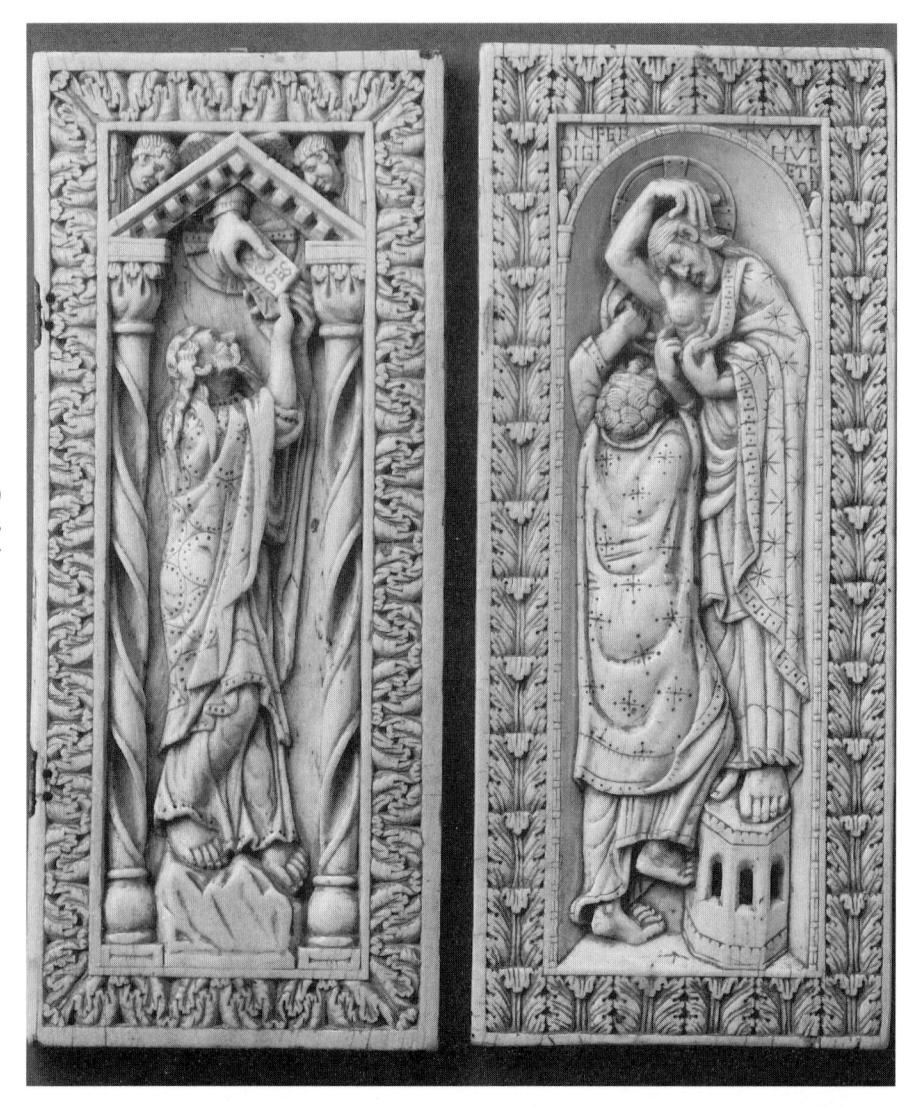

7.30 Diptych with Moses and Thomas, c. 990 or Echternach, c. 1050. Staatliche Museum, Berlin.

the group—Trier or Echternach, sometime between the end of the tenth and mid-eleventh centuries—but no one denies the power of the artist's imagination.

OTTONIAN ARCHITECTURE AND BRONZE SCULPTURE

Fortresses crumble; cities grow or die; secular buildings disappear, victims of fragile materials. Religious architecture is likely to survive—it is well built and it may be preserved, either because of genuine piety or because of conservative religious tradition. Nevertheless, Ottonian churches seem

particularly prone to disaster. The Cathedral of Mainz burned to the ground on the day of its consecration in 1009. Otto the Great's Cathedral at Magdeburg burned in 1008; rebuilt in 1049, it burned again in 1208. Trier, a center of Ottonian imperial art, saw its great Benedictine Church of St. Maximin destroyed in 1674; Hersfeld, the major Ottonian Cluniac monastery, burned in 1761 and was never rebuilt. The churches of Cologne and Hildesheim were rebuilt in the twelfth and thirteenth centuries, only to be destroyed in World War II and rebuilt yet again. Still, we must study Ottonian architecture, even in reconstruction, for it provides a link between the architecture of the

7.31 Convent of the Holy Trinity, Essen, mid-11th century; seven-branched candlestick, Hildesheim?, c. 1000.

Carolingian Empire and the Romanesque buildings of the eleventh and twelfth centuries.

When Ottonian rulers ordered their architects to create buildings that would recall the splendors of past empires, naturally, they looked to Carolingian buildings as models. The Palace Chapel at Aachen inspired the design of several chapels and sanctuaries. For example, Abbess Theophano (1039–1058), granddaughter of Empress Theophanu, added a chapel dedicated to St. Peter at the west end of her convent church in Essen [7.31]. Viewed from the nave, the structure resembles Charlemagne's chapel, but actually the central half-hexagon, ambulatory, gallery, stair turrets, and lateral bays are intricately interrelated forms unlike the relatively straightforward Carolingian structure. Furthermore, a tower rose two stories above the semidome of the chapel and, together with flanking stair towers, it forms a triple-towered westwork. This westwork probably retained its Carolingian imperial associations although it had many uses. Choirs may have sung from the galleries; certainly in the later Middle Ages it was used as a stage for a Passion play.

A magnificent candlestick given by the founder, Abbess Matilda (974-1011), a granddaughter of Otto the Great, copies the menorah from the Temple in Jerusalem, as represented on the Arch of Titus in Rome [see 1.4]. That the Ottonian emperors held court in Rome meant that the aristocratic patrons' admiration for ancient Rome was supplemented by first-hand knowledge of Roman imperial monuments. The Abbess's candlestick suggests the care with which Ottonian architects and artists selected, studied, and then reinterpreted their models as they sought to create a monumental imperial style for the German court.

The abbey church of St. Michael at Hildesheim (1001-1033) illustrates the Ottonian adaptation of Carolingian basilicas [7.32]. Archbishop Bernward (993–1022) consecrated the crypt in 1015. (The church suffered damaging fires and was rebuilt in

the eleventh, twelfth, seventeenth, and twentieth centuries.) The Carolingian preference for balancing the east and west ends of the building, seen at Fulda and St. Riquier, inspired the Ottonian builders [7.33]. Massive crossing towers, transepts, and stair turrets at the ends of the transepts created double vertical accents [7.34]. The building depends on severe geometric masses for its exterior effect. Lombard-Catalan masons working north of the Alps influenced the simple architectonic decoration of arched corbel tables and strip buttresses.

The building's design is based on a system of square units (cubical units of space or bays) established by the crossing, which is a square bay defined by polychrome masonry arches opening into

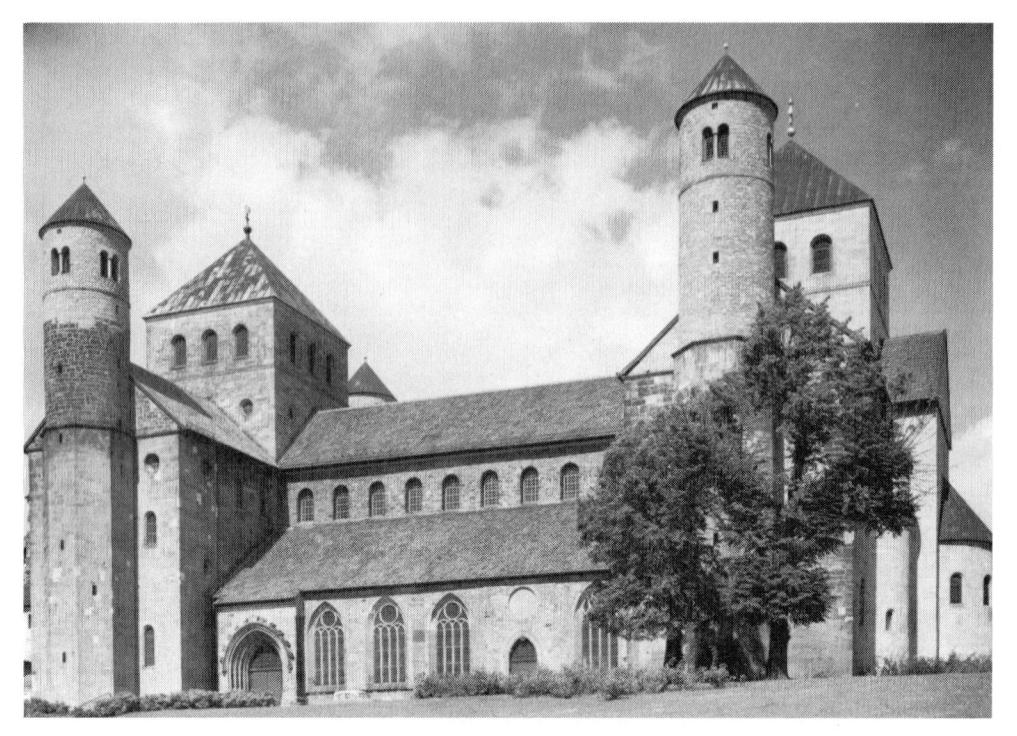

7.32 Monastery Church of St. Michael, Hildesheim, Germany, 1001–1033 (restored, 1958).

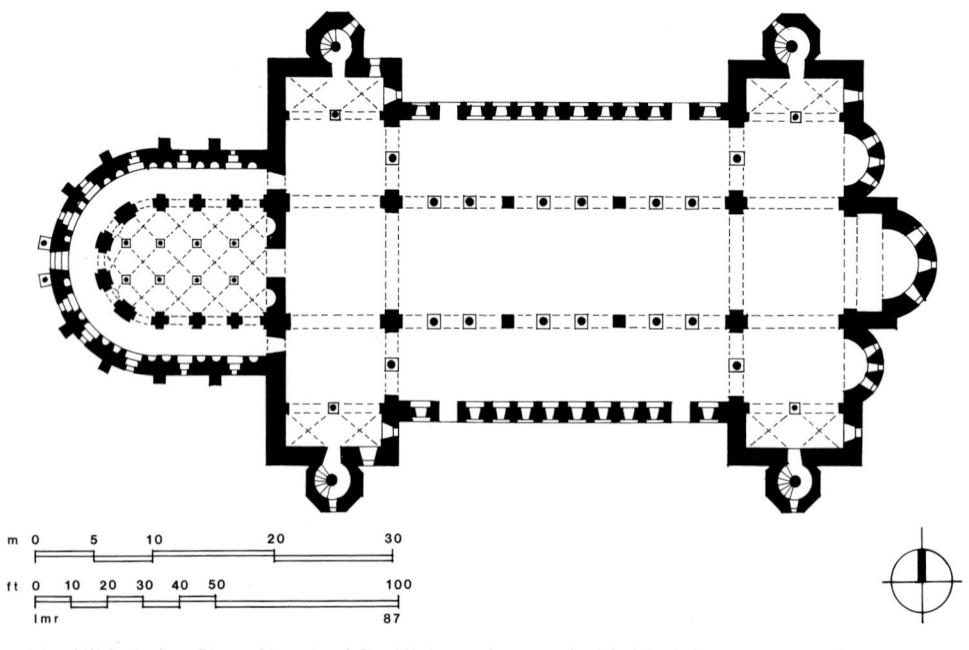

7.33 Hildesheim, Plan, Church of St. Michael, Saxony, 1001-1033 (restored, 1958).

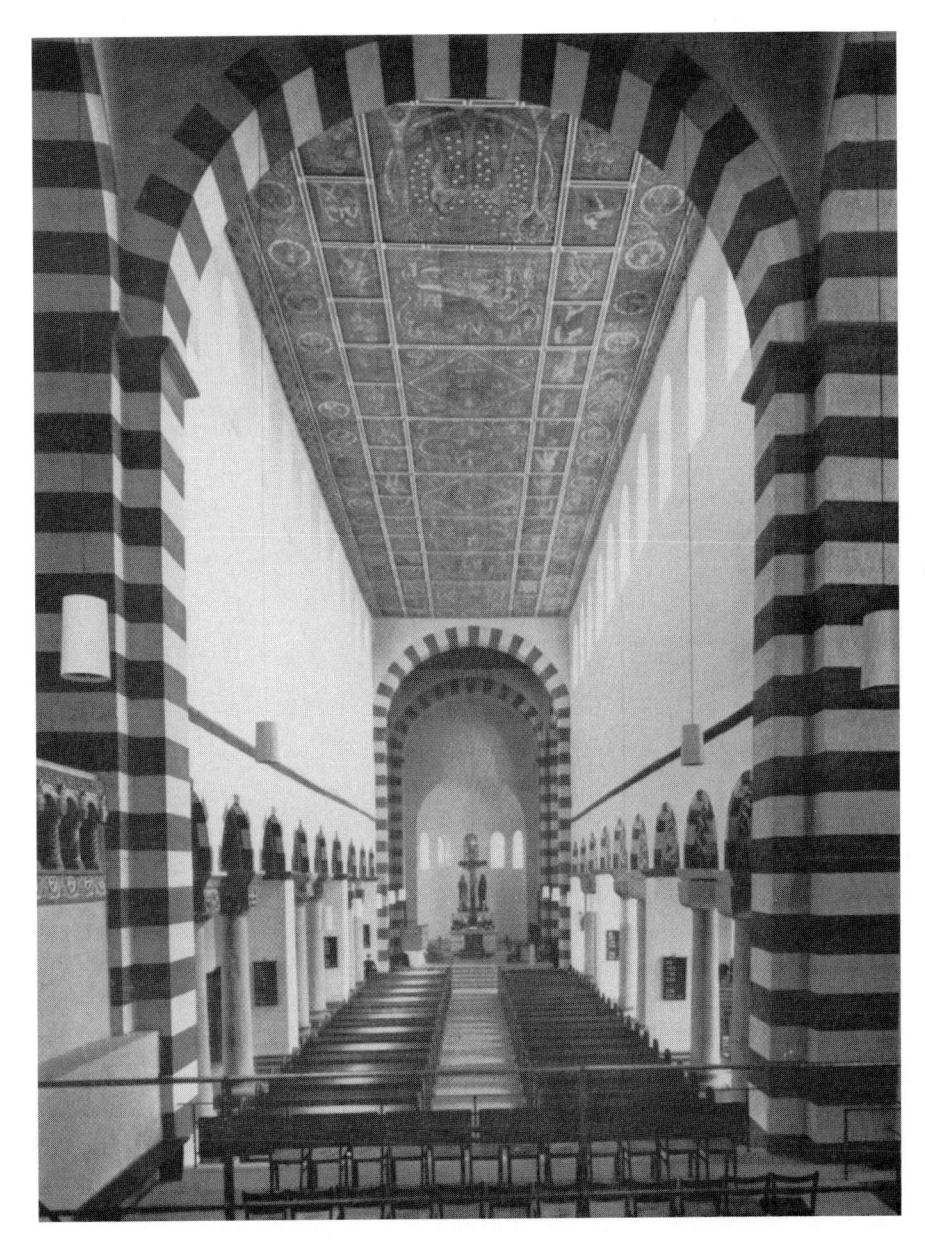

7.34 Nave and aisles. Church of St. Michael, Hildesheim, Saxony, 1001-1033.

the transept arms, the nave, and the sanctuary. This module is then repeated throughout the building with one unit for each transept arm and three units for the nave. Piers and columns form a rhythmic alternation of heavy and light supports, and rectangular and round forms. This contrasting horizontal and vertical movement characterizes the new architectural aesthetic and sets the Ottonian basilicas apart from their Early Christian and Carolingian prototypes.

The cloister monks and the public entered St. Michael's through side doors so that the aisles functioned as entrance halls. The nave ends in transepts and sanctuaries at both the east and the west, giving the church a divided focus. The increasing complexity of the liturgy required double choirs, for which the transept galleries, their floors connected by polygonal stair towers, offered ample accommodation. Decoration was reduced to the clear, cubical forms of architectural sculp-

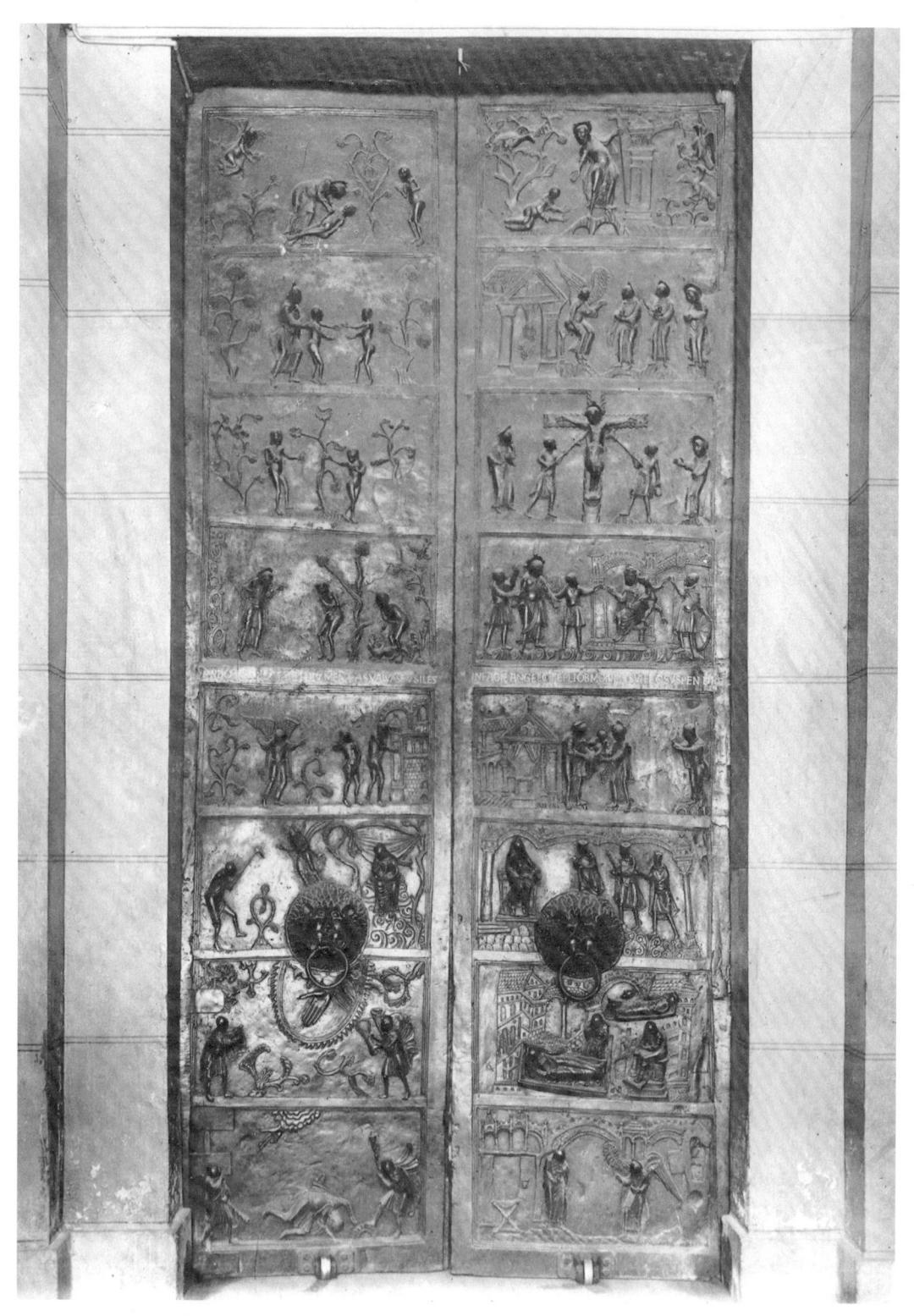

7.35 Old and New Testament scenes, doors of St. Michael's Church, Hildesheim, 1015. Cast and chased bronze. Height 16ft. 6in. (5m). Cathedral of Hildesheim.

Bronze Casting

A remarkable achievement in bronze casting for any age, the doors, each wing of which was cast in one piece, are a near miracle in the eleventh century. Earlier bronze doors had been constructed of small panels nailed to a wooden frame. At Hildesheim, the artisans used the lost-wax process, which they reintroduced to the Continent from Anglo-Saxon England (where the technology, used on a small scale, had never been lost). In the lost-wax process the artist modeled his sculpture in wax over a core. Then the casters made a mold with vents top and bottom so that, as they poured in the molten metal, the wax melted and ran out at the bottom. When they broke away the mold, if they were successful, the metal had the same form as the original wax sculpture. The process is more difficult in practice than its description implies, and the Hildesheim bronze foundry made a significant contribution to the history of technology as well as the history of art.

ture, which established a precedent for the severe and restrained style of the later eleventh and twelfth centuries.

Sculpture in bronze enriched the churches. More than the ivory or wood carver, the metalsmith had always been an important figure in the North. Ottonian smiths, with their roots deep in local tradition, were daring and innovative in the technical perfection of their work in precious metals and daring in the size of their bronzes. They rapidly developed the technical means to fulfill the most demanding patrons.

Bishop Bernward had seen carved doors and commemorative columns when he accompanied Otto III to Rome for the coronation. On his return to Germany in 1001, he ordered his artists to cast a set of bronze doors covered with scenes from the Old and New Testaments [7.35]. The doors were ready for the consecration of St. Michael's in 1015. The bronze casters of Hildesheim represent an unusually popular and dramatic narrative art. They created the first large-scale bronze sculpture in the North—a door 16 1/2 feet (5m) high and a column 12 1/2 feet (3.8m) high—for the Church of St. Michael (now in the Cathedral of Hildesheim). Surely the bishop looked back to the monuments of imperial Rome as he challenged his artists to do as well for the new Christian empire.

The intellectual content of the doors matches the audacity of their physical creation. Bishop Bernward probably designed the iconographical program himself, for only a scholar thoroughly familiar with both art and theology would have conceived of combining this clear narrative history with such subtle interrelationships. The chrono-logical history of the fall of humanity and salvation through Christ is so arranged that paired scenes from Old and New Testaments become a mutually interdependent explication and justification of each other. The left-door wing has eight scenes from Genesis, beginning at the top with the creation of Adam, moving downward, and ending with the murder of Abel. The right wing, beginning at the bottom of the door and running upward, illustrates the New Testament from the Annunciation to the post-resurrection scene of Christ and Mary Magdalen (*Noli me tangere*). A wide frame with a dedicatory inscription divides the narrative sequence into groups of four scenes. On the Old Testament side, events in Paradise ending with the discovery of Adam and Eve lie above the inscription, and events in the world beginning with the expulsion lie below. On the New Testament side, the first four scenes depict the life of Mary and the childhood of Christ; the upper four, the Passion, beginning with the trial before Pilate.

That a scholar designed the program for an educated, theologically sophisticated audience is apparent in the typological comparisons established by each horizontal pair of scenes. Here the theo-logical and moral significance of events is ampli-fied by comparison between the Old and New Testaments. The theme of the two Eves, a theme that became widespread in medieval art, runs through several scenes: Eve, who caused the Fall and Expul-

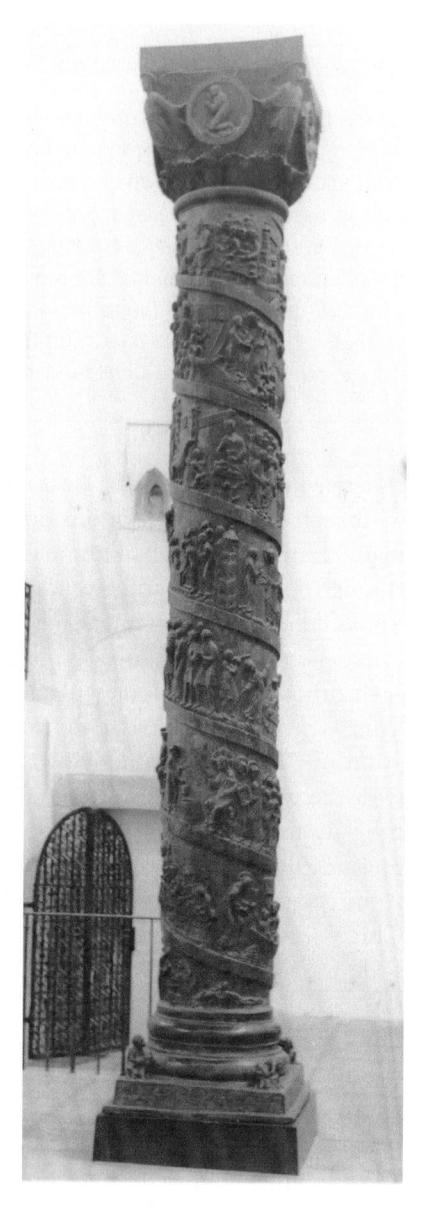

7.36
Spiral column with scenes from the Life of Christ, Hildesheim, 1015–1022. Cast bronze. Cathedral of Hildesheim.

sion from Paradise and whose son Cain committed the first murder, is contrasted with the "new Eve," Mary, through whose son Jesus salvation was granted. The wiping away of sin through Christ becomes a recurring theme: The Expulsion of Adam and Eve from Paradise is paired with the Purification of Mary and the Presentation of Christ in the Temple; Adam and Eve accused by God, with Christ accused before Pilate; the Fall, with the Crucifixion. Every pair of scenes becomes the subject for private meditation and public homily.

Such sophisticated intellectual content is expressed in forms of childlike simplicity and directness, composed by an artist who perhaps was more at home with the pen than the chisel. Small lively figures with a few plants and bits of architecture in open uncluttered space suggest the drawings of the Utrecht Psalter. The jutting heads and gesticulating figures of the Carolingian drawing have been recreated by tilting the upper parts of the figures out until the heads emerge entirely free from the ground. This partial freeing of the actors from the setting produces an exciting surface composition, and an emphatic concentration on human emotions and reactions. The joy and eagerness with which Adam and Eve greet each other, the shifting of blame from one to the other and finally to the serpent in the Fall, the simpering argument of Eve in the Expulsion, the surprise of Mary at the Annunciation, the weakness of Pilate, or the wonder of Mary Magdalen all relate immediately to erring humanity and produce a unique and powerful work of art.

After seeing the triumphal columns carved with the feats of the Roman emperors, Bernward must have decided to create just such a monument to record Christ's earthly life, from his baptism to his entry into Jerusalem—precisely the scenes omitted from the bronze doors [7.36]. The column was probably completed before Bernward's death in 1022. (The column lost its capital and surmounting cross in the seventeenth century.) In contrast to the retrospective Carolingian aura surrounding the doors, the column returns to an aggressively Ottonian style—to dense compositions in which large, intense figures are compressed into a narrow space. The artist built images notable for their expressionistic quality and raw strength. A new artistic personality must have joined the Hildesheim shop, one more attuned to the expression of power than to refinement.

The Cathedral of Speyer bridges the Ottonian and Romanesque periods, and in its final form it is a product of both. A huge crypt extending under both the transept and the sanctuary survives from the building begun in 1030 and dedicated in 1061 as a royal pantheon [7.37]. Here the Ottonian preference for compartmentalization and subdivision

Crypt, Cathedral of Speyer, 1030-1061.

continues. Piers divide the space into square bays, which are then further divided by heavy columns with cubic "cushion" capitals carrying connecting arches and groin vaults in the Lombard fashion. The cubic capital, an extreme simplification of the idea of square to round transition, suited the austere German taste so well that it was used throughout the succeeding Romanesque period.

raised sanctuary flanked by stair towers and covered by an octagonal tower. This imposing tower complex was balanced at the west by an enormous western wall 20 feet (6.1m) thick, to which builders added stair towers and a galleried porch covered by a central tower to form a kind of westwork. As finished, Speyer Cathedral was 435 feet (132.6m) long, making it one of the largest churches in Europe.

The crypt supported a transept and a

The interior of the first church must have been very imposing [7.38]. The timber-roofed nave and groin-vaulted side aisles were carried on rectan-

7.38 Speyer Cathedral, interior of nave, c. 1030-1061 and 12th century.

gular piers with engaged columns running the height of the nave (about 85 feet (25.9m)). A series of arches framed the windows of the clerestory, which were probably large even at this early date. At the end of the eleventh century (c. 1081–1106) the nave was rebuilt in a double bay system, which created an alternating system of heavy and light piers. Square nave bays were formed by combining two of the original bays into one under a groin

vault and reinforcing the weight bearing piers with pilasters (dosserets) faced with engaged columns. The vaults soared to 107 feet (32.61m). As an imperial cathedral, Speyer established the pattern for many later German churches.

Ottonian art is an aristocratic art of great splendor. The artists served the empire, although they also served a religion that held spiritual values above the material world and questioned the possibility of expressing truth in tangible form. Ottonian artists could be conservative, turning back to the arts of imperial courts of the past—Rome, Constantinople (Byzantium), and Aachen—and they could be equally innovative as they created a Western imperial style. The arts glorified and justified the combined secular and

religious authority of God-like emperors and aristocratic worldly clerics, but they also had a potent spiritual and intellectual impact. An art of contrast, Ottonian art combines simple narratives and complex metaphors, severe forms and intricate interlocking spaces, a denial of the flesh in the images of ecstatic saints and an adulation of material goods in the gold and jeweled sumptuary arts. This is a figurative art in which bodies have ornamental as well as narrative functions. Like St. Luke in the Gospels of Otto III, the art draws into itself the inspiration of the past and seemingly digests and then flings forth new forms. In their synthesis of old and new, East and West, Ottonian artists created a severe, monumental style for a Holy German/Roman Empire.

8.1
Bayeux Tapestry,
c. 1070. "Here
William came to
Bayeux, where
Harold swore a
sacred oath to the
Duke William."
Centre Guillaume
le Conquerànt,
Bayeux, by
permission of the
City of Bayeux.

CHAPTER

ROMANESQUE ART

n art and architecture emerged in Europe in the eleventh and twelfth centuries that is both international and regional, sophisticated and direct—an art for monks and emperors, pilgrims and crusaders, peasants and nobles. Romanesque art reflects the dichotomy of an age when the ideal of a universal Christian Church confronted a feudal, manorial society where every region had its unique history and traditions, yet as the leader of the Western Church, the Pope claimed dominion over all earthly rulers [8.1]. Not surprisingly, the Patriarch of Constantinople refused to recognize the claims of the man he considered simply the bishop of Rome, and the final break between the Latin and Greek Churches came in 1054.

Although clergy, nobility, and peasants had their assigned places in the social system, secular rulers could be equally resentful of papal claims. Europe was divided among many local authorities.

Church reforms begun in the Carolingian period but lost during the Viking invasions began again in the tenth century in Lorraine (northeastern France) at the Abbey of Gorze and Burgundy at the Abbey of Cluny. The Gorzian reformers worked within the existing social system, deferring to the bishops and secular lords. The monks of Cluny remained independent of lay control and subject only to the Pope. For 40 years the Cluniac monk Hildebrand was the power behind the papacy, first as adviser to Popes Leo IX (1048–1054) and Alexander II (1061–

The European Economy in the Twelfth Century

Europe at the beginning of the twelfth century was still rural. Individual manors, where peasants cultivated strips of land cooperatively, formed the basis of the economy. A manor might extend over a thousand or even two thousand acres and include crop land, pasture, and timber. The lord's manor house and its out-buildings (barns, mill, forge, brewery, and wine press), the church, and a cluster of peasant houses formed a manorial village. Gradually improvements in agriculture created a modest surplus. By the end of the twelfth century, free peasant landholders acquired their own land by participating in reclamation projects, clearing forests and draining swamps, or joining crusades and pilgrimages and remaining in newly conquered territories as settlers. With increased productivity, agricultural surpluses became a reality, trade revived, population increased, and villages grew into towns.

1073) and then as Pope himself (1073-1085). As Pope Gregory VII, he revitalized the Church in the eleventh century with edicts known as the Gregorian Reform. Gregory declared the Pope to be infallible, and he affirmed the independence of the Church and the power of canon law. He insisted on an educated, celibate clergy free from lay control. Gregory finally overreached himself in his conflict with the German rulers, and although he humiliated Henry IV at Canossa in 1077, by 1084 the German army threatened Rome and Gregory called on his Norman allies for aid. Soon the Normans turned on him and sacked Rome. Gregory escaped to Monte Cassino, then ruled by Abbot Desiderius, who would succeed him as Pope (1086-1087) [see 8.5]. Gregory died in 1085, but the Gregorian reform continued under his allies, Popes Victor III, Urban II, and Pascal II. In spite of the conflicts, and the rise and fall of individual men, the Church and with it church building and the liturgical arts flourished under the reformers.

Political and economic power also moved from tiny, fragmented parcels and powers toward increasing centralization as powerful laymen increased their landholdings, more efficient agriculture produced modest surpluses, and manufacture and trade revived. A political structure arose in western Europe

known as feudalism (from feudum, or fief, a parcel of land). Feudalism emerged from the tribal loyalties of the early Middle Ages as a system of landholding in return for military and judicial service. The parties to the agreement were bound by personal oaths. As we see Harold taking an oath on the relics of Bayeaux cathedral. The lord promised his people protection and justice; his vassals owed military service, administrative assistance, and a share of the produce of the land worked by peasants and serfs. Power and wealth, and consequently patronage of the arts, depended on local tradition yet all patrons and artists alike paid lip service to the Church.

Throughout the period, both the Iberian Peninsula and the Near East were battlegrounds. By 1085-1086 the Muslim (Moorish) stronghold of Toledo fell to the Castilian King Alfonso VI, but in the East the Seljuk Turks conquered former Byzantine lands in Syria and most of Asia Minor. In 1095 the Byzantine Emperor Alexius Comnenos appealed to the Pope for help. Pope Urban II rallied the French nobles for a crusade, and taking the cross as their symbol, the Christian army marched on the Holy Land. Between 1096 and 1271 the Christians launched seven crusades. The first Crusaders captured Jerusalem and set up Crusader Kingdoms; later Crusaders were not as successful, and in 1187 the great Muslim general Saladin recaptured Jerusalem.

The establishment of short-lived Crusader Kingdoms in Syria and Palestine as well as the determined reconquest of the Iberian peninsula brought the West into contact with Muslim and Byzantine culture. A productive cultural exchange occurred between adherents of rival religions. An international trade developed with the East, and a money economy replaced barter to finance expeditions, construct ships, and organize caravans. Meanwhile villages located on the trade routes grew into towns, and local market towns became cities where trade fairs combined business and pleasure. For example, Christian crusaders led by a Burgundian nobleman, Raymond of Burgundy, founded Avila in Castile as a military outpost; Avila soon grew into an important crossroads and cathedral city [8.2]. Artisans as well as merchants settled in towns where they made

Avila, late 11th and 12th centuries.

furniture, pottery, and metal utensils for the local markets. Increasingly complex government and economic organization required persons of intellectual ability rather than merely hereditary rights or military strength. The Church still attracted and educated men and women, but in the twelfth century, universities in Bologna, Paris, and Oxford began to challenge the educational monopoly of monasteries and cathedral schools. In short, the Church, the state, and the town all provided opportunities for intelligent and ambitious people.

SECULAR ARCHITECTURE

Castles are the most characteristic secular buildings of the period. Stone towers and walls replaced the earth and timber buildings characteristic of early medieval architecture, although the Norman motte-and-bailey castles continued in use through the eleventh century. Easily and rapidly built, the wooden tower on an artificial earth mound (motte) with wooden palisades around a large open yard (bailey) was efficient but vulnerable to fire. In the Bayeux Tapestry, Normans torch the stronghold of Dinan [8.3]. As soon as possible, the wooden palisades around the bailey were converted to stone, and the keep, as the tower was called, was strengthened to withstand a prolonged siege. Walls were reinforced at the base as protection against mining. Crenellated battlements (permanent stone shields behind which defenders could step for protection) topped the walls and towers. The flat tower roofs served as firing platforms. Courtyards within the castle walls provided refuge for both animals and people.

The internal arrangements of the keep were simple. The ground floor had no exterior entrance; it provided storage space and could be entered from the upper floors. A single fortified door high on the wall was the only entrance. The great hall on the principal floor (American second floor) might be two stories high, with private chambers in the thickness of the walls at the upper level. Spiral staircases in the corner turrets and passages in the walls provided access to the chambers, upper floors, and the roof, and latrines were also built within the walls. A windlass on the roof and a series of openings in the center of the floors provided an effective means of lifting supplies. Inconvenient and uncomfortable as a dwelling, the Norman castle was both an effective military building and a symbol of the local ruler's power and authority.

As military architecture became more sophisticated, rectangular forms gave way to circular or Dshaped towers (as at Avila) against which battering rams moved with less devastating effect. The bailey increased in size, and the surrounding curtain wall was strengthened. More comfortable living quar-

8.3 Storming of Dinant, Bayeux Tapestry, c. 1070. Wool embroidery on linen. Height 20in. (50.8cm); length of entire tapestry 229ft. 8in. (70m). Centre Guillaume le Conquerànt, Bayeux.

ters, as well as separate quarters for the garrison, could be built out of timber in the bailey. Additional circuit walls added to the strength and flexibility of the defenses. During the Crusades, both Christians and Muslims learned to increase the effectiveness of walls and towers with crenellations, loopholes, barbicans, vaulted towers, and bent passages to thwart new siege techniques. Elaborate fortified gatehouses [see 6.22] became especially important, symbolically as well as defensively.

THE EMPIRE AND THE PAPACY

Europe remained a collection of small states sometimes held together by personal ties, feudal oaths, and self-interested alliances sealed by marriages. In the lands of the former Ottonian Empire (Germany and Italy), two great families struggled for power, the Welfs of Saxony and the Hohenstaufens of Swabia. The power struggle between the Welfs and the Hohenstaufens spread into Italy, where Welfs were known as Guelfs and usually supported the Pope, and the Hohenstaufens became the Ghi-

belline, or imperial, party. The Papal States lay between the semi-autonomous cities in the north and the Norman Kingdom of the Two Sicilies in the south. In such circumstances it is not surprising to find many flourishing regional styles. Such unity as exists amid the complex crosscurrents can be attributed in part to the international outlook of the papacy and the dreams of power and reform of Pope Gregory VII and the Cluniac reformers of the Benedictine Order.

German architecture had found its definitive expression in the Cathedral of Speyer—the imperial pantheon and symbol of both religious and secular power and authority. The builders refined and adapted Ottonian architectural forms and Lombard exterior decoration. Ultimately, however, it is sheer size that makes Speyer Cathedral a symbol of the imperial challenge to the rest of the Christian world [see 7.38]. German Romanesque sculpture and painting, like the architecture, adopted themes and techniques from Carolingian and Ottonian art and in so doing created a style of unprecedented clarity, severity, and magnificence. Artists worked with a finesse associated with goldsmithing, and their drawing and choice of colors sometimes suggest the inspiration from enamelwork. The arts reached new heights of elegance and beauty in the Rhineland and Mosan regions where women as well as men worked as scribes and painters.

Artists in Lorraine—the Meuse River Valley, in the territory lying in the heart of Carolingian Lotharingia and including the cities of Aachen, Trier, Metz, Verdun, and Liège—revitalized and adapted Byzantine formulas and iconographical programs with exceptional effectiveness. Inspiration from Byzantine and Carolingian art enabled Mosan artists to achieve a uniquely humanistic style. Liège, a center of classical learning in northern Europe, was called the "Athens of the North" in its day. The interest of its scholars must have permeated the cultural atmosphere, for the art associated with the valley of the Meuse is truly "classical" in its harmony, simplicity, and dignity.

Mosan artists, and their neighbors in the

Rhineland, became masters of enamel and of metalwork. One of the first was Rainier, from Huy, south of Liège. Between 1107 and 1118 he cast a bronze baptismal font for Notre-Dame-des-Fonts in Liège (the font is now in the Church of St. Barthélémy) [8.4]. The font literally reproduces the "molten sea" standing on 12 oxen in Solomon's temple (I Kings 7:23–24). On the sides of the basin the traditional images of St. John the Baptist and Christ are extended to include the parallel themes of St. Peter baptizing the centurion Cornelius and St. John the Evangelist baptizing the philosopher Crato. Rainier of Huy has rendered his figures as a remarkable study, idealized bodies whose softly rounded forms convey tangible reality, whether nude or covered with heavy clinging drapery. Each figure is an independent unit, yet each relates to the others through movement and gesture. Rainier shows that the classical and humanistic tradition did indeed survive north of the Alps.

By mid-century, the Mosan and Rhine regions produced the finest enamel to be found in western Europe. We have seen a splendid example of their work in the Stavelot Triptych in Chapter 1 [see 1.1]. Abbot Wibald of Stavelot maintained good

8.4 Rainier of Huy, Baptismal font 1107-1118. Bronze, height 24in. (60cm). St. Barthélémy Church, Liège, Belgium.

relations with the German emperors and probably ordered the reliquary of the True Cross after a diplomatic mission to Constantinople undertaken for Frederick Barbarossa in 1154.

The intellectual revival in the North, inspired by Benedictine reformers, matched the intensity of the reforming Popes in Italy. In the eleventh century, a remarkable person became abbot of the monastery founded by St. Benedict at Monte Cassino, south of Rome. Abbot Desiderius, a nobleman from northern Italy, ruled the abbey from 1058 to 1086. In 1086 he left the abbey to become Pope Victor III. As abbot, Desiderius followed a conscious policy of reviving the arts and introducing Byzantine craftsmanship to the West. Beginning in 1066, he rebuilt his abbey church on a large scale and consecrated it in 1071 [see 8.5]. Not surprisingly Desiderius took St. Peter's in Rome as his model, but he made important changes. The abbey church did not have to accommodate crowds of laymen and pilgrims, so single aisles and a short transept provided sufficient space, but the Benedictines needed more altars, so Desiderius added chapels at the ends of the aisles. A

Desiderius Offering the Church to Christ. Fresco on the lower wall of the apse in S. Angelo in Formis. 1072-1100.

large apse with parallel smaller side chapels came to be known as the "Benedictine plan." The transept and three apses were raised eight steps above the nave in order to accommodate the tomb of St. Benedict. The builders also introduced important structural innovations such as Muslim pointed arches and catenary (hanging chain) vaults in the narthex and

atrium. As represented in the wall painting of St. Angelo in Formis, Desiderius holds a model of the church [8.5]. As the headquarters of Benedictine monasticism, the prestige of the abbey church made it a model for builders throughout Europe.

Desiderius' biographer, Leo of Ostia, enthusiastically recounted the decoration and furnishings of the Constantinople church. From Desiderius ordered bronze doors and a golden altar frontal decorated with gems and enamels representing stories from the New Testament and miracles of St. Benedict. He paved the steps to the altar with marble and added a choir screen of red, green, and white marble. A purple pulpit decorated with gold, six candlesticks of silver, a gilded silver column to hold the Easter candle, and a huge silver chandelier with 36 lamps are but a few of the items with which he enriched the sanctuary. The abbot brought in Byzantine mosaic workers to decorate the apse and narthex, and to instruct the monks who showed interest and aptitude.

Abbot Desiderius' elevation to the papacy enhanced the link between Monte Cassino and Rome, just as earlier Gregory VII had allied the papacy with Cluny. After the Norman sack of Rome in 1084, the city and its churches needed to be refurbished. Monte Cassino provided craftsmen and technical knowledge, as well as new models for the Romans.

Nowhere is the classical revival more apparent than in the Church of S. Clemente [8.6]. The basilica had a nave arcade of Ionic columns, mosaic-covered apse, and splendid furniture. The new church was consecrated in 1128. It stood over an earlier church, which surmounted, at a still lower level, a Roman street, houses, and a Mithraic shrine. Following the

Nave with choir and Cosmatesque pavement and furniture, Church of S. Clemente, Rome, rebuilt after 1084, consecrated 1128.

lead of Monte Cassino, the Church of S. Clemente had a nave and aisles ending in three apses. In the nave arcade piers interrupted the continuous pattern of columns and arches to add a dynamic rhythmic pulse to the stately basilican elevation.

The furnishings of S. Clemente provide a vivid illustration of Leo of Ostia's description of Monte Cassino. The choir extends into the nave as far as the piers, its low parapet marking the area reserved for the clergy. Marble inlay and sculpture salvaged from the chancel built by Pope John VIII in 872 were reused here. The raised lectern, a large Easter candlestick, and a baldachino over the altar are all decorated with the ornamental marble inlay called "Cosmati work" after the craftsmen of that name. The Cosmati workers inlaid white marble panels with fine geometric patterns made up of small pieces of colored glass and stones. Supported by the prestige of Monte Cassino and Rome, Cosmatesque decoration continued to be used well into the fourteenth century as far away as Westminster Abbey in England.

The gold and green apse mosaic at S. Clemente reaffirmed in its complex symbolism the Christian faith in the Resurrection [8.7]. Christ on the Cross is flanked by the mourning Virgin and St. John. Twelve white doves symbolize the apostles. The Cross emerges from an acanthus-vine scroll filled with birds, animals, and people, symbolizing the earthly life. By Christ's sacrifice the Cross becomes the Tree of Eternal Life. It joins heaven and earth as it emerges from the heart of the earthly acanthus and reaches to the canopy of the heavens, where the hand of God holds a victor's wreath, the ultimate classical symbol of triumph. The irregular setting of the tesserae actually increases their glitter and heightens the effect of the gold. Simplified shapes and sharp outlines turn the central figures into repeated patterns. Yet the representation of the suffering of Christ and the pathos of the mourners recall later Byzantine art. The mosaic, for all its imperial and Early Christian associations, is clearly twelfth century in technique and style.

North of Rome, in Tuscany, the Roman and Early Christian heritage of Italy also determined the special character of Romanesque art, in spite of the very different history and atmosphere of the emerging commercial cities. Florence was a Guelf city; and

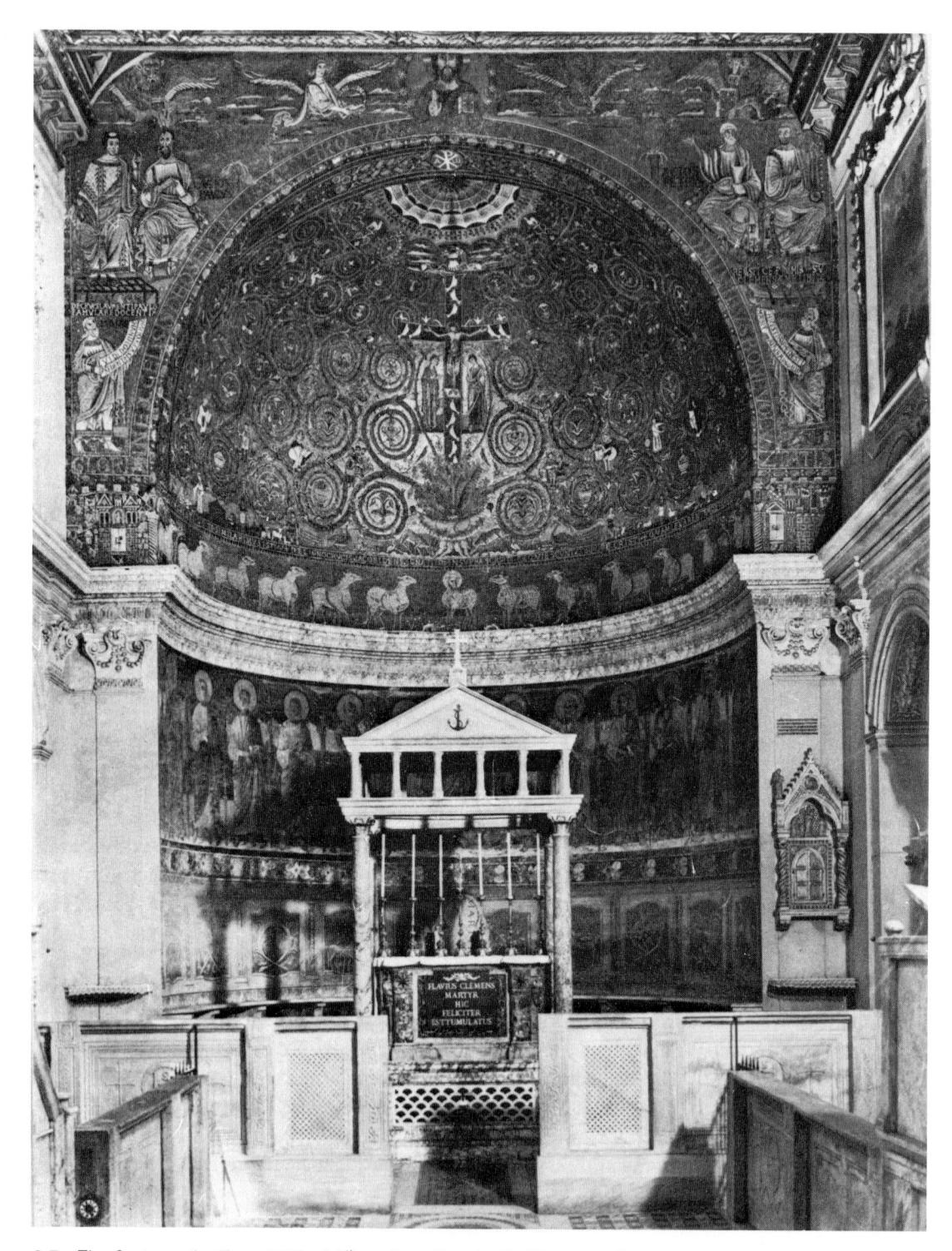

8.7 The Cross as the Tree of Life, 12^{th} century. Mosaic, S. Clemente, Rome.
Pisa. Ghibelline. Florence under the Countess Matilda (1046–1115) had a prosperous and enlightened citizenry, and Matilda herself was an educated woman, a patron of the arts, and a friend of Pope Gregory VII. The cities also became commercial rivals. Competition extended into the arts, and splendid Romanesque churches rose in both cities. The typical Tuscan church remained basilican in form following Roman tradition, but, unlike the Early Christian basilicas, both the exterior and the interior were richly decorated with marble sheathing—white and green geometric and architectural patterns at S. Miniato in Florence [8.8], and blind and false arcades at Pisa [8.9].

The cathedral complex at Pisa was begun in 1063 immediately after a Pisan naval victory over the Muslims. It is a tribute to civic pride and Pisan commercial success as well as to the Virgin, to whom it was dedicated. The cathedral is part of a complex that retains the Early Christian separation of functions in different buildings. Besides the cathedral, the Pisans built a separate baptistery, bell tower, and cemetery. The most distinctive feature of the buildings is their exterior encrustation with a veneer of pale marble enriched with pilasters and tiers of arcades. The famous "leaning tower of Pisa" was

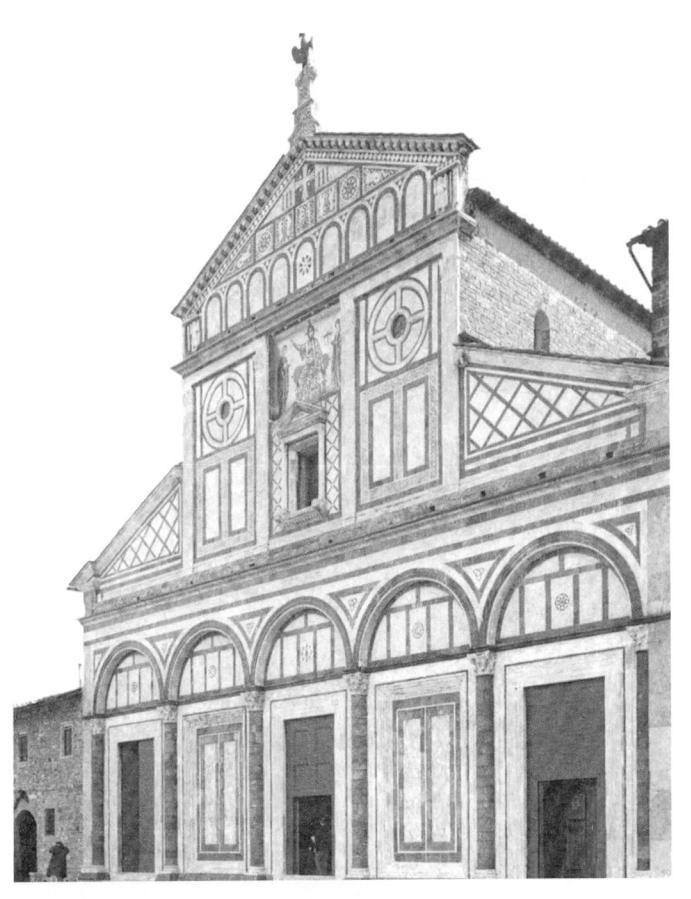

San Miniato al Monte, Façade. 1062-1150. Florence.

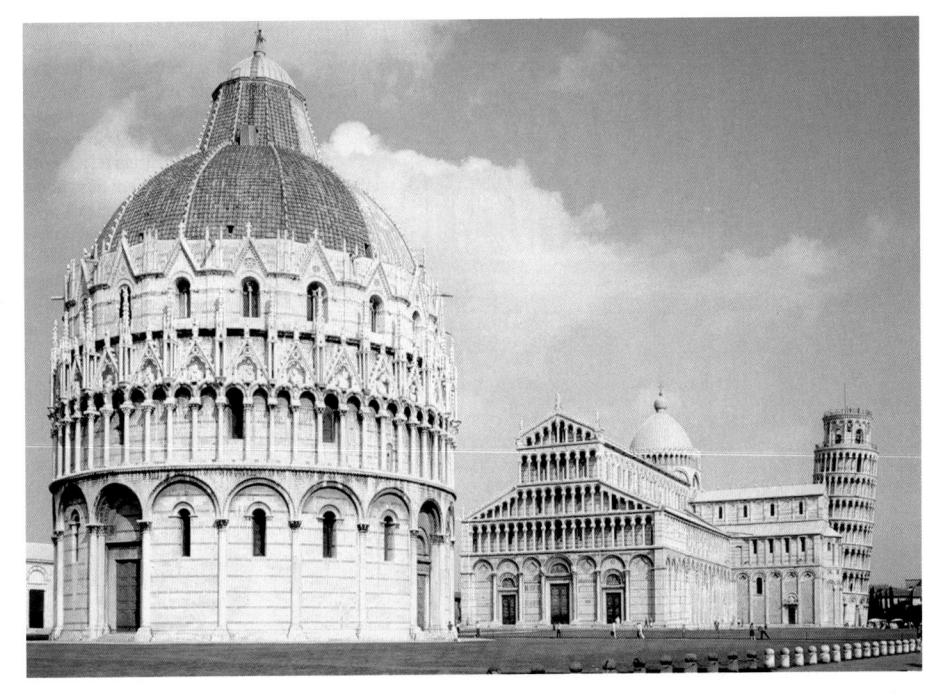

Baptistry 1153; Cathedral begun 1063; Campanile 1174. View from the west. Pisa.

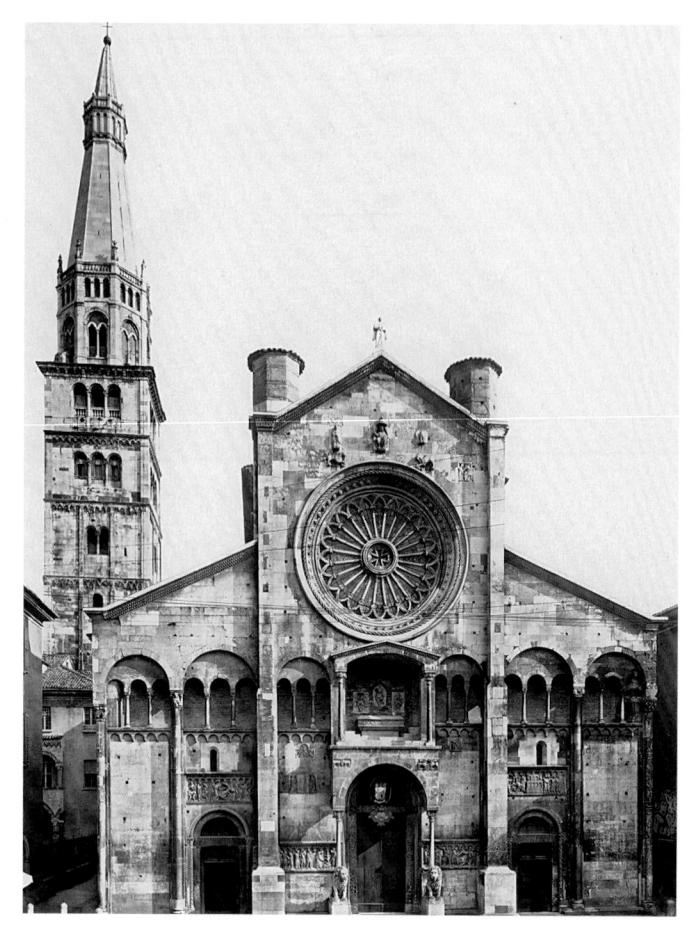

8.10 Cathedral of Modena. West façade. 1099-1120.

built by Bonanno of Pisa in the last decades of the twelfth century.

Farther north in Lombardy and Emilia, the church façades were decorated with bands of sculpture, and portals guarded by huge marble lions or griffins. The Cathedral of Modena had both sculptured friezes and lion portals. The friezes by the master sculptor Wiligelmo are among the earliest examples of monumental architectural sculpture. Four horizontal panels with scenes from Genesis once formed a continuous frieze on each side of a central portal [8.10] (they have since been reset at two different levels). They probably date from the time when the relics of the patron saint were transferred to the crypt in 1106.

A relief depicting scenes from Genesis—Cain shot by the blind Lamech, Noah's Ark, and the departure of Noah and his family from the Arkillustrates Wiligelmo's narrative and compositional skill [8.11]. In creating these ponderous figures, Wiligelmo exaggerated the Constantinian qualities of figural mass and stance and dense overall composition. Even in the dramatic forest scene, where Cain grasps a branch in a strangely poignant gesture as he falls dead, the figures seem compressed into the panel, although the framing arcade hints at a narrow stage on which the dramatic action may proceed. A comparison of the Modena reliefs

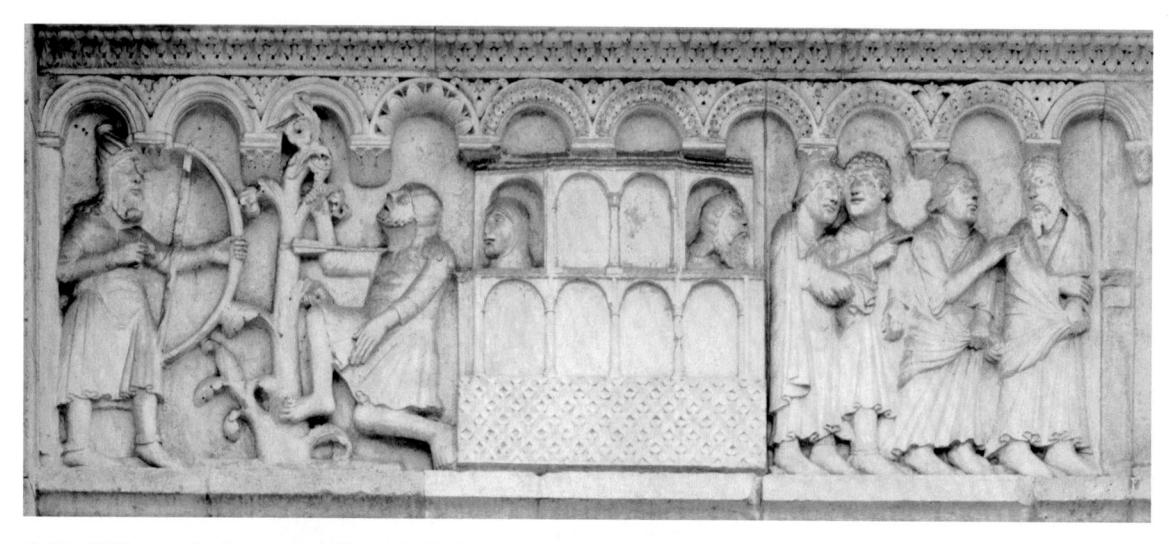

Wiligelmo (active, early 12th century), Cain and Lamech, Noah, relief from the west façade, c. 1100. Height about 36in. (91.4cm). Cathedral of Modena.

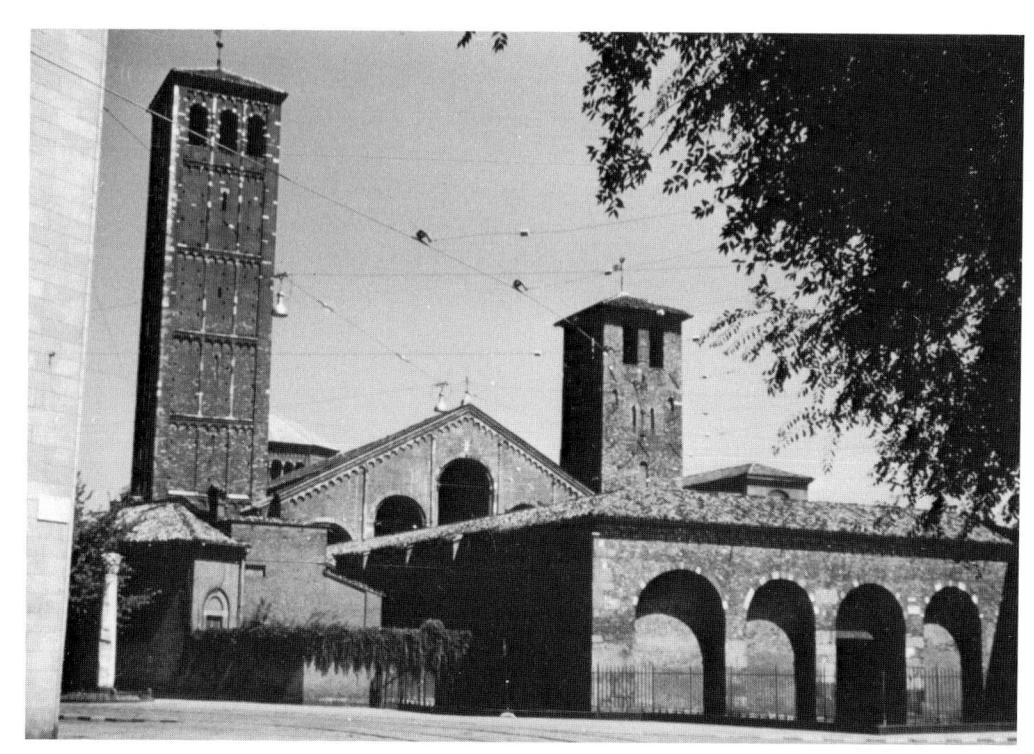

Church of S. Ambrogio, Milan, 11th and 12th centuries.

with the Ottonian bronze doors at Hildesheim is instructive [see 7.35]. Both sculptors may have had access to classical models; both created dramatic narrative compositions. But whereas the Ottonian artist worked with a loose, open composition and an illusionistic rendering of forms, the Romanesque sculptor created an intricately balanced and compressed composition. Restoration of the sculpture has revealed traces of the original brilliant colors, which would have increased the visual impact of the sculpture.

In Milan, the original home of the magistri comacini [see 7.8 and 7.10], the Lombard-Catalan style reached maturity in St. Ambrose's Church, the coronation church of the German emperors as kings of Italy. S. Ambrogio is a red-brick, aisled basilica of four bays ending in a raised sanctuary. The exterior has only architectural decoration of arched corbel tables and strip buttresses [8.12]. The present building was begun about 1080 and grievously damaged by an earthquake in 1117. After the earthquake, domical ribbed vaults of stuccoed rubble and brick with unmolded ribs were built over the nave [8.13]. Rising from compound piers, the

ribs emphasize the effect of repeated similar units. Groin vaults supported on light intermediate piers cover the square bays of the aisles. This structure two aisle bays for one in the nave-produced the same alternating system of supports used at the Cathedral of Speyer after its twelfth-century remodeling. In spite of the relative stability of the domical ribbed vault, the builders kept the walls heavy and the openings small, and they buttressed the nave with vaulted galleries, producing a relatively dark, two-story interior. Later they rebuilt the bay in front of the sanctuary as a lantern tower to bring light directly into the nave.

CATALONIA (CATALUNYA)

Politically and economically Catalonia (Catalunya) maintained close contact with Italy and the Germanys. By the second decade of the twelfth century, the counts of Barcelona had extended their territories to include Provence, on the very borders of the Holy Roman Empire. Furthermore, Catalonia increased its economic competition with northern Italy as it developed into a maritime and

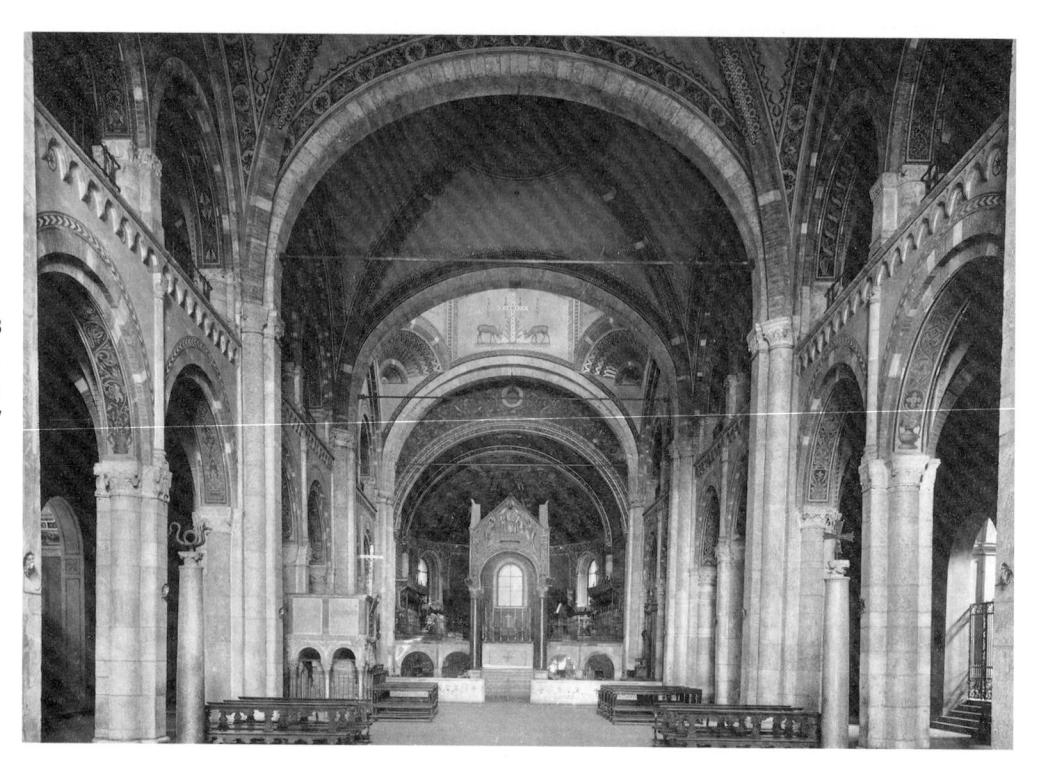

8.13 Nave, S. Ambrogio. Vaults, after 1117; baldachino, early 11th century.

commercial power in the western Mediterranean. Nevertheless, few churches could afford elaborate and costly mosaic decoration. Few westerners had the technical skill to make mosaics regardless of the ideals of the rulers and patrons. Paintings replaced mosaics in the apses and on the walls of churches, and Catalan paintings now stand among the prime examples of Romanesque art.

The Church of S. Clemente in Tahull, consecrated in 1123, has apse paintings depicting the apocalyptic vision of Christ in Glory surrounded by the symbols of the Evangelists [8.14]. Christ holds an open book bearing the text "Ego sum lux mundi" (I am the light of the world). Alpha and Omega, suspended on threads, swing from a pearled glory surrounding the image, and four vivacious angels grasp the four symbolic beasts. On the wall below, a painted arcade frames the Virgin Mary and Apostles. The formal geometric conventions seen in the paintings probably resulted from a blend of the imported Byzantine style with native Mozarabic qualities. In the extraordinary drapery patterns the Byzantine formulas for highlights have become an independent pattern of lines and circles. The

Mozarabic heritage is apparent in the elongated oval shape of the heads, the wide eyes with enormous pupils, and the long pointed noses. Hair and beards have become symmetrical, decorative patterns. Mozarabic, too, is the painter's use of wide horizontal bands of color as a background against which the figures are drawn with heavy black outlines. The deep colors—blue, green, red, carmine, ocher, and other earth colors, black and white—have a very high intensity. The skill of the artist in drawing with these colors revitalized the Byzantine formulas.

THE "PILGRIMAGE STYLE" IN LANGUEDOC AND NORTHERN SPAIN

A remarkable feature of Romanesque culture was the increase in travel. Crusaders and pilgrims, merchants and monks made dangerous journeys seeking both spiritual and worldly profit. Pilgrimages and crusades crossed geographical, social, and political boundaries. Pilgrims traveled to shrines of local saints, and to the Holy Sepulchre in Jerusalem, the tombs of Sts. Peter and Paul in Rome, and the tomb of St. James in Spain. The cloister of the

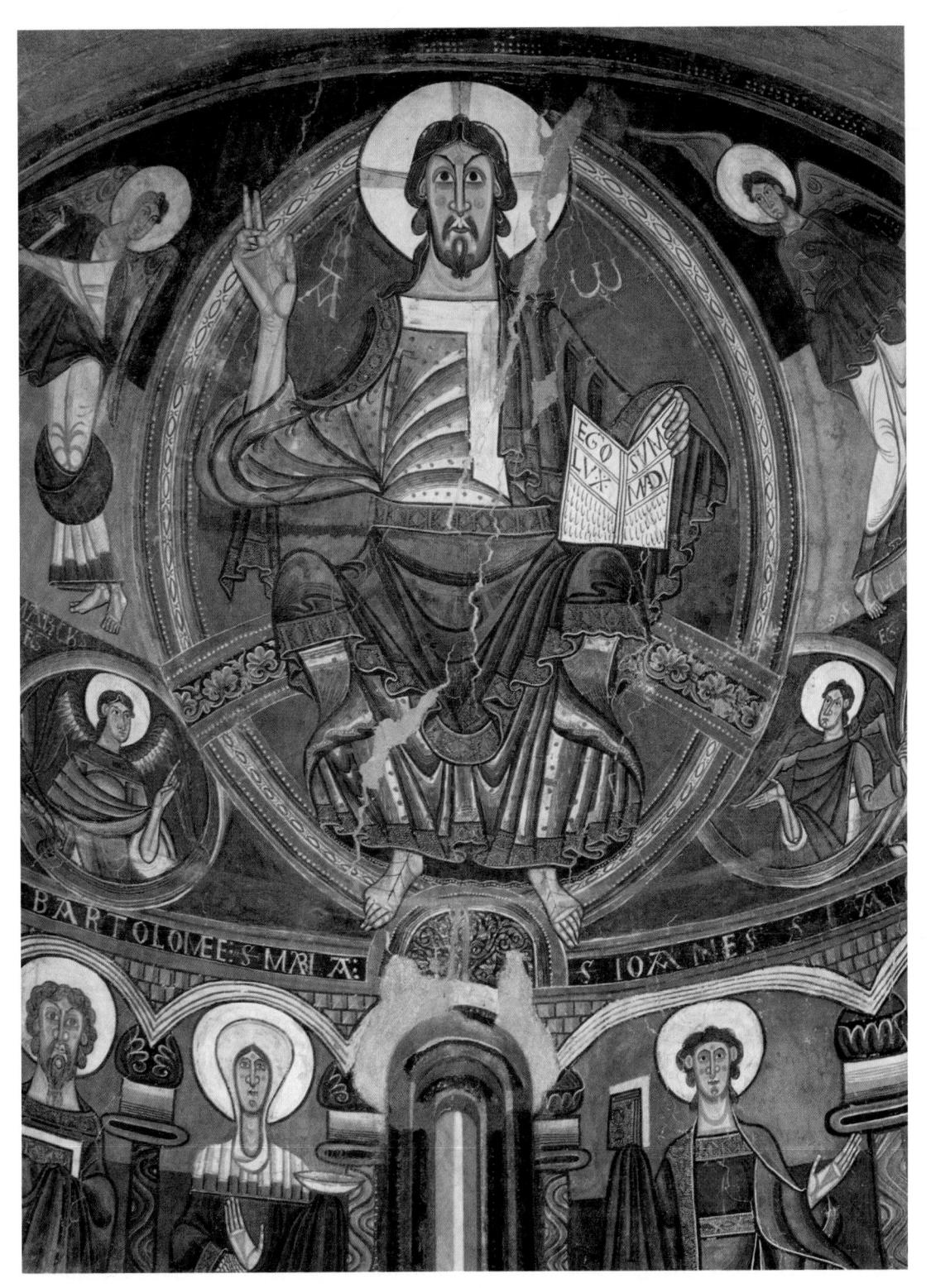

8.14 Christ in Glory, apse of the Church of S. Clemente, Tahull, Catalonia, 1123. Mural painting. Museo d'Arte de Catalunya, Barcelona.

Romanesque Aesthetics

Patrons and artists during the eleventh and twelfth centuries were united in their intention to represent the splendor of the Heavenly Jerusalem on earth and to prepare humanity for the life hereafter with art that was both didactic and magnificently decorative. They hoped to represent the perfect beauty of the wisdom of God rather than the accidents of nature and to lead the imperfect human mind to an understanding of the invisible and perfect beauty of God through images. This perfection underlying earthly forms could be expressed only in the generalizations of an abstract conceptual art. Unlike the Byzantines, the Western philosophers did not develop a complete and coherent theory of art. However, through imaginative intellectualization of organic forms, the Romanesque artist created new images of human beings and the world they inhabit.

monastery of Sta. Domingo de Silos, south of the main pilgrimage road in Old Castile, has among its richly carved capitals and pier reliefs a scene of pilgrims on the road to Emmaus [8.15]. Here Christ himself appears as a pilgrim to the shrine of St. James in Santiago de Compostela, wearing the scallop-shell pilgrim's badge on his satchel. Like the pilgrims, the sculptor's knowledge crossed boundaries, and he must have known both Mozarabic art and the new monumental art of stone sculpture. The three figures seem almost boneless as they step forward in graceful cross-legged poses, their bodies covered with tight sheaths of drapery. Scholars still disagree over the date of the Silos cloister sculpture: Did the master inaugurate a new style at the turn of the eleventh century or did he work later? But everyone can agree on the sensitivity and sophistication of the carving.

By the eleventh century the tomb of St. James, which had been discovered in Galicia in the ninth century, rivaled that of St. Peter in Rome and the Holy Sepulchre in Jersusalem as a pilgrim's goal. Four roads linked Compostela with the important cities of France. Three roads—one from Paris through Poitiers; a second through Vézelay; and a third joining Conques and Moissac-came together at Roncesvalles (Roncevaux) in the Pyrenees

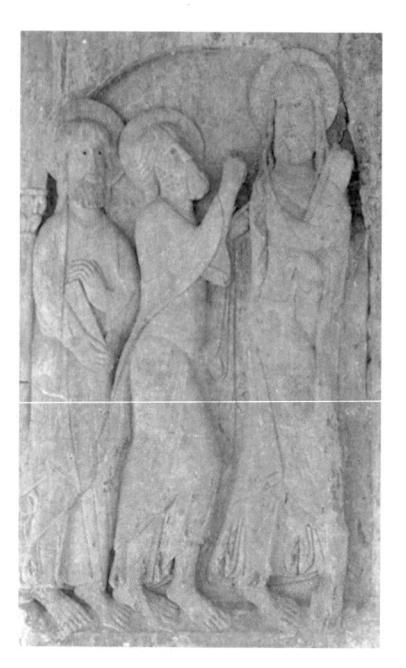

8.15 Christ on the way to Emmaus, c. 1100. Cloister pier relief at the Abbey of Santo Domingo, Silos.

mountains, the site of the massacre of Charlemagne's rear guard under the command of Roland (immortalized in the epic poem The Song of Roland). The fourth and southernmost road passed through Toulouse and joined south of the mountains to form a single road crossing northern Spain. Pilgrims trod a reasonably well-built road maintained by the guild of bridge builders and policed by the Knights of Santiago. Monasteries along the road provided lodging and assistance. The Pilgrim's Guide, describing the route and the most important shrines along the way, was compiled by a French pilgrim in the 1140s.

A great church, the Cathedral of Santiago de Compostela rose over the tomb of St. James, and a similar building stood on each of the four principal roads in France [8.16]. The Cathedral of Santiago and the churches of St. Sernin at Toulouse and St. Faith (Foy) at Conques have survived more or less in their Romanesque form. They illustrate a remarkably unified style in architecture and sculptural decoration. All were being built at the same time, and masons could have moved from site to site.

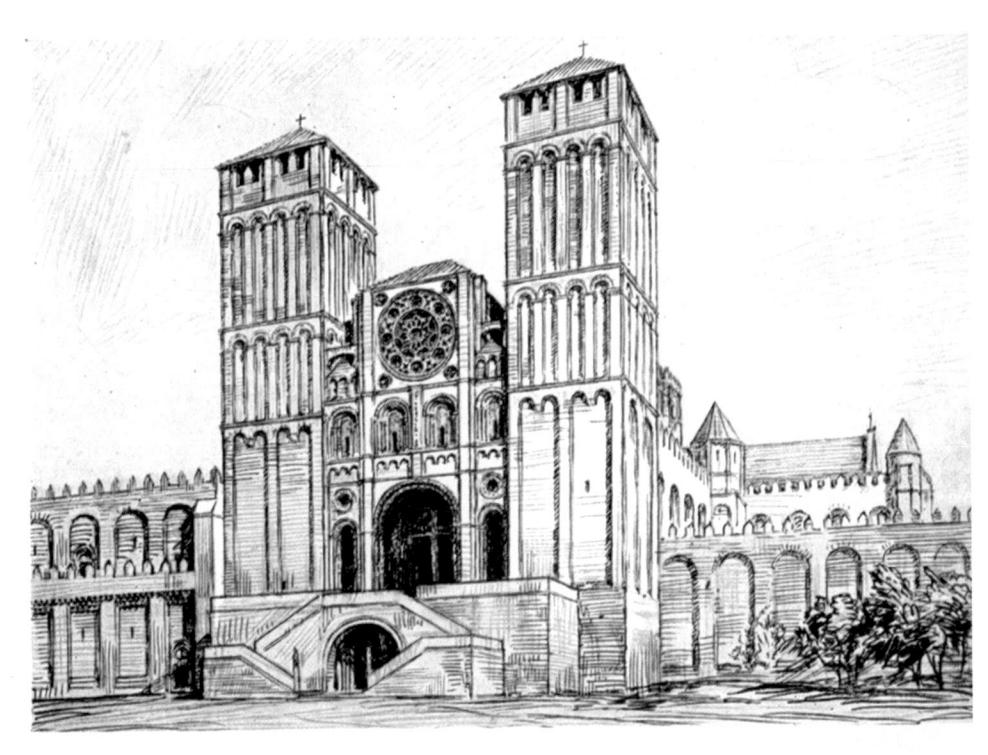

8.16 Drawing of the Cathedral of Santiago de Compostela as it might have appeared in the 12th century. 1078-1188.

In Galicia a series of churches had stood over the bones of St. James since the ninth century, and the present cathedral was begun sometime in the 1070s. An inscription on the south transept portal bears the date July 11, 1078, but work progressed slowly, and the main body of the church was not yet finished in 1117, when a citizen revolt set fire to the scaffolding and roof. Meanwhile in Toulouse a new church was begun about 1080 to house the relics of the first bishop of Toulouse, St. Saturnin, who was martyred about 250. In May of 1096 Pope Urban II consecrated the altar of the Church of St. Sernin. The altar table of St. Beat marble was carved by the sculptor Bernard Gelduin. In Conques, the church of the fourth-century martyr St. Faith also dates from the turn of the century.

The practical necessity of housing relics safely in impressive shrines but at the same time permitting large numbers of people access to these shrines determined the plan of these pilgrimage churches [8.17]. The architecture marked out a processional path through the building. On entering the church the pilgrims moved through the aisles and ambulatory visiting chapels built in the transept and circling the apse. Simple, geometric forms express the

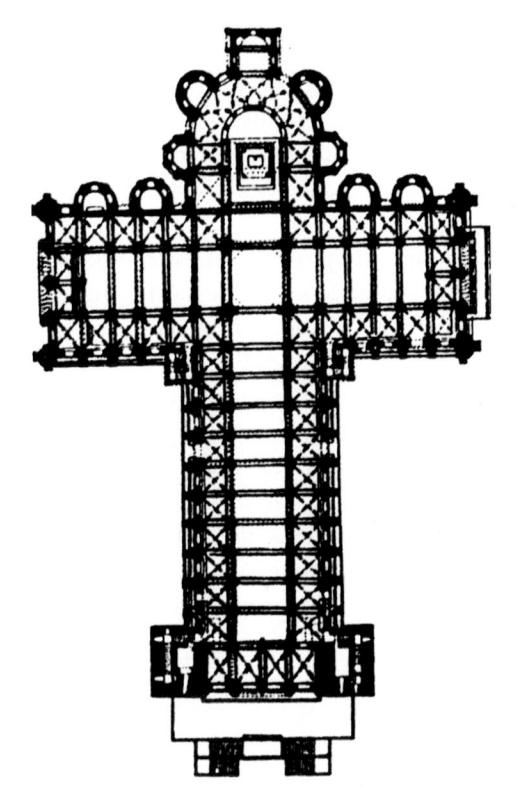

Cathedral of Santiago de Compostela, Plan.

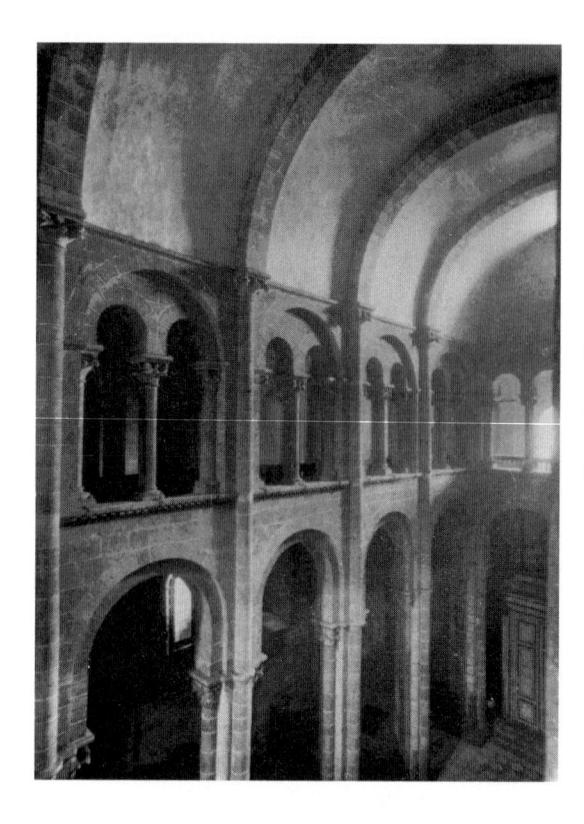

8.18 Transept interior, Cathedral of Santiago de Compostela, c. 1070-1120.

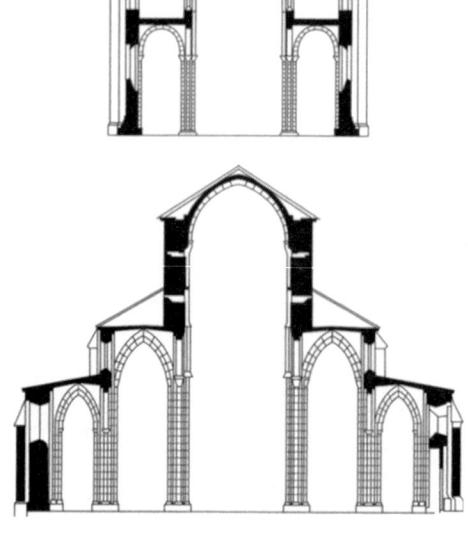

8.19 Alternative structural forms: crosssections, Santiago de Compostela (above) and Cluny III (below).

internal arrangements of the church on the exterior. Each unit was separate and distinct but added to the next to create, in the French scholar Henri Focillon's apt term, the "additive" character of Romanesque art.

Practicality (fireproofing and strength) and aesthetics (appearance and acoustics) required that the builders use masonry throughout the church. They built high, tunnel-like nave and transept vaults [8.18]. The elevation consists of the nave arcade and the gallery. Groin-vaulted aisles support full galleries covered by quadrant (half-barrel) vaults, which in turn carry the thrust of the high vault to massive outer walls strengthened by wall buttresses [8.19]. Compound piers and transverse arches divide the barrel vault into a succession of rectangular bays. A subtle verticality, enhanced by the engaged columns, the stilted arches of the arcade, and the close spacing of the piers counters the otherwise heavy, enclosing effect of the barrel vault. Although windows were confined to the outer walls of galleries and aisles, a dramatic lighting effect was achieved by constructing a lantern

tower at the crossing to flood the area in front of the altar with light. Severe, grand, and fortresslike, the pilgrimage churches are handsome utilitarian structures.

The Pilgrim's Guide described the Church of Santiago: "In the church there is indeed not a single crack, nor any damage to be found; it is wonderfully built, large, spacious, well-lighted; of fitting size, harmonious in width, length, and height; held to be admirable and beautiful in execution. And furthermore it is built with two stories like a royal palace. For he who visits the galleries, if sad when he ascends, once he has seen the perfect beauty of this temple, rejoices and is filled with gladness."

The internal structure of the church required a distinctive portal design. When aisles and galleries crossed the ends of the transepts, the heavy central supporting pier interfered with a single entrance, so the architects built a double door. This arrangement can still be seen in the Puerta de las Platerías (the Silversmiths' Portal) in the south transept at Santiago [8.20]. Over the centuries the Puerta de las

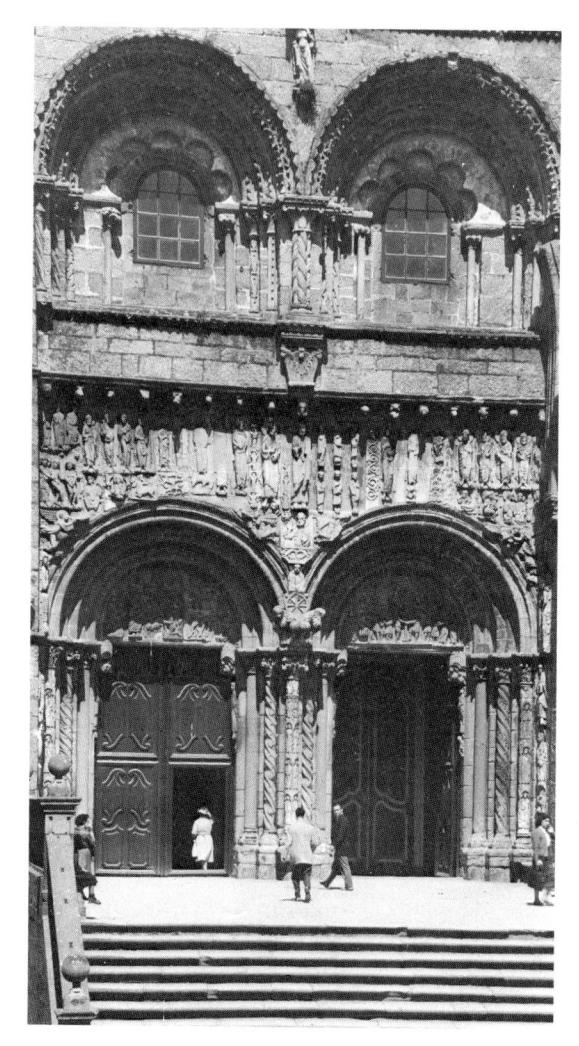

8.20 Puerta de las Platerías, south transept, Cathedral of Santiago de Compostela.

Platerías has become a veritable museum of sculpture. Individual figures of great beauty illustrate the variations within the early twelfth-century style.

Monumental sculpture developed early in southern France and northern Spain. Sculptors attempting to make Christian history understandable to the common people created a forceful narrative style. They captured the mass and weight of the human figures, although they lacked the classical artists' feeling for the articulation of the body. Early examples of Languedoc sculpture are to be seen in the Church of St. Sernin of Toulouse. A series of marble reliefs, probably by Bernard Gelduin, of Christ, the apostles, and angels (whose original lo-

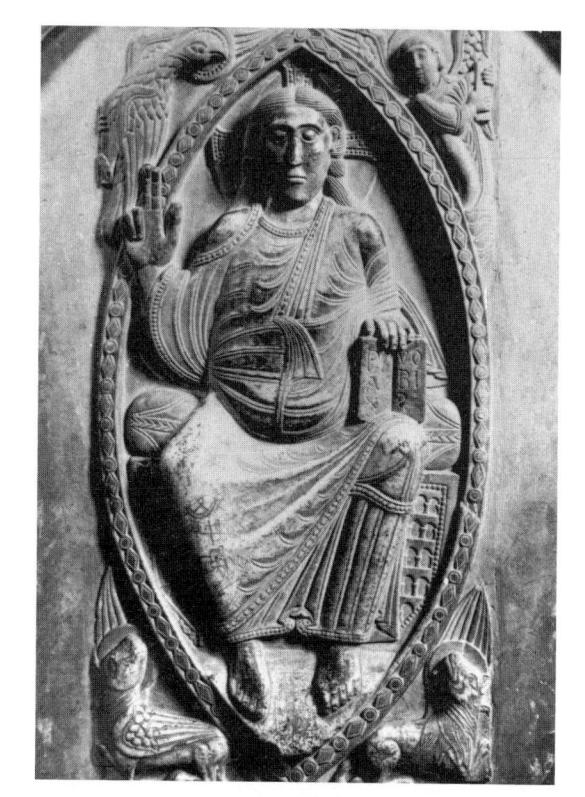

8.21 Bernard Gelduin, Christ in Glory, Church of St. Sernin, Toulouse, c. 1096. Marble. Height 49 1/2in. (125.7cm).

cation is unknown) are now set into the ambulatory wall [8.21]. Gelduin's figures look like sturdy, secular athletes with the thick necks, low brows, heavy chins, and caps of curling hair. Draperies imitate a heavy fabric with folds indicated by thick double lines. The relatively low relief, simplified silhouettes, reduction of three-dimensional forms to linear patterns, and compression of figures within heavy architectural frames created a sculpture as strong and distinct as the architecture it adorned.

This eleventh-century style matured in the Miègeville door (the door to the city, c. 1110-1115) in the south aisle at St. Sernin [8.22]. In the tympanum, Christ ascends into Heaven assisted by angels; in the lintel, apostles witness the event. St. Peter and St. James flank the scene in the spandrels above the door. Each element is an isolated form, and each figure is clearly contained with a single block of stone. Even the angels' wings fit around their haloes and into the rectangular panels. The

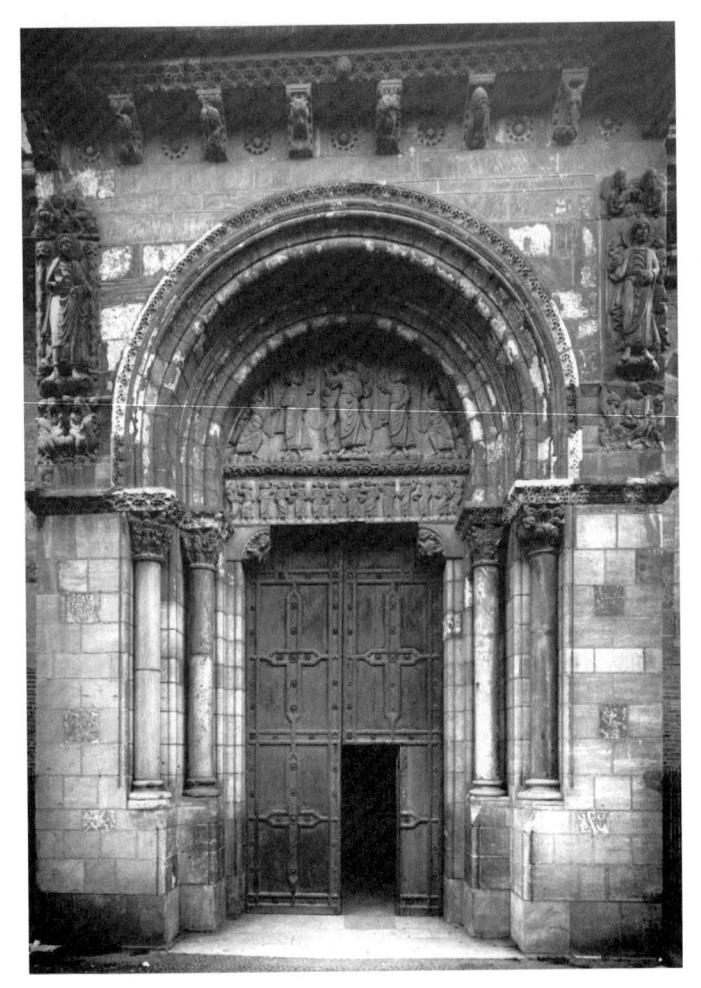

8.22 Miègeville door, Church of St. Sernin, Toulouse.

repeated curved edges of folds engraved and raised into double rolls, the almost metallic surfaces, and the severe horizontal terminations of the garments folded into repeated box pleats reflect the style created by Gelduin in the ambulatory reliefs. The sculptors, although carving in relatively low relief, produced massive architectonic figures. Their art seems strangely earthly for the Middle Ages.

BURGUNDY

Eleventh-century churches soon paled beside the renewed building activity at Cluny in Burgundy [8.23]. In 1088 Abbot Hugh began a huge church, the third on the site (called Cluny III by archeologists). A nobleman himself (and later canonized), St. Hugh applied to his relatives for financial contributions toward the building campaign. The Spanish King Alfonso VI and Queen Constance (St. Hugh's niece) made Cluny the recipient of large offerings of gold after their capture of Moorish Toledo in 1085-1086. St. Hugh needed these vast resources, for he planned his church to rival the Roman basilicas of St. Peter and St. Paul and to challenge the imperial Cathedral of Speyer in size and magnificence. Although St. Hugh did not live to see his dream realized, the great church eventually fulfilled his ambitions with its finished length of 555 feet (169.2m), double aisles, double transepts, and cluster of eastern towers. As an inspiration for succeeding generations, and as a school for masons and sculptors during its construction, the church and monastery at Cluny exerted a profound influence on the development of medieval art.

Two Cluniac monks, Gunzo and Hezelo, evidently supervised the construction of the church. Gunzo, a Spaniard, had been a notable musician and head of a Cluniac monastery. According to legend, St. Peter appeared to him in a dream with the church plan laid out in a complex pattern of ropes. The actual project supervisor was Hezelo, a mathematician. The monks began their new church on September 30, 1088, and Pope Urban II consecrated the high altar on October 25, 1095. Work continued at Cluny throughout the twelfth century, although the church was consecrated in 1150. A western narthex, begun in 1125, was finished only at the end of the century in an early Gothic style.

In the twentieth century, archeologists traced the plan and studied the fragmentary remains of the great church, which was largely destroyed after the French Revolution. To accommodate the many altars and the large congregation of monks, an ambulatory with semicircular radiating chapels surrounded the apse, and double transepts also had chapels projecting from their eastern walls. The dramatic pyramidal design of the east end includes octagonal towers over both crossings and over the center bay in each arm of the west transept. Around the high altar slender cylindrical piers crowned by Corinthianesque capitals supported

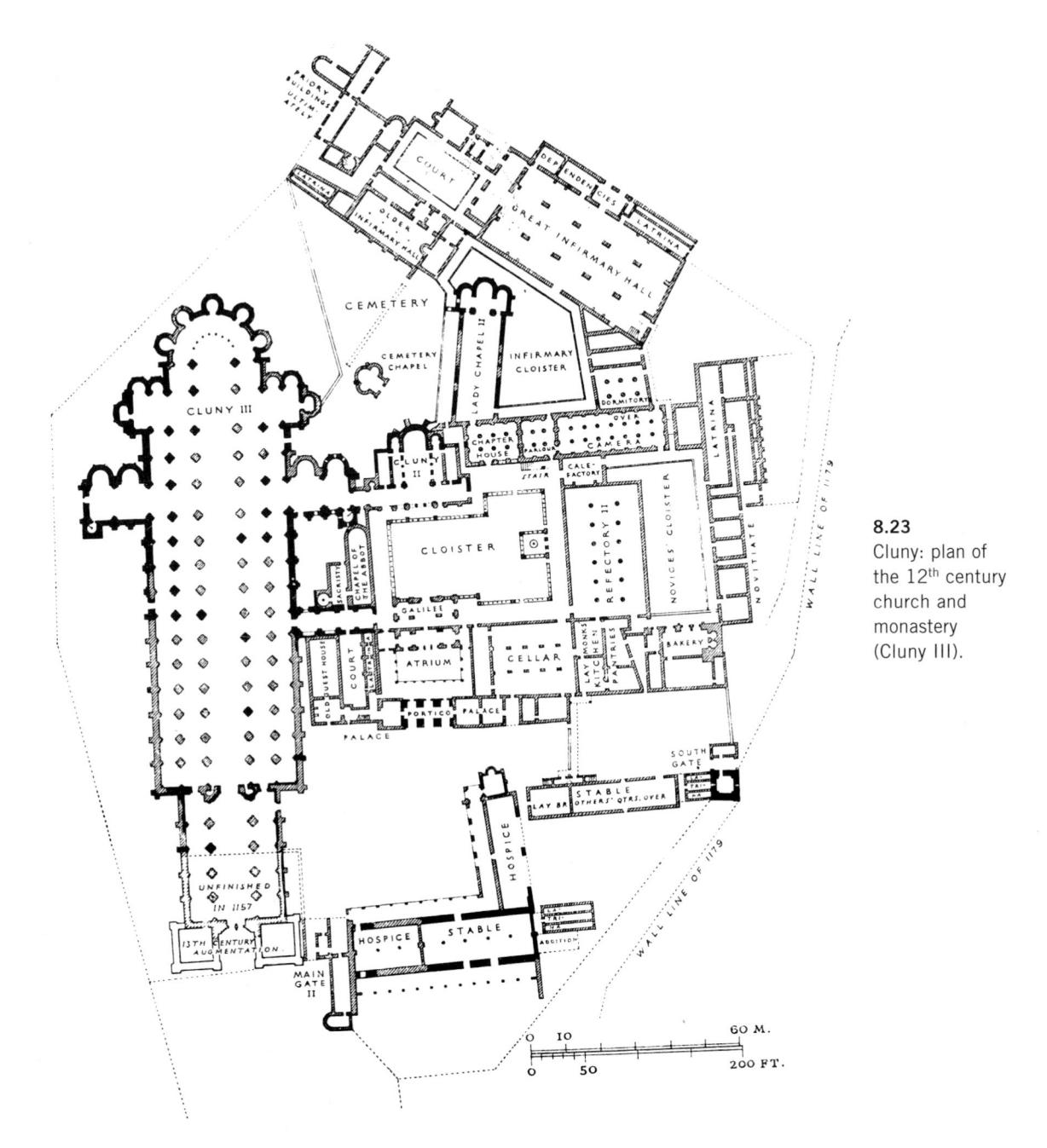

the upper wall and vault of the apse. The apse had a representation of Christ in Glory [see 8.14].

The nave with its double aisles and three-part elevation emulated Old St. Peter's [8.19]; however, classicizing details such as engaged columns, pilasters, capitals, and moldings could also have been inspired by the ancient Roman monuments still standing in Burgundy. Structurally the architects at Cluny built the thinnest possible vault, at a daring height of 98 feet (29.9m) in the nave and 119 feet (36.3m) at the crossing. The catenary (chain) vault shape helped to reduce the outward thrust of the vault because although it is rounded at its apex, at the sides it approaches the steeper and more stable slope of the pointed arch. Tall compound piers enriched with pilasters supporting pointed arches

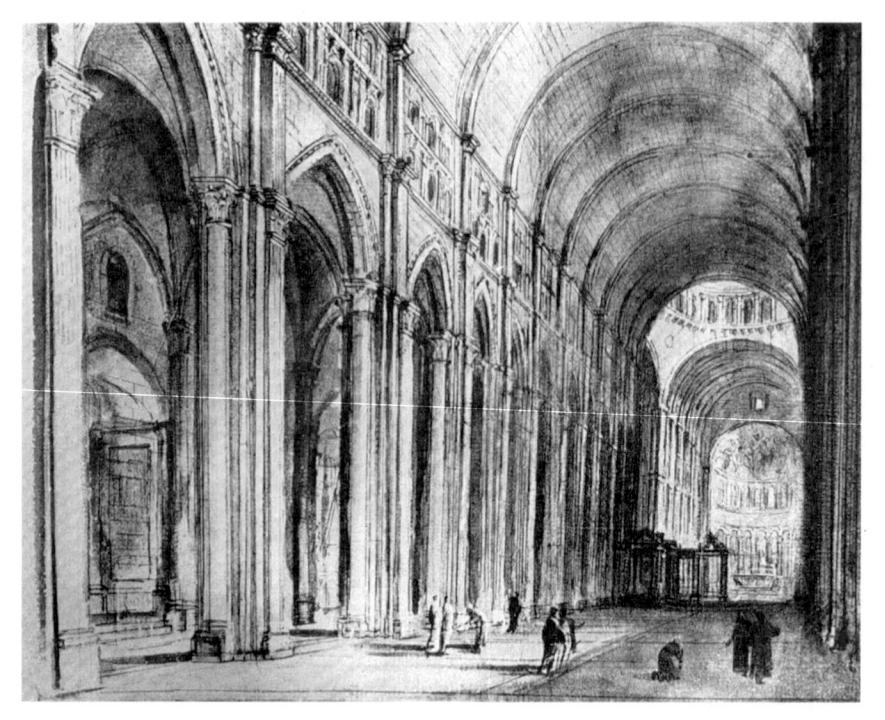

8.24 Interior, Cluny III, 1088-1130.

emphasized the height of the building. (The church at Paray-le-Monial, c. 1100, replicates Cluny III on a much smaller scale.) The pointed arch is a Muslim feature, and other Muslim elements such as polylobed arches and pearled moldings also appear in Cluniac decoration.

Just as the House of God was the center of the spiritual life of the community, the cloister was the center of domestic activity. The plan established in the Carolingian period evolved into a masterful arrangement of large, well-built halls housing the scriptorium, dormitory, the chapter house, parlor, refectory, kitchen and bakery [compare 8.23 and 5.6]. At Cluny, the west range contained the abbot's palace and the wine cellar. The guest house and stables also lay to the west. A novitiate and a huge hospital were added to the south and east of the central core of church and cloister buildings.

Cluny III served as an inspiration for artists and patrons. Some builders, such as those working in Autun, copied Cluny's elegant proportions and classical details [8.25]. At Autun, the church was dedicated to St. Lazarus, whose relics

were brought to Autun from Marseilles in 1079. (The church is now a cathedral.) Construction of the present building began about 1120; the church was consecrated in 1130, and again in 1146. The masons refined the architecture of Cluny by using such details as fluted pilasters, historiated capitals, and nearly classical moldings. The proportions used in the blind arcade and the clerestory might have been inspired by Roman gates to the city. Above this elegant wall, transverse ribs divided the pointed barrel vault into bays uniting pilasters, arches, and vault into a coherent whole.

Gislebertus, a uniquely gifted sculptor, directed the shop at Autun. (The name Gislebertus

Nave. Autun. 1120-1130.

is carved directly under the feet of Christ in the center of the western tympanum. It has been suggested that Gislebertus could be the name of the patron, not the sculptor.) The master carved, or directed the carving, of interior capitals and the north and west portal sculptures at the cathedral. In the design of capitals the Corinthian capital remains a constant reference point, but the form has been reinterpreted as a closely knit, two-dimensional linear composition [8.26]. Foliage curls upward into volutes, establishing an architectural frame for narrative scenes in which the figures and the foliage become a decorative symmetrical composition. In depicting the suicide of Judas, the sculptor captured the horror of Judas' death in the grimacing face and limp, dangling figure. The demons' scrawny limbs, flaming hair, contorted faces, and gnashing teeth make them convincingly energetic embodiments of evil, who defy even the architectonic requirements imposed on the sculptor.

On the central portal of the west façade, serene in the center of the swirling activity, Christ renders judgment [8.27]. The inscription reads, "May this terror frighten those who are bound by worldly error. It will be true just as the horror of these images indicates." Among the resurrected, human touches abound. Two men carry wallets bearing the cross and scallop-shell badges of the pilgrim—

8.26 Gislebertus, Suicide of Judas, nave capital, Autun Cathedral, c. 1125.

the cross for Jerusalem and a shell for Santiago. An angel juggles the scales and another boosts a soul through the floor of the Heavenly Jerusalem. Gigantic hands snatch one fellow away to Hell. Gislebertus contrasts the drama of the Last Judgment theme with the regularity of the tympanum's

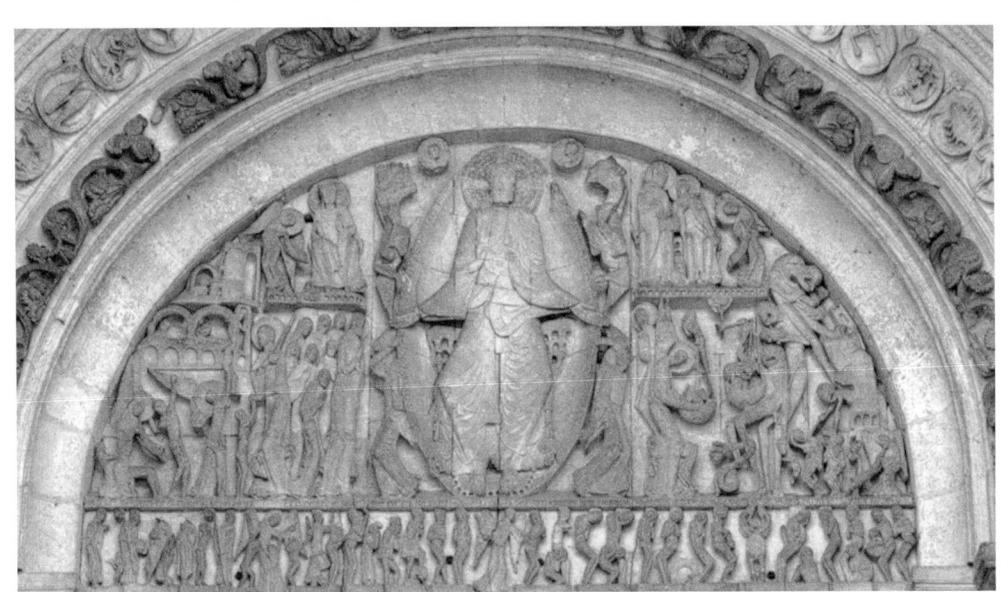

8.27 Gislebertus, Last Judgment Tympanum West porch of Autun Cathedral, c. 1140.

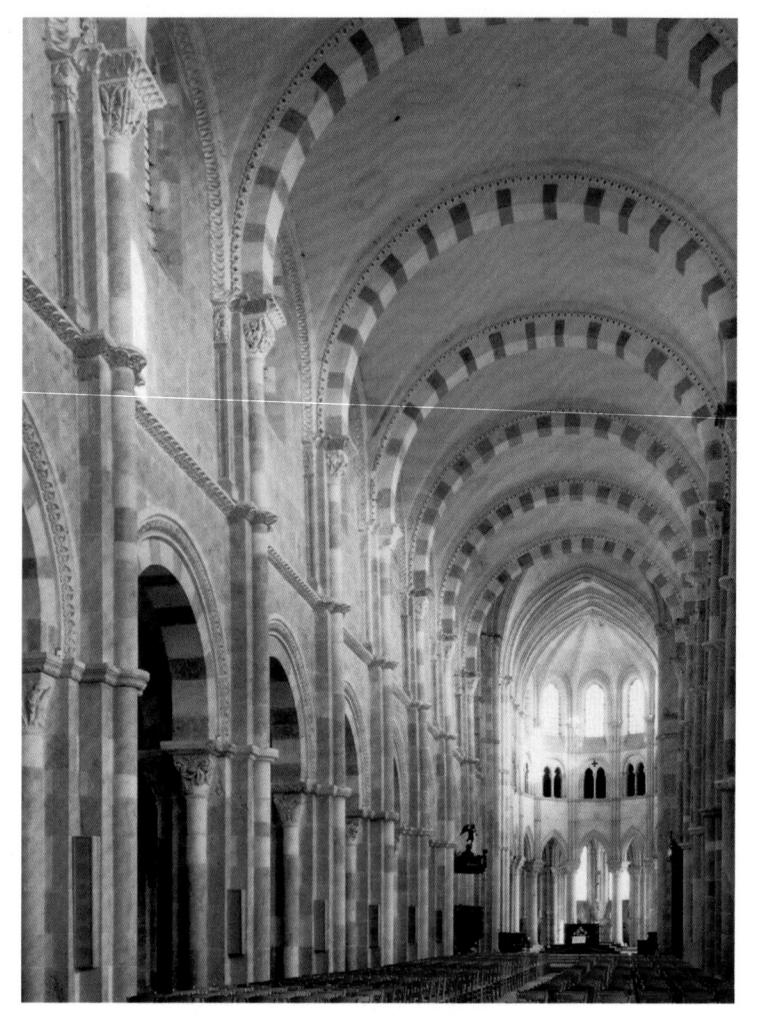

8.28 Church of the Madeleine, Vézelay, the nave, c. 1120-1132.

composition. A symmetrical frontal figure of Christ presides over events depicted in horizontal registers. Furthermore, although actually in high relief, the elongated and interlocking figures produce a two-dimensional effect. A delicate pattern of fine parallel lines covers sheath-like, overlapping, sharply pressed drapery folds. The clinging drapery covers slender bodies and twig-like limbs and flutters freely around ankles and at edges of cloaks. Gislebertus' monumental tympanum survived modernization under a layer of plaster (undecorated voussoirs replace the original carving).

South of Atun The builders of the abbey church at Vézelay seem to be heirs of the energetic, exper-

imental architects who built churches such as St. Philibert in Tournus. In 1050, when Pope Leo IX confirmed the existence of the relics of St. Mary Magdalen at Vézelay, pilgrimages to the shrine began. After a fire in 1120 the monks rebuilt in stone and consecrated a new church in 1132 [8.28]. The nave was finished 1135-1140 (the choir was rebuilt in an early Gothic style in the second half of the twelfth century). Vézelay was the site of dramatic events: St. Bernard preached the Second Crusade there in 1146, and a generation later Philip Augustus and Richard the Lion-Hearted met at Vézelay to leave for the Third Crusade. The church was a worthy site for twelfth-century spectacle, for its builders had been fearless in their innovations.

To create a light, open effect, the builders of Vézelay used widely spaced compound piers, eliminated the triforium, and inserted large clerestory windows. In order to build a stable masonry vault they erected a slightly flattened groin vault reinforced with concealed iron rods. Pilaster-backed engaged columns support transverse arches with alternating reddish-brown and white voussoirs, a decorative feature characteristic of Islamic architecture (as seen for example in the mosque at Córdoba, [see 6.20]). These arches dramatize the division of the space and give the building an exotic flavor.

Roman Corinthian capitals inspired the design of capitals with spiky acanthus leaves curling into volutes around an inverted bell shape. Against this, grand vigorous figures act out narratives and allegories. St. Paul turning the mystic mill of the Lord, grinding exceeding fine, can be seen in the aisle at the left [8.29]. Graceful poses animate clinging sheaths of drapery often ending in wind-tossed folds. Eyes with drilled pupils sparkle in round, doll-like faces, and large hands gesture expressively. The sculptors achieved a remarkable crispness, clarity, and linearity by undercutting forms so that edges are sharpened by shadows. The capitals seem related to the cloister crafts of manuscript illumination, ivory carving, and

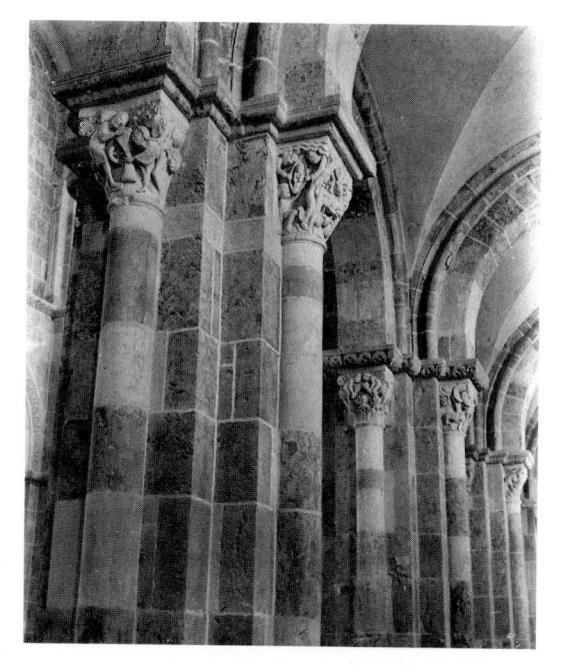

8.29 Detail of piers and aisle capitals, Church of the Madeleine, Vézelay (first capital: St. Paul grinding grain, the Mill of the Lord), 1120-1132.

goldsmithing, an effect undoubtedly enhanced by painting.

In Vézelay, about 1135-1140, the master created a dramatic tympanum [8.30]. The sculptural program covers three portals set within a narthex building. In the central tympanum he represented Pentecost or Christ's mission to the apostles. The small doors at the right and the left present the Incarnation and the Ascension. Recently it has been suggested that the portals depict the triumph of Christian peace. Either subject would have been unique in Romanesque art and singularly appropriate for a church that was both a center of pilgrimage and a staging point for crusades. The style, too, is energetic: dynamic angular forms fill the tympanum, and figures seem to writhe with energy. Christ becomes both the motivating force and a figure caught up in his own unearthly power as he twists into a compressed zigzag position, a pose enhanced by the spiral patterns of drapery at hip and knee joints. As though conscious of the need to exert an architectonic control, the sculptor has surrounded the tympanum with heavy archivolts: the inner archivolts have signs of the zodiac

and the outer moldings are covered with luxuriant foliage. That will become the hallmark of later Burgundian art.

In a way unusual in Romanesque art, the sculpture at Vézelay impinges on the spectators' space and draws them into the drama. Curving backgrounds and high relief create a dramatic play between the linear surface composition and three-dimensional forms. The mandorla surrounding Christ is a saucer-like plaque, and the rippling clouds above Christ and the undulating molding between lintel and tympanum cast shadows that make the background plane appear to move. The haloes of the apostles tip and slant, creating more shifting planes within the shallow stage provided by the architecture. In later Burgundian sculpture, this dynamic linear movement becomes mere restlessness. The study of the effects of light and shade turned into a fascination with surfaces, and delight in ornament led to a near obsession with detail, already hinted at in the Vézelay sculptor's masterpiece.

So beautiful is the stone that sometimes it is difficult to remember that most medieval sculpture was painted. A few mural paintings survive to give us an idea of the true medieval color sense. At Berze-la-Ville, a grange of Cluny only seven miles from the abbey, a regal Christ giving the law to St. Peter fills the apse, and scenes of martyrdom cover the walls [8.31]. The painting may even copy the apsidal decoration of Cluny III. The rich colors—a dark blue ground with rust brown and olive green-were applied in fresco secco (paint over remoistened plaster). Forms are built up in superimposed layers of color and finished with a fine linear net of highlights derived from the Byzantine practice of indicating folds of drapery with sprays of white or gold highlights. The free drawing, the loose yet dense composition in which figures seem to jostle for position, and even the multilinear drapery style are akin to the sculptured tympanum at Vézelay. With their painted walls and sculpture, Romanesque buildings must have dazzled the viewer.

The many currents in Romanesque art come to-gether outside Burgundy in the sculpture of the

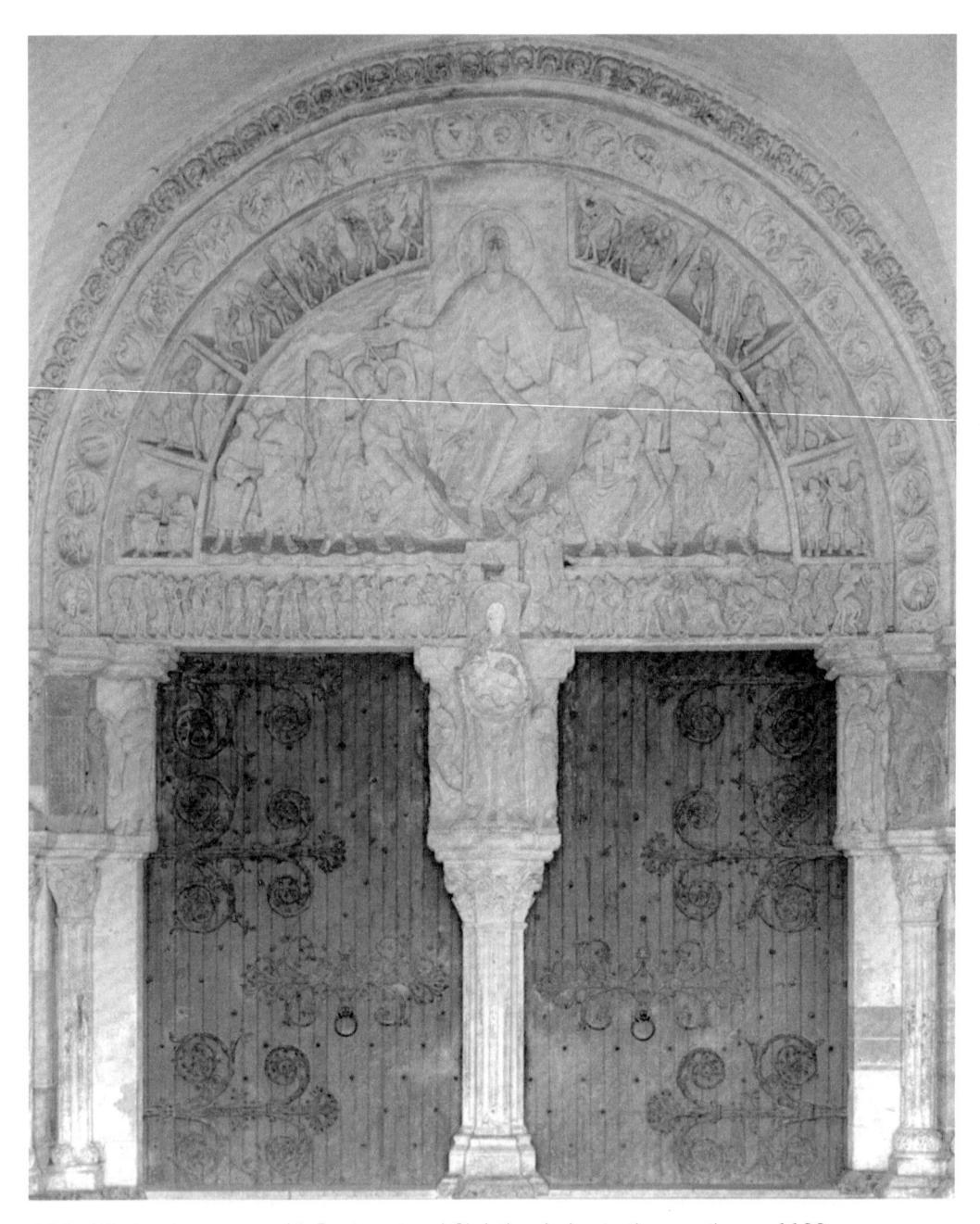

Vézelay, tympanum with Pentecost and Christ's mission to the apostles, c. 1130s.

Church of St. Peter at Moissac, a Cluniac abbey on the road to Santiago. Ruled by Abbot Durandus, who came from Cluny in 1047 and later became the bishop of Toulouse, Moissac stood second in importance to Cluny [8.32]. Abbot Durandus built a new church, dedicated in 1065, and when he died in 1072, he was buried in the cloister. There on a pier relief is his memorial portrait, a sculpture of uncompromising frontality and symmetry. The figure completely fills the arched panel; the vestments repeat both the arch of the frame and the rectangle of the pier. Crisp and delicate carving turns three-dimensional forms into flat patterns. Sheaths of drapery with edges marked by

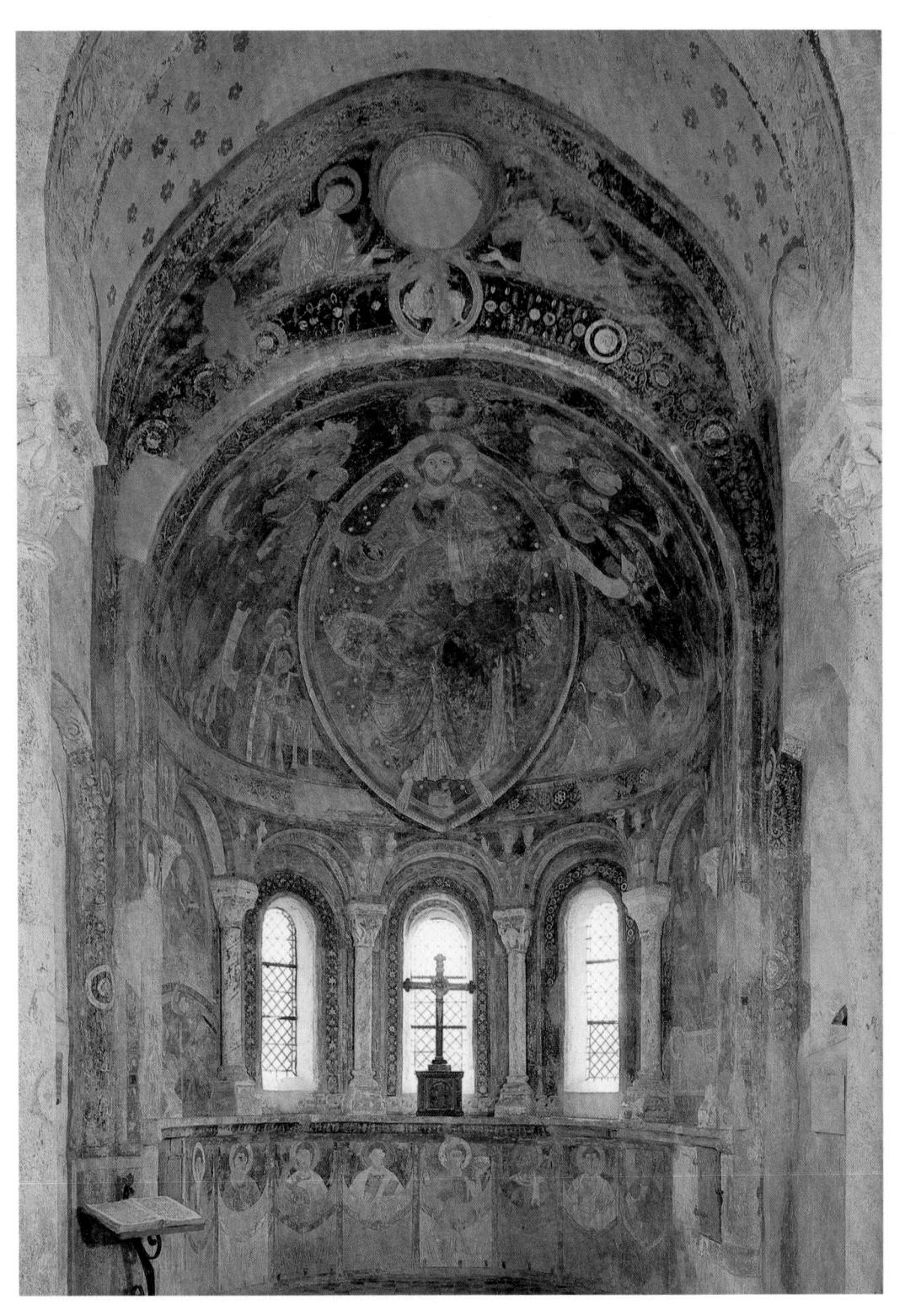

8.31 Berze-la-Ville, chapel, apse, Christ in Majesty, early 12th century, painting.

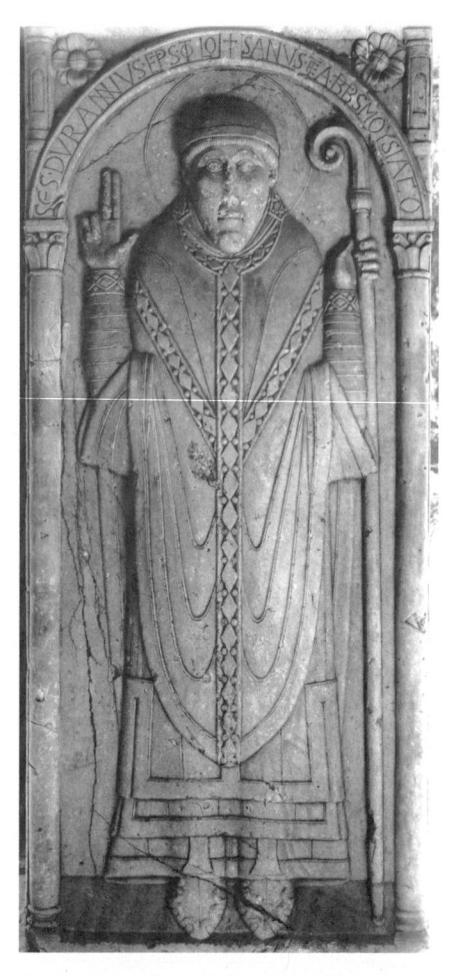

8.32 Durandus, cloister pier, Moissac, c. 1100.

parallel engraved lines create a delicate graphic quality that recalls carved ivory.

Later, during the reign of Abbot Roger (1115-1131), a new church was built. Here in the tympanum the illuminated Beatus manuscripts [see 7.6] popular in the region may have inspired the sculptor [8.33]. Christ in Glory, surrounded by seraphim and the symbols of the Evangelists, is adored by the twenty-four elders, who, divided by the rippling sea of glass, turn to look at the Pantocrator. Sts. Peter and Paul and the prophets Jeremiah and Isaiah on the door jambs and trumeau symbolically and literally support the vision. The figures' size is determined by their importance (a convention know as hieratic or social scale). Christ, a gigantic seated Pantocrator, extends

through three registers, while the Old Testament elders fill only one. The tympanum remains a surface composition, like a rich tapestry sweeping over the surface of the building. Ornamental patterns abound: jeweled borders and crowns, foliate archivolts and lintels, a starry mandorla, and exotic cusped jambs and trumeau [8.34].

In the prophets and apostles on the jambs and trumeau, the lines of the body follow the lines of the building [8.35]. A prophet is elongated to fill the narrow space, yet steps forward in a crosslegged pose popular among southern artists. He fits perfectly into the unusual cusped pattern of the trumeau, for his feet, knees, hips, shoulders, and head follow the outward movement of the cusps. On the front face of the trumeau, diagonally crossing pairs of lions nearly hide the rosette pattern which continues down from the lintel. The cusping, the heraldic beasts, the flat decorative rosettes, the pristine technique and taste for flowing tapestry-like decoration are all part of the Eastern heritage of Romanesque art, reinforced by renewed contact with Islamic culture through the Crusades.

THE CISTERCIANS

Disillusioned by Cluniac worldly success, Robert of Molesmes in 1098 established a new monastic community at Citeaux near Dijon. (The swampy land gave the name to the place and the order [Cistel-cistercian] from the medieval Latin word for reeds.) In 1112 a young Burgundian nobleman, Bernard de Fontaines, and 32 companions requested admission to the order. When Bernard found even Citeaux too liberal, he established another monastery at Clairvaux. Abbot there for 28 years and one of the leading figures of the twelfth century, St. Bernard died in 1153 and was canonized in 1174.

Unlike Cluny, with its strongly centralized government, each Cistercian monastery was independent within the limits of the rule. Cistercians established their self-sufficient communities in the wilderness, where they dedicated themselves to manual labor as well as to prayer. They cleared forests, drained swamps, and

8.33 Apocalyptic vision, detail of tympanum, south portal, Church of St. Peter, Moissac, 1125-1130.

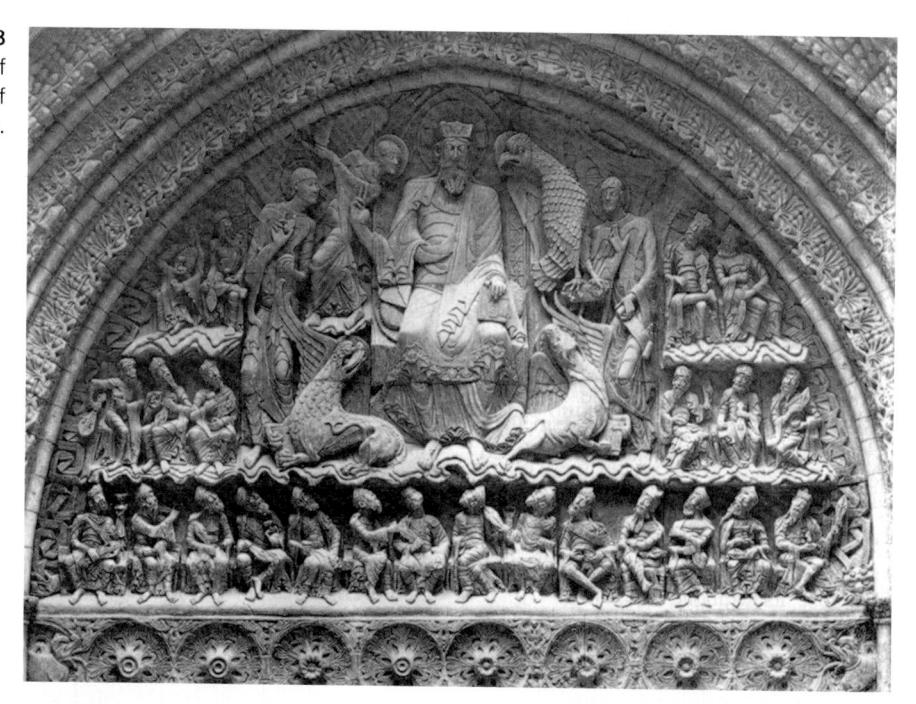

8.34 Apocalyptic vision, tympanum, south portal, Church of St. Peter, Moissac, 1125-1130.

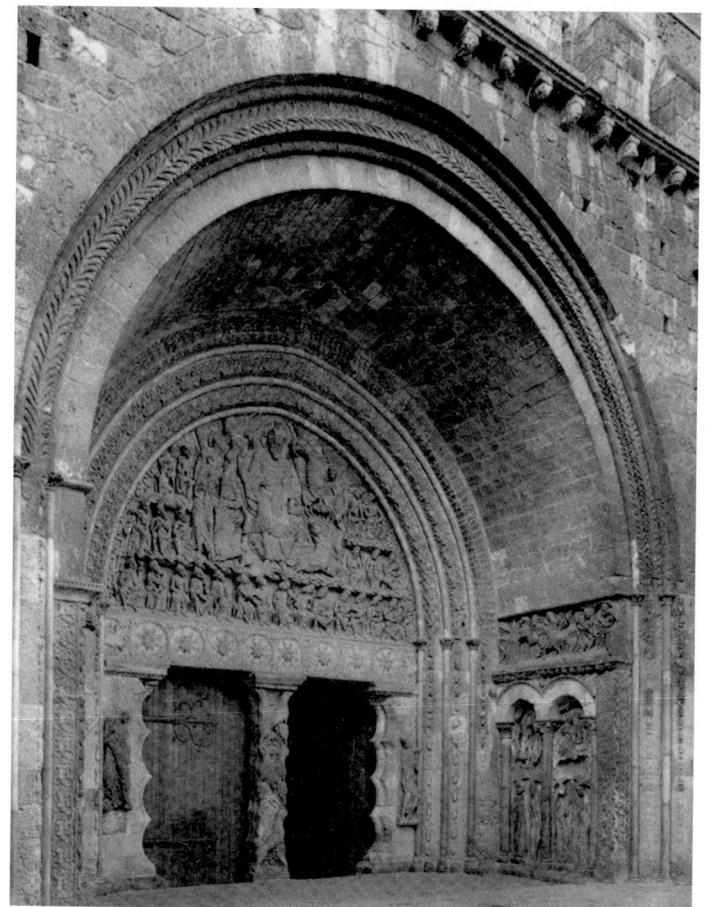

8.35 Prophet and lions, trumeau, south portal, Church of St. Peter, Moissac, 1125-1130.

bred fine flocks of sheep. Although individual Cistercians lived in poverty, their monasteries became wealthy landholders with splendid buildings. From Scotland to Italy, from Germany to Spain, Cistercian monasteries followed the same plan.

The Burgundian Abbey of Fontenay, founded in 1119, is typical of Cistercian architecture [8.36]. While following the usual plan with the church and adjoining cloister as the focal point of the complex, the Cistercian builders added some new practical details. Buildings were arranged around the cloister so that if the community grew, they could be extended in length. The refectory, for example, is placed at right angles to the cloister walks. Since the monastery depended on lay brothers, rather than serfs, to perform much of the manual labor on the land and in the workshops, extensive facilities were provided for them. The lay brothers' dormitory was often built above the cellar on the west side of the cloister. A guest house and chapel stood near the gate to the complex.

The church at Fontenay, begun in 1139 and consecrated to Mary in 1147 by Pope Eu-

Cistercian Building

Cistercian architects emphasized excellent masonry and perfect proportions in building. St. Augustine had used mathematics to create a theory of the universe whose perfection could be expressed in music as consonances: octaves, fifths, and fourths. These ratios could be reproduced in architecture. At the Abbey of Fontenay the perfect ratios of 1:1, 1:2, 2:3, and 3:4 determined the internal relationships of the plan and the elevation of the church. For example, the ratio of width to length in the transept is a musical fifth (2:3), while the octave determines the proportions of the bays of the aisles. Then the fourth (3:4) determines the relationship of nave and aisles to transept and chapels. These perfect ratios produced visual as well as musical harmony, and such harmony, according to St. Bernard and St. Augustine before him, could lead the soul to God.

St. Bernard, like the Byzantine philosophers, believed that light provided the trained and sensitive intellect with a method of transcending the mundane world. He compared the union of the soul with God to the illumination of the air by sunlight. He disapproved of colored glass in windows because of the expense and the distraction caused by the stories told by the painters, so Cistercians perfected the art of monochromatic painting known as grisaille.

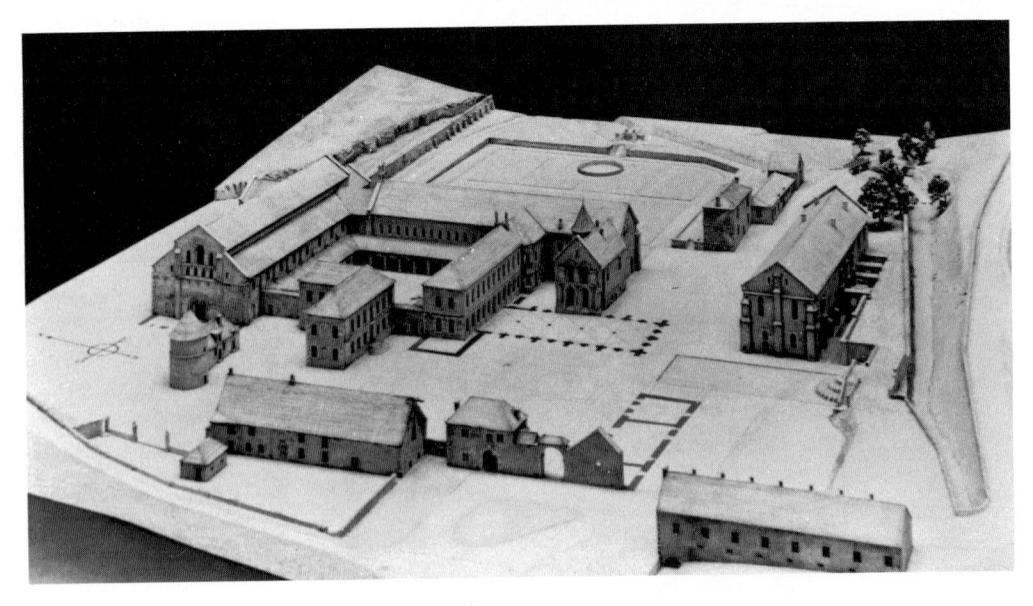

8.36 Model, Abbey Church, Fontenay, 1130–1147.

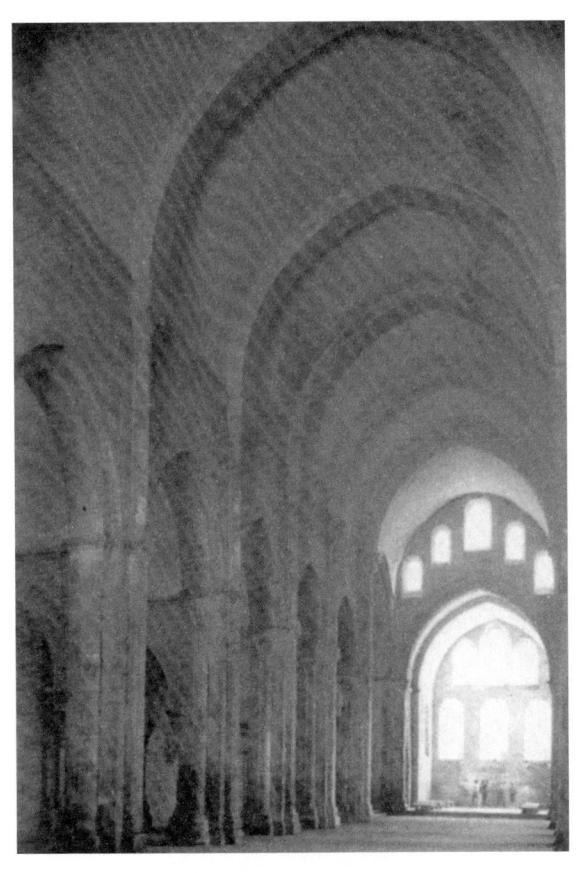

Nave interior, Fontenay, c. 1130-1147

gene III, is a typical Cistercian church [8. 37]. A rectangular sanctuary flanked by square chapels opens into a transept and a long nave and aisles. The monks' choir, enclosed by a choir screen, extended into the first two bays of the nave. The church has neither clerestory nor gallery but is lit by windows in the west wall, the upper east wall, and the sanctuary. The church was vaulted throughout with pointed barrel vaults. The high nave vault was buttressed by vaulted aisles in which transverse vaults spring from diaphragm arches. This austere interpretation of Burgundian forms characterizes Cistercian work wherever it is found.

The pictorial arts were anathema to St. Bernard. He banned "those unclean apes, those fierce lions, those monstrous centaurs" from churches and cloisters. He would not permit figured pavements, narrative stained glass, or elaborate liturgical vessels, and even prohibited bell towers (Cistercians preferred a low wooden gable holding two small bells). He wrote, "We are more tempted to read in the marble than in our books, and to spend the whole day in wondering at these things rather than in meditating the law of God. For God's sake, if men are not ashamed of these follies, why at least do they not shrink from the expense?" (St. Bernard, Apologia to Abbot William of St. Thierry, c. 1125).

Nevertheless, St. Bernard had a special devotion to the Virgin Mary; the Cistercian Order and all its churches were dedicated to her. The idea of the Virgin as an essential link in the genealogy of Christ finds artistic expression in the Tree of Jesse, a theme developed in Cistercian thought [8.38]. In the manuscript illumination a vine-like tree springs forth from Jesse. The rising branches enclose the Virgin and Child and culminate in the dove of the Holy Spirit. The page demonstrates the allegorical mode of interpretation known as typology in which the Old Testament foreshadows the New Testament. Four Old Testament "types" for the Virgin birth surround the tree: upper left, Daniel in the lions' den; upper right, the three Hebrew children in the fiery furnace; lower right, Gideon and the falling dew; and lower left, Moses removing his shoes before the burning bush. Mary is called Theotokos, Mother of God, a reminder that Byzantine art was now better known from pilgrimages and Crusaders' booty. Although Mary offers her breast to Jesus, the artist emphasizes regal rather than maternal qualities in a Mary who becomes a throne for the Christ and a symbol of the throne of Solomon, the seat of wisdom.

WESTERN FRANCE (AQUITAINE)

The fertile lands of western France supported a flourishing civilization in the Romanesque period. Music, poetry, and the visual arts could thrive under the patronage of the troubadour Count William IX (1071-1127), who, with his fellow poets, gave the language of the people literary form by writing in French as well as Latin. In literature,

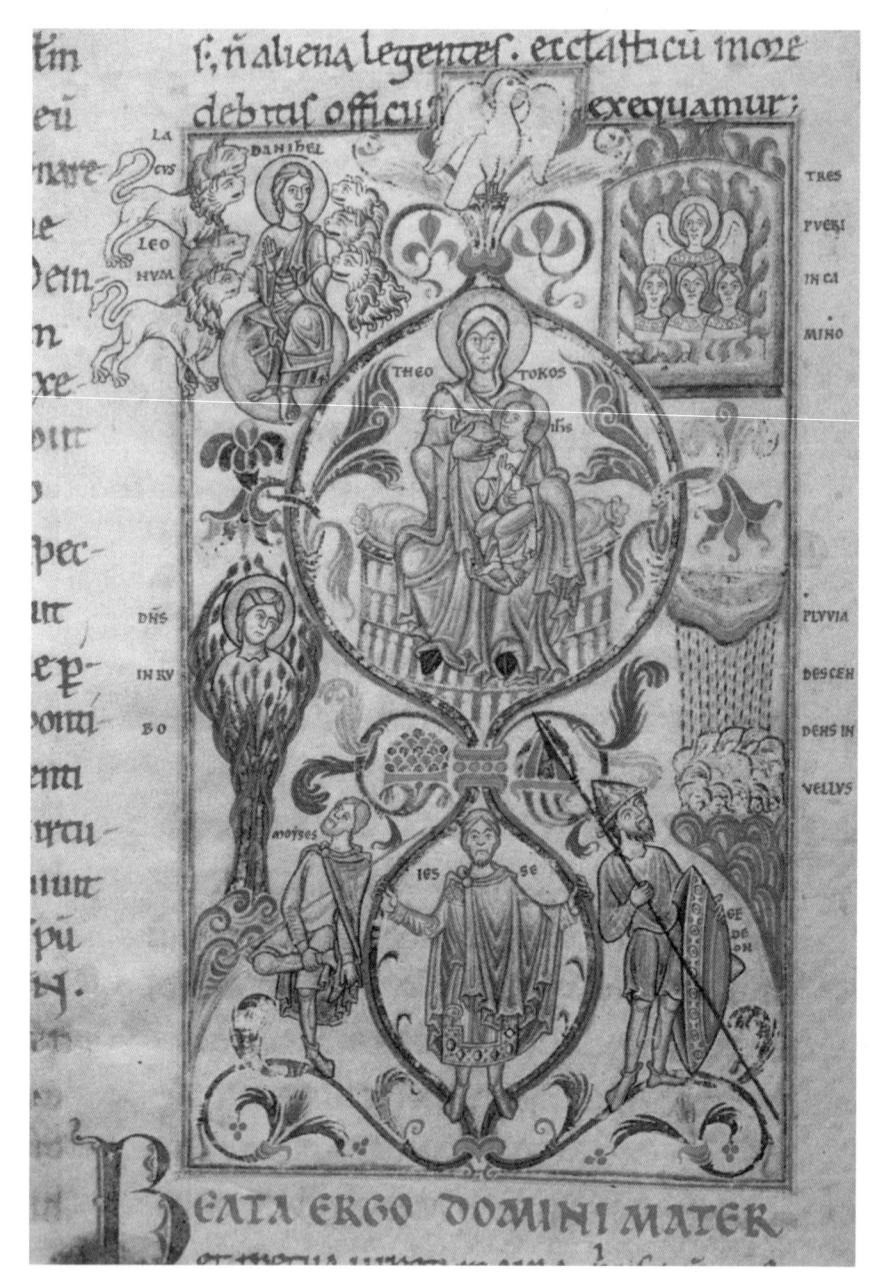

8.38 Tree of Jesse, c. 1130. Colored ink drawing on parchment, 5 x 3in. (12.5 x 7.5cm), Bibliothèque municipale, Dijon.

the violent warriors of the epics became the perfect knights of romance who dedicated their arms to unattainable ladies and to the Virgin Mary, Notre-Dame. The troubadors idealized the illicit and frustrated romantic love of the knight for the wife of his suzerain: Guinevere, Lancelot, and King Arthur or Yseult, Tristan, and King Mark. The

game of love with its elaborate rules became a courtly duty.

In this worldly environment the Abbey of Fontevrault offered a secure retreat. The abbey had been founded in 1099 by Robert of Arbrissel as a five-part establishment for nuns, noble ladies, monks, lepers, and the sick, each of whom had a

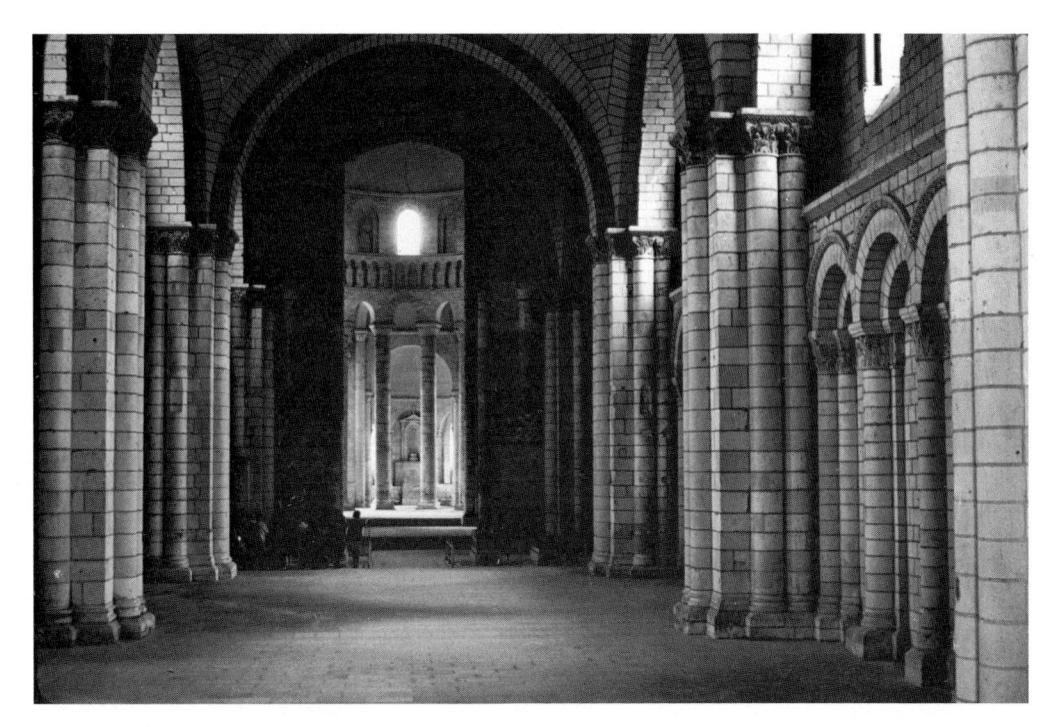

8.39 Nave, abbey church, Fontevrault. c. 1125.

chapel, cloister, and conventual buildings, ruled by an abbess. Patronized by the nobility and especially by the Angevin rulers of western France and England, the community grew into a small but wealthy independent order. The domed church of the nuns is typical of the rich and varied architec-ture of western France [8.39]. Regardless of superficial differences, the builders strove to create an open, well-lit space built with excellent ashlar masonry. The Church of Notre Dame at Fontevrault was built in two stages: the chevet, transept, and a crossing covered with a dome on pendentives was dedicated in 1119 and a few year later a wide, aisleless nave was added. In the nave walls reinforced by massive engaged piers supported four domes on pendentives. Domical architecture was popular in the area, and domed churches still stand at Périgueux, Angoulême, Cahors, and Souillac. The Romanesque dome on pendentives differed only minimally from Byzantine domes. Romanesque domes are balanced on slightly pointed arches, which require pendentives of irregular form, unlike the perfect spherical triangles of Byzantine building. The Western builders clearly defined the structural forms of piers, walls, vaults,

pendentives, and dome; however, the effect of distinct units must have been reduced when paintings covered the interior surfaces.

Typically, the façades of Western churches screen the nave with blind arcades, which may not reflect the interior arrangement of the building. Among the most elaborate Poitevin façades is to be seen on the Church of Notre-Dame-la-Grande in Poitiers (c. 1174), where the sculptors' evident delight in patterns extends to the entire wall surface. Superimposed ranges of sculpture present an elaborate iconographical program glorifying the Virgin [8.40]. Cylindrical towers, formed by engaged columns supporting drums, open arcades, and conical roofs capped by distinctive inverted scale patterns, flank the façade. This portal design without tympana but with repeated motifs fanning out in radiating archivolts spread through Angevin territories in France and England and along the pilgrims routes into Spain.

Inside the churches, domes or barrel vaults provided broad fields for the mural painter. The most extensive cycle of Romanesque painting still extant in western France is found in the Abbey Church of St. Savin-sur-Gartempe [8.41]. As usual, the paint-

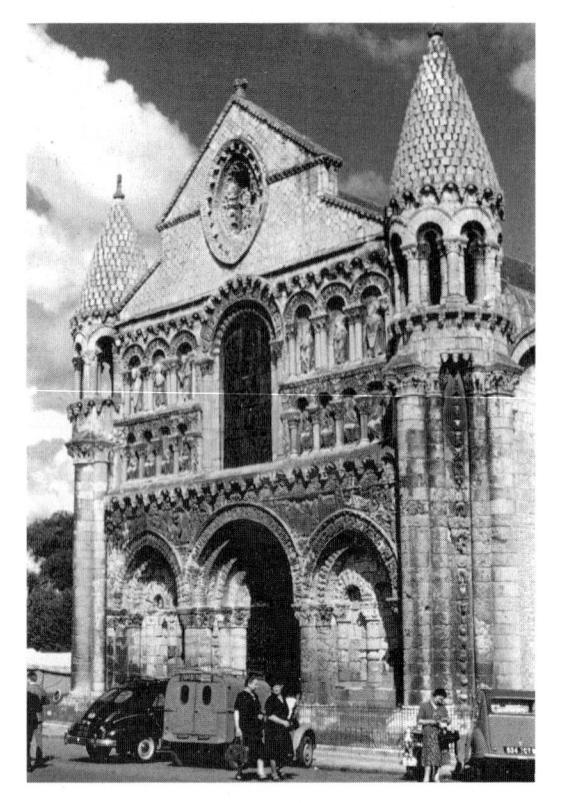

8.40 Church of Notre-Dame-la-Grande, west façade, Poitiers, 12th century.

ings form a didactic program aimed at instructing the viewer as well as decorating the building. Scenes from the Old Testament fill the barrel-vaulted nave; the infancy of Christ is depicted in the transept; the Passion, in the gallery over the porch; scenes from the lives of the saints, in the chapels and crypt; and finally the Apocalypse and the second coming of Christ cover the walls and vault of the entrance porch.

The nave vault was built between 1095 and 1115. The paintings must date from the same time, for they would have been executed while the masons' scaffolding was still in place. Scenes from the Old Testament unfold in continuous registers. The paintings were expected to do more than provide an effective decoration. Since the Carolingian period, art had been justified for its educational value. The painters of the nave vault, therefore, intended that their painting would be intelligible from a distance. They worked on a large scale, emphasized outlines and broad color areas, and simplified inter-

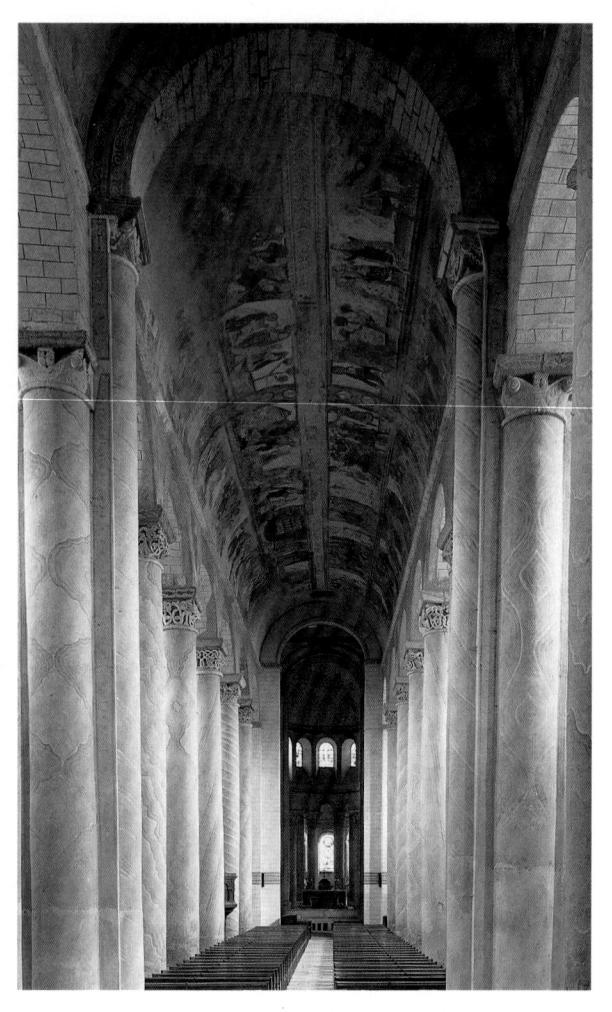

8.41 Abbey Church of St. Savin-sur-Gartempe, painting in vault, 1100–1115.

nal modeling of figures. A harmony of earth tones—ocher, sienna, white, and green—produces a warm, light tone throughout the building.

NORMANDY AND ENGLAND

The Duchy of Normandy and the Kingdom of England were united politically as well as culturally in the eleventh century, and artists and masons had traveled between the Norman and Anglo-Saxon courts. Duke William of Normandy (William the Conqueror) conquered England in 1066. In their capital at Caen about 1061, William the Conqueror and his wife Matilda established two monastic communities: one for men with its church ded-

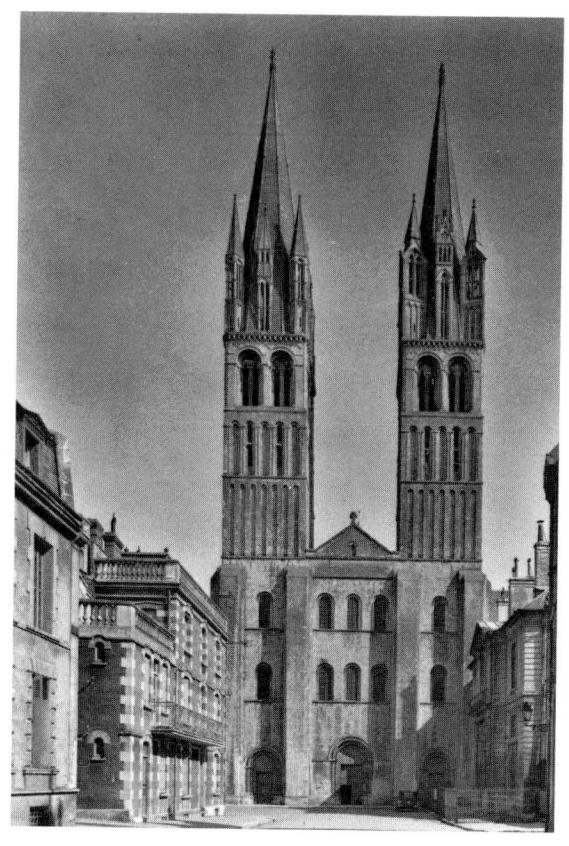

8.42 Abbey Church of St. Étienne, West façade, Caen, 1064-1087.

icated to St. Étienne (St. Stephen) and one for women with the Church of the Trinity. Through their extensive military and commercial contacts, the Normans had firsthand knowledge of art and architecture throughout Europe. Now the Norman builders combined structural innovation with a desire for soaring height and good illumination. The Church of St. Étienne was begun in 1064 and finished by 1087, in time for William the Conqueror's funeral. The façade was completed by the end of the eleventh century [8.42]. (The timber roof of the nave was replaced with a vault c. 1120, and the choir was rebuilt and spires added to the towers in 1202.) Massive compound piers with column shafts running the full height of the three-story elevation divided the nave into bays and emphasized the vertical lines of the interior. The addition of pilasters on alternate piers created a subtle rhythmic movement down the nave [8.43]. In the clerestory,

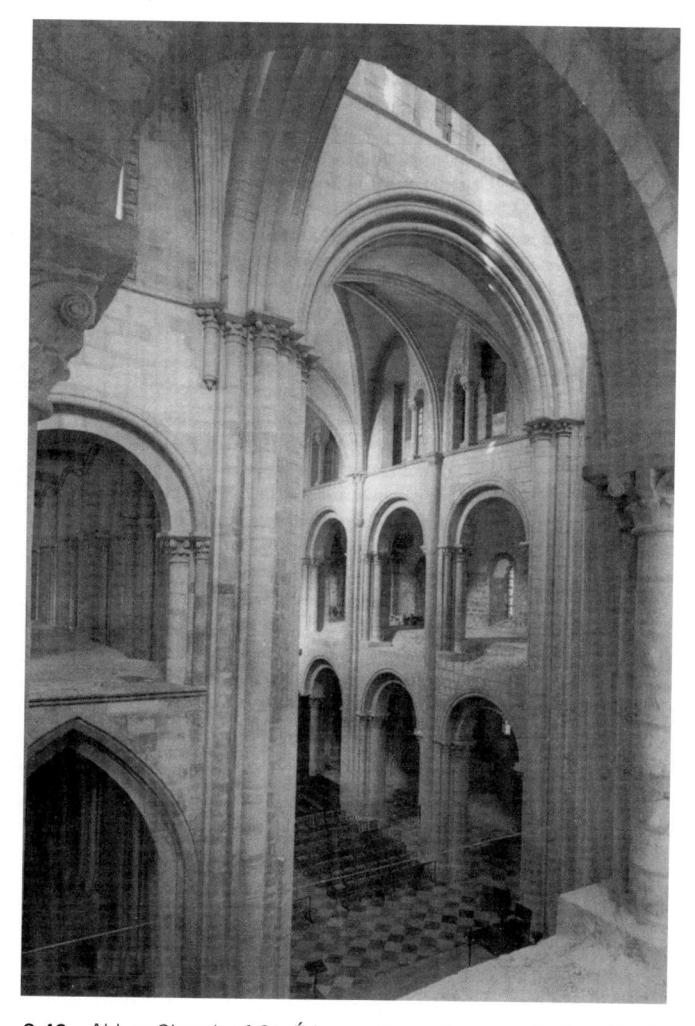

8.43 Abbey Church of St. Étienne, Nave, Caen; vaulted c. 1120.

between an arcade facing the nave and the outer windows, a passage within the thickness of the wall provided access to the upper areas.

In spite of the actual thickness of the walls, the Norman builders conceived of the interior as a skeletal framework of piers and arches which permitted wide openings in arcades, a tall gallery, and large clerestory windows. To lighten the masonry visually, the arches of the arcades were molded to correspond to the profiles of the piers. The result produces a contrast of vertical shafts and horizontal arcades. On the façade this ideal grid continues with enormous buttresses running unbroken the entire height of the façade to divide the wall into three vertical sections, while smaller string courses

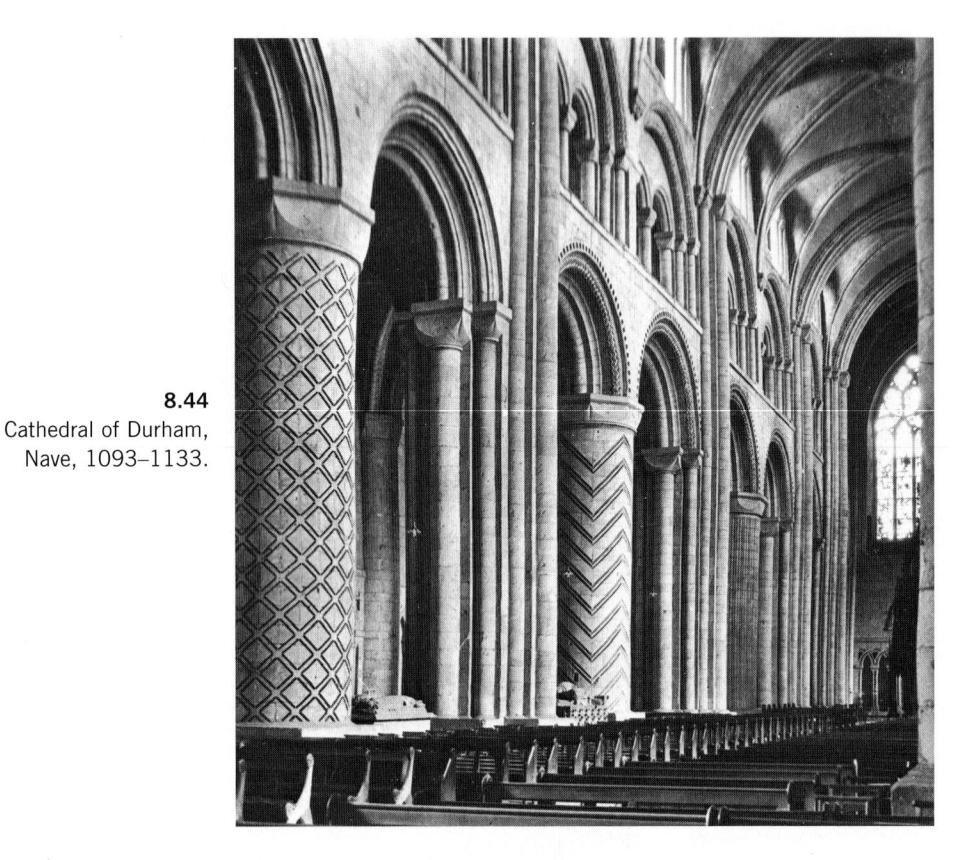

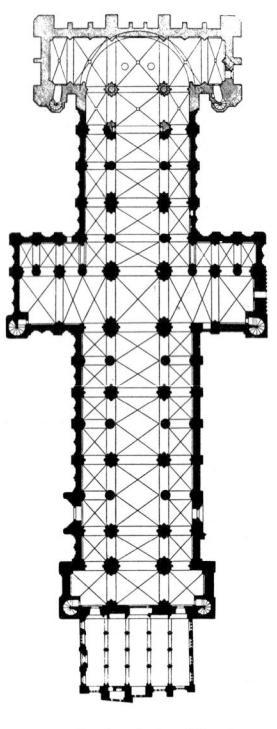

8.45 Cathedral of Durham, Plan, 1093–1133.

at the window sills mark the three horizontal stories of the elevation. Tall towers reinforce the essential verticality of the design.

The unadorned, vertical forms of St. Étienne's façade stand in marked contrast to the horizontal composition and richly textured façade of Notre-Dame-la-Grande in Poitiers. The façade at Caen reflects the arrangement of the three-part plan and three-part elevation, the divisions indicated by the buttresses and string courses, whereas at Poitiers a reredos-like screen conceals the interior arrangements. At Caen the façade is stripped to the essentials; at Poitiers, all is lavish sculpture. Even St. Bernard might have approved of Caen's severity, fine masonry, and harmonious proportions, although he would have disapproved of the tall towers and later Gothic spires.

By far the largest number of fine Norman buildings survive in England, where the new Norman clergy tried to outdo each other and their Anglo-Saxon predecessors in the size and splendor of their architecture. An aggressive builder, Bishop William de Carlief, replaced the Saxon church at Durham beginning in 1093. The vaulted choir was finished in 1104; the vaulting of the nave was completed in 1133 [8.44]. Following the alternating system of nave design used in Normandy but embellished almost beyond imagination, enormous primary piers of the tall nave and choir arcade have become clusters of vigorously projecting engaged columns, while the intermediate piers are cylinders equal in height and circumference and decorated with engraved chevrons, spiral fluting, and diaper patterns. Arches decorated with rolled moldings and chevrons spring from huge scalloped cushion capitals. On the second story, which is more like a triforium than a gallery, paired arches open into the nave. The clerestory, too, has a colonnade to screen wall passages and windows.

Above this vigorous wall design rise vaults, which mark an important step on the way to the development of the Gothic structural system [8.45]. The vaults of the double bays are separated by transverse arches and divided into seven parts by

two pairs of diagonal ribs. In the choir, these ribs spring from columns, but in the nave they were altered to rest on corbels. They seem aesthetically independent of the web of the vault. The segmental arches of the ribs enabled the architect to maintain a level crown for the vault and thereby to create a more unified interior space than the domical groin vaults of the Cathedral of Speyer or S. Ambrogio, Milan. At Durham, the great internal piers and stiffening exterior wall buttresses support and stabilize the vault; hidden buttresses in the galleries suggest the future development of flying buttresses.

The builders of Durham had little immediate effect on architecture in England where buildings such as Ely Cathedral [see 11.14] continued to be roofed with timber. In Normandy, however, in the second decade of the twelfth century the architects reconstructed St. Étienne at Caen with a six-part ribbed vault that was clearly influenced by the vault construction of Durham. Architects in England developed the decorative rather than the

On the Diverse Arts

A handbook for artists was written sometime between 1110 and 1140 by a master who called himself Theophilus. Modern scholars identify Theophilus as Roger of Helmarshausen, one of the finest metalworkers of the day. De Diversis artibus (On Diverse Arts) contains instructions on techniques of goldsmithing, bronze casting, enameling, painting, and stained glass as well as principles of composition and even a description of the ideal arrangements for a large workshop. Theophilus wrote from the point of view of the working artist for other craftsmen, not for scholars or patrons. He saw creation as a straightforward, step-by-step process of design and construction; not as a mystical experience but as the simple fulfilling of a commission. His approach reflects the point of view expressed earlier by the author of the Libri Carolini: Works of art should be well made, of fine materials, and they should serve a practical or didactic function. Theophilus' book transmitted techniques, images, and styles from region to region and generation to generation.

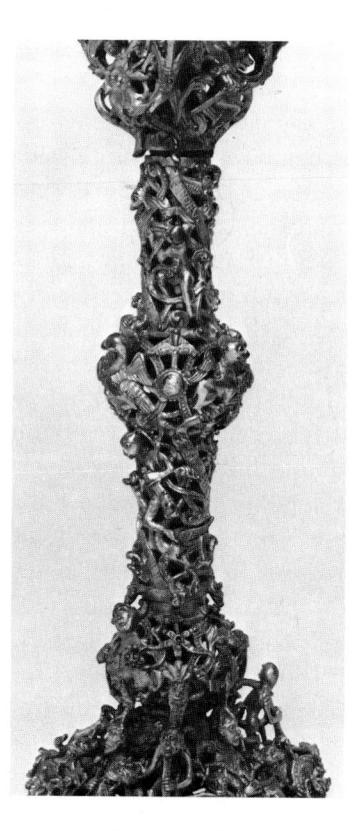

8.46 Gloucester Candlestick, detail, 1104-1113. Gilt bronze, Height. 23in. (58.4cm). The Victoria and Albert Museum, London.

structural possibilities of themes established at Durham. Incised patterns, roll and chevron moldings, interlaced arches (visible on the lower aisle wall at Durham), and some figure sculpture appeared in the later Anglo-Norman buildings.

The traditional skills of the metalworker flourished in Norman England. Here the Romanesque fascination with men and monsters appears in the magnificent gilt bronze candlestick, commissioned by Abbot Peter (1107-1113) for his monastery in Gloucester [8.46]. The small scale of the work did not lessen the monumentality of its conception: nothing less than humanity's struggle against the forces of evil and darkness to reach the true light of Christ. Through a twisting, writhing mass of dragons and foliage, loosely controlled by two encircling engraved bands, tiny men with bright blue glass eyes struggle upward, first to the symbols of the Evangelists half way up and then to the light itself, the candle. Not only is the candlestick a masterpiece of bronze casting, but the conception of the figure in motion, and the depiction of the tension of bitter struggle and the eventual joyous victory demonstrate the artist's acute awareness of human life.

English scribes also played a role in the twelfthcentury revival of the figurative arts. Carolingian, Anglo-Saxon, and Ottonian manuscripts were available to them in monastic scriptoria. Important as book production was in England, embroidery remains the quintessential English art. Closely related to the manuscripts, these fine embroidered textiles may have been designed by artists from the scriptoria. They probably drew the ornamental patterns and narrative scenes for the needle workers. The most famous English embroidery is the so-called Bayeux Tapestry [see 8.1 and 8.3]. Ordered by William's half brother Odo, bishop of Bayeux, and probably made in Canterbury about 1070, it records William's conquest of England. The "tapestry" is actually colored wool embroidery, worked in a difficult laid and couched stitch on linen. As a political document, the work justifies William's claims to the kingdom and recounts the preparation for the invasion, the course of the battle leading to the death of Harold, and the establishment of the new Norman dynasty.

No detail escaped the attention of the artist. In the siege of Dinan, the conformation of the land, the burning of the palisades, and the surrender as the keys are passed out from lance to lance are depicted in an energetic style which is closer to late Anglo-Saxon drawing than to the new Romanesque style. Accuracy in reporting is prized over calculated composition, specific details over idealized views, energy over elegance. The Bayeux Tapestry provides a fascinating source of visual information, not only of an important historical event but of daily life in the eleventh century.

In the eleventh and twelfth centuries, Romanesque art developed as a style with marked regional variations, reflecting the diversity in the religious, political, and social organization of western Europe. Yet certain elements are consistent. Romanesque builders defined the functions and spaces of the church with simple geometric shapes as they emphasized the symbolic content of the buildings. Towers, standing like city gates as

symbols of authority and temporal power, dramatize both castles and church façades, while sculptured portals of the church emphasize the sanctity and the importance the House of the Lord. A lantern tower or a cupola could give additional distinction to the crossing of the nave and transept and also serve as a reminder that every church was a martyrium. A complex choir provided space for the participating clergy and chapels to house the relics of saints. The impression given by the buildings is of solid, massive, uncompromising strength—the architectural expression of an essentially hierarchical and military society.

Architecture dominated the arts of the eleventh and twelfth centuries. The wall established the limits of the relief, and the architectural element, the frame. In painting, too, the illusion of three-dimensional space was reduced or eliminated through the use of strong outlines and brilliant colors. Manuscript illustrations and mural decorations alike had a geometric clarity and monumentality. The exquisite refinement of the decorative arts imported from the Byzantine and Muslim East reinforced the desire for superior craftsmanship. Artists looked again at the antique tradition of realism/humanism as distilled by Byzantine artists.

Painters and sculptors had an additional impetus to seek formal clarity, for their work had a didactic as well as a decorative purpose. The strong suspicion that images led to idolatry induced a feeling that art should be justified as educational. St. Bernard's concern over the ostentatious decoration of churches expressed a common Christian fear of graven images and a puritanical disapproval of the expense of art. St. Bernard considered the decoration of cloisters a distraction, but even he admitted the usefulness of narrative and symbolic art for instruction in parish churches. The visual arts became a system of signs and symbols often enhanced by explanatory inscriptions, but still difficult to unravel today when the common language of belief and folklore has been forgotten. This selection and combination of elements, as well as the submission to an architectural discipline, gave Romanesque art its distinctive character.

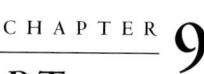

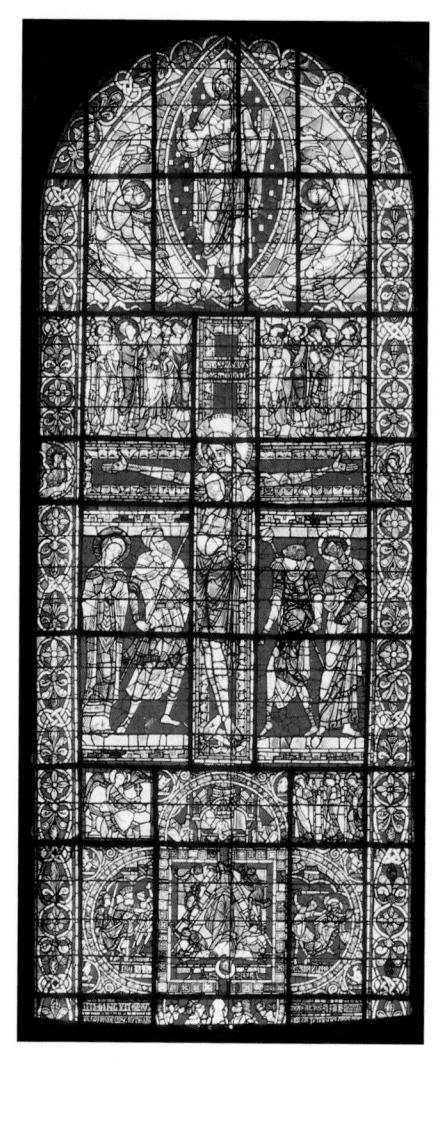

Poitiers, Cathedral, Crucifixion Window, given by Henry II and Queen Eleanor. Stained glass, 12th century.

ORIGINS OF GOTHIC ART

The "Year 1200" Style

ailed as "King of the Aquitainians, of the Bretons, of the Danes [Normans], of the Goths, of the Spaniards and Gascons, and of the Gauls," and elected because he posed little threat to the great nobles who actually held these lands, Hugh Capet, Count of Paris, became king of France in 987, and the Capetian dynasty began its 340-year rule. The archbishop of Reims crowned and consecrated Hugh Capet and so established the moral authority of the Capetian house. The new king's political authority was dependent on his own personal holdings around Paris—the Île-de-France—and such loyalty as he could exact or inspire. In theory, the king defended

the realm and dispensed justice. In fact, at the time of Hugh's succession, the title of king carried with it powers of moral suasion and very little else.

The Capetians, blessed with long lives and competent heirs, gradually turned a loose system of allegiances into a powerful, centralized monarchy. Remarkably enough, from the days of Hugh Capet until 1316, there was always a son of age to inherit the throne. Hugh Capet, Robert the Pious, Henry I, Philip I, Louis VI (the Fat), and Louis VII succeeded each other—only six kings in nearly 200 years. The prestige and wealth of the monarchy had grown slowly and steadily. The arts reflected this situation, and the regional styles of

the Romanesque gave way to the Gothic style of Île-de-France.

Into this family came one of the most brilliant women in French history. The granddaughter of the troubadour Count William IX, Eleanor of Aguitaine after the death of her brother and father ruled her domain with considerable political skill. In 1137 Eleanor married King Louis VII (ruled 1137-1180), and thus joined her vast lands to those of the Capetian house. Her marriage to Louis was annulled in 1152, after returning from the Second Crusade. Only two months later Eleanor married Henry Plantagenet, the dashing young count of Anjou. Henry inherited Anjou from his father, Geoffrey Plantagenet, and claimed Normandy and Brittany through his mother. Then in 1154, at the death of his cousin Steven, he claimed and won the English throne. Henry and Eleanor held court in Poitou, Normandy, Anjou, and England, but Fontevrault and Poitiers were Eleanor's favorite residences. She and Henry gave a magnificent stainedglass window to the Cathedral of Poitiers [9.1]. Eleanor and Henry kneel as donors below St. Peter and Christ.

Eleanor chose the Abbey of Fontevrault for her pantheon. When Henry died in 1189, at Chinon he was buried in the abbey church. Thirteenth-century tomb figures (*gisants* in French) of Henry II, Eleanor (d. 1204), their son Richard the Lion-Hearted (d. 1199), and daughter-in-law Isabelle of Angoulême (wife of King John) still lie in the vaulted crossing of the church.

Louis VII married again, and in 1165 his wife bore an heir, Philip, who later was given the title "Augustus." Philip Augustus (ruled 1180–1223) was a brilliant and determined ruler who combined the skills of politician, lawyer, and businessman. He realized the importance of the fact that the kings of England were his feudal vassals, and he used his legal skills to break their power on the continent. He first married Isabella of Hainault, the mother of Louis VIII, and when she died in 1190, he married Ingeborg, the sister of the Danish king. He repudiated Ingeborg the day after the marriage, and imprisoned the princess for the next 20 years. (Many

people believed that Philip was possessed by the Devil.) Eventually the Church forced him to recognize Ingeborg as the rightful queen of France.

Eleanor and Henry's son, Richard the Lionhearted (ruled 1189–1199), who inherited the English throne and his mother's French lands, was a great crusader but no match for the French king in the political arena. Challenging Philip for control of the north, in 1196-1198 Richard built a castle, Château Gaillard, on the border of Normandy. He had learned his lessons well as a crusader in the Holy Land, and he incorporated all the latest developments in both Christian and Muslim military architecture in his castle [9.2]. The site was perfect—a high cliff approachable only by a narrow ridge of land, which was easily defended by a strong independent fortification. The castle had a series of three massive walls, towers, and ditches so that, should the outer walls be breached, the enemy would face yet another, even stronger fortification. The walls of the inner bailey (courtyard) formed a continuous row of semi-towers around the final stronghold, the towering keep (donjon in France). Living quarters, great hall, kitchens, chapel, and other buildings stood in the courtyards outside this wall. The castle was as much a symbol of authority as it was a military stronghold. After Richard's death and a yearlong siege, Château Gaillard fell to the French king. Such was the fate of many castles—eventually their defenders succumbed to sieges, treachery, starvation, or disease. A few castles survived until the firepower of canons destroyed their usefulness.

In the eleventh and twelfth centuries, dwellings clustered for protection near castle walls; other villages arose near religious establishments and at transportation centers—crossroads, river fords, or seaports. By the twelfth century these villages had become real towns, often fortified with their own walls. Philip Augustus, for example, built new city walls for Paris as well as the royal fortress of the Louvre between 1190 and 1209. City walls were necessarily broken by more gateways than were desirable in a castle. Open spaces outside these gates provided an area for produce and livestock markets. Within the walls, houses crowded around the central mar-

Château Gaillard, 1196-1198, Les Andelys.

ketplace, which had a community well, ovens, a market hall, parish churches, and the finer houses.

While most of the buildings were relatively flimsy structures of timber and wattle and daub, the finest twelfth-century houses, such as those that have survived in Cluny, were masonry structures two or three stories high [9.3]. Facing the street, the townhouse often had a large, arched opening closed by a shutter, which was lowered during the day to form a counter for a shop. An inner courtyard had a fountain and led to kitchens and stables [9.4]. On the upper floor, a row of windows, sometimes beautifully carved, lit a spacious hall where the family lived. Private rooms as well as workrooms and servants' quarters were placed at the back of the house and in attics under the roof. The prosperous burgher in the twelfth century had his factory, warehouse, sales room, and home all in one compact building.

THE FIRST GOTHIC CHURCHES

Just as the kings began to form nations from many feudal counties, so architects and artists wove together the many strands of Romanesque art to create a new style. Two great churchmen, Abbot Suger of St. Denis (1122-1151) and Archbishop Henri

Sanglier of Sens (1122-1142) provided patronage and inspiration. The Abbey Church of St. Denis just north of Paris and the Cathedral of Sens 75 miles southeast testify to their dreams and energy. In its own day Gothic architecture was called opus francigenum, "French work," in clear recognition of its origin. The Gothic style dominated the arts for the next 300 years.

The Gothic Age was a period of ferment. Power and patronage moved to lay and ecclesiastical courts;

The Term "Gothic"

Gothic art has nothing to do with the Ostrogoths or Visigoths. Italian writers in the fifteenth and sixteenth centuries called the art of the Middle Ages the maniera dei Goti, for they considered all art from the fall of Rome to their own day as crude and barbaric, or "Gothic." In the eighteenth and nineteenth centuries, French, German, and English scholars, inspired by the romantic and nationalistic attitudes of the times, saw in medieval art an anti-classical style expressive of the "native genius" of the people outside Italy. They adopted the term "Gothic" and turned the adjective from a pejorative to one of high praise.

9.3 House of Cluny, 12th century.

learning, from monasteries to universities; and wealth, if not prestige, from landed nobility to merchants in the cities. Cities rivaled each other in the magnificence of the churches they provided for communal worship, and the cathedrals of the bishops became symbols of civic pride; sometimes, however, if the cost of their construction became too great, the huge building projects became the focus of urban unrest! The monastic orders continued to play a role. Abbot Suger began the rebuilding of the Benedictine Abbey Church of St. Denis [9.5], while Abbot Peter the Venerable of Cluny enriched his abbey and St. Bernard thundered against ostentation. Abbot Suger, a man of humble origins nurtured by the Benedictines, identified himself with the Abbey of St. Denis and the fortunes of the French monarchy. He justified the material splendor and visual beauty of his abbey as a path to the understanding of God.

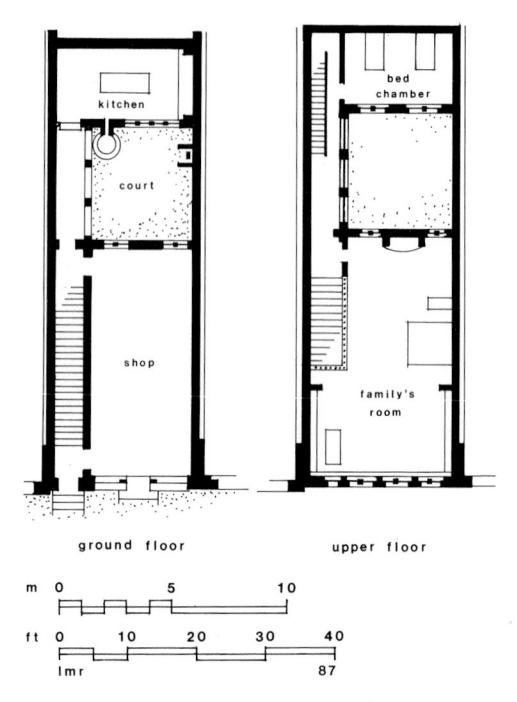

9.4 Merchant's house, Cluny, 12th century. Plan.

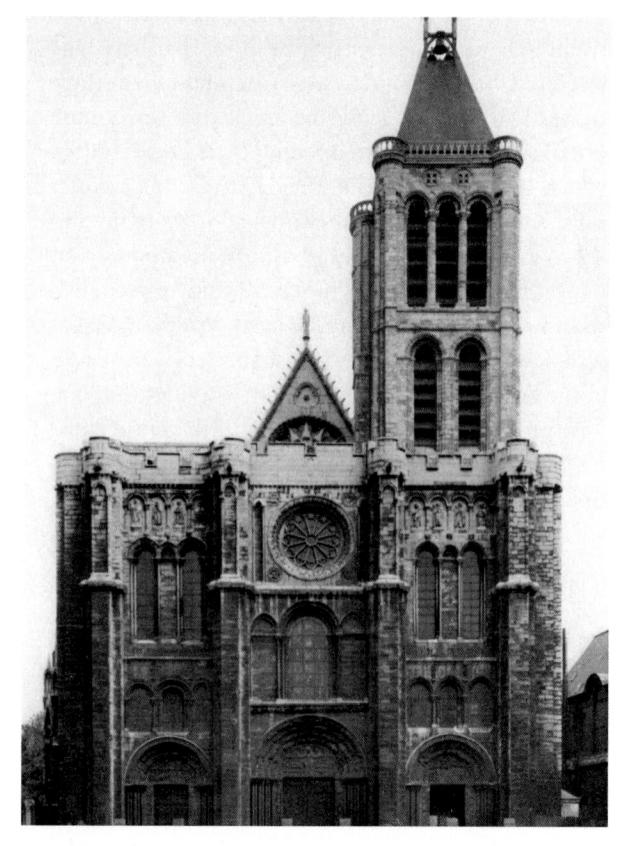

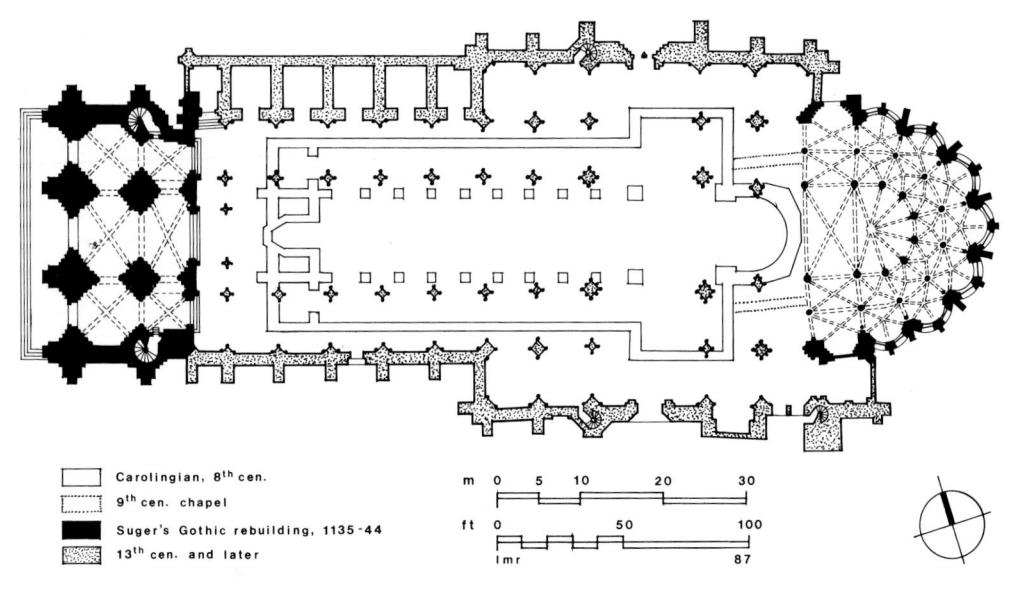

9.6 St. Denis, Carolingian church, Suger's building at west and east, 1137-1144, 13th century nave and transept.

Abbot Suger served Louis VI and remained as Louis VII's adviser, chancellor, and friend, but the abbot was no royal sycophant. In his eyes the Abbey of St. Denis could claim precedence over the royal court, for his church sheltered the relics of St. Denis, the apostle to the Franks who was martyred in the third century on the hill even today called Montmartre (from Mount of the Martyrs). The abbey had been an important Carolingian center; it was the pantheon of the Capetian royal house; and in the twelfth century, it housed the royal crowns and the Oriflamme, the king's war banner. Religious, political, and personal goals made Suger's aggrandizement of St. Denis a just cause in his eyes. The abbey symbolized France in an age when symbols could be reality.

When the Benedictine monks elected Suger abbot in 1122, they still worshipped in a Carolingian church, which tradition said had been consecrated by Christ. To finance his plans, Suger reorganized the abbey and its finances, and soon received royal patronage as well. Out of respect (and a shrewd understanding of human nature), Suger left the Carolingian church standing and began a new two-towered narthex in front of the old building [9.6]. The narthex was well under way by 1137 and was consecrated in 1140. Then, Suger decided to rebuild the choir. This work was completed in three years and three months, a success attributed by Suger to miraculous intervention. Seventeen bishops gathered to dedicate the altars of the choir in the presence of King Louis VII and Queen Eleanor of Aquitaine on June 14, 1144.

Norman influence is apparent both in the design and in the structure of the new façade and narthex [see 8.42]. Continuous vertical wall buttresses divide the square mass of the façade into three sections, and lofty towers reinforce this vertical subdivision. Behind the façade stood a narthex covered with rib vaults supported on piers whose elaborate cross sections recall the complex new pier designs developed in Anglo-Norman architecture. Sculptured portals, like those of Burgundy or the southwest, were added to this Norman composition. The central tympanum combined the images of the Last Judgment and the Apocalypse—a majestic Christ with symbols of his Passion, surrounded by the 24 elders. Old Testament kings and queens were carved on the columns of the splayed door jambs (known in France by the descriptive term statue-colonne, statue-column). Remarkably, a gold mosaic filled

the north tympanum—a reflection of the still experimental nature of the design. The components of the Gothic façade—two western towers, an essentially vertical composition organized in units of three, sculptured portals, and a round window—came together here for the first time.

Sculptors, like the architects, created a new art. The sculpture of the west façade at St. Denis, like the architecture that supported it, introduced a new style at mid-century. Changes appear in the iconographical programs, in the relationship of the sculpture to the architecture, and in the style of individual works of art. These changes derive in part from the patrons' desire for more effective communication of ideas and in part from the artists' attempt at greater integration of content, function, and form. A new conception of human beings is evident in the heads of Old Testament kings from the central portal of the west façade [9.7]. Sensitive modeling of the features and hair replaces the geometric simplification and expressive intensity of Romanesque art, although sharp cutting and severe stylization still add an unnatural force to the eyes. Perhaps the bronze-casters and enamelers influenced the sculptors. Suger wrote that he brought enamelers from the Mosan region, the homeland of the Stavelot masters [see 1.1] and Nicholas of Verdun [see 9.32 and 9.33]. He does not mention stone masons or sculptors.

Suger's account of his administration and of the building of St. Denis leaves many questions unanswered—for example, he mentions enamelers and metalworkers but never architects and sculptors. Suger's concern in writing his books was to justify the building and to immortalize himself as the founder abbot. He described the effect of the church, the miracle of its construction, and his gifts—altar, cross, and the jewels and gold that went into these lavish fittings—but he left our desire to know something about the master mason and the artists who invented the Gothic style unfulfilled.

After the consecration of the western portion of the church in 1140, Suger's masons moved to the east end, where they built a new choir. The choir consisted of a double ambulatory and seven radiating chapels [9.8]. Here Suger's masons carried the

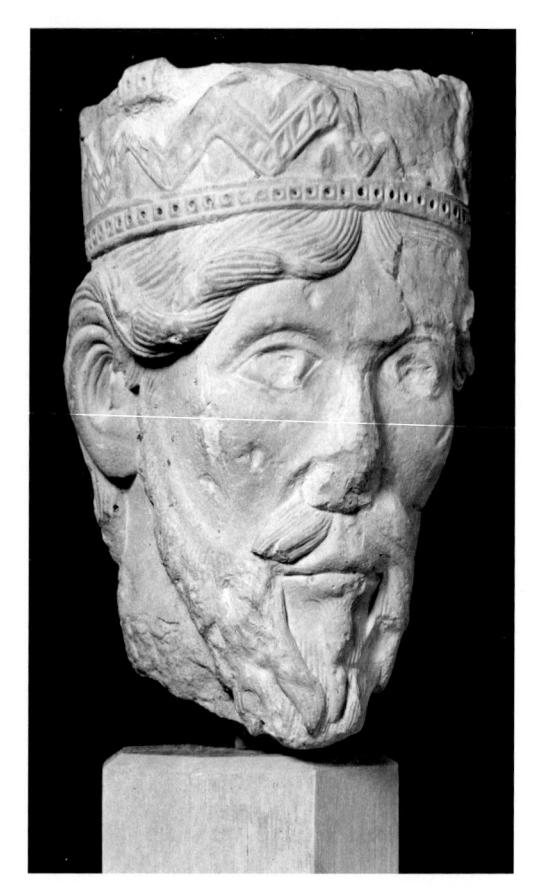

9.7 St. Denis, Abbey Church, Head of a King. Walters Art Museum.

skeletal structure developed by Norman builders to its logical conclusion. They reduced the walls to massive piers and buttresses, sheathed the whole with stained-glass windows, and so filled the space with colored light. By using rib vaults and pointed arches, they had the flexibility in construction to cover a very complex plan [see 9.6]. Each outer ambulatory bay is united with a chapel by five ribs joining in a common keystone to form a single unit. Carved moldings further reduce the visual impression of weight. The chapel walls become a continuous series of angled windows divided by buttresses. The builders brought together individual elements designed and developed by Anglo-Norman builders—the ribbed vault of Durham [8.44], the skeletal frame and linear quality of the wall of Caen[8.43], the emphasis on light and space in the Angevin buildings [see 9.24]. They developed a

Abbey Church of St. Denis, Interior of choir, ambulatory, 1140-1144.

new architectural system that created a light-filled, flowing space. In short, an architectural aesthetic of light, space, and line replaced one based on continuous planes and solid, cubical forms.

Suger intended to complete his church by joining the narthex and the choir with a new nave. He began work on the foundations, but his duties as regent for the absent king at the time of the Second Crusade consumed his energy, as the Crusade did the wealth of the monarchy. Abbot Suger died in 1151, shortly after the return of King Louis and Queen Eleanor from the crusade, and his church waited one hundred years to be completed. As Sumner Crosby, who devoted his life to the study of the abbey, suggested, the western narthex was "a symbol of the monarchy and terrestrial power. By contrast the choir, with the lightness of the structure, evoked the immaterial universe of the celestial hierarchy. The transept and nave, envisioned and begun by Suger but never finished, would have provided the symbolic link effected by the Papacy

How We Refer to Cathedrals

As the seat of the bishop, the cathedral is located in the urban headquarters of the See and is known by that city's name. Consequently we have the Cathedral of Paris, the Cathedral of Chartres, and the Cathedral of Bourges. Like all churches, the cathedral is also dedicated to a saint, whose relics it holds; and so we have the Cathedral of Notre-Dame (Our Lady) of Paris, the Cathedral of Notre-Dame of Chartres, and the Cathedral of St. Pierre (Peter) at Bourges. Traditionally, the name may be shortened simply to the city, thus, Chartres, and Bourges, although the Cathedral of Paris is popularly referred to as Notre-Dame.

To distinguish parish churches within the diocese, both the name of their patron and the city are used; thus, the Church of St. Urbain, Troyes. In an abbreviation, the phrase "church of" is dropped, but the possessive "'s" is used (as in "We visited St. Urbain's") since the building is St. Urbain's church.

between the celestial and terrestrial realms" (Blum and Hayward, Gesta, XXII/1, 1983).

While Suger was building St. Denis, southeast of Paris in Sens, two archbishops, Henri Sanglier (1122-1142) and Hugues de Toucy (1142-1168), were building the first cathedral in the Gothic style [9.9]. Sens was very influential since the archbishop administered a huge area that included both Paris and Chartres. Sanglier was a reformer and friend of St. Bernard; the church synod that condemned Abelard in 1140 was held at Sens. The new cathedral was well underway in the 1140s. Pope Alexander III dedicated an altar in the choir in 1164, and the nave must have been built soon thereafter, for it had to be repaired after a fire in 1184.

Sens Cathedral had a compact plan—transepts were reduced to chapels and the side aisles of the nave extended around the apse to form an ambulatory with a single axial chapel. The nave combined the six-part ribbed vaults over square double bays developed in Normandy with the three-part nave elevation seen in the nearby Burgundian churches

9.9 Cathedral of Sens, Nave, begun before 1142. Height of vault about 81ft. (24.7m).

of Cluny and Autun. Massive compound piers formed by engaged columns running through two stories carried the transverse and diagonal ribs of the vaults. Paired cylindrical piers—a new form, invented by the Sens Master and used again in Canterbury Cathedral [see 9.27]—supported the intermediate arches.

"Symbolic geometry," as it is called today, continued to be an essential element in building design. At Sens, the master evidently used the equilateral triangle to establish key points in the elevation and cross section, abandoning the Anglo-Norman galleries and clerestory passages and using a narrow triforium and thin clerestory wall. When the windows were enlarged in 1230, this single

plane of stone and glass had to be supported with flying buttresses [see box]. The compact plan, the union of the three-part nave elevation with six-part ribbed vaults, and the alternation of piers and columns at Sens established a new model for builders.

STAINED GLASS

Abbot Suger saw the church as the Heavenly Jerusalem, as did other people of his time, and he wrote of it in metaphors of dazzling light and colored jewels—especially rubies and sapphires. The architecture became a mere skeleton to support stained-glass windows. These windows were walls of glowing color that, with the movement of the sun and clouds in the sky, changed the interior of a building into shifting waves of red, blue, and purple light.

Abbot Suger took special care to describe the stained-glass windows in the new choir at St. Denis. He tells of bringing masters to do the work, and he arranged for a specialist to care for the windows. The windows were to him the epitome of art used in the service of religion, for they led the worshipper to God, "urging us onward

from the material to the immaterial in an anagogical fashion." One window, for example, began with an allegory in which the Old Testament prophets carried sacks of grain to be ground into flour by St. Paul, the New Testament (as we have seen at Vézelay [see 8.29]). Twelfth-century scholars studied and explained the images, using typological analysis to give depth and meaning to human action through perceived relationships with the Old Testament.

The St. Denis windows have been badly damaged or destroyed, but fragments of glass can be studied in museums and in the restored panels in the church. At Chartres and Bourges Cathedrals, however, twelfth-century windows are still in

9.10 Chartres Cathedral, West façade, Stainedglass windows. Scene from the Life of Christ. c. 1150-1170.

place. Above the portal in the western wall at Chartres, three great lancet windows represent the Tree of Jesse, the life of Christ [9.10], and his Passion. In the Life of Christ window, the designers organized the narratives in a series of alternating circular or square frames and also alternated the background colors between red and blue. (This simple color pattern was also used to heighten the carrying power of designs in heraldry and is referred to as heraldic alternation.) The elegant, painted figures recall the sculpture on the portal below [see 9.13, 9.14, and 9.15], while the wide

borders of clasping leaves and beaded vines enhance the decorative quality of the windows. Since stained-glass windows control the interior light, they affect the worshippers' perception of the architecture. The subdued but brilliant Chartrain glass makes the interior seem to be simultaneously dark and luminous. The windows are essential to the creation of the Gothic ideal—a continuous and unified interior space filled with light.

The principal window in the choir of the Cathedral of Poitiers—from a few years later, 1165-1175—depicts the Crucifixion and Ascension of Christ [see 9.1]. A huge red and blue cross with the monumental image of Christ fills the central panels. Its arms frame the figures of mourners and torturers below and the apostles who witness the Ascension above. Angels carry Christ heavenward and confront the Marys at the tomb (a tiny scene under the cross). Directly under Christ's cross is the crucifixion of St. Peter, the patron saint. This lower panel has the martyrdom of St. Paul and a representation of the donors, Henry II and Eleanor of Aquitaine, a reminder of the essential role of royal patronage. A wide border of stylized plants and interlacing stems frames the images. Dazzling reds and blues dominate this extraordinary wall of glass, rising directly over the high altar-red, the color of martyrs, and royal blue and purple.

Abbot Suger discussed the significance of the windows and their intended effects in his justification for the enrichment of his abbey when he wrote about the relationship of light and color to the Christian's search for perfection and union with God. Suger had studied the writings of the fifth-century philosopher known as the Pseudo-Dionysius, which he found in the abbey library, and whom he (and other twelfth-century scholars) thought was St. Denis of Paris whose relics his abbey housed. The Pseudo-Dionysius provided a justification in Neoplatonic philosophy for Gothic aesthetics. (see Box: Neoplatonism and the Aesthetics of Light.) Through the colored light created by walls filled with stained glass, the interior of the church could take on the mystical essence of the One and provide a path for mortals to rise spiritually toward union with God. Architectural structure, no matter how ingenious, was simply a means to achieve effects of space and light that would recreate in this world the celestial light of Heaven. Suger described his intentions and the effects that he hoped to produce.

"Thus when out of my delight in the beauty of the house of God—the loveliness of the many-colored gems has called me away from external cares, and worthy meditation has induced me to reflect, transferring that which is material to that which is immaterial, on the diversity of the sacred virtues; then it seems to me that I see myself dwelling, as it were, in some strange region of the universe which neither exists entirely in the slime of the earth nor entirely in the purity of Heaven; and that, by the grace of God, I can be transported from this inferior to that higher world in an anagogical manner" (Suger, *De administratione*, Chapter XXXIII, translated by Erwin Panofsky).

His words on the doors in the west façade could also apply to the windows and other treasures.

Whoever thou art, if thou seekest to extol the glory of these doors,

Marvel not at the gold and the expense but at the craftsmanship of the work,

Bright is the noble work; but being nobly bright, the work

Should lighten the minds, so that they may travel, through the true lights,

To the True Light where Christ is the true door, In that manner it be inherent in this world the golden door defines:

The dull mind rises to truth through that which is material

And, in seeing this light, is resurrected from its former subversion.

(Suger, De administratione, Ch. XXVII)

EARLY GOTHIC SCULPTURE

In sculpture as well as stained glass, Chartres Cathedral provides an introduction to the early Gothic style. The western Royal Portal has survived fires, pilgrims, tourists, and industrial-age

How to Make a Stained-Glass Window

Great care and expense went into making stained-glass windows, and understanding the challenges their creation presented to the artists and craftsmen renders their final effect all the more impressive. Theophilus included detailed instructions for making stained-glass windows in his book On the Diverse Arts (see Box: On the Diverse Arts). First molten glass colored with minerals had to be blown into spheres, which could be opened into circular panes, or into cylinders, which would be slit lengthwise and rolled open to make rectangular panels. The best glass blowers dipped their rods into pots of different shades of color or else swirled colored and clear glass together to produce layered cross sections, which enhanced light refraction. This blown glass varied in color and thickness, and sometimes the final color was un-

9.11 Chartres Cathedral, Tree of Jesse, west façade, 1150-1170. Stained glass.

planned. Theophilus advised the glass workers to save all the colors made by accident to use for special effects [9.11].

The artists planned the windows carefully because the materials were very precious. The master drew the designs for the window full size on a pattern board. Then colored glass pieces were cut to fit specific locations, and painters added the details of draperies. anatomy, faces, and ornamental designs in brownish-black enamel. After the glass was refired to fix the drawing, the pieces were joined with lead cames. In the finished window, the lead cames appear black; they enhance the intensity of the color of the glass by preventing the colors from blending visually. After finishing all the individual panels, the artists assembled the leaded panes into an iron frame. This armature strengthened and stiffened the window and became another black pattern against which the brilliant colors seem to vibrate.

Finally the glass was set into the window opening in the masonry wall. Early Gothic builders used plate tracery, in which simple lancet or circular shapes were pierced in the wall. Later they developed bar tracery, which they formed using slender masonry mullions and decorative curvilinear forms. Tracery added yet another element to the window's composition.

Windows were often so far from the spectator that the fine painting of the individual scenes was lost. The master designers learned to place large-scale, single figures in the distant clerestory windows, while using narrative compositions consisting of many small scenes in the aisles and chapels.

Much has been written about the brilliant blue glass of Chartres Cathedral. To a large extent this famous effect is due to the resistance of blue glass to the effects of age and weathering. Blue remains transparent while the glass of other colors becomes semi-opaque from corrosion and pitting.

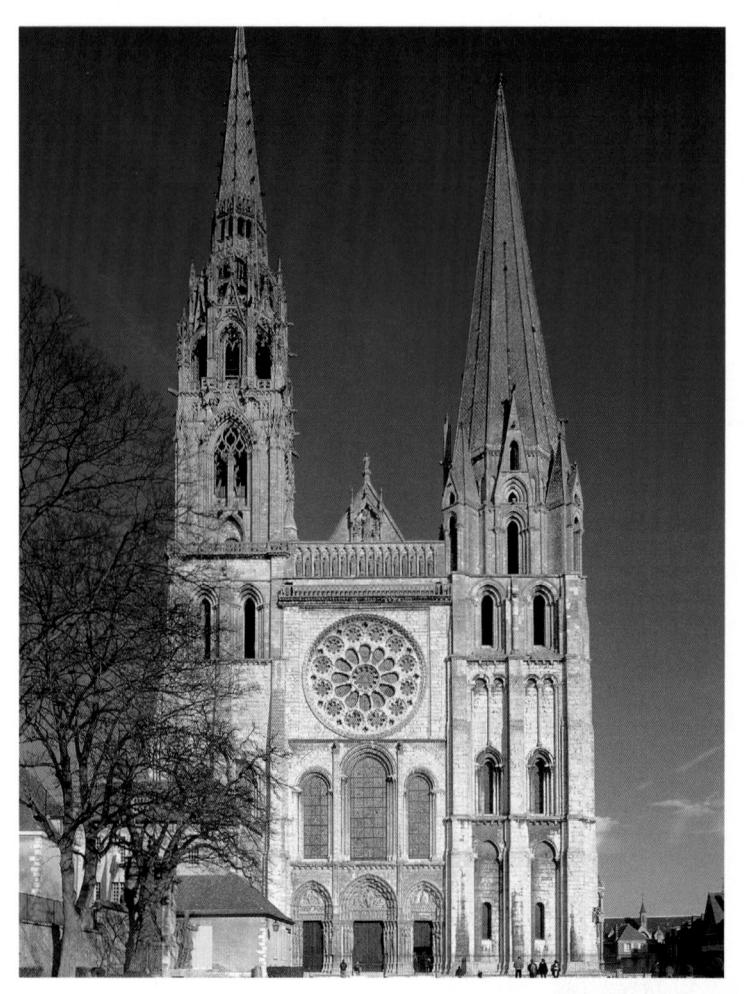

9.12 Chartres Cathedral, the Cathedral of Notre-Dame, West façade, Chartres, France, c. 1134–1220; south tower c. 1160; north tower 1507–1513.

pollution [9.12]. After a fire in 1134, rebuilding of the west façade began at once with the towers. The sculptured portals between the towers must have been carved between 1140 and 1150 [9.13]. When, in 1194, lightning struck the wooden roofed eleventh-century building, which burned to the ground, the Royal Portal survived, protected by its masonry vault and flanking towers.

Sculpture does not spread over the façade as it does in some Romanesque buildings in Queen Eleanor's Aquitaine. Certain architectural members seemed most appropriate for sculptural enrichment—door jambs, lintels, tympana, and archivolts. The sculpture is not compressed or controlled by the architecture, as it had been in the Romanesque style, but instead conforms naturally to the shape of the architectural element and visually reinforces the architecture. The figures carved around the doors, for example, become columns themselves, in contrast to the lively jamb figures at Vézelay or Moissac. Vertical elements dominate the composition; consequently, in the voussoirs, figures follow the line of the arches, rather than radiating out from a center, the better to harmonize with the vertical lines of the statue columns. Lintels might be filled

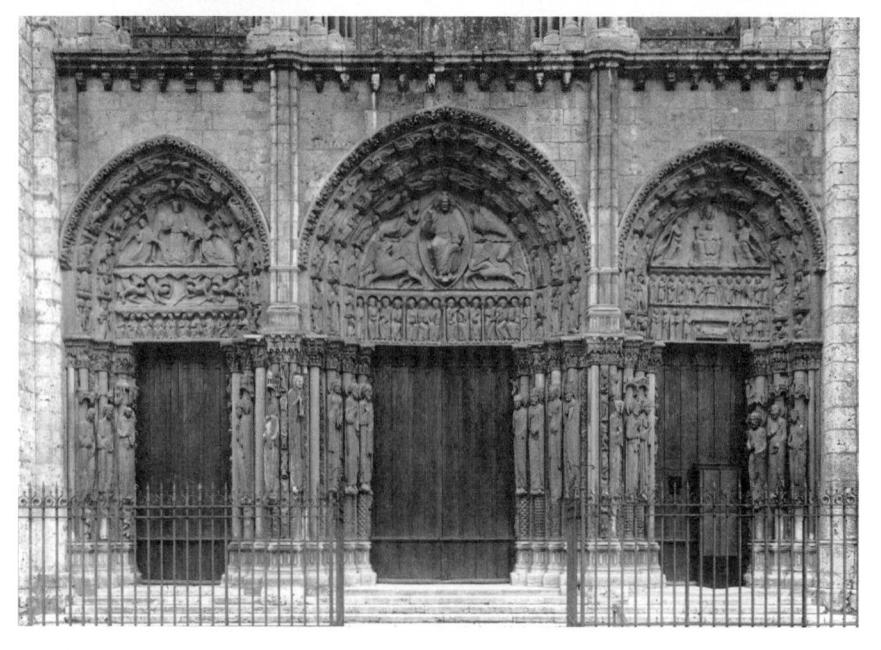

9.13 Chartres Cathedral, Royal Portal, west façade, c. 1140–1150.

with standing figures under an arcade—the arcade reinforces the horizontal lines of the lintel and the figures establish a pattern of verticals within the horizontal block. Within the lunette of the tympanum, through the continued use of hieratic scale, the central figure of Christ naturally rises to fill the apex while apocalyptic beasts fit gracefully into the remaining triangular sections. The number of figures is reduced and their relationship to each other and to the architecture is clarified so that the tympana of Chartres are composed of self-contained and balanced units, in contrast to the intricate interlocking Romanesque forms.

With the exception of some ornamental patterns on subsidiary colonnettes and moldings, the portal sculpture conveys a message. The idea that the Old Testament supported the New is clearly stated in the actual physical relationship of jambs and archivolts. The Old Testament kings and queens of Judea lead to the New Testament with Christ and the Virgin. Furthermore, as jamb figures flanking the portals, the kings and queens literally draw the worshipper into the House of God. The columns support sculptured capitals, which become a continuous arcaded frieze with scenes from the life of Christ. In the tympana, Christ is glorified, as is His mother; he appears in the past, present, and future at the end of time.

The right-hand portal depicts Mary, the Christ Child, and scenes from the early life of Christ [9.14]. In the Nativity, on the lowest lintel, the Virgin reclines on a bed, which at the same time forms an altar on which the Christ Child lies. Next, in the Presentation in the Temple, Christ stands on the altar, again in the center of the composition. In the tympanum, Christ and Mary assume the position of the traditional "Throne of Wisdom" statues. (The baldachino over their heads is lost, but the bases of the columns that supported it are visible at each side of the throne, and the line of the gable roof and arch can still be traced.) Since the narrative progresses logically from left to right and bottom to top, the adjustment of the three representations of Christ (lying, standing, and then sitting in the center of the composition) had to be carefully calculated. In each case, he appears not as a living child but enshrined

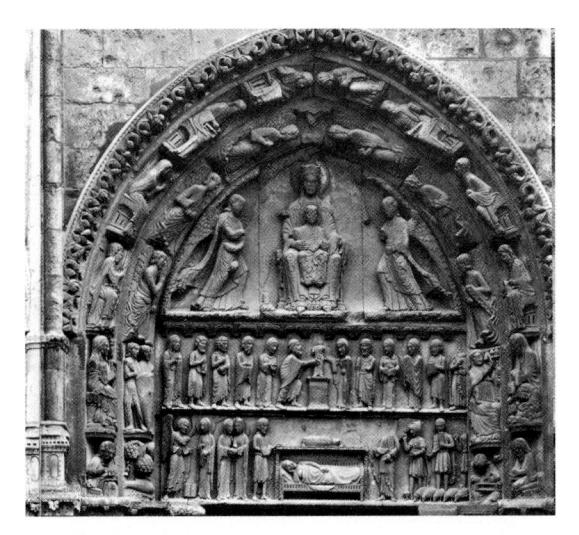

9.14 Chartres Cathedral, Virgin Portal, west façade, right bay, mid-12th century.

as a cult object. In the voussoirs, perhaps in recognition of the cathedral school of Chartres, studious ancient philosophers and the personifications of the liberal arts surround Mary, their patron. The dedication of an entire portal on the principal façade of a cathedral to Mary has been seen as a significant change in her status (and through her, perhaps that of other women) in the twelfth century.

On the left-hand side of the portal, Christ ascends heavenward in a cloud, adored and supported by angels. In the voussoirs, signs of the zodiac and works of the months symbolize earthly time, which comes to an end in the glory of the Second Coming. The final vision of glory fills the central tympanum. Christ as the Pantokrator of the Apocalypse, with the four beasts and 24 elders and choirs of angels, rises over the 12 apostles. The Chartrain theologians have organized all of Christian history on the façade of their cathedral, and the master sculptor, known today as the Head Master, has created a logical and convincing architectural composition in fulfillment of their wishes. Later masters had only to expand or condense the themes of the Royal Portal. Indeed, elaborate portals added to the transepts of Chartres in the thirteenth century provide extended Old Testament themes on the north side and the Last Judgment and the saints on the south.

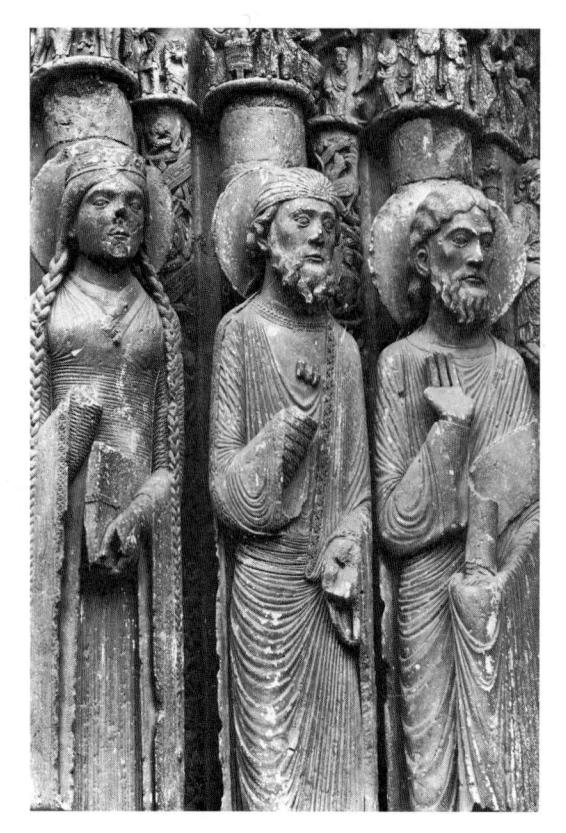

9.15 Chartres Cathedral, Ancestors of Christ. west façade.

Perhaps the most characteristic new element introduced at mid-century is the use of columnar figures flanking the portals, first at St. Denis and Chartres, and then on most Gothic buildings [9.15]. At Chartres the extremely elongated proportions of the figures, emphasized by finely pleated garments with trailing sleeves, reinforce the vertical lines of the shafts. Emerging from these columnar bodies are heads of astounding beauty and hands raised in blessing or lightly holding books and scrolls. In spite of the essentially architectonic quality of the figures, they express the artists' and patrons' new interest in physical appearance. The modeling of the heads is so delicate that the bone structure seems to support soft flesh, the hair forms a delicate linear pattern against the skin, and the eyes lie under the lids rather than stand forth as jewels in frames. The Head Master established a new standard for sculpture in the second half of the twelfth century. The west façade of Chartres influenced sculpture in Burgundy, Languedoc, and Provence, as well as the country around Paris.

THE NEW GOTHIC CATHEDRALS

Within a generation, Gothic buildings began to rise in Paris, Laon, Chartres, Poitiers, and Canterbury, in England, and elsewhere, under the patronage of kings, bishops, and the new urban middle class. In 50 more years the Gothic style had spread from the Île-de-France throughout western Europe, ranging from Scotland and Scandinavia to Spain and Italy. The pointed arches, the rib vaults and supporting column shafts and responds, the traceried windows and diaphanous walls of stained glass became easily recognizable hallmarks of the new opus francigenum, "French work," in cathedrals, parish churches, palaces, and market halls. Architects of genius created a new structural technique based on an articulated skeleton of masonry rather than massive walls and vaults or the timehonored post and lintel system. Sculptors and painters were equally innovative as they attempted to capture the appearance of the material world as well as its spiritual essence.

In the second half of the century, architects in France experimented with the techniques and forms introduced at Sens and St. Denis. The cathedrals of Laon, Paris, and Poitiers, begun in the decade after mid-century, represent three dramatically different approaches to Gothic structure and aesthetics. (The subtle crosscurrents between Anglo-Norman and French architecture at work in the mid and later twelfth century cannot be detailed in this brief overview.)

Whereas the Abbey of St. Denis was identified with the Capetian dynasty and Sens with the archbishops, Laon can be seen as the prototypical "new town," a cloth-making and -trading center lying northeast of Paris on the road to Flanders [9.16]. The townspeople and the bishop were in constant conflict, and violent uprisings slowed construction. A new church was begun shortly after 1150, and by 1175 the choir and transept were nearly finished. Construction continued in the nave for the rest of the century, with the western bays and façade finally

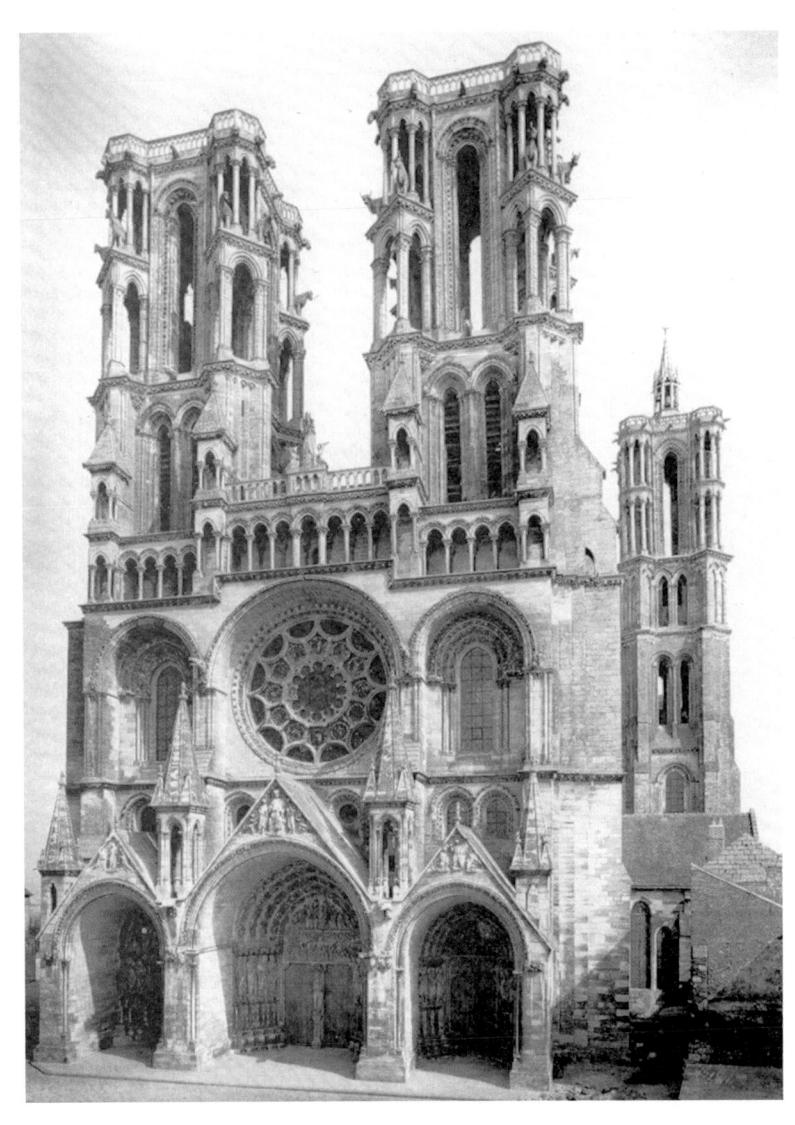

9.16 Cathedral of Laon, begun 1160s, west façade, 1190-1215.

built between 1190 and 1205. The eastern arm was extended with a long rectangular choir about 1205, and this new eastern wall with its triplet lancet windows surmounted by a rose provided a fitting climax to one of the finest early Gothic interiors. The lantern tower, a Norman feature that focused attention at the crossing, reinforced this drama of light.

The Laon towers, built in the thirteenth century, continue the rich sculptural treatment of architecture seen in the nave and the west façade. From the massive heavily buttressed bases, to octagonal belfries, the towers become lighter as they soar into the sky, their slender elongated galleries abutted by diagonally placed, openwork corner turrets. Space seems to penetrate every stone, for such masonry walls as remain are carved as a series of moldings and enriched with detached colonnettes. The architect has denied the weight of the stone as he creates a fantasy of light and space. Even in their own day the towers were considered masterpieces. The thirteenth-century architect Villard de Honnecourt marveled, "I have been in many lands but nowhere have I seen a tower like that of Laon." Seven towers were planned: a lantern tower at the crossing, a pair of towers at the west façade, and pairs on the transept façades.

The cathedral at Laon, with its nave, extended aisled transept, two-story chapels, and soaring

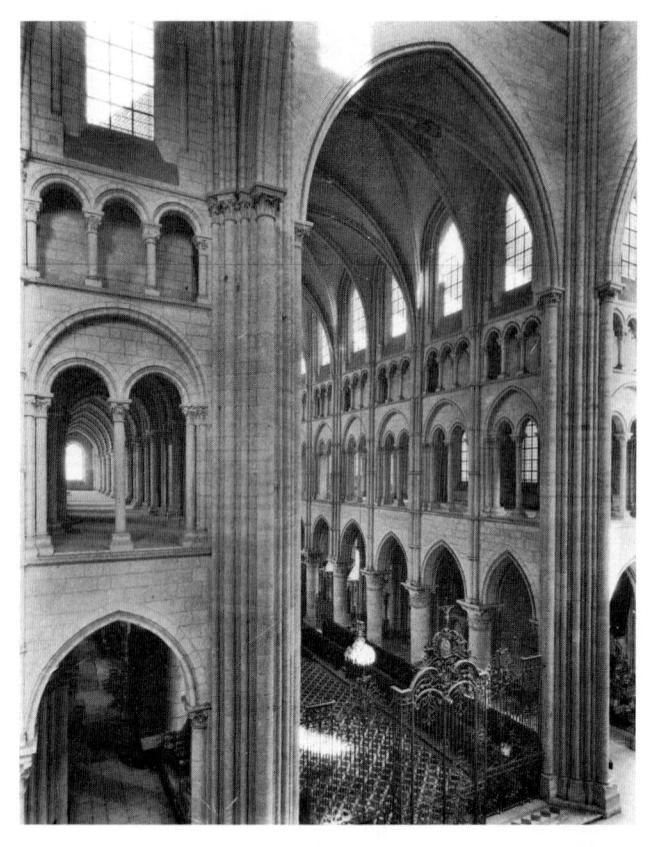

9.17 Cathedral of Laon, Nave, from tribune crossing. Height of vault about 79ft. (24.1m).

towers appears to spread over the hilltop and thrust into the sky. On entering the nave, one is immediately impressed by the space—the height of the interior and the changing quality of the light [9.17]. The narrow proportions (approximately 79 x 35 feet (24.1 x 10.7m) as compared to Sens' nearly 81 x 49 feet (24.7 x 14.9m)), narrow bays, multiplication of engaged shafts running through the upper three stories, and the actual reduction of the wall surface make the nave appear to be much taller than it actually is [9.18]. Each of the four stories—the nave arcade, gallery, triforium, and clerestory-has a different height, depth, and intensity of light. The sculptural quality of the wall design, with its implication of walls behind walls, creates a shifting movement as the eye follows the wall shafts up to the vault. Four-part vaults stabilize the six-part ribbed vault spanning the nave over the aisles and galleries, a triforium, and

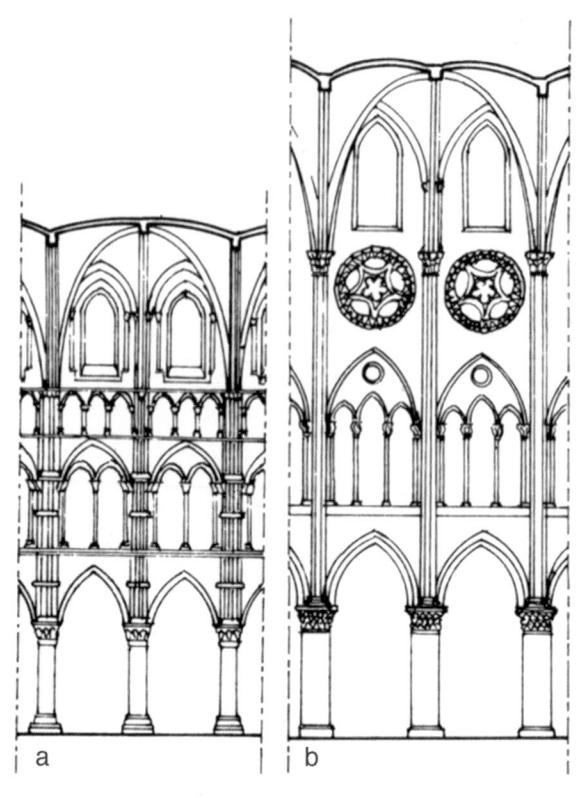

9.18 Comparison of nave elevations in the same scale: a. Laon; b. Paris.

hidden buttressing under the gallery roofs. This vault determined the details of the elevation from the alternating square and octagonal bases and abaci of the cylindrical piers to the wall shafts in bundles of five or three responding to the ribs of the vault. Even the new design known as the crocket capital, in which simplified foliage emphasized the form and function of the capital, accords with the early Gothic architects' concern with the definition of structure and proportion.

Meanwhile, in the royal city of Paris, Maurice de Sully, a famous teacher and preacher and the bishop of Paris from 1160 to 1196, was not to be outdone by an abbot or another bishop, and so in 1163 he began rebuilding the cathedral, dedicated to Our Lady, Notre-Dame. The church was the largest of all the early Gothic cathedrals—over 400 feet (121.9m) long and rising 108 feet (32.9m) to the keystone of the choir [9.19]. The Cathedral of Paris was a worthy rival to the huge Romanesque

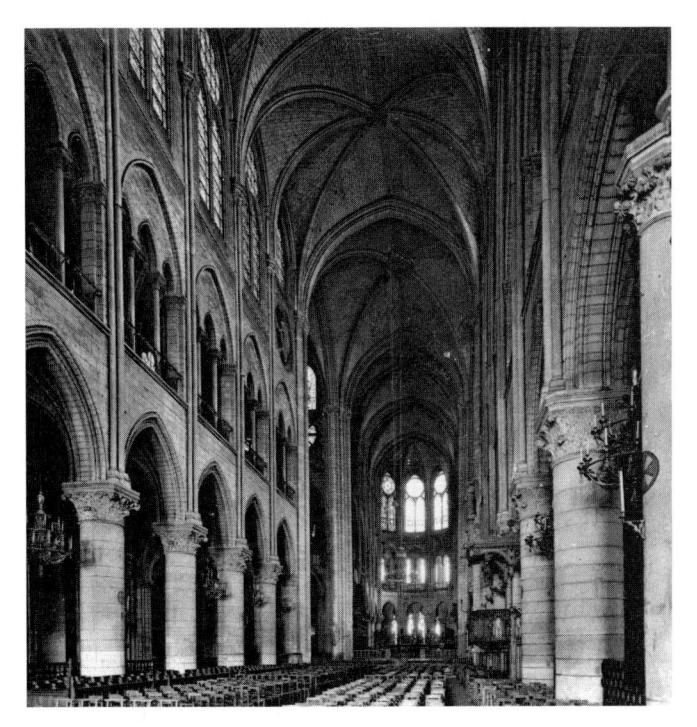

9.19 Cathedral of Notre-Dame, Nave, begun 1163; nave, 1180-1200. Height of nave vault, 102ft. (31.1m). Paris.

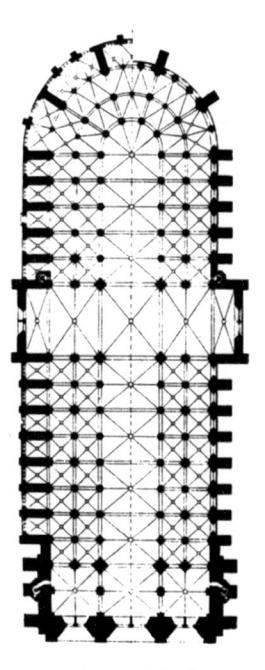

9.20 Cathedral of Notre-Dame, Plan, Paris.

churches of Cluny and Speyer. Bishop Maurice de Sully, like Abbot Suger, seems to have identified himself with his church. The son of a peasant, educated by the Benedictines, his career lay in Paris. He pushed forward the construction of a new cathedral, planned as early as mid-century when he was administrator of the See. Building may have begun at both east and west ends since the canons acquired the sites of two older churches: One, dedicated to the Virgin, lay under the choir of the present cathedral, and the other, St. Étienne, under the western bays of the nave and the façade.

In Paris the architects repeated the compact plan of Sens but added a transept within the line of the aisle buttresses [9.20]. The large choir of two and a half bays allowed the keystone of the ribs of the high vault of the choir to be abutted by two additional ribs-that is, half of a six-part vault. The church has double aisles and a double ambulatory without projecting radiating chapels. The architects solved the problem of the trapezoidal form of the ambulatory bays through an ingenious system of diagonal ribs that divide the ambulatory bays

into triangular forms. The choir must have been finished by 1182, when Pope Urban consecrated the high altar.

In the original design for the nave, 1150-1182, the architects created a variation on the four-story elevation [9.18]. Above the arcade a vaulted gallery opened into the nave through triplet arches. Then a range of round windows at the triforium level and simple lancets in the clerestory completed the four-part elevation. Architectural historians debate whether or not flying buttresses were included in the design. In about 1230, the nave was "modernized" by combining the lancets and round openings into single large windows. (In the nineteenth century, the French architect Eugène Emmanuel Viollet-le-Duc restored the bay next to the crossing to the original design, just visible in [9.19].) The repeated circular windows would have broken the vertical lines of the individual bays and enhanced the longitudinal movement toward the altar established by the massive cylindrical piers. The timehonored alternating support system was not abandoned entirely by the Parisian builders, however,

Flying Buttresses

Sometime in the twelfth century—perhaps after the collapse of the nave at Cluny, perhaps at the Cathedral of Parismasons desperate to shore up or support nave vaults and steep roofs found a daring technical solution to the problem of the vault's thrust and the force of the wind. In the new system of abutment, struts (fliers) carried the thrust of the high vault to buttresses—massive masonry walls standing at right angles to the line of the building's walls and free above the roofs of the aisles. Flying buttresses revolutionized building practice and made possible the soaring vaults and huge windows of the thirteenth and fourteenth centuries. Weighted with spire-like pinnacles, these powerful, elegant structures seem to merge form and space to create interpenetrating solids and voidsthe dematerialized architectural forms so congenial to later medieval taste [9.21].

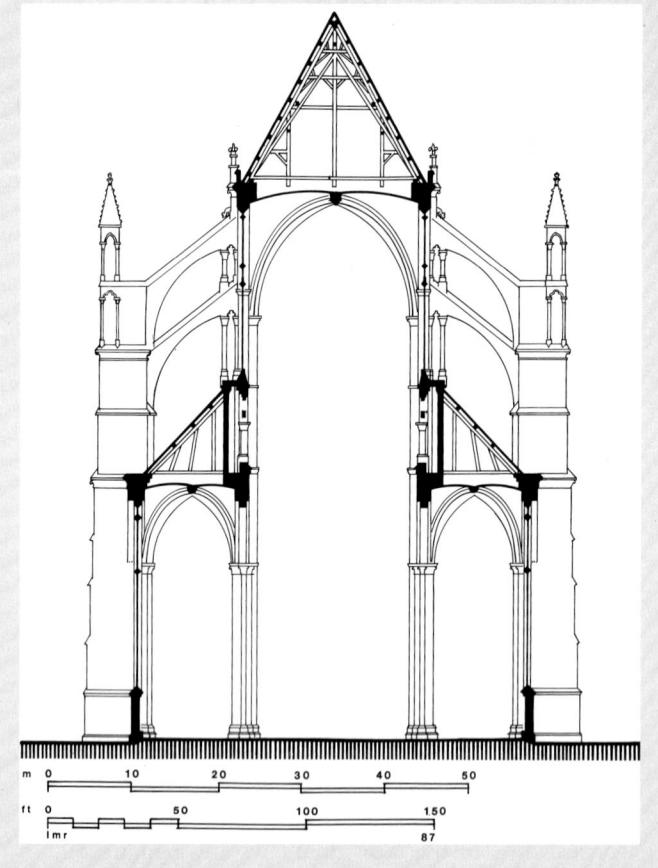

9.21 Amiens Cathedral. Fully developed flying buttresses. 13th century [see interior 10.17].

for the piers dividing the double aisles alternate between clustered shafts and columns. By the end of the century the desire for verticality led a new master to add engaged half-columns to the piers in the western bay of the nave.

The façades of Laon and Paris, both built at the beginning of the thirteenth century, provide a dramatic contrast. Laon's façade dates 1190-1205 [9.16]. The lower part of the façade at Paris was finished by 1200; the rose window, by 1236; and the towers were finished by 1250 [9.22]. Erwin Panofsky suggested that the pattern of thought typified by Abelard's rationalism, the balance of opposites, Sic et Non, permeated architectural thinking. He contrasted the spreading plan of Laon, which also surges upward in towers, with the compact, enclosed form of Paris. The architect at Laon thought in terms of sculptured mass and void; the builders of Paris, of mural surfaces. The façade of Laon is a composition of interpenetrating forms—towers, turrets, deep porches, projecting wall buttresses, and windows set within great arches. The Paris façade is a perfectly proportioned wall. It is balanced, with all its forms moving within a shallow plane, and calculated in modular units based on the diameter of the great rose, which forms a halo for the statue of the Virgin.

On the west façade of Notre-Dame, Parisian sculptors provided variations on Chartrain themes. The Portal of Ste. Anne, now on the right side of the west façade, copied the iconography and composition of the Virgin's portal at Chartres [compare 9.13]. The head of King David, now in the Metropolitan Museum of Art in New York, came from this portal [9.23]. The sculpture has a crisp, polished appearance, and a decorative quality associated with the courtly elegance of the later Parisian sculpture. King David's imperious expression, an impression created by the highly arched brows and staring eyes (originally inlaid with lead), makes him seem a more worldly colleague of the king at Chartres. Sculptures from Chartres

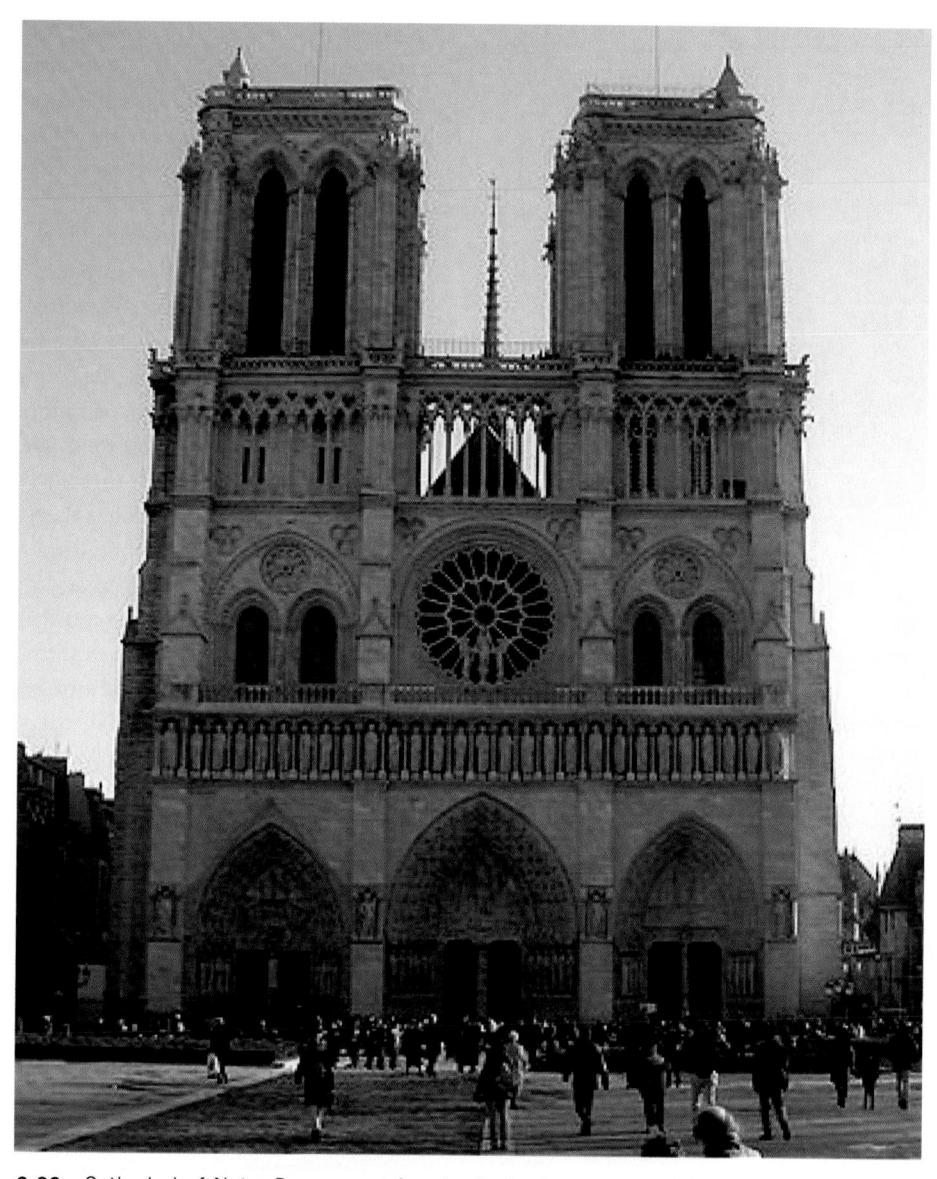

9.22 Cathedral of Notre-Dame, west façade, Paris, first half of 13th century.

and Paris are similar in their subtle and sophisticated precision, in their still decorative organization of draperies, in their elegance and refinement of proportions and details, and in their emphasis on a spiritual rather than a tangible visible world.

Outside the Île-de-France, one of the most successful regional architectural styles appeared in Angevin lands, in the Cathedral of Poitiers [9.24].

In Poitiers the builders also looked to Romanesque sources. They continued both the Western preference for a wide, open nave like Fontevrault and the high vaulted nave flanked by almost equally tall side aisles (sometimes called a "hall church") used at St. Savin-sur-Gartempe [see 8.41]. Inspired by their Norman neighbors, Angevin architects also experimented with ribbed vaults. Their eight-part ribbed vaults are steeply pointed, so that the

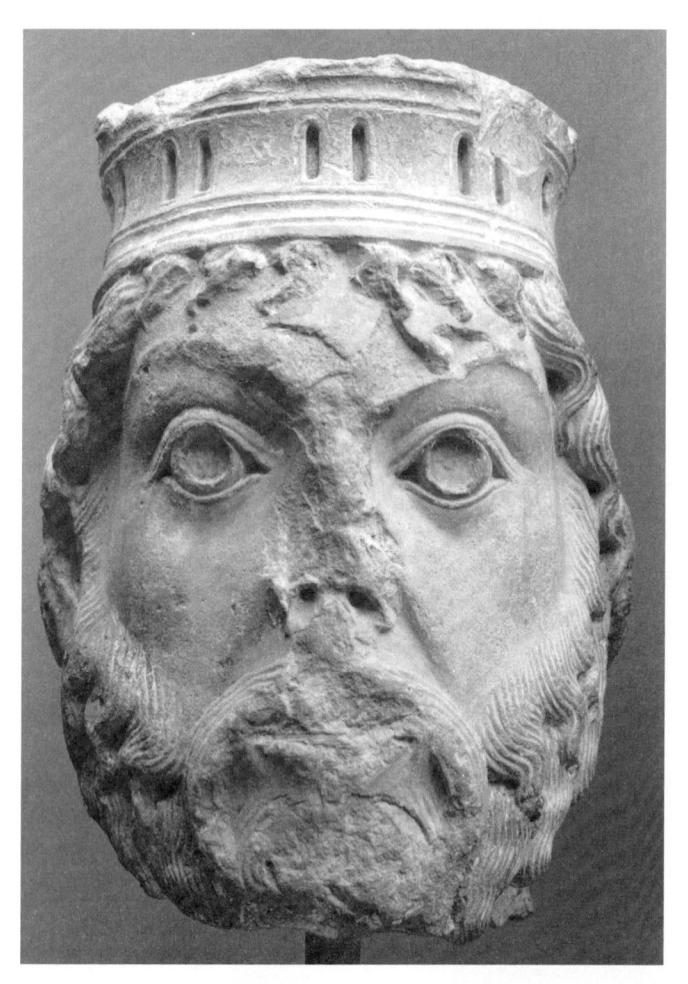

9.23 King David, Ste. Anne Portal, west façade, Cathedral of Notre-Dame, Paris, 1165-1170. The Metropolitan Museum of Art.

domed-up form recalls the shape of earlier Romanesque domes. In the Cathedral of St. Pierre, built about 1162-1180, slender piers support ribbed vaults over three aisles of nearly equal height. The vaults buttress each other, and the outer walls became sheaths around a cubical space. English architects soon adopted this form for chapels—for example, in the Cathedral of Salisbury [see 10.33] and Germans often used it, for example at St. Elizabeth's, Marburg [see 10.37]. It was very popular in secular architecture, for markets and palace halls. The light, open rectangular building did not suit the taste of Île-de-France builders, however, and not until the fourteenth century was the hall church form widely used there.

Two great works of art with the crucifixion as their theme, one in stained glass and one in champlevé enamel, remind us of the continuation of the rich artistic tradition of southwestern France and the great centers of Poitiers, Limoges, and Bordeaux. At the end of the nave of the Cathedral of Poitiers the great Crucifixion Window seems to float about the altar [see 9.1]. On a smaller scale but still essentially an art of colored glass and an adornment of the altar is the cross in champlevé enamel. The technique is called Limoges, but these enamels were produced in several workshops in

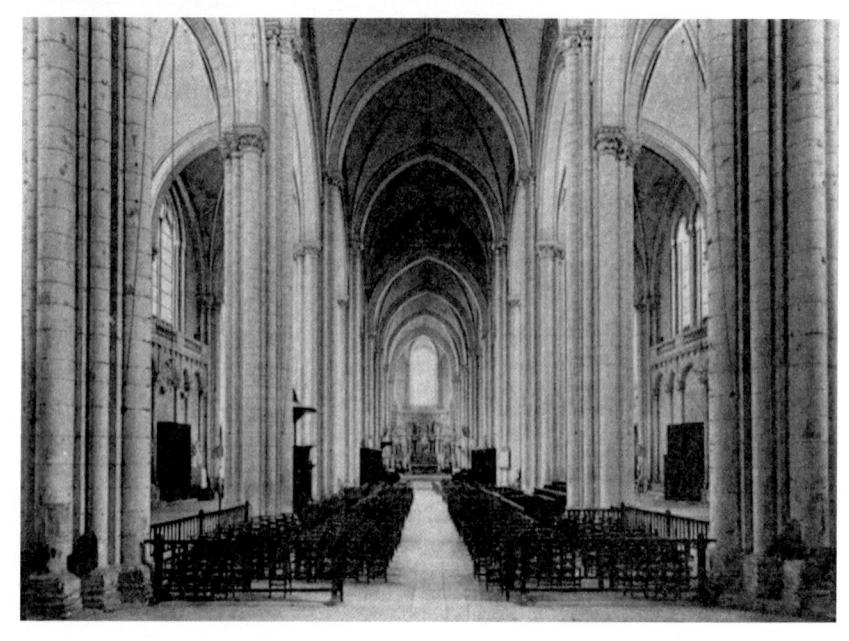

9.24 Cathedral of Poitiers, Nave. St. Pierre, begun 1162.

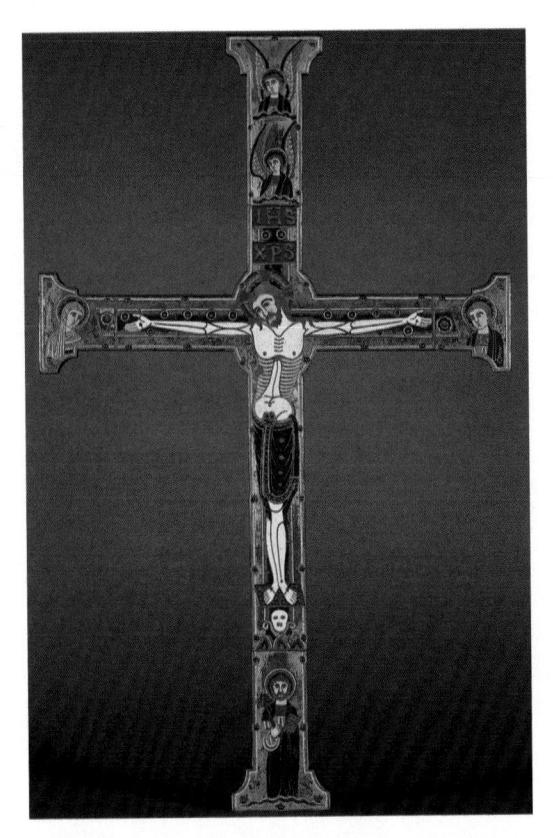

9.25 Grandmont Altar, Christ on the Cross, Limoges, c. 1189. Champlevé enamel. The Cleveland Museum of Art.

southern France and northern Spain. The cross is probably the work of the Master of the Grandmont Altar and can be dated about 1189–1190 [9.25].

The Limoges cross recalls the precious jeweled "True Cross" that was venerated in Jerusalem. The cross within the cross stands on Golgotha, literally identified as "the place of the skull" by Adam's skull resting on the ground beneath Christ's feet. Christ is stretched on the cross; however, the slight sway of his body and the droop of his head, as in Byzantine art, suggest a sacrificial rather than a triumphant figure. Of course, the cool stylization of anatomy is based on artistic convention, not observation, although the contrast of the pale pink face with the white flesh of the torso hints at the artist's awakening concern for natural appearances. The cross is a special object, and the Grandmont Master gave his work an extraordinarily delicate finish by stippling the metal walls that hold the enamel

pastes with tiny punch marks and then gilding these contour lines. As the cross is moved, the contours catch the light, and the image appears to be a golden drawing on a field of glowing color.

ENGLISH GOTHIC ART

Across the channel in England, Henry II had as dynamic, powerful, and loyal a second in command in Thomas Becket as the French kings had in Abbot Suger. When Becket became archbishop of Canterbury, however, he defended the Church against the king. His murder in the cathedral in 1170 gave England a new martyr and, in 1173, a saint. His shrine in Canterbury became the focus of a great pilgrimage, immortalized by Geoffrey Chaucer in The Canterbury Tales.

On the night of September 5, 1174, a fire destroyed the choir of the Canterbury cathedral. Gervase of Canterbury described the fire and the rebuilding of the cathedral in an invaluable firsthand account of medieval building practice. Reconstruction began almost at once under the direction of William of Sens. The architect was responsible for the overall design, and for relations with the patrons (the cathedral chapter), for the organization of the masons, for acquiring material (William imported fine building stone from Caen), and for direct supervision of the work. William salvaged the surviving crypt and some of the outer walls of the building, so this Norman structure gave the new church its curiously pinched plan and diagonally placed chapels [9.26]. The six-part vault, the molded ribs, the foliate capitals, and the three-part elevation of the new work all reflect the builders' knowledge of modern French architecture [9.27]. The passage in the thick clerestory wall, the detached colonnettes on the piers, and the increasing elaboration of the design, especially the addition of Purbeck marble shafts, whose dark brown and black color contrast dramatically with the white Caen stone, reflect English preferences and building traditions. Gervase tells us that William of Sens fell from a scaffold in 1178 and returned to France. His place was taken by William the Englishman, who finished the building of the choir and the eastern chapel in

9.26 Canterbury Cathedral, Plan, 12th–15th centuries.

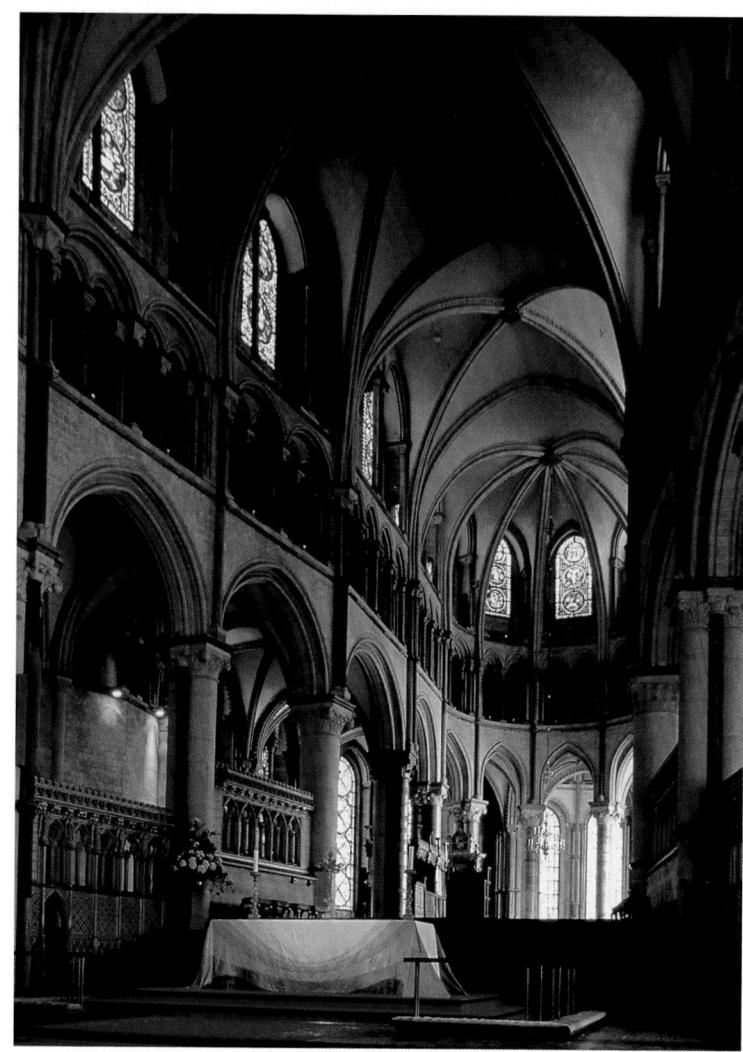

9.27 Canterbury Cathedral, choir, William of Sens, after 1174.

1184. The personal quality of Gervase's narrative provides us with some of the useful and homely detail we miss in Abbot Suger's description of building of his abbey. These two accounts could serve as an introduction to the Gothic age, but, as Gervase wrote, "All may be more clearly and pleasantly seen by the eyes than taught in writing."

Winchester, where so many great Anglo-Saxon manuscripts had been made, continued to be the site of a major scriptorium. A Bible, now known as the Winchester Bible, was created by several artists over a period of about 50 years. Their different styles have been related to such widely scattered works as murals from Sigena in Spain, mosaics in Palermo [see 6.30], and the other cloister crafts of

the second half of the twelfth century. The Winchester Bible is a veritable repertory of painting styles.

Among the most impressive artists working in Winchester was the Master of the Morgan Leaf, so called from a detached page now in the Pierpont Morgan Library in New York [9.28]. The painter depicts the story of David: David slaying Goliath, playing the harp for Saul, anointed by Samuel, and finally mourning Absalom. Well-proportioned figures enhanced by flowing form-revealing draperies act out the drama within a shallow stage-space. This interest in the representation of three-dimensional forms in a limited spatial environment suggests a renewed contact with Roman and Byzan-

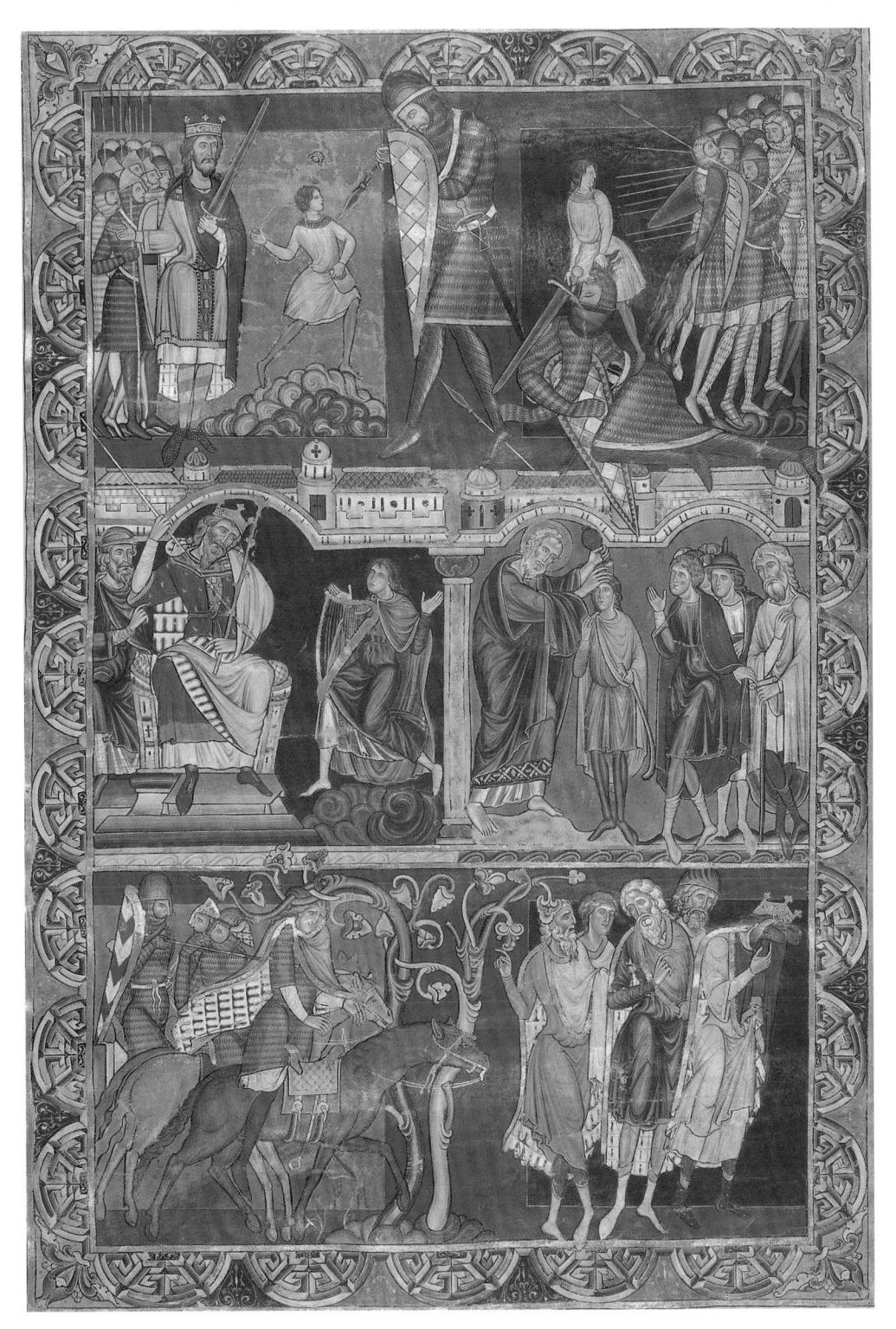

9.28 Morgan leaf, scenes from the life of David, Winchester (possibly Winchester Bible), third quarter of the 12^{th} century. 22 5/8 x 15 1/4in. (57.5 x 38.7cm). The Pierpont Morgan Library.

9.29 Flying fish of Tyre from a Bestiary, c. 1185. The Pierpont Morgan Library.

tine art, perhaps through Norman Sicily. In the second half of the twelfth century, artists began again to study aesthetic and technical problems posed by the revival and reevaluation of the humanistic tradition of the ancient world.

This budding interest in the physical world is suggested by the popularity of books known as bestiaries, which combine descriptions of both real and imaginary creatures with moralizing, theological allegories [9.29]. The flying fish of Tyre, which followed ships only until it grew tired, represented sinners who lacked the faith and stamina to take the rigorous path to salvation. In an English illustration of the monstrous fish, two sailors gesture

vigorously while the fish flies above their billowing sail. The painter uses large blocks of clear, brilliant color bounded by strong outlines to produce a balanced, decorative pattern, but he allows the wings of the fish to sweep through the frame and models the men and sail with fine repeated lines. During the last decades of the twelfth century, painters rendered observable nature—and fantasy-with ever-increasing enthusiasm and skill.

The content of the art became more and more complex, and illustrated books became important educational tools as well as luxury items. The symbols and narratives of earlier Christian art seem relatively straightforward in comparison to the complex typological programs devised by the scholars and mystics of the Church, but the intricate interrelationship of meaning so difficult to follow in philosophical argument could be made clear in art.

BOOKS FOR WOMEN

Women as well as men participated in the new learning, especially in the Rhineland convents under the direction of abbesses such as Hildegard of Bingen and Herrad of Landsberg, abbess of Hohenburg. The unique illuminated manuscripts of their writings—Scivias and Hortus deliciarum—

did not survive the wars of the nineteenth and twentieth centuries, but copies exist to remind us of the intellectual activity and patronage of women in the Middle Ages. The lost manuscripts had extraordinary illustrations to express the complex visions. Hildegard of Bingen recorded her visions, or caused them to be recorded. Today she is known for her music and letters as well as her mystical writing. She described herself as a mere spokeswoman for God—"the sound of a small trumpet." She claimed to record His messages, and she is represented with the flames of inspiration touching her head. As her secretary takes dictation, Hildegard writes and draws on wax tablets [9.30].

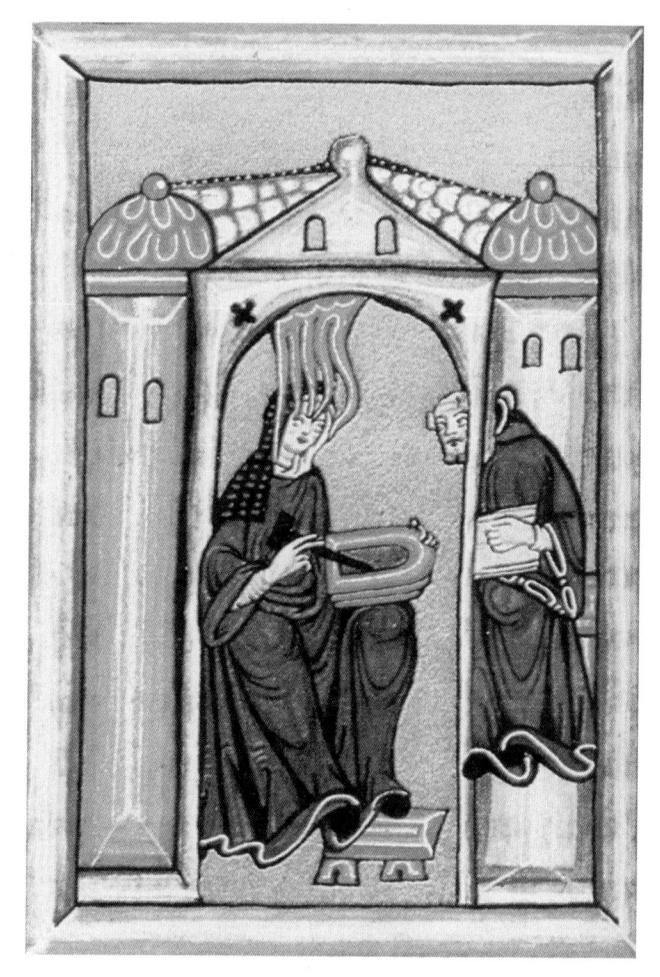

9.30 Facsimile of page with Hildegard's Vision, Liber Scivias, c. 1150-1200. Original manuscript lost during World War II.

Hundreds of tinted drawings illustrated Herrad's *Hortus deliciarum* (Garden of Pleasures). Abbess Herrad (1167–1195) composed the encyclopedia for the use of the nuns in her convent, whose names and portraits she records at the end of the book. Like St. Isidore of Seville, she attempted to write a universal history, from the Creation to the Last Judgment, into which all human knowledge would be incorporated [9.31].

A Psalter that some scholars consider the finest of all French medieval illuminated manuscripts was made in northern France for the sorely putupon wife of Philip Augustus, Ingeborg of Denmark [9.32]. The Psalter became more than a book

of Psalms at this time. With the addition of the litany of the saints and other prayers, it was the principal book used for private prayers. Divided into the eight hours of the Divine Office, the Psalter eventually became the prayer book known as the Book of Hours. In the scene of Pentecost in the Ingeborg Psalter, Mary/Ecclesia (the personification of the Church) is seated with the apostles. Beams of light and wisdom descend to their heads, and three beams touch Mary. The monumental figures with their rich drapery falling in looping folds (also known as the damp-fold style because of the way the drapery clings to the figures) create a sense of three dimensions in spite of their placement against backgrounds of flat color or gold. A generation later than the sculpture, the paintings nevertheless recall the Cathedral of Senlis.

ART OF THE "YEAR 1200"

A distinctive style, exemplified by the Ingeborg Psalter, emerged in the later years of the twelfth century. Its point of origin and center seems to have been in the valleys of the Meuse, Moselle, and Rhine Rivers, in today's northeastern France and Belgium, artistically dominated by Mosan bronze and enamel workers [see 1.1]. Examples of the style can be found from Spain to England. Artists at the end of the twelfth century developed a new interest

the twelfth century developed a new interest in natural appearances, perhaps influenced by the survival of ancient art in the region and by examples of Byzantine art, or the Byzantine style as filtered through the imagination of Ottonian artists. The organizers of an important exhibition at the Metropolitan Museum in New York called the phenomenon the "Style of the Year 1200"; others have called it "the Transitional Style" or "the Classicizing Style."

The royal residence of Senlis lies not far from the center of Mosan art. The western portal of the cathedral, dated about 1170, glorifies the Virgin Mary—her Coronation in the tympanum, prophets and precursors below in the jambs, and the Tree

9.31 Herrad of Landsberg Hortus Deliciarum after 1170. The manuscript was destroyed and this is a modern reconstruction.

The Ingeborg Psalter, Pentecost. Musée Condé, Chantilly.

of Jesse winding around the voussoirs above [9.33]. Her Dormition, with the miraculous gathering of apostles, and her Assumption, assisted by angels, fill the lintel. For the first time, Mary is represented as crowned and enthroned beside her Son, elevated above all other human beings. Once established at Senlis as an appropriate theme for monumental church portals, the Coronation of the Virgin appears often in medieval art.

The sculpture from the Cathedral of Senlis established an alternative to the Chartrain tradition in the second half of the twelfth century. The Senlis master, like the painters of the Ingeborg Psalter, created a world in which figures and objects occupy a narrow but clearly defined stage—a space that expands beyond Romanesque planar control. In the scene of the Assumption, an angel even pushes aside the wings of another in order to see. The very idea that an angel's wing was a tangible object occupying space and obscuring another angel's view is remarkable. What seems a charming detail today was a revolutionary concept in the twelfth century. This spatial consciousness continues in the typanum sculpture. Christ and Mary are seated under a swelling arcade in which round windows are filled with angels. The artist has carefully depicted the relationship of the architecture and the overlapping figures. Christ and Mary, chunky figures with normal human proportions, sit firmly on their thrones. The looping folds of their robes, modeled with metallic precision, recall the art of Mosan metalworkers. This concern with space and form continues in the sculpture at the Cathedral of Laon, where the deep portals and porches themselves establish a three-dimensional framework for the sculpture.

Nowhere is the reinforcing Byzantine style and the revitalized humanism of the ancients more apparent than in the art of goldsmiths and enamelers. In the twelfth century two important centers of enamel

work arose: one, as we have seen, centered in southwestern France and northern Spain (the Limoges type) and one in the Rhine and Meuse River valleys (the Mosan type). When Abbot Suger wanted enamel and gold fittings for his church, he turned to Mosan artists. Since the beginning of the century, they had produced the very finest bronze sculpture and enamels. Artists from the Mosan region, like the anonymous masters of Stavelot [see 1.1], had been inspired by Byzantine and Carolingian interpretations of ancient art. Nicholas of Verdun, as heir to the Mosan artistic tradition and a draftsman, sculptor, and enameler of unique achievement, seems particularly sensitive to the

9.33 Cathedral of Senlis, Dormition, Assumption, and Coronation of the Virgin, west façade, c. 1170.

more realistic, humanistic art of the earlier Christian world. His masterpiece is a pulpit made for the Benedictine Abbey of Klosterneuburg near Vienna [9.34]. According to the inscription, Nicholas made the pulpit in 1181. After a fire in 1320, the enamels were reassembled into an altarpiece.

Nicholas combined niello (engraved lines inlaid with black, blue, or red) and champlevé enamel techniques. To heighten the effect of the engraving, enameling, and gilding, he used a plain blue background. This flat ground-color, together with the reduction of setting to a few details, tended to universalize the scenes. Elaborate inscriptions and intricate ornamental frames reinforce the didactic and decorative quality of the work.

The iconography of the Klosterneuburg altar is based on typological comparisons between the life of Christ and events in the Old Testament. Scenes from the New Testament fill the middle register of the altarpiece and are framed above and below with appropriate Old Testament parallels. In the center is the Crucifixion, with the sacrifice of Isaac and the spies bringing grapes from Canaan (Numbers 13). Obedient to God, Abraham prepares to sacrifice his son, just as God sacrificed Christ. The drama of the event is expressed in the contorted figures as Abraham grips Isaac by the hair and raises his sword while Isaac lies bound hand and foot on the altar. The intercession of the angel, who grasps Abraham's upraised sword, adds to the

Nicholas of Verdun, altarpiece, 1181. Gold and enamel. Stiftsmuseum, Klosterneuburg.

immediacy of the image. Equally energetic are the triumphant spies who stride along bearing an enormous bunch of grapes, their muscles bulging and their drapery flying.

The Crucifixion as depicted by Nicholas [9.35] dramatizes the suffering of Christ and the sorrow of Mary and St. John. The entire figure conveys the heavy sense of grief through sagging postures and gestures. Mary and John seem to stand firmly on the ground, and their solid figures are rendered more massive by rippling classicizing drapery. Even Christ seems like an idealized athlete, although Nicholas followed Byzantine conventions in the stylized muscles. The emotional quality of the scene is reduced by the sumptuousness of the ornament, the intense color, and the use of gold. Nicholas has backed the cross with a diamond pattern in repeated enamel bands, the only place where he used a pattern ground. This unique device focuses attention on the central place of the Crucifixion, both in this work of art and in the Christian faith.

Nicholas of Verdun, Crucifixion (detail), 1181. Enamel; size of plaque, 5 1/2 x 4 1/2in. (14 x 11.4cm), Stiftsmuseum, Klosterneuburg.

THE SPREAD OF EARLY GOTHIC ART

Although many sculptors and architects working in the last decades of the twelfth century were inspired by St. Denis and Senlis, sculptors in many places remained conservatively tied to the Romanesque aesthetic. The portal of the Church of St. Trophime in Arles copies the iconography and composition of the central portal at Chartres. However, the Romanesque conception of sculpture as a low relief decorating a flat wall surface and the strict architectonic organization and control of all the elements remain in force [9.36]. The monuments of classical antiquity in the region also influenced the portals. The sculptors skillfully adapted such classical architectural decoration as fluted pilasters, Corinthian capitals, and acanthus relief panels. These antique forms appear beside ferocious Romanesque lions gnaw-

9.36 Church of St. Trophime, Portal, west façade, second half of the 12^{th} century, Arles.

ing people and animals. The standing figures of saints lack the sense of inner life seen in the Gothic sculpture of the north. They remain flat relief panels inserted between pilasters. Even at the end of the century, sculptors who had seen the Early Gothic innovations continued to work in the rich and beautiful but essentially conservative Provençal Romanesque style.

In contrast, in far-off Santiago de Compostela, the Portico de la Gloria of the Cathedral provides another version of the transition from the late Romanesque to the early Gothic style [9.37]. Linked to St. Denis in iconography and Senlis in its humanism, this magnificent narthex was constructed by Master Matthew, who inscribed his name and the date 1188 on the lintel. The document in which the king commissioned the work in 1168 also survives. Master Matthew's vision of the Apocalypse, combined with a Last Judgment as it was at St. Denis, included apostles and prophets in the door jambs, angels trumpeting from the vaults, and the 24 elders playing harps and viols. On the trumeau, above a representation of the Tree of Jesse and a capital with sculpture of the Trinity, St. James sits on a lion throne holding his pilgrim's staff. The adjustment of the seated figure to the pier is but one example of Master Matthew's acute observation and technical skill. In the apostles, prophets, and angels, he even captured fleeting smiles and spontaneous gestures. Yet he and others of his shop used ornament with Romanesque profusion: folded and crinkled hems, engraved borders imitating jeweled embroideries, and corkscrew curls. Master Matthew, more than many artists of his generation, blended accurate observation with decorative abstraction. The musical instruments of the 24 elders, for example, are represented with such fidelity that they have been successfully reproduced and played by modern students of medieval music.

Master Matthew was only one of many masters who began to adopt elements of Gothic technique, style, and sensibility. Benedetto Antelami in Parma as early as 1178, the date of his Deposition relief,

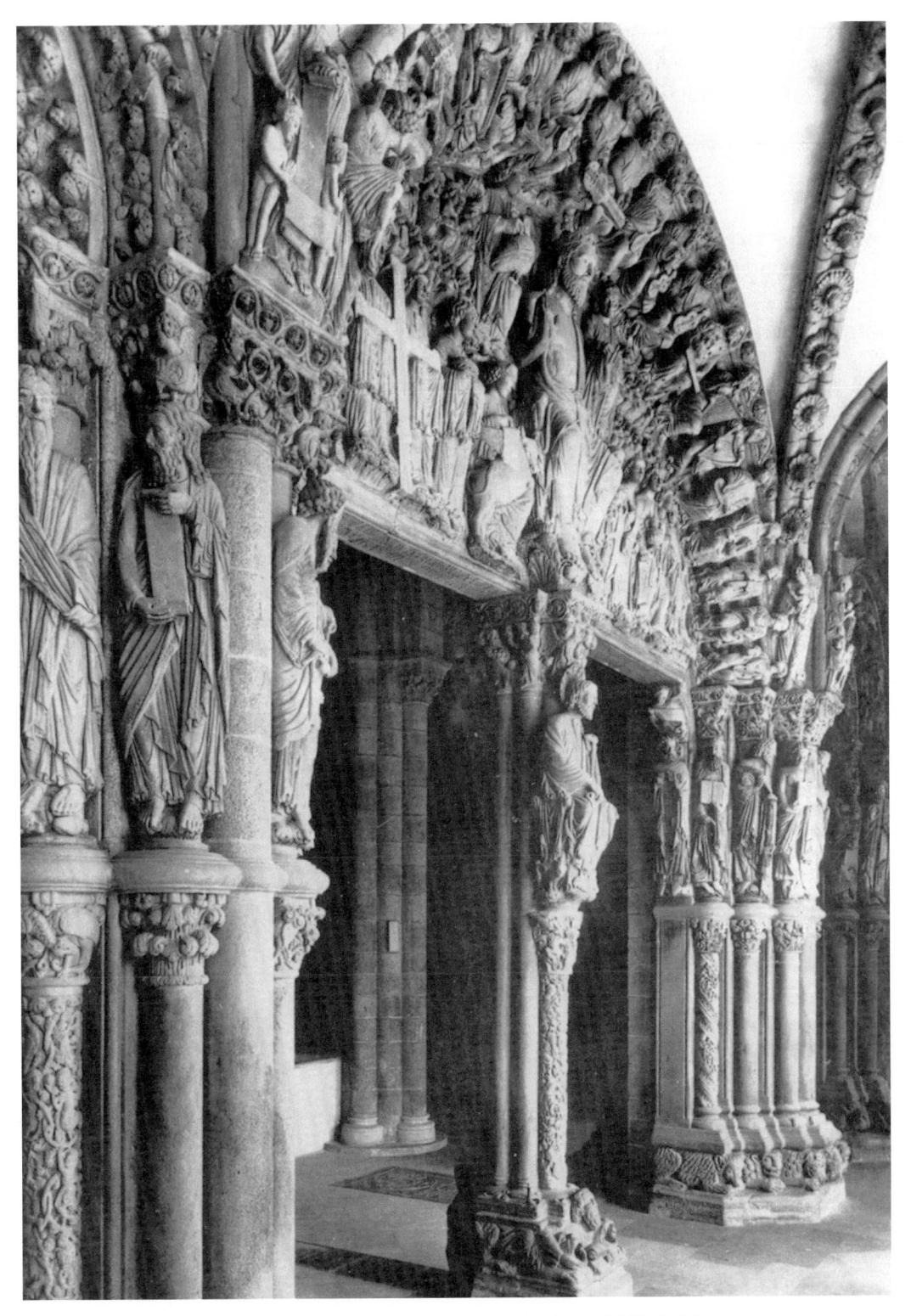

9.37 Cathedral of Santiago de Compostela, Portico de la Gloria, c. 1168–1188.

and after 1196 in the Parma baptistery, and the masters of Bamberg Cathedral in Germany introduced the new Gothic humanism into the local milieu.

During the twelfth century, artists began to think of the human figure as an independent and majestic form worthy of representation in art. They could justify their art because man had been given the outer appearance adopted by God while on earth. The Father and Son, and even the ranks of angels, had to be represented in human form. However, the human figure continued to be treated in a religious or educational context and not as beautiful in itself. Here a distinction can be drawn between Western and Byzantine art. Whereas

in Byzantium images of Christ and the saints became icons to be venerated, in the West figures usually had a didactic role. Whereas Romanesque artists had merely borrowed figure conventions and compositions, early Gothic artists assimilated the Byzantine lessons and then looked at the world afresh when they had to create actors in the sacred drama. Both Romanesque art and Gothic art still make a powerful impact on the mind and the emotions of the viewer. However, the final impression created by Romanesque art is one of naked power, that of the Early Gothic of humanized force. The Romanesque artist seemed to expect the Apocalypse; Gothic artists hoped for salvation and the joys and splendor of Paradise.

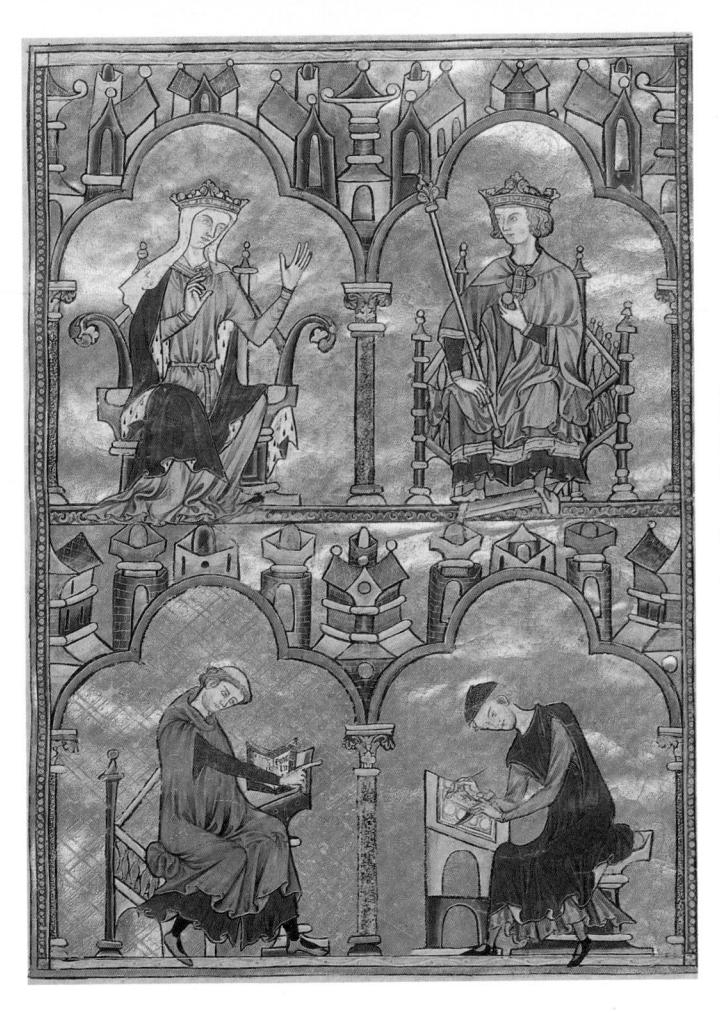

Page with Louis IX and Queen Blanche of Castile, Moralized Bible, Paris. 1226–1234. Ink, tempera, and gold leaf on vellum, 15 x 10 1/2in. (38 x 26.6cm). The Pierpont Morgan Library.

MATURE GOTHIC ART

In the Moralized Bible, the Queen Mother, Blanche of Castile, and her son, St. Louis, preside over the scriptorium where a scholar and illuminator work on a manuscript [10.1]. "And even as the scribe that hath made his book illumineth it with gold and blue, so did the said King illumine his realm with the fair abbeys," wrote John, Lord of Joinville, about St. Louis as a patron of the arts (Book 2, ch. CXLVI). The reign of King Louis IX of France (1226–1270) coincided with the mature phase of the Gothic style in France. Louis IX owed the peace and resources that enabled him to patronize the arts to the skillful politics of his grandfather, King Philip Augustus. The wars between Philip Augustus and King John of

England ended in 1204 with Philip's victory. Ten years later a French-Hohenstaufen coalition defeated the English-Welf alliance at the battle of Bouvines, assuring French political, economic, and cultural independence. During the thirteenth century the French kings (and queens, like Blanche of Castile, who ruled as regent from 1226 to 1234) established a strong centralized government with a staff of civil servants dependent on royal favor. From their court in Paris the rulers defended their realm with professional mercenary troops hired with the income they received from their towns.

The kings granted privileges to old towns and founded new ones, and this new city wealth made them independent of nobles and feudal armies.

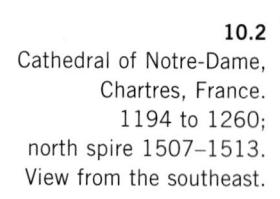

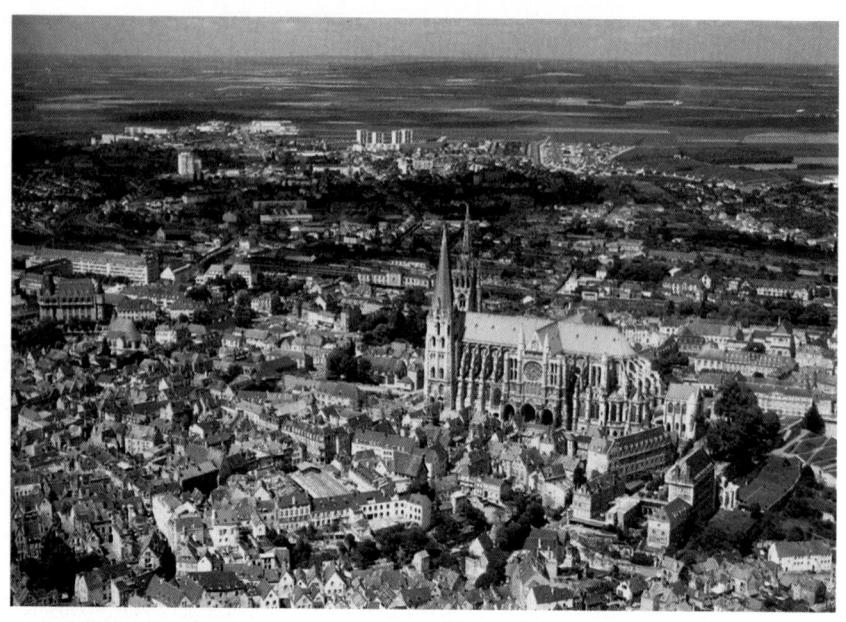

Meanwhile, townspeople had a stake in the success of monarchs because they needed the peace, which a strong central government could ensure, in order to operate their business ventures successfully [10.2]. With the growth of commerce and industry, artisans and merchants organized guilds to control the production and prices of goods and to ensure that their members maintained high standards of quality. They kept careful watch on the education and welfare of members. Women, too, became guild members when, as widows, they carried on the family's business. Guild members had their confraternities and their patron saints, whose chapels they maintained, but this growing urban middle class needed more spiritual guidance and help than the parishes and rural monastic communities provided. New religious orders, the Franciscan and Dominican friars (from the Latin frater, brother), worked in the cities, caring for those in need. The friars had a special interest in education, first of all to combat heresy, and some friars also became outstanding scholars and teachers. Many taught at the University of Paris, which was founded in 1200 and officially recognized in 1215.

The Crusades to take Jerusalem and other Christian holy sites from the Muslims had begun at the end of the eleventh century and continued throughout the thirteenth century. The later cru-

saders often had unacknowledged economic as well as religious goals. During the Fourth Crusade at the beginning of the century, Venetian merchants and French knights turned the campaign into raids against Christian cities, and in 1204 they sacked and looted Constantinople itself. They installed one of their number as emperor and ruled the sadly reduced Byzantine Empire until they were driven out by a new Byzantine dynasty in 1261. King Louis of France led a crusade in 1244-1254, and he died while crusading in 1270. (The Church recognized his efforts and piety by making him a saint in 1297.)

The association of western European crusaders with the Byzantine and Muslim East had a profound impact on Europe. Scholars gained access to Muslim science: astronomy, astrology, mathematics (including Arabic numerals and the concept of zero), and the rudiments of biology and medicine. They also learned about such practical devices as chimneys, clocks, and windmills. With travel, knowledge of geography improved and so did mapmaking and navigation. Trade fairs became clearing houses for imported as well as native products as markets and a money economy expanded. New products appeared in Europe: rice, lemons, melons, apricots, sugar, sesame, cloves, incense and sandalwood, cotton and damask, carpets, and jewels.

THE CATHEDRAL OF CHARTRES

Of first importance to the builders and patrons of Gothic art was the quality of the stained-glass windows and the colored light they created [10.3]. Today, when buildings have lost most of their medieval glass and are without the color that once infused the space, the churches may seem emotionally cold and austere in a way never intended by their creators.

Fortunately Chartres is an exception, and here the full effect of color in an interior can still be appreciated. Not only are the walls rich, luminous sheaths but the space itself is animated by beams of colored light slanting through the air. The beams shift and move, and the quality of light and color changes depending on the time of day and the movement of clouds across the sun. Thus nature—sunlight and weather—unite with artistry to create an awe-inspiring work of art.

In the Cathedral of Chartres, superb twelfthcentury glass survives in the west façade windows [see 9.10 and 9.11]. Between 1215 and 1240, most of the other windows were glazed, and the entire program was finished for the consecration of the building in 1260. The simple lancets in the aisles and chapels, which were low enough to be easily seen, had complex narratives from Christian history. Many small scenes were arranged in geometric panels, whose frames of iron formed a black pattern across the rich colors of the glass. These vivid windows emerge as glowing panels in the dark mass of the wall. In the choir, the guild of furriers donated a window with scenes from the story of Charlemagne, who had been the original Western owner of the Virgin's tunic, Chartres's most important relic [10.4]. The exploits of Charlemagne and his knights are depicted in an elaborate interlocking composition. The artists demonstrate a remarkable skill in adjusting the narrative to the armature of the window. The Christian hero Roland charges against the Moorish champion, whose lance breaks in the violence of combat. Color clarifies and emphasizes the scene—the red of Roland's tunic and the glittering yellow of his helmet against the blue ground are picked up again in the red disc of the Moor's shield. Above in a circular medallion, Roland finally blows his horn to summon help from Charlemagne's army. Fluid brush strokes in enamel on the colored glass render the essential details of the armor, drapery, and horses' heads.

The high clerestory windows have single figures of saints, prophets, and apostles. There the designers have used larger figures, simple drawing, and brilliant color so that the images can be seen at a distance. In the north transept, lancets and a huge rose window (over 42 feet (12.8m) in diameter) are filled with deep-blue and ruby-red glass and emblazoned with the heraldic golden lilies of France and the castles of Queen Blanche of Castile, who may have been the royal patron [10.5]. In the heart of

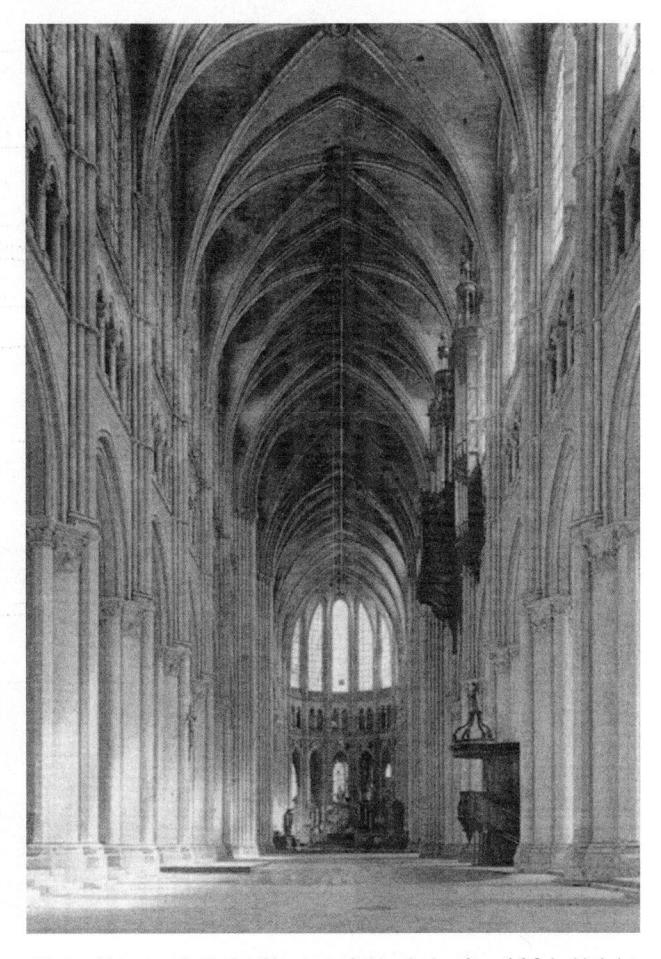

10.3 Nave and choir, Chartres Cathedral, after 1194. Height of vault approximately 122ft. (37.2m).

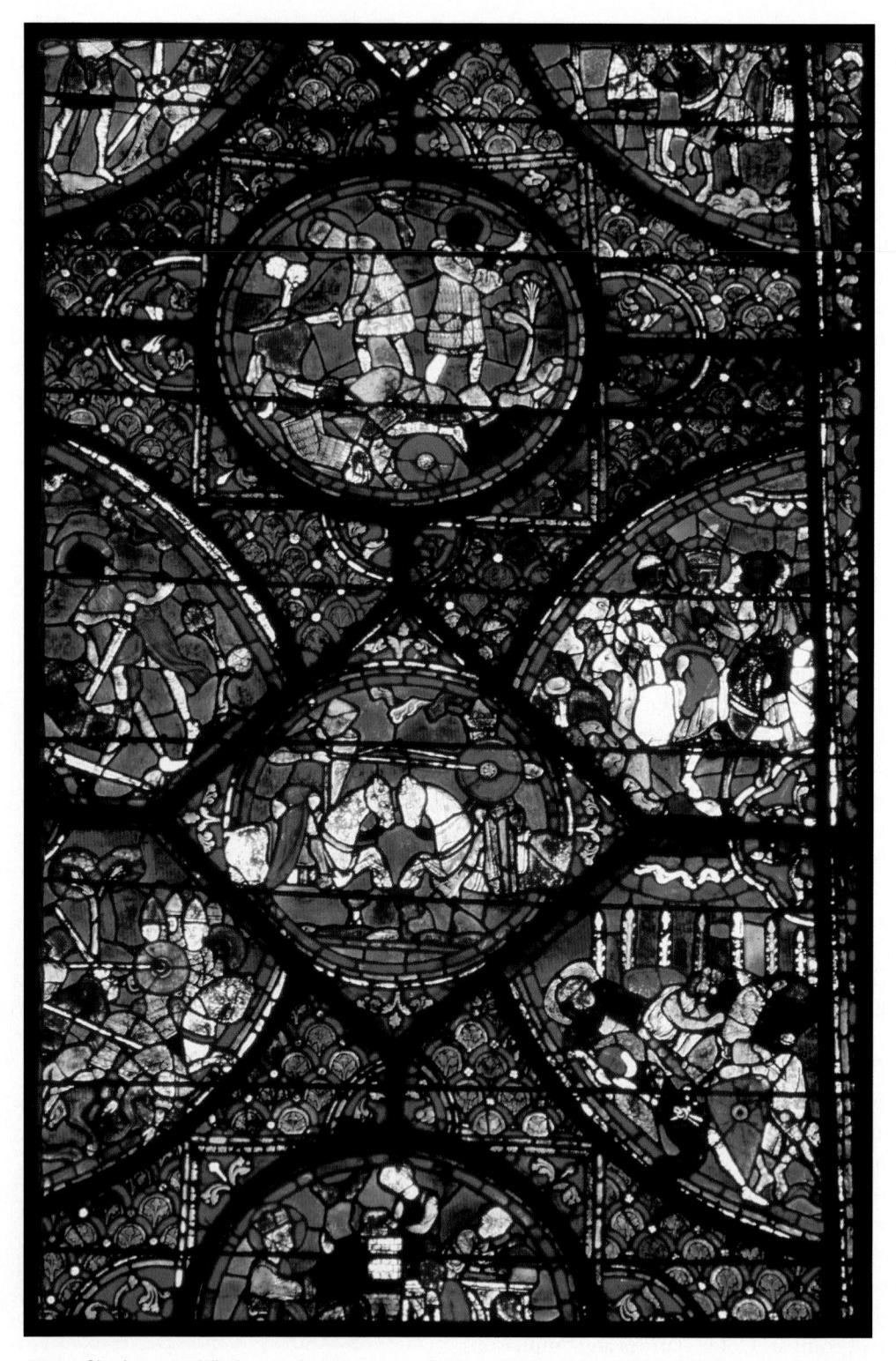

10.4 Charlemagne Window, ambulatory apse, Chartres Cathedral, c. 1210–1236. Stained glass.

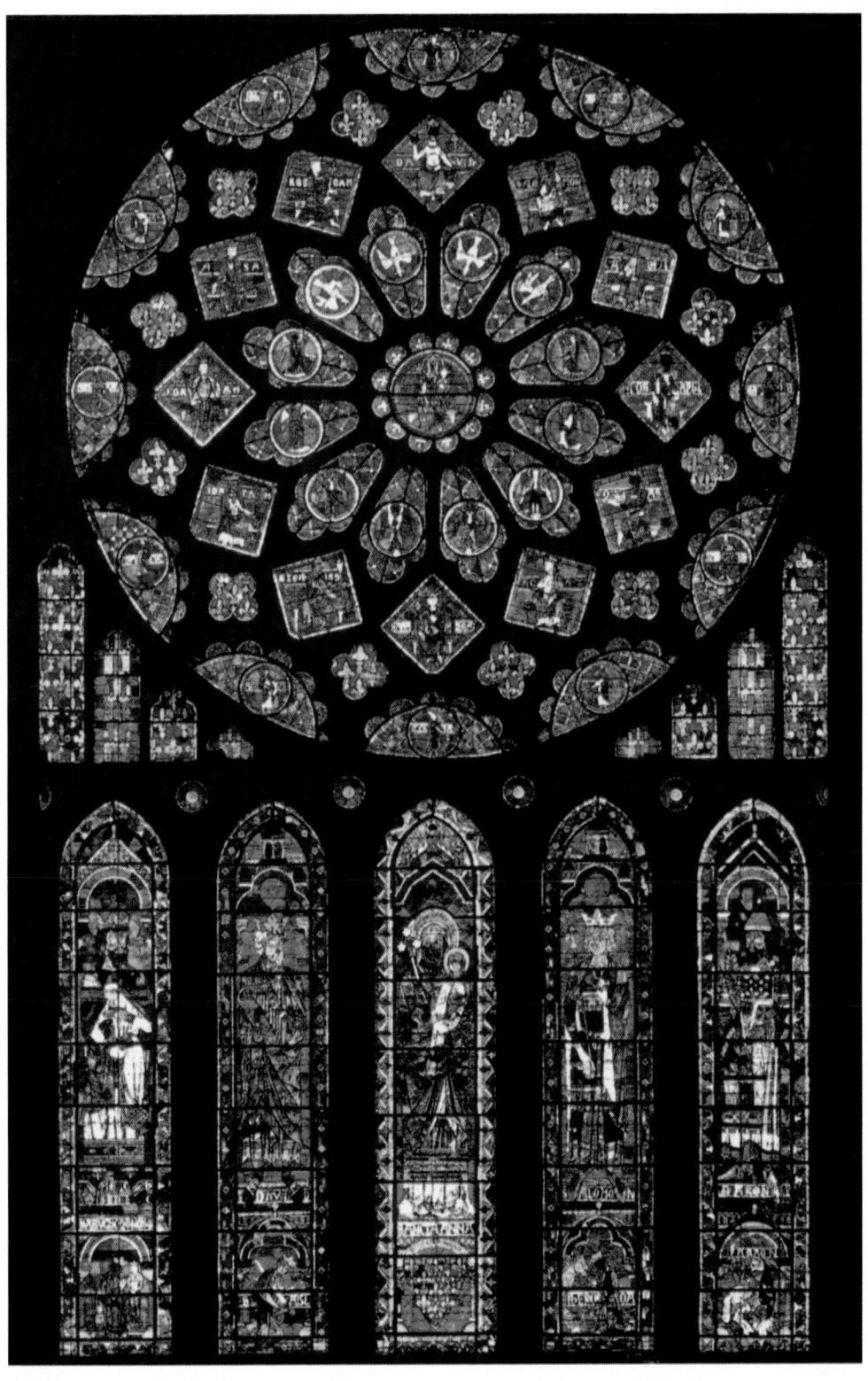

10.5 Chartres cathedral, north transept, interior rose window and lancets, c. 1220.

the rose, the Virgin and Child are surrounded by four doves (the Gospels) and eight angels. Old Testament kings and prophets, the ancestors of Christ, sit in the circle of lozenges, and around the rim of the rose, medallions bearing prophets float in a redand-blue diapered (checkered) ground. St. Anne holds the infant Mary in the center lancet above the royal coat of arms.

Artists and patrons gave St. Anne a place of honor in the iconographical program of the north transept because the Count of Blois had presented the precious relic of her skull, acquired in Byzantium, to the cathedral when he returned from the Fourth Crusade in 1204. Both the portal sculpture and the stained-glass windows glorify St. Anne. In the lancets, St. Anne and Mary are flanked by Old Testament figures: Melchizedek, David, Solomon, and Aaron. Melchizedek and Aaron prefigure the priesthood of Christ, and David and Solomon are his royal ancestors. Melchizedek and Solomon triumph over the idolatry of Nebuchadnezzar and Jeroboam, represented in panels below their feet, while David stands above the suicide of Saul, and Aaron (Moses' brother) watches the destruction of Pharaoh in the Red Sea. Outside on the triple entrance into the north transept, St. Anne has the position of honor on the trumeau of the central portal [see 10.18]. Scenes from the life of Mary fill the lintel and tympanum, and Old Testament kings and prophets stand in the jambs.

THE ARCHITECTURE OF CATHEDRALS

At the beginning of the thirteenth century, builders, sculptors, and painters achieved a synthesis of form and meaning that seems to summarize the aspirations of Western Christendom. Earlier artists had experimented with structural and decorative features—ribbed vaults supported by a variety of wall and buttress systems, complex interior elevations with galleries and clerestories, regularized iconographical and compositional programs in sculpture and stained glass. Now thirteenth-century masters resolved the technical and aesthetic problems posed by their twelfth-century predecessors, and in so doing they created a style characterized by

order, harmony, and balance. The builders of the thirteenth-century Gothic cathedrals expressed Western Christian ideals just as seven centuries earlier the architects Anthemius and Isidorus and the Emperor Justinian had made the Church of Hagia Sophia a visible symbol of Byzantine culture and belief.

The Chartres Cathedral [10.6] still stands in a small city surrounded by rich agricultural landland that provided the wealth that made building possible at the beginning of the thirteenth century [see 10.2]. The structure became a model for builders throughout northern France: Its design was challenged at Bourges and both emulated and perfected in the Cathedrals of Reims and Amiens. Built on the foundations of the church destroyed by fire June 10, 1194, in a remarkably short time this new cathedral rose on the site behind the surviving Royal Portal. The massive western towers of the old church had protected the precious twelfthcentury sculpture and stained glass. The new nave may have been finished about 1210 and the east end (apse, ambulatory, and radiating chapels composing the chevet) by 1220, when the first dedication took place [10.7]. The clergy tried to convince the nobles and the townspeople to pour their resources into the rebuilding campaign, but they were not always successful.

The master builders of Chartres Cathedral simplified, clarified, and regularized elements introduced in the twelfth century [10.8a]. They combined the long nave, aisled transept, and multiple towers of Laon Cathedral with the compact double ambulatory and radiating chapels of St. Denis and Paris. In the elevation, they adopted the three-part scheme of Sens [see 9.9] in preference to the fourpart elevations of Paris and Laon [see 9.18]. Alternating cylindrical and polygonal compound piers articulated by contrasting shafts divide the nave into vertical bays. Ribbed, four-part vaults cover both the rectangular bays in the nave vault and the square aisle bays. Pointed arches permit the keystones of transverse and diagonal ribs to be set at the same height in order to produce the level vault and continuous space leading to the sanctuary. In contrast to this horizontal forward movement, the verticality

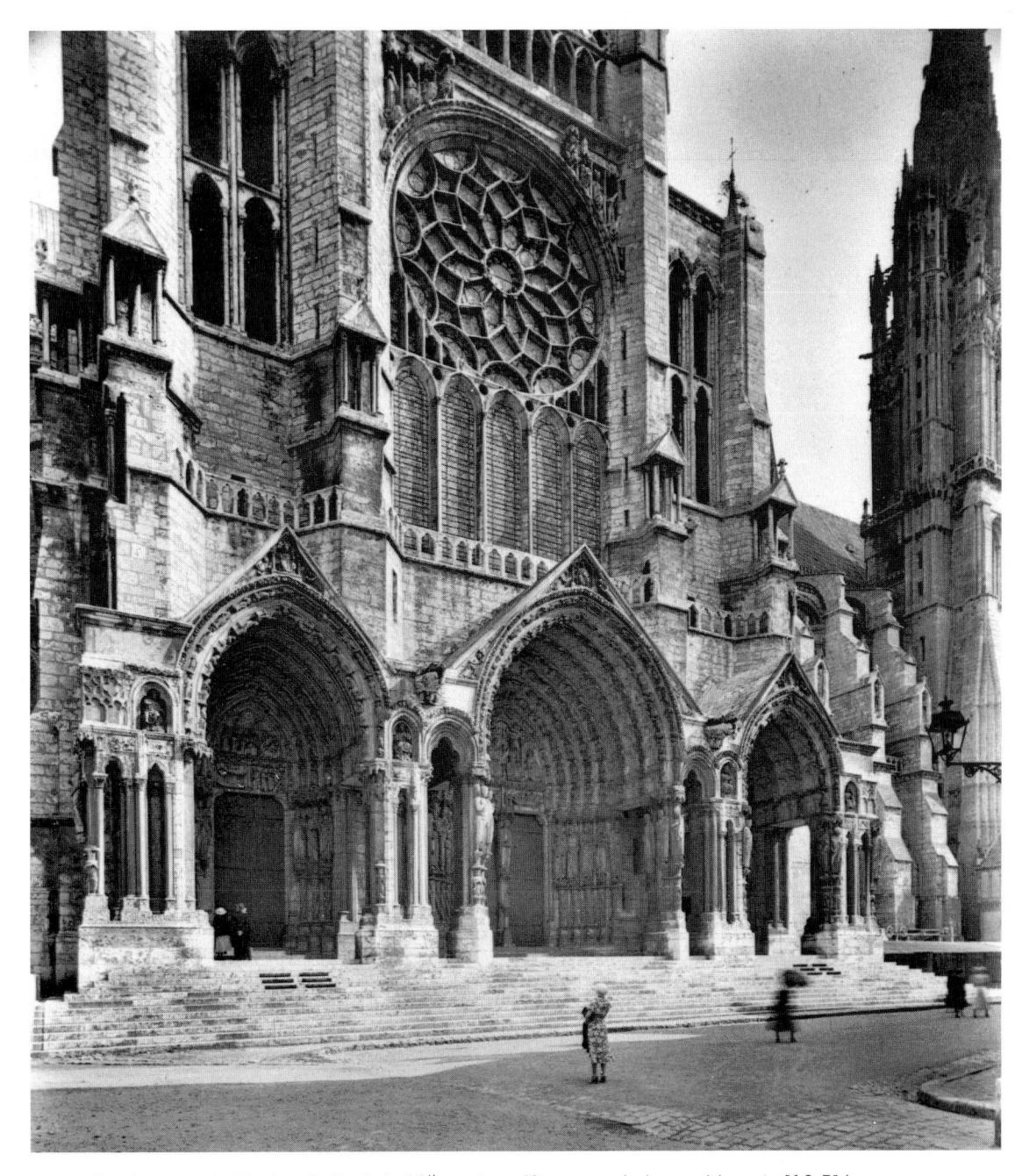

North transept, Chartres Cathedral, 13th century. (See rose window and lancets [10.5].)

of the tall arcade and clerestory and the linear thrust of compound piers and clustered wall shafts of diminishing diameter carry the eye into the high ribbed vault [10.9a]. Structurally the piers, vaulting ribs, and the exterior flying buttresses form an independent architectural skeleton. Unlike earlier build-

ings, the wall is not a series of discrete units but a continuous, subdivided, arched frame for stained glass. By balancing a nave arcade and a clerestory of equal height divided by an arcaded triforium passage, the designer created an impression of balance and harmony in the interior.

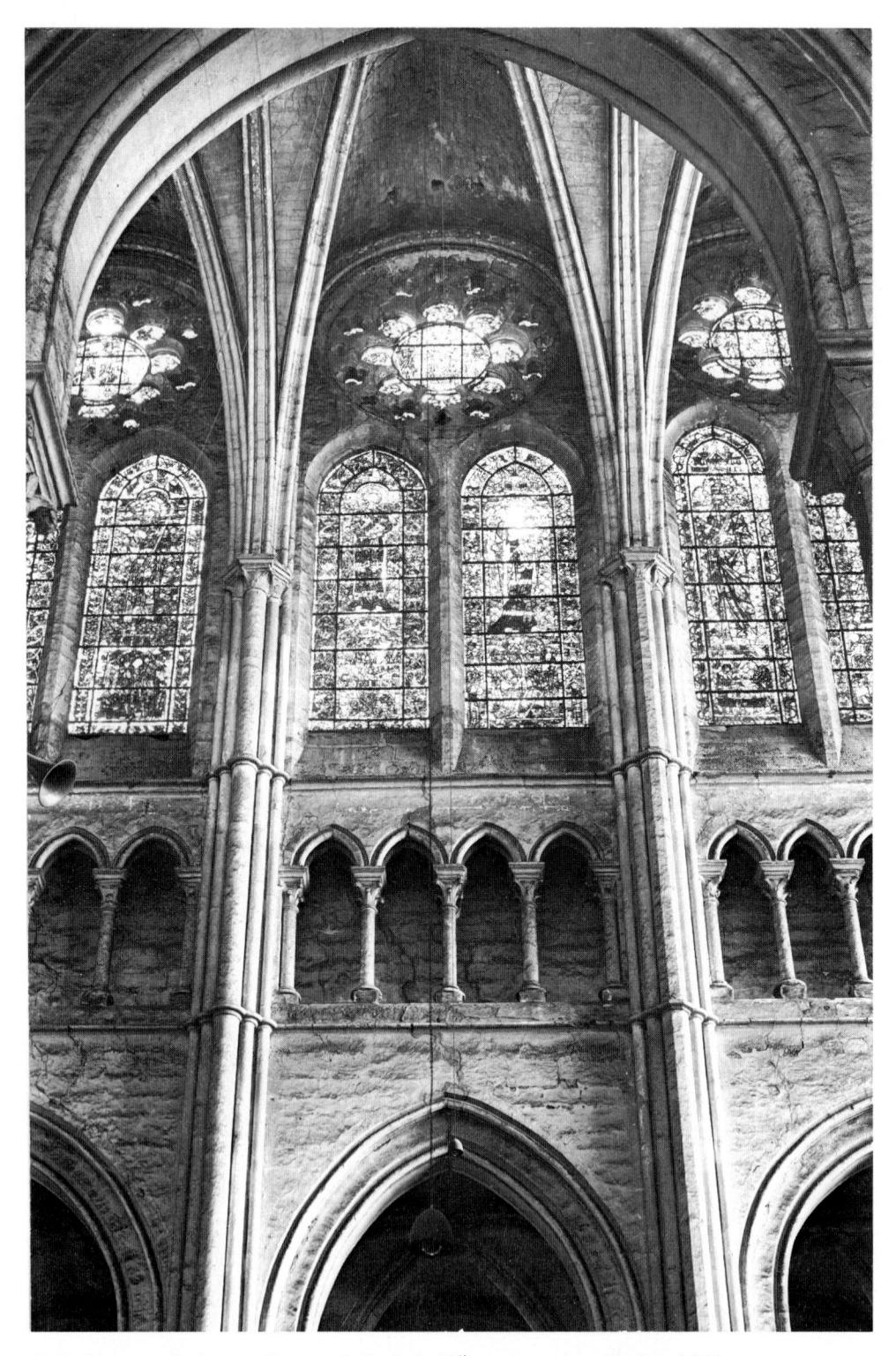

10.7 Upper wall of nave, Chartres Cathedral, 13th century, glazed before 1260.

The upper wall reads as a plane, not as masonry mass [10.7]. In each bay, two lancets and a rose pierce the wall to form clerestory windows 45 feet (13.7m) tall. Inside, the wall holds sheets of glowing color; outside, it is shimmering gray. Flying buttresses make this enlargement of the windows possible. Double arches joined by arcades of round arches on short columns divide the double struts that carry the weight of the vault over the aisle roofs to buttresses so massive that even today one senses the architect's determination to build for the ages.

In the choir the architect subtly modified the elevation. The triforium continues around the hemicycle with paired arches, while in the clerestory, a single lancet window fills each bay [see 10.3]. In the high vault, ribs radiate out from a central keystone, and their lines are continued in lower trapezoidal ambulatory bays and polygonal chapels. Double flying buttresses support the hemicycle and carry the thrust of the vault to massive buttresses set wall-like between the chapels. St. Denis's continuous ring of chapels with stained-glass walls must have inspired the builders of Chartres; however, at Chartres, the builders had to incorporate the foundations of the original crypt, with its three strongly projecting chapels into the plan. They used three different designs for the seven chapels of the chevet. Three strongly projecting and separately vaulted chapels over the earlier foundations (the second, fourth, and sixth chapels) alternate with shallow chapels vaulted together with the outer ambulatory bays, as at St. Denis. The third and fifth copy St. Denis's double lights and vaulting system exactly, but in the first and sixth the Chartres Master increased the number of windows from two to three so that a window stands on the axis of the chapel, enhanc-

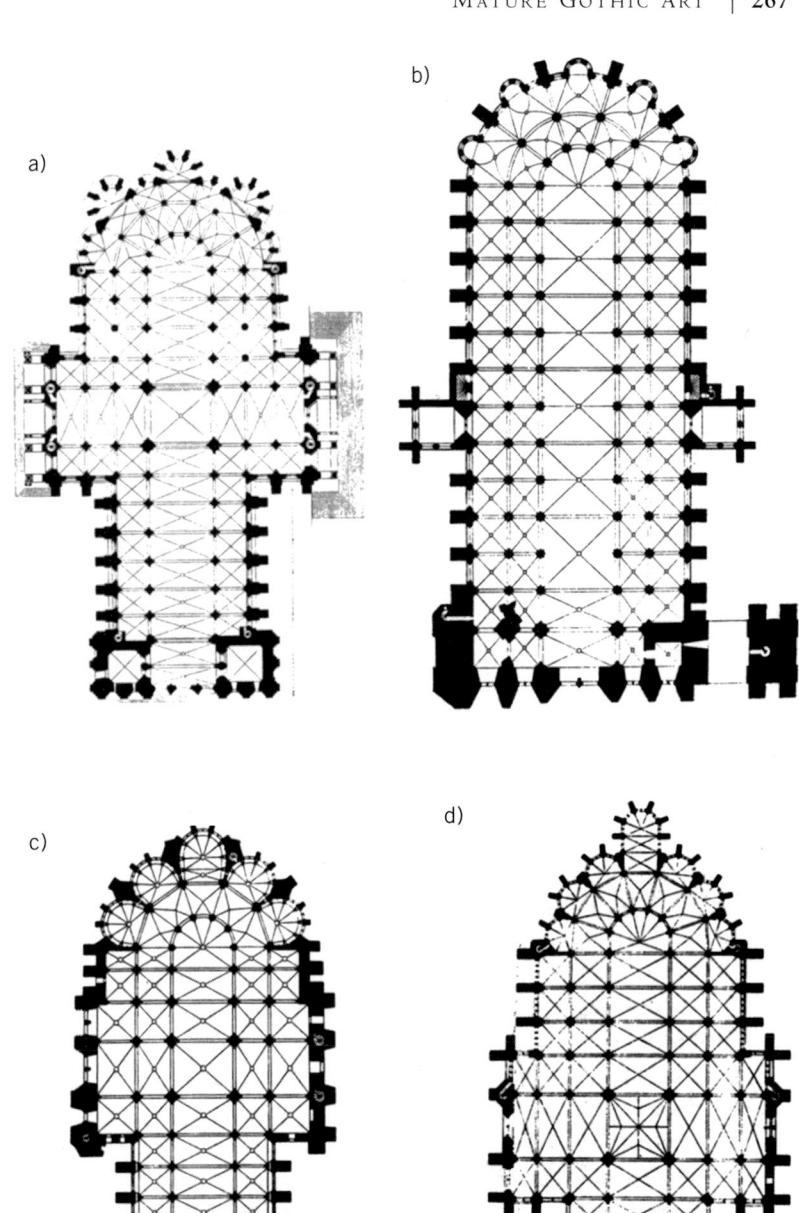

- a) Plan, Chartres Cathedral, begun 1194.
- b) Plan, Bourges Cathedral, begun 1195.
- c) Plan, Reims Cathedral, begun 1211.
- d) Plan, Amiens Cathedral, begun 1218.

Cathedrals of Chartres (a), Reims (b), and Amiens (c). Comparative nave elevations.

a) Chartres

b) Reims

c) Amiens

ing the effectiveness of the stained glass. The ring of chapels formed an aureole of colored light around the high altar.

10.9

Contemporary with the Chartres Cathedral but inspired by different models, a cathedral dedicated to St. Étienne (Stephen) was built between 1195 and c. 1225 in Bourges, 140 miles south of Paris [10.10]. Here the architect created a building whose spatial complexity and lateral extension established an alternative to Chartrain architecture. The compact plan with double aisles and ambulatory, and six-part vaults over double bays [see 10.8b], has been compared to Notre-Dame, Paris [see 9.19 and 9.20]; however, the builders emphasized space and light rather than mass, and line rather than surface. At the Cathedral of Bourges, in spite of the divisive effect of the six-part vault, the eye moves rapidly down a nave and choir uninterrupted by a transept. Contrarily, attention may be distracted laterally into the double aisles. Relatively light piers in the nave arcade articulate the space, their slender verticality enhanced by eight thin column shafts. The triforium and clerestory, squeezed between this tall arcade and the vault,

have bays subdivided into narrow units—the triforium into six arches under a relieving arch and the clerestory into triplet windows. So high are the flanking aisles (59 feet (18m)) that they, too, have triforia and clerestories. The arcades open into yet lower side aisles lit by lancet windows. Thus three ranges of windows, alternating with two triforia, form bands of stained glass and shallow arcading. As they seem to rise and approach each other, they create diagonal sight lines contradicting the primary focus on the sanctuary. This remarkable outward expansion of the interior space contrasts with the balanced verticality of Chartres. The Bourges design inspired builders in such far-flung places as Tours and Le Mans in France and Burgos and Toledo in Spain.

Chartres, instead of Bourges, provided a model for the architects and patrons in Reims and Amiens, cathedral cities, north and east of Paris. A Roman and then a Merovingian stronghold, Reims was the site of the baptism of the Frankish king Clovis in 496. Reims came to be identified with the monarchy as the coronation church as well as the seat of the archbishop. The archbishop claimed

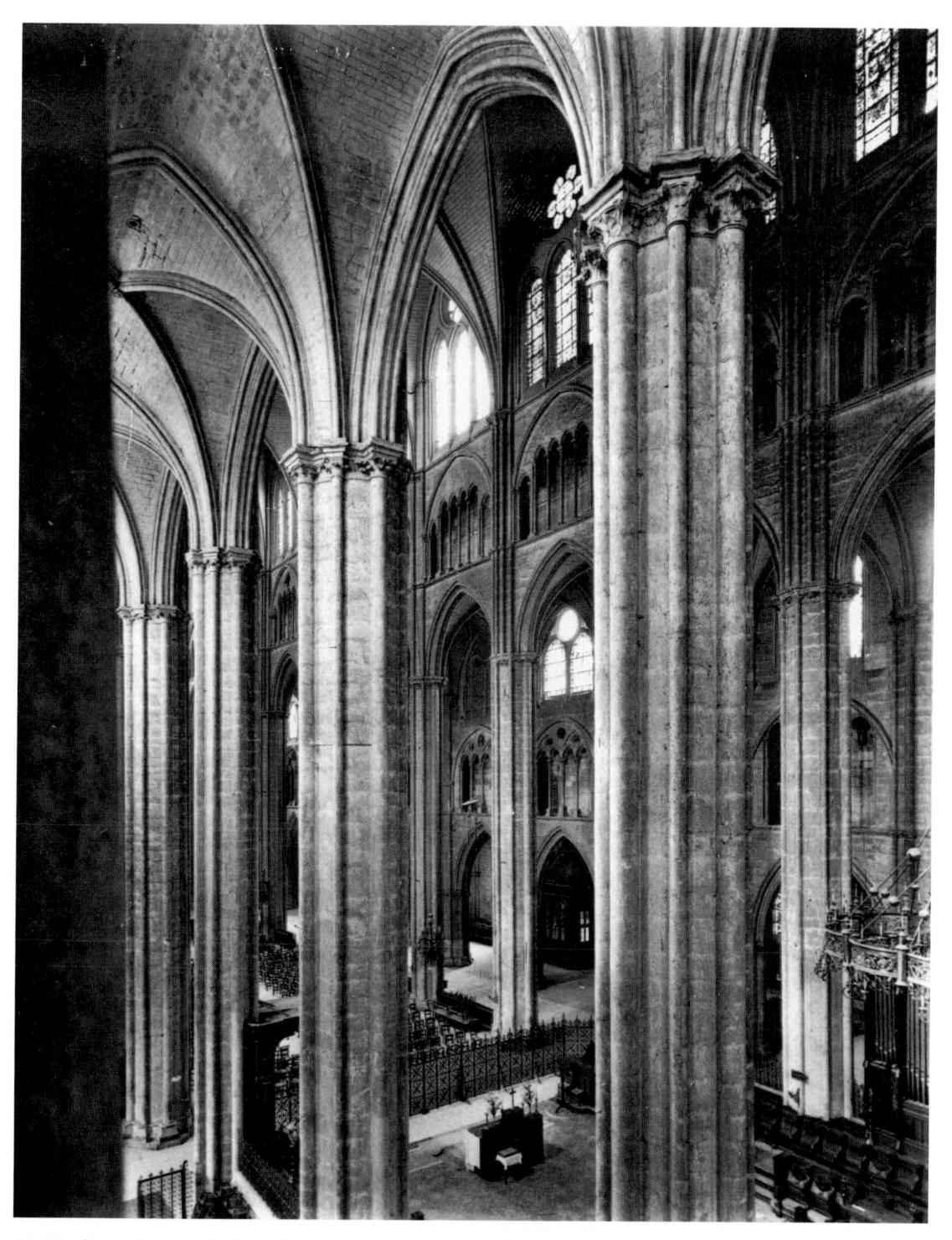

10.10 Nave, Bourges Cathedral, from south choir aisle triforium, begun 1195.

precedence although both the abbot of St. Denis (where the crown and other regalia were kept) and the archbishop of Sens also challenged Reims's primacy. Many buildings had stood on the site of Reims Cathedral: Roman baths, then a fourth-century Roman palace, a baptistry, Archbishop Ebbo's Carolingian cathedral with its westwork and transepts, and finally Archbishop Samson's midtwelfth-century addition of a two-tower western façade and a new sanctuary. After a fire destroyed the city in 1210, masons, probably led by the architect Jean d'Orbais, laid the first stones of the building we see today [10.11].

Work on the cathedral continued for over a hundred years, from 1211 until it was left unfinished in the fourteenth century. At times the church officials and the citizens did not enjoy good relations, and money for building became scarce. Nevertheless in the course of the thirteenth century, five architects directed the work. A labyrinth laid in the pavement of the nave (destroyed in 1776) recorded four of their names and some cryptic comments about their tenure and accomplishments. (Architectural historians do not agree on the interpretation of the inscriptions.) The most likely sequence of builders and their work follows: Jean d'Orbais established the plan and elevation and oversaw work on the choir between 1211 and 1220 [10.9b]. He was followed by Jean le Loup, who was master for 16 years, according to the labyrinth's inscription. Jean must have overseen the construction of the transepts. Then Gaucher de Reims became master for eight years, during which time the chevet, transepts, and three bays of the nave were finished. Gaucher may have also begun the west façade. Bernard de Soissons, master for 35 years from 1254 to 1289, built the western bays of the nave and the west façade. The rose window was finished in 1287.

Construction had proceeded rapidly at first, but the oppression by the archbishops as they collected money for the building led to urban uprisings in the 1230s. Archbishop Henri de Braine (1227–1240) was particularly ruthless. Fighting broke out, and for a few years the canons even had to abandon their residence on the north side of the cathedral. In 1241 the canons were reinstalled in

the liturgical choir located in the eastern bays of the nave. The chronology of work on the west façade and especially the sculpture of its portals has been vigorously debated. Some sculpture was being carved in the 1230s; work was in progress in the 1250s and 1260s and continued as late as 1285, when the cathedral prepared for the coronation of King Philip on January 6, 1286. Stained glass in the western rose and gallery dates from the end of the thirteenth and beginning of the fourteenth century. Robert de Coucy, who was not included in the commemorative labyrinth but who worked at Reims from 1290 until his death in 1311, finished the façade and roofed the building with lead but never completed the proposed towers and spires. The towers as we see them today were built in the fifteenth century.

The masters of Reims altered the Chartrain scheme by lengthening the nave, shortening the transept, and improving the geometric regularity of the choir by turning the ambulatory and radiating chapels into regular wedge-shaped sections [10.8c]. This compact yet spacious plan at the east end of the building gives the effect of a centralized structure attached to the nave. It becomes a martyrium for the first bishops [10.12 and 10.13]. The rippling pattern of windows and radiating flying buttresses enhances the circular movement of the ambulatory and chapels. Even the sculptured angels in the buttresses ringing the choir seem appropriate to a martyrium church.

The builders of Reims Cathedral achieved for the Western Roman Catholic Church a solution to the Christian architectural dilemma—that is, they combined the central plan and vertical movement of the martyrium (the tomb of Christ and the martyrs) with the horizontal axis of the basilican hall in a single building and so satisfied both liturgical and congregational requirements of the church [10.13]. The worshippers' gaze might rise upward into vaults, or to the heights of towers outside, but their attention was also directed forward to the sanctuary. The builders maintained the dramatic focus on the altar found in the Early Christian basilica and added a light-filled rotunda surrounded by a ring of subsidiary chapels to create a
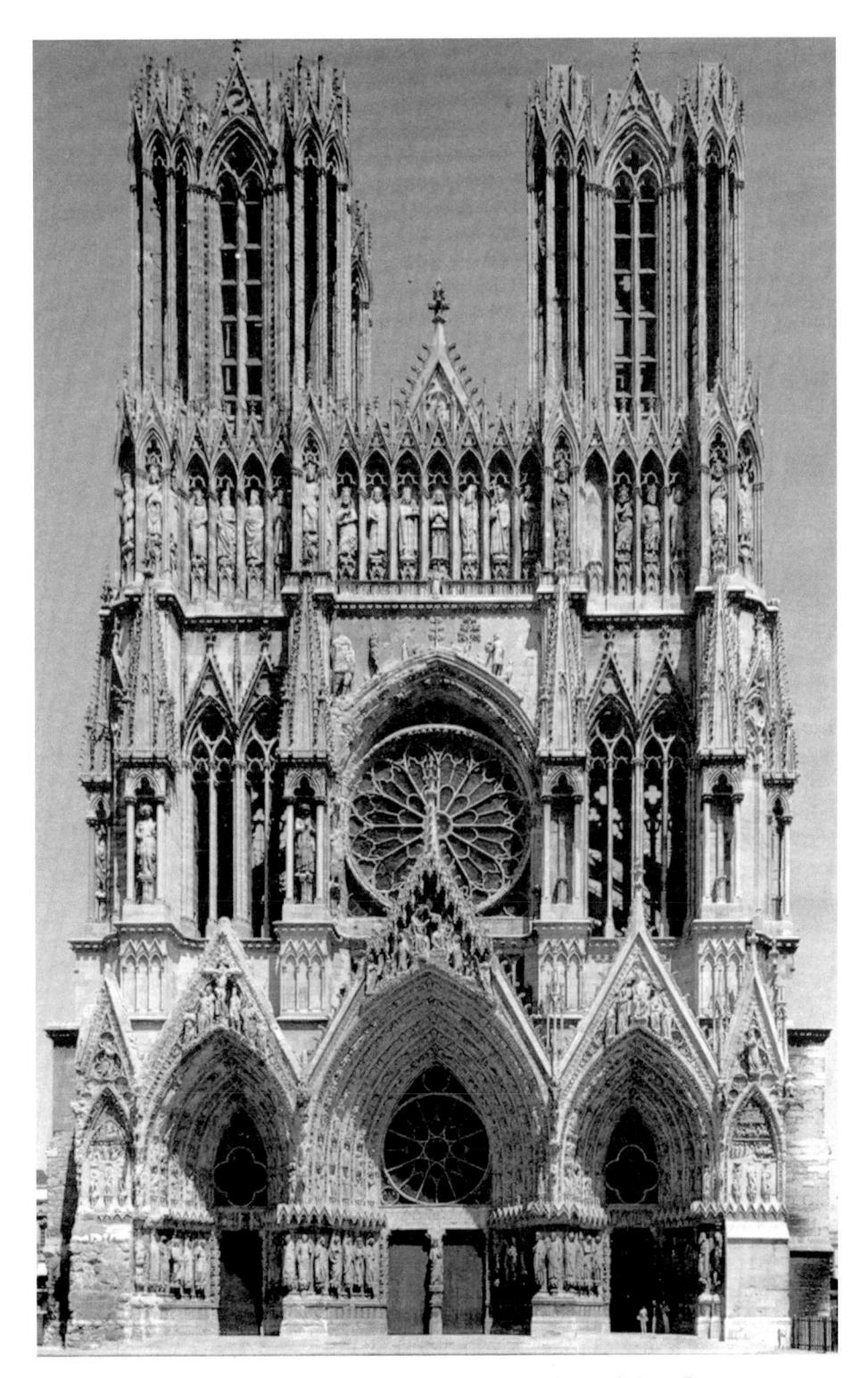

10.11 Reims Cathedral, west façade, Cathedral of Notre-Dame, Reims, France. Rebuilding begun c. 1211 after fire in 1210; façade 1230s to level of rose by 1260; towers left unfinished in 1311; additional work 1406-1428.

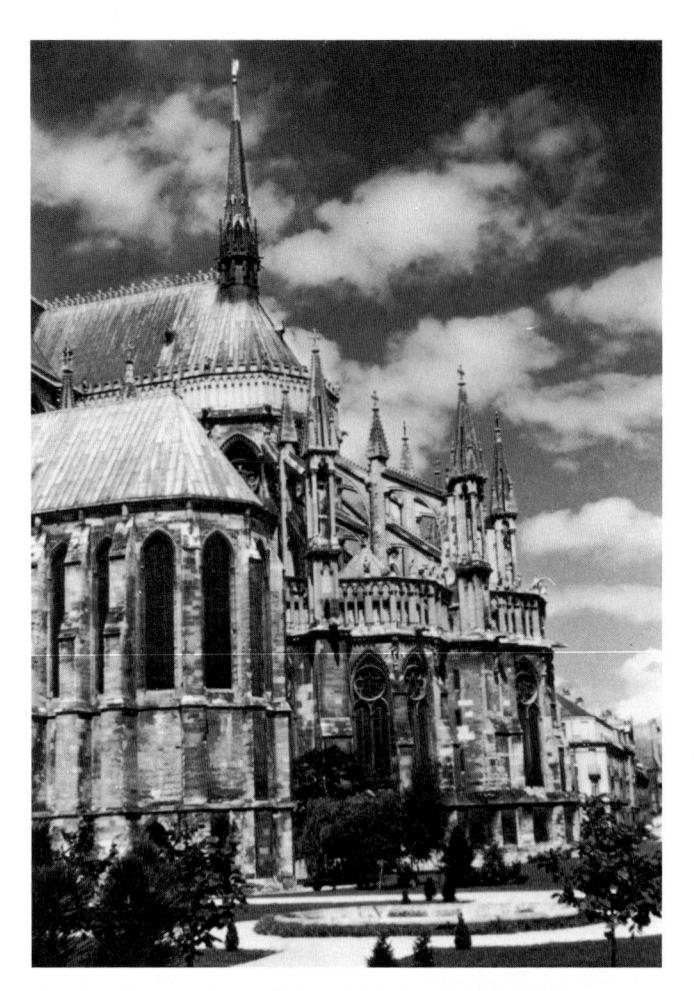

10.12 Chevet exterior, Reims Cathedral, 1211–1260.

sanctuary that had connotations of the Dome of Heaven. Not content with the Byzantine glitter of reflected light from gold mosaics, the Western artists turned the entire church interior into colored light by replacing masonry walls with colored glass. The Virgin Mary with Jesus and the Crucified Christ, as well as all the archbishops, look down from the choir windows on the celebrations at the high altar below.

The logic and clarity inherent in Gothic architecture become even more apparent in the nave at Reims. The ideal of soaring height is achieved through actual height (125 feet (38.1m) to the crown of the vault), through proportion (Reims's 2.8 to 1 as compared to Chartres's 2.2 to 1), and through an emphasis on the vertical lines of pro-

jecting wall shafts and sharply pointed arches [10.9a,b,c]. Identical compound piers at Reims replace the cylindrical and polygonal piers of the Chartres arcade [10.14]. Capitals, which are doubled on all four attached column shafts, wrap the piers with broad bands of foliage. The capitals interrupt the upward surge of the compound piers and wall shafts, their bands of foliage creating a horizontal element in the nave elevation. Meanwhile the triforium loses its horizontal continuity. for it lies behind the projecting wall shafts. Furthermore, the slight thickening of the central column in the triforium arcade suggests a relationship with the double lancets of the clerestory above and even hints at the merger of these two elements.

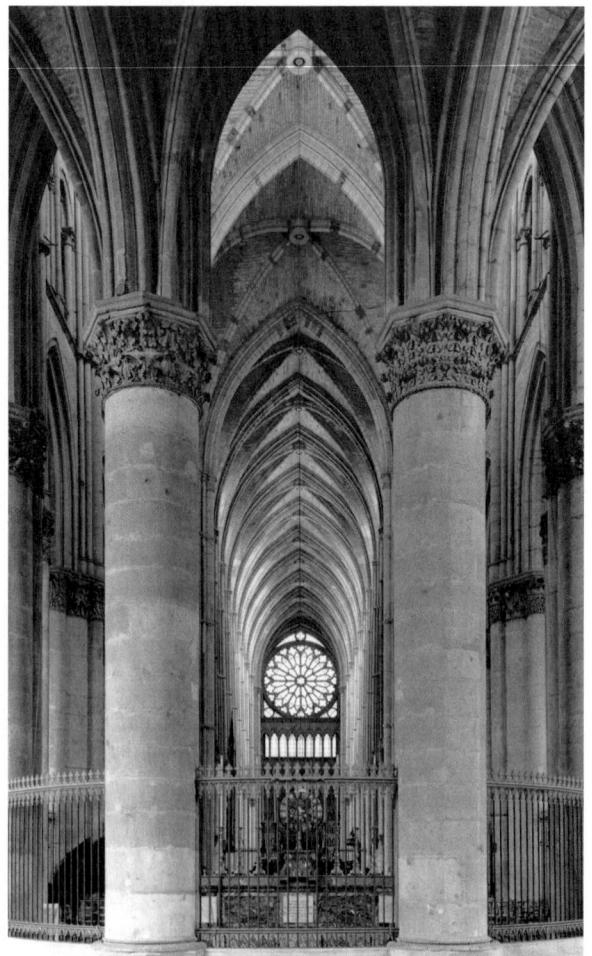

10.13 Interior, choir looking west, Reims Cathedral. Height of nave vault 125ft. (38.1m).

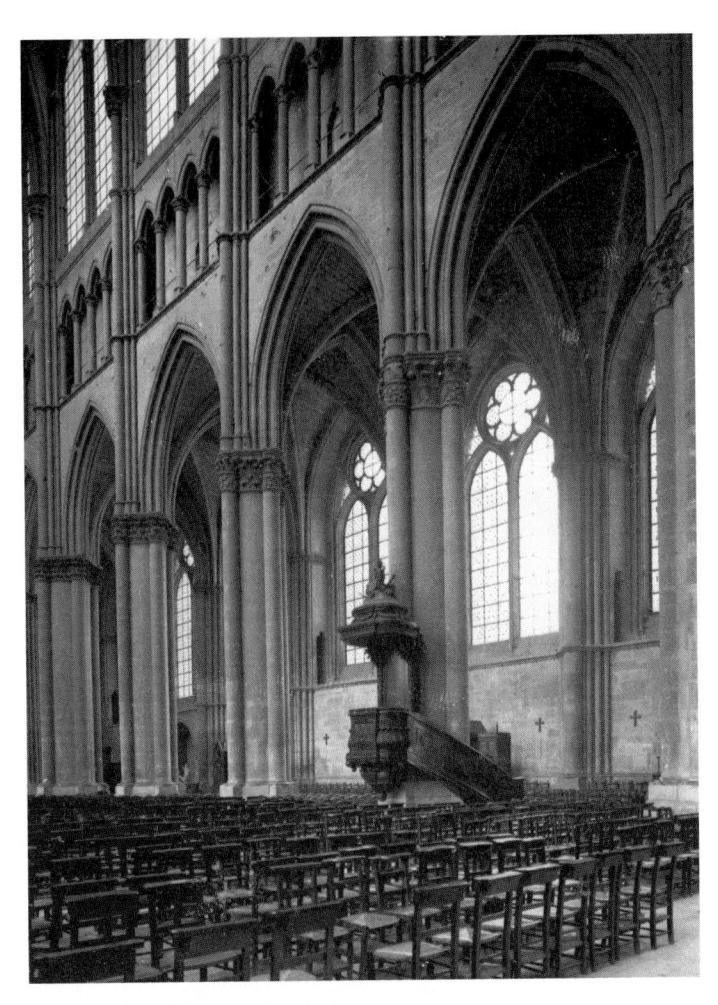

Nave, Reims Cathedral. 10.14

In the clerestory and aisles, the Reims masters revolutionized window design with the invention of bar tracery. Earlier windows simply pierced the walls in a technique known as plate tracery, but at Reims the builders enlarged the open area, divided it with tracery, and filled it with glass. In each bay of the aisle and clerestory, mullions rise into pointed arches to form a pair of lancets supporting a rose. The repeated design links the upper and lower stories of the building since the aisle windows can be seen through the arches of the nave arcade, and these bands of colored light seem to be both joined and divided by a dark triforium. The invention of bar tracery and the expansion of the fields of glass at the Cathedral of Reims had a profound impact on the glazers' art.

The masons' increasingly skillful use of flying buttresses made the enlarged windows possible. Profiting from generations of experience, they calculated thrusts and loads and stabilized the vaults and roofs with slender struts and arches attached to massive, tower-like buttresses (see Chapter 9, Box: Flying Buttresses). At Reims every buttress terminates in a pinnacle-weighted tabernacle housing a sculptured angel. Had the full complement of seven towers and spires been completed, the cathedral would have seemed to soar into the clouds, the House of the Lord guarded by flights of angels.

The architects of the Cathedral of Amiens-Robert de Luzarches and Thomas de Cormont—refined the solutions reached by builders at Chartres and Reims [10.16]. The city of Amiens in the thirteenth century was a rich textile manufacturing and trading center. A Romanesque cathedral and a church dedicated to St. Firmin, the first bishop of Amiens, stood on the site of the present cathedral. The cathedral burned in 1218; and Bishop Evrard de Fouilloy, the cathedral chapter, and the wealthy townspeople seized the opportunity to rebuild their cathedral on a scale they deemed appropri-

ate to the importance of their city. Recent studies of the building show that the masons may have begun building at the east end of the nave and worked in both directions—down the nave, first in the north aisle and then the south, and eastward to the transept and choir [see 10.8d]. The crossing is located near the center of the building (with five choir bays and seven nave bays). A few other events provide guidance for the building's chronology; for example, bells were hung in the south transept in 1243. Robert was working on the west façade between 1220 and 1236, and work was finished by 1247. For a time, money was scarce, but building began again under Thomas de Cormont in the 1250s. After an outburst of civil unrest in 1258, in which people tried to burn down the cathedral,

The Seven-Spire Church

The nineteenth-century French architect and conservationist Viollet-le-Duc was also an excellent draftsman. He detailed his conception of the completed Gothic church, with its seven towers, in an elegant and persuasive drawing. The architect's intention for the complete cathedral is difficult to imagine today, even while we admire the rich sculpture of the deep porches and contrast the pure lines of the soaring Gothic towers. The Cathedral of Chartres is one of the few with a thirteenth-century spire (on the southwest tower). The northwest spire is a delicate web of flamboyant tracery, built in the sixteenth century. Patrons and masons planned seven towers for Laon and as many as nine towers for Chartres: a pair for each façade—west, north, and south—another pair at the beginning of the choir and a great tower over the crossing; consequently, nine spires should have pierced the heavens above the church of the Virgin. These spires, and the ingenious plan of the chevet with its circular and rising forms, create a Gothic equivalent of the symbolic Dome of Heaven encountered in Early Christian and Byzantine art.

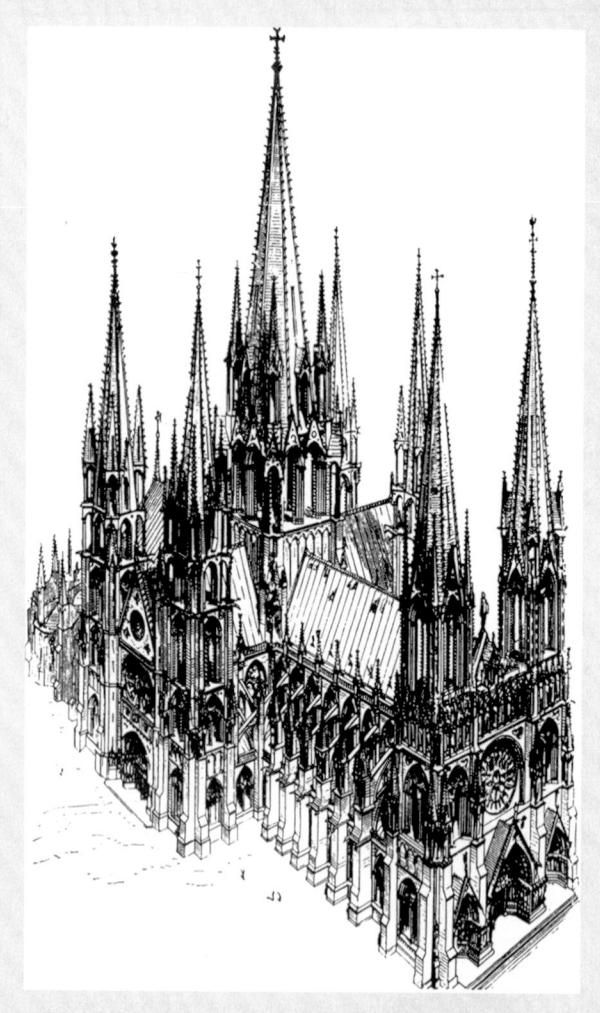

10.15 E. Viollet-le-duc, Seven Spire Church. The Ideal Cathedral, E. Viollet-le-Duc, Dictionnaire raisonné de l'architecture française du XI au XVI siècle, vol. II, Paris, 1859.

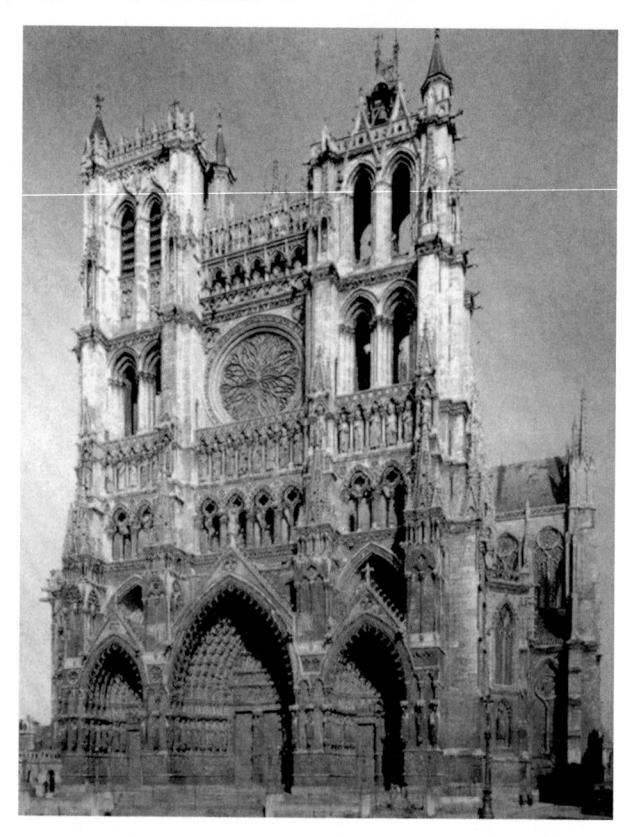

10.16 Amiens Cathedral, west façade, c. 1220-1236. Work continued through the 15th century.

Thomas's son Regnault de Cormont was able to build the upper stories of the choir, finishing about 1269. Regnault worked in the elegant, luminous Rayonnant style preferred by Parisian court circles (see 10.45). At the end of the century and in the fourteenth century, chapels were added between

the buttresses of the nave, and the belfry towers of the façade were built. The rose window tracery dates from 1500, and the arcade between the towers is a nineteenth-century addition.

The Amiens builders' passion for height and light should have been satisfied [10.17]. The Amiens nave is higher than that of Reims (144 feet (43.9m) in comparison with Reims's 125 feet (38.1m)), but the width remains about the same (about 48 feet (14.6m)) [see 10.9]. These proportions, as well as the increased vertical subdivision of the elevation and the steeply pointed arches of the vault, give an appearance of height that matches the real space. Furthermore, the extraordinary 60-foot-high (18.3m) nave arcade and aisles dwarf the spectator.

The addition of chapels between the outer wall buttresses in the fourteenth century changed this effect. Today the impression of lateral extension in the nave approaches that of Bourges. Uniform compound piers line the nave, and, as in Chartres, the shafts that support the transverse arches run the full height of the elevation. Stringcourses link the shafts and the wall, but the primary shafts are uninterrupted by capitals. With exquisite logic, the elements in the shaft bundle increase in number and diminish in size at each stage—that is, above the major capital, two shafts lead to the diagonal ribs of the vault; at the triforium level and running through the clerestory two additional shafts lead to the lateral wall arches.

"Creation by division" characterizes the design of the triforium and clerestory. The triforium arcade is composed of two large arches enclosing triple arcades and trefoils; in the clerestory, pairs of lancets and roses are subdivided into identical repeating motifs. The mullions of the clerestory extend down to form wall shafts in the triforium, uniting the upper two registers into a single unit and dividing each bay into narrow segments. One horizontal element intrudes into this essentially vertical composition. At the base of the triforium, a continuous band of idealized curling foliage completely encircles the main vessel of the church. This decorative molding emphasizes the horizontal continuity of the triforium and provides an enrichment comparable to the capitals at Reims. The sculptors

introduce the world of nature into the logic and precision of the architecture with foliage carving.

In the choir at Amiens, the Cormonts introduced a new architectural mode, one that developed into the light, elegant Rayonnant style. By placing windows in the triforium, they eliminated the last horizontal band of darkness in the elevation. The choir suggests a two-story building: a spacious ambulatory leading to chapels as the first level with a united triforium and clerestory above. The sanctuary becomes a luminous space captured by delicate vertical lines and the open spiky forms of tracery that now spreads over the walls as well as the windows.

ARCHITECTURAL SCULPTURE

Just as architecture served as a frame and support for stained-glass windows whose effect is appreciated inside the building, so too the masonry provided the underlying structure and material for sculpture outside. The sculptures at Chartres, Amiens, Reims, and elsewhere demonstrate the all-encompassing nature of the iconographical program devised by the churchmen. Only scholars could have devised a vision of the world that included all medieval knowledge. As the French scholar Émile Mâle wrote nearly a hundred years ago, the sculpture of a cathedral resembles an encyclopedia in stone, the Speculum of Vincent of Beauvais.

At the Chartres Cathedral, where the west façade already illustrated history as it was then known from the Incarnation to the Apocalypse, the north and south transept portals seemed to expand and comment on the earlier program. The north transept portal sculpture—like the stainedglass windows above—displayed the precursors of Christ and the Life of the Virgin, in short, the Old Testament world before Christ's ministry [see 10.6]. The triple portal culminates in the coronation of the Virgin. St. Anne supports the scenes in the tympanum as the trumeau, and the Old Testament ancestors of Christ stand in the door jambs. St. Anne's sweeping, almost metallic drapery encompasses both her elongated rounded form and the functional architectural post, the trumeau [10.18]. A twist of drapery at St. Anne's feet stabi-

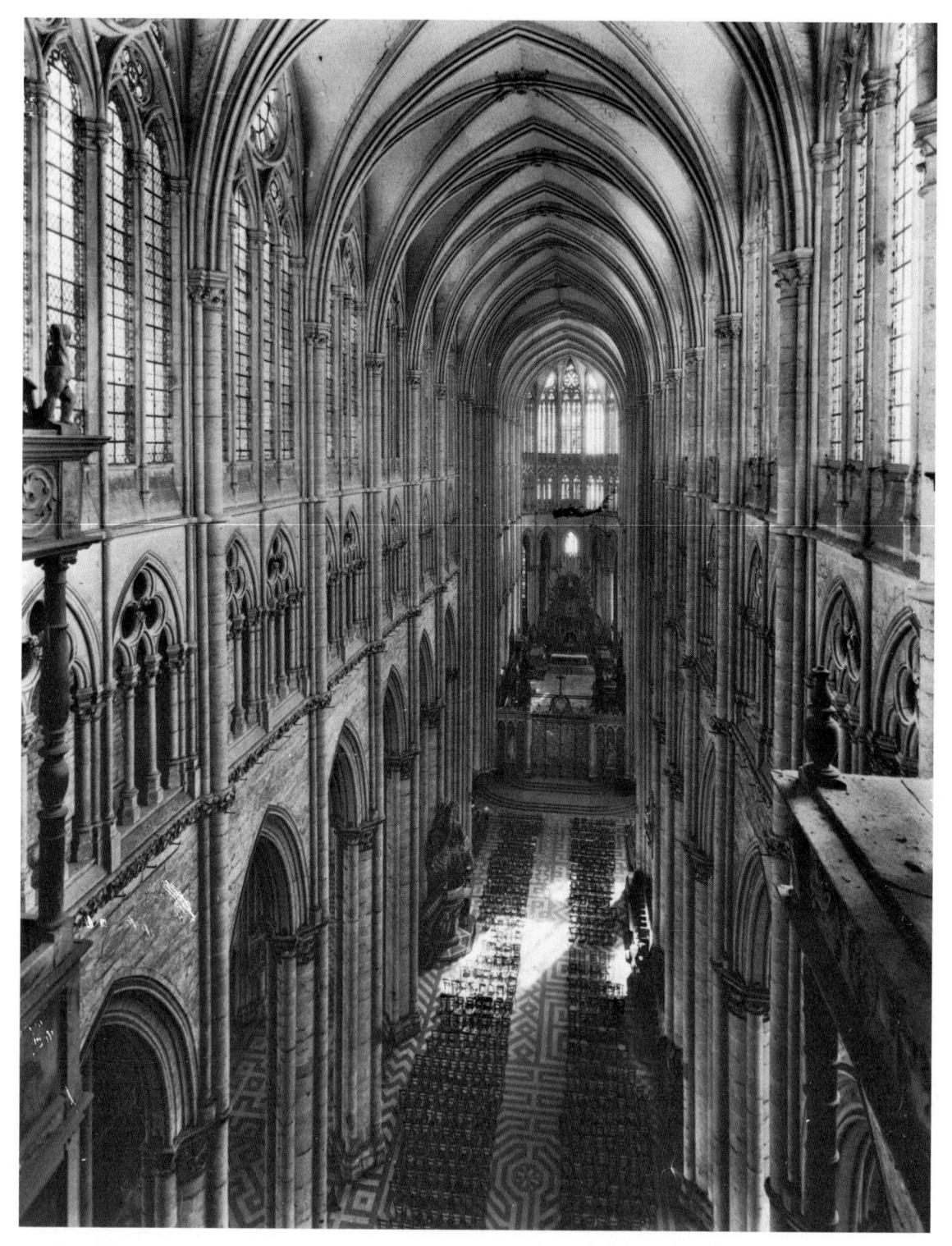

10.17 Nave looking east, Amiens Cathedral. Height of nave vault, 139ft. (42.4m). 1220–1288, upper choir reworked after 1258.

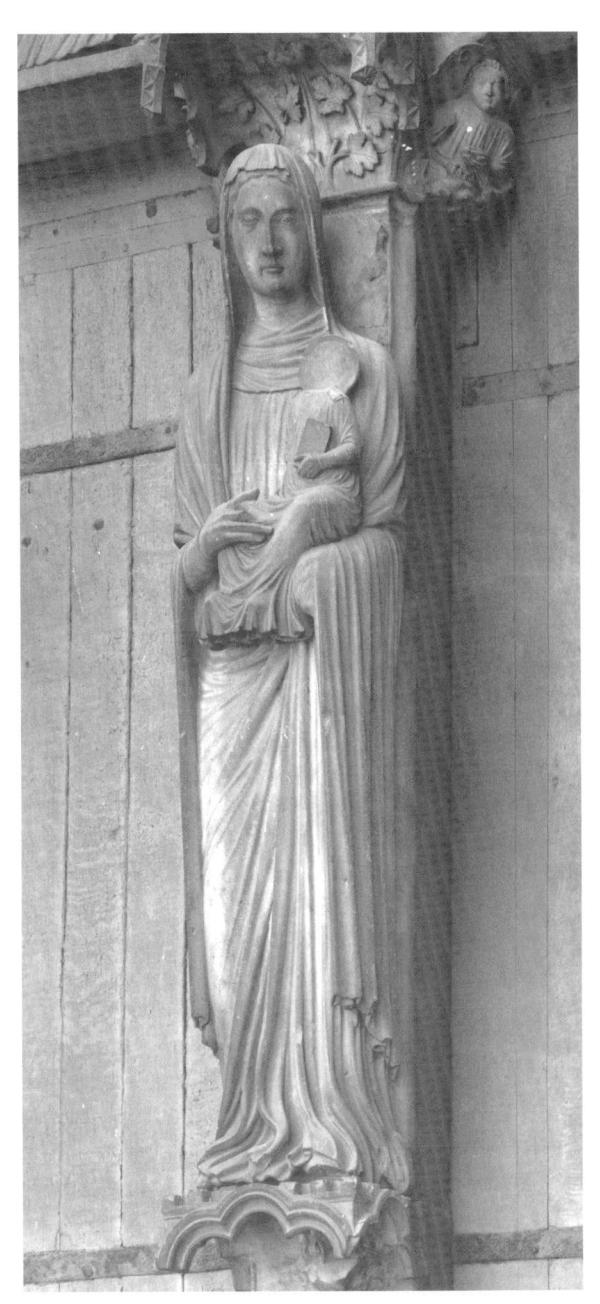

10.18 St. Anne and the Virgin Mary, central portal, north transept, Chartres Cathedral, after 1204.

lizes the upward surging movement of the elongated figure. The south transept was dedicated to the New Testament, the saints, and the Last Judgment, that is, to events after the Incarnation. Christ and the apostles on the trumeau and jambs lead to the Last Judgment in the tympanum. The

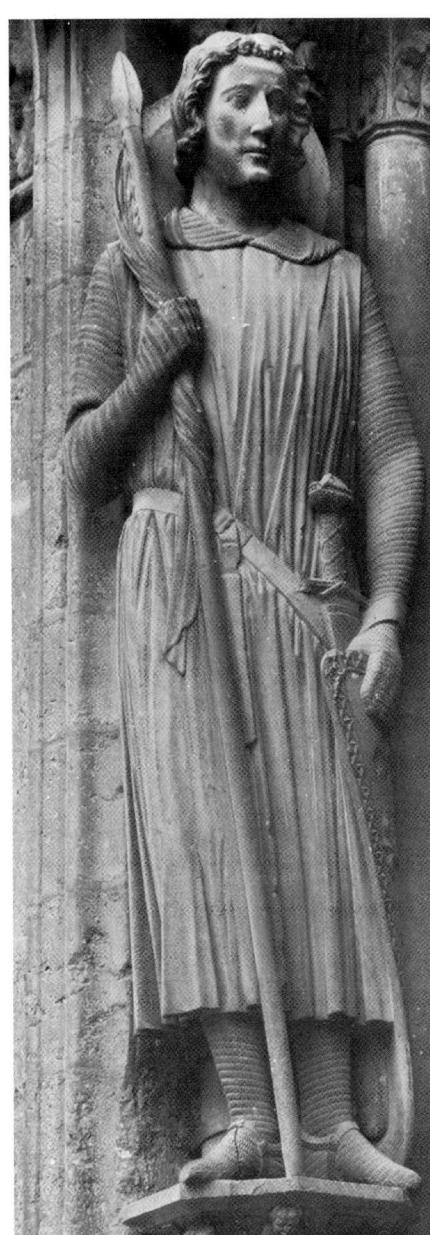

10.19 St. Theodore, south portal, Martyrs' bay, mid-13th century. Chartres Cathedral.

side portals of the transept have themes taken from church history—martyr saints at the left, confessor saints, including St. Theodore, at the right.

In Chartres, by 1224, the builders had planned porches and additional figures for the portals, and the grand program was finished at mid-century. St. Theodore, in the left jamb of the left portal, represents the ideal of Christian chivalry [10.19]. The complex pose, firm stance, and detailed rendering of a body clad in chain mail under a silky drapery suggests the sculptor's increased awareness of the material world. A new individualism pervades the design, and yet the sculptor retains the idealism and reserve of High Gothic art. The delicate flowing drapery maintains the vertical lines appropriate for a figure that is also an architectural element. Remarkably enough, however, the sculptor has carved the saint as if standing on a flat platform. This represents a significant step in the conception of a human being as a unique entity in a spatial environment. With such a figure the Chartrain masters take an irrevocable step away from earlier abstraction and toward realism of types, if not of individuals.

The elaborate sculpture program at Chartres, spreading over nine portals on the west façade and the north and south transepts, was not repeated on other buildings. Instead a distillation of the scheme, found on the west façade at Amiens, became the most popular model. At Amiens the central portal repeated the iconography of the central portal of the south transept at Chartres, the Last Judgment with Christ and the apostles [10.20]. The left entrance was dedicated to local saints; at Amiens the figure of St. Firmin, whose church had been destroyed to make way for the new cathedral, serves as a trumeau. At the right was the Virgin's portal, repeating the general form of her portal at Chartres but with the Virgin and Child rather than St. Anne on the trumeau. Deeply splayed portals filled with sculpture-statue columns, tympana, and a broad expanse of figured voussoirs—are set within shallow porches. Sculpture spreads across porches and wall buttresses, as columnar figures and bands of quatrefoil reliefs unite and enrich the three portals.

Clearly, the central portal with its huge tympanum filled with relief sculpture remains the focal point of the façade. Earlier tympana often had the image of Christ in Glory and the Second Coming, but patrons in the thirteenth century preferred the more direct and personal Last Judgment. In the central tympanum on the west façade at Amiens, angels blowing trumpets summon the dead from their tombs in the lowest register. St. Michael weighs souls and separates the

blessed and the damned, while above all this activity Christ, enthroned as judge and showing his wounds, is flanked by Mary and John, who intercede for sinful humans. Angels with the instruments of Christ's passion remind the viewer of God's sacrifice of his only son. Tier upon tier of saints—all the heavenly host—fill the voussoirs. The Wise and Foolish Virgins from the Gospel According to Saint Matthew are carved in relief on the door posts, and the Apostles holding the instruments of their martyrdom stand in the jambs. In a broad band at the base are quatrefoil frames enclosing vivid depictions of the vices and their less interesting corresponding virtues. They are just the right height to attract the attention of anyone entering the church. The decorative quatrefoil frames, enclosing lively narratives and energetic figures, become a textile-like pattern across the base of the portals.

On the trumeau of the central portal, Christ (popularly known as the Beau Dieu) tramples the lion and the serpent as prophesied in Psalm 91, verse 13. This is Christ triumphant, yet he blesses the people. Christ is quite literally the door into the Heavenly Jerusalem, and he welcomes the worshippers to his house, the church. As St. Augustine wrote, "He stood in the door because by Him we come unto the Father and without Him we cannot enter the City of God." The triumphant Savior supported by the apostles led to the Last Judgment above, a scene made immediate and personal by intercessors and angels with the instruments of Christ's passion [10.21].

The master sculptors of the Amiens shop (1220-1236) created one of the most influential styles of the thirteenth century. Their large standing figures became synonymous with "Gothic" art. In order to produce many figures rapidly, the master sculptors may have made three-dimensional models for use in the workshops. They developed an easily reproduced figure type that emphasized verticality. Voluminous and concealing cloaks and tunics fall in broad folds, and cloaks drawn across the body form diagonal lines leading to hands holding attributes, and then fall in a cascade of curving decorative hems. The vertical lines create a rising movement that denies the

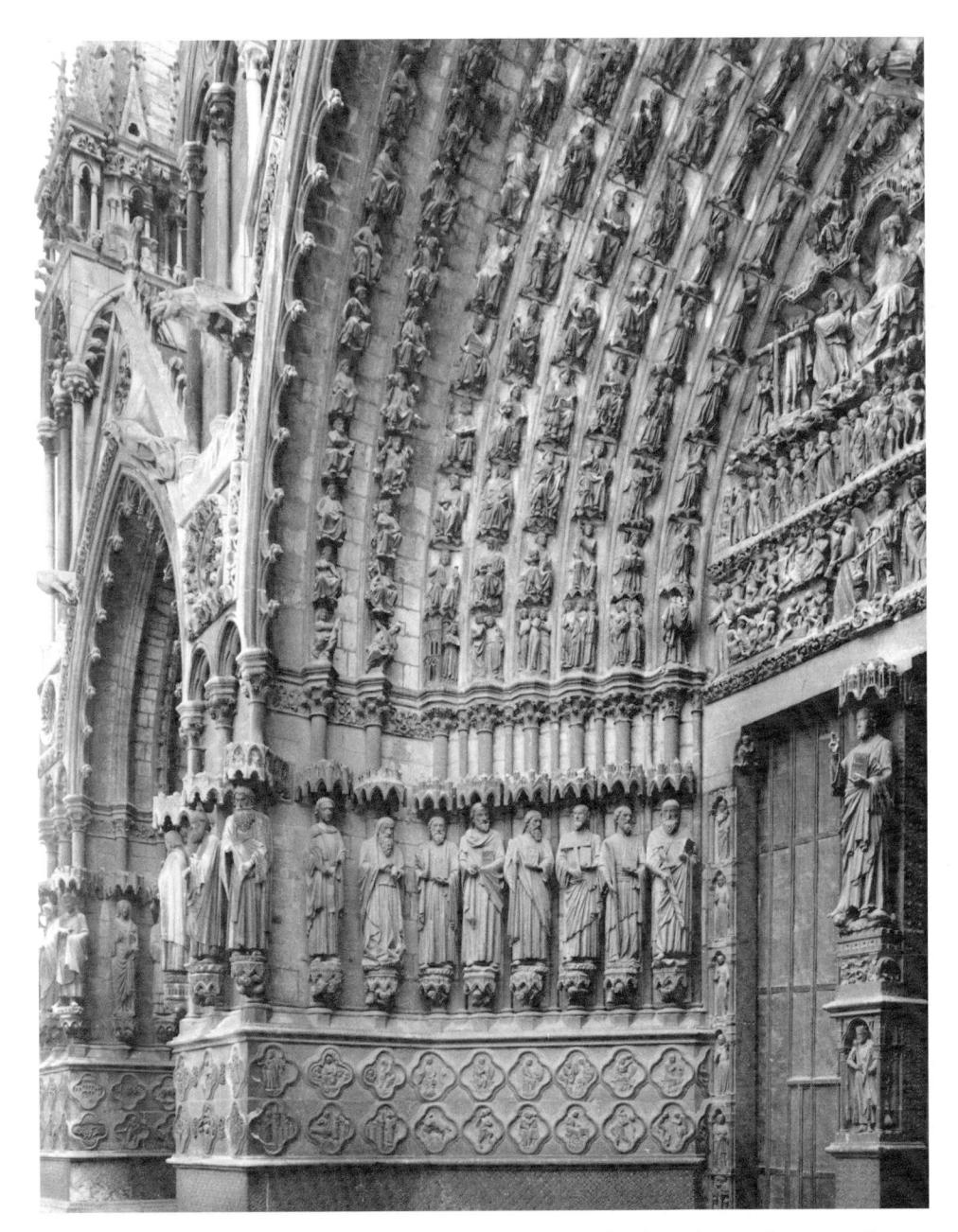

10.20 Amiens Cathedral, west portal, center doorway. Left jamb: major prophets, apostles. Doorpost: Wise Virgins. Trumeau: Christ. 1225-1235. Tympanum and archivolt. Last judgment.

real weight of the stone and the imagined weight of the figure. Projecting bases and canopies define spaces for the figures, but the dense continuous line of sculpture uniting the three portals denies their individuality. The importance of the figures lies in their meaning, not in their earthly humanity. The

broadly conceived, idealized style of Amiens-inspired sculptors from Reims to Bourges provided the basis for the Parisian Court Style and spread to southern France, Spain, and Italy.

Sculptors from Amiens also worked in Paris. Individuals seem to have moved back and forth be-

10.21 Christ, "Le Beau Dieu," trumeau, central portal, west façade, Amiens Cathedral.

tween the shops, and some traveled far afield seeking new projects. Much has been lost in Paris, but the Last Judgment tympanum in the center of the triple portal façade at Notre Dame, as we see it today, attests to the sophistication and strength of the shop. The tympanum sculpture was the product of several campaigns [10.22]. The original Paris style of about 1210 can be seen in the outer figures in the upper part of the tympanum; however, shortly after 1240 a new personality appeared in the shop. The figure of Christ and the lancebearing angel have the delicate features and elegant flowing draperies associated with the Parisian Court Style. In the lowest register, the writhing figures of the Resurrected replace figures destroyed

when the portal was enlarged for coronation processions. They form an interesting visual comparison between the modern "medievalism" and true medieval art of the Court Style.

The Amiens-Paris style spread south to Bourges and on to the Iberian Peninsula. Close personal ties existed between the royal houses of France and Castile since the queens (Blanche of Castile and Berenguela of León) were sisters. Both served as regents, and both had sons who were canonized—St. Ferdinand of Castile (1217-1252) and St. Louis of France. When Bishop Maurice of Burgos was entrusted with the task of escorting King Ferdinand's bride, Beatrice of Swabia, to Spain, he also visited Paris, where he had been a student. King Ferdinand and Beatrice were married in the old Cathedral of Burgos in 1219, and not surprisingly in 1221 they donated money for a new building. Bishop Maurice and his architect Martin (who may have come from Paris) began a modern French-style building in 1222. Work moved along

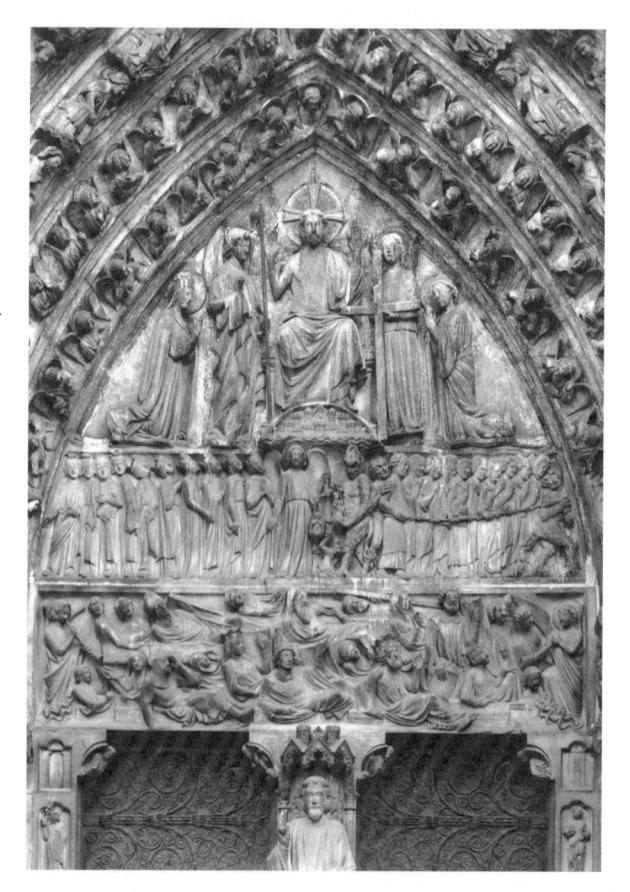

10.22 Paris, Notre-Dame, west portal, center doorway. Tympanum: Last Judgment. 1220-1230.

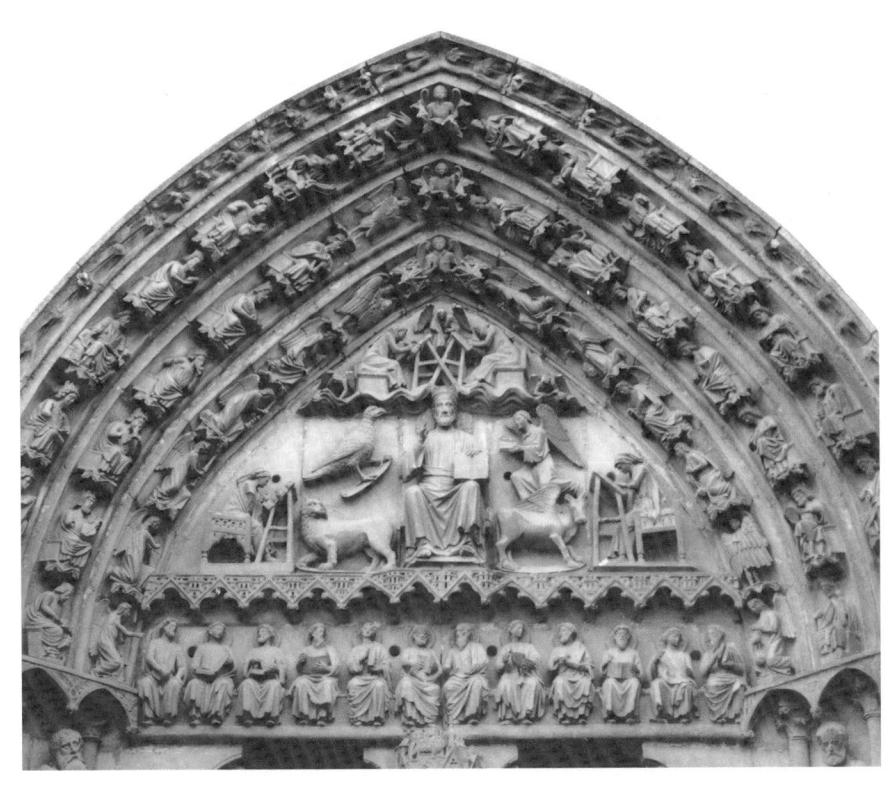

10.23 Cathedral of Burgos, 1224-1230/40, south transept. Tympanum.

rapidly; the bishop celebrated mass in his new choir in 1230 and was buried there in 1238. Only the love of repeated decorative pattern seen in the tracery, the emphasis on horizontal lines, and the nearly flat roof mark the building as Castilian.

Sculpture for the Cathedral of Burgos was inspired by the modern art of Amiens and Paris, although the south transept portal (1224-1230/1240) had a conservative iconography based on the Apocalypse, not the Last Judgment [10.23]. In the tympanum, Christ is surrounded by symbols of the evangelists, and then by the authors themselves. Apostles are seated in the lintel, and angels fill the voussoirs. The idealized faces and quiet dignity of the figures encased in broad folds of drapery recall the Amiens style so closely that scholars have suggested that a master from that shop worked in Burgos. However, the Castilian interpretation of the theme as a scene in a scriptorium suggests the participation of local sculptors. The Burgos artists were not content with generalized figures and symbols. They represented the evangelists hunched over desks loaded with equipment, hard at work writing their Gospels.

Sculptors from Chartres, Paris, and Amiens all worked in Reims. The cathedral, with its changes of plans and masters, illustrates the variety of styles possible within the Gothic canon. Appropriate to the coronation church of the Capetian dynasty, coronation themes pervade the imagery of the façade. In the tall central gable, Christ crowns his mother Mary, and so emphasizes the theme of royal coronation [10.24]. Lower in the jambs, key events in the life of the Virgin unfold: at the right, the Annunciation and Visitation; at the left, the Presentation in the Temple. In the eight figures that make up these scenes, three different sculptors or workshops can be identified. Placement marks allow us to reconstruct the intended positions of the figures. Nearest the door on the right is the Annunciation; however, the angel has been moved here from his place with a local saint on the lefthand portal. The Visitation follows on the far right. At the left is the scene of the Presentation of Jesus in the Temple. Here the figures should have been set in two pairs, with the servant girl placed next to St. Joseph.

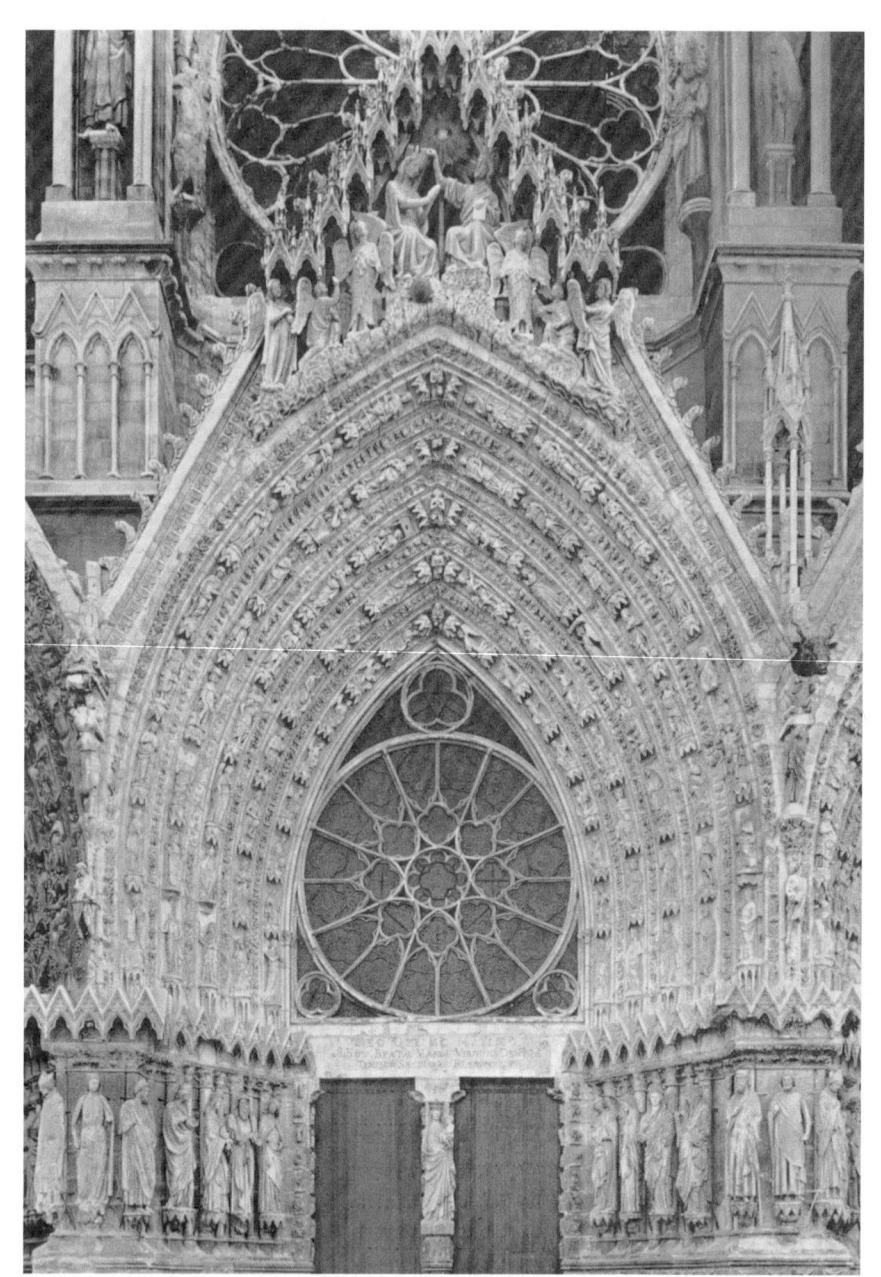

10.24 Reims Cathedral, west façade, central portal, 1230-1255.

In the Visitation, Mary and Elizabeth, the mothers of Jesus and John the Baptist, turn toward each other in greeting [10.26]. The weight shift of their stance produces a slightly swaying spiral motion so that the figures seem almost detached from the architecture. This freedom of movement together with the classicizing faces and drapery recall the art of ancient Rome. Mary's mature beauty and gently waving hair contrast with the severe realism of the

depiction of the aged Elizabeth. Both women are enveloped in heavy drapery falling in trough-like folds that conceal rather than reveal the figures.

The Visitation is the finest, most mature work of a master called the Master of the Antique Figures. The shop was the earliest at Reims and worked on the chevet and north transept. The sculptors were profoundly influenced by classical art as interpreted by Mosan artists such as Nicholas

Villard de Honnecourt

Villard de Honnecourt is a mysterious but engaging figure who in the 1220s traveled though northern Europe and as far east as Hungary. He recorded things that interested him in a series of remarkable drawings. Villard was a native of Picardy in northeastern France. He was once thought to have been an architect, but scholars such as Carl F. Barnes, Jr., who have studied his work question whether he was a professional builder, a cleric with architectural responsibilities, or simply an interested layperson.

In his so-called sketchbook—in fact a portfolio of 33 parchment sheets-Villard drew people, animals, insects, and plants (a hedgehog and a lion "from life"), mechanical devices, geometric figures, figure sculpture (and the tomb of a "Saracen"), and buildings including plans, elevations, and structural details. His drawings of the eastern chapels of Reims Cathedral and the towers of Laon Cathedral are remarkable for their careful observation. He traveled in France. Switzerland, and even Hungary, drawing the cathedrals of Cambrai, Chartres, Meaux, and Lausanne, as well as Reims and Laon. On this sheet he illustrates the technique of "drawing figures according to the lessons taught by the art of geometry."

10.25 Villard de Honnecourt, sketchbook, ink on parchment, French, 1230-1240. Bibliothèque nationale, Paris. Pair of draped female figures.

of Verdun and the Master of the Ingeborg Psalter in the late twelfth century. The sculpture of this shop is characterized by exceptionally bulky figures whose broad shoulders and firmly planted feet emphasize their tangibility. But for all their classical references, the figures remain architectural sculpture. The shafts and capitals of the columns rise above their heads as a reminder of the architectural function of portal figures. The thirteenth-century architect Villard de Honnecourt was so impressed with this sculptural style when he visited Reims that he recorded similar figures in his notebook.

Shortly after 1230 some of the sculptors from Amiens and Paris evidently moved to Reims. They introduced the "modern" style and techniques being used in Paris and the court. This shop pro-

duced much of the sculpture for the west façade of the cathedral. (Dates of the sculpture of the west façade are hotly debated.) Bland faces with slightly pinched features, and slender bodies concealed under broad drapery surfaces characterize the style represented by the Virgin of the Annunciation. In the finest figures, sculptors and architects aimed at achieving the same kind of integration of the worldly and divine being discussed in the universities and cathedral schools. Theologians no longer insisted on the dual nature of human beings, glorifying the spirit while denying the flesh, but instead wrote of the union of body and soul. Sculptors, like architects and churchmen, built their images on a concept of totality, which gave equal place to both physical appearance and intangible inner life.

10.26 Reims Cathedral, west portal, center doorway. Right jamb: Annunciation, c. 1245-1255 and Visitation, c. 1230. Installed approx. 1245-1255.

Roman de la Rose (Romance of the Rose)

This allegorical poem was begun by Guillaume de Lorris (active 1220-1240) and finished by Jean de Meun (1235/40-1305). Popular for three centuries, 250 manuscripts still exist most of which are illustrated. Most begin with the Lover asleep and continue with his awakening and departure for the garden where he sees evil beings excluded at the wall. Dame Idleness allows him in and there he meets all the good qualities of love and life as he tours. Looking into the fountain of Narcissus, he sees the Rose and at once falls in love. Instructed by the God of Love, he seeks the Rose despite the obstacles. Assisted by Reason, the Lover reaches the castle. Fair Welcome allows him to approach the Rose but then Jealousy intervenes. As the Lover laments his loss of the Rose, the poem ends. In 1264-74 Jean de Meun took up the tale and the serious mood changed to one of irony and even comedy. Everyday speech replaces courtly language and naturalistic detail, the idealized images. The Lover and the God of Love, with Venus leading, attack the castle and the Lover at last gains the Rose. Jean seems to imply that the golden age is over, and the reader must learn to live with the evil and violence of the world.

Their figures exist on a spiritual or symbolic plane as well as on a material level.

Out of this Paris-Amiens workshop emerged a strikingly individual sculptor whose work at Reims revolutionized monumental sculpture. Called the "Joseph Master" or the "Master of the Smiling Angels" by modern historians, this individual reminds us that even when we know nothing about the artist, individuals, not some amorphous "will-toform," establish the future directions of art. The Joseph Master [10.27] turned the statue column into an autonomous figure seemingly inspired by selfconscious, courtly elegance. From the Amiens school, he adopted simple, heavy drapery with deep folds and undulating borders; however, he dramatized the folds of cloaks and made even more elaborate their curling edges. From the Master of the Antique Figures, he learned to create substantial figures, but he exaggerated the shifting weight, swaying pose, and spiral twist of the body. He invented a new facial type with delicate features, almond eyes under arched brows, and broad forehead framed by short, curly hair. He turned a quiet smile into a piquant expression suggesting

worldly amusement as well as pleasure and affection. The cocky stance and twirling mustache turn his St. Joseph from a dignified saint into an elegant dandy.

St. Joseph's focused gaze, jaunty pose, and voluminous drapery can also be seen in the angel of the Annunciation [10.26]. The smile flickering over the thin, oval, adolescent face of the angel seems merry and sad at the same time. In this figure, the formal elegance of the drapery pattern and the subtle gesture raise the sculpture to the highest level of sophistication. The Joseph Master sought a new kind of abstraction; he created an anti-natural style characterized by elegant formalism and sharpness of expression. In so doing he rejected not only the basic premise of architectural sculpture but in a sense all of the preceding styles of medieval art.

Even the Joseph Master saw the world as God's creation, to be contemplated but not dissected. Thirteenth-century sculptors studied neither anatomy nor botany scientifically, but they observed the world with care and sympathy. To be sure, artists continued to define figures through attributes, to emphasize gestures and facial expressions, and to arrange drapery in architectonic patterns. While drapery might suggest the movement of the body, it has an aesthetic and expressive function of its own, and its geometric composition continues to integrate the figures into the complex overall design of the building. Interested as they might be in the organization and representation of figures in space, even in narrative reliefs or paintings, the artists worked within a narrow stage space where figures moved within the limits set by distinct frontal and background planes—just as they lived within the constraints of their society and traditions of their trade.

GOTHIC ART IN ENGLAND

"Lackland" and "Soft Sword," the nicknames of King John, remind us that the thirteenth century did not begin auspiciously for England. King John lost his French lands to Philip Augustus, his control over the church to Pope Innocent III, and his royal prerogatives to his own barons. During his reign (1199-1216), the English barons strengthened the power of common law over the whims of

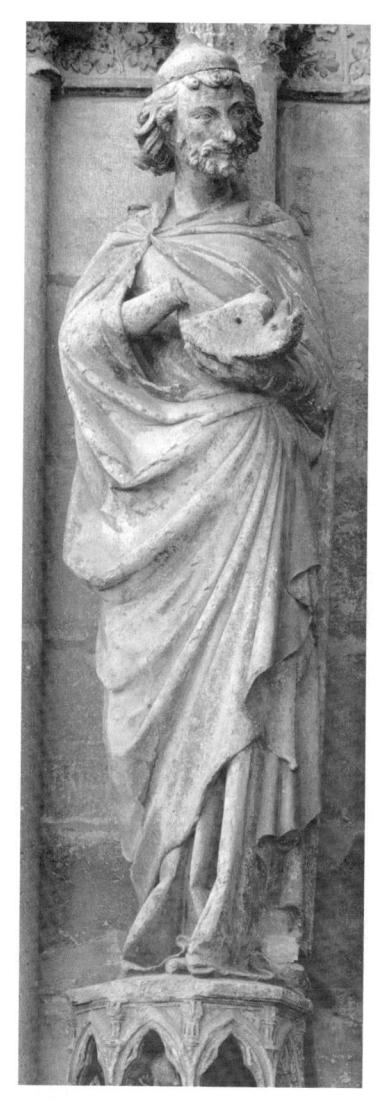

10.27 Reims Cathedral, west portal, center doorway. Left jamb: Presentation in the Temple, with Joseph, c. 1245-1255.

the monarch. Their power culminated in the king's acceptance of the Magna Carta, or the Great Charter of Rights, which remains to this day the basis of English democracy. Meanwhile work continued on churches in Canterbury and Wells, and the construction of a new cathedral at Salisbury. Henry III's reign (1216-1272) saw the widespread acceptance of the new, Gothic art in England.

Local building traditions as well as competition with France determined the pattern of English

10.28 Interior, Winchester Hall, 1235–1236. The far wall shows King Arthur's Round Table.

thirteenth-century art. In Canterbury, the master builders William of Sens and William the Englishman had adapted French Gothic architecture to local practices and taste, but other models also influenced the evolution of a distinctive English Gothic style. The tradition of fine carpentry dating back to the Anglo-Saxons and Vikings meant that timber construction remained important, and many Gothic buildings had spectacular timber roofs. In the great hall at Winchester (1235-1236), huge timbers and delicate wooden tracery support and enrich the roof [10.28]. Cistercian buildings reinforced the Norman preference for rectangular plans, fine masonry vaulting, and geometric or foliate decoration. The monastic influence on the English church remained strong. Many buildings, set in extensive grounds with cloisters and chapter houses, still retain their rural, monastic character.

The Cathedrals of St. Andrew in Wells [10.29] and St. Mary in Salisbury are typically English. Bishop Reginald (1174–1191) began a new church at Wells at the end of the twelfth century. Documents of 1184 and 1191 refer to funds raised for work in the choir (this early choir was rebuilt in the fourteenth century). Bishop Jocelin (1206–1242) pushed the work forward and consecrated the church in 1239.

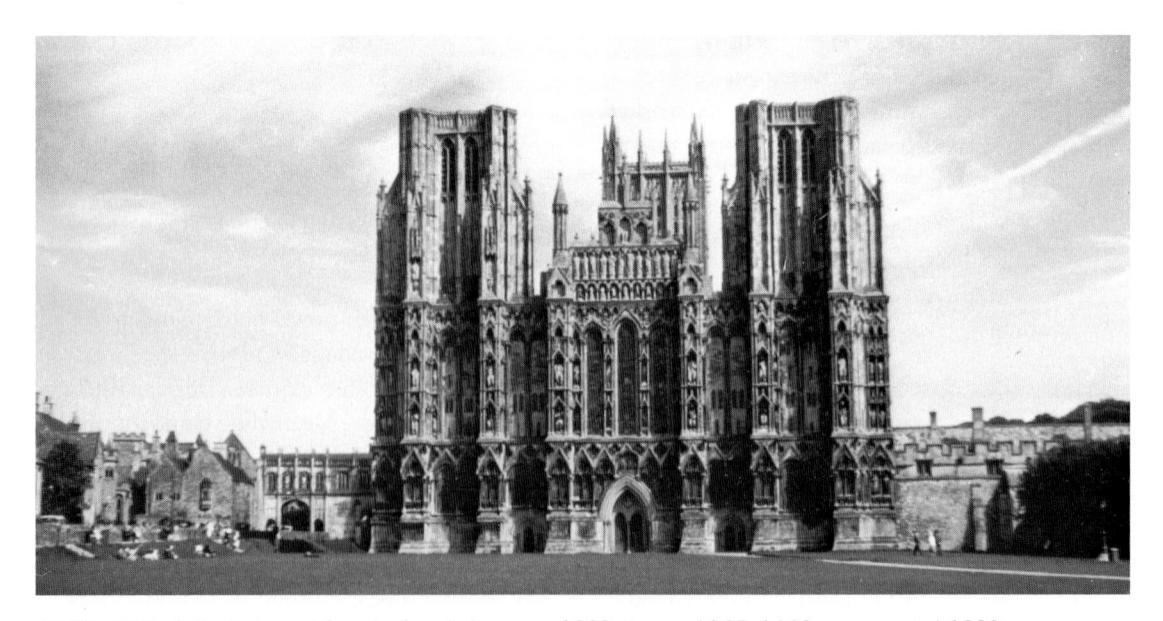

10.29 Wells Cathedral, west façade, façade begun c. 1220, towers 1365-1440; consecrated 1239.

The façade of the Cathedral at Wells (begun c. 1225) is a rich screen across the front of the building. In contrast to French cathedral façades with their soaring towers over deep, triple portals, the designer of the Wells façade dramatized sweeping horizontality, increasing the breadth of the façade to 147 feet (44.8m) by setting the heavy bases for western towers outside the line of the nave walls. (The towers were built in the fourteenth and fifteenth centuries.) With row upon row of moldings, arcades, gables, and bands of quatrefoils, the master turned the wall and its six huge buttresses into an overall surface pattern. The quatrefoils, for example, bend around the corners of the buttresses in a fashion that would have struck the French as illogical and inappropriate but serves to enhance the continuous horizontal movement across the façade. Slender lancet windows and insignificant western doorways replace the French rose windows and great gabled portals. The architecture becomes a scaffold for sculpture whose crisp linearity is typically English. Red, green, and black paint, gilding, and metal fittings as well as contrasting colored stones originally turned the west front at Wells into a dazzling replication of a polychromed altarpiece. If the French church façade suggests a triumphal gateway, then the English screen façade becomes the glittering, jeweled wall surrounding the Heavenly Jerusalem.

The nave demonstrates the English preference for length rather than height [10.33b]. The English builders emphasized the horizontal quality inherent in the basilican elevation. The 64-foot-high (19.5m) vault of the nave is slightly higher than the side aisles of Amiens Cathedral. The thick walls, low proportions, and relatively small lancet windows in the clerestory enabled the masons to build ribbed vaults without flying buttresses (arches concealed under aisle roofs stabilize the vault). In the nave arcade, piers composed of clusters of 24 shafts support deeply splayed and molded arches. The zigzag movement this design creates down the nave is speeded in the second story, where a continuous arcade eliminates any reference to the medieval bay system. Column shafts springing from elaborate foliate corbels and framed by moldings resting on human heads support the vaulting ribs.

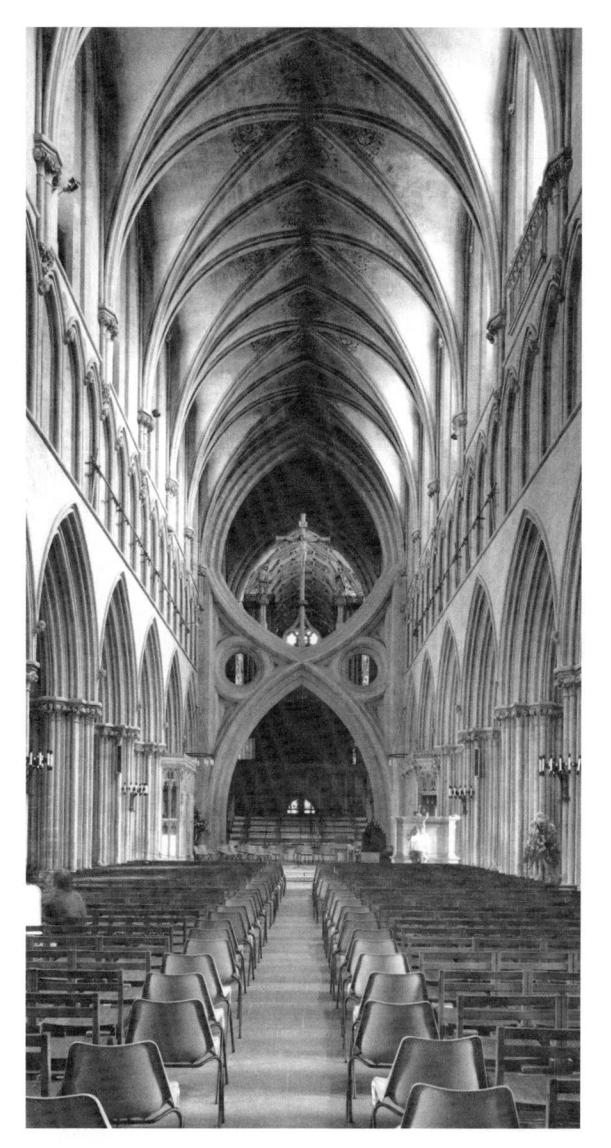

10.30 Nave and crossing, Wells Cathedral, begun after 1184; nave, 13th century; strainer arches, 1338.

The masons used sculpture lavishly in capitals, corbels, and as terminations for the moldings that frame the arches. The "dog-tooth" pattern—a threedimensional, pointed quatrefoil—gives a staccato accent to the smooth curves of the arch moldings. Dog-tooth moldings became a widely used thirteenth-century English ornament. The foliage of the capitals recalls lively, luxurious Anglo-Saxon acanthus ornament [10.31]. The introduction of amusing figures and grotesques among the leaves shows a distinctively English sense of humor. The

10.31 Wells Cathedral. Capitals in south transept. Man with a toothache, c. 1220.

man with a toothache seems observed from life, and the fellow pulling a thorn from his foot is a motif dating back to Roman art that had sexual innuendos in the Middle Ages. Manuscript illuminators used images like this as marginal "drolleries."

The Cathedral of St. Mary at Salisbury was built in a single campaign and suffered little remodeling until the eighteenth century [10.32]. Set in a broad open park (known as a close) and dominated by its soaring early fourteenth-century tower and spire, the Cathedral of Salisbury has been considered the prototypical English Gothic cathedral. In 1217, Bishop Richard Poore asked the Pope's permission to relocate his cathedral in the valley of the River Avon because, he argued, the winds howled so loudly around his church on the hill at Old Sarum that the clergy could not hear themselves sing the Mass. Permission was granted, and the church was built on a new site between 1220 and 1258. No preexisting structures determined its design, although the Cathedral of Canterbury may have inspired the axial chapel and double transepts, and Cistercian architecture the rectangular plan [10.33a]. Massive walls and simple lancet windows in pairs and triplets permitted the

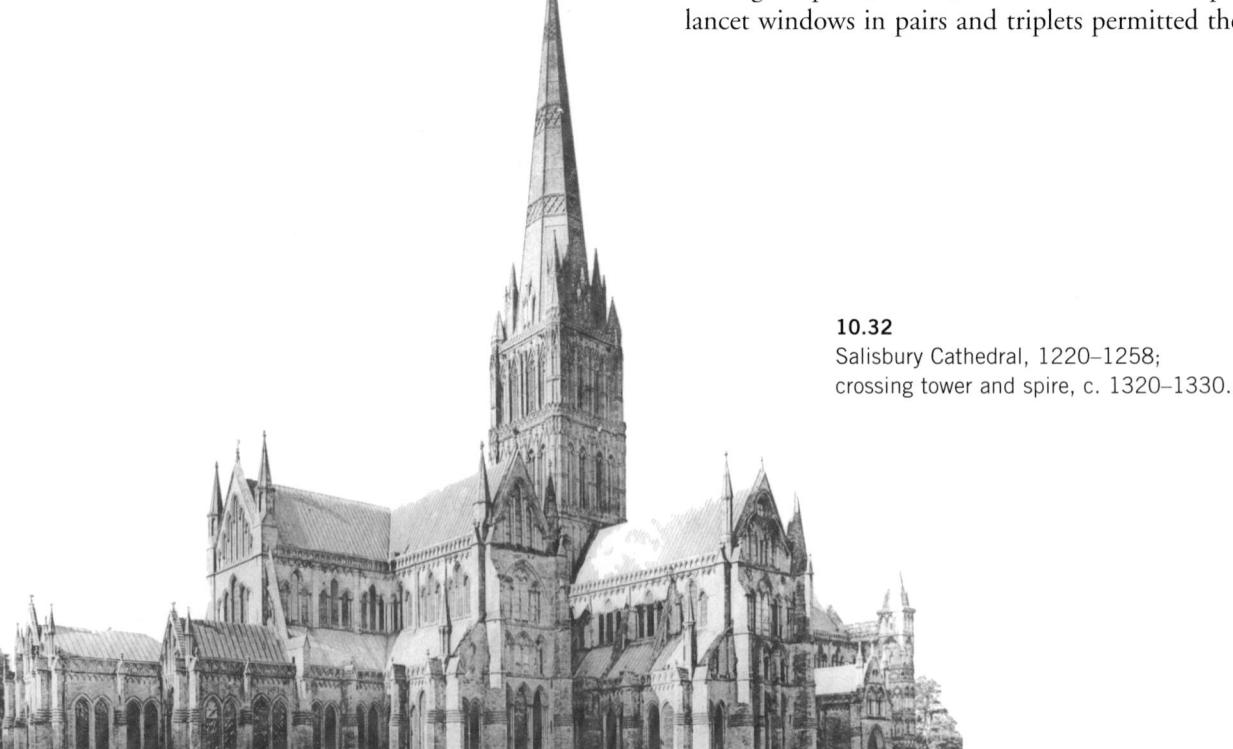

builders to construct a ribbed vault without flying buttresses although such buttresses had to be added later to support the fourteenth century crossing tower and occasionally to reinforce the upper walls.

Work began at the east, and between 1220 and 1225, Master Nicholas of Ely built the chapel dedicated to the Trinity and All Saints [10.34]. United to the sanctuary by an ambulatory that forms its western bay, the cubical space is formed by three aisles of equal height. Slender Purbeck marble shafts carry the vault. Although the architect may have been inspired by buildings in western France, where the English held extensive territory, technically and aesthetically the chapel is a new building type in England. The aisled hall was widely used in secular architecture. The nave follows the traditional basilican plan with side aisles and a threepart elevation [10.35]. The use of Purbeck marble shafts applied to piers of the nave arcade and triforium emphasize horizontal over vertical lines as well as the colorful effects preferred by the English builders.

10.33

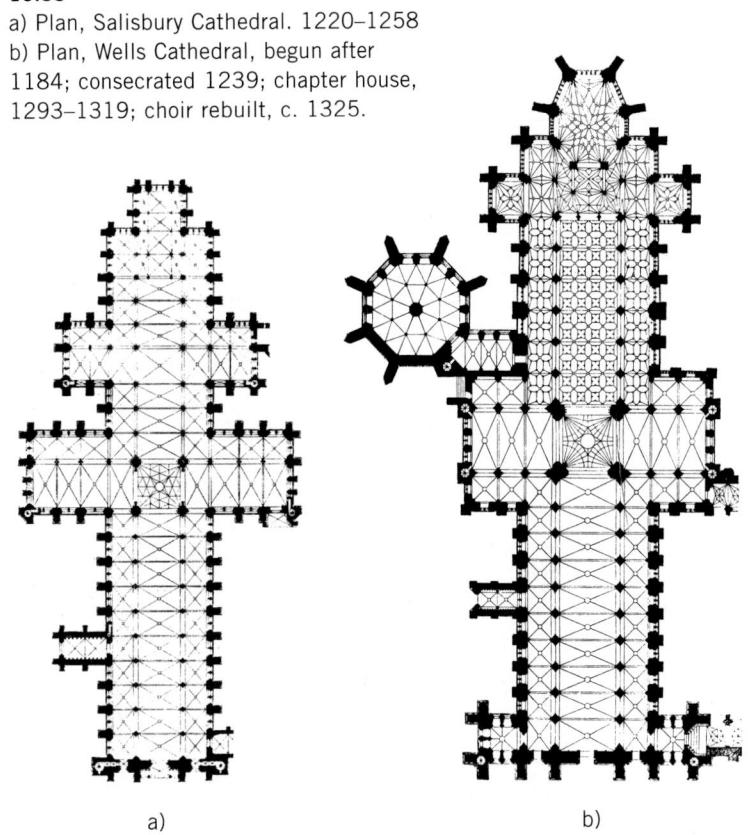

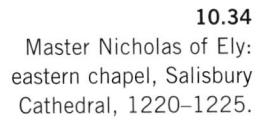

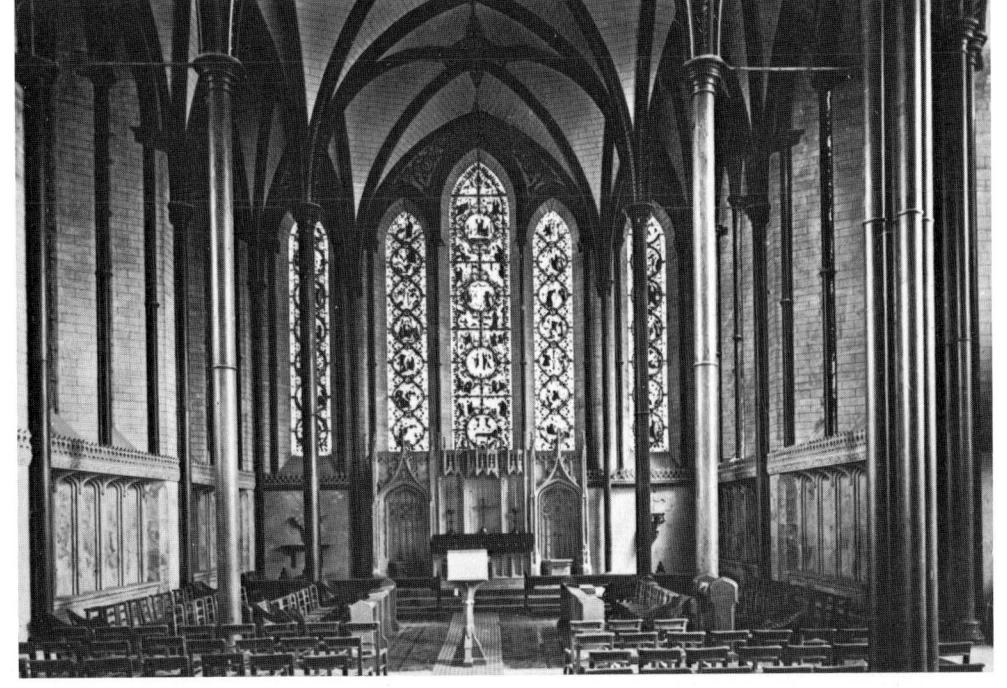

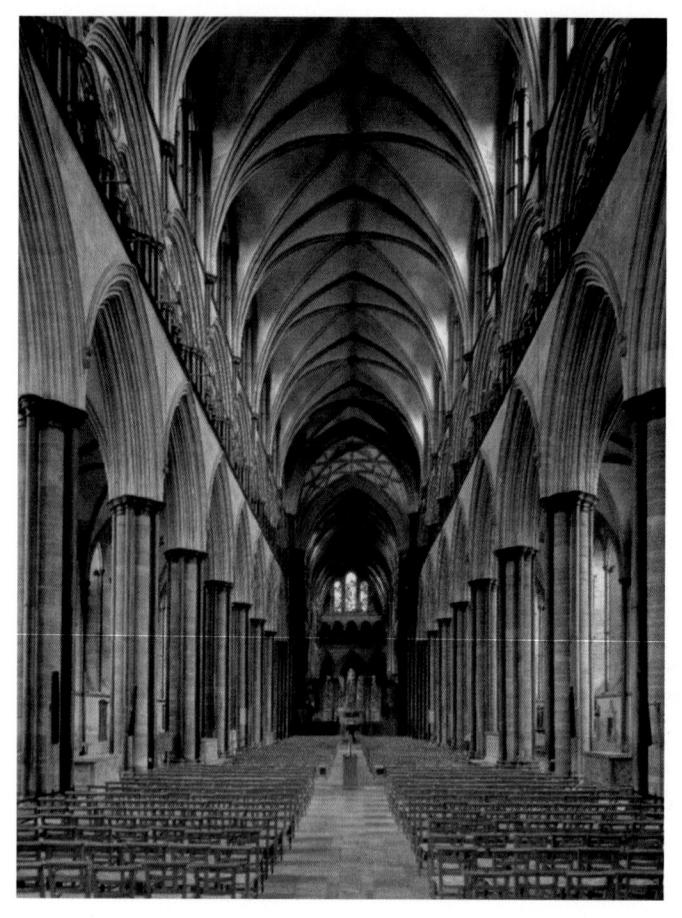

Nave, Salisbury Cathedral.

English painting in the thirteenth century had some of the distinctive characteristics of English architecture and sculpture. Even in the most solemn themes, images of the material world emerge, often in the margins of the manuscripts. The Oxford painter William de Brailes (active 1230-1260), while creating a monumental fullpage painting of the Last Judgment, includes his own portrait [10.36]. William is on the left side of Christ, among those about to be damned, but he is saved from the demons of Hell by a swordwielding angel, and he carries a scroll with the words "W De Brails me fecit" (W. de Brailes made me). Opposite William, St. Peter uses his keys like a weapon as he swoops down to select and defend additional souls. The Hell mouth spreads across the bottom of the page and is filled with tormented souls and vicious demons. Above in the

Heavens, Christ tramples a pair of dragons. The oval and semi-circular framed compartments dividing the scenes resemble the composition of stained glass windows while the gold embossed with diapered patterns recalls the metalwork of reliquaries.

GOTHIC ART IN THE EMPIRE: GERMANY AND ITALY

As France and England emerged as strong monarchies, the rest of Europe remained a decentralized conglomeration of independent counties, bishoprics, and towns under the nominal but often ineffectual rule of an emperor or king. In the Iberian Peninsula, Castile-León increased in power; the Christians defeated the Moors at Las Navas de Tolosa in 1212, and in 1236 the center of Muslim culture in Spain, Córdoba, fell to St. Ferdinand. The Christians took Seville in 1248, leaving only the tiny kingdom of Granada as an outpost of Islamic culture on the peninsula. In imperial lands, the brilliant scion of the Hohenstaufens, Frederick II, crowned king in Aachen (1212) and emperor in Rome (1220), spent most of his time in Italy. His death in 1250 left Germany in a state of near anarchy. The Papal States, semi-autonomous city states and ducal territories, had to share land and resources in the Italian peninsula. Neither the Germanies nor the Italian states found political peace and unity in the Middle Ages.

German art and architecture remained conservatively bound to designs going back to Romanesque and even Ottonian and Carolingian times. Details from France might be added to traditional double-ended buildings, as for example the rose windows in the Cathedral of Worms. Other churches were refurbished with such additions as the painted ceiling at Hildesheim, where the wooden ceiling had been renewed after a fire in 1186. In Germany architectural painting remained important, but the conservative character of German art in the early years of the thirteenth century is apparent. Imperial artists had looked to Byzantium for inspiration since the days of the Ottos, and thus it is not surprising to find

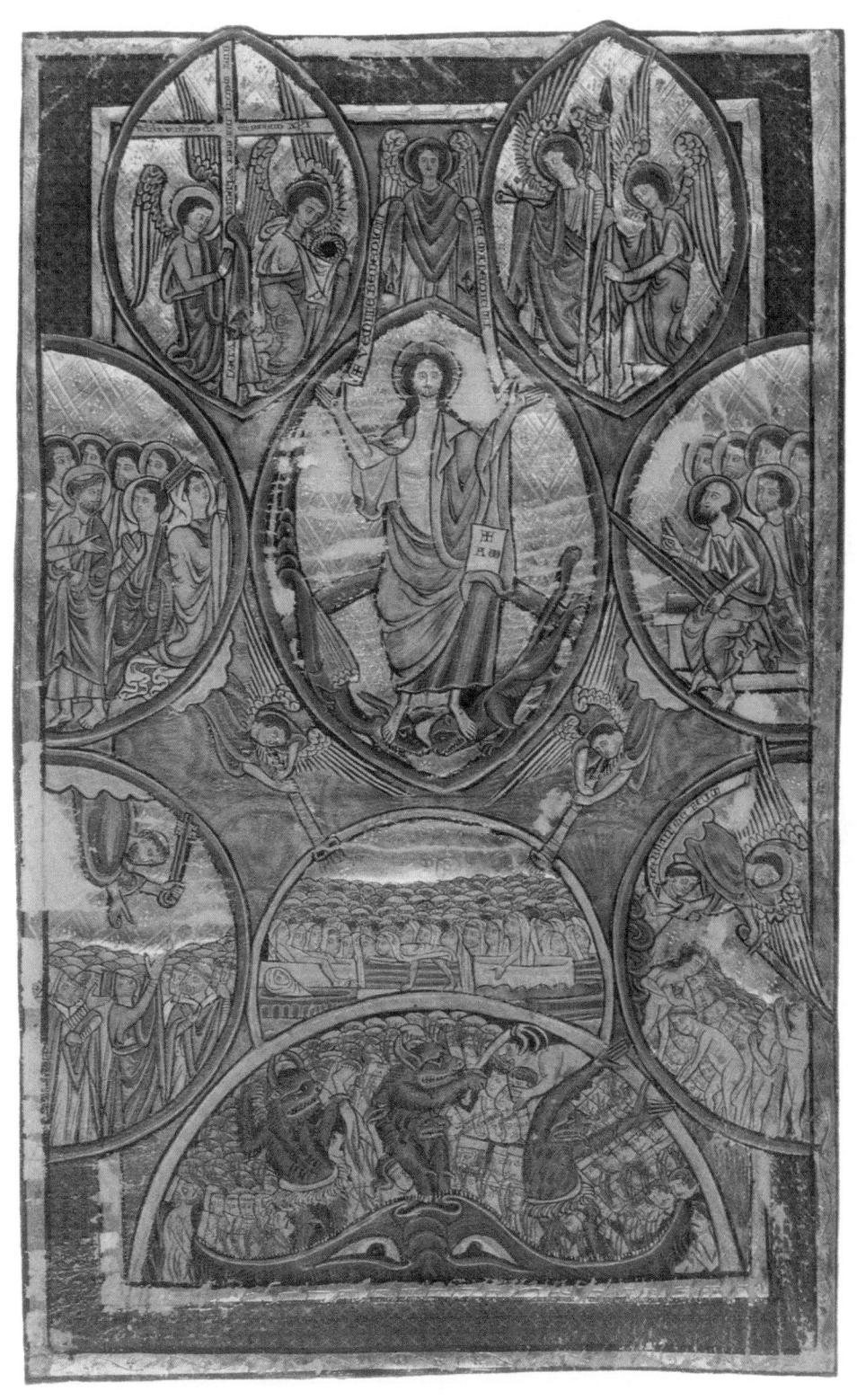

10.36 Last Judgment, William de Brailes, 1230–1260. Fitzwilliam Museum.

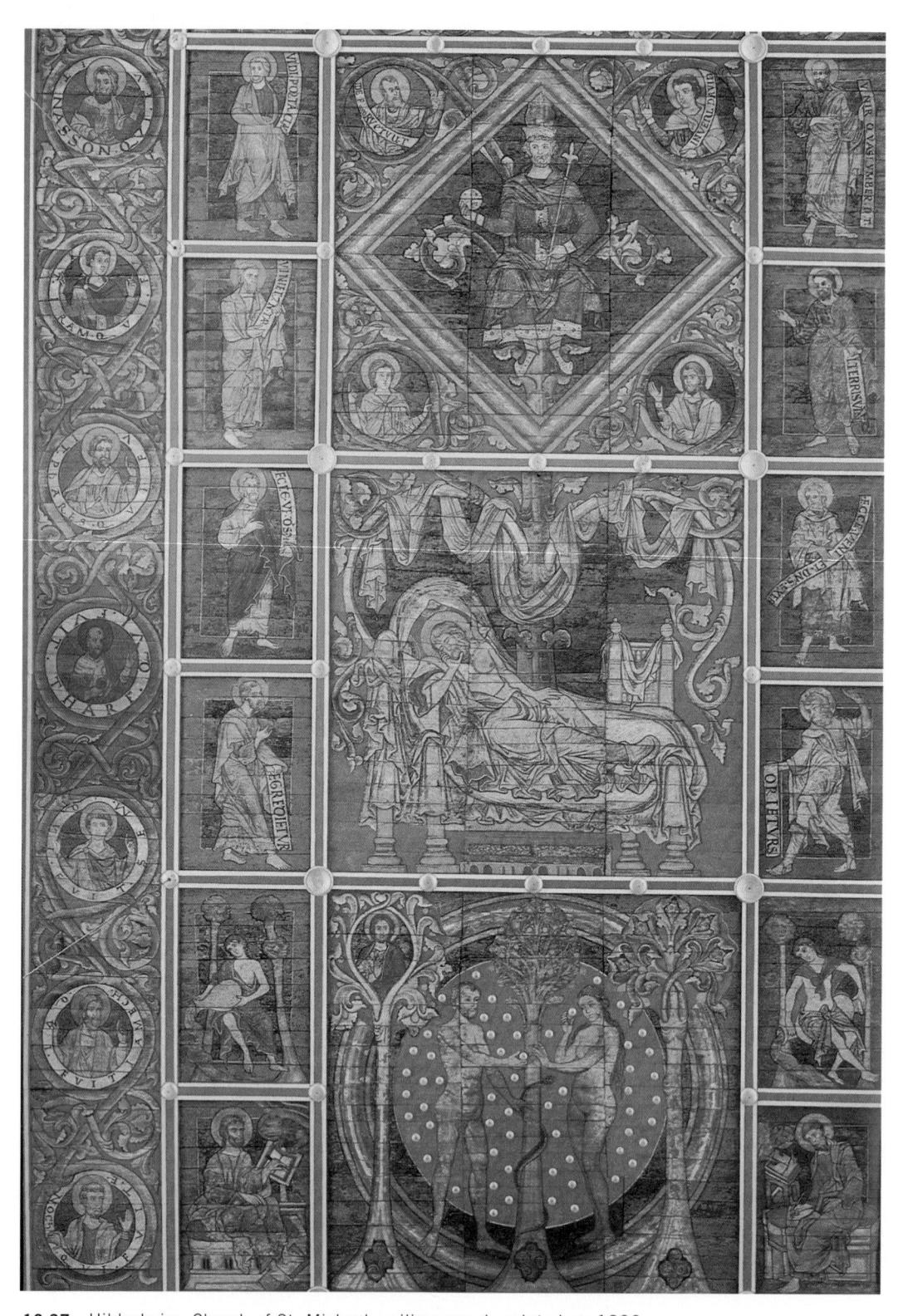

10.37 Hildesheim, Church of St. Michael, ceiling, wood, painted, c. 1230.

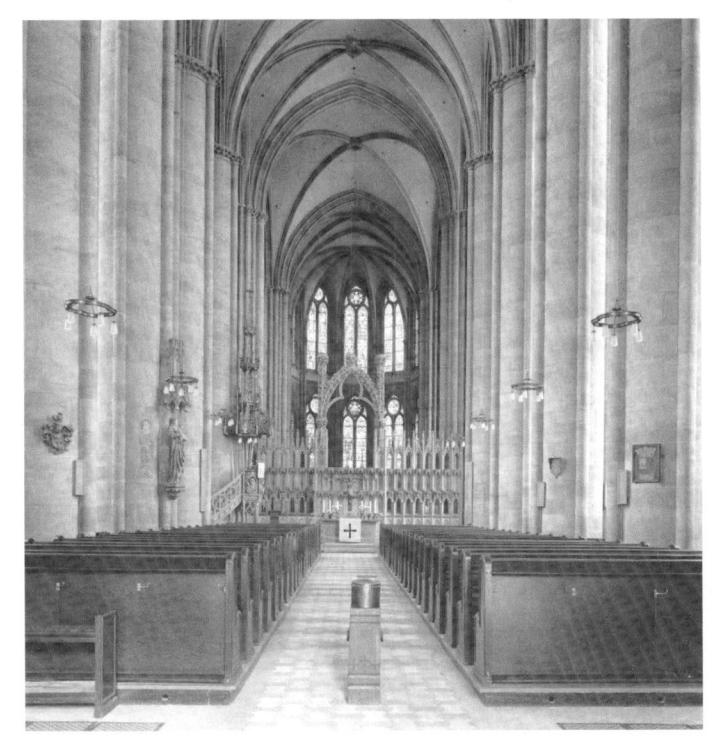

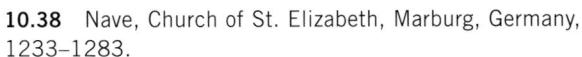

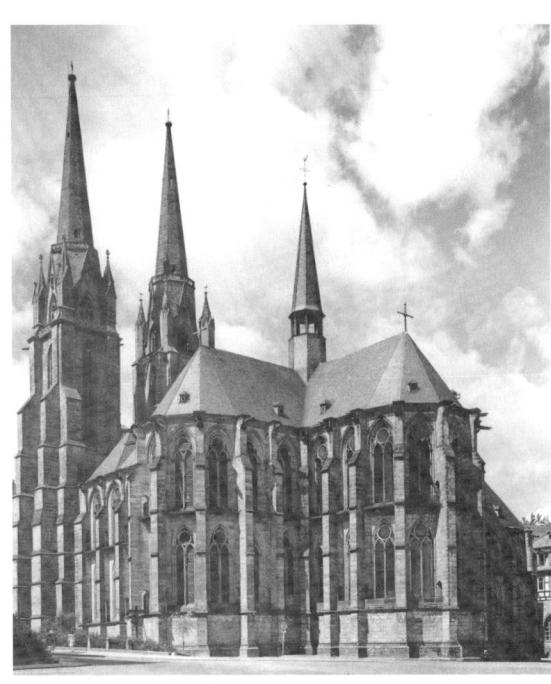

10.39 Church of St. Elizabeth, Marburg, Germany.

German painters in the early thirteenth century maintaining contact with Byzantine art. In the hands of the German painters-for example, at Hildesheim, where a Tree of Jesse was painted on the wooden ceiling about 1230 [10.37]—the Byzantine style became ornamental and mannered but also highly emotional. The painting recalls Imperial Romanesque art.

Builders satisfied the requirements of the preaching friars as well as the demands of pilgrims by creating large halls whose open spaces could accommodate large crowds. They perfected the triple aisled hall church. The church of St. Elizabeth (Elisabethkirche) at Marburg, built between 1233-1283, is an early example of such a hall church [10.38]. The builders adapted the scheme of parallel aisles of equal height used in western France (Poitiers), and for crypts (Speyer), chapels (Salisbury), and secular halls to create a new kind of church interior. The spatial unity and pervasive light made hall churches excellent congregational auditoriums. They could accommodate the crowds

of people who gathered to hear the inspiring Franciscan and Dominican preachers as well as the pilgrims venerating the shrines. Outside, the building presents an elegant vertical image of tall buttresses and a double rows of windows [10.39]. With aisles rising to the height of the nave, wall buttresses rather than flying buttresses are sufficient to support the vaults; consequently the church presents a compact exterior to the viewer.

German sculpture and painting followed a course of resistance to, and then adoption of, the new French art. At Naumburg, a church was built on the site of the castle of Margraves Hermann and Ekkehard, whose idealized portraits stand in the western choir of the church. Their descendant, Bishop Dietrich II of Wettin (1244-1272), built his choir between 1245 and 1260 as an expiatory chapel for his ancestors [10.40]. The Naumburg choir differs from French architecture in important ways: in the increased proportion of masonry to glass, in the frank statement of weighty mass in the base and supporting piers, in the emotional con-

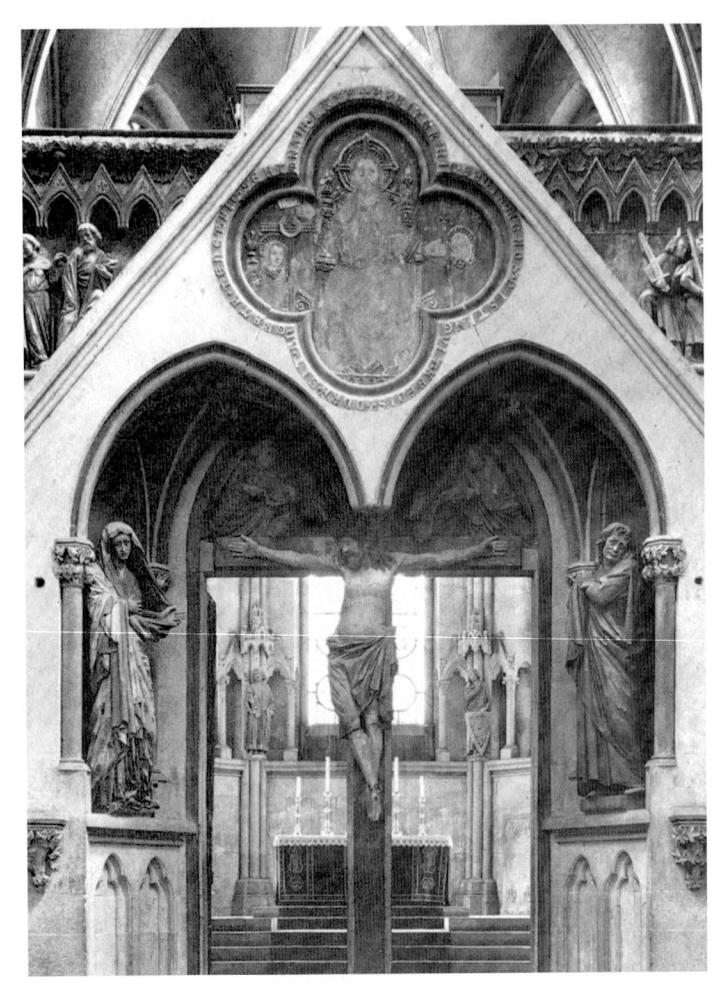

10.40 Choir screen with the Crucifixion. Ditmar and Thimo seen through door, c. 1245–1260. Naumburg Cathedral, Germany.

tent of the iconographical program, and in the realism of the sculptured figures.

Architecture, sculpture, and stained glass unite to express the single theme of sin and atonement. On the choir screen the Passion and Crucifixion of Christ face the congregation in the nave as a constant reminder of the sins of mankind, the sacrifice of Christ, and the coming Last Judgment. On the choir screen, in the narrow, compressed stage space formed by columns and spiky gables, large figures act out the drama of the Passion. The worshipper walks into the choir by passing under the very arms of the crucified Christ and so seems to join the grieving Virgin and St. John. In the grim Crucifixion, the dignity of the Virgin and the pathos of the

dead Christ give way to an almost hysterical grief in St. John, who twists both his body and his face in a spasm of grief. Within the chapel, directly opposite the entrance, stand the two men most in need of intercession—Ditmar, a traitor who died in ordeal by combat, and Thimo, a murderer. Between the windows, members of the houses of Billung and Wettin seem to observe and participate in the Mass. The stained-glass windows portray the heavenly host, which surely the bishop hoped he and his ancestors would join.

At each side of the chapel the original founders of the church and their wives are portrayed: Margrave Ekkehard of Meissen, a proud, doughty warrior, and Uta, the epitome of feminine grace and elegance [10.41]. Uta draws her

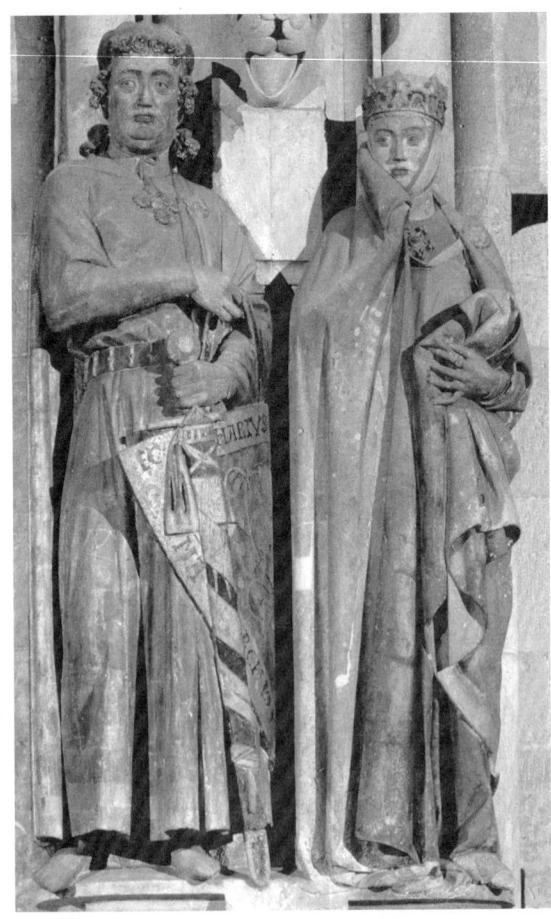

10.41 Ekkehard and Uta, west chapel sanctuary, Naumburg Cathedral, Germany, c. 1245–1260. Stone, originally polychromed, 6ft. 2in. (1.88m).

cloak up to her face in a simple, telling gesture. The broad, heavy fold of her cloak, grasped with delicate figures into a Gothic cascade of mannered folds, represent the most mature and elegant version of Gothic sculpture in Germany, comparable to the art of the Joseph Master in Reims.

In Italy, the single-nave preaching hall was popularized by the followers of St. Francis in Assisi. The Church of St. Francis at Assisi (1228-1253) [10.42] illustrates the Italian Franciscan solution to the problem of inspiring and educating the congregation. It provides an impressive hall with good acoustics, uninterrupted sight lines, and broad expanses of wall for didactic mural paintings. This church in Assisi, however, has an unusual design. It has two stories and a crypt at an even lower level.

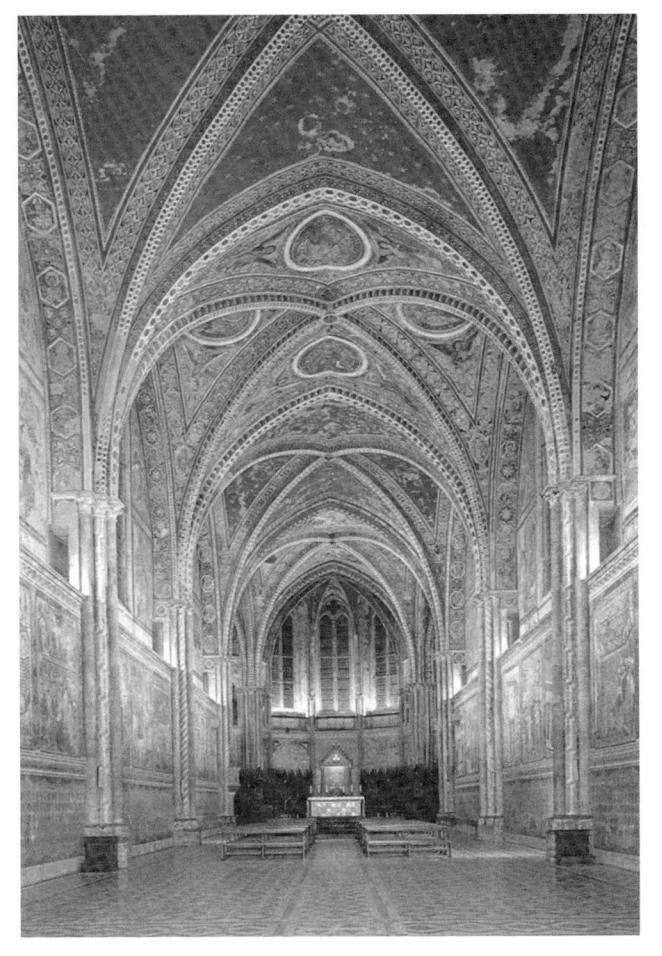

10.42 The Church of St. Francis. Upper church, 1228-1253, Assisi.

Franciscans and Dominicans

Franciscans could be recognized by their dark gray or brown habits and rope belts, whose three knots symbolized their vows of poverty, chastity, and obedience. Their founder, St. Francis of Assisi (c. 1182-1226, canonized in 1230), preached a life of poverty, service, and love. St. Francis's love of Christ was so intense that the stigmata, or wounds suffered by Christ on the cross, are believed to have appeared on his own body. Franciscan emphasis on the emotional aspects of religion found expression in a renewed dedication to the Virgin Mary as an earthly mother rather than Queen of Heaven. Under Franciscan influence the theme of pity (pietà in Italian) appeared in sculpture and painting.

Franciscans became renowned preachers, missionaries, and teachers. Among their most illustrious members were Roger Bacon (c. 1214-1290), "Doctor mirabilis" and defender of the study of experimental sciences, and Duns Scotus (c. 1265-1308), who challenged scholastic philosophers by his insistence on the importance of the works of St. Augustine.

The Dominican Friars were established in 1206 by a Castilian nobleman, Domenico Guzmán (1170-1221, canonized in 1234), as the order of Friars Preachers, Members were also known as Black Friars because they wore a black cloak over a white tunic. The Dominicans became teachers in order to combat heresy by combatting ignorance. Dominicans number among their members some of the greatest scholars of the thirteenth century: Vincent of Beauvais (c. 1190-1264), Albertus Magnus (c. 1200-1280), and Thomas Aguinas (c. 1225-1274). Vincent of Beauvais compiled an encyclopedia of eighty books, the Speculum Maius (The Greater Mirror). Albertus Magnus and Thomas Aquinas applied the intellectual discipline of Greek philosophy to balance the conflicting claims of Christian faith and scientific reason. Aguinas's Summa Theologica (The Summary of Theology), is still the basis for Roman Catholic theology.

In the Summa Theologica, St. Thomas developed a comprehensive system of argument. In St. Thomas's view, since both natural law and revealed truth came from God, they are compatible, and both human logic and faith illuminate the truth. In 1328 the Church recognized the creation of the Summa to be a miracle and canonized its author.

The lower church is a nave flanked by chapels. The upper church, which is the principal congregational hall, is a single open space divided into bays by clustered engaged shafts and ribbed vaults. The heavy walls are set back at the window level to provide for a wall passage running the length of the building, and the upper section of the wall is pierced in each bay with a single two-light window. Painted imitations of architecture and textiles divide the lower wall into a drapery-covered dado surmounted by narrative panels. The extension of the painting over the upper wall and vault turns the actual architecture into an ornamental fantasy. The paintings belong to a later phase of Gothic art [see 11.31].

Sculpture in Italy is focused on church furniture, such as pulpits. The interior decoration of floors, furniture and the shafts of cloister columns with inlays of colored marble in geometric patterns becomes popular in Rome. Many families became outstanding practitioners of this artform, known as Cosmati work [see 8.6].

Much of what was most prized in its own time—the precious jewels, textiles, tableware (the arts of feasting and display), and the movable church equipment such as reliquaries and liturgical vessels—has been lost. Jewels and precious metals are stolen or taken and formed into new treasures. Wood easily burns. The most highly prized arts, the woven and embroidered textiles, are fragile and easily destroyed; they are best described for the faded fragments barely stimulate our imaginations.

THE ART OF THE FRENCH COURT AND THE RAYONNANT STYLE

The royal residence in Paris, as recorded in a Book of Hours made for the king's brother by the Limbourg brothers about 1415, shows the palace, the tops of the plantings in the queen's garden, and the palace chapel, secure behind walls and the River Seine [10.43]. The court of Louis IX provided ample work for artists, but so did the city of Paris itself with its university, cathedral, many abbeys and parish churches, and increasingly wealthy middle class. By mid-century, artists and architects

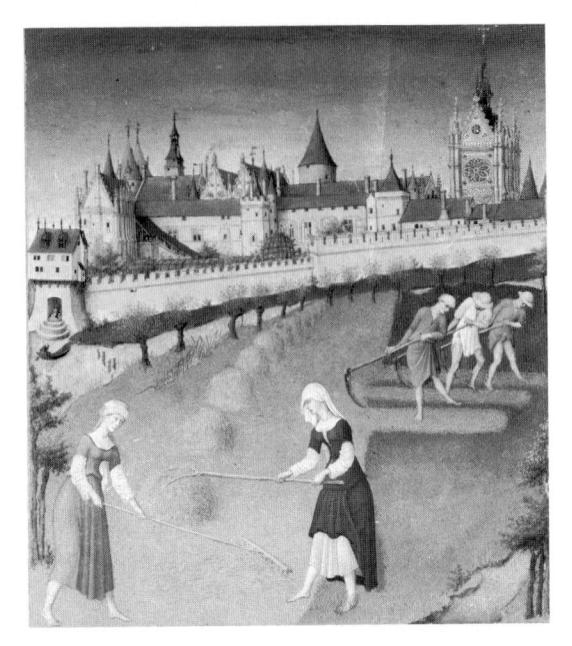

10.43 The Limbourg Brothers (active 1390–1416): June, Royal Palace with the Ste. Chapelle, *Très Riches Heures* of the Duke of Berry, France, c. 1415. 11 1/2 x 8 1/4in. (29.2 x 21cm). Musée Condé, Chantilly, France.

created a new style attractive to the sophisticated courtiers and independent merchants.

Architects moved in new directions, first by refining traditional elements, and then by experimenting with new relationships of solid and void, structure and ornament. As befits a style developing around a royal court, an ideal of elegance seems to permeate the architecture, sculpture, and painting. Subtlety and refinement together with technical virtuosity give to all the arts of the period an intellectual as well as a sensuous appeal. In the Court Style, also known as the Rayonnant, masonry walls seem to disappear, to be replaced by glowing expanses of stained glass divided and framed by thin, clusters of column shafts and overlaying patterns of tracery. The new style has been called (by Robert Branner) the Court Style because of the intimate association of its major monuments—St. Denis, Ste. Chapelle, and the Cathedral of Notre-Dame with the Parisian court of St. Louis.

One of the first projects to be executed in the new style was the completion of the Abbey Church

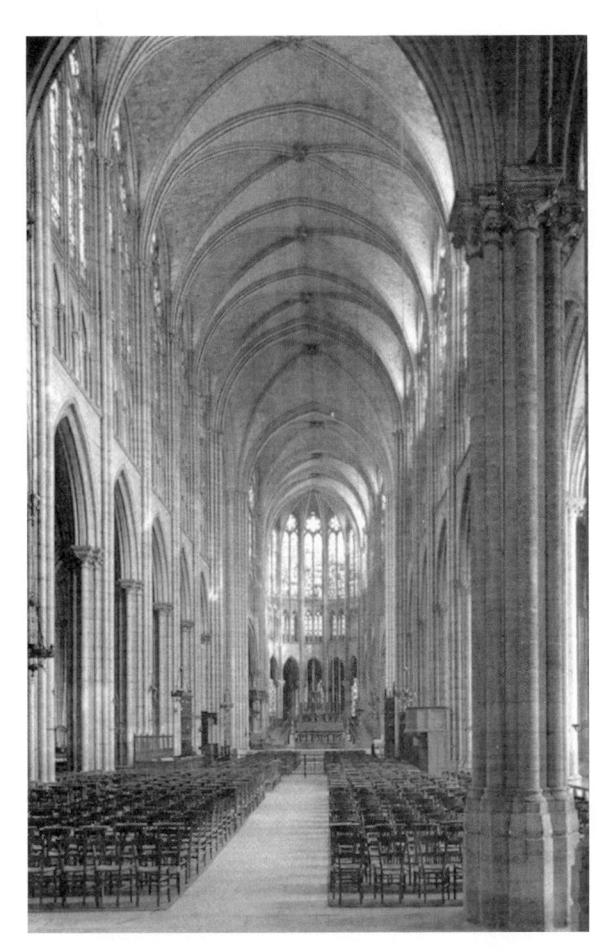

10.44 Interior of nave, Abbey Church of St. Denis. 1231-1281.

of St. Denis [10.44]. In 1231 work began again on the choir, and the completed church was dedicated in 1281. Although the designs of the upper choir, transept, and nave are based on the Cathedral of Amiens, so beautifully does the thirteenth-century work harmonize with the twelfth-century narthex and lower choir that today the viewer is hardly aware of the intervening century. Pierre de Montreuil was recorded as the architect, but most scholars agree that the work must be attributed to an anonymous "Master of St. Denis."

The court architects also modernized earlier buildings, such as the Cathedral of Notre-Dame in Paris. By the 1220s Notre-Dame must have seemed dark and old-fashioned. Beginning about 1225, the clerestory of the nave was enlarged by combining the third-story oculi and the fourthstory lancets into single traceried windows, thereby increasing the level of illumination and converting the interior into a "modern" three-part elevation [see 9.16]. Chapels were added between the buttresses (1236-1245) and around the choir in the 1270s, and the transept façades were rebuilt by Jean de Chelles at mid-century.

In 1265, Pierre de Montreuil took over the position of master of works for the cathedral. His role in architectural projects in and around Paris and the relation of his work to that of the Cormont family from Amiens has been the subject of lively debate among scholars. At one time, Pierre was thought to be the leader of the Parisian Court School, and the Ste. Chapelle was attributed to him. However, it has been argued that Thomas de Cormont left Amiens to work for the French court and that the palace chapel is his creation. Certainly the court chapel and the Amiens choir have much in common.

In 1243 King Louis had ordered the exquisite Ste. Chapelle as a palace chapel to house the relics of the Crucifixion: the crown of thorns, a bit of the lance that pierced Christ's side, the sponge, and a fragment of the True Cross. The king had purchased these treasures in 1239 from his cousin Baldwin of Flanders, who was then ruling as emperor in Byzantium. The building consisted of two parts: an upper chapel [10.45] connected to the king's private apartments and reserved for royal use and the display and protection of the relics, and a lower chapel dedicated to the Virgin, which was used as a parish church by members of the royal household. With its encrustation of sculpture, painting, gilding, and glass, the chapel must have been the epitome of courtly splendor when it was completed in 1248. Robert Branner justly likened it to a giant reliquary "turned outside in."

The upper chapel is a simple, open room twice as high as it is wide, having an entrance loggia and a polygonal east end. Above a blind-arcaded base, piers with clustered shafts sweep up into the ribs of the vault. The piers and tracery form a skeletal network supporting the glass of the walls and the web of the vault; in other words, the wall has become a translucent screen of tracery and stained glass.

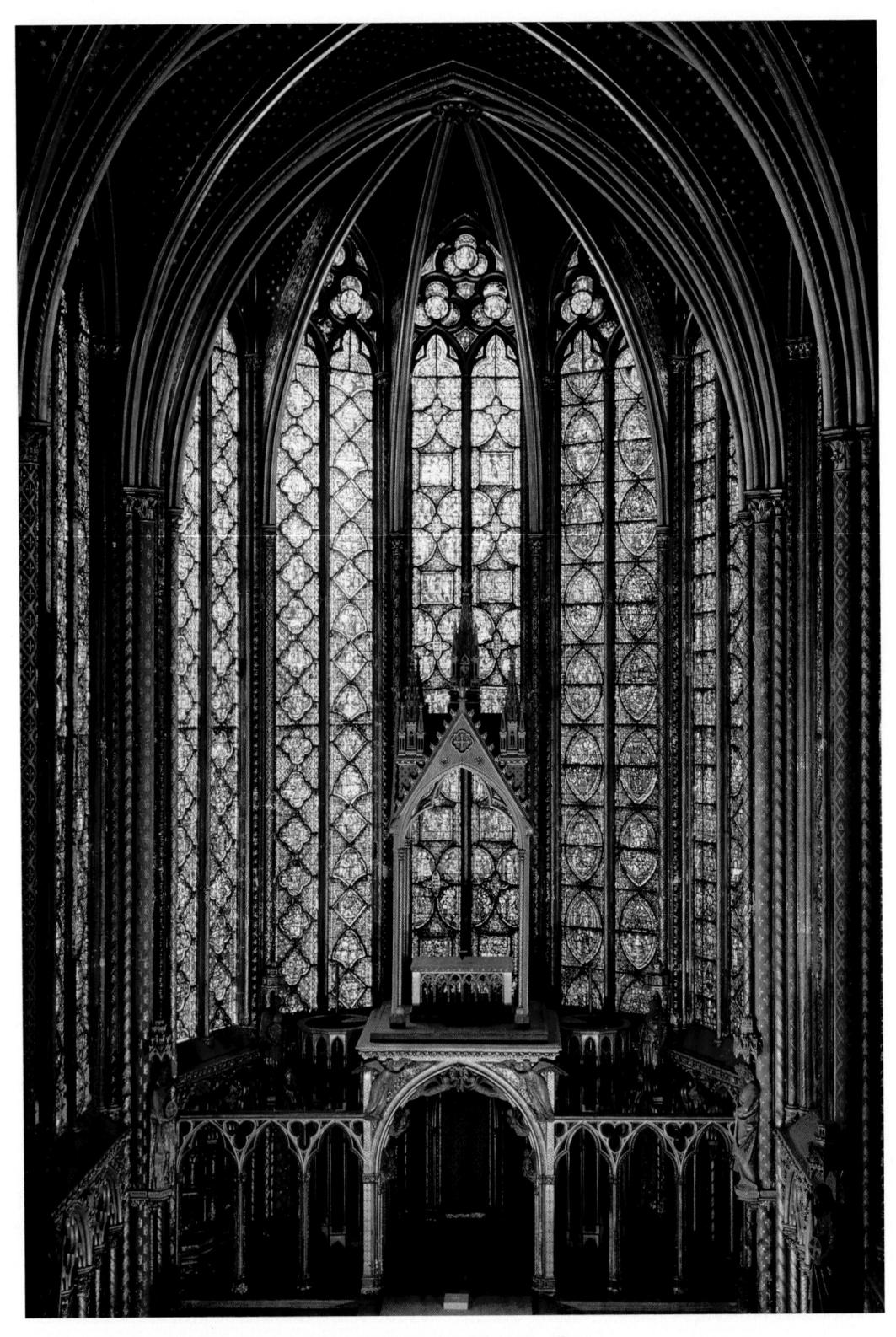

10.45 Interior of upper chapel, 1243–1248. Sainte-Chapelle, Paris.

Sculptured figures of the twelve apostles on the piers link the painted and gilded lower wall to the stained-glass windows above. The windows are glazed with deep red and blue glass so that sunlight fills the interior space with violet light. Small scenes set in repeated medallions against diapered backgrounds are framed with heraldic devices, such as the castles of Castile for the Queen Mother, Blanche. Although the rapid construction of the windows encouraged repetition of motifs and scenes, as a composition in colored light and as a sensual experience, the Ste. Chapelle is an unqualified success.

On the exterior of the chapel [see 10.43], wall buttresses terminating in pinnacles mark each bay of the tall, narrow structure. Each window is framed by an arch that rises up into the gable, which in turn breaks through the roof line. This interpenetrating pattern of gables and arches became a popular decorative framing device in all the arts. The original rose window of radiating fields of tracery can be seen in the miniature painting. Popularized by the French court, the Rayonnant Style soon spread throughout western Europe.

Parisian workshops produced splendid illustrated books for secular patrons as well as the church, and noble and royal bibliophiles assembled great private libraries. Commercial workshops sprang up in Paris, and buyers no longer depended on monastic scriptoria. In order to supply the increased demand for fine books, masters hired many scribes and painters who became specialists within the shop, able to answer the demands for more and more books. The masters, unlike the anonymous monks of earlier scriptoria, were secular artists whose careers can be traced in the legal and business records of Paris and the French court—tax rolls, contracts, sales, and inventories.

In the Psalter made for St. Louis [10.46], architectural motifs from the exterior of the Ste. Chapelle—interpenetrating arches and gables, large rose windows—frame the narratives. Events occur on a narrow stage, acted out by slender but wellmodeled figures. Like other Gothic artists, the manuscript illuminators worked within architectural constraints; figures lie as clearly within the frame

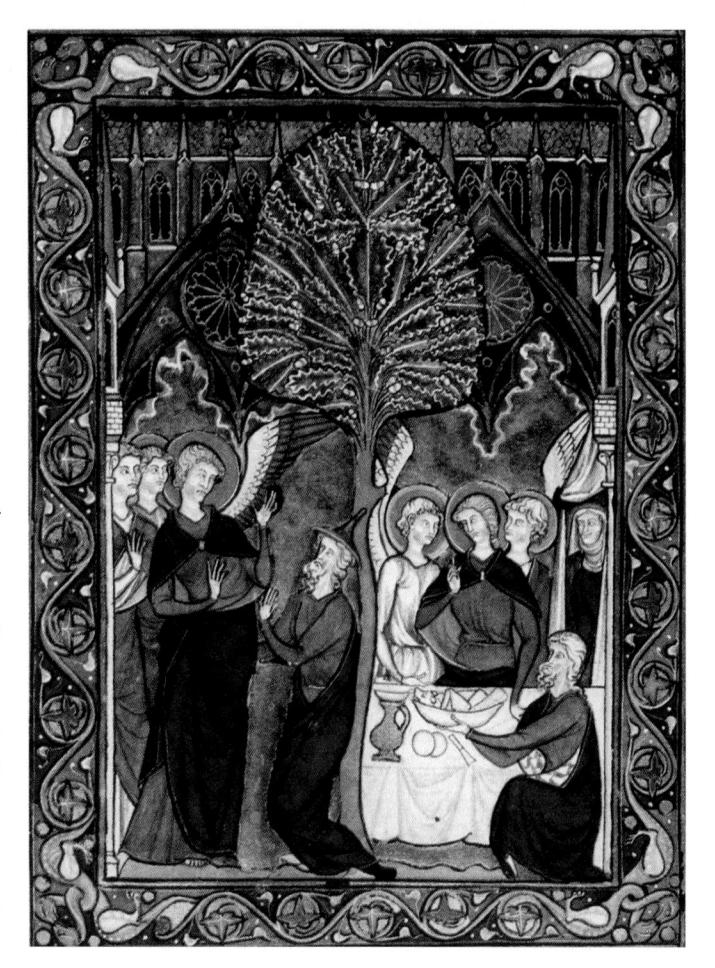

10.46 Page with Abraham, Sarah, and the Three Strangers, Psalter of St. Louis, Paris. 1253-1270. Ink, tempera, and gold leaf on vellum, 5 x 3 1/2in. (136. x 8.7cm). Bibliothèque nationale, Paris.

and on the plane of the vellum folio as do jamb figures in the architecture of the portal. They may move and gesture gracefully within a setting established by miniature landscape and architectural elements. The hint of realism in the oak of Mamre with its distinctive leaves and acorns, like the foliage sculpture of Amiens and Reims, is a realism of detail not of overall form or underlying essence.

The Rayonnant Style triumphs in the west front of the Cathedral of Reims (c. 1230/1254-1287). The façade at Reims as we see it today, like the choir at Amiens, introduces the new sensibility [see 10.11]. Deep porches lavishly decorated with sculpture emphasize the entrance and provide a

stable base for the intricate spatial composition above. Stained glass, with its impressive interior effect, supplants sculptured tympana; and inside the nave the west wall becomes a giant trellis of niches filled with sculptured figures punctuated by the rose windows. Sculpture unites the portals and porches on the exterior as well. Porches with magnificent sculptured gables disguise wall buttresses; and tracery and relief sculpture cover the buttresses of the outer walls. At the level of the rose, the buttresses become spired tabernacles, and the semitransparent towers are pierced with open traceried lancets through which the diagonal lines of the flying buttresses of the nave can be seen. The façade becomes a reaffirmation of Gothic delight in complex linear articulation of space and interpenetrating spaces and forms. The rose window seems to float above and behind the central gable, where under a filigree of turrets, Christ himself crowns his mother. The kings' gallery above the rose masks the gable of the nave and also ties the towers into the composition by providing a dense, horizontal element. Had spires been completed over the tall open towers, the verticality and apparent weightlessness of the design would have made the stabilizing breadth of the sculptured portals essential to the harmony of the composition.

On the reverse façade, the life of the Virgin (left) and the story of St. John the Baptist (right) flank a portal where a rose window replaces the tympanum sculpture [10.47]. In ascending order, history and prophecy reinforce each other, alternating with bands of almost realistic foliage. Narratives are reduced to single or paired figures dressed in contemporary costume. They move with ritualized gestures: Melchizedek celebrates the Mass; Herod and Herodias strike arrogant poses, Herodias, the embodiment of evil. Proud and defiant, she confronts John the Baptist, and in this world she emerges the victor—for she will be presented with his head.

APPROACHES TO GOTHIC ART

Writers have defined and redefined the Gothic style. Inspired by Johann Wolfgang von Goethe's

praise of Strasbourg Cathedral, in the nineteenth century, Romantics saw in the Gothic cathedral an architecture whose vertical proportions, accented by pointed arches, slender piers, and intricate tracery, created a soaring space and engendered in human beings intuitions of the sublime. Nationalists found in the Gothic style a Northern Germanic aesthetic, a will-to-form inspired by the vast Northern forests. In contrast, architects and engineers such as Eugène Viollet-le-Duc looked at the masonry of the buildings and saw the pointed arches and ribbed vaults stabilized by flying buttresses weighted by pinnacles as the epitome of rationality.

In the twentieth century, Henri Focillon and Jean Bony wrote of skeletal structures created to mold space, and Paul Frankl, in a brilliant reversal of Focillon's definition of the Romanesque "additive" aesthetic, suggested that the Gothic style was one of "creation by division." The Gothic cathedral was seen as a complete statement of Christian history and belief: For Émile Mâle it was a Summa Theologica and a Speculum in stone and glass; for Hans Sedlmayr, the House of God and the New Jerusalem; for Erwin Panofsky, the demonstration of Scholastic principles and methodology in tangible form. Otto von Simson found in its geometric proportions and luminosity the expression of Augustinian mysticism. Louis Grodecki found that light as form and symbol, transfiguring space, remained essential to the definition of Gothic.

Today while archaeologists excavate foundations and engineers calculate thrusts and the force of wind, historians search archives to document financial and workshop organization and the careers of patrons and builders. The liturgy and the music of the church inspire as much interest as the light of stained-glass windows; and church furniture, vessels, and reliquaries are given the attention once reserved for architecture and architectural sculpture. All the arts of the thirteenth century, but especially stained glass, ivory carving, enamels, and manuscript painting, are studied as assiduously as the monumental arts. And secular art and building and even the ephemeral arts of the garden, spectacle and pageant, and household arts of daily life have inspired scholarly attention.

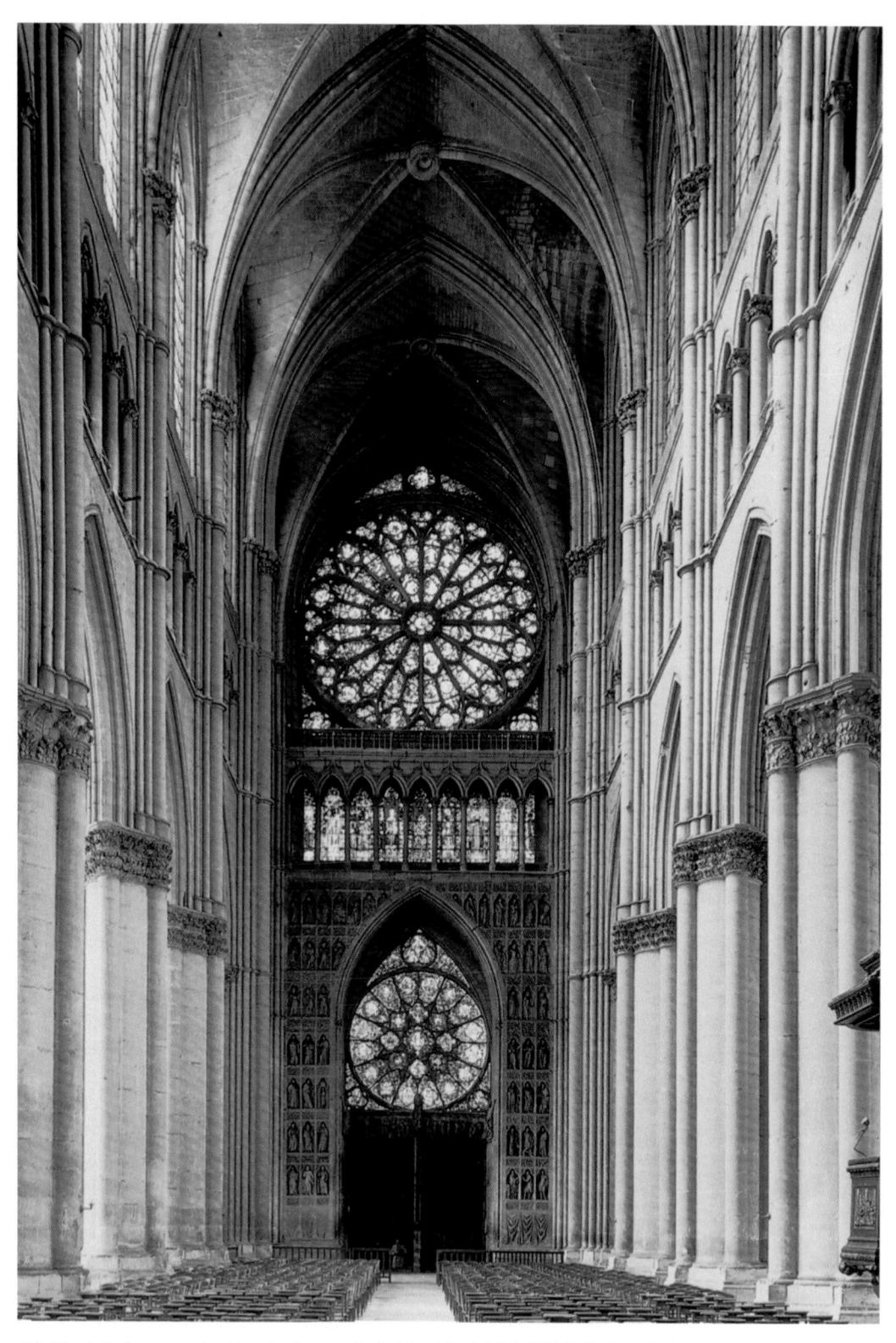

10.47 Interior, nave looking to the west, finished by 1286–1287, Reims Cathedral.

The Royal Ideal: The Gothic Reaction to the Romanesque

The story of Medieval art, history, and culture could be told as one of triumph of unity over diversity, as a struggle between forces for nationalism represented by the king and regionalism represented by his nobles, and in the arts by supplanting the Romanesque style with the Gothic. Romanesque art reflected the ruthless energy of the 11th and 12th centuries. Gothic art suggests the growing peace and prosperity stimulated by royal authority that reduced local warfare and brigandage, favored the growth of towns and the artisan/merchant class, and shifted intellectual leadership from rural monasteries to universities in the cities.

As the kings of France and England asserted control over their vassals, the arts of peace took precedence over the arts of war. Resources could be directed away from the building of fortifications to the churches, palaces, and civic buildings rising in the increasingly rich and influential cities. Peasants could bring in their crops and artisans produce their goods unmolested by robber barons. Merchants and traders created new wealth, and scholars and artists flourished. Both the church and the lay community in the towns had the resources to express their piety and civic pride by supporting buildings programs of stunning magnitude, complexity, and magnificence.

In theory, the king owned and ruled the land as God's representative. He defended the realm from external enemies and maintained peace, dispensed justice, and settled disputes within the kingdom. Royal authority was an ideal, and the title "king" did not guarantee power or wealth. In fact, the great nobles often took over the rights and duties of the king. Nevertheless, the Church endowed kingship with moral authority through the ceremonies of coronation and consecration, creating a king by divine right and the grace of God.

Feudalism, the political system of the Romanesque and Gothic periods in Europe in which great estates were exchanged for military service, had originated to provide basic protection and resolution of disputes. However soon the landholders took over the powers that in theory belonged to the king, that is, a militia and a court of law. By the 12th century, intelligent and energetic kings like Philip Augustus of France and Henry Plantagenet of England established their authority. Forces for unity, centralization, even nationalism, supplanted the diversity and regionalism found in the earlier periods.

Gothic art flourished under royal as well as ecclesiastical patronage as the Kings and Queens of France and England, and later of royalty from Castile to Bohemia, directed part of their wealth to building enterprises and the arts. The massive walls and piers, the enclosing vaults, the mural painting, and round headed windows of the Romanesque style gave way to walls of colored glass, piers of linear clustered colonettes, soaring spaces with intricate diagonal sight lines and ever larger windows filled with tracery, painted, and stained glass. The Romanesque style reflected the regionalism of the feudal age where every locality had its own traditions and course of development. Themes, media, and design all reflected a world filled with terrifying fantasy.

Gothic artists worked toward simplicity and clarity—whether ribbed vaulting of the architecture or the representation of the human figure in the visual arts. They aimed to achieve a mathematical perfection that also included an ever-greater observation of the material tangible world. Architecture remained the queen of arts, the underlying controlling force, the scaffold on which painting and sculpture depended whether on actual building or the architectural structure of a capital letter in a manuscript. Builders of royal palaces for kings and queens, architects and artists, also strove to create the image of the heavenly Jerusalem on earth, glowing and light-filled fantasies of soaring spires and towering portals covered with figures depicting stories from the Bible and legends of the saints. Once inside the church, stained glass windows turn the space into shimmering colored light where the worshippers joined images of the Virgin and Child and the saints. The music of the plainsong and the perfume of incense assailed the senses. Through this sensuous space move kings and clergy whose cloaks, embroidered with colored silks and gold and silver threads, turn them into a part of the visual and architectural environment; royal and ideal human elements in the Gothic style.

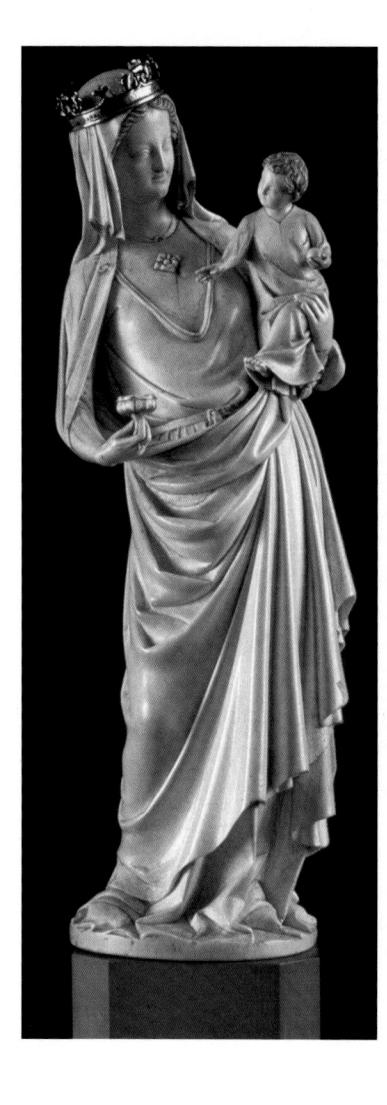

11.1 Virgin and Child, Abbey Church of St. Denis, Paris, c. 1260–1280. Ivory, 13 1/4in. (34.8cm). The Taft Museum.

CHAPTER T

RAYONNANT GOTHIC AND ITS REVERBERATIONS

othic art and architecture may always be associated with St. Louis and the Capetian dynasty of France. The Rayonnant Gothic art of the middle years of the thirteenth century is even referred to as the Court Style. The dynasty continued successfully under St. Louis's successors, Philip III the Bold (1270–1285) and Philip IV the Fair (1285–1314). Then in the fourteenth century, problems arose: The economy slowed; disputes with the Papacy led to the so-called Babylonian Captivity with the Pope residing in Avignon (followed by rival popes in Avignon and Rome); and finally political instability as the crown passed from brother to brother, each of whom died after a short reign without an heir—Louis X (1314–1316),

Philip V (1316–1322), and Charles IV (1322–1328). In 1328, Philip of Valois ascended the throne, ending 340 years of Capetian rule. Edward III of England also claimed the French throne, resulting in the Hundred Years' War between France and England.

How kings and bishops must have envied the luminous soaring buildings of France! In the second half of the thirteenth century, royal, ducal, and episcopal courts all over Europe emerged as centers of patronage. French masters replicated the Gothic splendors of Paris, Amiens, and Reims. In London, Henry III emulated Louis IX as a patron of the arts, and from Naumburg in Germany to Burgos and Toledo in Spain, local master builders replicated

and modified the *opus francigenum* with unabashed enthusiasm. Using local materials and building techniques, they created new regional styles. In an age that ended with the disastrous Black Death, beginning in 1347, men and women found the courage, resources, and faith to build magnificent churches, chapels, and palaces and to fill them with treasures.

THE LATER RAYONNANT STYLE

The Court Style of Paris spread through France and neighboring countries in the later years of the thirteenth century. Private commissions of chapels and parish churches, rather than huge cathedrals, and luxury arts, rather than monumental sculpture and painting, dominate the arts. Figures made of precious materials like ivory and intended to be used for private devotions became popular. An early (1260-1280) example is the elegant Virgin and Child, once in the treasury of St. Denis [11.1]. A new theme appears; now Mary is a youthful mother admiring her baby rather than a regal Queen of Heaven. This Gothic princess, with her oval face, high forehead, small sharp features, and almond eyes, could be a beauty from the Parisian court. The sculptor exaggerated the formula of swaying stance, smiling tilted head, and billowing drapery, and enhanced the S-curve of the figure with such broad sweeping folds that the drapery alone seems to support the Child. Made of rare luxury material and delicately tinted, gilded, and bejeweled (she has lost her medieval jeweled crown and brooch), the sculpture reminds us that in the thirteenth and fourteenth centuries Paris was the center of the production of luxury items for both secular and ecclesiastical courts in western Europe.

The new Rayonnant Style soon spread from the Île-de-France through Europe. As an architectural style, the Rayonnant period has two phases: the first, associated with the Parisian court of St. Louis, and the second, exemplified by the Church of St. Urbain at Troyes in eastern France [11.2]. In Troyes Pope Urban IV (1261–1264) founded a church on the site of his birthplace (his father's cobbler's shop) and dedicated it to his patron saint, St. Urbain. The

architect, Jean Langlois (John the Englishman?), inaugurated a new phase of the Rayonnant Style characterized by a fanciful use of Gothic architectural forms produced by crisp precise stone cutting that gives an almost metallic effect. The interior of the church is brilliantly illuminated by huge windows filled with pale stained glass [11.3]. For the Church of St. Urbain, built between 1262 and 1270, John Langlois designed a simple three-aisled building with a square transept and a choir of two bays ending in a polygonal apse flanked by polygonal chapels [11.4]. Two bands of windows enclose the apse: The first story is a traceried passageway with a glazed outer wall; the second is a huge clerestory. Continuous repeated tracery patterns flowing over masonry walls and glazed openings alike unite the two stories. Engaged shafts turn piers into clusters of rippling moldings; their insignificant capitals allow the channeled shafts to flow unbroken into the ribs of the vault. Light streaming in through pale glass illuminates the tracery, moldings, and interior sculpture. Like the Ste. Chapelle, the choir of St. Urbain is a glass cage, but the color and quality of the light now has changed from a mysterious royal purple to the silvery light of day.

At St. Urbain the glass may have been begun at the same time as the building and may have been finished by 1277. The expectation of patrons and the skills of artists in combining grisaille and col-

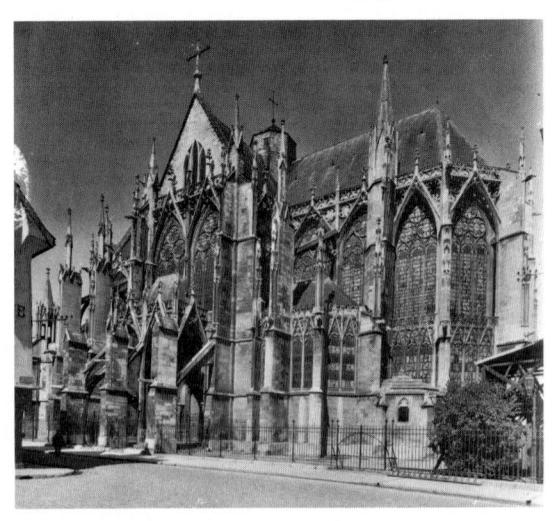

11.2 Church of St. Urbain, Troyes, 1262–1270, rebuilt after 1266.

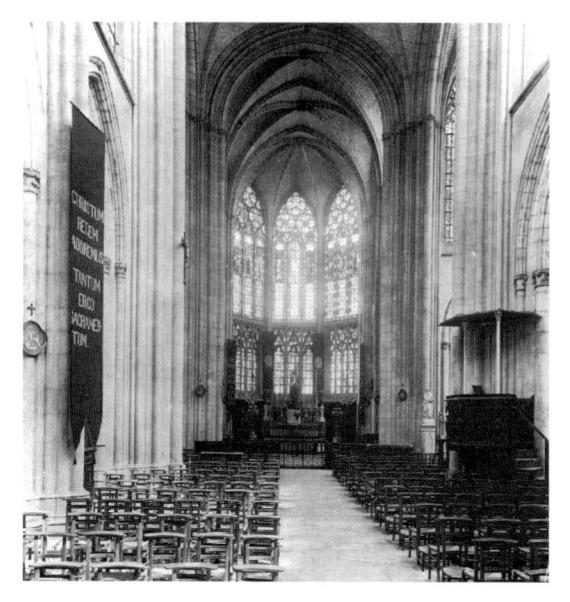

11.3 Interior, Church of St. Urbain, Troyes.

ored glass produced dramatically different interior effects. Grisaille glass—clear glass painted with geometric patterns or foliage in black or dark brown had been used when windows had to be glazed rapidly and economically. Abbot Suger's artists at St. Denis worked in grisaille as well as color, and this glass was even approved of by St. Bernard and the Cistercians. Some of the finest is to be seen in the fourteenth-century windows in the Church of St. Ouen in Rouen [11.5]. In the later years of the thirteenth century, artists and patrons chose grisaille glass to complement interiors enriched with intricate tracery and painted sculpture. Artists also combined the traditional techniques of glazing by inserting stained-glass panels of figures into grisaille windows to form horizontal bands of color. The colored panels, surrounded by delicately patterned grisaille, satisfied the desire for rich color and narrative at the same time the grisaille allowed an increased amount of light in the interior.

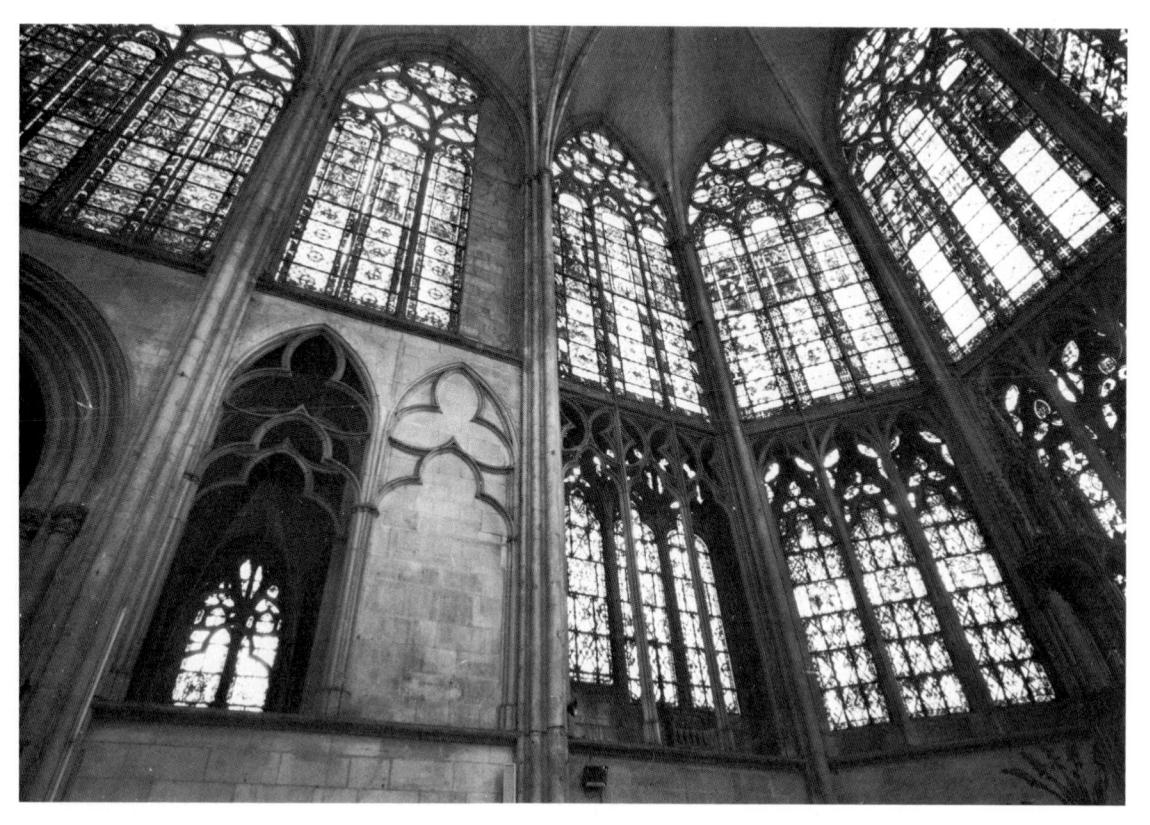

11.4 Interior, Church of St. Urbain, windows c. 1270 and later.

11.5 Stained-glass window, with grisaille decoration. c. 1325. Potmetal and colorless glass, with silver stain and vitreous paint: 10ft. 7 1/2 x 35 1/2in. (323.9 x 90.2cm). Abbey Church of St. Ouen, Rouen. The Metropolitan Museum of Art, The Cloisters Collection.

The discovery that silver oxide could produce a wide variety of shades of yellow from pale lemon to rich browns had added to the aesthetic possibilities available to the glaziers [11.6]. Artists painted on larger panels of glass and so reduced the amount of leading; consequently fewer dark lines broke up the surface of the window. Flashed glass, in which one color was coated with another to lighten, darken, or change the original color, had made more variations possible, but now even brighter colors could be made easily—pinks by coating clear glass with ruby red, or brilliant greens from blue glass flashed with yellow. Pale silvery whites and lemony golds replaced the deep colors of the twelfth and thirteenth centuries. The spacious, well-lit, and richly decorated interiors of the Rayonnant buildings in the later thirteenth and the fourteenth centuries provided a new impetus for independent sculpture and painting.

In the fourteenth century, Paris remained the center of luxury arts, gold and enamel work, fine

11.6 The Annunciation and Visitation c. 1330, Abbey Church of St. Ouen, Rouen.
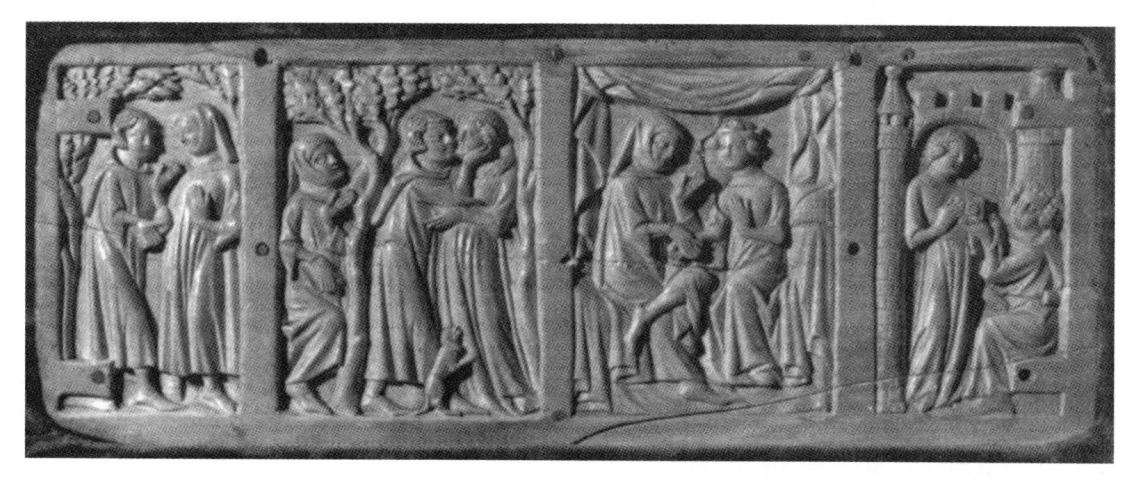

11.7 La Châtelaine de Vergi, first half of the 14th century. Ivory, 3 1/2 x 9 1/2in. (8.9 x 24.1cm). Spencer Museum of Art.

manuscripts, jewelry, and clothing. The elegance and small scale of work in precious materials—gold, silver, enamel, ivory—appealed to aristocratic private patrons, who ordered objects for secular use, such as pendants, belts, clasps, goblets, ewers, basins, and knives as well as prayer books and shrines for private worship. Ivory carvers produced mirror backs, combs, and jewel boxes as well as devotional images like the St. Denis Virgin and Child. Often these deluxe objects were carved with scenes from the new vernacular literature. The literate upper class enjoyed tales of intrigue and romance, such as the story of Tristan and Iseult in the Roman de la Rosa (Romance of the Rose). [See Box: Roman de la Rosa.]

The tragic love of the Châtelaine de Vergi [11.7] provides the subject for an ivory box. The meeting of the Châtelaine (or lady of the manor) and her knight is witnessed by the duke of Burgundy, and in the third scene the jealous duchess pries the secret from the duke. She sends the Châtelaine an invitation to a dance, where all will be revealed, leading to the lovers' suicide. In the ivory carver's shorthand, the representation of a few trees indicates a forest or orchard, and a swag of drapery the private apartments of the duchess. Such condensed narratives were possible, for these were well-known tales and the artist was a skilled story-teller.

The gilded silver reliquary statue of the Virgin and Child, dated 1339 and presented to the Abbey of St. Denis by Queen Jeanne d'Evreux, the widow

Guillaume de Machaut

Guillaume de Machaut (c. 1300-1377) is generally regarded as the leading French composer of the fourteenth century. A poet as well as a musician, he wrote both lyrics and music, composing about 420 lyric poems as well as eight long narrative poems, twenty three motets, many shorter works, and the earliest surviving polyphonic Mass written by one composer. He wrote in both Latin and French.

Guillaume took care with the preservation and visual presentation of his works as well as their musical performance. He evidently personally oversaw the preparation of the manuscripts containing individual and collected works, organizing them chronologically. The manuscripts are beautifully illuminated. The illustrations include portraits of the author, sometimes at work and often assisted by personifications of Nature, the Virtues, and the Arts. In the most famous, Madam Nature presents her daughters to Guillaume.

of Charles IV, illustrates the fine craftsmanship and conservative style of royal goldsmiths [11.8]. Again Mary appears as a loving human mother as well as the majestic Queen of Heaven. Her delicate features shine with timeless beauty, yet their melancholy cast suggests that she contemplates her son's fate on earth, even as Jesus reaches up to caress her

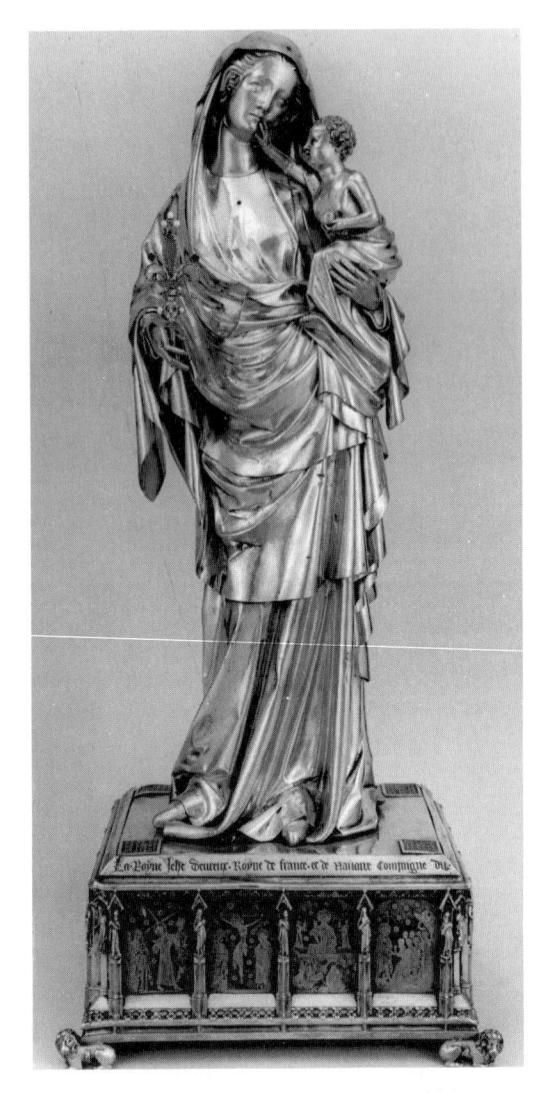

11.8 The Virgin of Jeanne d'Evreux, 1339. Silver gilt with basse-taille enamel. The Louvre, Paris.

face. Mother and son seem isolated by the enveloping folds of the mantle and veil, an effect of enclosure perhaps felt less when Mary still wore her golden crown adorned with sapphires, garnets, and pearls. She still carries a rock-crystal, jeweled fleur-de-lis—the symbol of the French monarchy as well as a sign of Mary's purity—which serves as a reliquary container for strands of the Virgin's hair.

The rectangular base of the reliquary rests on four crouching lions and bears a dedicatory inscription and the royal arms. Miniature buttresses

decorated with tiny figures under gables divide the sides of the base into 14 rectangular panels enameled with scenes representing the Life and Passion of Christ. The familiar story begins on the right side with the Annunciation, continues on the back and left side, and finally on the front it concludes with Christ carrying the Cross, the Crucifixion, Resurrection, and Descent into Limbo. Delicate figures, whose appearance owes much to the painter Jean Pucelle [11.9], act out the sacred drama against a ground of translucent blue and green enamel enriched with golden flowers with opaque red centers. The artist achieves an effect allied to grisaille paintings by reserving the figures, engraving them, encrusting them with enamel, and then gilding them to create the appearance of drawing in color on gold. A new technique, known as basse-taille (very low relief) enamel, became popular in the fourteenth century. Translucent enamel is applied over the modeled surface of the plate and appears deeper in color where it collects in the recesses and consequently shades to a deep color. The technique produces an effect that is both delicate and rich, subtle yet brilliant.

Charles IV ruled for only a short time (1322-1328), but he did commission a masterpiece of fourteenth-century painting, the Book of Hours by Jean Pucelle (1325-1388) that he gave to his wife [11.9]. The book can be dated between 1325, when Jeanne d'Evreux and Charles married, and 1328, when Charles died (Jeanne lived on until 1371). Jean Pucelle was mentioned in the queen's will. Jeanne's Book of Hours is personalized by the inclusion of the Hours of St. Louis. Only 40 years after his canonization, the king had become a popular saint with the ladies of the French court.

Jean Pucelle, in making this luxurious prayer book, having 25 full-page paintings and many historiated initials and line endings, revitalized Parisian book illustration. He worked in a modified grisaille technique, using ink washes but adding flesh tones and light background colors and picking out a few details in red, blue, or pink. He painted

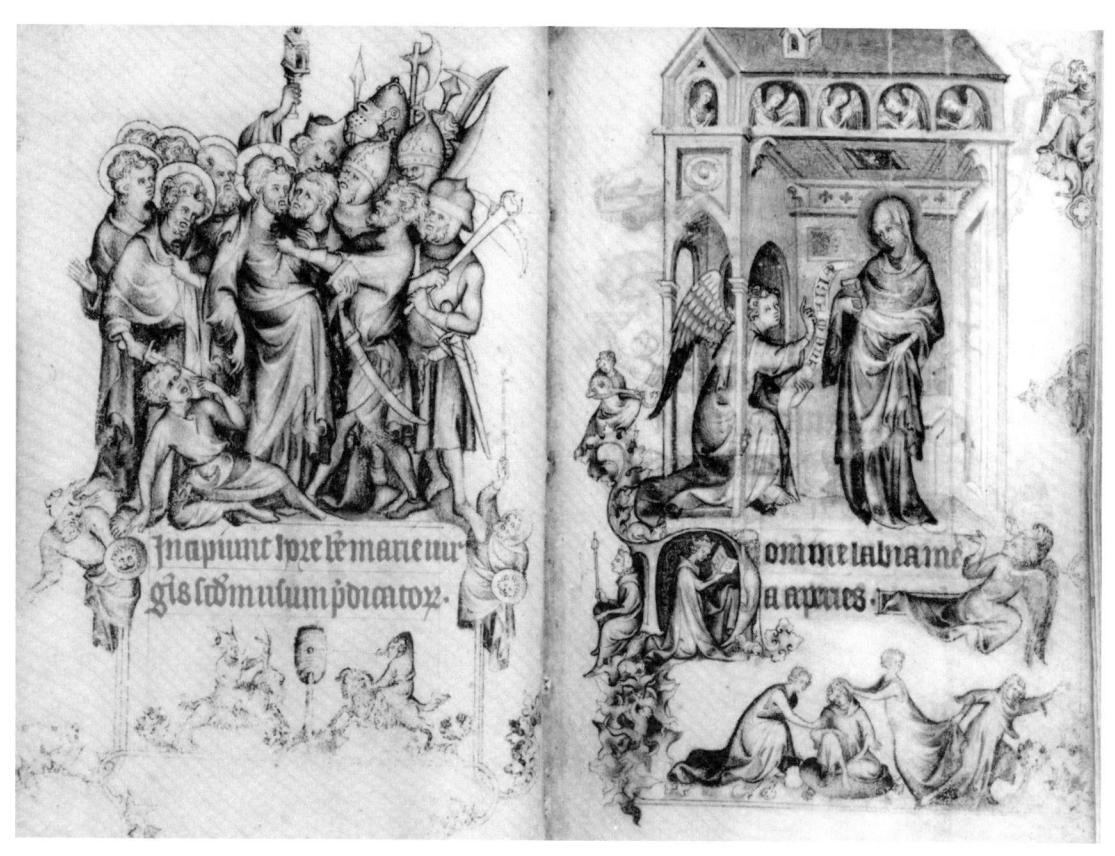

11.9 Annunciation, Betrayal, in the Book of Hours of Jeanne d'Evreux, Paris, 1325-1328. Painted by Jean Pucelle. Miniature on vellum. The Metropolitan Museum of Art, The Cloisters Collection.

both folios of an opening, juxtaposing scenes from the Life of the Virgin and the Passion of Christ. This foreshadowing of torture and death in even the most joyous scenes creates a somber atmosphere consonant with Pucelle's choice of the grisaille technique. In one opening, the paired images of the Annunciation and the Arrest of Christ introduce the prayer for matins. The Virgin receives the angel Gabriel in her home as the dove of the Holy Ghost flutters through an opening in the paneled ceiling and angels rejoice from the upper windows. In the initial the queen kneels with her book, guarded from unwanted visitors by a youth with a club, or, in another interpretation, a man with a candle. Both the guarded door and the lighted way would be appropriate for a queen praying to the Virgin Annunciate. The letter "D" sprouts foliage and supports a musician and a monkey. In the lower margin, known as the bas-de-page, the energy of the angels seems to spread to the children playing Froggy in the Middle, a game that in the Middle Ages symbolized the mocking of Christ. This lower scene relates to the opposite page, where Judas and the Roman soldiers crowd around Christ. One fellow helps Judas identify Christ by holding a lantern up over Christ's head. Judas embraces Christ and Peter cuts off Malchus' ear. In the border image below, figures riding goats mock knightly jousts.

Pucelle borrowed widely but selectively, and by assimilating ideas from England, Italy, and his own French predecessors, he created a distinctive, harmonious personal style. The mixture of religious narrative with secular allegory, the fantasy of the grotesque and foliate borders, and the supplementary bas-de-page reflect English painting. The new spaciousness, especially the architectural interior rendered in linear perspective, was Italian in origin, and may be traced to Duccio's *Maestà* altarpiece of 1308–1311 [see 11.38]. Inspired by Italy, Pucelle increased the depth of modeling in his painting, although he still retained the linear surface patterns characteristic of Gothic art. Subtly modeled, voluminous draperies gathered up into swags of elegant rippling folds hide graceful, swaying figures. Queen Jeanne d'Evreux's Book of Hours provides an elegant and royal culmination for this courtly art just before the ravages of the Black Death and the Hundred Years' War temporarily stifled French creativity. By mid-century, new artistic centers in England, Germany, Spain, and Italy challenged French leadership in the arts.

ENGLAND AND THE DECORATED STYLE

In England, Henry III (1216-1272) inaugurated a new period of royal patronage of the arts and a new wave of French influence when he rebuilt Westminster Abbey in self-conscious competition with his brother-in-law Louis IX. Henry's son Edward I (1272-1307) turned his attention from art to the efficient administration of his realms. For example, to incorporate Wales into the kingdom, he made his young son Prince of Wales—the title still held by the heir to the British throne. Nevertheless, he commissioned a remarkable series of memorials to his queen, Eleanor of Castile. Soon regional centers began to flourish. During the reigns of Edward II (1307-1327) and Edward III (1327-1377) creativity and patronage of the arts moved from London to Exeter and Gloucester in the west or Lincoln and York in the north.

In 1245, only two years after St. Louis began to build the Ste. Chapelle in Paris, Henry started rebuilding Westminster Abbey in London to house the shrine of Edward the Confessor. The architect, Henry of Reynes (active 1246–1253), replaced the Norman apse of the abbey with an ambulatory and radiating chapels in the French manner. He used flying buttresses to support thin clerestory walls and vaults and filled the window openings with bar tracery resembling the tracery of the Cathedral of Reims. The lavish sculptured and painted deco-

rations in red, green, and gold can only be imagined today, but Westminster Abbey introduced the Parisian Court Style into England.

At the Cathedral of Lincoln, the Angel Choir became the first major building in the new Decorated Style [11.10]. Between 1256 and 1280, a chapel whose upper walls were carved with angels was added to the east end of the cathedral. The chapel had the traditional nave and side aisles and three-part elevation leading to a ribbed vault; however, the close spacing of piers and the steep pointing of the arches in the arcade created the impression of verticality. In the vault additional ribs, known as tiercerones, rise to the ridge rib from short wall shafts supported by elaborate foliate corbels. Polished Purbeck marble shafts enhance the linearity of the design. In the second story, the wall surface disappears behind the decorative overlay of sculptured moldings, foliage, and angels. The clerestory becomes a diaphanous screen of double tracery in which foliage seems to creep out around marble shafts and even the moldings seem to flower. Angels holding musical instruments spread their wings to fill the spandrels of the triforium gallery [11.11]. All this exuberant decoration is clearly visible since light floods the space from a huge window, measuring about 59 by 29 feet (18 x 8.8m), that fills the eastern wall. The tracery doubles the motif of cusped arches and roses established in the clerestory (the stained glass was replaced in 1885). King Edward and Queen Eleanor witnessed the solemn transfer of the relics of St. Hugh to the completed chapel in 1280.

The Angel Choir stands at the beginning of an exciting experimental phase in English art, a period characterized in architecture by lighter construction, increased ornament, and large windows filled with flowing tracery. Designers turned vaults into intricate nets by adding extra ribs, or lierns, to the already decorative tiercerone vaults. They made piers into diamond-shaped clusters of slender shafts. Then by eliminating galleries or reducing them to simple balustrades, they developed two-story elevations. They covered the surfaces of their structures with complex shallow moldings, tracery, foliage, and figure sculpture.

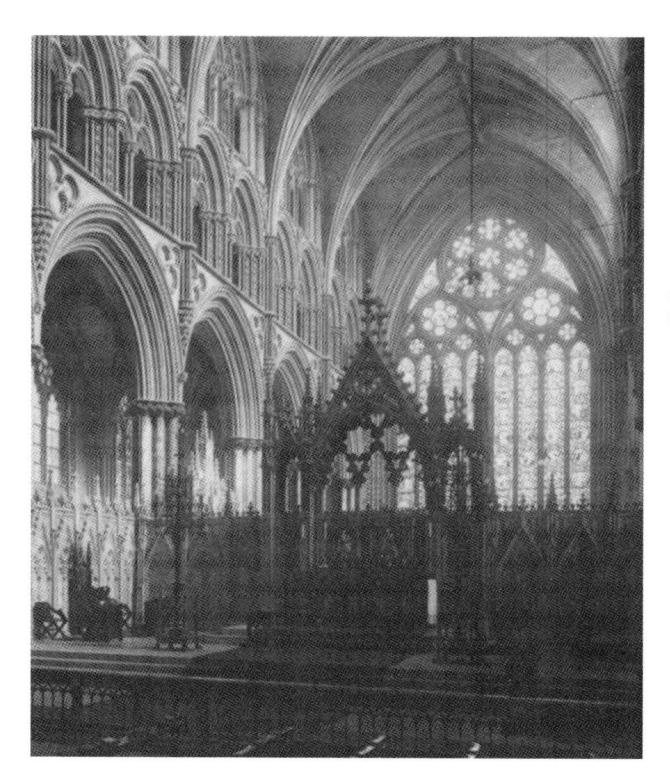

11.10 Angel Choir, Lincoln Cathedral, 1256-1280.

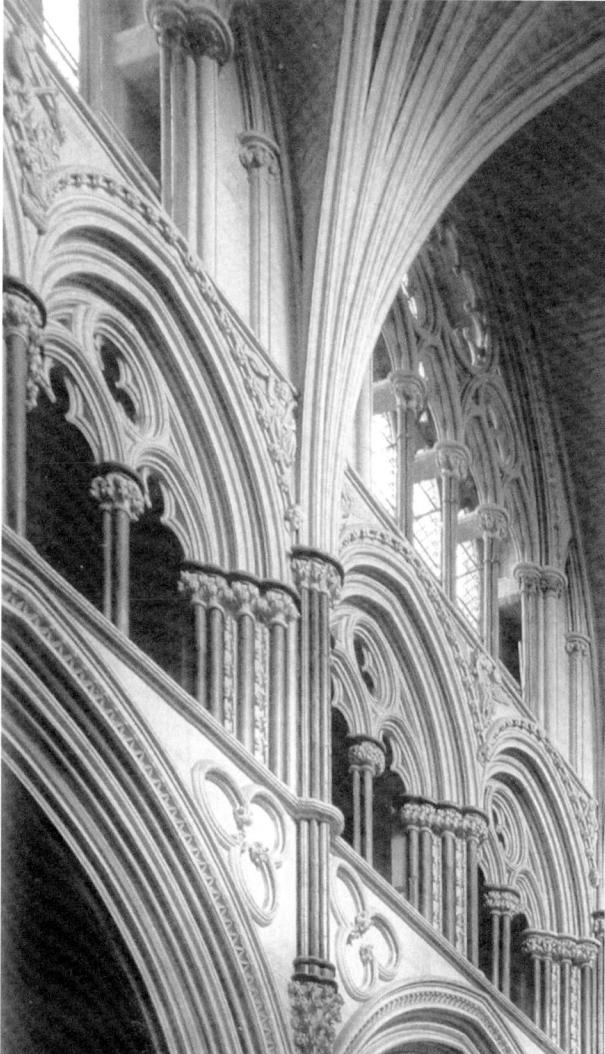

11.11 The Triforium Angel, Choir, 1256-1280, Lincoln Cathedral.

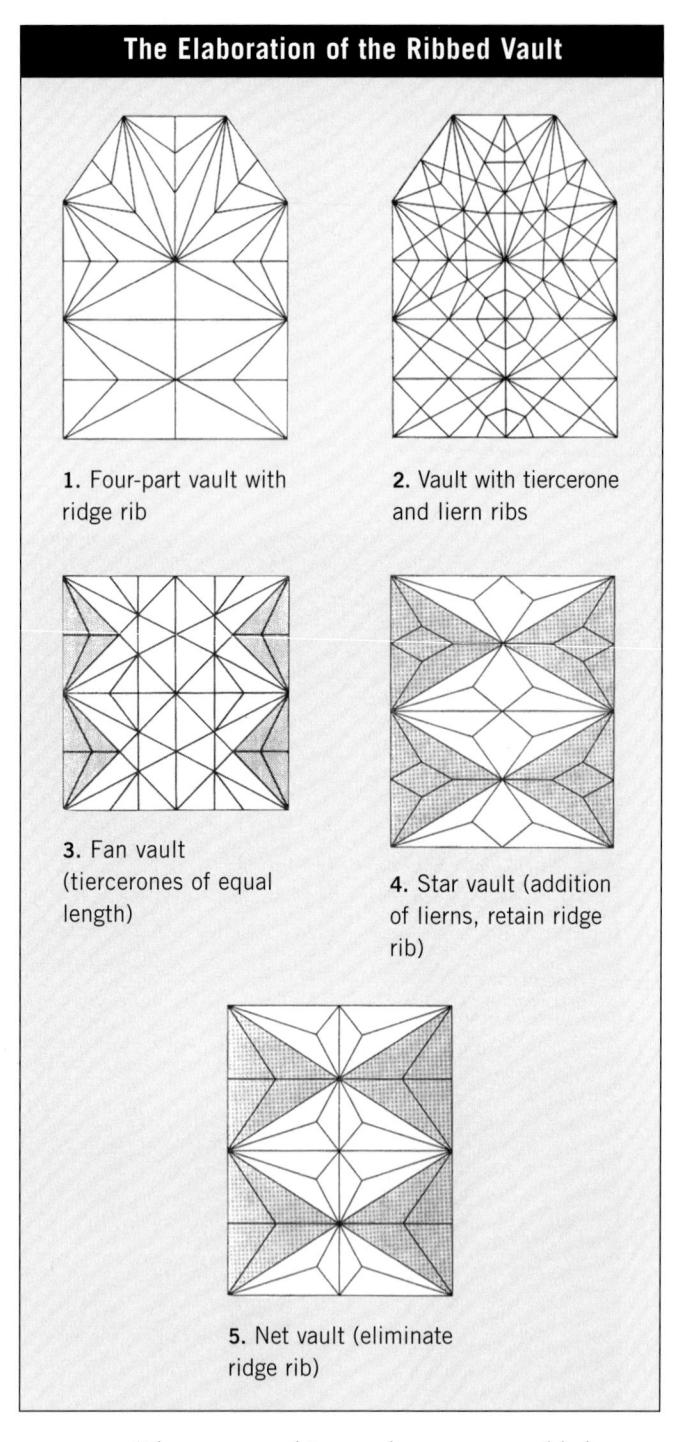

Three new architectural ornaments added notes of lighthearted elegance: sea weedy "bubble foliage," tightly closed, stylized rose buds called "ball flowers," and the "nodding ogee arch" composed of ogee curves that move in S-shapes outward as well as upward to produce the rippling "nodding" effect. By the fourteenth century, this ornamental, curvilinear style took on even more extravagant forms. The bishop's throne from the Cathedral of Exeter demonstrates the appropriateness of the style to wood [11.12]. Its towering canopy was completed in 1312. Tiers of pinnacles seemingly set on slender piers are united by arcades of nodding ogee arches carved with angels and foliage. Every surface seems to undulate; bubble foliage ripples over the surface while the arches twist in and out in the flame-like forms. The serpentine forms disguised the actual mechanics of the structure. Such a technique is diametrically opposed to the rationality and explicit statement of function found in French Gothic art. The Decorated Style was decorated indeed!

The Decorated Style reached its apogee in the Cathedral of St. Peter in Exeter. Rebuilding of the Norman Cathedral of Exeter began about 1270, and a new master mason, Roger, headed the shop by 1299 [11.13]. The nave vault was completed only in the 1360s, after the country began to recover from the ravages of the Black Death. The effect of the interior is startling; every surface, whether wall, pier, or vault, has been reduced to line. Diamond-shaped piers, whose surfaces are concealed by thin, sharply molded shafts, speed the zigzag movement toward the altar. A tiercerone vault runs uninterrupted the length of the nave and choir. Eleven vaulting ribs in each bay spring from shafts supported on richly carved corbels and spread to meet bosses on the ridge rib only 69 feet (21m) above the pavement. An arcade of cusped arches in the second story and a continuous balustrade of quatrefoils along the clerestory passage emphasize the horizontality of the building. Fourlight clerestory windows have complex tracery heads whose very inventiveness invites the eye to wander over painted and gilded surfaces. Finally, in the east window of the choir, a combination of grisaille and stained glass produces a silvery gold light.

Many earlier buildings had their towers and spires finished in the fourteenth century. At the Cathedral of Wells, a crossing tower (1315–1322), larger and heavier than the original builders had intended, caused the masonry to crack. In 1338

Bishop's throne, 1312. Exeter Cathedral.

the architect inserted strainer arches (masonry braces) formed by four pairs of inverted arches between the piers on all four sides of the crossing [see 10-29]. These sweeping arches turned dire necessity to aesthetic advantage by dramatizing the

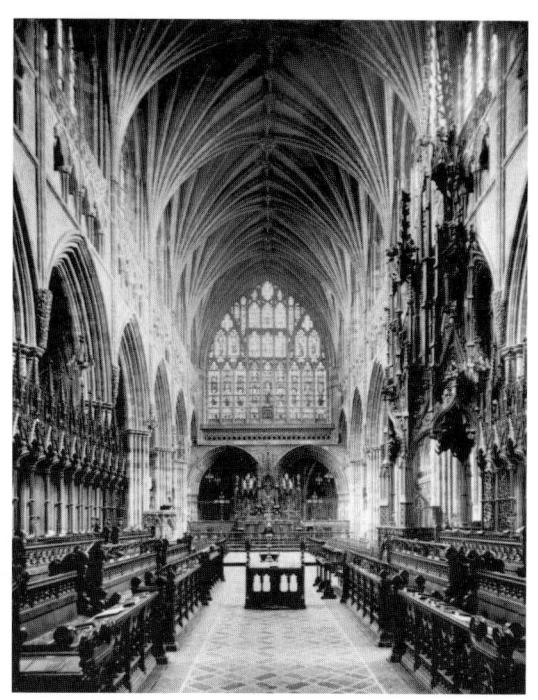

11.13 Choir, 14th century, Bishop's throne, 1312. Exeter Cathedral.

crossing and the entrance to the choir, and because the cathedral is dedicated to St. Andrew, many people imagine the arches to be gigantic St. Andrew's crosses.

In Salisbury, about 1320-1330, Master Richard of Farleigh built a crossing tower for the cathedral with a spire rising to the extraordinary height of slightly over 400 feet (121.9m) [see 10-31]. He divided the tower section horizontally into two stories and vertically with four pairs of tall lancets on each face. Massive buttresses at each corner support the structure. A double tier of pinnacles at each corner and gable in the center of each face lead the eye from the square tower to the octagonal spire. Far higher than anything visualized by the original builders, the spire has such harmonious proportions that it seems the logical, and indeed inevitable, focal point of the architectural composition.

The most brilliant of the series of crossing towers, erected before the Black Death brought major building campaigns to a halt at mid-century, is the timber octagonal lantern tower at Ely [11.14].

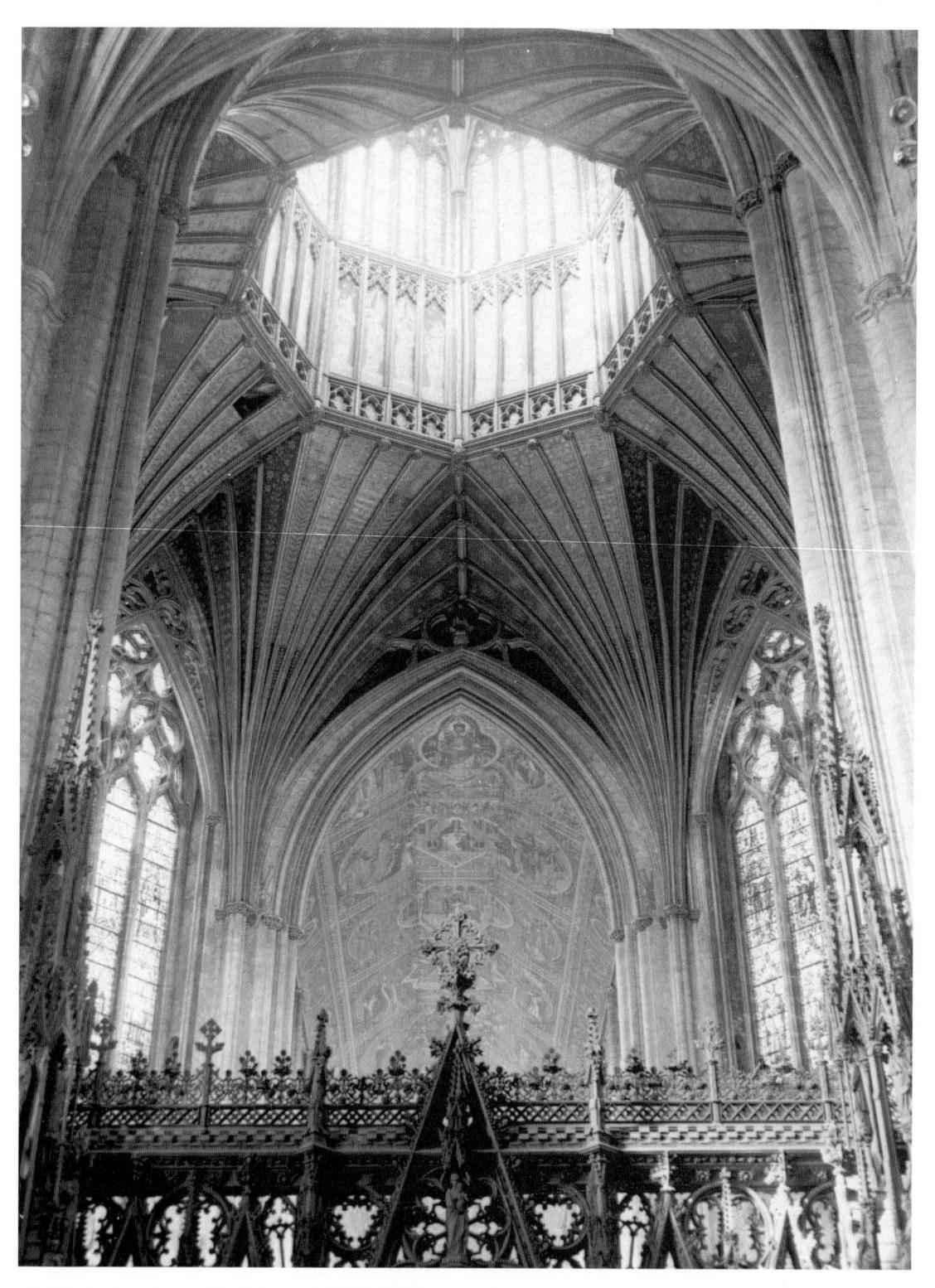

11.14 Lantern tower, Ely Cathedral. 1328–1347.

When the Norman crossing tower of the Cathedral at Ely collapsed, the chapter decided to rebuild it at once in a spectacular fashion with a tower and lantern. Alan of Walsingham, the sacristan, brought the king's carpenter, William Hurley, from London to design and supervise the construction (1328-1347). Instead of restoring the four original piers and rebuilding the square tower, William constructed eight masonry piers to form an octagon 72 feet (21.9m) in diameter. The piers support a wooden superstructure having a tiercerone vault and octagonal lantern closed by a star vault. Oak timbers 63 feet (19.2m) long and over 3 feet (.9m) thick at the base form the vertical members of the lantern. These huge posts were supported on hammer beams (see glossary) cantilevered out from the walls and hidden by the tiercerone vault. The octagon is more than a technical achievement; it is one of the finest spatial designs produced in a period famed for the ingenuity of its builders. The tiercerone ribs literally shape the space, sweeping the viewer/worshipper through the streaming light from the lantern into the star of the vault.

The repetitive linear quality of the Exeter nave and choir and the Ely octagon suggests the emergence of a new aesthetic, based on the forms of carpentry. The new style, known since the nineteenth century as "Perpendicular," is a court style that appeared first in London or in monuments closely related to the royal court-for example, the tomb of Ed-

ward II in Gloucester, made between 1329 and 1334 [11.15]. Edward II had failed to live up to his father's or his country's expectations. Defeated by Robert the Bruce at Bannockburn in 1314, he retired to London, where he lived in luxury, only to be deposed and later murdered at Berkeley Castle. After the monks of Gloucester courageously accepted Edward's body for burial, Edward III found it expedient to treat his father as a royal martyr. Gifts made possible a splendid tomb and, as a cult arose around the monarch, the influx of pilgrims stimulated the rebuilding of the church.

11.15 Tomb of Edward II, Gloucester Cathedral, 1329–1334.

Only two years after Edward II's murder, Edward III ordered an elaborate freestanding tomb. The effigy is not a portrait but rather an idealized image based on the traditional representations of God the Father. Using alabaster for monumental figure sculpture for the first time, the artist exploited his material to produce undulating forms and a translucent surface finish that suggest an almost decadent luxury. The canopy over the tomb has nodding and cusped ogee arches, battlemented string courses, gables framed by gables, and a veritable forest of buttresses and pinnacles. The sharp

11.16 Beatus vir qui no abiit: Windmill Psalter, England, 1270-1280. 12 3/4 x 8 3/4in. (32.3 x 22.2cm). The Pierpont Morgan Library.

angularity of the forms and the rectilinearity of the composition produce a brittle effect, which contrasts with the soft idealized figure. The Perpendicular Style, used here in miniature architecture, soon appeared in full-sized buildings.

The flowering of English Gothic painting and embroidery coincided with the Decorated Style in architecture, and the supreme skill of English artists shines in the Windmill Psalter, the Queen Mary Psalter, and the Chichester-Constable Chasuble. The Windmill Psalter [11.16] from about 1270-1280, like other English Gothic psalters, contains scenes from the Old and New Testaments and a calendar with signs of the zodiac and labors of the months. A large initial "B" indicated the beginning of the Psalter proper with the opening words of the

first psalm, Beatus vir, "Blessed is the man." In most psalters the Beatus initials interlaced with acanthus vines filled the entire page. In the Windmill Psalter the great "B" holds the Tree of Jesse, including Jesse, his son King David, the Virgin and Child, and God the Father adored by saints and prophets.

The heavy colorful painting of the "B" contrasts with the smaller "E", its opposite in the opening. Here King Solomon renders his famous judgment, enthroned on the cross bar of the letter with the baby at the terminal and the contending mothers above and below. (It is the essential story of the wisdom of Solomon: Two women claim that a baby is hers. Solomon rules that the child be cut in half, and when one woman gives up her claim to save the child's life, the wise king awards the child to her,

knowing that the true mother would do anything to save her baby's life.) An angel swoops down toward the text holding a pennant containing the remaining letters of the opening phrase. A windmill, which gives the psalter its name, and an equally realistic pheasant add lively genre elements. As if to complete the repertory of ornament, an elderly male grotesque with a winged serpentine body and tail ending in a bird's head completes the line. The "E" is filled with a filigree of pale olive-green ivy leaves surrounded by energetic and elegant red and blue scribal flourishes. "The blessed man" who takes delight in the law of the Lord is exemplified by Solomon the just judge, and he is likened to the tree whose leaf does not wither, justification enough for the evergreen ivy leaves. The letter "E" seems to lie over the transparent leafy background, and it establishes a forward plane behind which the figures move. The swordsman hooks his toe under the "E"; the angel somersaults over the text; the ornament spreads like tracery over the page. Skilled draftsmanship characterized the art of the British Isles since the Hiberno-Saxon period, and the pen work of the Windmill Psalter is a worthy successor to the interlaces of the Lindisfarne Gospels.

In the Queen Mary Psalter, produced in East Anglia about 1310, narrative supplants fantasy [11.17]. To illustrate the text, the youthful Christ debating with the elders in the Temple sits on a tall columnar stool under a round tower. The disputants stand or sit under an arcade, and an amazed Mary and Joseph look in through the door. The figures occupy a narrow space established by the architectural canopies, like sculptured figures on church portals. Diapered gold backgrounds close off any suggestion of movement into a deeper space. The bas-de-page is a tinted drawing completely unrelated to the biblical narrative above: Two ladies and a gentleman on spirited horses are hunting ducks. The realistic falcon, the escaping ducks, the energetic activity of the falconer, and the fluttering veils of the ladies bring the moment to life. The delicate drawing of well-observed natural detail makes such marginal illustrations brilliant heralds of a new style.

Closely related to painting is the pictorial embroidery perfected by English needleworkers who

11.17 Christ in the Temple, Queen Mary Psalter, England, c. 1310. 7 x 4 1/2in. (17.8 x 11.4cm). The British Library.

dominated the art in the thirteenth and fourteenth centuries. Fine embroidery in colored silk and gold thread came to be known as opus anglicanum, or English work. In this embroidery technique, fine couching and satin stitches completely cover the linen base; couching stitches with gold thread reproduce the appearance of the burnished gold backgrounds of manuscript illuminations, and colorful satin stitches model faces and draperies in three dimensions. The Chichester-Constable Chasuble (1330-1350) of red velvet embroidered in silk and gold thread has as its principal themes the

11.18 Life of the Virgin, back of the Chichester-Constable Chasuble, from a set of vestments embroidered in opus anglicanum, from southern England, 1330-1350. Red velvet with silk and metallic thread and seed pearls; length 5ft. 6in. (167.6cm), width 30in. (76.2cm). The Metropolitan Museum of Art.

Annunciation, Adoration of the Magi, and Mary crowned and enthroned with Christ [11.18].

Archives contain the names of many embroiderers; however, none can be attached to a specific piece of embroidery. One would like to have seen the three bed spreads embroidered with fantastic beasts and knots made in 1330 for Queen Philippa, wife of Edward III, in honor of the birth of their son. William de London, the queen's tailor, re-

Mabel of Bury St. Edmonds

Mabel is one of several artists whom we know only from official records. She was an expert embroiderer making pictorial embroideries in silk and gold, known as opus anglicanum. Her name appears 24 times in the accounts of Henry III between 1239 and 1245, when she was actively engaged in embroidering collars, cuffs, and ornamental pieces for the court. She spent three years working on a chasuble, using gold, pearls, and silk. She also made a banner to be hung in Westminster Abbey. Then for ten years her name disappears from the accounts. In 1256 the king made a pilgrimage to Bury St. Edmonds, and while there Henry rewarded Mabel for her service to the royal family with a valuable gift of six ells (nine yards) of valuable cloth as well as enough rabbit fur to line a robe.

By Mabel's time, embroiderers had adopted a guild organization. Originally embroidery could be done at home with simple tools (embroiderers seem to have owned their own needles), but when gold and pearls were added to the colored silks, a secure workshop became a necessity. The materials for an altar frontal made for Westminster Abbey and paid for in 1271 cost 220 English pounds for gold and silk thread, pearls, enamels, and garnets set in gold and silver. Four women worked on the frontal for three years, nine months, and they were paid 36 English pounds. The highly skilled people who made gold thread earned more than the embroiderers.

For more information see Embroiderers by Staneland in the Medieval Craftsmen series, British Museum Press, 1991.

ported a workforce consisting of two artists (John de Kerdyff and John de Chidelee) and 112 workers, 70 men, and 42 women. The team finished the project in three months. Guild regulations limited embroiderers to work only during daylight hours because of the fineness of the work, but under pressure from royal patrons the embroiderers could extend their hours, fortified by wine and candles.

Vestments like chasubles and copes presented an especially difficult problem for the designer. Not only did the composition have to fit the shape of the garment but the figural scenes had to be distributed

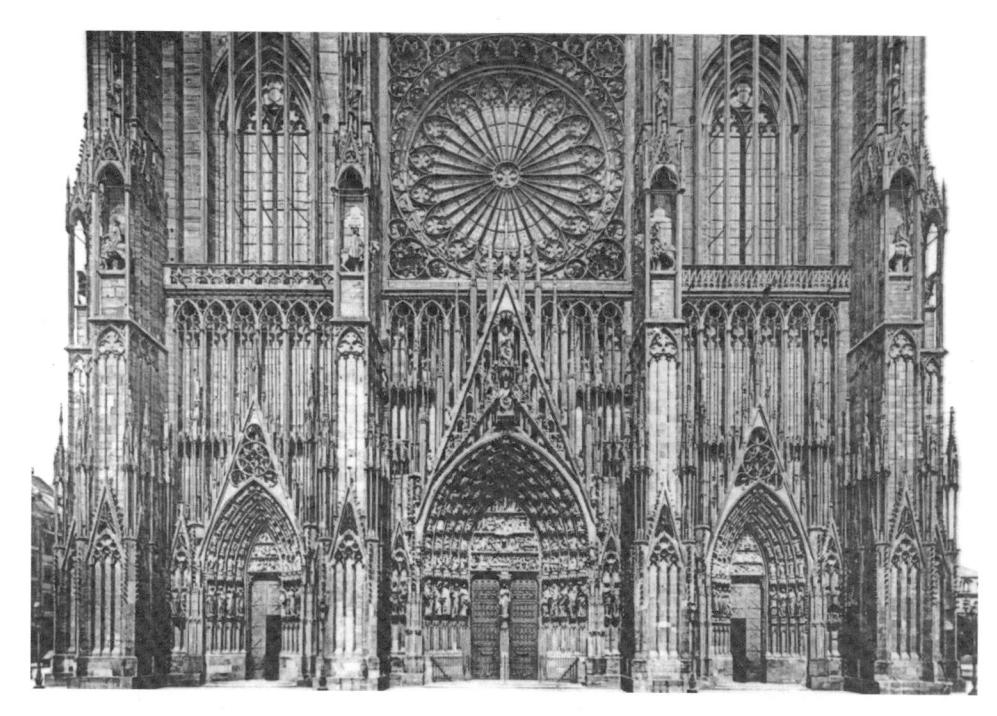

11.19 West façade, Strasbourg Cathedral. Begun 1277; upper stories 1365, 1384-1399.

so that they presented an effective picture when the vestments were worn. Well-designed vestments turn the celebrating clergy into almost architectural elements, aesthetically harmonious with the altar and surrounding choir. In the fourteenth century, English artists created vestments, altar frontals, retables, liturgical vessels—and buildings—which achieve a rare unity and continuity of form.

GOTHIC ART IN GERMAN LANDS

The lands of the Holy Roman Empire consisted of many independent states. From the eighth century until Napoleon delivered the coup de grâce in 1806, the Holy Roman Empire survived—even though, in Voltaire's famous phrase, it was "neither holy nor Roman nor an empire." By 1273, even the fractious German nobles realized that they needed a central organization, and they elected Rudolph of Hapsburg to be their emperor. In spite of political turmoil, patronage of the arts continued, and the German spirit and style seems stronger and more consistent than the history of the country would suggest.

German patrons and artists accepted the innovations of French art and architecture slowly. Masons understood the structural advantages of

French building; however, not until mid-century did patrons demand the aesthetic effect produced by increased light and height. Once they adopted the principles of French architecture, German architects sometimes carried the style to extremes, dematerializing forms beyond anything attempted in France. Acceptance of the new art may have been stimulated by a change in religious attitude. The inspired preaching by the friars turned people toward private meditation, and personal mystical experience became as important as communal celebration of the mass. The idealized geometry and diaphanous quality of French Gothic art became an instrument for the expression of the new mysticism, and the architects looked to buildings like the Cathedral of Reims, the Ste. Chapelle, or the Church of St. Urbain at Troyes for inspiration.

Had it been completed, the west façade of Strasbourg Cathedral [11.19] might have been the finest piece of Rayonnant design in either France or Germany (over the centuries Strasbourg has been claimed by both countries). In 1277, Erwin von Steinbach designed a new façade for the cathedral. Although he must have studied French Rayonnant buildings, he created an entirely new and daring façade, conceived of as a gigantic trellis, a "harp

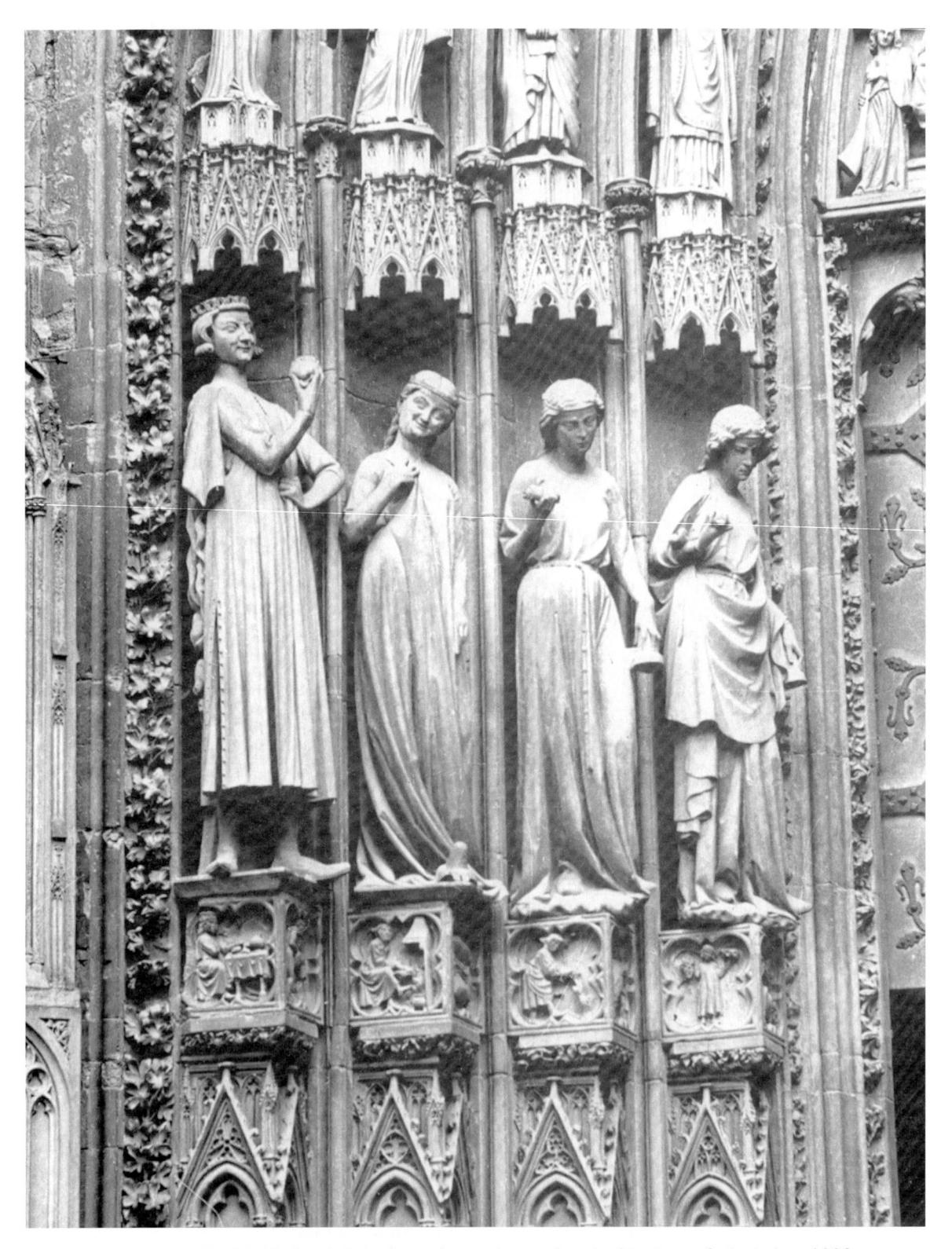

11.20 Satan and the Foolish Virgins. Left jamb, north portal, west façade, Strasbourg Cathedral, c. 1280.

work" in stone, two feet in front of the old façade and hiding the original wall behind a delicate screen of vertical columns. A series of steeply pointed gables, tabernacles, or pinnacles breaks every horizontal line. The façade was built to the height of the rose window in the Middle Ages, and the existing tower and dwarf spire only hint at the elegance of the original conception—a pair of open towers supporting slender spires. Erwin intended to create a triumph of Gothic transparency in stone.

German sculpture and painting followed a similar course of resistance to, and then adoption of, the new French art. Strasbourg's western portal sculpture reflects the art of the Joseph Master of Reims [see 10.25, 10.26]. Simpering and foolish maidens seem eager to succumb to the temptations of Satan in the guise of an elegant prince [11.20]. His garments split open to reveal the toads and lizards that replace his body and warn the onlooker of his true character and evil intent. The sculpture serves as a personal morality play, like the plays that were performed on the steps of the churches. Religion became increasingly personal and immediate, driven home by the preaching of the friars.

The visual arts responded to the impact of the new mysticism with themes of both joy and suffering that spoke directly to people beset by disease, warfare, and starvation. The crucified Christ was no longer triumphant or pathetic but instead a hideous, emaciated figure, a victim of humanity's viciousness. Images of the mourning Virgin holding the body of Christ, known in Germany as the Vesperbild (that is, a picture for meditation at evening prayers) and in Italy as the pietà, replace the triumphant or joyous Mary. The powerful new theme spread from the Rhineland across Europe from the Netherlands and Scandinavia, to Central Europe, to Spain.

The tenderness found in images of the Virgin and Child now appeared in a new theme expressing the deep friendship of St. John and Christ, when John seems to sleep with his head on Christ's chest. Yet even in this gentle image, devoted Christians knew that they saw before them the Last Supper, and in a moment John would lift his head to ask who among the apostles was the

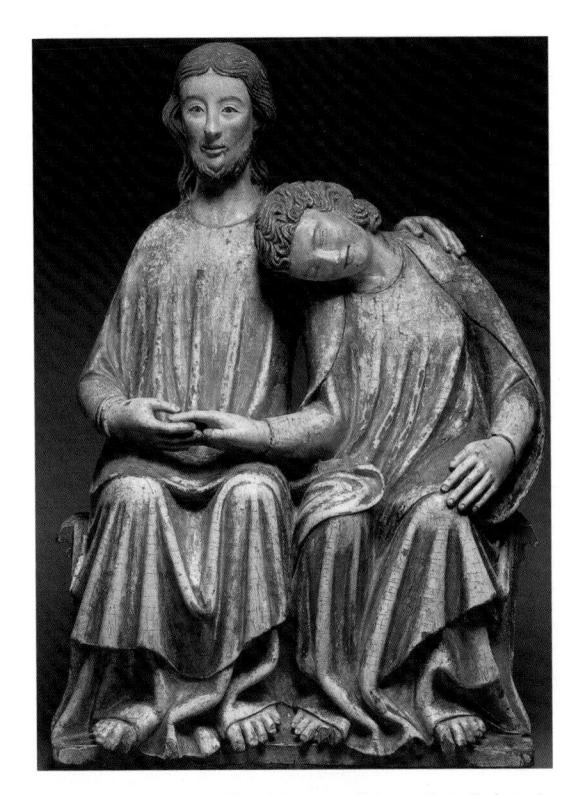

11.21 Christ and St. John the Evangelist. Painted wood. Germany, Swabia, near Bodensee (Lake Constance), early 14th century. 36 1/2in (92.7cm). The Cleveland Museum of Art.

traitor (John 13:23-25 and 21:20) [11.21]. Christ and John seem united as a single figure in a devotional image appropriate for those who sought solace in religion and a mystical union with God through meditation.

In the fourteenth century, the Parler family in southern Germany and Bohemia formed an architectural dynasty lasting four generations. Heinrich Parler was the head of this large and prolific family. His son Peter (c. 1330-1378) at age 23 became court architect to Charles IV (1316-1378) in Prague, the new capital of the Holy Roman Empire. Peter's earliest work may be the choir of the Church of the Holy Cross at Schwäbisch Gmünd, where he collaborated with his father [11.22]. Heinrich Parler began the nave of the church in 1317, and in 1351 he was joined by Peter. They designed the choir as a hall church but enlarged it with a ring of low chapels between the buttresses [11.23]. Large tracery-filled windows in two stages

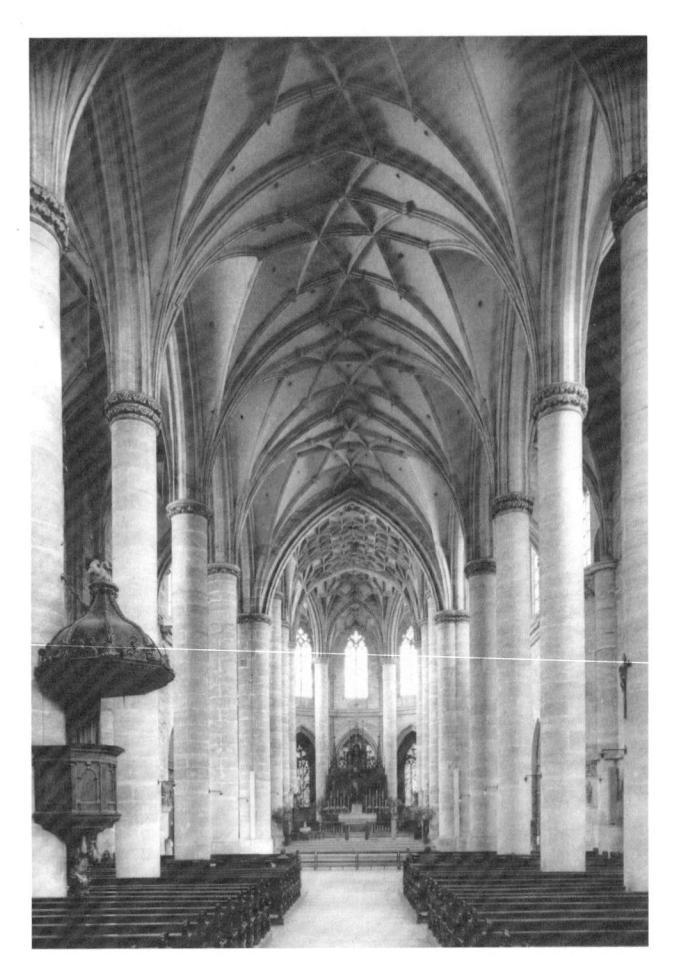

11.22 Interior, Church of the Holy Cross, Schwäbisch Gmünd, begun 1317.

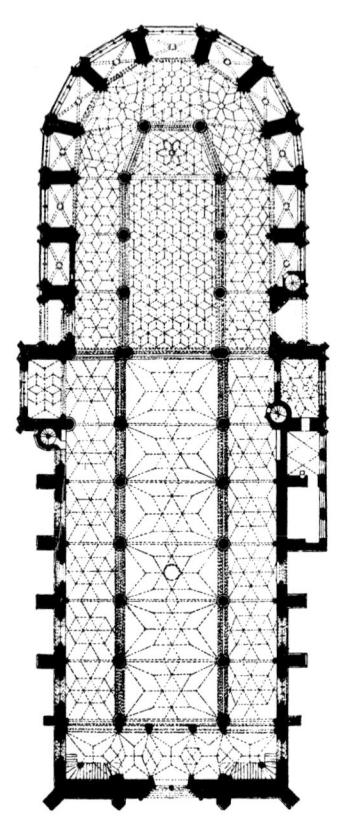

11.23 Church of the Holy Cross, Plan, nave, 1317; choir, 1351. Schwäbisch Gmünd.

light the choir of this unified interior space, causing the net vault to appear to float weightlessly above.

Peter Parler proved to be one of the inventive designers of the century. Like the English architects whose work he must have known, Peter experimented with vaults, elevations, and lighting. He elaborated on such technical devices as flying ribs and openwork tracery; and he designed the first net vaults built in the Germanies. The contrast between the nave and choir vaults at Gmünd makes the increasing complexity of the vault patterns readily visible. By increasing the number of ribs and eliminating the ridge rib and transverse arches. Peter turned star vaults into intricate decorative nets. Peter Parler's influence spread throughout Central Europe after 1353 when he began work on Prague Cathedral and the imperial pantheon for Charles IV.

THE SYNAGOGUE

The oldest still-functioning synagogue in Europe, known as the Old New Synagogue (Altneuschul), was built in the later years of the thirteenth century in Prague [11.24]. The building is a rectangular hall with two aisles of equal height vaulted with ribbed groin vaults. (As the standard building technique of western Europe, Gothic architecture was neither Christian nor ecclesiastical exclusively.) The same masons probably worked for both Christian and Jewish communities. The synagogue was a place of prayer and a community center. Men gathered in the main hall; women had their own adjoining rooms [11.25]. A raised reading platform, the bimah, with its fifteenth-century ironwork, dominates the room. It is lit by tall lancet windows in the outer wall and by candles in chandeliers. An arched

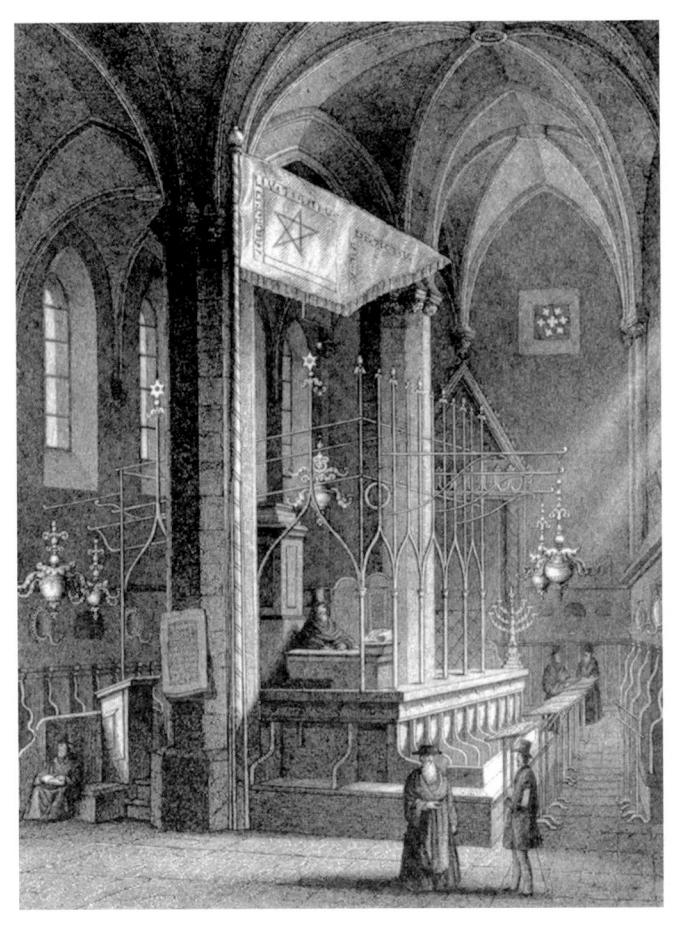

11.24 Interior, Altneuschul, Prague, Czech Republic. c. late 13th century; bimah after 1483; later additions and alterations. Engraving, 1864. Avery Architectural and Fine Arts Library.

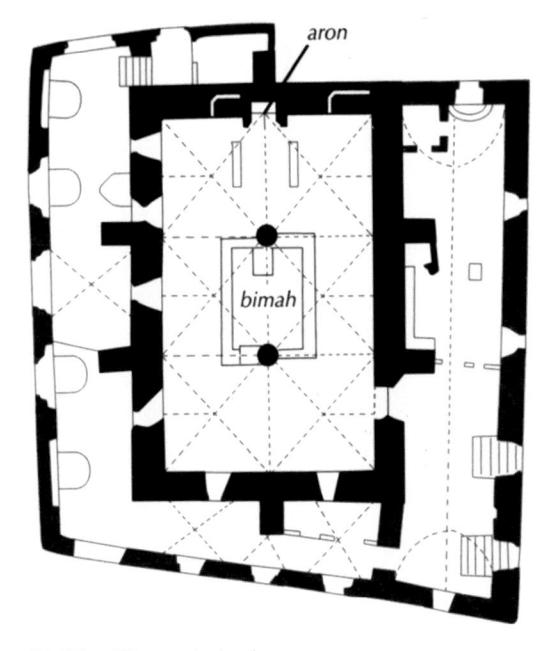

11.25 Altneuschul, plan.

niche for the Torah scrolls, the aron, was placed in the center of the short wall. The prohibitions against graven images prevented the addition of any sculptural enrichment, although some decorative wall painting enlivens the interior. The exterior is modest, and no elaborate portal calls attention to the entrance. Surviving medieval synagogues are rather small buildings, in part because of local restrictions on size and in part because the Jewish community itself was often rather small.

In the Iberian Peninsula, Mudejar art continued the traditions of fine craftsmanship and colorful, abstract geometric design long associated with Muslim art [11.26]. The Mudejars were Moors (Muslims) living and working in the Christian kingdoms. At first the artisans were Muslims; however, Mudejar taste for decoration and craftsmanship soon became associated with Christian and Jewish artists as well. Some workshops claimed to produce decorations in the Gothic, the classical Roman, or the Moorish style—whatever the patron ordered. Elaborately patterned brickwork, carved and molded plaster, and brilliantly colored tiles cover surfaces of architecturally conservative buildings. Church towers, especially in Aragón, resemble minarets covered with decorative geometric patterns in brick and tile work. Palaces, churches, and synagogues had carved stucco walls, tile floors, and painted and gilded wooden muqarnas ceilings. The synagogue known as el Transito in Toledo preserves much of its splendid decoration. Built in 1355-1357 by Samuel Levi, the treasurer of the Castilian King Pedro the Cruel, for the wealthy Jewish community in Toledo, the building is a simple rectangular room with a gallery for women. On the exterior, its plain brick walls blend into the surrounding cityscape, but inside an exuberant decoration of calligraphy, foliage, and geometric

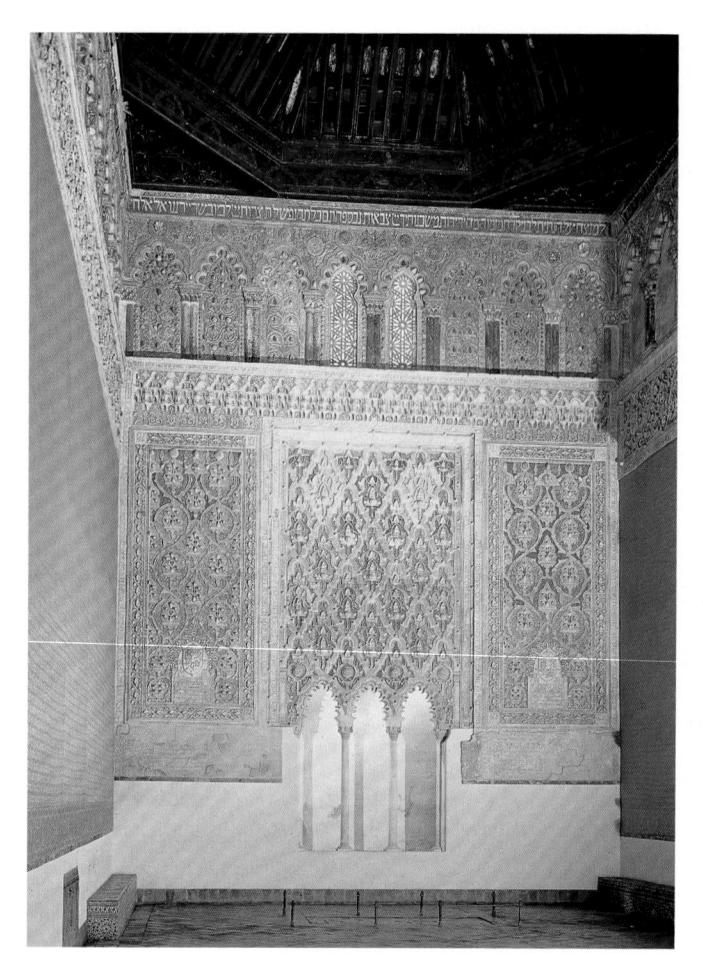

11.26 Synagogue, el Transito, Toledo, 1355-1357.

patterns of interlacing arches in painted stucco covers the walls. Much of the color has disappeared, but large panels of refined low relief sculpture survive. The ceiling is a dazzling display of polychromed woodwork. The inscriptions identify the patron and extol the sacred character of the building through references to Solomon's Temple and the Tabernacle. Over the years, Jewish craftsmen replaced the Moors as skilled artisans, and the Mudejar style became associated with synagogues, palaces, and secular architecture.

CATALONIA (CATALUNYA)

Catalonia became a major commercial power in the Mediterranean in the thirteenth and fourteenth centuries. A distinctive Catalan Gothic style

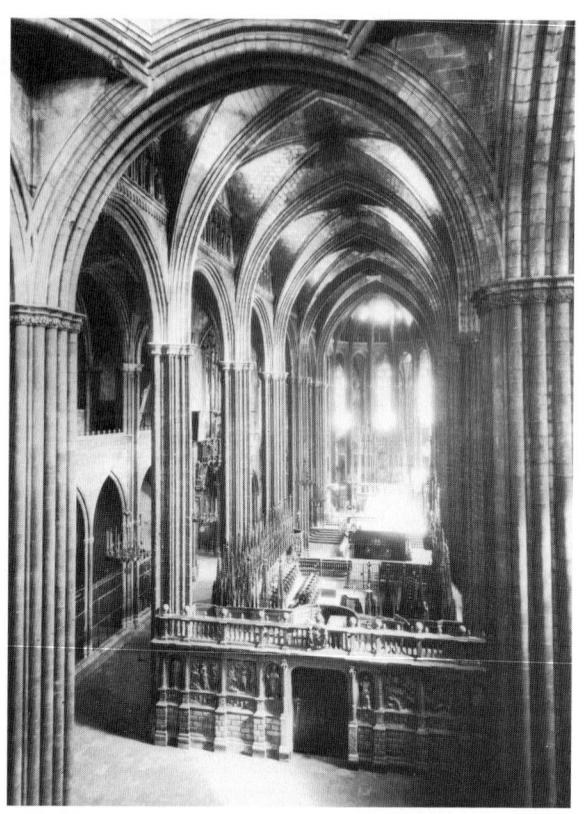

11.27 Cathedral of Sta. Eulalia, Nave and choir, begun 1298, Barcelona.

appeared in southern France and northeastern Spain. From Albi to Barcelona to the Balearic Islands, palaces, market halls, and parish churches as well as cathedrals rose in the prosperous cities. In both French and Spanish Catalonia, the architects and masons were only indirectly inspired by the Gothic of the Île-de-France and the North. They built huge halls covered with internally buttressed rib vaults or transverse diaphragm arches supporting timber roofs. In a three-aisles building, the interior approached the form of the hall church since the aisle vaults rose almost to the height of the nave. Often tranverse vaulted chapels between the interior buttresses stabilize the structures.

In 1298, building began on the Cathedral of Sta. Eulalia in Barcelona under the direction of Bertrand Riquer, and by 1318 the famous Mallorcan architect Jaime Fabre had begun to give the cathedral its distinctive character [11.27]. The east end was completed in 1329; however, work

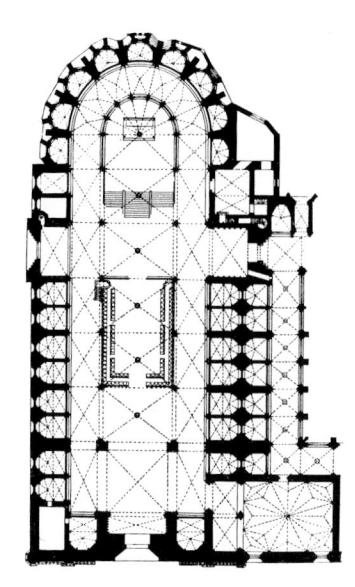

11.28
Plan, Cathedral of
Sta. Eulalia, Barcelona,
14th century.

continued for another hundred years, and the cathedral was only finished in the nineteenth century. Clustered shafts ending in tiny capitals form piers, which support the ribs of both the nave and the aisle vaults [11.28]. Enormous internal buttresses form the lateral walls of chapels. In the nave the triforium and clerestory oculi seem squashed between the high arcade and the vault. By the fifteenth century, tall altarpieces, called retablos in Spain, blocked the chapel windows. Windows in the outer wall above the chapels are too distant to light the aisles and nave effectively, and this reduced light creates a dark mysterious space. Flickering candlelight reflects off the glittering retablos seen through grills (rejas). The sculptured bosses of the vault were lost in shadow (today, electric lights illuminate the interior but destroy the original effect of space and filtered light).

The many parish and convent churches of Catalonia are simplified versions of the monumental architecture of the cathedrals [11.29]. At the convent church of Sta. María in Pedralbes, a single nave flanked by unconnected chapels between deep buttresses ends in a polygonal apse. A double ring of circular and lancet windows lights the interior. The preference for flat mural surfaces and simple ribbed vaults reflects the taste of the practical merchant bankers of Catalonia as well as the friars.

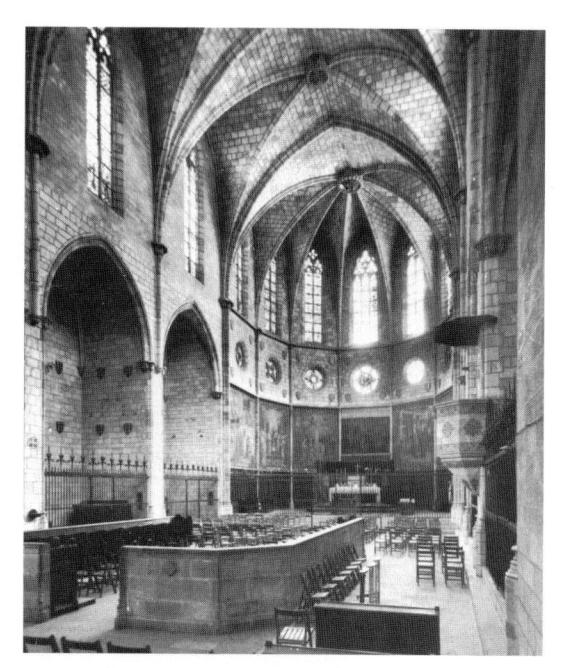

11.29 Convent church, Sta. María Pedralbes, Barcelona, founded 1326.

The broad expanse of masonry walls encouraged the efforts of mural painters. In 1346 the Barcelona artist Ferrer Bassa painted the Chapel of St. Michael in the convent's cloister at Pedralbes with scenes from the life of Christ and portraits of Franciscan saints [11.30]. Bassa's activity in Catalonia is well documented between 1320 and 1348, but earlier he must have traveled and studied in Italy. Only in Italy could he have learned to represent such monumental figures in a coherent space or to break with the traditional medieval subordination of painting to architecture. He simply divided the chapel wall into rectangular panels and created a series of stagelike spaces into which he set his figures. Ferrer Bassa's work, so deeply imbued with the style of Giotto and Italy [11.35, 11.36, below], established the direction of Catalan painting for the rest of the century.

GOTHIC ART IN ITALY

After the death of Frederick II in 1250, wars of conquest led first by Charles of Anjou and then by Pedro III of Aragón turned the once flourishing south into a political and cultural backwater. In

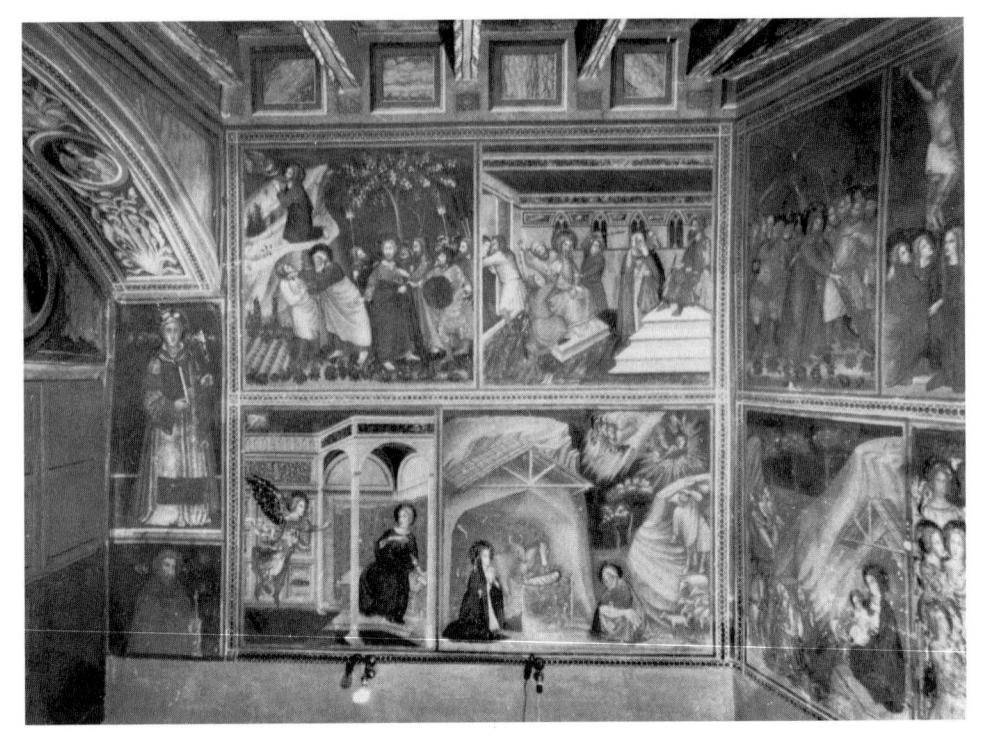

11.30 Chapel of St. Michael, cloister, Pedralbes, Barcelona, 1346. Fresco. Ferrer Bassa (active 1320-1348).

central Italy the papacy provided little artistic or political direction, especially in the fourteenth century, when the Pope and the papal court resided in Avignon, France (1309-1377). Conditions existed for effective patronage of the arts principally in northern cities such as Florence, Milan, and Venice. There powerful families had behind them a long tradition of municipal freedom and commercial rivalry, a heritage that stimulated artistic development. Even the Black Death at mid-century could not long halt progress in that region.

The decoration of the Church of St. Francis was one of the most important artistic undertakings at the end of the thirteenth century [see 10.42]. The Franciscans did not adhere strictly to St. Francis's insistence on poverty and austerity; the Pope had granted permission for the construction of the church we see today shortly after his death in 1226, and an extensive program of mural decoration followed. Eventually paintings covered the walls of both the upper and lower churches. Gothic unity of the arts—that is, the subservience of painting and sculpture to an all-embracing architecture—broke down as the paintings within

semi-independent rectangular frames gained an independence from the architecture.

Paintings of the life of St. Francis cover the walls of the upper church [11.31]. Their style resembles work being done in Rome and also seems related to paintings by Giotto, but whether Giotto, his shop, or some anonymous Roman master worked at Assisi remains an unresolved debate among students of Italian art. The paintings are dated between 1295 and 1330. In the scene of the Miracle of the Crib at Greccio, the artist has depicted the origin of the Christmas Crib (the precepio or manger scene). The painting is also interesting for its portrayal of an Italian Gothic church with a choir screen, pulpit, lectern, altar, and baldachino. This church furniture is depicted as decorated with the brilliantly colored marble, known as Cosmati work (see San Clemente, Rome [8-6]), popular in Italy since the twelfth century.

A huge painted wooden cross, seen from the back, tilts over the door into the choir. Such crosses became a special feature of Franciscan art [11.32]. Many of these crosses, like the mid-thirteenthcentury Santa Bona Cross, once belonged to the

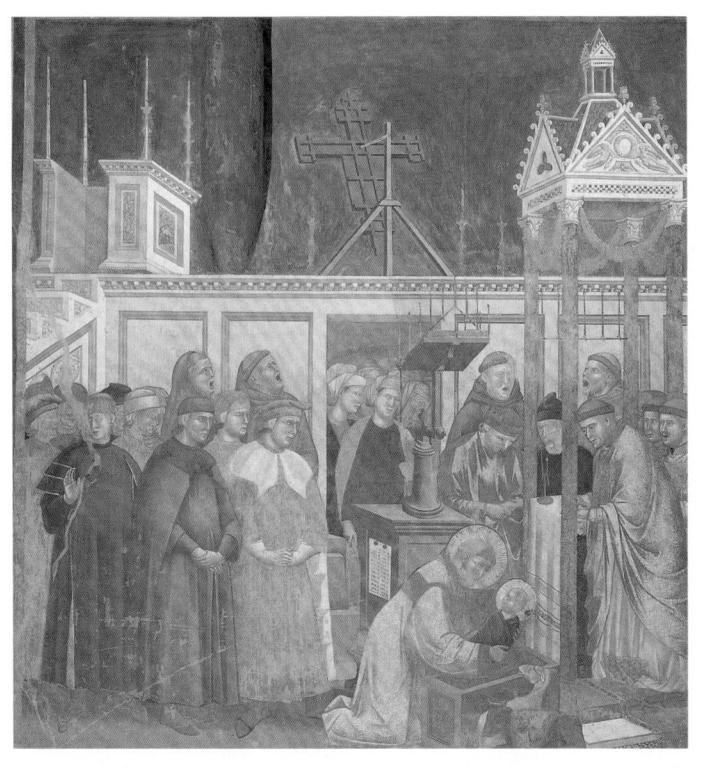

11.31 Miracle of the Crib at Greccio. Fresco in upper church of St. Francis, c. 1295–1330. St. Francis Master.

experimental science, where the presence of Roman antiquities and of patrons who appreciated ancient art would reinforce his interest in observed detail and tangibility.

Nicola's first documented work is the pulpit in the baptistery at Pisa, which is inscribed, "In the year 1260 Nicola Pisano carved this noble work. May so gifted a hand be praised as it deserves." The pulpit is indeed a magnificent creation worthy of the confidence expressed in the inscription. The Corinthian-like columns, three of which stand on the backs of lions, support a hexagonal pulpit [11.33]. Columns and moldings, individ-

Franciscan nuns, the Clares of S. Martino, Pisa. The Clares possessed the relics of Santa Bona, who is represented at the end of the right arm of the cross. Christ is shown as alive and triumphant over death, and the cross has flanking narrative paintings of the Passion cycle with appropriate themes for meditation—on the left the Betrayal, Flagellation, and Christ Bearing the Cross; on the right the Deposition, Entombment and Three Marys at the tomb. The mystical experience induced by meditation on these images could be very intense. According to a biography of St. Francis, the cross in S. Damiano, where St. Clare lived in Assisi, actually spoke to her brother, just as the doll in the crib at Greccio came to life as the baby Jesus.

Much of the finest thirteenth- and fourteenth-century sculpture often can be found in church furniture, although splendid cathedral façades were begun at Siena and Orvieto. The Gothic Style in sculpture first appears in the work of Nicola Pisano (active 1258–1284). Perhaps Nicola came from southern Italy, for twice documents refer to him as Nicola of Apulia. He might have worked at the court of Frederick II, a center of classical studies and

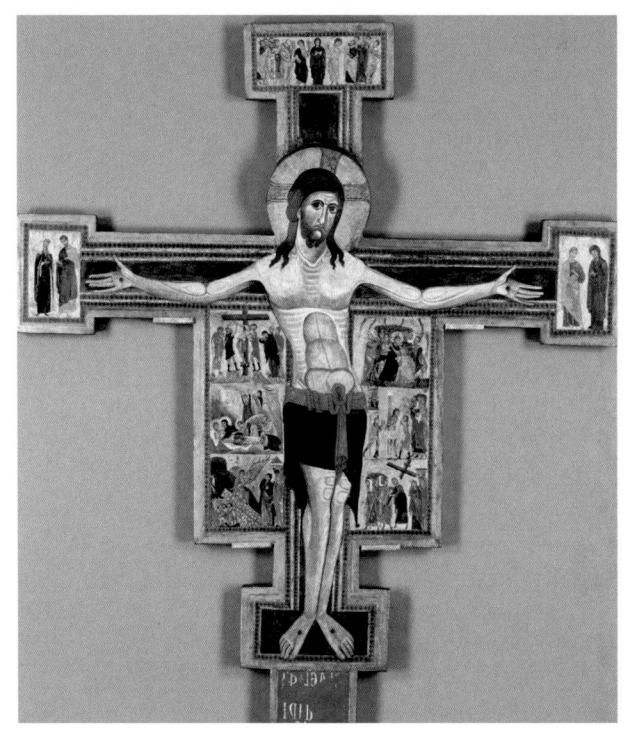

11.32 Crucifixion of the Christus Triumphans type, Pisan School, c. 1250. Tempera on panel, 6ft. 1 1/5in. x 5 2 1/3 (1.85 x 1.60m). The Cleveland Museum of Art.

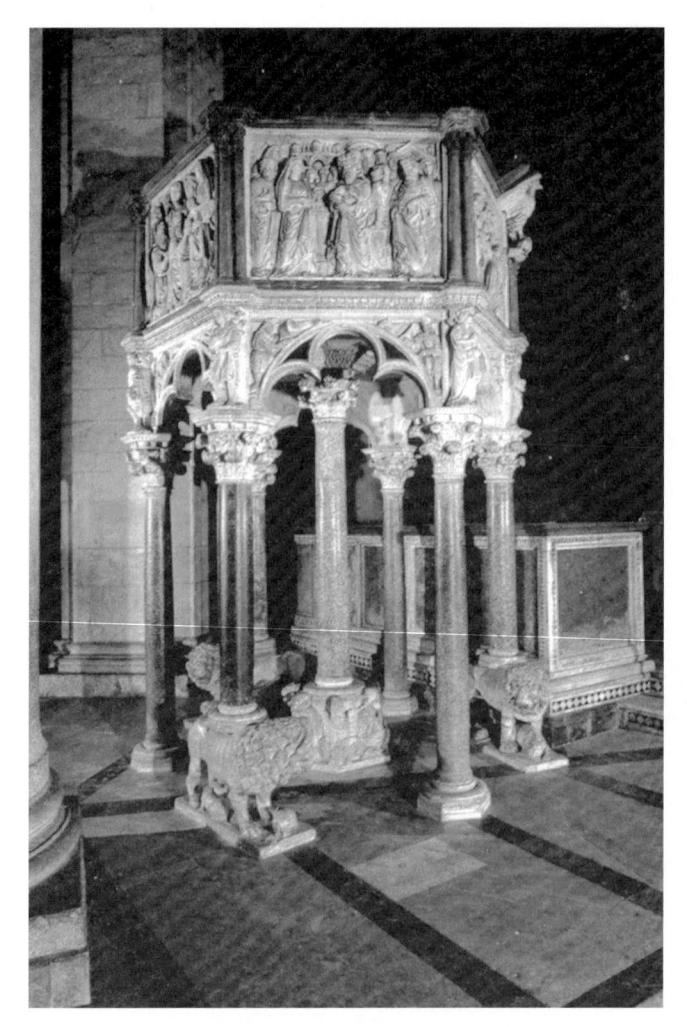

11.33 Marble pulpit. 1260. Pisa Baptistry. Height approximately 15ft. (4.6m). Nicola Pisano.

ual figures and faces, architectural backgrounds, even carving techniques are based on Roman models that he could have seen in Pisa. On the other hand, the heavy angular draperies falling in repeated V folds and camouflaging the figures are medieval. On the body of the pulpit each panel is an independent, self-contained unit and each has a dense, frieze-like composition. Nicola indicated a series of narrow planes in depth, the first occupied by the chief actors in the drama, the next by the crowd, and the last by the cornices and roof lines of the buildings. In spite of this definition of a stage on which the actors move, the sense of almost intolerable compression of the figures re-

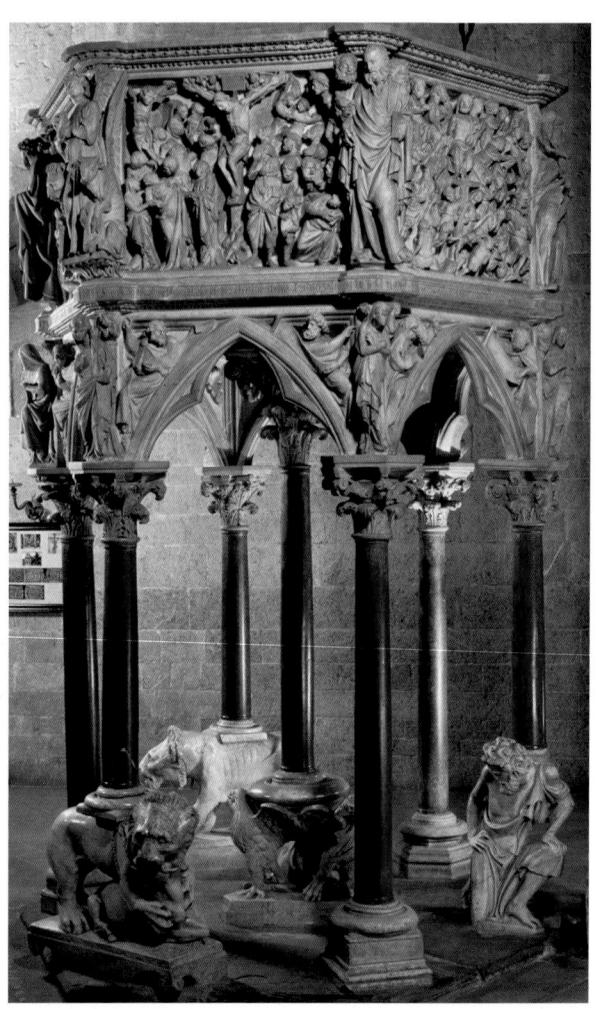

11.34 Marble pulpit. 1298–1301. Church of Sant' Andrea, Pistoia. Height 12ft. 9in. (3.93m). Giovanni Pisano.

mains to enhance the emotional quality of the scenes. Thus, in spite of his debt to ancient Roman art, Nicola Pisano remains a Gothic artist.

Nicola Pisano's son Giovanni (c. 1250-c.1314) became a leading sculptor during the later years of the thirteenth century. Giovanni learned his trade from his father and eventually took charge of the family shop. After 1284 he was employed as sculptor and architect for the Cathedral of Siena, where he designed the lower part of the façade and carved splendid figures of prophets and sibyls. Between 1298 and 1301 he carved a marble pulpit, commissioned by Canon Arnoldus, for the church of Sant' Andrea in Pistoia [11.34]. In this work Gio-

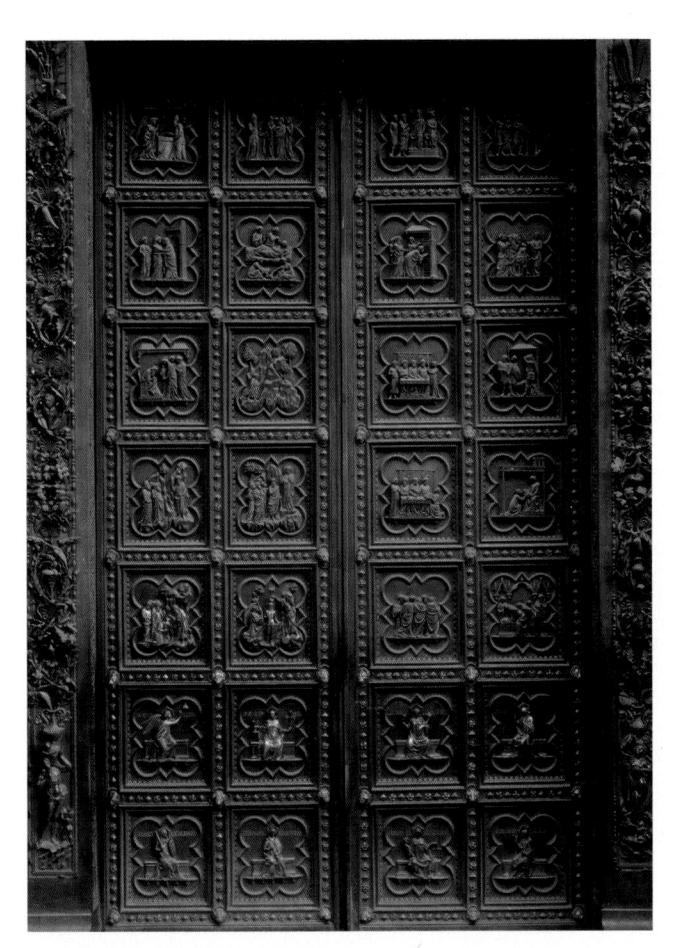

11.35 Andrea Pisano. Life of John the Baptist, south doors, Baptistery of San Giovanni, 1330–1336. Gilded bronze. Florence.

vanni no longer seems inspired by classical models, and instead he carves slender, graceful figures who seem inspired by intense emotions that recall German art. He also seems concerned with the setting as well as the figures and so varies the height of relief to create a natural pattern of light and shadow. Pulpits, tombs, and even public fountains inspired some of the finest Gothic sculpture in Italy.

Elaborate bronze doors became a focus of patrons' attention. For the south doors of the Baptistry of San Giovanni in Florence (1330–1336), Andrea Pisano (no relation to Nicola and Giovanni; simply a man from Pisa) created twenty-eight scenes from the life of St. John the Baptist [11.35]. A direct reference to French art is apparent here. The scenes are set in barbed quatrefoils—yet another variation on the decora-

tive motif introduced by the sculptors of Amiens Cathedral [10.20]. Andrea used a grid pattern of diamond points and lion heads to add to the effect of an overall pattern that completely covers the surface. In contrast to this geometrical pattern, he surrounds the doors with vine scrolls rising from classical figures and filled with flowers, fruits, birds, and putti. Within the individual quatrefoils, the drama unfolds with a few well-modeled figures depicting the action with dignified motion and gestures. The minimal settings create a remarkable illusion of space, almost like the paintings of Jean Pucelle, who also owed a debt to fourteenth-century painters.

FOURTEENTH-CENTURY ITALIAN PAINTING

The simplicity, or directness of statement, intensification of emotion, and refinement of drawing and color already present to some degree in Italian art were reinforced by Byzantine art and artists who came to Italy after the fall of Constantinople to Western Crusaders. Just as Byzantine art reinvigorated Northern gart in the years about 1200, so too it revitalized Italian art in the later years of the thirteenth century. By 1300, however, Byzantine

art had become old-fashioned. In the eves of later writers—such as the first historian of Renaissance art, Giorgio Vasari—the young Giotto di Bondone (c. 1277-1337) came as the savior of painting. Giotto traveled widely. He must have known contemporary Roman painting, and he may have worked in Assisi [see 10.42 and 11.31]. By 1301 he was in Florence. Then in 1303 Enrico Scovegni of Padua commissioned Giotto to decorate the walls of the family chapel, also known as the Arena Chapel because of its location—along with the family palace—in the ruins of an ancient Roman arena [11.36]. Giotto transformed this modest building into a testament to Christ and the Virgin Mary, and unwittingly to the power of Italian painting. He divided the walls and barrel vault with ornamental bands to suit his compositional

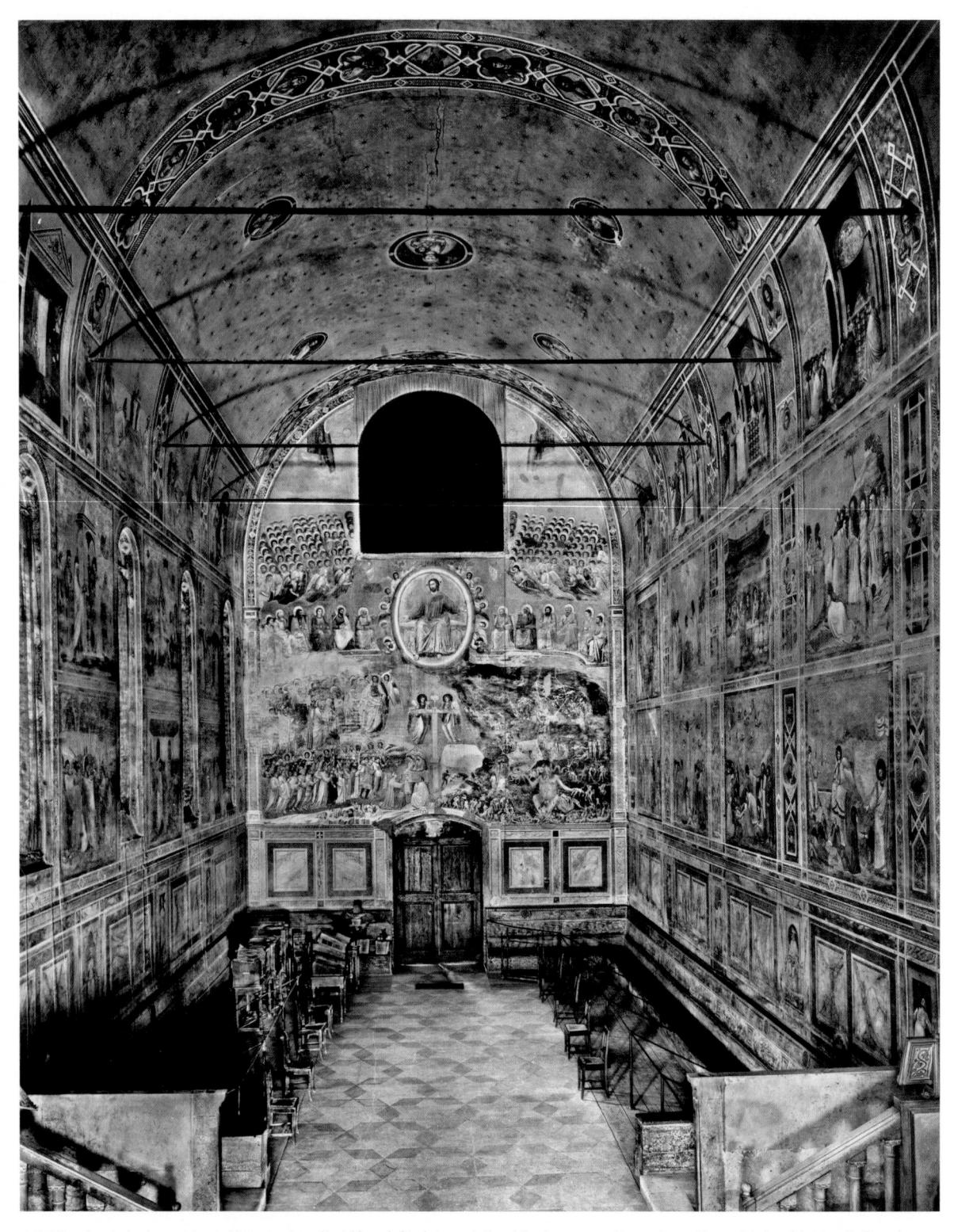

11.36 Last Judgment on the west wall, Life of Christ and the Virgin on north and south walls by Giotto di Bondone (c. 1277-1337). Arena Chapel, consecrated 1305. Padua.

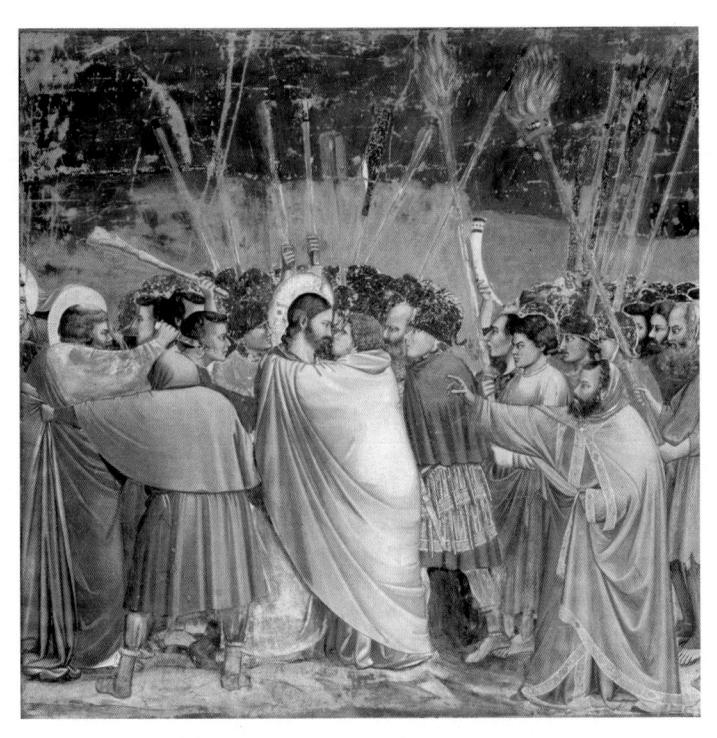

11.37 Betrayal. Fresco, Giotto. 78 3/4 x 72 7/8in. (200 x 185.1cm). Arena Chapel, Padua.

Giotto's strength as an artist comes from his ability to distill a complex narrative into a single telling moment [11.37]. In the Betrayal or Kiss of Judas, he focused the elements of the composition and thus the viewer's attention on one intimate detail, the juxtaposed heads of Christ and Judas. Giotto revolutionized art through the technique as well as the content of his paintings. He defined the fictive space almost entirely by means of figures. These figures are truly monumental creations, each of which creates its own space by means of simple contours and sculptural modeling. Giotto rendered figures as color masses, painting the darkest areas with the most intense color and modeling toward

white so that the final effect is of high-keyed color even in a somber scene. Figures normally fill the lower part of the scene, with the center of interest such as the two confronted faces slightly to the side in a perfectly balanced but asymmetrical composition. In the Betrayal, however, the monstrous yellow cloak of the traitor Judas fills the center of the panel. The mob is reduced to faceless helmets. A man seeking to restrain the knife-wielding St. Peter repeats

scheme: a grid of simple rectangular panels filled with scenes from the life of the Virgin and Christ. The Annunciation flanks the opening into the chancel and an awesome Last Judgment covers the western wall. Kneeling among the blessed is Enrico Scrovegni offering his chapel. The theme of expiation and salvation is further personalized in a series of allegorical figures of the virtues and vices painted in grisaille in the dado.

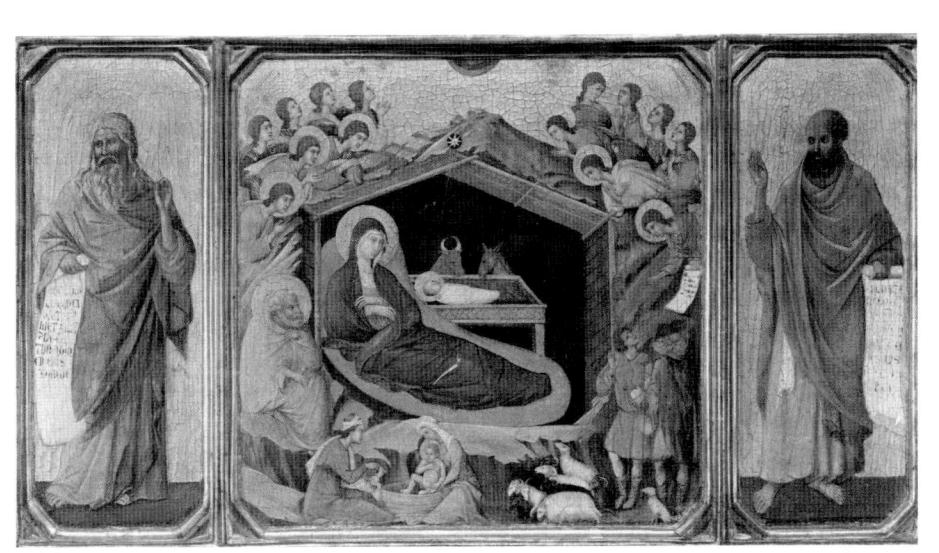

11.38 The Nativity, the Prophets Isaiah and Ezekiel, from the Maestà altarpiece, Siena Cathedral, 1308-1311. Tempera on panel, 17 1/4 x 17 1/2in. (43.8 x 44.5cm), 17 1/4 x 6 1/2in. (43.8 x 16.5cm). Duccio (active 1278-1311). The National Gallery of Art.

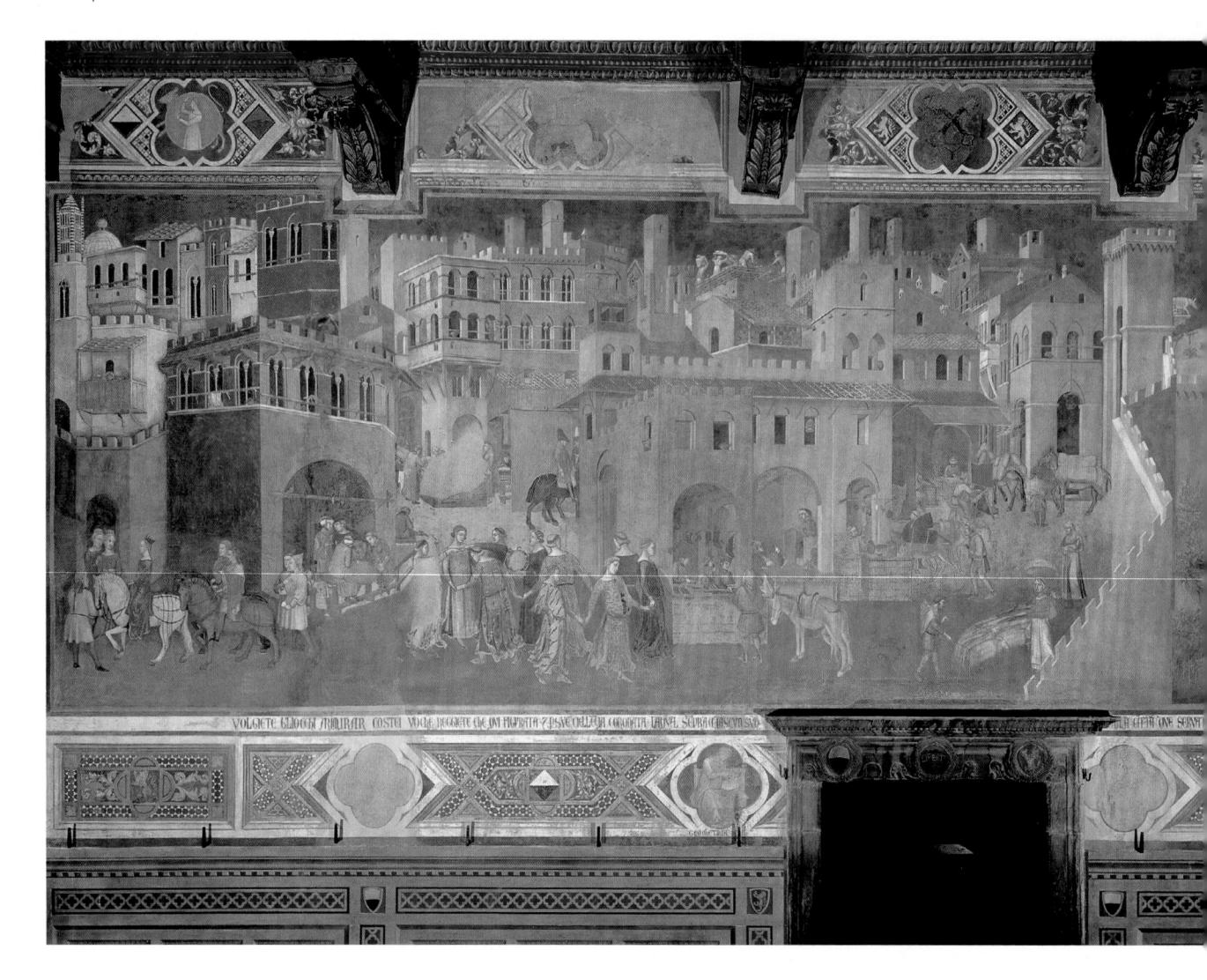

the drapery of the central figure and establishes a functional space. The sky is filled with torches and poles—their unruly positions reflecting the spirit of the faceless mob. Giotto balances the decorative effect of the chapel as a whole with the intellectual and emotional impact of the individual scenes to produce a narrative art unsurpassed in any age.

In Siena, Duccio di Buoninsegna (active 1278–1318/1319) became the principal painter. His masterpiece, the altarpiece of the Virgin in Majesty, is known simply as the *Maestà*—Majesty. So admired was the work in its own day that when the altarpiece was finished in 1311, the people formed a festive procession to carry it through the city streets from the workshop to the cathedral.

The huge altarpiece is made up of many smaller panels: On the front, Mary is enthroned as Queen of Heaven; scenes from her life fill the predella; and the Life and Passion of Christ are found at the back. (The altar piece has been disassembled and moved several times. The major part is now in the Cathedral Museum. Some of the smaller panels are now in other museums.)

Duccio combined elements of Italo-Byzantine and courtly French art to form his own unique style. Like a Byzantine icon painter, he represents the Nativity in a cave with the Virgin lying on a mattress [11.38]. The scene takes place in a stylized mountain landscape against a golden sky. In contrast to these Byzantine elements, the delicate,

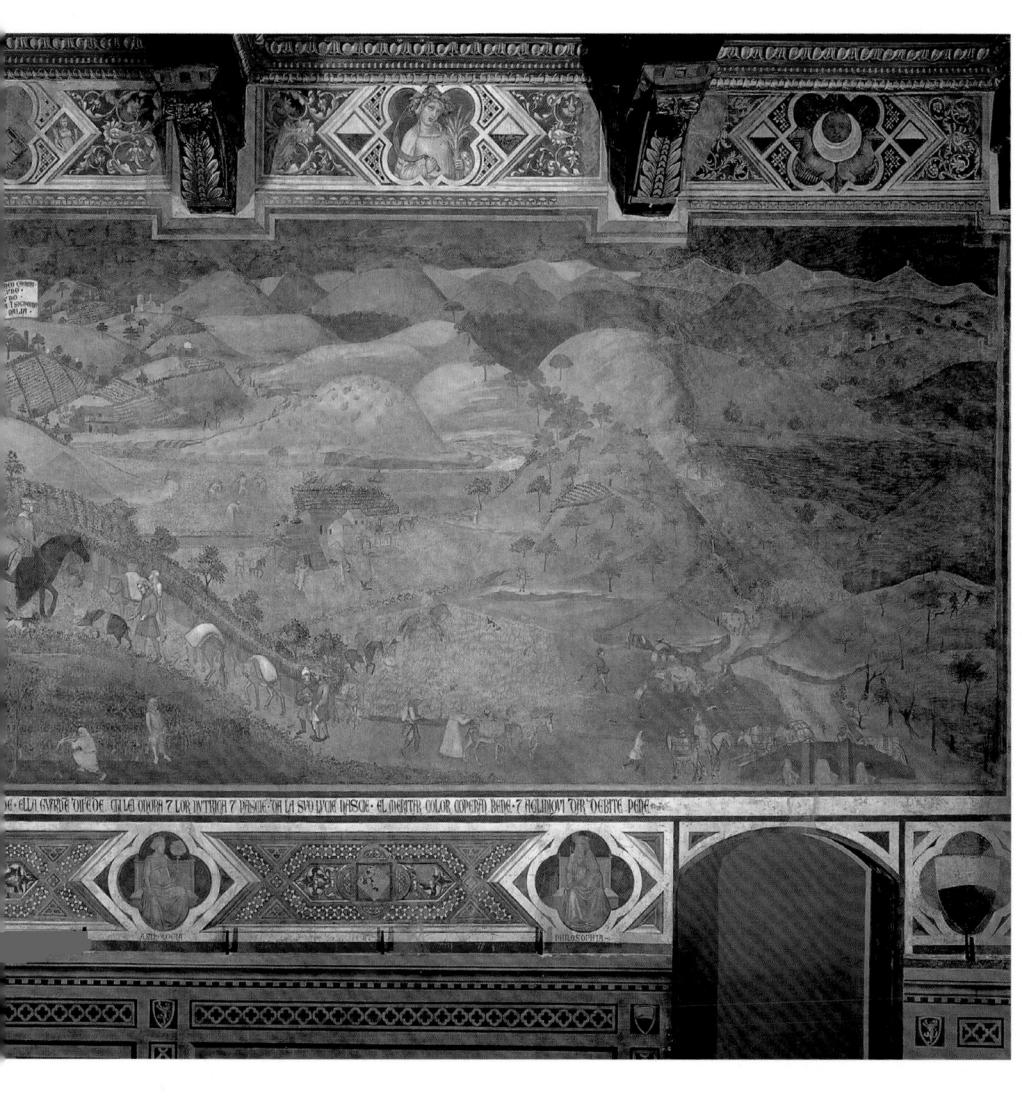

11.39
Allegory of Good
Government in the City
and Allegory of Good
Government in the
Country, frescoes in the
room of peace, meeting
place of the city's
magistrates, the Nine.
1338–1339.
Approximately 46ft. long
(14m). Ambrogio
Lorenzetti. Siena.

graceful figures and miniature architectural setting recall Parisian art. The decorative quality of the light, intense colors, especially the pinks and blues, the meticulously rendered details, and the calligraphic quality of the line all suggest the art of manuscript illumination. In spite of his tentative use of linear perspective, the architecture never quite establishes a spatial environment. Nevertheless, through his sensitivity to gesture and feeling, to nuances of color and subtle modeling of drapery and figures, Duccio achieves a convincing interrelationship of figures. The grace, even the gentleness, of his art and its lingering courtly elegance contrast with Giotto's severe monumentality. While Giotto inspired artists like Ferrer Bassa in

Catalonia, Duccio influenced Jean Pucelle and the painters of France and Flanders.

Just before the Black Death struck Europe in 1347, killing millions of people and eliminating an entire generation of artists, two brothers, Pietro and Ambrogio Lorenzetti (active 1319–1348), became the leading painters in Siena. In 1338, the City Council commissioned Ambrogio to paint murals in the City Hall having as their theme the effects of good and bad government. Ambrogio recorded the appearance of Siena and a rather idealized view of the activities of its citizens [11.39]. Merchants come and go; masons finish a tall building; shops are open; and a circle of young women dance to the rhythm of a tambourine. This is the good life as it

was enjoyed—or at least imagined—in fourteenthcentury Siena. Even the best government, however, could not save its citizens from the terrible plague that would come upon them in ten years. Nearly half the population of Florence and Siena, including the Lorenzetti brothers, died in the summer of 1348 as the Black Death changed the face of Europe.

THE CHARACTER OF GOTHIC ART

From the Île-de-France, the Gothic Style spread throughout western Europe. Whether they accepted the new art and architecture enthusiastically or cautiously, artists and patrons soon absorbed and then subtly changed the French style to suit their native traditions. While England rivaled France as a creative center, the rest of Europe followed more slowly, learning from both France and England. New styles arose in Spain, Germany, and Italy in the later years of the thirteenth century.

Art remained didactic and symbolic in the Middle Ages. The elaborate allegories and esoteric symbolism of Romanesque art never entirely disappeared, but clear didactic narratives gained importance as the churchmen ordered visual sermons in stone and glass for their churches. The new iconographical programs aimed not only to expound Christian truths but to be encyclopedic in nature, and in this intuitive understanding and love for all of God's works, artists differed from their predecessors. Gradually a new realism crept into art—a realism based on specific observable details. The artists recorded surfaces and did not try to understand and organize the world in human terms. God remained the supreme creator; the artist, His humble acolyte; the viewer was merely God's creature who could only try to understand through reasoned analysis or through emotional identification.

Even when external appearances of people or plants might be lovingly depicted, little attempt was made to understand the underlying physical

structure or to place the figures in a mundane space. Delicate figures move gracefully through their miniaturized environment. They act on a narrow stage and are surrounded by a symbolic architecture and landscape. As the scholars of the Church found justifications for the study of the natural world, artists too began to represent not only abstracted drapery forms and expressive gestures but also individualized faces, the weight and fall of garments, tangible forms, and spatial settings. When artists realistically rendered the details of creation, they still sought the immaterial essence of the form. Generous use of gold translated events and figures in painting and sculpture out of this world into an ideal atmosphere; light and color conveyed the mystical experience of Heaven.

Painting and sculpture submitted to the overall control of a greater entity, be it the page of the manuscript, the tracery of a window, or the overall architecture of the church. Architects, too, attempted to create a luminous, ideal Heavenly Jerusalem. The builders concentrated on the interior effects of their churches, on a mysterious darkness or jewel-like brilliance, on the changing quality of color and light. They disguised walls and vaults, dematerialized them, and turned them into luminous sheaths of color, diaphanous screens, or enclosing linear nets. The technical innovations of the later twelfth and thirteenth centuries—pointed arches, ribbed vaults, flying buttresses, pinnacles, piers with engaged shafts, and tracery windows-allowed the builders to lighten walls, reduce support visually if not actually, and turn vaults from surfaces into linear patterns. Thus, although Gothic art constantly evolved and every region created its own style, certain general characteristics remained constant. In all the arts, artists sought to balance the real and the ideal, reason and imagination, observation and fantasy in an effort to capture the cosmic quality of the religion they served.

12.1 St. George and the Dragon, Flanders. Panel, painted surface, 5 5/8 x 4 1/8in. (14.3 x 10.5cm). Rogier van der Weyden (1399/1400-1464), The National Gallery of Art.

LATE GOTHIC ART

In spite of religious controversies and political disasters, the arts reached new and unrivaled splendor at the end of the Middle Ages [12.1]. As Europe recovered from the ravages of the Black Death (1348–1349), the very dislocations caused by the loss of population and leadership permitted new political and economic institutions to emerge. The Church, torn by heresy and the claims of rival papal factions, lost its preeminence as a patron of the arts. From 1305 until 1377, the Popes lived in Avignon in southern France (Petrarch called the period the Babylonian Captivity). When an Italian Pope was finally elected and settled in Rome, Avignon remained the home of the French or Spanish anti-Popes. These rival Popes struggled for power,

condemned each other, and ex-communicated each other's adherents until finally in 1417 the Council of Constance confirmed the authority of the Roman Popes. At the same time radical thinkers like John Wycliffe (d. 1384) in England and John Huss (d. 1415) in Bohemia prepared the way for the Protestant Reformation of the sixteenth century.

Religious struggles were reflected in the political alliances and changing fortunes caused by the wars between France and England, known as the Hundred Years War (c. 1337–1453). Scotland, Castile, and Aragón supported France and the anti-Pope in Avignon; Flanders, Scandinavia, Hungary, and Poland supported England and the Pope in Rome. The German princes and northern Italian cities were divided

in their allegiances. In spite of this turmoil, by the end of the fifteenth century, Louis XI (1461–1483) in France, Henry VII Tudor (1485–1509) in England, and Ferdinand and Isabella (1479–1504) in Spain had united their territories under effective centralized governments. Their official bureaucracies were joined by modest representative bodies in ruling the new nation-states.

As manufacture and trade flourished, towns and villages grew into great cities, and bankers and merchants joined the princes of the Church and state as patrons of the arts. These city dwellers looked at the world with hard, cautious eyes, for they had seen plague, fire, theft, and commercial disasters, as well as warfare and treachery. Those who survived the Black Death had watched virtuous people struck down, families and fortunes destroyed without reason; but they also noted and took advantage of the new opportunities for skilled workers and shrewd entrepreneurs. Not surprisingly, their buildings vary from severely functional warehouses to ostentatious townhouses and market halls; their painting and sculpture, from genre realism to an emotional mysticism profoundly influenced by the preaching friars.

The ideal of chivalry became more important in the fourteenth and fifteenth centuries than ever before, just as knights in armor were rendered obsolete by the English archers at the battles of Crécy (1346), Poitiers (1356), and finally Agincourt (1415). When the Turks using cannon breached the mighty land walls of Constantinople in 1453, a new age in warfare began. Nevertheless, the nobility engaged in spectacular tournaments and pageantry as if to reaffirm their importance in the face of the reality of their diminished role. New chivalric orders were founded: the Order of the Golden Fleece in Burgundy, the Order of the Star in France, and the Knights of the Garter in England. Yet, while paying lip service to a chivalric code, Charles VII (ruled 1422-1461) let Joan of Arc (to whom he owed his crown) burn at the stake in 1431. Across the Channel in England, the Wars of the Roses (1455-1485) pitted family against family, the symbolic white rose of York against the red rose of Lancaster. Finally Henry Tudor defeated Richard III at Bosworth Field and established the powerful new Tudor dynasty. (The heraldic Tudor rose had both red and white petals.) Even the Crusades came to an end when in 1492 Ferdinand and Isabella captured Granada, the last Muslim kingdom in the West. In the same year Spanish ships reached America and inaugurated the great age of exploration and expansion that would change every aspect of European life. Art and architecture could not remain isolated from such ferment. Some artists, writers, and philosophers began to study the physical world in minute detail, while others turned inward to a contemplative mysticism. They combined objective realism with personal emotional expression to create a brilliant new art.

Secular architecture gained stature in the late Gothic period. A better idea of the appearance of these late medieval towns can be gained from paintings than from the few surviving buildings. In Rogier van der Weyden's painting of St. George and the Dragon, a fanciful castle with high walls, bristling towers, and an elegant residence sits atop an imaginary, stylized rock formation. In fact, cannon had rendered such traditional castles obsolete. As prolonged sieges gave way to battles in open fields, the castle became a garrison headquarters, a supply depot, and a symbol of power and authority. In his painting, Rogier records the appearance of a prosperous city at the base of the castle rock. Walls and towers protect houses, churches, and a city hall or merchants' exchange. Townspeople displayed their civic pride by erecting large guildhalls, markets, town halls, and other civic buildings. In the town center, the spires and transept façade of a large church contrast with the heavy square tower and simple walls of older buildings. Houses crowd together, with their steep gable fronts facing the street, their roof lines broken by stepped gables, chimneys, and dormer windows. Masonry construction and tile or slate roofs reduced the danger of fire in cities. In contrast, the farmsteads lying outside the walls have large half-timbered buildings and wattle fences. Two bridges lead into the city, and a tavern or inn with red and white signs stands ready to sustain the traveler. This peaceful view of a prosperous domestic economy contrasts

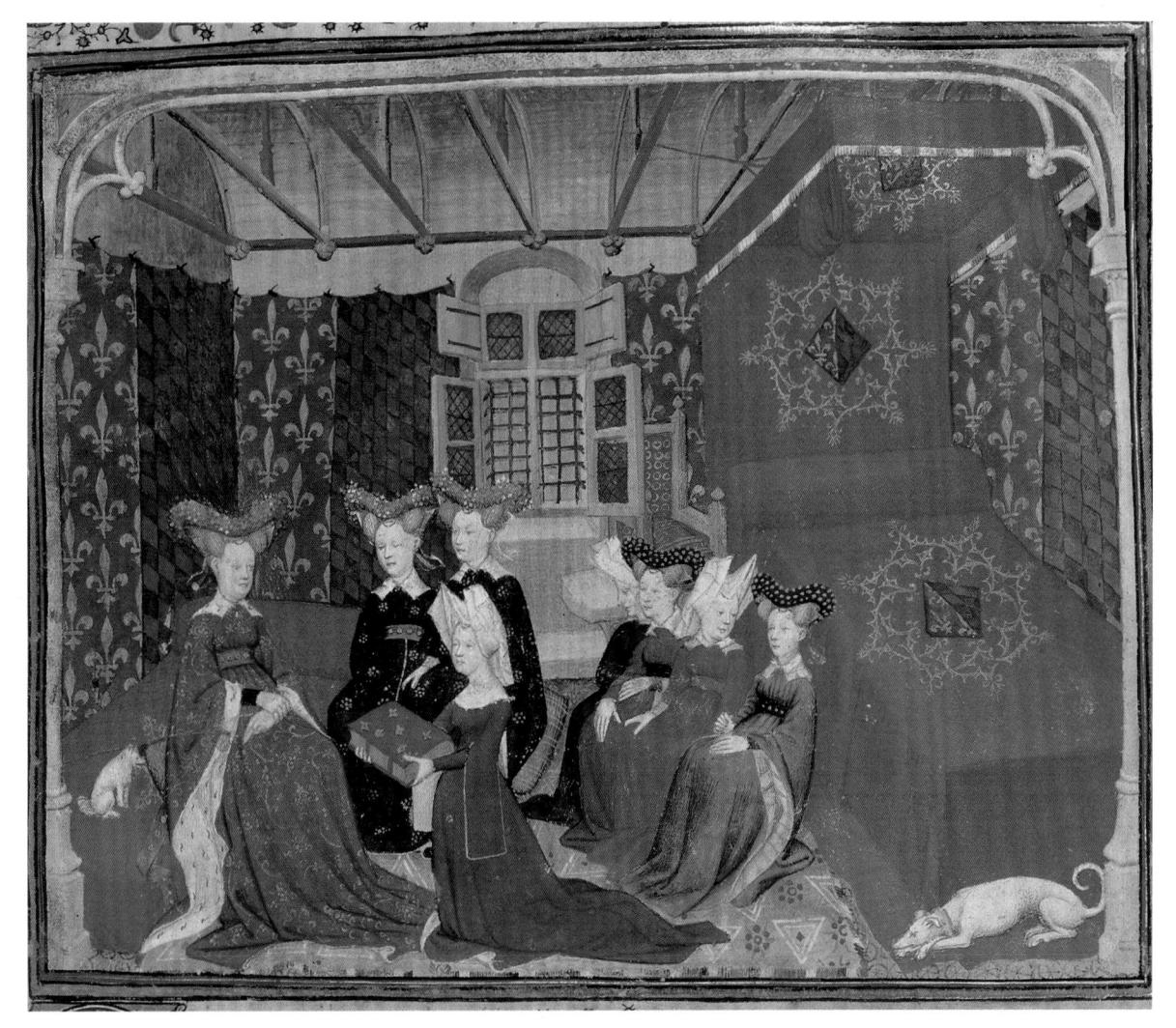

12.2 Christine presenting her book to the Queen of France. 1410-1415. Tempera and gold on vellum, image approximately 5 1/2 x 6 3/4in. (14 x 17cm). The British Library.

with the fantasy of the princess in her blue-andgold brocaded gown and St. George, a knight in plate armor. The saint's impossibly long scalloped sleeves, elegant as they are, would have rendered him helpless in battle or in his confrontation with this nasty but not very frightening dragon.

Less fantasy and greater realism pervade the Limbourg brothers' representation of Paris in the Très Riches Heures, the book of hours made for the Duc de Berry [see 10.43]. The River Seine and neat fields tended by peasants surround the city, while the buildings of the royal palace and the Ste. Chapelle rise above the city walls. Stairs lead down

from the queen's apartments to a pleasure garden where a trellis and vine-covered lattice bower are visible above the walls. The palace interior is depicted in a manuscript illustration in which the author Christine de Pizan presents a book to the queen [12.2]. The queen's chamber is painted and hung with tapestries and embroideries to enhance its beauty and comfort. Luxurious furniture and glass and shuttered windows complete the sumptuous setting for the ladies of the court.

Well-to-do merchants also lived in comfortable, well-furnished houses. Fifteenth-century paintings of the Virgin and Child at home illustrate the com-

12.3 The Holy Family, Flanders, 1472. Oil on wood panel, 27 3/8 x 20in (69.5 x 50.8cm). Petrus Christus (c. 1415–1472/1473), The Nelson-Atkins Museum of Art.

forts available to a skilled artisan like St. Joseph [12.3]. Petrus Christus (active 1444-1473) placed the Holy Family in a room with glazed and shuttered windows opening onto a walled garden. He surrounded them with fine furniture, including a curtain-hung bed, benches piled with pillows, and an elaborate brass chandelier. Although the apple in the window may refer to the Fall in the Garden of Eden and Mary as the new Eve, the brass chandelier with its ropes and pulley, the stacked red and green cushions, the chamber pot, and the threelegged stool surely hold no subtle iconographical messages. Such genre details establish a mundane setting for the activities of the Holy Family and so bring the religious figures into association with the daily life of the painting's owners.

Artists and architects produced imaginative buildings and filled them with sumptuous arts.

Carpenters rivaled stone masons in their use of sophisticated techniques and subtle decorations. In England the Perpendicular style and in Germany the Parler style dominate late Gothic architecture with their technical and aesthetic innovations. The Perpendicular style became the "national style" of England. The repetitive linear quality of the towers added to Wells Cathedral [see 10.29] suggests the emergence of a new aesthetic, based on the forms of carpentry and perhaps also influenced by the French Rayonnant. The new style appeared in monuments closely related to the royal court like the tomb of Edward II [see 11.15], but it soon spread throughout the country. Rectangular tracery patterns, distinctive "linen fold" paneling, the translation of carpentry patterns into stone, and an emphasis on family pride in the decorative use of heraldry characterize the style.

At the Abbey of St. Peter at Gloucester (elevated to cathedral status and rededicated to the Trinity after the Reformation), the dean and chapter decided to modernize their Norman Romanesque building in the 1330s. The masons preserved the stonework of the Norman choir behind a screen of perpendicular tracery, and they added a new clerestory, east window, and vault in the Perpendicular style [12.4]. Old and new work, walls and windows are united by tracery in repeated rectangular panels formed by mullions and transoms in the windows and extended as a blind tracery over wall surfaces. Curvilinear tracery in the head of each rectangular frame relieves the austerity of slender mullions. The linear quality of the design continues into the vault, where a pointed barrel vault is disguised by decorative net-like ribbing. The vault seems to float weightlessly above the piers and windows.

At Gloucester, the east window (c. 1350–1360) is an enormous tripartite wall of glass measuring 72 by 38 feet (21.9 x 11.6m), enlarged by setting the side walls at an angle to accommodate even more glass [12.5]. The great window rises like a glowing altarpiece dedicated to the Virgin and Child. Around these central figures are elegant angels, apostles, saints, and deceased members of the community, each swathed in voluminous draperies. A

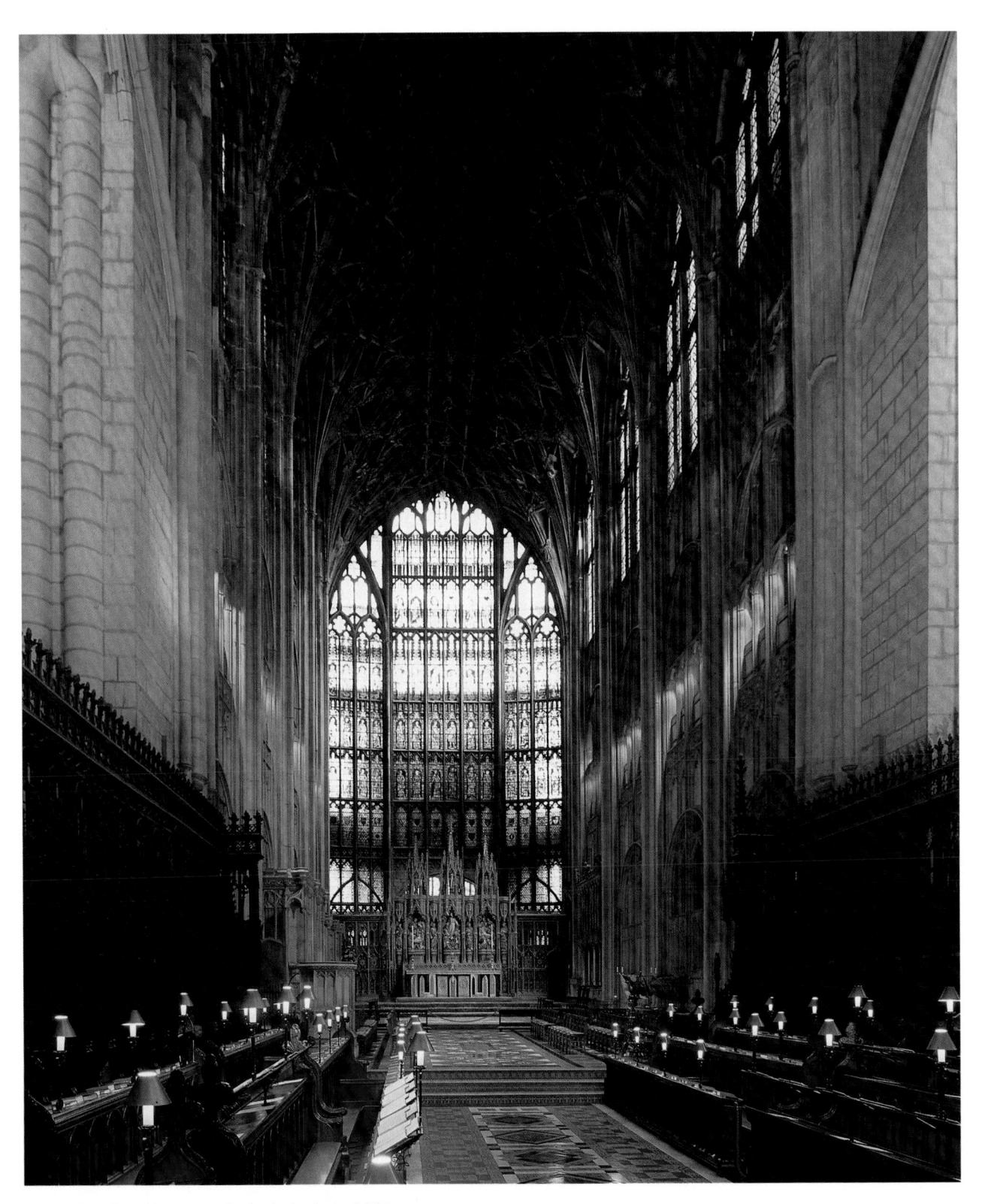

12.4 Interior, Gloucester Cathedral, choir, 1330s.

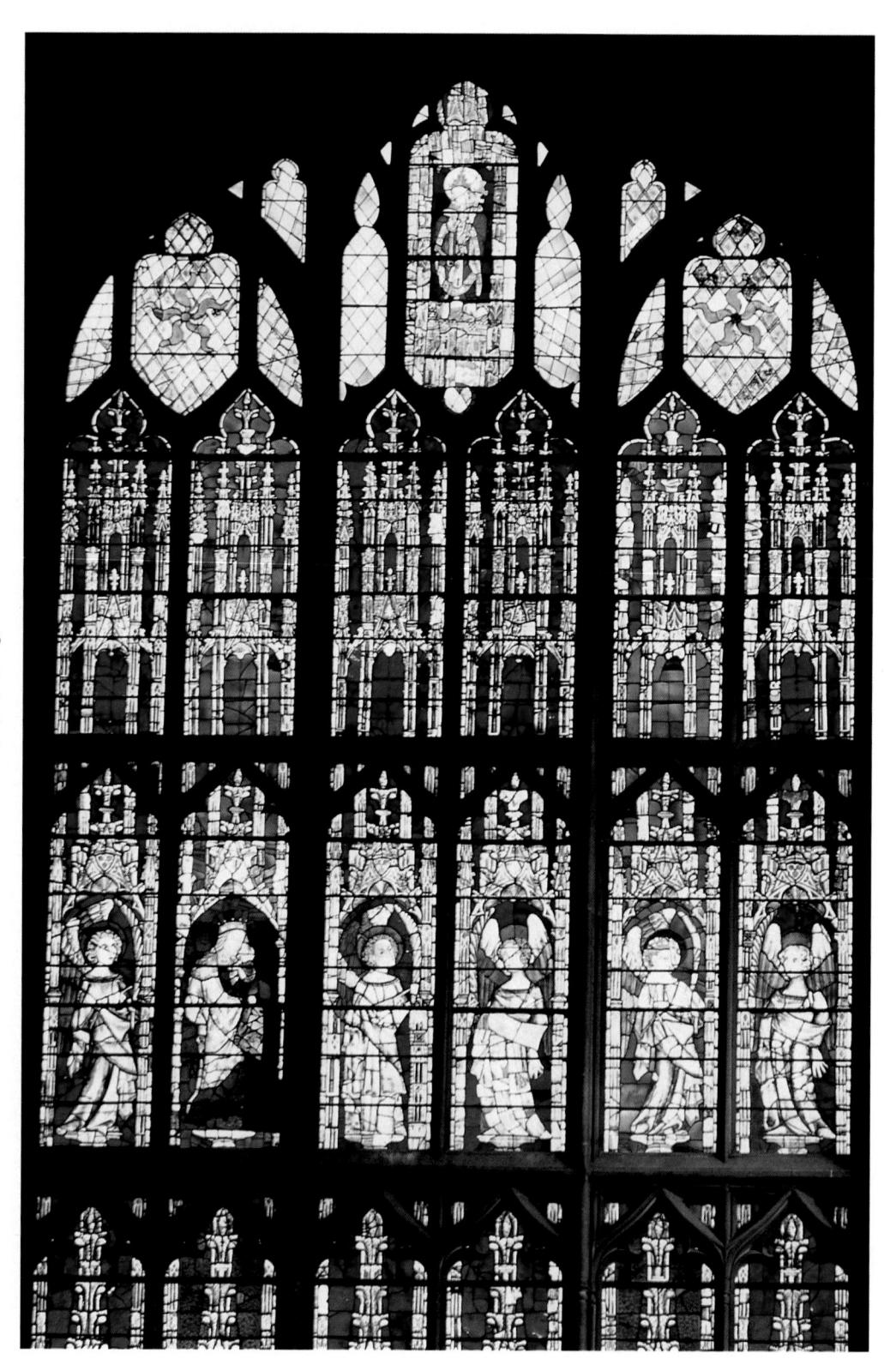

12.5 East window, stained glass, Gloucester Cathedral, c. 1350-1360.

single figure stands in each light of the window under a canopy that becomes an extension of the stone tracery. The grisaille figures and architecture are silhouetted against colored glass backgrounds so that at a distance the window seems to be composed of alternating bands of red, blue, and gray, reinforcing the lines of the mullions and transoms. It has been suggested that the window might be a memorial to those who fought in the Hundred Years War.

In the fourteenth century, English masons created yet another variation on the rib vault, known as the fan vault. One of the earliest fan vaults was built in the cloister at Gloucester Cathedral between 1351 and 1377; the entire cloister was finished by 1412 [12.6]. The structural principle of the fan vault is simple: Curving, cone-shaped corbels laid up in horizontal courses support a series of flat panels along the crown of the vault. In other words, the masons replaced the skeletal structure of Gothic architecture with massive walls and vaults. The false ribs, each with the same curvature and the same length, seem to spring from each pier; however, they are not structural but instead are merely tracery carved out of the corbels. The handsome form of the fan vault with its rich ornamental pattern of moldings is heightened by the silvery light from large windows. The new architectural aesthetic plays on the contrast of walls and windows, but at the same time bonds opposing masses and voids behind a delicate screen of rectilinear tracery.

By the time many cathedral chapters were ready to finish their buildings taste had changed; consequently, many churches are graced with towers in the later style. At Wells Cathedral [see 10.29], for example, beautifully proportioned towers designed by William of Wynford and built between 1365 and 1440 provide a severe but handsome foil to the vivid color and texture of the thirteenth-century façade. Perpendicular architecture embodies the characteristics of clarity and balance, juxtaposition of horizontal and vertical, mass and void. The architects stated and restated the verticality of the

12.6 Gloucester Cathedral, cloister, south range, 1351-1412.

towers but tempered the severity of the structure with delicate vertical moldings, cusped headings, and narrow gables.

One of the most characteristic building complexes, and one for which the Perpendicular style proved to be especially satisfactory, was the university. The oldest colleges of Oxford and Cambridge provide excellent examples of the secular and religious architecture of the later Middle Ages (and are often copied in American collegiate architecture). Cloister-like quadrangles surrounded by living quarters, assembly rooms, refectories and kitchens, and of course the library and chapel, illustrate the essentially functional character and the adaptability of the style. One of the most beautiful of these collegiate buildings is King's College Chapel at Cambridge, built by Regionald

Interior, King's College Chapel, Cambridge, 1446–1515.

Ely and John Wastell between 1446 and 1515 [12.7]. The chapel is a large, rectangular hall lighted by enormous windows filled with sixteenth-century Flemish stained glass and covered by a fan vault. Massive walls are enriched on the interior by the Tudor emblems of roses and portcullises in high-relief sculpture. This heraldic decoration also surrounds the entrances. The opposition of horizontal and vertical lines, which gave the style its popular name, Perpendicular, produces a building that heralds the classical Renaissance style in its regularity, its horizontal lines, and its sheer wall surfaces. When Tudor monarchs introduced classical art of the Italian Renaissance into the British Isles, builders did not have to rethink the form and structure of their buildings; they simply changed the decoration from Gothic to classical ornament.

English medieval styles lingered on in the Tudor period. At Westminster Abbey, Henry VII, the founder of the dynasty, ordered a new Lady Chapel which would also function as a mausoleum and a chantry chapel for himself (a chantry is an endowment for perpetual Masses for the soul of the founder). Between 1503 and 1519, William Vertue built an exquisite chapel, incorporating yet another variation on the theme of the rib vault, known as the pendant fan vault [12.8]. The underlying structure of the vault consists of enormous transverse arches, but these arches nearly disappear under a filigree of stonework. About a third of the way around the arches, Vertue elongated the voussoirs into pendants 8 feet (2.4m) long, from which fan vaults spring. These pendant fans are actually openwork, and transverse arches are visible through the tracery. To enliven the rich surface of the vault still further, additional pendant fans drop from the flat panels along the crown. The building is a master mason's tour de force. The wall is reduced to octagonal piers, which on the exterior become turret-like bases for heraldic beasts carrying gilded weather vanes. Inside, the walls and windows are bound together by a trellis of rectangular paneling and a broad band of sculpture beneath the windows. The stalls and banners of the Knights of the Bath, whose chapel this has become, now add the final touch of fantasy to a building as sumptuous and extravagant as late medieval chivalry itself.

In Spain in the fifteenth century two national styles appeared: Mudejar, inspired by Moorish craftsmen and design [see Box: Mozarabic Art and Mudejar Art], and Isabellan Gothic. The Isabellan style can be seen at its most ornate in the Church of San Juan de los Reyes (St. John of the Kings) in Toledo, founded in 1477 by Isabella and Ferdinand and designed by Juan Guas [12.9]. Parish and monastic churches built during the reign of Ferdinand and Isabella were usually of modest size, but they are often richly decorated. This new Isabellan church type has a single nave flanked by unconnected lateral chapels between the buttresses, a raised choir over the western entrance bay, raised pulpits at the crossing, and a low lantern tower. This compact and efficient design

12.8 Westminster Abbey, Henry VII Chapel, London, 1503–1519.

12.9 Church of S. Juan de los Reyes, Toledo, Spain, begun 1477. Juan Guas (active 1459-1496),

allowed ample space for altars, pulpits, and tombs (if the church was intended as a burial chapel), a nave free for the congregation, and wall space suitable for an educational or propagandistic decorative program [12.10]. The Isabellan church became the Spanish "mission" type built in the Americas by the conquistadores.

Lavish interior decoration at San Juan honored the Catholic sovereigns. Heraldry became a principal decorative feature (as it was in Tudor England), and the royal coats of arms are as prominent as the assembly of saints. In friezes of tracery and foliage, the artists' attention to the accurate representation of visual details rivals the painters' realism. Carved insects, birds, and animals appear to climb in vines that sometimes seem entirely independent of the buildings. Other prominent features such as stalactite corbels and inscriptions in continuous friezes were inspired by Moorish art. Years

12.10 Church of S. Juan de los Reyes, plan.

of contact with Moorish art led the Christian builders and patrons to appreciate extravagant surface decoration. They used the visual arts to good effect in the glorification of the valor of the monarchs and the power of the state. The sculptors of San Juan de los Reyes, with their delight in realistic detail, combined with an equal enthusiasm for abstract or geometric ornament, indicate the direction late Gothic art would take throughout Europe: On the one hand, the style became elegantly decorative, and on the other, it could be meticulously realistic.

In Germany, as in England and Spain, architects experimented with the structure and decoration of buildings. In the "hall church," spatial unity and an even, pervasive light had been made possible by elevating the side aisles to the height of the nave and enlarging the windows in the outer walls. In the fourteenth century, German architects, led by the Parler family, gave the form new monumentality and dignity. Peter Parler developed new forms for vaults, elevations, and windows. He elaborated on such technical devices as flying ribs, open-work tracery, and net vaults. His ideas spread throughout

Germany and central Europe, especially after he was called to Prague by Charles IV to complete the Cathedral of St. Vitus in the royal residence, Hradcany Castle. By the time he died in 1399, Peter had introduced nearly every innovation found in later German Gothic architecture. His sons and nephews continued the building tradition.

Indirectly Peter inspired the Vladislav Hall in Hradcany Castle. The magnificent hall was built by Benedict Rieth in 1487-1502 as a place to hold indoor tournaments [12.11]. Here the ribs of the net vault turn into decorative, flowing shapes with little or no function. In fact iron tie rods bind the walls together, and the vault resembles a giant canopy floating over a tournament pavilion. Ultimately, builders eliminated even token ribs and returned to the shell of the groin vault. In northern Germany, Poland, and the Baltic lands, they created vaults that were a series of interlocking cells. Arnold van Westfalen is credited with inventing this technique in Meissen Castle. The cloister vaults in the neighboring cathedral illustrate the cell vault in its most elegant form [12.12].

Dazzling effects became the stock-in-trade of German architects in the fifteenth century. The eastern choir of the Church of St. Lawrence, Nuremberg, begun by Konrad Heinzelman (c. 1390-1454) in 1439, also copied the Parler style [12.13]. Lower chapels surround the three-aisled hall church choir, and a projecting cornice and pierced parapet emphasizes the division of the elevation into two stories. Hexagonal piers with engaged shafts rise unbroken to merge with the vaulting ribs. Konrad Roriczer (c. 1410-1475) added an extraordinarily complex, star-patterned vault in 1472-1477. Huge aisle and chapel windows bring light to the interior sculpture, church furniture, and painted decorations. Veit Stoss's Annunciation seems to float in the center of the sanctuary, and Adam Kraft's flamboyant, open-work tabernacle for the reserved Host (1493-1496) stands by a pier at the left, so tall that its spire must bend to follow the line of the vault. The intricate wooden tracery of the tabernacle is the ultimate enlargement of the towered reliquary, with all its associations of a mar-

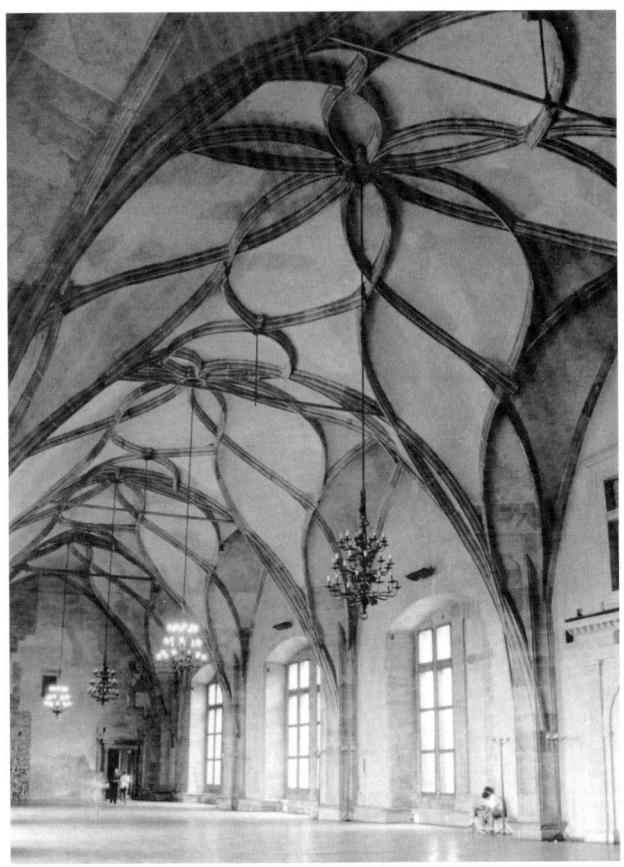

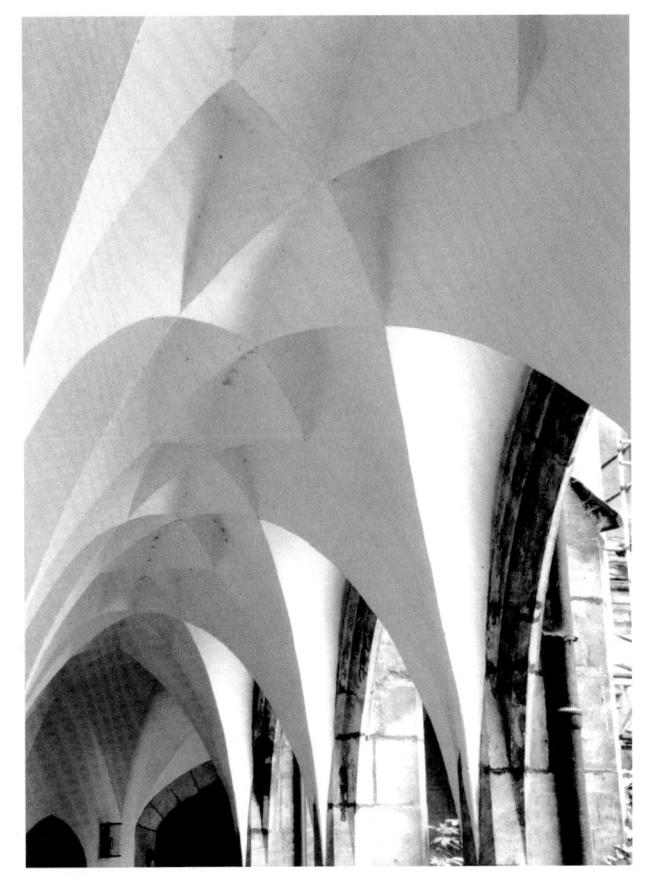

12.12 Meissen, Albrechtsburg, cloister vaults, 1491

tyrium. It is a spire within, rather than outside, the church.

Veit Stoss (c. 1440–1533) carved a giant rosary (1518) for the choir [12.14]. A garland of roses interspersed with scenes from her life surrounds Mary and the angel Gabriel. The Dominicans popularized the prayers as part of the devotion to Mary. As he gives prayers visual form, Stoss removed the image from the everyday world by disguising the figures with draperies treated as crisp, entirely decorative forms and then gilding the resulting sculpture. The interpenetration of space and solids combined with the natural movement of light and shadow produced a sculpture that seems to float over the altar as an object for contemplation and adoration. Such sculpture is a mystical experience made tangible.

In the late fourteenth and fifteenth centuries, France developed a new style known as Flamboyant from the flamelike twisting of its characteristic ogee arches. The Flamboyant style originated in northern France and Flanders, lands either under the control of the English regent, the duke of Bedford, or closely connected with England through the cloth trade. The flamelike tracery that gave the style its name may have been inspired by the English Decorated style. In Flamboyant architecture and decoration the visual dissolution of the architecture in an intricate play of space and form reached its climax. The transparency seen in the Reims Cathedral façade was intensified. Every element is made up of open tracery. Ogee arches form soufflets (daggers) and mouchettes (curved daggers), as can be seen in the rose windows in Amiens

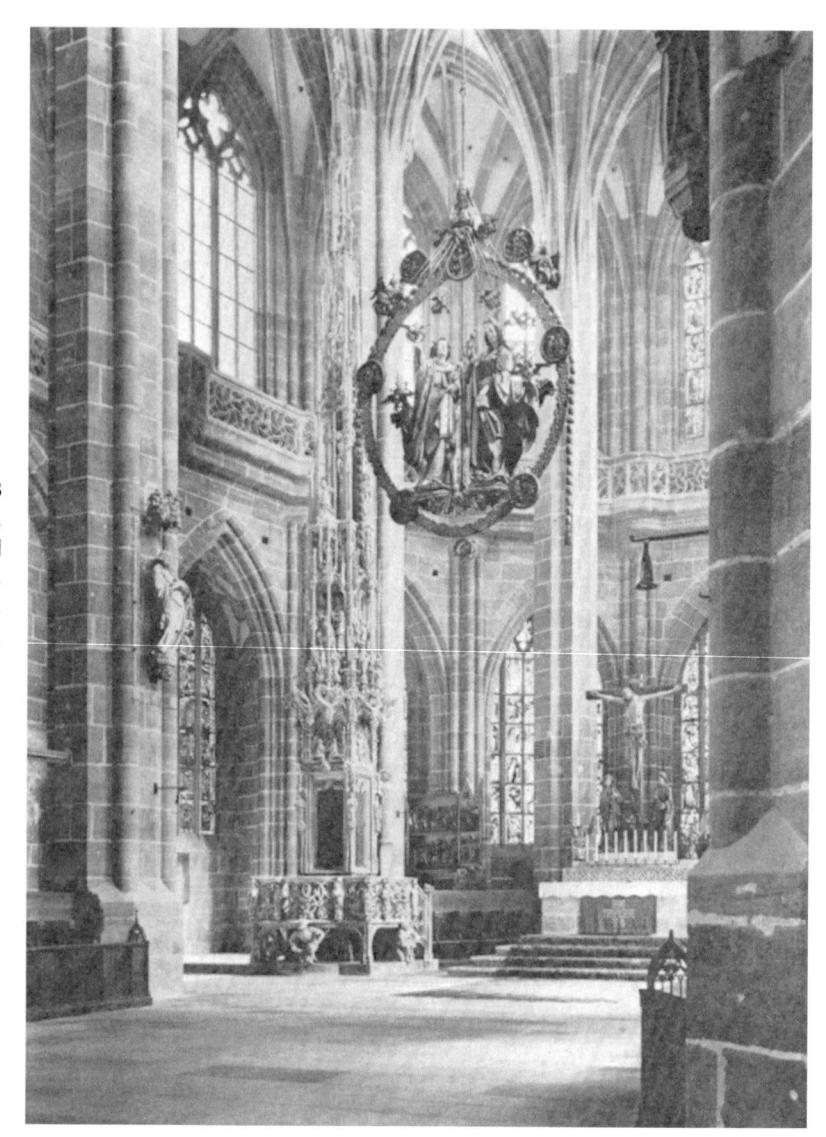

Church of St. Lorenz, Nuremberg, begun 1439, Konrad Heinzelman and Konrad Roriczer. Vaulted, 1472–1477. Tabernacle, 1493–1496, Adam Kraft. The Annunciation, 1518, Veit Stoss.

Cathedral [see 10.16]. Ultimately, Gothic structural elements turned into applied decoration.

Pinnacles, traceried gables, and ogee curves even in the flying buttresses created the finest tracery spire in France, designed by Jehan de Beauce in 1507 for the north tower at the Cathedral of Chartres [see 9.12]. The profusion of geometric and natural ornament seems to merge the stone structure with the surrounding atmosphere. Such a tracery spire is entirely symbolic architecture. Nevertheless, in its challenge to the solid mass of the

building, it is a telling expression of the late Gothic spirit.

In the visual arts at the end of the fourteenth century, the papal court at Avignon was the creative center of a truly international style. Patrons demanded a richly ornamental and graceful style that combined the characteristics of the Parisian and English court styles with Italian art. Attracted by papal patronage, Duccio's pupil Simone Martini (c. 1284–1344) had moved from Siena to Avignon about 1335, and at the same time northern

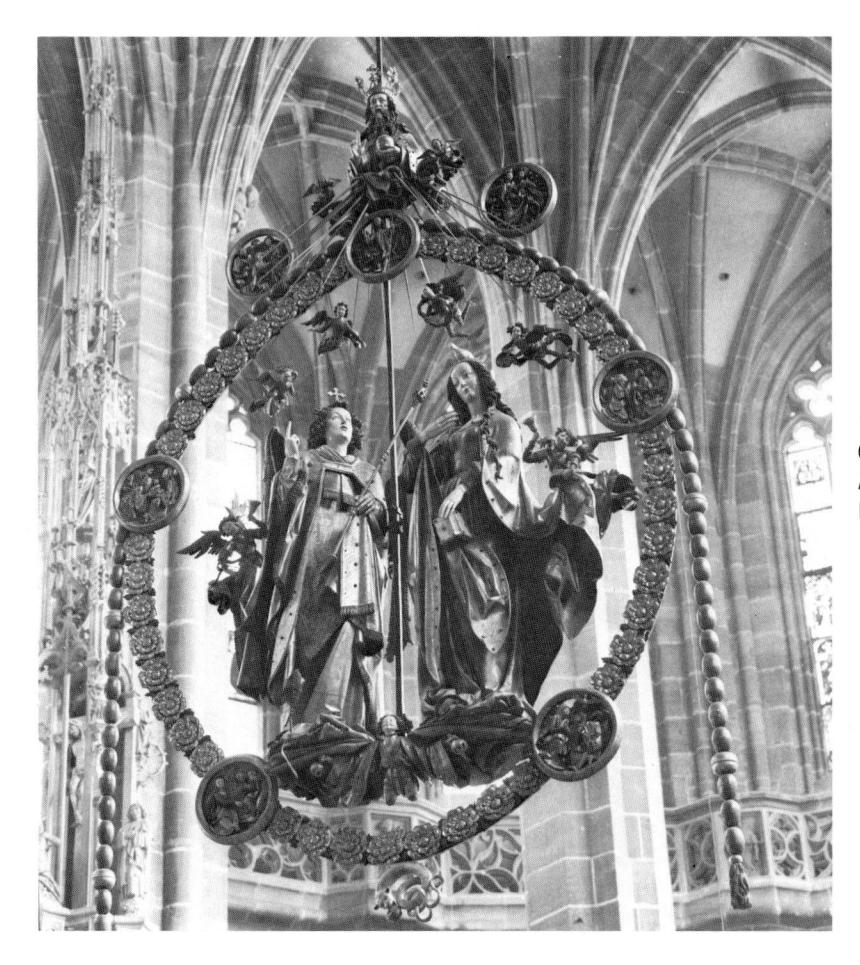

12.14 Church of St. Lorenz, The Annunciation, Veit Stoss, Nuremberg, 1518.

artists also flocked to the new court. The synthesis of the art of Paris and Siena that took place in southern France spread throughout Europe from about 1380 until about 1430. This International style was first and foremost an art of royal and ducal courts: Paris, London, Prague, Burgundy, Berry, and Anjou. Superb abstract designs using bright colors and rhythmic lines enhance the artists' detailed rendering of surface textures especially of textiles and plants. Inspired by Sienese painting, northern artists learned to represent spacious architectural settings, although they still saw the landscape as a tapestry-like collection of plants and fantastic rocks. They left the study of mathematical, linear perspective to the Italians while they concentrated on capturing the ephemeral quality of light and atmosphere.

Traveling artists and portable works of art—tapestries, manuscripts, and panel paintings-carried the International style from Avignon throughout Europe. In the Loire Valley of France, a suite of tapestries, known as the Angers Apocalypse, was woven between 1376 and 1381 for the Cathedral at Angers [12.15]. Jean Bondol designed the cartoons, using an illuminated manuscript of the Apocalypse as his model, and Nicolas Bataille supervised the weaving. Rectangular panels alternate between blue and red grounds, enriched with vine scrolls or diapered with fleur-de-lis. They provide backgrounds for elegant, courtly figures, miniature architecture and trees, and impossible, charming beasts and monsters. Images that could be merely pretty or decorative are saved by the solemnity of the theme, the monumental size of the hangings,

12.15 Apocalypse tapestries, 1376-1381. Angers. Jean Bondol and Nicolas Bataille. Caisse Nationale des Monuments Historiques et des Artes.

and the abstract quality inherent in the medium. The catastrophic events at the end of the world envisioned by St. John are captured in subtle drawing, rich color, and delicate shading as weavers reproduced the models supplied to them by the painter.

In the fifteenth century, tapestries and embroideries brightened the dreary winter days in northern Europe by turning walls into heraldic fields or flower-strewn meadows, as we saw in the French queen's chamber [12.2]. Suites of tapestries were carried from one residence to another to provide appropriately luxurious state rooms for the owner. Tapestries not only created sumptuous, warmly insulated inner rooms, they were seen as major investments and therefore appropriate royal gifts and sought-after booty. The typical millefleur tapestry, inspired by murals or by the custom of fastening bunches of flowers and

branches to walls on festive occasions, had plants of recognizable species scattered over a field of dark blue or red. Depending on the cartoons in the workshop, the depiction of individual plants varied from realistic images to a dense pattern of highly stylized daisies, pinks, columbines, Solomon's seal, and strawberries. The entire tapestry could be packed with flowers, or the plants could function as a background for other images. Animals and birds were often placed at random, with no attempt to reproduce realistic relationships in space even in figural scenes.

Working on a smaller scale, but even more innovative visually than the weavers, were the painters of illustrated books and altarpieces. Women became major artists. Christine de Pizan described the painting of Anastasia, one of her assistants, as superior to all others. The anonymous illustrator of Boccaccio's stories of famous women shows a series

of women artists at work [12.16]. The painter Thamyris works in a well-appointed studio where her youthful male apprentice prepares her colors. Painters working for the dukes of Berry and Burgundy studied the visual appearances and captured effects of light, space, and atmosphere; at the same time they painted in an elegant, linear, ideal mode inherited from the Gothic world. Luxury book production culminated in the manuscripts created for the book-loving Duc Jean de Berry. Among his leading painters were Pol, Jean, and Herman Limbourg.

The Limbourg brothers appeared first about 1390 in Paris as goldsmiths, but in 1401 or 1402 Pol was in Burgundy and by 1413 all three were working in Berry for Duc Jean. The brothers died in the plague of 1416, leaving their masterpiece, the Très Riches Heures, unfinished. Like other books of hours, the Très Riches Heures contained a calendar and the prayers for the canonical hours. The Limbourgs illustrated the calendar with the labors of the months represented as scenes of daily life and set in specific landscapes. For example, in June peasants mow the fields outside the walls of Paris [see 10.43]. Not only is the architecture of the Île-de-la-Cité depicted with meticulous detail but the very quality of the light, color, and atmosphere of early sum-

mer was captured by the painters. Such a study of the French countryside is remarkable, although, true to the traditions of their art, the Limbourgs thought in terms of the manuscript page. Even when the principal miniature presents a window on the world, the artists used a decorative frame to bring the eye back to the surface. Part of the success of a manuscript illumination depends on this respect for the page, and when the representation of three-dimensional space overshadows the unity of the page, the illustration no longer belongs to the art of the book.

Burgundy under the rule (1362-1404) of Philip the Bold (the brother of the king and those other great patrons, the Dukes of Berry and Anjou) became the creative leader of northern Eu-

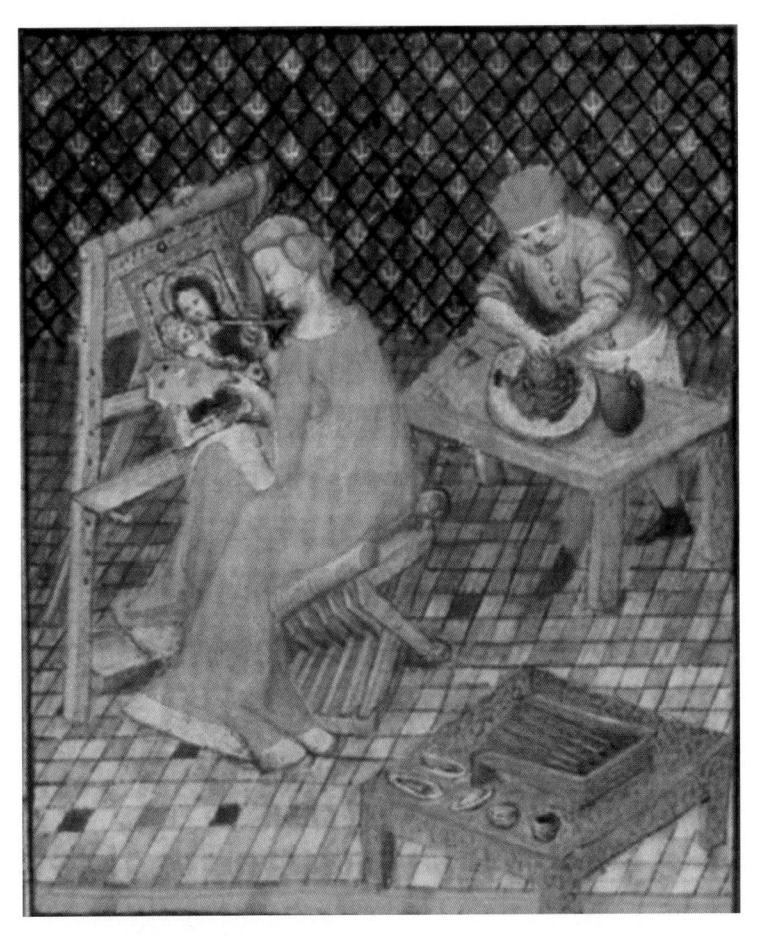

12.16 Page with Thamyris, from Giovanni Boccaccio's De Clairs Mulieribus (Concerning Famous Women). 1402. Ink and tempera on vellum. Bibliothèque nationale, Paris.

rope. Philip inherited the Duchy of Burgundy in 1363. When six years later he married the heiress of Flanders, he became one of the wealthiest and most powerful rulers in Europe. His capital city, Dijon, became a great cultural center. In 1385, Philip established the ducal pantheon in the Carthusian monastery of Champmol near Dijon. He entrusted the project first to Jean de Marville and then, on Jean's death in 1389, to Jean's assistant, the Netherlandish sculptor Claus Sluter (c. 1360-1406). Sluter worked continuously at the Chartreuse de Champmol, on the chapel and cloister, completing a well but leaving the tombs unfinished at his own death in 1406.

In his relatively short career Sluter created a memorable and influential new style [12.17]. The

12.17 The Well of Moses, cloister, Carthusian monastery of Champmol, Dijon, 1395-1406. Claus Sluter, Height of figures 5ft. 8in. (1.7m).

base of Sluter's Well of Moses (1395-1406) still stands in the cloister. From the bottom of the well rose a pier bearing a complex sculptured group consisting of Old Testament prophets supporting a crucifix (only a fragment of the crucifix survives). The prophecies painted on the prophets' scrolls were taken from a contemporary mystery play, *The Judgment of Jesus*. In the play Mary pleaded the cause of her Son before the great men of the Old Testament, and each replied that

Christ must die to save mankind. Sluter could have seen the play, and the theatrical quality of his sculpture may not be simply a product of our imagination.

In sculpture at once monumental and human, Sluter combined realistic portraiture with massive figures enveloped in voluminous, sweeping draperies. He created such life-like images that the spectator feels that he or she is standing in their presence. To create his effects, Sluter combined intense surface realism and dynamic movement with a carefully calculated light and shade pattern. Sluter observed the world so acutely and carved so deftly that he could capture the essence of his subjects without the scientific anatomical study that had begun to captivate his Italian contemporaries.

Moses is justly considered the masterpiece of the group. His sad old eyes blaze out from a memorable face entirely covered by a fine filigree of wrinkles. A mane of curling hair and huge beard cascade over his heavy figure, and an enormous cloak envelops him in deep horizontal folds. Jean Malouel's painting and gilding of the sculpture (traces of which remain) must have enhanced its impact. Sluter's mastery of dramatic representation and volumetric breadth completely transformed the contemporary ideal of sculpture. Under Sluterian influence, realism, bordering at times on caricature, took the place of the sophisticated and often superficial elegance of the court schools and the International style.

Sculptors and painters still reflected the deep piety of the Middle Ages. They and their patrons sought an underlying significance and symbolic meaning in natural objects and everyday activities. They explored the visual and symbolic possibilities of an art based on the observation of nature. In their desire for ever greater and finer detail in the rendering of the surfaces of objects, the painters developed a new painting technique, using oil as a medium for the pigments, building up colors in a series of semi-transparent glazes that had a greater intensity and luminosity than tempera paints. The technique had been used earlier where

durability was required—for example, when a painting might be exposed to the weather. The Flemish masters extended and popularized the medium.

Rogier van der Weyden (1399/1400-1464) and other Flemish painters such as Jan van Eyck (d. 1441) and Petrus Christus (c. 1420-c. 1473) popularized the technique. Rogier typifies the new age in art. Instead of working for the aristocracy, he was the official painter for the city of Brussels. His straightforward, appealing paintings made him the most copied of all Flemish masters [see 12.1]. Rogier seems to have taken delight in every detail of St. George and the Dragon, from the brocades of the princess's gown to the scales of the dragon, from the swirling lines of St. George's trailing red sleeves to the glittering highlights of his armor. The landscape rises in a series of flat, sharply defined planes from the narrow foreground stage, on which the confrontation of saint and dragon takes place, to the fantastic rock formations and a high horizon line. In his painting of the distant city, however, Rogier achieved an effect of sweeping landscape. The reason for Rogier's popularity is apparent: He is an excellent storyteller, a

superb draftsman and colorist, and his people have about them a quality of idealized nobilitymaking him unsurpassed as a portrait painter as well as a painter of religious themes.

During the fifteenth century, the Flemish style and painting technique spread throughout Europe as local artists adopted the luminous colors and careful realism of Flemish painting. The style extended into other mediums as well as painting. In Strasbourg, for example, about 1477 Peter Hemmel organized the stained-glass painters into an extended workshop to supply windows for the new or remodeled buildings. Carefully modeled grisaille figures seem to float in front of or emerge from elaborate curling foliage and deep red or blue damask-like backgrounds [12.18]. Peter's

12.18 Hemmel family. The Mater Dolorosa. German (Swabia), about 1480. Pot-metal glass and vitreous paint, 19 5/8 x 16 3/8in. (49.8 x 41.6cm). Cathedral of Constance. The Metropolitan Museum of Art. The Cloisters Collection.

son (or perhaps son-in-law) painted the sorrowing Virgin for the chapterhouse and former library of the Cathedral of Constance. True to the requirements of their medium, the glass painters retained some of the two-dimensional elements of the local late Gothic art in their adaptation of the Flemish style.

Influenced by German mystics who advocated the renunciation of reason and the dependence on subjective personal feelings to unite the soul with God, the artists were concerned with the emotional impact of their work and aimed for perfect harmony by using simple compositions and limiting colors to the primary hues. They emphasized expressive lines and abstract colors rather than realistic images and coherent spatial relationships. In sculpture, the figure and drapery style created and popularized by Sluter—the broad voluminous draperies drawn into horizontal patterns at the waist and falling into rippling folds at each side of the figure—spread throughout Europe from royal and ducal courts to wealthy cities such as the imperial free city of Nuremberg. Such a figure is the nearly life-sized sandstone sculpture of the Virgin and Child (1425–1430) that once stood outside a house overlooking a Nuremberg square [12.19]. A protective canopy preserved the delicate carving and the colors adding to the immediacy of the work. The new desire for a personal communion with God inspired the artist to represent the joys of Mary as a mother as well as her sorrows.

Sculptures like these are not meant to be studied as isolated objects. They are part of a total visual and emotional experience created by the controlled space of the great altarpiece and shifting light of the church interior. Dramatic visual effects were achieved in architecture through the manipulation of light and space. The builders intended to create a sublime environment in which meditating worshippers, with the help of paintings and sculpture, might achieve an intense personal religious experience. As subjectivity rather than rationality became an ideal, worshippers hoped to transcend the material world by means of the senses. Meister Eckhardt and other mystics advised that a subjective mysticism was the only possible way to achieve understanding and union with God.

THE END OF THE MIDDLE AGES

Rogier van der Weyden, Claus Sluter, Veit Stoss, and Petrus Christus are only a few of the hundreds of painters and sculptors who bridge the years between the Middle Ages and the modern world. But along the Rhine River, in Mainz and

12.19

Virgin and Child, Nuremberg, about 1425-1430. Sandstone, 57 $1/2 \times 21 \ 1/4 \times 15$ in. ($146.1 \times 54 \times 38.1$ cm). The Metropolitan Museum of Art.

Strasbourg, other artists and craftsmen with new techniques were working over their printing presses, unknowingly destroying the medieval world. Before Rogier had finished his St. George, unknown printers began to cut and stamp out woodblock prints to satisfy the desire of the common people to own a sacred image [12.20]. Now St. Dorothy, crowned with roses, becomes a maiden with a mundane basket of flowers, while the Christ Child is a toddler supporting himself in a baby walker. Roses symbolized the Virgin Mary and also St. Dorothy, to whom Christ appeared bearing roses. The saints have become personalized indeed.

While scribes and illuminators still labored over exquisite vellum books of hours, Johannes Gutenberg (c. 1396-1468) had six presses, each manned by several workmen, printing so many copies of the Bible that over 40 so-called Gutenberg Bibles still exist. They were printed in Mainz in 1456. Twenty years later the first English printer, William Caxton (c. 1422-1491), set up his press in Westminster, where he produced both secular and religious texts, including Geoffrey Chaucer's Canterbury Tales (1484). The printing press did to the scribe and manuscript what the English longbowmen did to the French knights at Crécy; and the introduction

12.20 St. Dorothy, Germany, 15th century. Woodcut. The National Gallery of Art.

of relatively inexpensive printed books produced a knowledge explosion comparable to the computer revolution in the twentieth century. The intellectual and spiritual life of the West-and with it the arts—changed forever.

TIMELINE Europe in the Middle Ages

	A.
	30/33Crucifixion of Jesus
	43Romans invade Britain
	54–68Nero, Emperor
	64First persecution of Christians
	79 Eruption of Vesuvius, destruction of
	Pompeii
6-1	79–81Titus, Emperor
Colosseum completed	
Arch of Titus, Rome	
Column of Trajan	
	98–117 Trajan, Emperor; greatest extent of the
	Roman Empire
	117–138 Hadrian, Emperor
	161–180 Marcus Aurelius, Emperor
	238Goths cross the Danube; invade Gaul, 280s
Christian house, synagogue, Dura-Europos	- before 256
	260 Christianity made a "permitted religion"
	284–305 Diocletian, Emperor
Catacomb paintings and sarcophagi, Rome;	
Christ-Helios mosaic, Vatican;	- c. 300–400
Diocletian's Palace, Split	300–305
	303–311 Persecution of Christians
	306–337 Constantine, Emperor
	312Battle of the Milvian Bridge, Constantine
	defeats Maxentius
	313Edict of Milan; religious toleration
Arch of Constantine, Rome	
Church of St. Peter, Rome	
	324Founding of Constantinople
Church of the Holy Sepulchre, Jerusalem	
Imperial Palace and churches,	
Constantinople	- 501010 337
Constantinopic	345Goths become Arian Christians
Church of Sta. Costanza, Rome	
Church of Sta. Costanza, Rome	
Canada and a filming Danier Danier	d. 356St. Anthony, hermit
Sarcophagus of Junius Bassus, Rome	
	373–397 St. Ambrose, Bishop of Milan
	379–395 Theodosius I, Emperor
	380Christianity made official religion of the empire
	382–405St. Jerome translates the Bible into Latin
Church of St. Paul Outside the Walls, Rome	
Missorium of Theodosius	
iviissofium of Theodosius	
	393–430St. Augustine, Bishop of Hippo
	395Division of Roman Empire East and West

LIV ILIVS	Leopie & Lients
	402Honorius moves western capital to Ravenna
Walls of Constantinople	
	410 Goths under Alaric sack Rome
	413-426St. Augustine writes City of God
	416–418Visigoths conquer Spain
Sta. Sabina, Rome	
Mausoleum of Galla Placidia, Ravenna	
Tradsoledin of Gana Factoria, Partenna	425–437Galla Placidia, Regent for her son, Valentinian III
	432–461St. Patrick in Ireland
Sta. Maria Maggiore, Rome	
Church of St. John, Ephesus	452-440
Church of St. John, Ephesus	433–453 Attila, King of the Huns, destroys Milan, 450,
	spares Rome, 452
	440–461Pope Leo I
Province of the Outheder Devenue	4년 1일 전 1일 1 전 1일 를 기업 2 전 1일 전 1일 전 1 전 1 전 1 전 1 전 1 전 1 전 1 전
Baptistery of the Orthodox, Ravenna Church of Hosios David	
Church of Hosios David	
	471–526 Theodoric, King of Ostrogoths; founds
	kingdom in Italy, 493
	475–476Romulus Augustulus, last western Roman
	emperor
	481–511 Clovis, King of the Franks, accepts
	Christianity, 496
	500 500
	500–599
	D 1 D' ' (D' ' 1 A ')
	500Pseudo Dionysius (Dionysius the Areopagite)
Dioscorides' Materia Medica	
Beth Alpha Synagogue	
Tomb of Theodoric, Ravenna	
Church of S. Apollinare Nuovo, Ravenna	
	527–565 Justinian, Byzantine emperor
	529 St. Benedict of Nursia (d. 543) founds
	Benedictine Order at Monte Cassino
	532Nike rebellion
Church of Hagia Sophia, Constantinople;	532–537
dome rebuilt 558	
Church of S. Apollinare in Classe	
Church of Holy Apostles, Constantinople, rebuilt-	
	540Ravenna becomes Western Byzantine capital
Church of S. Vitale, Ravenna, consecrated	
	563St. Columba founds monastery in Iona
Church of St. Catherine, Mt. Sinai: mosaic	before 565

People & Events

	The Arts	People G Events
		568Lombards establish kingdom in northern Italy; accept Christianity
	Rabbula Gospels	586
	Tancouna Goopeio	590–604 Pope Gregory the Great
		596–597St. Augustine to England
		599–636 Isidore, Bishop of Seville
		600–699
		622Hijra, beginning of Muslim history
	Sutton Hoo treasure	
	Crypt of St. Paul, Jouarre	
	Crypt of St. Faul, Jouanne	632 Death of Muhammad
		634–644 Caliph Omar, captures Jerusalem, 638
		635St. Aidan founds monastery at Lindisfarne
		649–672Reccesswinth, king of Visigoths
	Votive crown of Recceswinth	649
	votive crown or recessmin	662 Death of Theodolinda, first abbess of Jouarre
		664Synod of Whitby, decides in favor of
		Roman liturgy
		673–735The Venerable Bede
	Book of Durrow	
	Lindisfarne Gospels	
	Emdistante Gospeis	030-721
		700–799
	Franks Casket	
	Franks Casket	
	Franks Casket	c. 700
	Franks Casket	c. 700 c. 700–730 Beowulf
	Franks Casket	c. 700 c. 700–730 Beowulf 711 Muslim conquest of Visigothic Spain 726–843 Iconoclastic controversy 732 Muslim invasion turned back in France
Church of Sta		c. 700 c. 700–730 Beowulf 711 Muslim conquest of Visigothic Spain 726–843 Iconoclastic controversy 732 Muslim invasion turned back in France by Charles Martel
Church of Sta	ı. Maria-in-Valle, Cividale del Friuli	c. 700 c. 700–730 Beowulf 711 Muslim conquest of Visigothic Spain 726–843 Iconoclastic controversy 732 Muslim invasion turned back in France by Charles Martel
Church of Sta	ı. Maria-in-Valle, Cividale del Friuli Abbey Church, Fulda	c. 700 c. 700–730 Beowulf 711 Muslim conquest of Visigothic Spain 726–843 Iconoclastic controversy 732 Muslim invasion turned back in France by Charles Martel
Church of Sta	ı. Maria-in-Valle, Cividale del Friuli	c. 700 c. 700–730 Beowulf 711 Muslim conquest of Visigothic Spain 726–843 Iconoclastic controversy 732 Muslim invasion turned back in France by Charles Martel c. 712–747
Church of Sta	ı. Maria-in-Valle, Cividale del Friuli Abbey Church, Fulda	c. 700 c. 700–730 Beowulf 711 Muslim conquest of Visigothic Spain 726–843 Iconoclastic controversy 732 Muslim invasion turned back in France by Charles Martel c. 712–747 c. 750 754 Pepin crowned King of the Franks at St. Denis
Church of Sta	ı. Maria-in-Valle, Cividale del Friuli Abbey Church, Fulda	c. 700 c. 700–730 Beowulf 711 Muslim conquest of Visigothic Spain 726–843 Iconoclastic controversy 732 Muslim invasion turned back in France by Charles Martel c. 712–747 c. 750 754 Pepin crowned King of the Franks at St. Denis 755 Caliphate of Cordova, independent Muslim states
Church of Sta	ı. Maria-in-Valle, Cividale del Friuli Abbey Church, Fulda	c. 700 c. 700–730 Beowulf 711 Muslim conquest of Visigothic Spain 726–843 Iconoclastic controversy 732 Muslim invasion turned back in France by Charles Martel c. 712–747 c. 750 754 Pepin crowned King of the Franks at St. Denis 755 Caliphate of Cordova, independent Muslim state d. 755 Boniface converts Germanic People
Church of Sta	ı. Maria-in-Valle, Cividale del Friuli Abbey Church, Fulda	c. 700 c. 700–730 Beowulf 711 Muslim conquest of Visigothic Spain 726–843 Iconoclastic controversy 732 Muslim invasion turned back in France by Charles Martel c. 712–747 c. 750 754 Pepin crowned King of the Franks at St. Denis 755 Caliphate of Cordova, independent Muslim state

The Arts	People & Events 359
Great Mosque, Córdobabegun 784-	785
	Council of Nicaea, rejects iconoclasm
Palatine Chapel, Aachen begun c. 7	
	Vikings destroy Lindisfarne
,,,,,,,,,,,,,,,,,,,,,,,,,,,,,,,,,,,,,,,	mango desero) Emaistaine
800–899	
800 -	Charlemagne crowned emperor, Rome
Ardagh Chalice, Book of Kells;c. 800	
Ada Gospels	
Lorsch Gospels, ivory cover 810	
Oseberg ship 815–820	
	Discovery of tomb of St. James in Galicia
Crypt of St. Germain, Auxerre: murals	
Coronation Gospels	
First church, Santiago de Compostela after 813	
	Louis the Pious
Ebbo Gospels 816-832	
Plan of ideal monastery, St. Gallc. 817	
	Muslims invade Sicily; capture Palermo, 831
	Charles the Bald
843 -	Council of Constantinople, ends the
	iconoclastic controversy
Drogo Sacramentary 844-855	
Vivian Bible c. 845	
845 -	Vikings destroy Centula; Tours, 853; lay siege
	to Paris, 885–886
860 -	Vikings discover Iceland
866 -	Danish kingdom established in York
Church of Hagia Sophia 867	
Constantinople: apse mosaic	
Lindau Gospels, cover c. 870	
	Alfred the Great of England
891 -	Anglo-Saxon Chronicle begun
200 200	
900–99	9
000 000	Charles the Simple of France and a Normanda
898–923	3 Charles the Simple of France, cedes Normandy
E:	to Rollo the Viking, 911
First church at Cluny910 -	Ciuniac Order founded
Cross of Muiredach, Monasterboice, Ireland 923	

	936–973 Otto the Great, crowned emperor, 962
Beatus manuscripts	355 (CHEC 2004) AND
Second church at Cluny, dedicated 981	
·	960 Danes accept Christianity
New Minster Charter, Winchester	966
	c. 970 Exeter Book, Anglo-Saxon poetry
	973–993,Otto II, marries Byzantine princess
	Theophano, 972
Benedictional of St. Ethelwold	c. 980
	983–1002 Otto III, (regents: Theophano, d. 991;
	Adelaide, d. 999)
	Arabic numerals adopted in West
	987–996 Hugh Capet, French king
	Vikings colonize Greenland
	c. 993–1022 Bishop Bernward of Hildeshein
	997–1000 Otto III (ruled)
	1000 1000
	1000–1099
	1000–1002 Leif Ericson reaches North America
Gospels of Otto III	
Church of St. Michael, Hildesheim	
Church of St. Wichael, Phiaesheim	1014–1035 Canute, ruler of Denmark, England, and Norway
Bronze doors, Hildesheim	
2101132 40013, 111140112111	1016 Normans arrive in Sicily
Liber Vitae of New Minster	
Lintel of St. Genis des-Fontaines	
Cathedral, Speyer	
1 7	1035-1087 William the Conqueror, 1035-1087: Duke of
	Normandy, after 1066 King of England
Abbey church, Jumièges	1037–1067
	1054 Final break between Roman Cathedral and
	Byzantine churches
	1061–1073 Pope Alexander II
Church of St. Mark, Venice	after 1063
Cathedral of Pisa; consecrated 1118	begun 1063
Church of St. Etienne, Caen; vaulted 1120s	1064–1087
	1066–1071 Norman conquest of England
Bayeux Tapestry	
Cathedral of Santiago de Compostela;	begun 1070s
south portal c. 1117	
Byzantine ivories	
	1073–1085 Pope Gregory VII (Cluniac monk Hildebrand)
	100000 Annual State 1 Annual 1

1152–1190 -----Frederick Barbarossa, German Emperor 1154–1189 -----Henry II Plantagenet, King of England

1162–1170 - - - - Thomas à Becket, Archbishop of Canterbury

The Arts	People & Events
1075–1122	Investiture controversy between Papacy and German emperors
1077	Gregory VII confronts Henry IV at Canossa
Church of San Ambrogio, Milan; vaulted after 1117 1080	,
1084	St. Bruno founds Carthusian Order, Normans sack Rome
Church of San Clemente, Rome after 1084	
1085	Christians take Toledo
Cluny III 1088–1130	
1088–1099	Pope Urban II
Cathedral of Durham begun 1093	
1095–1099	First Crusade, founding of Latin Kingdom of Jerusalem
1098	Robert of Molesmes founds Cistercian Order
Cathedral of Modena 1099-1106	
1100–1199	
Albani Psalter 1100–1150	
Wiligelmo, sculpture, Cathedral of Modena c. 1100	
Abbey church, St. Savin-sur-Gartempe	
Cloister, Moissac; portal 1115–1131	
Gloucester Candlestick 1104-1113	
Rainier de Huy, baptismal font, Liège 1107–1110	
1115–1153	St. Bernard, abbot of Clairvaux
Church of San Clemente, Tahull: murals 1123	
1122–1151	Suger, abbot of St. Denis
Church of St. Lazare, Autun; 1120s-1130s	
Church of the Madeleine, Vézelay	
	Wibald, Abbot of Stavelot
Abbey church of St. Denis 1135–1144	
	Moses Maimonides, Jewish philosopher
Cathedral of Sens 1130s-1180s	
1137–1152	Eleanor of Aquitaine, French queen,
	English queen, 1154–1189, dies, 1204
	Louis VII, King of France
Cathedral of Chartres: west façade 1140s	S1 C1
1146/1147–1149	Second Crusade

Church of St. Trophime, Arles----- 1150s

Cathedral of St. Pierre, Poitiers----begun 1162

	People & Events
athedral of Notre-Dame, Paris; nave, 1180–1200	
Cathedral of Senlis: west façade	
	1170Pope Alexander III establishes rules for
	canonization
	1170–1193 Saladin; captures Jerusalem, 1187
"Leaning Tower," Cathedral of Pisa	
Cathedral of Canterbury, rebuilt	
Nicolas of Verdun: enamels, Klosterneuberg	
Cathedral of Wells	
	1189–1199 Richard the Lion-Hearted, King of England
	1189–1192 Third Crusade, frees Jerusalem
	Universities founded in Bologna, Paris, Oxford
Cathedral of Chartres, rebuilt	
Cathedral of Bourges; completed 1225	
Chateau Gaillard	1190–1198
	1200–1299
	1200 1233
	1201–1204 Fourth Crusade, Sack of Constantinople; Latin
	Kingdom in Byzantium, 1204–1261
	1170–1226 St. Francis (d. 1226), founds Franciscan
	Order, 1209; confirmed, 1226;
	St. Dominic (d. 1221) founds Dominican orde
Cathedral of Reims burns, rebuilding	
begins 1211, façade by 1260	
	1212 Frederick II crowned king at Aachen; emperor
	at Rome, 1220; dies, 1250
	1215 Magna Carta; reissued, 1217, 1225
Cathedral of Amiens; south portal, c. 1260	
Cathedral of Burgos begun	1221
Cathedral of Salisbury	1220–1258
•	1225-1230 Bartholomaeus Anglicus, On the Nature of Thin
Church of St. Francis, Assisi	
Winchester Hall	1235
Cathedral of Naumberg: choir and screen	- c. 1240–1260
	1241 Hanseatic League
SteChapelle, Paris	
	1248–1254 Seventh Crusade, led by Louis IX
	1254/57 Sorbonne founded
Cathedral of Lincoln: Angel Choir	1256-1280
Cathedral of Lincoln: Angel Choir	1258 House of Commons established in England
Cathedral of Lincoln: Angel Choir Nicola Pisano: Pisa baptistery, pulpit	1258 House of Commons established in England

Ine Arts	reopie & Events
	66–1273 St. Thomas Aquinas (d. 1274): Summa Theologica
	1266 Roger Bacon (d. 1290): <i>Opus Maius</i> ; imprisoned for heresy, 1277
Cathedral of Exeter begu	n c. 1270
Windmill Psalter 127	
Cathedral of Strasbourg: new west façade design	'1–1295Marco Polo travels to China and India 1277
	th 1280)Albertus Magnus, scientist and philosopher
Giovanni Pisano: Siena Cathedral façade	
Synagogue, Prague 1280	
	1290Dante Alighieri (d. 1321): <i>La Vita Nuova</i> 1291Turks drive Christians from Holy Land
	1297 Louis IX canonized
Cathedral of Barcelona beg	un 1298
130	0–1399
Giotto: Arena chapel, Padua, murals c.	
Duccio: Maestà altarpiece 130	
130	05–1376 Papacy moves from Rome to Avignon— "Babylonian Captivity"
Queen Mary Psalter c.	
Exeter Bishop's Throne	
	4–1321 Dante Alighieri (d. 1321): Divine Comedy
Heinrich and Peter Parler: Church of the 131 Holy Cross, Swäbisch Gmünd	7, 1351
Jeanne d'Evreux's Book of Hours 132	25–1328
Cathedral of Ely: Octagon 132	
Tomb of Edward II, Gloucester 132	9–1334
Avignon: walls, papal palace, murals 133	
	87–1453 Hundred Years War between France and England
Ambrogio Lorenzetti, Good Government 133 Gloucester Cathedral: east window c. 1350–1360;	
choir; cloister, 1351–1412	
134	17–1350 Black Death
	18–1353 Boccaccio (d. 1375): Decameron
Cathedral of Prague 135	
Frauenkirche, Nuremberg 135 El Transito, Synagogue, Toledo 135	
Angers Apocalypse, tapestry 137	
	1378 Papacy returns to Rome, 1378; Great Schism,
	1270 1/17

1378-1417

Claus Sluter: Well of Moses, - - - - 1395-1406

1384 - - - - - Dukes of Burgundy become rulers of Flanders

1387-1400 - - - - - Chaucer (d. 1400): Canterbury Tales

1399–1413 Henry IV of Lancaster, King of England 1400–1518 Cathedral of Seville 1402–1517 Limbourg Brothers: Très Riche Heures of 1411–1416 Duc de Berry 1414–1418 Council of Constance, ends Great Schism 1415 John Hus burned at stake for heresy 1419–1467 Philip the Good of Burgundy Masaccio, Brancacci Chapel, Florence c. 1427 d. 1430 Christine de Pizan 1431 Johann Gutenberg (d. 1468) invents printing with movable type 1440 Johann Gutenberg (d. 1468) invents printing with movable type 1441 King's College, Cambridge, founded by Henry VI King's College, Cambridge, chapel 1446–1515 1452 Turks capture Constantinople 1455–1485 Wars of the Roses in England d. 1464 Cosimo the Elder (Medici) S. Juan de los Reyes, Toledo begun; 1477 Peter Hemel, stained glass Petrus Christus: The Holy Family 1472 1479–1504 Ferdinand and Isabella of Spain 1484	Chartreuse de Champmol	1000 1400
Cathedral of Seville 1402–1517 Limbourg Brothers: Très Riches Heures of 1411–1416 Due de Berry 1414–1418 Council of Constance, ends Great Schism 1415	Chartrease de Champino.	1399-1413 Henry IV of Lancaster King of England
Cathedral of Seville 1402–1517 Limbourg Brothers: Très Riches Heures of 1411–1416 Duc de Berry 1414–1418 Council of Constance, ends Great Schism 1415 John Hus burned at stake for heresy 1419–1467 Philip the Good of Burgundy Masaccio, Brancacci Chapel, Florence c. 1427 d. 1430 Christine de Pizan 1431 Joan of Arc burned at Rouen Rogier van der Weyden: St. George and the Dragon c. 1432 1438–1918 Hapsburg Empire 1440 Johann Gutenberg (d. 1468) invents printing with movable type 1441 King's College, Cambridge, founded by Henry VI King's College, Cambridge, chapel 1446–1515 1453 Turks capture Constantinople 1455–1485 Wars of the Roses in England d. 1464 Cosimo the Elder (Medici) S. Juan de los Reyes, Toledo begun; 1477 Peter Hemel, stained glass Petrus Christus: The Holy Family 1472 1479–1504 Ferdinand and Isabella of Spain 1484 Papal decree against witchcraft and sorcery Hradcany Castle, Vladislav Hall 1487–1502 1492 Fall of Moorish capital of Granada to Christians; Columbus lands on North American soil Leonardo da Vinci, The Last Supper 1495–1498 Chapel of Henry VII, Westminster 1503–1519		Tremy IV of Laneaster, King of England
Cathedral of Seville 1402–1517 Limbourg Brothers: Très Riches Heures of 1411–1416 Duc de Berry 1414–1418 Council of Constance, ends Great Schism 1415 John Hus burned at stake for heresy 1419–1467 Philip the Good of Burgundy Masaccio, Brancacci Chapel, Florence c. 1427 d. 1430 Christine de Pizan 1431 Joan of Arc burned at Rouen Rogier van der Weyden: St. George and the Dragon c. 1432 1438–1918 Hapsburg Empire 1440 Johann Gutenberg (d. 1468) invents printing with movable type 1441 King's College, Cambridge, founded by Henry VI King's College, Cambridge, chapel 1446–1515 1453 Turks capture Constantinople 1455–1485 Wars of the Roses in England d. 1464 Cosimo the Elder (Medici) S. Juan de los Reyes, Toledo begun; 1477 Peter Hemel, stained glass Petrus Christus: The Holy Family 1472 1479–1504 Ferdinand and Isabella of Spain 1484 Papal decree against witchcraft and sorcery Hradcany Castle, Vladislav Hall 1487–1502 1492 Fall of Moorish capital of Granada to Christians; Columbus lands on North American soil Leonardo da Vinci, The Last Supper 1495–1498 Chapel of Henry VII, Westminster 1503–1519		
Cathedral of Seville 1402–1517 Limbourg Brothers: Très Riches Heures of 1411–1416 Duc de Berry 1414–1418 Council of Constance, ends Great Schism 1415 John Hus burned at stake for heresy 1419–1467 Philip the Good of Burgundy Masaccio, Brancacci Chapel, Florence c. 1427 d. 1430 Christine de Pizan 1431 Joan of Arc burned at Rouen Rogier van der Weyden: St. George and the Dragon c. 1432 1438–1918 Hapsburg Empire 1440 Johann Gutenberg (d. 1468) invents printing with movable type 1441 King's College, Cambridge, founded by Henry VI King's College, Cambridge, chapel 1446–1515 1453 Turks capture Constantinople 1455–1485 Wars of the Roses in England d. 1464 Cosimo the Elder (Medici) S. Juan de los Reyes, Toledo begun; 1477 Peter Hemel, stained glass Petrus Christus: The Holy Family 1472 1479–1504 Ferdinand and Isabella of Spain 1484 Papal decree against witchcraft and sorcery Hradcany Castle, Vladislav Hall 1487–1502 1492 Fall of Moorish capital of Granada to Christians; Columbus lands on North American soil Leonardo da Vinci, The Last Supper 1495–1498 Chapel of Henry VII, Westminster 1503–1519		
Cathedral of Seville 1402–1517 Limbourg Brothers: Très Riches Heures of 1411–1416 Duc de Berry 1414–1418 Council of Constance, ends Great Schism 1415 John Hus burned at stake for heresy 1419–1467 Philip the Good of Burgundy Masaccio, Brancacci Chapel, Florence c. 1427 d. 1430 Christine de Pizan 1431 Joan of Arc burned at Rouen Rogier van der Weyden: St. George and the Dragon c. 1432 1438–1918 Hapsburg Empire 1440 Johann Gutenberg (d. 1468) invents printing with movable type 1441 King's College, Cambridge, founded by Henry VI King's College, Cambridge, chapel 1446–1515 1453 Turks capture Constantinople 1455–1485 Wars of the Roses in England d. 1464 Cosimo the Elder (Medici) S. Juan de los Reyes, Toledo begun; 1477 Peter Hemel, stained glass Petrus Christus: The Holy Family 1472 1479–1504 Ferdinand and Isabella of Spain 1484 Papal decree against witchcraft and sorcery Hradcany Castle, Vladislav Hall 1487–1502 1492 Fall of Moorish capital of Granada to Christians; Columbus lands on North American soil Leonardo da Vinci, The Last Supper 1495–1498 Chapel of Henry VII, Westminster 1503–1519		1400-1518
Limbourg Brothers: Très Riches Heures of 1411–1416 Duc de Berry 1414–1418 Council of Constance, ends Great Schism 1415 John Hus burned at stake for heresy 1419–1467 Philip the Good of Burgundy Masaccio, Brancacci Chapel, Florence c. 1427 d. 1430 Christine de Pizan 1431 Joan of Arc burned at Rouen Rogier van der Weyden: St. George and the Dragon c. 1432 1438–1918 Hapsburg Empire 1440 Johnan Gutenberg (d. 1468) invents printing with movable type 1441 King's College, Cambridge, founded by Henry VI King's College, Cambridge, chapel 1446–1515 1453 Turks capture Constantinople 1455–1485 Wars of the Roses in England d. 1464 Cosimo the Elder (Medici) S. Juan de los Reyes, Toledo begun; 1477 Peter Hemel, stained glass Petrus Christus: The Holy Family 1472 1479–1504 Ferdinand and Isabella of Spain 1484 Papal decree against witchcraft and sorcery Hradcany Castle, Vladislav Hall 1487–1502 1492 Fall of Moorish capital of Granada to Christians; Columbus lands on North American soil Leonardo da Vinci, The Last Supper 1495–1498 Chapel of Henry VII, Westminster 1503–1519		
Limbourg Brothers: Très Riches Heures of 1411–1416 Duc de Berry 1414–1418 Council of Constance, ends Great Schism 1415 John Hus burned at stake for heresy 1419–1467 Philip the Good of Burgundy Masaccio, Brancacci Chapel, Florence c. 1427 d. 1430 Christine de Pizan 1431 Joan of Arc burned at Rouen Rogier van der Weyden: St. George and the Dragon c. 1432 1438–1918 Hapsburg Empire 1440 Johnan Gutenberg (d. 1468) invents printing with movable type 1441 King's College, Cambridge, founded by Henry VI King's College, Cambridge, chapel 1446–1515 1453 Turks capture Constantinople 1455–1485 Wars of the Roses in England d. 1464 Cosimo the Elder (Medici) S. Juan de los Reyes, Toledo begun; 1477 Peter Hemel, stained glass Petrus Christus: The Holy Family 1472 1479–1504 Ferdinand and Isabella of Spain 1484 Papal decree against witchcraft and sorcery Hradcany Castle, Vladislav Hall 1487–1502 1492 Fall of Moorish capital of Granada to Christians; Columbus lands on North American soil Leonardo da Vinci, The Last Supper 1495–1498 Chapel of Henry VII, Westminster 1503–1519	Cathedral of Seville	1402–1517
Duc de Berry 1414–1418 Council of Constance, ends Great Schism 1415 John Hus burned at stake for heresy 1419–1467 Philip the Good of Burgundy Masaccio, Brancacci Chapel, Florence C. 1427 d. 1430 Christine de Pizan 1431 Joan of Arc burned at Rouen Rogier van der Weyden: St. George and the Dragon c. 1432 1438–1918 Hapsburg Empire 1440 Johann Gutenberg (d. 1468) invents printing with movable type 1441 King's College, Cambridge, founded by Henry VI King's College, Cambridge, chapel 1446–1515 1453 Turks capture Constantinople 1455–1485 Wars of the Roses in England d. 1464 Cosimo the Elder (Medici) S. Juan de los Reyes, Toledo begun; 1477 Peter Hemel, stained glass Petrus Christus: The Holy Family 1472 1479–1504 Ferdinand and Isabella of Spain 1484 William Caxton prints Chaucer's Canterbury Tales 1484 Papal decree against witchcraft and sorcery Hradcany Castle, Vladislav Hall 1487–1502 1492 Fall of Moorish capital of Granada to Christians; Columbus lands on North American soil Leonardo da Vinci, The Last Supper 1495–1498 Chapel of Henry VII, Westminster 1503–1519		
1414–1418 Council of Constance, ends Great Schism 1415 John Hus burned at stake for heresy 1419–1467 Philip the Good of Burgundy Masaccio, Brancacci Chapel, Florence c. 1427 d. 1430 Christine de Pizan 1431 Joan of Arc burned at Rouen Rogier van der Weyden: St. George and the Dragon c. 1432 1438–1918 Hapsburg Empire 1440 Johann Gutenberg (d. 1468) invents printing with movable type 1441 King's College, Cambridge, founded by Henry VI King's College, Cambridge, chapel 1446–1515 1453 Turks capture Constantinople 1455–1485 Wars of the Roses in England d. 1464 Cosimo the Elder (Medici) S. Juan de los Reyes, Toledo begun; 1477 Peter Hemel, stained glass Petrus Christus: The Holy Family 1472 1479–1504 Ferdinand and Isabella of Spain 1484 William Caxton prints Chaucer's Canterbury Tales 1484 Papal decree against witchcraft and sorcery Hradcany Castle, Vladislav Hall 1487–1502 1492 Fall of Moorish capital of Granada to Christians; Columbus lands on North American soil Leonardo da Vinci, The Last Supper 1495–1498 Chapel of Henry VII, Westminster 1503–1519	e	
1415 John Hus burned at stake for heresy 1419–1467 Philip the Good of Burgundy Masaccio, Brancacci Chapel, Florence c. 1427 d. 1430 Christine de Pizan 1431 Joan of Arc burned at Rouen Rogier van der Weyden: St. George and the Dragon c. 1432 1438–1918 Hapsburg Empire 1440 Johann Gutenberg (d. 1468) invents printing with movable type 1441 King's College, Cambridge, founded by Henry VI King's College, Cambridge, chapel 1446–1515 1453 Turks capture Constantinople 1455–1485 Wars of the Roses in England d. 1464 Cosimo the Elder (Medici) S. Juan de los Reyes, Toledo begun; 1477 Peter Hemel, stained glass Petrus Christus: The Holy Family 1472 1479–1504 Ferdinand and Isabella of Spain 1484 William Caxton prints Chaucer's Canterbury Tales 1484 Papal decree against witchcraft and sorcery Hradcany Castle, Vladislav Hall 1487–1502 1492 Fall of Moorish capital of Granada to Christians; Columbus lands on North American soil Leonardo da Vinci, The Last Supper 1495–1498 Chapel of Henry VII, Westminster 1503–1519	,	1414–1418 Council of Constance, ends Great Schism
Masaccio, Brancacci Chapel, Florence c. 1427 d. 1430 Christine de Pizan 1431 Joan of Arc burned at Rouen Rogier van der Weyden: St. George and the Dragon c. 1432 1438-1918 Hapsburg Empire 1440 Johann Gutenberg (d. 1468) invents printing with movable type with movable type 1441 King's College, Cambridge, founded by Henry VI King's College, Cambridge, chapel 1446-1515 1453 Turks capture Constantinople 1455-1485 Wars of the Roses in England d. 1464 Cosimo the Elder (Medici) S. Juan de los Reyes, Toledo begun; 1477 Peter Hemel, stained glass Petrus Christus: The Holy Family 1472 1479-1504 Ferdinand and Isabella of Spain 1484 William Caxton prints Chaucer's Canterbury Tales 1484 William Caxton prints Chaucer's Canterbury Tales 1484 Papal decree against witchcraft and sorcery Hradcany Castle, Vladislav Hall 1487-1502 1492 Fall of Moorish capital of Granada to Christians; Columbus lands on North American soil		
Masaccio, Brancacci Chapel, Florence c. 1427 d. 1430 Christine de Pizan 1431 Joan of Arc burned at Rouen Rogier van der Weyden: St. George and the Dragon c. 1432 1438-1918 Hapsburg Empire 1440 Johann Gutenberg (d. 1468) invents printing with movable type 1441 King's College, Cambridge, founded by Henry VI King's College, Cambridge, chapel 1446-1515 1453 Turks capture Constantinople 1455-1485 Wars of the Roses in England d. 1464 Cosimo the Elder (Medici) S. Juan de los Reyes, Toledo begun; 1477 Peter Hemel, stained glass Petrus Christus: The Holy Family 1472 1479-1504 Ferdinand and Isabella of Spain 1484 William Caxton prints Chaucer's Canterbury Tales 1484 Papal decree against witchcraft and sorcery Hradcany Castle, Vladislav Hall 1487-1502 1492 Fall of Moorish capital of Granada to Christians; Columbus lands on North American soil Leonardo da Vinci, The Last Supper 1495-1498 Chapel of Henry VII, Westminster 1503-1519		
d. 1430 Christine de Pizan 1431 Joan of Arc burned at Rouen Rogier van der Weyden: St. George and the Dragon c. 1432 1438–1918 Hapsburg Empire 1440 Johann Gutenberg (d. 1468) invents printing with movable type 1441 King's College, Cambridge, founded by Henry VI King's College, Cambridge, chapel 1446–1515 1453 Turks capture Constantinople 1455–1485 Wars of the Roses in England d. 1464 Cosimo the Elder (Medici) S. Juan de los Reyes, Toledo begun; 1477 Peter Hemel, stained glass Petrus Christus: The Holy Family 1472 1479–1504 Ferdinand and Isabella of Spain 1484 William Caxton prints Chaucer's Canterbury Tales 1484 Papal decree against witchcraft and sorcery Hradcany Castle, Vladislav Hall 1487–1502 1492 Fall of Moorish capital of Granada to Christians; Columbus lands on North American soil Leonardo da Vinci, The Last Supper 1495–1498 Chapel of Henry VII, Westminster 1503–1519	Masaccio, Brancacci Chapel, Florence	
Rogier van der Weyden: St. George and the Dragon c. 1432 1438–1918 Hapsburg Empire 1440 Johann Gutenberg (d. 1468) invents printing with movable type 1441 King's College, Cambridge, founded by Henry VI King's College, Cambridge, chapel 1446–1515 1453 Turks capture Constantinople 1455–1485 Wars of the Roses in England d. 1464 Cosimo the Elder (Medici) S. Juan de los Reyes, Toledo begun; 1477 Peter Hemel, stained glass Petrus Christus: The Holy Family 1472 1479–1504 Ferdinand and Isabella of Spain 1484 William Caxton prints Chaucer's Canterbury Tales 1484 Papal decree against witchcraft and sorcery Hradcany Castle, Vladislav Hall 1487–1502 1492 Fall of Moorish capital of Granada to Christians; Columbus lands on North American soil Leonardo da Vinci, The Last Supper 1495–1498 Chapel of Henry VII, Westminster 1503–1519	,	
Rogier van der Weyden: St. George and the Dragonc. 1432 1438–1918		
1438–1918 Hapsburg Empire 1440 Johann Gutenberg (d. 1468) invents printing with movable type 1441	Rogier van der Weyden: St. George and the Dragon-	
1440 Johann Gutenberg (d. 1468) invents printing with movable type 1441	, , ,	
with movable type 1441 King's College, Cambridge, founded by Henry VI King's College, Cambridge, chapel 1446–1515 1453 Turks capture Constantinople 1455–1485 Wars of the Roses in England d. 1464 Cosimo the Elder (Medici) S. Juan de los Reyes, Toledo begun; 1477 Peter Hemel, stained glass Petrus Christus: The Holy Family 1472 1479–1504 Ferdinand and Isabella of Spain 1484 William Caxton prints Chaucer's Canterbury Tales 1484 Papal decree against witchcraft and sorcery Hradcany Castle, Vladislav Hall 1487–1502 1492 Fall of Moorish capital of Granada to Christians; Columbus lands on North American soil Leonardo da Vinci, The Last Supper 1495–1498 Chapel of Henry VII, Westminster 1503–1519		
1441 King's College, Cambridge, founded by Henry VI King's College, Cambridge, chapel 1446–1515 1453 Turks capture Constantinople 1455–1485 Wars of the Roses in England d. 1464 Cosimo the Elder (Medici) S. Juan de los Reyes, Toledo begun; 1477 Peter Hemel, stained glass Petrus Christus: The Holy Family 1472 1479–1504 Ferdinand and Isabella of Spain 1484 William Caxton prints Chaucer's Canterbury Tales 1484 Papal decree against witchcraft and sorcery Hradcany Castle, Vladislav Hall 1487–1502 1492 Fall of Moorish capital of Granada to Christians; Columbus lands on North American soil Leonardo da Vinci, The Last Supper 1495–1498 Chapel of Henry VII, Westminster 1503–1519		
King's College, Cambridge, chapel 1446–1515 1453 Turks capture Constantinople 1455–1485 Wars of the Roses in England d. 1464 Cosimo the Elder (Medici) S. Juan de los Reyes, Toledo begun; 1477 Peter Hemel, stained glass Petrus Christus: The Holy Family 1472 1479–1504 Ferdinand and Isabella of Spain 1484 William Caxton prints Chaucer's Canterbury Tales 1484 Papal decree against witchcraft and sorcery Hradcany Castle, Vladislav Hall 1487–1502 1492 Fall of Moorish capital of Granada to Christians; Columbus lands on North American soil Leonardo da Vinci, The Last Supper 1495–1498 Chapel of Henry VII, Westminster 1503–1519		
1453 Turks capture Constantinople 1455–1485	King's College, Cambridge, chapel	
1455–1485 Wars of the Roses in England d. 1464 Cosimo the Elder (Medici) S. Juan de los Reyes, Toledo begun; 1477 Peter Hemel, stained glass Petrus Christus: The Holy Family 1472 1479–1504 Ferdinand and Isabella of Spain 1484 William Caxton prints Chaucer's Canterbury Tales 1484 Papal decree against witchcraft and sorcery Hradcany Castle, Vladislav Hall 1487–1502 1492 Fall of Moorish capital of Granada to Christians; Columbus lands on North American soil Leonardo da Vinci, The Last Supper 1495–1498 Chapel of Henry VII, Westminster 1503–1519		
d. 1464 Cosimo the Elder (Medici) S. Juan de los Reyes, Toledo begun; 1477 Peter Hemel, stained glass Petrus Christus: The Holy Family 1472 1479–1504 Ferdinand and Isabella of Spain 1484 William Caxton prints Chaucer's Canterbury Tales 1484 Papal decree against witchcraft and sorcery Hradcany Castle, Vladislav Hall 1487–1502 1492 Fall of Moorish capital of Granada to Christians; Columbus lands on North American soil Leonardo da Vinci, The Last Supper 1495–1498 Chapel of Henry VII, Westminster 1503–1519		
S. Juan de los Reyes, Toledo begun; 1477 Peter Hemel, stained glass Petrus Christus: The Holy Family 1472 1479–1504 Ferdinand and Isabella of Spain 1484 William Caxton prints Chaucer's Canterbury Tales 1484 Papal decree against witchcraft and sorcery Hradcany Castle, Vladislav Hall 1487–1502 1492 Fall of Moorish capital of Granada to Christians; Columbus lands on North American soil Leonardo da Vinci, The Last Supper 1495–1498 Chapel of Henry VII, Westminster 1503–1519		
Petrus Christus: The Holy Family 1472 1479–1504 Ferdinand and Isabella of Spain 1484 William Caxton prints Chaucer's Canterbury Tales 1484 Papal decree against witchcraft and sorcery Hradcany Castle, Vladislav Hall 1487–1502 1492 Fall of Moorish capital of Granada to Christians; Columbus lands on North American soil Leonardo da Vinci, The Last Supper 1495–1498 Chapel of Henry VII, Westminster 1503–1519	S. Juan de los Reyes, Toledo begun;	
Petrus Christus: <i>The Holy Family</i> 1472 1479–1504 Ferdinand and Isabella of Spain 1484 William Caxton prints Chaucer's <i>Canterbury Tales</i> 1484 Papal decree against witchcraft and sorcery Hradcany Castle, Vladislav Hall 1487–1502 1492 Fall of Moorish capital of Granada to Christians; Columbus lands on North American soil Leonardo da Vinci, <i>The Last Supper</i> 1495–1498 Chapel of Henry VII, Westminster 1503–1519		
1479–1504 Ferdinand and Isabella of Spain 1484 William Caxton prints Chaucer's Canterbury Tales 1484 Papal decree against witchcraft and sorcery Hradcany Castle, Vladislav Hall 1487–1502 1492 Fall of Moorish capital of Granada to Christians; Columbus lands on North American soil Leonardo da Vinci, The Last Supper 1495–1498 Chapel of Henry VII, Westminster 1503–1519	Petrus Christus: The Holy Family	1472
Hradcany Castle, Vladislav Hall 1487–1502 1492 Fall of Moorish capital of Granada to Christians; Columbus lands on North American soil Leonardo da Vinci, <i>The Last Supper</i> 1495–1498 Chapel of Henry VII, Westminster 1503–1519		
Hradcany Castle, Vladislav Hall 1487–1502 1492 Fall of Moorish capital of Granada to Christians; Columbus lands on North American soil Leonardo da Vinci, <i>The Last Supper</i> 1495–1498 Chapel of Henry VII, Westminster 1503–1519		1484 William Caxton prints Chaucer's Canterbury Tales
1492 Fall of Moorish capital of Granada to Christians; Columbus lands on North American soil Leonardo da Vinci, <i>The Last Supper</i> 1495–1498 Chapel of Henry VII, Westminster 1503–1519		
Columbus lands on North American soil Leonardo da Vinci, <i>The Last Supper 1495–1498</i> Chapel of Henry VII, Westminster 1503–1519	Hradcany Castle, Vladislav Hall	
Leonardo da Vinci, <i>The Last Supper 1495–1498</i> Chapel of Henry VII, Westminster 1503–1519		1492 Fall of Moorish capital of Granada to Christians;
Chapel of Henry VII, Westminster 1503–1519		Columbus lands on North American soil
	Leonardo da Vinci, The Last Supper	1495–1498
Abbey, London	Chapel of Henry VII, Westminster	1503–1519
	Abbey, London	
Cathedral of Chartres: north spire 1507	Cathedral of Chartres: north spire	1507
Michelangelo: Sistine Chapel ceiling 1508–1512	Michelangelo: Sistine Chapel ceiling	1508–1512
Veit Stoss: The Annunciation, St. Lorenz, Nuremberg 1518	Veit Stoss: The Annunciation, St. Lorenz, Nuremberg	1518

GLOSSARY

abbey A monastery; a community of men or women living under religious vows; the buildings, especially the church, used by the community.

addorsed Two figures placed symmetrically back to back.

Adoptionism The heretical belief that Christ was born a man and subsequently adopted by God as His Son.

aedicule A shrine or niche framed by columns or pilasters and surmounted by a gable or entablature and pediment.

affronted Two figures placed symmetrically facing each other.

Agnus Dei Lamb of God; a name given to Jesus by St. John the Baptist (John 1:29); a symbol of Christ; a prayer in the Mass.

aisle Corridor or passageway; in a church the aisles flank and run parallel to the nave.

alb A long, white, sleeved linen tunic worn by the celebrants of the Mass under the other vestments. See also vestments.

alfiz A rectangular panel framing an arched opening, especialy in Islamic architecture.

alpha and omega First and last letters of the Greek alphabet, thus the beginning and the end; in Christian art, associated with the representation of Christ as judge to indicate enernity and infinity.

altar frontal A carved, painted, embroidered or otherwise decorated panel covering the front of an altar.

ambo A raised platform for a reader in a church, later replaced by the pulpit. Often two ambos were used, one on the north from which the Gospel was read and one on the south for the reading of the Epistle. (The phrases "Gospel side" and "Epistle side" make clear the location in churches without an east-west orientation.)

ambulatory A walkway; the passage around the apse in a basilican church.

amice A square of white linen worn by a priest on his neck and shoulders. See also **vestments**.

anastasis Greek: resurrection. A church dedicated to the Resurrection of Christ; the rotunda built over the tomb of Christ in Jerusalem.

Anachtsbild A devotional image. See also Vesperbild.

angels Intelligences not united to bodies, serving as messengers between God and the world. Angels are ordered into three "hierarchies" of three "choirs": seraphim, cherubim, and thrones; dominions, virtues, and powers; principalities, archangels, and angels.

annular Ring-shaped, as in annular vault or annular crypt (a crypt in which a circular aisle surrounds the chamber housing the relics). See also **crypt**, **relics**.

antependium See altar frontal.

antiphons Sentences from scripture sung alternately by two choirs.

Apocalypse The Book of Revelation; the last book of the New Testament, attributed to St. John the Evangelist.

Apocrypha Early Christian writings rejected by the editors of the New Testament; thus of questionable authenticity.

apostles The disciples of Christ: Sts. Peter, Andrew, James, John, Philip, Bartholomew, Matthew, Thomas, James son of Alphaeus, Jude (Thaddeus), Simon Zelotes, and Judas Iscariot. After the betrayal and suicide of Judas, Mattheas was chosen as his replacement. In art, St. Paul and the Evangelists St. Mark and St. Luke are sometimes substituted for Sts. Jude, Simon Zelotes, and Mattheas, but the number of figures remains at twelve.

Apostoleion Church dedicated to the twelve apostles.

apse A vaulted semicircular or polygonal structure; in a church it faces the nave and houses the altar. A large church may have additional apses in the transepts.

aquamanile A water pitcher, often in the shape of an animal, for handwashing at meals or at the altar.

arcade A series of arches, often supporting a wall, as in the nave arcade of a church. See also **blind arcade**.

archangel The eighth order of angels. The archangels are Michael, Gabriel, Raphael, and Uriel. See also **angels**. **archbishop** A bishop having jurisdiction over an ecclesiastical province which includes several dioceses.

architrave The lowest element in the entablature; a horizontal beam supported by columns or piers.

archivolt The molding following the contour of the arch and framing the opening. **Voussoirs** are sometimes referred to as archivolt blocks.

arcuated lintel A lintel which breaks upward into a central arch.

Arianism A Christian heresy which denied the doctrine of the Trinity and the eternal divinity of Christ. Expounded by Arius of Alexandria (ca. 256–336). Declared heretical at the Council of Nicaea in 325 but accepted by the barbarian Goths and Lombards.

armature A supporting framework, as in the iron bars supporting stained glass in a large window opening.

articulated Divided into units.

ashlar masonry Masonry of squared, even-faced blocks laid in horizontal courses.

Assumption The taking up of the Virgin Mary into heaven, body and soul.

atrium An open courtyard; in Christian architecture, the court in front of a church.

Augustinian Canons Also known as Austin, Black, or Regular Canons; priests living under the rule of St. Augustine.

azulejos Glazed, colored tiles.

bailey The open courtyard in a castle. See also motte-and-bailey.

baldachino, **baldachin** A freestanding or suspended canopy over an altar, throne, or tomb.

ball flower Architectural decoration of carved, tightly closed, stylized rose buds.

baluster A short post supporting a railing, forming a balustrade.

baptistery A building, or a room, set aside for baptismal rites.

barbican Defensive structure in front of a gate.

barrel vault An arched masonry ceiling or roof; a continuous vault which must be buttressed its entire length and may be divided by transverse arches into bays.

bar tracery See tracery.

bas-de-page Drawing or painting at the bottom of the manuscript page often with humorous or genre subjects.

basilica Greek: basilikos, royal. In Christian architecture, a church of longitudinal plan consisting of a high central nave lit by clerestory windows, lower side aisles, and an apse at one end of the nave.

bay A compartment, or unit of space, bounded by architectural members.

beakhead Decoration consisting of animal, bird, or human heads biting a roll molding.

Beatus manuscript A copy of Beatus' commentary.

Beatus of Liébana A Spanish theologian (ca. 730–98) who wrote treatises against Adoptioniam and a commentary on the Apocalypse.

bema A speaker's platform; the raised apse in an Early Christian church.

Benedictines Also known as Black Monks; persons who live by the rule drawn up by St. Benedict of Nursia (ca. 480–ca. 550) for the monks of Monte Cassino in Italy. The first responsibility of the Benedictine is prayer; the Divine Office was called *opus Dei*, the work of God.

benedictional A book of blessings used by a bishop when celebrating the Mass.

Bible The sacred writings of the Christians, comprising the Old Testament (the Jewish scriptures) and the New Testament. St. Jerome's Latin translation, the *Vulgate*, forms the basis for the Roman Catholic Bible. An English translation of the *Vulgate*, the *Douay Bible*, was made at Douai, France, 1582–1610. Protestant editions of the Bible include the King James version of 1611, and Martin Luther's German translation in the early sixteenth century.

billet molding A series of cubical or cylindrical projections.

blind arcade An arcade placed against a wall as decoration.

Book of Hours An abbreviated version of the Divine Office used primarily by the laity for private prayer; it includes a liturgical calendar, the Little Office of the Blessed Virgin, the litany of saints, Penitential Psalms, Office of the Dead, and additional personal prayers.

boss Decorative projection covering the intersection of the ribs in a vault.

breviary A liturgical book containing the psalms, hymns, prayers and readings to be recited during daily devotions.

buttress A mass of masonry built to strengthen a wall and to counter the thrust of a vault. In Gothic architecture, flying buttresses carry the thrust of the nave vault over the side aisles through masonry struts and arches to massive piers and buttresses along the outer walls.

cabochon A round or oval, unfaceted, polished stone or gem.

caesaropapism A political system in which an absolute ruler assumes both secular and religious authority.

calligraphy The art of penmanship.

came The thin lead strip used to hold pieces of glass in a stained glass window.

campanile Latin: *campania*, bell. A bell tower, usually free standing.

campo santo Italian: holy field. Burial ground.

canon A clergyman on the official staff of a cathedral or collegiate church; a system of ideal proportions.

canon of the Mass The fixed elements in the Mass; the Eucharist or commemorative sacrifice of bread and wine.

canon table A concordance of the four Gospels; parallel passages arranged in columns.

capital The decorative upper part of a column, pier, or pilaster, which creates a transition from the vertical support to the horizontal lintel, entablature, or arcade. A Corinthian capital has acanthus leaves and corner volutes around a bell-shaped core. Cushion, cubic, or block capitals are cubes whose lower corners have been rounded off to fit a circular shaft. A crocket capital is decorated with small stylized leaves.

carpet page Full page of intricate geometric decoration, especially in Hiberno-Saxon manuscripts.

Carthusians Strict contemplatives living in individual cells under a vow of silence and meeting only for the Office, Mass, and a mean on feast days. Founded by St. Bruno (ca. 1030–1101) in 1084. The order takes its name from the original monastery, the Grand Chartreuse, near Grenoble in France.

cartoon A full-scale drawing made as a guide for painters or weavers.

catacombs Subterranean burial places consisting of multi-level galleries and small rooms for memorial services. See also **loculi**.

catechumen A person being instructed in the Christian religion.

catenary arch or vault Theoretically having the curve or shape of a cable suspended from two points.

cathedra The bishop's official chair or throne.

cathedral The church containing the bishop's cathdra, thus his principal church.

cell A compartment, as in a vault or in cloisonné enamel; individual monastic habitation.

cenotaph A monument to a dead person, but not his or her tomb.

cense To perfume with incense.

censer An incense burner, usually on chains so that it can be swung; also called a thurible.

centering The frame built to support an arch or vault during construction.

chalice A cup; used in the Mass to contain the Eucharistic wine.

chamfer Bevel, cut at an angle.

champlevé See enamel.

chancel See choir.

chantry chapel A chapel endowed for perpetual celebration of Masses for the soul of the founder.

charger A large plate or dish; a war-horse.

Chartreuse A Carthusian monastery.

châsse A house-shaped reliquary.

chasuble The outermost garment worn by the priest celebrating Mass. See also **vestments**.

cherubim The second highest of the nine orders of angels. See also **angels**.

chevet The apse, ambulatory, and radiating chapels of a church.

chevron A V-shape.

choir The part of the church reserved for the clergy and singers, also known as the chancel; the entire eastern end of the church beyond the crossing. See also **chevet**.

choir screen A screen between the choir and the nave separating the clergy and the congregation; in England called a **rood screen** when it supports the "rood," or cross. Hung with icons in a Byzantine church, it is known as an **iconostasis**.

Christ in majesty Christ enthroned; often surrounded by symbols of the four evangelists.

Christus patiens Latin: suffering Christ. A cross with a representation of the dead Christ.

Christus triumphans Latin: triumphant Christ. A cross with a representation of the living Christ.

church council See ecumenical council.

ciborium A baldacchino. A vessel for the consecrated host.

cinquefoil A five-petal shape.

Cistercians Reformed Benedictines; an austere order founded in 1098 by St. Robert of Molesme at Cîteaux in Burgundy. Its most famous member was St. Bernard of Clairvaux.

clerestory Literally a "clear story;" the upper story of basilica pierced by windows.

cloisonné See enamel.

cloister A monastery or convent; an open courtyard surrounded by covered passageways connecting the church with the other monastic buildings.

cloister vault A cupola rising in curved segments from a square or octagonal base; also known as a domical vault.

Cluny, the congregation of Cluny Reformed Benedictines who emphasized strict adherence to the founder's rule and a life focused on the Divine Office; famed for their use of the arts to enhance the splendor of the church services. Founded in 910 by William I at Cluny in Burgundy, eastern France. The entire international congregation was ruled by a single abbot at Cluny.

codex (pl. **codices**) A manuscript in book form rather than a scroll.

collects Short prayers said or sung during the Mass.

collegiate church A church which has a chapter or college of canons, but is not a cathedral.

colobium The long robe worn by Christ in Byzantine and Byzantine-inspired art.

colonnette A small column.

colophon Information about the production of a manuscript, placed at its end (comparable to the title page in a modern book).

column A cylindrical, vertical element supporting a lintel or arch and usually consisting of a base, shaft, and capital. A column may stand alone (as a monument), or as one of a series (a colonnade), or may be attached to a wall (engaged column).

column-figure or **statue-column** A human figure carved as part of a column.

compound pier A pier with attached columns, pilasters, or shafts, which may support arches or ribs in an arcade or vault.

conch Shell-like in shape. A half-dome covering a semicircular structure such as an apse or exedra.

confessio An underground chamber, near the altar, containing a relic.

confessor saints Christians who have demonstrated extraordinary service to the Church through their exemplary lives, especially as scholars and interpreters of scripture, but who did not suffer martyrdom.

cope A cape worn by a bishop.

corbel An architectural support; a bracket.

corbel table A row of brackets, supporting a molding.

cornice Uppermost element of the entablature; crowning element in a building.

corpus Christi Latin: the body of Christ. The figure of Christ on a crucifix; the consecrated bread (the host) in the Eucharist; the feast commemorating the institution of the Eucharist (Thursday after Trinity Sunday).

Cosmati work Marble inlay and mosaic used as pavement and on church furniture, originating in Italy.

couching An embroidery technique in which threads laid on the face of the material are tacked down by threads carried on the back.

crenelated battlements, crenelation A technique of fortification in which the upper wall has alternating crenels (notches) and merlons (raised sections) forming permanent shields for the defenders.

crocket Stylized leaves used as decoration along angles of spires, pinnacles, gables, and around capitals.

crosier, crozier The staff carried by bishops, abbots, and abbesses; in the West having a spiral termination or the form of a shepherd's crook, and in the East, a cross and serpent.

cross Roman instrument of execution; the cross on which Christ was crucified became the principal Christian symbol.

ankh Egyptian looped cross, a symbol of eternity.

Constantinian cross Combined with the monogram of Christ.

cross-standard A long-handled cross with a flag, a symbol of triumph.

crucifix The cross with the figure of Christ.

Greek cross Cross with four equal arms.

Latin cross Cross with three short and one long arm.

St. Andrew's cross Diagonal, X-shaped cross.

tau cross T-shaped, or three-armed cross.

wheel cross Celtic form in which the arms are joined by circular bracing.

crossing In church architecture, the intersection of nave and transepts.

crucks Pairs of timbers in which the shape of the natural tree trunk and branches forms the posts and rafters of a timber-framed building.

crypt A vaulted chamber usually beneath the apse and choir, housing tombs or a chapel.

cubiculum (pl. cubicula) Chamber in a catacomb.

curtain wall Outer wall of a castle.

cusp The pointed projection where two curves (foils) meet. See also **foil.**

dalmatic Knee-length tunic worn by deacons and occasionally by bishops at High Mass. See also **vestments**.

damp-fold Clinging draperies, represented as if wet.

deacon Greek: servant, minister. A cleric who assists a priest, acts as reader, leads prayers, distributes communion, receives offerings, and distributes alms. An archdeacon is the principal administrative officer in a diocese.

Deësis Greek: supplication. Christ enthroned between the Virgin Mary and St. John the Baptist, who act as intercessors for mankind at the Last Judgment.

diaconicon In Early Christian and Byzantine architecture, a chamber beside the sanctuary where the deacons kept vestments, books, and liturgical vessels.

diaper All-over decoration of repeated lozenges or squarees.

diaphragm arch A transverse arch carrying an upper wall supporting the roof and dividing the longitudinal space into bays.

diocese The district and churches under the jurisdiction of a bishop.

diptych Two-leaved, hinged plaques containing painting, carving, or wax on which to write. In the early church, they were used to record the names of donors and others for whom special prayers were to be offered. Later they were used as portable altarpieces. See also triptych.

Divine Office Daily public prayer. Monastic communities celebrated seven day hours (Laudes, Prime, Terce, Sext, None, Vespers, and Compline) and one nigh hour (Matins) as fixed by St. Benedict, who called it *opus Dei*, the work of God. In cathedrals and parish churches a simple office consisted of morning and evening prayers. See also **hours**.

dogtooth molding Architectural ornament consisting of square, four-pointed, pyramidal stars.

dome A hemispherical vault; to erect a dome over a square or octagonal structure, the area between the walls and base of the dome is filled with pendentives or squinches. See also **pendentive**, **squinch**, **vault**.

Dominicans A preaching and teaching Order founded at Toulouse in 1206–16 by the Spaniard Domenico Guzmán (ca. 1170–ca. 1221, canonized 1234); also known as the Black Friars from the black claok worn over a white habit. The great scholar St. Thomas Aquinas (1225?–1274), author of the *Summa Theologica*, was a Dominican friar. See also **friars**.

domus Latin: house. Domus Ecclesiae: House church. Domus Dei: House of the Lord, the Church.

donjon The keep or principal tower stronghold of a castle.

dorte Dormitory.

double-shell octagon A church plan in which a central octagon is surrounded by an ambulatory and gallery.

dowel A pin used to hold two pieces of material together.

drôleries French: jokes. Marginal decorations in Gothic manuscripts.

drum The cylindrical or polygonal wall supporting a dome.

ecumenical council (also oecumenical) A world-wide council of bishops, called by the Pope, to decide doctrinal matters to be confirmed by the Pope and thenceforth binding on the Church.

elevation The side view of a building. The raising of the host and chalice during the Mass.

enamel Powdered colored glass fused to a metal surface and then polished.

champlevé enamel French: raised ground. The area to be enameled is cut away from the plate.

cloisonné French: partition. The cells or compartments for enamel are formed by strips of metal fused to the surface.

enceinte The outer fortified castle wall or the space enclosed by the wall.

entablature The horizontal structure carried by columns or piers; in Classical architecture, it consists of the architerave, frieze, and cornice.

epigraphy The study of inscriptions; compare **paleography**, the study of ancient written documents.

Epiphany The manifestation of Christ to the Gentiles, first through the Magi, the wise men from the East, who

brought gifts to the newborn King of the Jews (Matthew 2:1–12). The gifts of the Magi were gold (royalty), frankincense (divinity), and myrrh (suffering and death). The Feast of the Epiphany is January 6.

Epistles Apostolic letters; 21 books of the New Testament, 14 of which are attributed to St. Paul.

Eucharist Greek: thanksgiving. The central act of Christian worship; the commemoration of Christ's sacrifice on the cross by the consecration and taking of bread and wine, signifying the body and blood of Christ (the actual nature long debated by the Church). See also **Host.**

evangeliary A liturgical book containing selections from the Gospels to be read by the deacon during the Mass.

evangelists The traditional authors of the four Gospels, St. Matthew, St. Mark, St. Luke, and St. John. The evangelists' symbols are the winged creatures from Ezekiel's vision (Ezek. 1:5–14, Rev. 4:6–8): the winged man or angel for St. Matthew, the lion for St. Mark, the bull or ox for St. Luke, and the eagle for St. John.

exarchate A province of the Byzantine Empire, as for example Ravenna.

exedra (pl. **exedrae**) A semicircular recess, apse, or niche covered by a conch.

façade The face of a building, usually the front but also applied to the transepts of a church.

fald-stool Folding seat, like a modern camp stool; as a throne it may be claw-footed and lion-headed and covered with drapery and a large cushion.

fan vault A Late Gothic form in which solid, semicones, nearly meeting at the apex of the vault and supporting flat panels, are decorated with patterns of ribs and tracery paneling to give the appearance of an ornamental rib vault.

Fathers of the Church Scholars and teachers of the early Church.

The Latin Fathers St. Jerome, St. Ambrose, St. Augustine, St. Gregory.

The Greek Fathers St. John Chrysostom, St. Basil, St. Athanasius, St. Gregory Nazianzus.

feast A religious festival commemorating an event or honoring the Deity or a saint. The Feasts of the Church are of three types: (1) Sundays—weekly commemoration of the Resurrection, declared a general holiday by Constantine in 321; (2) Movable Feasts—Easter and Pentecost (seventh Sunday after Easter), the annual commemoration

of the Resurrection and the Descent of the Holy Ghost; (3) Immovable Feasts—Christmas, Epiphany, and the anniversaries of martyrs (saints' days). The Twelve Great Feasts, in the order of the liturgical calendar, are: Epiphany (Jan. 6), Presentation of Christ in the Temple (Feb. 2), Annunciation to Mary (March 25), Palm Sunday, Ascension Day, Pentecost, Transfiguration (Aug. 6), Death and Assumption (Dormition) of the Virgin (Aug. 15), Nativity of the Virgin (Sept. 8), Holy Cross (Sept. 14), Presentation of Mary in the Temple (Nov. 21), and Christmas (Dec. 25). Easter, as the Feast of Feasts, is in a class alone and is not counted as one of the twelve.

fibula Metal fastener, on the principle of the safety pin, with ornamented foot and head plates and spring fastener.

filigree Intricate ornament made from fine, twisted wire, hence any delicate fanciful decoration.

finial Ornamental terminal, especially at the peak of a gable or spire.

flêche A tall slender spire.

fleur-de-lis French: lily flower. Stylized flower of the iris. In heraldry a three-petal form; the royal arms of France.

foil The lobe formed by cusps making a leaf-like design. The prefix designates the number of foils, hence the shape of the figures, as trefoil, quatrefoil, cinquefoil; a thin sheet of metal, used as backing for translucent enamel or garnets.

font A receptacle for baptismal water.

Franciscans A mendicant Order founded in 1209 at Assisi by St. Francis (Giovanni di Bernardone, ca. 1182–1226, canonized 1230); also known as Grey Friars from the color of their robes (later, habits were brown and tied with knotted cord).

fresco Mural painting in which pigments in water are applied to wet plaster which absorbs the colors. In *fresco secco* the dry plaster is remoistened so that the pigments adhere to the wall surface.

friar A member of a mendicant Order, such as the Dominicans or Franciscans.

frieze The middle element in the entablature; a horizontal band of carvings or paintings.

frontal See altar frontal.

Galilee In architecture, a large entrance porch or vestibule; a narthex.

gargoyle A waterspout often carved as a monster or animal.

garth The open space within a cloister.

gesso Plaster of Paris used as a ground for painting or gilding.

gisant The effigy of the deceased on a tomb.

glory The light emanating from a figure indicating sancity; a **halo** or **nimbus** surrounds the head; a **mandorla** surrounds the entire figure.

gloss Commentary on a text.

Golgotha Aramaic: skull. "The place of the skull;" the site of the Crucifixion outside Jerusalem, also called Calvary from the Latin for skull.

Gospels Old English: Godspel, "good news." The term came to be used for the first four books of the New Testament in which the evangelists record the life of Christ. Since the "good news" (the "glad tidings of redemption") is the same in all the Gospels, the proper form is "The Gospel according to Matthew," etc.

gradual Choir book; antiphons from the Psalms.

Greek cross See cross.

grisaille Monochromatic painting or stained glass.

groin The edge of two intersecting vaults. See also vault.

guilloche Interlacing bands forming a braid; used as a decorative form of molding.

habit Monastic dress.

hall church From German, *Hallenkirche*. A church with nave and aisles of equal height.

hammerbeam A horizontal beam projecting at right angles from the top of a wall, carrying arched braces and posts and thus reducing the span of a timber roof.

Harrowing of Hell or Descent into Limbo According to the Apocryphal Gospel of Nicodemus, between Christ's Entombment and Resurrection He descended into Limbo where souls waited to be admitted into Heaven. Christ is often represented rescuing Adam, Eve, and other souls from Hell (a misunderstanding of Limbo).

haunch In an arch or vault the point of maximum outward thrust.

hemicycle A semicircular structure.

heresy A belief contrary to established doctrine. See Adoptionism, Arianism, Monophysitism, Nestorianism.

Hetoimasia The throne prepared for the second coming of Christ, as foretold in Revelations.

hieratic Sacerdotal, hence conventionalized art governed by priestly tradition; formal; stylized.

hieratic scale A convention in which the size of a figure indicates its relative importance.

historiated Decorated with a narrative subject, as historiated capitals or historiated initials.

Hodegetria Greek: showing the way. The Virgin holding and gesturing toward the Infant Christ.

Holy Ghost Third Person of the Trinity. Gifts of the Holy Ghost: Wisdom, Understanding, Counsel, Fortitude, Knowledge, Piety, Fear of the Lord (Isaiah 11:2); often represented as seven doves.

homily A lecture or sermon.

hood molding A projecting molding over a window or door to throw off rain. Also called a label or dripstone.

horseshoe arch An arch of horseshoe shape which, however, can be pointed as well as round.

hospice Lodging for guests.

Host Latin: *Hostia.* The sacrificial victim; thus the consecrated bread in the Eucharist; the body of Christ.

hours Cycle of daily prayers: Lauds (morning prayer, on rising), Prime (6 AM), Terce (9 AM), Sext (noon), None (3 PM), Vespers (originally variable but before sunset, now about 4:30 PM), Compline (variable, said just before retiring), and Matins (2:30 AM). The hours varied with the season, depending on time of sunrise and sunset. The liturgical day was composed of nine services, that is, the eight hours and Mass which was said between Terce and Sext.

icon An image of Christ, the Virgin Mary, or saint venerated in the Eastern (Orthodox) Church.

iconography The study of the meaning of images.

iconostasis A screen separating chancel and nave in a Byzantine church; by the fourteenth century a wall covered with icons and pierced by three doors leading to the altar, the diaconicon, and the prothesis.

impost The element below the springing of an arch; the blocks on which the arch rests.

impost block A downward tapering block, like a second capital, above the capital of a column.

inhabited initial or scroll Entwined foliage and small figures.

Instruments of the Passion See Passion.

intaglio Designs cut into a surface.

jamb The side of a door or window; often splayed and decorated with column-figures.

Jesse, Tree of A genealogical tree showing the descent of Christ from the royal line of David according to the prophesy of Isaiah (11:1–2).

Kaiserdom German: Imperial Cathedral.

katholikon The principal church of a Byzantine monastery.

keep The principal tower of a castle, provisioned to withstand siege. See also **donjon**.

keystone The wedge-shaped central stone of an arch or vault.

knop A decorative knob, part of the stem of a candlestick, chalice, or similar item.

Koran Muslim sacred writings.

Kufic script An angular written Arabic script, often used as decoration.

label See **hood molding**. Sculptured ends of labels are called label-stops.

Lady, Our Lady Domina nostra, Nôtre Dame, the Virgin Mary.

Lady Chapel A chapel dedicated to the Virgin Mary forming part of a larger church; in England often a large chapel east of the high altar.

Lady Day The Feast of the Annunciation, March 25; in the Middle Ages considered to be the first day of the civil year.

lancet window A tall pointed window without tracery. lappet A ribbon-like extension from the lip or the back of the head of a human or fantastic animal.

Latin cross See cross.

lauratron The image of the emperor; the symbol of the imperial presence.

lavabo A wash basin.

lectern A reading desk in a church, often having the form of an eagle.

lectionary A liturgical book containing selections from scripture to be read during the worship service, organized according to the church calendar. Sometimes divided into epistolaries and evangeliariees, and finally supplanted by the missal.

Liberal Arts The Medieval educational system of the trivium (grammar, rhetoric, and logic) and the quadrivium (arithmetic, music, geometry, astronomy). Often personified and associated with the Virgin Mary.

Liber Pontificalis Latin: the Papal Book. The official collection of Biographies of the Popes.

Liber Vitae Latin: Book of Life. List of benefactors.

Libri Carolini Latin: Caroline Books. Carolingian treatise attacking the work of the Council of Nicaea (787) and the restoration of the veneration of icons.

lierne A tertiary rib; a rib springing from neither a main springer nor a central boss but running from one rib to another to decorate the vault.

linenfold Decorative paneling evoking a conventionalized pattern of vertically folded fabric.

lintel A horizontal element spanning an opening.

liturgical calendar. See feast, The Twelve Great Feasts.

liturgy The public services or rites of worship in the church, the principal one of which is the Mass or Eucharist; also written texts giving the order of service.

loculi Niches in the walls of a catacomb to hold the dead.

loggia An arcaded gallery.

lunette A flat semicircular surface.

lustre A shining surface on ceramics produced by metallic glazes fired at a low temperature.

machicolation A gallery supported by brackets on the outer face along the top of fortified walls. Openings in the floor permit missiles to be dropped on attackers.

Maestà Italian: majesty. The Virgin in majesty; an altarpiece with a representation of the Virgin enthroned, adored by saints and angels.

magistri comacini Traveling masons working from Lombardy to Catalonia in the ninth and tenth centuries.

Magus (pl. Magi) Persian priest. The three wise men who paid homage to the Infant Christ, representing the recognition of Christ by the Gentiles.

majuscule Upper-case letter.

mandorla See glory.

maniple A narrow strip of cloth worn over the left arm by the celebrant of the Mass. See also **vestments**.

Maria Regina Latin: Mary Queen of Heaven.

marquetry Inlay of thin pieces of colored wood, ivory, mother-of-pearl.

martyr Greek: witness. One who has suffered death for the faith. The anniversary of a martyr's death was celebrated by the church (saint's day). A relic of a martyr had to be placed in every consecrated altar (until 1969). martyrium (pl. martyria) A church built over the tomb of a martyr.

martyrology The official register of Christian martyrs; at first simply a list of names and dates of martyrdom; later writers added stories. (A Passion described the death of an individual martyr in detail.)

Mass Latin: *missa*, referring to the dismissal of the congregation after the service, *Ite, missa est,* "Go, you are dismissed." The central rite of the Christian Church. See also Eucharist.

mausoleum (pl. mausolea) A tomb, so-called after the fourt-century B.C. tomb of Mausolus at Halicarnassus.

meander A fret or "Greek key" pattern.

medium The material out of which the work of art is made.

mihrab In a mosque, the niche in the qibla wall indicating the direction of Mecca.

millefiori Italian: thousand flowers. Enamel patterns produced by fusing rods of colored glass and then slicing off thin sections to set in the field.

mille-fleurs tapestry French: thousand flowers. An overall, repeated pattern of plants which may be highly stylized or quite naturalistic.

minaret In Islamic architecture, a tower from which the faithful were called to prayer.

minbar A pulpit or reader's platform in a mosque.

miniature From *minium*, a red pigment. A painting or drawing in a manuscript, hence tiny.

minster Once any monastery or its church; later applied to some cathedrals and churches especially in England and Germany.

minuscule Lower-case letter.

miracle A fact or event transcending the normal order of things, produced through divine intervention.

misericord A bracket on the underside of the seat of a choir stall which, when the seat is tipped up, provides support for the occupant.

missal A liturgical book containing the text and instructions for the celebration of the Mass throughout the year; combines the lectionary and sacramentary.

missorium A commemorative dish.

miter A cap with two points and lappets, worn by bishops and some abbots. See also **vestments**.

moat Defensive ditch around a castle or town.

molding A projecting or recessed decorative strip.

monastery A community of monks or nuns; the buildings housing the community. In addition to the church, a large self-sufficient monastery had a cloister, chapter-house, scriptorium and library, dormitory, refectory, kitchen, hostelry or guesthouse, infirmary, novitiate, and supporting farm buildings, workshops, and storerooms.

monograms and symbols of Christ

Chi Rho (XP) The first two letters of the Greek word for Christ, *Xpictoc*, combined to form a cross.

IHC, IHS The first three letters of the Greek word for Jesus (*Ihcuc* or *Ihsus*).

INRI (*Iesus Nazarenus Rex Iudaeorum*) Latin: Jesus of Nazareth, King of the Jews (tablet on the cross).

ichtus The sign of the fish, *ichtus* in Greek, comes from the initial letters of the Greek phrase, "Jesus Christ, Son of God, Savior." The fish symbolizes Christ and also the rite of baptism.

Monophysitism Greek: one nature. The doctrine of the single divine nature of Christ; as opposed to the Orthodox belief in the dual nature (human and divine, dyophysite) of Christ after the Incarnation; condemned as heretical by the Council of Chalcedon in 451; the belief continued in Syria, Egypt, Armenia, and Georgia.

monotheism Belief in one God. The three great monotheistic religions are Judaism, Christianity, and Islam. In Christianity the three Persons of the Trinity remain one Godhead.

monsters, fabulous beasts

basilisk Bird's head and body with serpent's tail; kills with a glance.

dragon Gigantic reptile with four legs, lion's claws, serpent's tail, and scaly wings and skin; often fire breathing.

griffin Lion with eagle's head and wings.

harpy Woman's face and body with bird's wings and claws.

quadruped Unidentifiable four-legged beast.

unicorn Horse or deer-like animal with a single horn.

wyvern Two-legged dragon.

mosaic A surface decoration composed of small colored stones or glass cubes laid in cement or plaster forming figurative or abstract designs.

mosque Prayer hall.

motte-and-bailey Fortification consisting of a central earthen mound (motte) supporting a wooden tower and

an encircling open yard (bailey) all enclosed by a ditch and earthen bank with timber palisade.

mukarnas The stalactite dome or vault; an ornamental ceiling formed of corbeled squinches usually of brick or timber; as a decorative form may be used on capitals.

Muldenstil German: trough. Trough-like depressions represent folds of drapery.

multiple-fold drapery Drapery surface covered by fine, parallel lines.

naos Greek: the principal room in a temple. The sanctuary; the space in which the liturgy is performed. In a Byzantine church the naos includes apse, choir, and nave.

narthex The vestibule of a church; a transverse hall in front of the nave.

nave Latin: ship. Central vessel of a church, extending from the entrance to the crossing or choir.

Necropolis City of the Dead.

Neskhi Cursive Arabic script. See also Kufic.

nested V-fold Drapery represented as forming a series of V-shapes, one inside the other.

Nestorianism From Nestorius (d. ca. 451), a Syrian priest. The belief in two separate Persons of Christ (human and divine) as opposed to the Orthodox doctrine of a single Person at once God and man; emphasis on Christ's human nature and thus the denial of the title "Mother of God" to Mary. Condemned as heretical by the Council of Ephesus in 431. The belief continued in Persia.

net vault A vault with lierne and tiercerone ribs arranged in an intersecting, net-like pattern.

niello Metal decoration in which incised designs are filled with a sulphur alloy and fused by heat to form a dark pattern.

nimbus See glory.

nodding ogee arch Ogee arches curving outward as well as upward.

nook shaft A shaft set in the angle of a pier, respond, or jamb.

Octateuch The first eight books of the Bible; the Pentateuch plus the books of Joshua, Judges, and Ruth.

oculus (pl. oculi) Latin: eye. A round window.

Office See Divine Office.

ogee An S-shaped curve; in an ogee arch the two S-shaped curves are reversed to meet in a central point.

opus alexandrium Marble laid in geometric patterns.

opus anglicanum The elaborate figurative embroidery,

used especially for vestments, produced in England in the Gothic period.

opus francigenum Medieval term for the new architectural style and technique of northern France; later to be known as Gothic.

opus reticulatum A form of Roman masonry, lozenge-shaped stones forming a net-like pattern.

orant Latin: praying. A figure with hands raised in prayer.

oratory A chapel; a small building for prayer.

orb A sphere symbolizing the earth.

order (architectural) In Classical architecture, the style of building as determined by the proportions and form of the total structure, columns, and entablature; in Romanesque architecture, the recessions of an arch, in a doorway or arcade.

Order (ecclesiastical) A group of people united by a rule or aim; thus, a monastic institution. A choir of angels. Grades in Christian ministry.

Orders or Holy Orders The sacrament of ordination; thus, the clerical status (priests, deacons, and subdeacons).

Palatine Chapel Palace chapel.

paleography The study of ancient written documents.

pallium A strip of white wool with front and back pendants decorated with black crosses worn around the shoulders, given by the Pope to archbishops as a symbol of authority.

palmette A stylized palm frond.

paradise Persian: enclosed park. The Garden of Eden; the heaven of the Blessed. An open court of atrium in front of a church (Parvis). A monastic garden or cemetery, especially in the cloister.

parapet Low, protective wall.

parchment Treated animal skin used for books and documents. See also vellum.

parish Greek: district. A subdivision of a diocese under the care of a priest.

Pasch Jewish: Passover. Christian: festival of Easter. Paschal lamb: lamb eaten at Jewish Passover after being sacrificed in the Temple, thus Christ as the sacrificial lamb. Paschal candle: a candle lighted during the Easter season.

Passion Latin: suffering. The Passion refers to the last days of Christ, His suffering, and Crucifixion. The events

of the Passion begin with the Entry into Jerusalem and the Last Supper and include Christ washing the feet of the Disciples, the Agony in the Garden, the Betrayal by Judas, the Denial of Peter, Christ before Pilate, the Flagellation, the Crowning with Thorns, Christ Carrying the Cross, the Crucifixion, the Descent from the Cross, the Pietà or Lamentation, the Entombment, the Descent into Limbo, the Resurrection, the Ascension. Also, the account of a martyrdom. Instruments of the Passion as represented in art take three forms: (1) instruments used in the torture of Christ, such as column, whips, crown of thorns, (2) objects recalling the events of Christ's last hours on earth, such as the wash basin (Pilate), purse (Judas), and crowing rooster (St. Peter), and (3) objects specifically associated with the Crucifixion, such as ladder, hammer, dice.

paten A platter on which the bread is offered and the consecrated Host is placed. See also **chalice**.

patriarch Head of an ecclesiastical province in the Eastern Church, comparable to an archbishop in the West.

pectoral cross A cross worn on the chest.

pediment The triangular area enclosed by the entablature and raking cornice.

pendentive A spherical triangular section of masonry making a structural transition from a square to a circular plan; four pendentives support a dome.

Penitential Psalms Vulgate 6, 31, 37, 50, 101, 129, and 142; King James 6, 32, 38, 51, 102, 130, 143

Pentateuch Greek: five books. The first five books of the Bible, that is, Genesis, Exodus, Leviticus, Numbers, and Deuteronomy.

Pentecost Greek: Fiftieth day after Passover (the Jewish Feast of Weeks). The Descent of the Holy Ghost (Acts 2:1–4); hence, the beginning of the apostles' mission.

pericope Greek: section. Selected passages of scripture to be read at church services.

peristyle An open court surrounded by columns.

perspective A system for representing three-dimensional objects on a two-dimensional surface. One point linear perspective: parallel lines at right angles to the picture plane appear to vanish at a single point on the horizon; thus, figures and objects appear to grow smaller in the distance. Aerial or atmospheric perspective: distant objects are represented as lighter and grayer in color and less distinct in outline than nearby figures. Reverse perspective: lines diverge as they recede, and objects appear to tip up and grow larger.

pier A solid masonry support.

pietà Italian: pity. The mourning Virgin seated with the body of the crucified Christ in her lap.

pilaster A flat vertical element projecting from a wall or pier; often divided into base, shaft, and capital.

pilgrimages Journeys to holy places made as acts of piety or penance; the great pilgrimages of the Middle Ages were to Jerusalem, Rome, and Santiago de Compostela.

pinnacle A small turret, usually ornamental but also used to load a buttress.

piscina Latin: fishpond. At first a pool for baptism; later a niche near the altar with a drain for the disposal of water used in the ceremonies.

plate drapery The representation of cloth as a series of superimposed, sheath-like layers.

plate tracery See tracery.

plinth The projecting base of a column or wall.

polychromy The use of colors on architecture and sculpture.

porphyrogenitus Greek: born in the purple. The birth room in the Byzantine Imperial Palace was decorated with porphyry, a reddish-purple stone.

precentor The leader of the church choir.

predella Italian: kneeling-stool. The base of a large altarpiece, often painted or carved.

presbyters Overseers and administrators of the church. **priory** A monastic house, or community dependent on an abbey; ruled by a prior or prioress.

propylaeum Monumental entranceway.

prothesis The chamber, in a Byzantine church, used for the storage and preparation of the bread and wine used in the Mass. See also **dioconicon**.

psalter Book containing the Psalms. Benedictine monks recited all the Psalms every week.

pulpit A raised stand for a reader; it replaced the ambo in the late Middle Ages.

pulpitum A choir screen.

putto (pl. putti) A small, winged boy.

pyx A container for the reserved sacrament, that is, a consecrated Host saved for later use.

qibla The wall in a mosque indicating the direction of Mecca.

quadripartite vault A vault divided into four cells or compartments.

quatrefoil A design having four lobes or foils; a four-leaf clover shape used in ground plans and as a decorative motif.
 quincunx Five objects (such as domes in a Byzantine church) arranged in a square with one in the center and one in each corner.

rampant In heraldry, an animal standing on its hind legs.

recension The revision of a text, or a revised text.

reconquista Spanish: reconquest. The crusade against the Moors in Spain.

refectory Dining hall.

regalia Symbols of royalty such as the crown and sceptre.

reja Spanish: a grill.

relics The venerated remains of saints or objects associated with saints.

relieving arch An arch built into a masonry wall over an opening to disperse (and thus to relieve) the weight above.

reliquary A container for relics.

repoussé A metal relief made by pounding out the design from the back.

reredos A sculptured or painted screen behind the altar. Also known as a **retable** or *retable* (Spanish).

reserved To save for future use, as in the reserved sacrament. In enameling the raised area of polished, often gilded, metal without enamel.

respond A shaft or pilaster attached to a wall to support an arch.

retable See reredos.

rib An arched, molded band dividing and supporting the cells of a vault.

rib vault A vault built on a framework of arched ribs.

rinceau Ornament composed of scrolls of foliage.

rite The prescribed form for conducting a religious service; a ceremonial act; the liturgy.

roll molding A semicircular, convex molding.

rood A cross or crucifix, often placed above the screen at the entrance to the choir.

rubble masonry Rough building stones laid in irregular courses.

rule The regulations drawn up by the founder of a religious order to govern the life and observances of its members as, for example, the Benedictine Rule.

rune Twig-like northern script.

rune stone A commemorative stone inscribed with runes.

sacramentary A liturgical book containing the canon of the Mass and prayers but not the Epistles and Gospels (see lectionary)or the sung portions (see gradual) in use until the thirteenth century for the celebration of the Mass. Replaced by the missal.

Sacraments Rites of the church: Baptism, Confirmation, the Eucharist, Penance, Matrimony, Holy Orders, Extreme Unction.

sacrifice The offering of a gift, often a living creature, to a deity. In Christianity the Eucharist symbolizes or reenacts the sacrifice of Christ.

sacristy A room in a church near the altar where liturgical vessels and vestments are kept.

sarcophagus (pl. sarcophagi) A large stone coffin.

scriptorium (pl. **scriptoria**) A place where manuscripts are written.

sedilla Seats for the celebrating clergy in the south wall of the choir (usually three seats, for priest, deacon, and subdeacon).

see Latin: *sedes*, seat. The official seat of a bishop. The town where the throne and cathedral are located and by extension the jurisdiction of the bishop. See also **diocese**.

seraphim The highest order of angels.

sexpartite vault A vault divided into six cells or compartments.

soffit The underside of an arch, lintel, or cornice.

solar The upper living room in a medieval house.

spandrel The triangular space formed by the curve of arches in an arcade.

spire A tall, pyramidal, polygonal termination rising over a tower.

springers The stones supporting the arc of an arch.

squinch A corbeled arch or niche across the corner of a square bay serving to convert the space to an octagon on which a dome or vault can be raised.

stalactite vault See mukarnas.

star vault A vault with ribs (see **lierne** and **tiercerone**) arranged in a star pattern.

Stations of the Cross Popular devotions commemorating the Passion of Christ, based on the Way of the Cross in Jerusalem, developed by the Franciscans in the later Middle Ages.

stave church A Norwegian timber church supported by vertical timber posts.

stele A commemorative stone carved with reliefs and inscriptions.

stole A strip of material worn over the shoulders by priests and deacons.

strainer arch An arch inserted between two walls or piers to prevent them from leaning.

string-course A horizontal molding on a building.

stucco Fine plaster, often used decoratively.

synod An ecclesiastical council.

tabernacle A receptacle for the Holy Sacrament or relics; often a decorated, freestanding canopy.

tau cross A T-shaped cross. See also cross.

terracotta Italian: baked earth. Used for building, sculpture, and ceramics.

tessera (pl. tesserae) Small cubes of stone or glass making a mosaic.

tetraconch A building consisting of four conch-covered exedrae enclosing a cubical central space. See also **conch**, **exedra**.

tetrarchy Four-man rule.

theophany The temporary and immaterial appearance of God in visible form, in contrast to the Incarnation in which God and man were permanently and completely united.

Theotokos Greek: Mother of God. The Virgin Mary was proclaimed *Theotokos* at the Council of Ephesus. See also Nestorianism.

tiercerone Secondary rib springing from a main springer and leading to the ridge rib.

timber framing A construction technique in which timber framework is filled with wattle and daub, brick, or plaster to form walls; also known as half-timbering.

torque A neck ornament, usually twisted bars or strands of gold.

tracery Ornamental stone work applied to wall surfaces or used to fill the upper part of windows. In plate tracery openings are cut through the stone spandrels above the arched lights. In bar tracery mullions divide the window into lights and continue to form decorative patterns in the head of the window.

transept The transverse element of a basilican church, often as high or higher and as wide as the nave.

Transfiguration The revelation of the Divinity of Christ to the Apostles Peter, James, and John. Christ appeared in glory with Moses and Elias on Mount Tabor (Mat. 17:1–13, Mark 9:2–13, Luke 9:28–36).

transom A horizontal cross bar in a window.

trefoil A three-lobed shape. See also foil, cusp, quatrefoil.

tribune An arcaded gallery above the aisle and open to the nave of a church.

triclinium Dining room in a Roman house.

triforium In the elevation of a basilican church, the space at the height of the aisle roofs between the nave arcade and the clerestory; an arcaded passage in that position.

triptych Three hinged panels; the narrower outer panels can be folded over the inner panel to protect it. See also **diptych**.

triquetra An ornament of three interlaced arcs.

triskele A three-legged, running figure found in Celtic ornament.

triumphal arch In ancient Rome, a freestanding monument in the form of a gateway to commemorate a military victory. In the Christian church, the transverse wall at the end of the nave pierced by an arched opening into the sanctuary.

trumeau The central post of a portal supporting a lintel and tympanum.

truss The timber framework forming rigid triangles to support the roof; may be left open or covered with a wooden ceiling.

tympanum The area between the lintel and the arch of a portal.

typology The Old Testament prefiguration of events in the New Testament; Old Testament types are paired with New Testament antitypes, for example Abraham's sacrifice of Isaac with the Crucifixion of Christ, the story of Jonah with the death and Resurrection of Christ.

uncial A Roman alphabet with rounded letters.

vault A masonry covering built on the principle of the arch; the two simplest forms are the barrel vault, a tunnel-like extension of the arch, and the groin vault in which two barrel vaults of equal size intersect at right angles. In a ribbed vault masonry ribs are constructed to concentrate the load and thrust and to reduce the

amount of centering needed for construction. See also groin, ribs.

vellum A fine parchment prepared for writing and illumination.

vermicule Foliate scroll or wormlike patterns engraved as a background for enamel and on masonry.

Vesperbild German. An image for meditation at evening prayers.

vestments The distinctive dress worn by the clergy when performing the services of the church. See also alb, amice, chasuble, miter, cope, stole.

vestry A room for the storage of vessels, vestments, and other liturgical equipment. See also **diaconicon**.

vices The seven deadly sins, usually pride, covetousness or avarice, lust or unchastity, envy, gluttony, anger, and sloth. Folly, inconstancy, injustice are also often represented among the vices. Vices are often paired with virtues.

Victory As a personification or deity, usually represented as a winged female holding a laurel wreath.

virtues The theological virtues are faith, hope, and charity; the cardinal virtues are prudence, justice, fortitude, and temperance. The combat of virtues and vices (Psychomachia) is a popular theme in Medieval art.

Visitation The visit of Mary to her cousin Elizabeth, mother of St. John the Baptist, after the Annunciation (Luke: 36, 41–42).

volute A spiral or scroll form, as on Corinthian capitals.voussoir A wedge-shaped block used in the construction of an arch. The central voussoir is known as the keystone.

Vulgage St. Jerome's Latin translation of the Bible.

wattle and daub Interwoven laths or branches plastered over with clay.

westwork A complex structure at the west end of a church consisting of superimposed entrance, a chapel, and often a throne room flanked by towers or stair turrets.

Zackenstil German: zigzag. A convention in which angular drapery folds end in a zigzag pattern.

zodiac The path of the sun, moon, and planets around the earth, divided into twelve parts marking the times of the year; used in Christian art to suggest the extension of time of God's dominion. The signs of the zodiac are named after the constellations: Aries (the ram), Taurus (the bull), Gemini (the twins), Cancer (the crab), Leo (the lion), Virgo (the Virgin), Libra (the scales), Scorpio (the scorpion), Sagittarius (the archer), Capricorn (the goat), Aquarius (the water carrier), Pisces (the fishes).

zoomorphic The use of animal forms as decorative and symbolic devides.
SELECTED ENGLISH-LANGUAGE READINGS IN MEDIEVAL ART

I. HISTORY AND CULTURE

- Abou-el-Haj, Barbara. The Medieval Cult of Saints: Formations and Transformations. Cambridge, 1997.
- Abulafia, D. The Western Mediterranean Kingdoms 1200–1500. London and New York, 1997.
- Adams, Henry. *Mont-Saint-Michel and Chartres*. Boston and New York, 1904 and many later editions.
- Bartlett, R. The Making of Europe: Conquest, Colonization and Cultural Change 950–1350. London, 1993.
- Baxter, R. Bestiaries and Their Users in the Middle Ages. Stroud, 1998.
- Benson, R. L. and G. Constable with C. D. Lanham. *Renaissance and Renewal in the Twelfth Century.* Cambridge, Mass., 1982/1991.
- Binski, P. Medieval Death: Ritual and Representation. London, 1996.
- Bitel, Lisa M. Women in Early Medieval Europe, 400–1100. Cambridge, 2002.
- Bowersock, G. W., Peter Brown, and Oleg Grabar, eds. Late Antiquity: A Guide to the Postclassical World. Cambridge, Mass., 1999.
- Brown, Peter. The Cult of the Saints: Its Rise and Function in Latin Christianity. Chicago, 1981.
- _____. The Rise of Western Christendom: Triumph and Diversity A.D. 200–1000. Oxford, 1996.
- _____. The World of Late Antiquity, A.D. 150–750. London, 1971.
- Bynum, C. W. The Resurrection of the Body in Western Christianity 200–1336. New York, 1995.
- Clanchy, M. T. From Memory to Written Record: England 1066–1307. 2nd ed. Oxford, 1993
- Collins, Roger. *Early Medieval Europe, 300–1000.* New York, 1991.

- Cross, F. L., ed. *The Oxford Dictionary of the Christian Church*. 3rd ed., ed. E. A. Livingstone. Oxford, 1997.
- Duby, Georges. The Europe of the Cathedrals, 1140–1280. Geneva, 1966.
- _____. Foundations of a New Humanism, 1280–1440. Geneva, 1966.
- _____. The Making of the Christian West, 980–1140. Geneva, 1966.
- Durandus, William. The Symbolism of Churches and Church Ornaments: A Translation of the First Book of the Rationale Divinorum Officiorum. Trans. John Mason Neale and Benjamin Webb. London, 1893.
- Eco, U. Art and Beauty in the Middle Ages. New Haven and London, 1986.
- Ferguson, George Wells. Signs and Symbols in Christian Art. New York, 1967.
- Flint, Valerie I. J. *The Rise of Magic in Early Medieval Eu*rope. Oxford, 1991.
- Fossier, Robert, ed. *The Cambridge Illustrated History of the Middle Ages.* 3 vols. Trans. Janet Sondheimer and Sarah Hanbury Tenison. Cambridge, 1986–1997.
- Friedman, J. B. *The Monstrous Races in Medieval Art and Thought.* Cambridge, Mass., 1981.
- Geary, Patrick J. Before France and Germany: The Creation and Transformation of the Merovingian World. Oxford, 1988.
- Hall, James. *Dictionary of Subjects and Symbols in Art.* Rev. ed. New York, 1979.
- Harper, J. The Forms and Orders of Western Liturgy from the Tenth to the Eighteenth Century. Oxford, 1991.
- Harvey, John H. Medieval Gardens. London, 1981.
- Holmes G., ed. *The Oxford Illustrated History of Medieval Europe.* Oxford, 1988.

- Holt, Elizabeth Gilmore, ed. *A Documentary History of Art* (Vol. 1 of 3). 3 vols. New Haven, 1986.
- Hooper, N. and M. Bennett. *Warfare in the Middle Ages*, 768–1487. Cambridge Illustrated Atlas. Cambridge, 1996.
- Huizinga, Johan. *The Waning of the Middle Ages*. London, 1924. New York, 1954.
- Hyman, A., and J. J. Walsh. *Philosophy in the Middle Ages: The Christian, Islamic and Jewish Traditions.* Indianapolis, 1974.
- Klauser, T. A Short History of the Western Liturgy. Oxford, 1965/1979.
- The Koran. Rev. ed. Trans. N. J. Dawood. London, 1993.Kostof, Spiro. A History of Architecture: Settings and Rituals. 2nd ed. Rev. Greg Castillo. New York, 1995.
- Labarge, Margaret Wade. A Small Sound of the Trumpet: Women in Medieval Life. London, 1990.
- Le Goff, J. ed. The Medieval World. London, 1990
- Livingstone, E. A. The Concise Oxford Dictionary of the Christian Church. Oxford, 2000.
- Mackay, A. with D. Ditchburn. *Atlas of Medieval Europe*. London and New York, 1997.
- McCash, J. Hall, ed. *The Cultural Patronage of Medieval Women.* Athens, Ga., 1996.
- McLean, Teresa. Medieval English Gardens. New York, 1980.
- Nicholas, D. *The Evolution of the Medieval World* 312–1500. Harlow, 1992/1998.
- Nicholson, H. ed. *The Military Orders*. 2 vols. London, 1998.
- Noble, Thomas F. X. and Thomas Head, eds. Soldiers of Christ: Saints and Saints' Lives from Late Antiquity and the Early Middle Ages. University Park, Pa., 1995.
- Plummer, John. Liturgical Manuscripts for the Mass and Divine Office. New York, 1964.
- Randsborg, Klaus. *The First Millennium A.D. in Europe and the Mediterranean*. Cambridge, 1991.
- Roberts, Helene, ed. *Encyclopedia of Comparative Iconog*raphy. Themes Depicted in Works of Art. 2 vols. Chicago, 1998.
- Rosenberg, C. M., ed. Art and Politics in Late Medieval and Early Renaissance Italy, 1250–1500. South Bend, Ind., 1990.
- Saul, N. ed. The Oxford Illustrated History of Medieval England. Rev. ed. Oxford, 2000.
- Sed-Rajna, Gabrielle. *Jewish Art.* Trans. Sara Friedman and Mira Reich. New York, 1997.
- Southern, R. W. Western Society and the Church in the Middle Ages. London, 1970.
- Stokstad, Marilyn, and Jerry Stannard. *Gardens of the Middle Ages*. Lawrence, Kans., 1983.

- Swanson, R. N. Religion and Devotion in Europe c. 1215-c.1500. Cambridge, 1995.
- Voragine, J. de. *The Golden Legend*. Trans. and adapted by G. Ryan and H. Ripperger. New York, 1969.
- Webster, Leslie, and Michelle Brown, eds. *The Transfor*mation of the Roman World A.D. 400–900. London, 1997.
- White, Lynn, Jr. Medieval Technology and Social Change. Oxford, 1962.

2. GENERAL STUDIES OF MEDIEVAL ART

- Alexander, J. J. G. Medieval Illuminators and Their Methods of Work. New Haven, 1992.
- Andrews, Francis B. *The Medieval Builder and His Methods*. New York, 1993.
- Barral i Altert, X. The Early Middle Ages from Late Antiquity to A.D. 1000. Cologne, 1997.
- Belting, H. The Image and Its Public in the Middle Ages: Form and Function in the Early Paintings of the Passion. New York, 1990.
- _____. Likeness and Presence: A History of the Image Before the Era of Art. Trans. E. Jephcott. Chicago, 1994.
- Binski, Paul. Painters, Medieval Craftsmen. London, 1992.
- Braunfels, Wolfgang. Monasteries of Western Europe: The Architecture of the Orders. Princeton and London, 1972.
- Brown, Michelle P. Understanding Illuminated Manuscripts: A Guide to Technical Terms. London, 1994.
- Brown, Sarah, and David O'Connor. Glass-painters, Medieval Craftsmen. London, 1992.
- Calkins, Robert. *Illuminated Books of the Medieval Ages*. Ithaca, N.Y., 1983.
- _____. Medieval Architecture in Western Europe: From A.D. 300 to 1500. New York, 1998.
- Camille, Michael. *The Gothic Idol: Ideology and Image-Making in Medieval Art.* Cambridge, 1989.
- _____. The Medieval Art of Love: Objects and Subjects of Desire. New York, 1998.
- Cherry, John F. *Goldsmiths, Medieval Craftsmen.* London, 1992.
- "The Cloister," *Gesta.* 12 (1973), special issue with articles by Wayne Dynes, Alfred Frazer, Jane Hayward, Walter Horn, Paul Meyvaert, and Leon Pressouyre.
- Coldstream, Nicola. Masons and Sculptors, Medieval Craftsmen. London, 1991.
 - _____. Medieval Architecture. Oxford, 2002.
- Conant, Kenneth John. *Carolingian and Romanesque Architecture*, 800–1200. 3rd ed. Hamondsworth, Eng., 1973, 1978.

- Davis-Weyer, Caecilia, Early Medieval Art, 300–1150: Sources and Documents. Englewood Cliffs, N.J., 1971.
- De Hamel, Christopher. Scribes and Illuminators, Medieval Craftsmen. London, 1992.
- The Dictionary of Art., 34 vols. New York, 1996.
- Dodwell, C. R. *The Pictorial Arts of the West*, 800–1200. New Haven and London, 1993.
- Duby, Georges. Sculpture: The Great Art of the Middle Ages from the Fifth to the Fifteenth Century. New York, 1990.
- Eames, Elizabeth S. English Tilers, Medieval Craftsmen. London, 1992.
- Egbert, Virginia W. *The Medieval Artist at Work*. Princeton, 1967.
- Encyclopedia of World Art. 16 vols. New York, 1972–83. Evans, Joan. Dress in Medieval France. Oxford, 1952.
- Fletcher, Banister. Sir Banister Fletcher's A History of Architecture. 20th ed. Ed. Dan Cruickshank. Oxford, 1996
- Harvey, John H. English Medieval Architects. Rev. ed. Gloucester, 1984.
- _____. The Master Builders: Architecture in the Middle Ages. New York, 1972.
- Hetherington, P. The Painter's Manual of Dionysius of Fourna. London, 1974.
- Hurlimann, Martin, and Jean Bony. French Cathedrals. Rev. and enl. London, 1967.
- Kennedy, H. Crusader Castles. London, 1994.
- Kenyon, John. Medieval Fortifications. Leicester, 1990.
- Krautheimer, R. Rome, Profile of a City, 312–1308. Princeton, 1980.
- Lasko, P. *Ars Sacra, 800–1200.* 2nd ed. New Haven, 1994.
- Little, Charles John, Williams, Jerrilynn Dodds, Serafin Moralejo, et al., eds. *The Art of Medieval Spain, A.D.* 500–1200. New York, 1993.
- Martindale, A. Painting the Palace: Studies in the History of Medieval Secular Painting. London, 1995.
- Monreal y Tejada, L. *Medieval Castles of Spain*. Eng. trans. Cologne, 1999.
- Muir, R. Castles and Strongholds. London, 1990.
- Oakeshott, Walter. The Mosaics of Rome from the Third to the Fourteenth Centuries. London, 1967.
- O'Neill, John Philip, ed. *Enamels of Limoges: 1100–1350.* Trans. Sophie Hawkes, Joachim Neugroschel, and Patricia Stirneman. New York, 1996.
- Ousterhout, Robert and Leslie Brubaker, eds. *The Sacred Image East and West.* Urbana, Ill. and Chicago, 1995.
- Parker, E. C. and M. B. Shepard, eds. *The Cloisters: Studies for the Fiftieth Anniversary.* New York, 1992.

- Pevsner, Nikolaus. *The Buildings of England* (vols., by county). Harmondsworth, Eng., 1951–.
- and Priscilla Metcalf. *The Cathedrals of England.* 2 vols. Harmondsworth, Eng., 1985
- Pfaffenbichler, Matthias. *Armourers. Medieval Craftsmen.* London, 1992.
- Radding, Charles M., and William W. Clark. *Medieval Architecture, Medieval Learning: Builders and Masters in the Age of Romanesque and Gothic.* New Haven, 1992.
- Sears, Elizabeth and Thelma K. Thomas, eds. *Reading Medieval Images: The Art Historian and the Object.* Ann Arbor, Mich., 2002.
- Sekules, Veronica. Medieval Art. Oxford, 2001.
- Snyder, James. Medieval Art: Painting-Sculpture-Architecture, 4th–14th Century. New York, 1989.
- Stalley, Roger. Early Medieval Architecture. Oxford, 1999.Staniland, Kay. Embroiderers, Medieval Craftsmen. London, 1991.
- Stoddard, Whitney. Monastery and Cathedral in Medieval France. Middletown, Conn., 1966; reissued as Art and Architecture in Medieval France. New York, 1972.
- Theophilus. De *Diversibus Artibus*. 2nd ed. Trans. and ed., John G. Hawthorne and Cyril S. Smith. New York, 1979.
- _____. *The Various Arts, De Diversibus Artibus.* Trans. C. R. Dodwell. Oxford, 1986.
- Thompson, D. V. Cennino Cennini: The Craftsman's Handbook. New York, 1933.
- Trachtenberg, Marvin, and Isabelle Hyman. *Architecture From Prehistory to Postmodernity.* Upper Saddle River, N.J., 2001.
- Van Os, H. *The Art of Devotion in the Late Middle Ages in Europe 1300–1500.* London and Amsterdam, 1994.
- Viollet-Le-Duc., E. Dictionnaire raisonné de l'architecture française du XI au XVI siècle. 10 vols. Paris, 1859–1868.
- Webb, G. Architecture in Britain: The Middle Ages. 2nd ed. Harmondsworth, Eng., 1965.
- Wieck, Roger S. Painted Prayers: The Book of Hours in Medieval and Renaissance Art. New York, 1997.
- Wood, D. ed. The Church and the Arts. Oxford, 1992.
- Zarnecki, George. The Art of the Medieval World: Architecture, Sculpture, Painting, the Sacred Arts. New York, 1975.

3. EARLY CHRISTIAN, JEWISH, AND BYZANTINE ART

Baddeley, O. and E. Brunner. *The Monastery of Saint Catherine*. London, 1996.

- Beckwith, John. *The Art of Constantinople: An Introduction to Byzantine Art, 330–1453.* 2nd ed. London, 1968.
- _____. Early Christian and Byzantine Art. 2nd ed. Harmondsworth, Eng., 1979.
- Bianchi-Bandinelli, R. Rome: The Late Empire, A.D. 200–400. New York, 1971.
- Borsook, Eve. Messages in Mosaic: The Royal Programmes of Norman Sicily. Oxford, 1990.
- Brown, Peter. Society and the Holy in Late Antiquity. London, 1982.
- Buckton, David. ed. *Byzantium: Treasures of Byzantine Art and Culture.* London, 1994.
- _____, ed. The Treasury of San Marco, Venice. Milan, 1985.
- Carr, Annemarie Weyl. *Byzantine Illumination*, 1150–1250: The Study of a Provincial Tradition. Chicago, 1987.
- Cioffarelli, Ada. Guide to the Catacombs of Rome and Its Surroundings. Rome, 2000.
- Cormack, Robin. Byzantine Art. Oxford, 2000.
- Curcic, S. and D. Mouriki, eds. *The Twilight of Byzan-tium*. Princeton, 1991.
- Cutler, Anthony. The Hand of the Master: Craftsmanship, Ivory, and Society in Byzantium (9th–11th Centuries). Princeton, 1994.
- Demus, Otto. Byzantine Art and the West. New York, 1970.
- _____. Byzantine Mosaic Decoration: Aspects of Monumental Art in Byzantium. New Rochelle, 1976.
- _____. The Church of San Marco in Venice: History, Architecture, Sculpture. Washington, D.C., 1960.
- _____. The Mosaics of Norman Sicily. London and New York, 1950.
- _____. The Mosaics of San Marco in Venice. Chicago and London, 1984.
- _____, and E. Diez. Byzantine Mosaics in Greece: Hosios Lucas and Dephni. Cambridge, Mass., 1931.
- Elsner, Jas. Art and the Roman Viewer: The Transformation of Art from the Pagan World to Christianity. Cambridge, 1995.
- _____. Imperial Rome and Christian Triumph. Oxford, 1998.
- ______, ed. Art and Text in Roman Culture. Cambridge, 1996.
- Evans, Helen C., and William D. Wixom, eds. *The Glory of Byzantium*. New York, 1997.
- Fine, Steven, ed. Sacred Realm: The Emergence of the Synagogue in the Ancient World. New York and Oxford, 1996.
- Finney, Paul Corbie. *The Invisible God: The Earliest Christians on Art.* New York and Oxford, 1994.

- Forsyth, G. H. and K. Weitzmann. *The Monastery of Saint Catherine at Mount Sinai, The Church and Fortress of Justinian*. Ann Arbor, n.d.
- Gough, Michael. Origins of Christian Art. London, 1973.
 Grabar, André. The Art of the Byzantine Empire: Byzantine Art in the Middle Ages. Trans. Betty Forster. New York, 1966.
- _____. Byzantine Painting: Historical and Critical Study.
 Trans. Stuart Gilbert. New York, 1979.
- ______. Early Christian Art: From the Rise of Christianity to the Death of Theodosius. Trans. Stuart Gilbert and James Emmons. New York, 1969.
- _____. The Golden Age of Justinian from the Death of Theodosius to the Rise of Islam. Trans. Stuart Gilbert and James Emmons. New York, 1967.
- Hussey, J. M. The Orthodox Church in the Byzantine Empire. Oxford, 1986.
- James, L. Light and Colour in Byzantine Art. Oxford, 1996
- Jenson, Robin Margaret. *Understanding Early Christian Art.* London, 2000.
- Kitzinger, Ernst. *The Art of Byzantium and the Medieval West.* Ed. W. Eugene Kleinbaurer. Bloomington, Ind., 1976
- ______. Byzantine Art in the Making: Main Lines of Stylistic Development in Mediterranean Art. 3rd–7th Century. Cambridge, Mass., 1977.
- Krautheimer, Richard. Corpus Basilicarum Christianarum Romae (The Early Christian Basilicas of Rome). 5 vols. Vatican City, 1937–1977
- _____. Three Christian Capitals: Topography and Politics. Berkeley, 1983.
- _____. Early Christian and Byzantine Architecture. 4th ed. Harmondsworth, Eng., 1986.
- _____. Rome, Profile of a City, 312-1308. Princeton, 1980.
- L'Orange, H. P. Art Forms and Civic Life in the Later Roman Empire. Princeton, 1965.
- Lowden, John. Early Christian and Byzantine Art. Art & Ideas. London, 1997.
- MacMullen, Ramsay. Christianizing the Roman Empire A.D. 100–400. New Haven, 1984.
- _____. Christianity and Paganism in the Fourth to Eighth Centuries. New Haven and London, 1997.
- Maguire, Henry. The Icons of Their Bodies: Saints and Their Images in Byzantium. Princeton, 1996.
- ______,ed. Byzantine Court Culture from 829 to 1204. Washington, D.C., 1997.
- Mainstone, R. J. Hagia Sophia: Architecture, Structure and Liturgy of Justinian's Great Church. London, 1988.
- Malbon, E. S. *The Iconography of the Sarcophagus of Junius Bassus.* Princeton, 1990.

- Manafis, K. ed. Sinai: Treasures of the Monastery of Saint Catherine. Athens, 1990.
- Mango, Cyril. Art of the Byzantine Empire, 312–1453: Sources and Documents. Upper Saddle River, N.J., 1972.
 - _____. Byzantine Architecture. New York, 1985.
- Manincelli, Fabrizio. Catacombs and Basilicas: The Early Christians in Rome. Florence, 1981.
- Mark, Robert, and Ahmet S. Cakmak. *Hagia Sophia from* the Age of Justinian to the Present. Cambridge, 1992.
- Mathew, Gervase. Byzantine Aesthetics. London, 1963.
- Mathews, Thomas F. Byzantium: From Antiquity to the Renaissance. New York, 1998.
- _____. The Clash of Gods: A Reinterpretation of Early Christian Art. Princeton, 1993, rev. ed. 1999.
- _____. The Early Churches of Constantinople: Architecture and Liturgy. University Park, Pa., 1971.
- Milburn, R. L. P. Early Christian Art and Architecture. Berkeley, 1988.
- Oxford Dictionary of Byzantium. Alexander Kazdham et al., eds. 3 vols. New York and Oxford, 1991.
- Rice, David Talbot. *Byzantine Art.* Harmondsworth, Eng., 1968.
- Rodley, Lyn. Byzantine Art and Architecture: An Introduction. Cambridge, 1993.
- Rostovtzeff, M. I. Dura-Europos and Its Art. Oxford, 1938
- Rutgers, Leonard Victor. Subterranean Rome: In Search of the Roots of Christianity in the Catacombs of the Eternal City. Leuven, 2000.
- Safran, L., ed. *Heaven on Earth: Art and the Church in Byzantium.* University Park, Pa., 1998.
- Schapiro, Meyer. Late Antique, Early Christian, and Mediaeval Art. New York, 1979.
- Simson, Otto George von. Sacred Fortress: Byzantine Art and Statecraft in Ravenna. Chicago, 1948.
- Stevenson, James. The Catacombs: Rediscovered Monuments of Early Christianity, Ancient Peoples and Places. London, 1978.
- Taft, R. F. Liturgy in Byzantium and Beyond. Aldershot, Eng., 1995.
- Tronzo, W. The Cultures of His Kingdom: Roger II and the Capella Palatina in Palermo. Princeton, 1997.
- Van Nice, R. L. St. Sophia in Istanbul: An Architectural Survey. Two instalments. Washington, D.C., 1965 and 1986.
- Weitzmann, Kurt. *The Icon: Holy Images, Sixth to Four-teenth Century.* New York, 1968; Eng. ed., New York, 1982.
- _____. The Monastery of St. Catherine at Mount Sinai, The Icons: Vol. I, From the Sixth to the Tenth Century. Princeton, 1976.

- _____, ed. *The Age of Spirituality: A Symposium.* New York, 1980.
- ______,et al. *The Age of Spirituality*. Exhibition catalogue. New York, 1978–1979.
- Wharton, Annabel Jane. Art of Empire: Painting and Architecture of the Byzantine Periphery: A Comparative Study of Four Provinces. University Park, Pa., 1988.

4. ISLAMIC ART

- Al-Faruqi, Ismail R. and Lois Lamya'al Faruqi. *Cultural Atlas of Islam.* New York, 1986.
- Atil, Esin. Art of the Arab World. Washington, D.C., 1975
- _____. Renaissance of Islam: Art of the Mamluks. Washington, D.C., 1981.
- _____, W. T. Chase, Paul Gett. *Islamic Metalwork*. Washington, D.C., 1985
- Blair, Sheila S. and Jonathan Bloom. *The Art and Architecture of Islam, 1250–1800.* New Haven, 1994.
- Brend, Barbara. Islamic Art. Cambridge, 1991
- Cresswell, K. A. C. A Short Account of Early Muslim Architecture. Rev. ed. Supp. by J. Allan. Aldershot, 1989.
- Denny, W. B. and R. Pinner, eds. Carpets of the Mediterranean Countries 1400–1600: Oriental Carpet and Textile Studies II. 1986.
- Dodds, Jerrilynn D., ed. *al-Andalus: The Art of Islamic Spain.* New York, 1992.
- Ettinghausen, Richard, and Oleg Grabar. *The Art and Architecture of Islam: 650–1250.* New Haven, 1994.
- Frishman, Martin, and Hasan-Uddin Khan. *The Mosque: History, Architectural Development and Regional Diversity.* London, 1994.
- Glasse, Cyril. *The Concise Encyclopedia of Islam.* San Francisco, 1989.
- Grabar, Oleg. The Alhambra. Cambridge, 1978.
- _____. The Formation of Islamic Art. Rev. ed. New Haven, 1987.
- _____. The Mediation of Ornament. Princeton, 1992.
- ______, Mohammad al-Asad, Abeer Audeh, and Said Nuseibeh. *The Shape of the Holy: Early Islamic Jerusalem*. Princeton, 1996.
- Hillenbrand, Robert. *Islamic Architecture: Form, Function and Meaning.* Edinburgh, 1994.
 - _____. Islamic Art and Architecture. London, 1999.
- Irwin, Robert. *Islamic Art in Context: Art, Architecture, and the Literary World.* New York, 1997.
- Khatibi, Abdelkebir, and Mohammed Sijelmassi. *The Splendour of Islamic Calligraphy.* Rev. and exp. ed. New York, 1996.
- Robinson, Francis, ed. *The Cambridge Illustrated History of the Islamic World*. Cambridge, 1996.

- Ruggles, D. F. Gardens, Landscape, and Visions in the Palaces of Islamic Spain. University Park, Pa., 2000.
- Safwat, N. Art of the Pen: Calligraphy of 14th to 20th Centuries. Oxford, 1995.
- Schimmel, Annemarie. Calligraphy and Islamic Culture. New York, 1983.
- Ward, R. M. Islamic Metalwork. New York, 1993.
- Welch, Anthony. Calligraphy in the Arts of the Muslim World. Austin, Tex., 1979.

5. EARLY MEDIEVAL ART IN EUROPE

- Backhouse, Janet. *The Lindisfarne Gospels*. Oxford, 1981.
 ______, D. H. Turner, and Leslie Webster, eds. *The Golden Age of Anglo-Saxon Art*, 966–1066. London, 1984.
- Beckwith, John. Early Medieval Art: Carolingian, Ottonian, Romanesque. New York, 1974.
- Carver, Martin O. H. ed. *The Age of Sutton Hoo: The Seventh-Century in North-Western Europe.* Woodbridge, 1992.
- Carver, Martin O. H. Sutton Hoo: Burial Ground of Kings? Philadelphia, 1998.
- Diebold, William J. Word and Image: An Introduction to Early Medieval Art. Boulder, 2000.
- Dodds, Jerrilynn D. Architecture and Ideology in Early Medieval Spain. University Park, Pa., 1990.
- Dutton, P., and H. Kessler. *The Poetry and Paintings of the First Bible of Charles the Bald.* Ann Arbor, 1997.
- Evans, Angela Care. *The Sutton Hoo Ship Burial*. Rev. ed. London, 1994.
- Farkas, Ann. From the Lands of the Scythians. New York, 1975.
- Farr, Carol. *The Book of Kells: Its Function and Audience*. London, 1997.
- Fernie, E. C. The Architecture of the Anglo-Saxons. London, 1983.
- Fitzhugh, William W., and Elisabeth I. Ward, eds. Vikings: The North Atlantic Saga. Washington, D.C., 2000.
- Fletcher, R. *The Barbarian Conversion from Paganism to Christianity.* New York, 1997.
- The Gauls: Celtic Antiquities from France. London, n.d.
- Graham-Campbell, James, and Dafydd Kidd. *The Vikings*. London and New York, 1980.
- Harbison, Peter. The Golden Age of Irish Art: The Medieval Achievement, 600–1200. London, 1998.
- Harting, H. M. Ottonian Book Illumination. London, 1991.
- Henderson, George. From Durrow to Kells: The Insular Gospel-Books, 650–800. London, 1987.

- Henderson, George. Vision and Images in Early Christian England. Cambridge, 1999
- Hohler, E. Bergendahl. Norwegian Stave Church Sculpture. 2 vols. Oslo, 1999.
- Horn, Walter W., and Ernest Born. Plan of Saint Gall: A Study of the Architecture and Economy of and Life in a Paradigmatic Carolingian Monastery. 3 vols. Berkeley, 1979.
- Hubert, Jean, Jean Porcher, and W. F. Volbach. *Carolingian Renaissance*. New York, 1970.
- Hubert, Jean, Jean Porcher, and W. F. Volbach. Europe of the Invasions. Trans. Stuart Gilbert and James Emmons. New York, 1969.
- Jope, E. M. and P. Jacobsthal. *Early Celtic Art in the British Isles*. 2 vols. Oxford, 1984.
- Kent, J. P. C. and K. S. Painter. Wealth of the Roman World: A.D. 300–700. London, 1977.
- Laing, Lloyd. Art of the Celts. New York, 1992.
- Mayr-Harting, Henry. Ottonian Book Illumination: An Historical Study. 2 vols. 2nd rev. ed. London, 1999.
- Megaw, Ruth, and Vincent Megaw. Celtic Art: From Its Beginnings to the Book of Kells. New York, 1989.
- Mentre, Mireille. *Illuminated Manuscripts of Medieval Spain*. New York, 1996.
- Mutherich, Florentine, and Joachim E. Gaehde. *Carolingian Painting*. New York, 1976.
- Nees, Lawrence. Early Medieval Art. Oxford, 2003.
- ______, ed. Approaches to Early-Medieval Art. Cambridge, Mass., 1998 (first appeared in Speculum 72, 1997).
- Neuman de Vegvar, C. The Northumbrian Renaissance: A Study in the Transmission of Style. Selinsgrove, Pa., 1987.
- Nordenfalk, Carl. Early Medieval Book Illumination. New York, 1988.
- Palol, Pedro de, and Max Hirmer. *Early Medieval Art in Spain*. Trans. Alisa Jaffa. London, 1967.
- Pohl, Walter, ed. Kingdoms of the Empire: The Integration of Barbarians in Late Antiquity. Leiden, 1997.
- Price, L. The Plan of St. Gall in Brief. Berkeley, 1982.
- Richardson, Hilary, and John Scarry. An Introduction to Irish High Crosses. Dublin, 1990.
- Tschan, Francis Joseph. Saint Bernward of Hildesdeim. 3 vols. South Bend, Ind., 1942–1952.
- Van der Horst, K., W. Noel, and W. Wustefeld, eds. *The Utrecht Psalter in Medieval Art: Picturing the Psalms of David.* London, 1996.
- Webster, L., and J. Backhouse, eds. *The Making of England: Anglo-Saxon Art and Culture, AD 600–900.* Toronto, 1991.
- Williams, John. The Illustrated Beatus. London, 1994.

- Wilson, David M. Anglo-Saxon Art: From the Seventh Century to the Norman Conquest. London, 1984.
- _____ and Ole Klindt-Jensen. *Viking Art.* 2nd ed. Minneapolis, 1980.
- Wolfram, H. The Roman Empire and Its Germanic Peoples. Berkeley, 1997.
- Youngs, S., ed. "The Work of Angels": Masterpieces of Celtic Metalwork, Sixth-Ninth Centuries A.D. London, 1989.

6. ROMANESQUE ART

- Armi, C. Edson. Masons and Sculptors in Romanesque Burgundy: The New Aesthetics of Cluny III. 2 vols. University Park, Pa., 1983.
- Barral i Altet, Xavier. *The Romanesque: Towns, Cathedrals and Monasteries.* New York, 1998.
- Braunfels, Wolfgang. *Monestaries of Western Europe: The Architecture of the Orders.* Trans. Alastair Laing. New York, 1993.
- Brooke, Christopher, Richard Gem, George Zarnecki, et al. *English Romanesque Art*, 1066–1200. London, 1984.
- Brown, S. A. *The Bayeux Tapestry: History and Bibliogra*phy. Woodbridge, N.J., 1998.
- Cahn, Walter. Romanesque Bible Illumination. Ithaca, N.Y., 1982.
- _____. Romanesque Manuscripts: The Twelfth Century. 2 vols. London, 1996.
- _____. Romanesque Sculpture in American Collections, vol. 1. New York, 1979.
- Collon-Gevaert, Suzanne, Jean Lejeune, and Jacques Stiennon. A Treasury of Romanesque Art: Metalwork, Illuminations and Sculpture from the Valley of the Meuse. London, 1972.
- Conant, Kenneth John. *Cluny: Les églises et la maison du chef d'ordre*. Cambridge, Mass., and Mâcon, France, 1968.
- Conant, Kenneth John. The Early Architectural History of the Cathedral of Santiago de Compostella. Cambridge, Mass., 1926. Gallegan edition, with introduction by Serafin Moralejo Alvarez. Arquitectura Romanica da cathedral de Santiago de Compostela. Santiago de Compostela, Spain, 1983.
- Demus, Otto. Romanesque Mural Painting. New York, 1970.
- Evans, Joan. Cluniac Art of the Romanesque Period. Cambridge, 1950.
- _____. The Romanesque Architecture of the Order of Cluny. Cambridge, 1938.
- Fergusson, Peter. Architecture of Solitude: Cistercian Abbeys in Twelfth-Century Europe. Princeton, 1984.

- Focillon, Henri. *The Art of the West in the Middle Ages.* 2 vols. Ed. Jean Bony. Trans. Donald King. London, 1963.
- Folda, J. The Art of the Crusaders in the Holy Land, 1098–1187. Cambridge, 1995.
- Forsyth, Ilene H. The Throne of Wisdom: Wood Sculptures of the Madonna in Romanesque France. Princeton, 1972.
- Grape, Wolfgang. The Bayeux Tapestry: Monument to a Norman Triumph. New York, 1994.
- Grivot, Denis, and George Zarnecki. *Gislebertus, Sculptor of Autun*. Paris, 1960; English ed. New York, 1961.
- Hearn, M. F. Romanesque Sculpture: The Revival of Monumental Stone Sculptures in the Eleventh and Twelfth Centuries. Ithaca, N.Y., 1981.
- Jacobs, Michael. Northern Spain: The Road to Santiago de Compostela. San Francisco, 1991.
- Katzenellenbogen, Adolf. Allegories of the Virtues and Vices in Mediaeval Art. New York, 1939, 1964.
- Kennedy, Hugh. Crusader Castles. Cambridge, 1994.
- Kubach, Hans Erich. *Romanesque Architecture*. New York, 1988.
- Kuhnel, Blana. Crusader Art of the Twelfth Century: A Geographical and Historical, or an Art Historical Notion? Berlin, 1994.
- Lasko, P. Ars Sacra. London, 1972-1994.
- Little, Bryan D. G. Architecture in Norman Britain. London, 1985.
- Mâle, Émile. Religious Art in France, the Twelfth Century. A Study of the Origins of Medieval Iconography. Ed. H. Bober, Princeton, 1984.
- Norton, Christopher, and David Park. *Cistercian Art and Architecture in the British Isles*. Cambridge, 1986.
- O'Neill, John Philip, ed. *Enamels of Limoges*, 1100–1350. Trans. Sophie Hawkes, Joachim Neugroschel, and Patricia Stirneman. New York, 1996.
- Petzold, Andreas. Romanesque Art. New York, 1995.
- Porter, Arthur Kingsley. *Romanesque Sculpture of the Pil-grimage Roads*. 10 vols. Boston, 1923 (Hacker reprint in three volumes).
- Schapiro, Meyer. Romanesque Art. New York, 1977.
- _____. The Romanesque Sculpture of Moissac. New York, 1985.
- Scher, Stephen. *The Renaissance of the Twelfth Century.* Providence, 1969.
- Shaver-Crandell, Annie, Paula Gerson, and Allison Stones. *The Pilgrim's Guide to Santiago de Compostela*. London, 1995.
- Stokstad, Marilyn. Santiago de Compostela in the Age of the Great Pilgrimages. Norman, Okla., 1978.

- Stones, Allison, and Jeanne Krochalis, Paula Gerson, and Annie Shaver-Crandell. *The Pilgrim's Guide: A Critical Edition*. London, 1998.
- Swarzenski, Hanns. Monuments of Romanesque Art: The Art of Church Treasures of North-Western Europe. 2nd ed. Chicago, 1967.
- Tate, Robert Brian, and Marcus Tate. *The Pilgrim Route to Santiago*. Oxford, 1987.
- Toy, S. Castles: Their Construction and History. New York, 1985.
- Voelkle, William. The Stavelot Triptyche: Mosan Art and the Legend of the True Cross. New York, 1980.
- Whitehill, Walter M. Spanish Romanesque Architecture of the Eleventh Century. Oxford, 1941; reprinted, 1968.
- Wilson, David M. *The Bayeux Tapestry: The Complete Tapestry in Color.* New York, 1985.
- Zarnecki, George. Romanesque Art. New York, 1971
- _____, Janet Holt, and Tristam Hollard. *English Romanesque Art, 1066–1200.* London, 1984.

7. GOTHIC AND LATE GOTHIC ART

- Alexander, J. J. G., and Paul Binski, eds. Age of Chivalry:

 Art in Plantagenet England, 1200–1400. London, 1987.
- Andrews, Francis B. *The Mediaeval Builder and His Methods*. New York, 1993.
- Armi, C. Edson. The "Headmaster" of Chartres and the Origins of "Gothic" Sculpture. University Park, Pa., 1994.
- Avril, François. Manuscript Painting at the Court of France: The Fourteenth Century (1310–1380). New York, 1978.
- Baxandall, Michael. *The Limewood Sculptors of Renaissance Germany*. New Haven and London, 1980.
- Bony, Jean. The English Decorated Style: Gothic Architecture Transformed, 1250–1350. Oxford, 1979.
- _____. French Gothic Architecture of the 12th and 13th Centuries. Berkeley, 1983.
- Branner, Robert. Manuscript Paintings in Paris During the Reign of Saint Louis: A Study of Styles. Berkeley, 1977.
- _____. St. Louis and the Court Style in Gothic Architecture. London, 1965.
- Bruzelius, Caroline A. *The Thirteenth-Century Church at St.-Denis*. New Haven and London, 1986.
- Calmette, J. The Golden Age of Burgundy: The Magnificent Dukes and Their Courts. New York, 1963.
- Camille, Michael. Gothic Art: Glorious Visions. New York, 1996.
- Cavallo, Adolph S. *The Unicorn Tapestries at the Metro*politan Museum of Art. New York, 1998.

- Chiellini, Monica. *Cimabue*. Trans. Lisa Pelletti. Florence, 1988.
- Coe, Brian. Stained Glass in England, 1150-1550. London, 1981.
- Cole, Bruce. Giotto and Florentine Painting, 1280–1375.New York, 1975.
- Crosby, Sumner McKnight. The Royal Abbey of Saint-Denis from Its Beginnings to the Death of Suger, 475–1151. New Haven, 1987.
- _____, Jane Hayward, Charles Little, and William Wixom. *The Royal Abbey of Saint-Denis in the Time of Abbot Suger (1122–1151)*. New York, 1981.
- Derbes, A. Picturing the Passion in Late Medieval Italy: Narrative Painting, Franciscan Ideologies, and the Levant. Cambridge, 1996.
- Donovan, C. The Winchester Bible. London, 1993.
- Erlande-Brandenburg, Alain. *Gothic Art.* Trans. I. Mark Paris. New York, 1989.
- _____. Notre-Dame de Paris. New York, 1998.
- Favier, Jean. *The World of Chartres*. Trans. Francisca Garvie. New York, 1990.
- Frankl, P. Gothic Architecture. New ed. P. Crossley. New Haven and London, 2001
- Frankl, Paul. The Gothic Literary Sources and Interpretations Through Eight Centuries. Princeton, 1960.
- Frisch, Teresa G. Gothic Art, 1140-c.1450: Sources and Documents. Upper Saddle River, N.J., 1971.
- Gerson, P., ed. Abbot Suger and Saint-Denis. New York, 1986.
- Gomez-Moreno, Carmen. Sculpture from Notre-Dame, Paris: A Dramatic Discovery. New York, 1979.
- Gordon, D., L. Monnas, and E. Elam, eds. *The Regal Image of Richard II and the Wilton Diptych.* London, 1998.
- Grant, L. Abbot Suger of St.-Denis: Church and State in Twelfth-Century France, London, 1998.
- Green, R., M. Evans, and C. Bischoff. *Herrad von Landsberg, Abbess of Hohenbourg.* London, 1976.
- Grodecki, Louis. Gothic Architecture. Trans. I. Mark Paris. New York, 1985.
- _____ and Catherine Brisac. Gothic Stained Glass, 1200–1300. Ithaca, N.Y., 1985.
- Hahnloser, H. R. Villard de Honnecourt. Graz, 1972.
- Hartt, Frederick, revised by David Wilkins. *History of Italian Renaissance Art.* New York, 2002.
- Harvey, J. The Cathedrals of Spain. London, 1957.
- _____. The Perpendicular Style, 1330–1485. London, 1978.
- Hayward, Jane, and Walter Cahn. Radiance and Reflection: Medieval Art from the Raymond Pitcairn Collection. New York, 1982.

- Henderson, George. Chartres. London, 1968.
- _____. *Gothic: Style and Civilization.* Hamondsworth, England, 1967.
- Heydenreich, L. Architecture in Italy, 1400–1500. rev. ed. P. Davies. Hamondsworth, England, 1996.
- Heyman, J. The Stone Skeleton: Structural Engineering of Masonry Architecture. Cambridge, 1995.
- Hoffman, K., ed. *The Year 1200*. 2 vols. New York, 1970.
 ______, ed. *The Year 1200*. New York, 1970. Symposium, 1973.
- Husband, Timothy, and Jane Hayward. *The Secular Spirit: Life and Art at the End of the Middle Ages.* New York, 1975.
- Lane, Barbara G. *The Altar and the Altarpiece*. New York, 1985.
- Mâle, Émile. Religious Art in France: The Late Middle Ages: A Study of Medieval Inconography and Its Sources. Ed. H. Bober. Princeton, 1984.
- Meiss, Millard. French Painting in the Time of Jean de Berry: The Late Fourteenth Century and the Patronage of the Duke. London, 1967.
- _____. French Painting in the Time of Jean de Berry: The Limbourgs and Their Contemporaries. 2 vols. New York, 1975.
- _____. Painting in Florence and Siena After the Black Death. Princeton, 1951.
- Meulen, J. van der, R. Hoyer, and D. Cole. *Chartres:* Sources and Literary Interpretations: A Critical Bibliography. Boston, 1989.
- Morgan, Nigel J. Early Gothic Illuminated Manuscripts. 2 vols. Oxford, 1988.
- Murray, S. Building Troyes Cathedral. Bloomington, 1987.
- Neagley, L. Disciplined Exuberance: The Parish Church of Saint-Maclou and Late Gothic Architecture in Rouen. University Park, Pa., 1998.
- Nussbaum, N. German Gothic Church Architecture. New Haven and London, 2000.
- Opus Anglicanum: English Medieval Embroidery. London, 1963.
- Panofsky, Erwin. *Gothic Architecture and Scholasticism*. Latrobe, Pa., 1951.
- _____, trans. and ed. Abbot Suger on the Abbey Church of St. Denis and Its Art Treasures. 1946. 2nd ed. Ed. Gerda Panofsky-Soergel. Princeton, 1979.
- Platt, C. *The Architecture of Medieval Britain*. New Haven and London, 1990.
- Plummer, John. *The Last Flowering French Painting in Manuscripts*, 1420–1530. New York, 1982.
- Pope Hennessy, John. *Italian Gothic Sculpture*. 1955. 3rd ed. Oxford, 1986.

- Prache, A. Cathedrals of Europe. Ithaca, N.Y., 2000
- Raguin, V., K. Brush, and P. Draper, eds. *Artistic Integration in Gothic Buildings*. Toronto, Buffalo, London, 1995.
- Randall, Lilian. *Images in the Margins of Gothic: Manuscripts.* Berkeley, 1966.
- Randall, Richard H., Jr. The Golden Age of Ivory: Gothic Carvings in North American Collections. New York, 1993.
- _____. Ivories. Exhibition catalogue. Baltimore, 1986.
- Rudolph, C. Artistic Change at St-Denis: Abbot Suger's Program and the Early Twelfth-Century Controversy over Art. Princeton, 1990.
- Sandler, Lucy Freeman. *Gothic Manuscripts* 1285–1385. 2 vols. London, 1986.
- Sauerlander, Willibald. *Gothic Sculpture in France*, 1140–1270. Trans. Janet Sandheimer. London, 1972.
- Scher, Steven. *Transformation of the Court Style: Gothic Art in Europe 1270–1330.* Providence, 1977.
- Scott, Kathleen L. Later Gothic Manuscripts, 1390–1490. 2 vols. A Survey of Manuscripts Illuminated in the British Isles, 6. London, 1996.
- Simson, Otto Georg von. The Gothic Cathedral: Origins of Gothic Architecture and the Medieval Concept of Order. 3rd ed. Princeton, 1988.
- Smart, Alastair. The Dawn of Italian Painting, 1250–1400. Ithaca, 1978.
- Souchal, Genevieve. *Masterpieces of Tapestry from the fourteenth to the Sixteenth Century*. New York and Paris, 1973.
- Street, G. E. Some Account of Gothic Architecture in Spain. Ed. G. G. King. 2 vols. London, 1914.
- Stubblebine, James. Assisi and the Rise of Vernacular Art. New York, 1985.
- _____. Giotto: The Arena Chapel Frescoes. New York, 1969.
- Swaan, W. The Late Middle Ages: Art and Architecture from 1350 to the Advent of the Renaissance. London, 1977.
- Toman, R. ed. *The Art of Gothic*. Eng. trans. Cologne, 1998.
- Verdier, Philippo and P. Brieger, eds. Art and the Courts France and England from 1259 to 1328. 2 vols. Ottawa, 1972.
- White, John. Art and Architecture in Italy, 1250 to 1400. 3rd ed. Harmondsworth, Eng., 1993.
- _____. Duccio: Tuscan Art and the Medieval Workshop. New York, 1979.
- Wieck, Roger S. Time Sanctified: The Book of Hours in Medieval Art and Life. New York, 1988.

Williamson, Paul. Gothic Sculpture, 1140-1300. New Haven, 1995.

Wilson, Christopher. The Gothic Cathedral: The Architecture of the Great Church, 1130–1530. New York, 1990.

8. ART HISTORY JOURNALS WITH ARTICLES ON MEDIEVAL ART IN ENGLISH

Art Bulletin. The journal of the College Art Association Gesta. The journal of the International Center of Medieval Art, The Cloisters, New York. Journal of the Society of Architectural Historians.

Medieval Feminist Forum (formerly Medieval Feminist Newsletter). Publication of the Society for Medieval Feminist Scholarship

Ars Islamica, and Muqarnas. Journals devoted to Islamic Art.

Museums with notable collections of medieval art, such as the Metropolitan Museum of Art and the Cloisters (New York), the Cleveland Museum of Art, and the Walters Gallery (Baltimore) publish articles on works of art in their own collections.

PHOTO CREDITS

PREFACE

Maps: © Meridian Mapping, Philip Schwartzberg

CHAPTER I

- **1.1** Stavelot Triptych: © The Pierpont Morgan Library, New York. AZ 001
- **1.2** Stavelot Triptych: © The Pierpont Morgan Library, New York. AZ 001
- 1.3 Ivory with depiction of the mass: ©
 Stadt und Universitatsbibliothek
- **1.4** Arch of Titus: © Archivi Alinari, Florence
- **1.5** Arch of Constantine: © Archivi Alinari, Florence
- **1.6** Portrait of Constantine: © The Metropolitan Museum of Art, NY, bequest of Mary Clark Thompson
- 1.7 Missorium of Theodosius:

 Academy of History, Madrid. Photo: Deutsches Archeologisches Institut Rom.

CHAPTER 2

- **2.1** Mausoleum of Galla Placidia, Ravenna, Italy: © Scala / Art Resource, NY
- 2.2 Museum of the Diasporah, Tel Aviv, Israel: © Erich Lessing / Art Resource, NY
- 2.3 The Good Shepherd, baptistery in the Christian House: drawing by Henry Pearson: © The Dura-Europos Collection, Yale University Art Gallery, New Haven
- **2.4** Rome, Jewish catacomb: © Garielle Sed-Rajna
- 2.5 Rome, Catacomb of Priscilla, view of Crypt of the Veiled Lady: © foto Pontificia Commissione di Archeologia Sacra
- **2.6** Rome, Catacomb of Priscilla, Hebrew Children: © Hirmer Fotoarchiv
- **2.7** Rome, Catacomb of Priscilla, Mary and Jesus: © Hirmer Fotoarchiv
- 2.8 Jonah sculpture: © The Cleveland Museum of Art, purchase from the John L. Severance Fund
- 2.9 Tomb of Julii: © Fabbrica di S. Pietro in Vaticano
- **2.10** Sarcophagus of Junius Bassus: © Hirmer Fotoarchiv
- 2.11 Passion Sarcophagus: © Rolf Achilles
- **2.12** Santa Sabina, exterior of apse: © Bayerische Staatsbibliothek München
- **2.13** Santa Sabina, interior of nave: © Art Resource, NY
- **2.14** Santa Sabina, plan: © drawing by Leland M. Roth

- **2.15** Fresco, interior of San Giovanni in Laterano: © Scala / Art Resource, NY
- 2.16 Santa Agnese/Santa Costanza complex, plan: © drawing by Leland M. Roth
- **2.17** Santa Costanza, interior: © Bildarchiv Foto Marburg
- **2.18** Santa Costanza, mosaic: © Bildarchiv Foto Marburg
- **2.19** Church of the Holy Seplchre, Conjectural plan: © Kenneth J. Conant
- **2.20** San Martino ai Monti, interior: © Scala / Art Resource, NY
- 2.21 Holy Women at the Tomb of the Ascension: © Bayerische Staatsbibliothek München
- **2.22** St. Peter's Cathedral, plan: © after Dehio
- **2.23** St. Peter's Cathedral, drawing of the exterior: © Kenneth J. Conant
- exterior: © Kenneth J. Conant 2.24 Church of St. Paul, interior: © Blum
- **2.25** The Crucifixion and the suicide of Judas: © The British Museum, London. Museum photo
- **2.26** Santa Maria Maggiore, nave: © after Dehio
- **2.27** Santa Maria Maggiore, nave mosaic: © Alinari / Art Resource, NY
- 2.28 Santa Maria Maggiore, triumphal arch mosaic: © Alinari / Art Resource, NY
- 2.29 Mausoleum of Galla Placidia, exterior, Ravenna, Italy: © Courtesy of R.G. Calkins
- 2.30 Mausoleum of Galla Placidia, interior, Ravenna, Italy: © Scala / Art Resource, NY
- 2.31 Mausoleum of Galla Placidia, main vaults, Ravenna, Italy: © Alinari / Art Resource, NY
- **2.32** Baptistery of the Orthodox, Ravenna: © Hirmer Fotoarchiv
- **2.33** Baptistery of the Orthodox, dome, Ravenna: © Rolf Achilles
- 2.34 Christ in Glory, Hosios David, Thessalonika, Greece: © Hirmer Fotoarchiv

- 3.1 Hagia Sophia, exterior, Istanbul: © Turkoglu
- 3.2 Land Walls of Constantinople: © Josephine Powell photograph, courtesy of Historic Photographs, Fine Arts Library, Harvard College Library
- **3.3** Court of Justinian, S. Vitale, Ravenna, Italy: © Scala / Art Resource, NY
- 3.4 Hagia Sophia, interior: © Wim Swaan

- **3.5** Hagia Sophia, plan: © after drawings by Van Nice and Antoniades
- **3.6** Diagram of pendentives: © drawing by Leland M. Roth
- **3.7** Hagia Sophia, interior of dome: © Courtesy of Dumbarton Oaks, Center for Byzantine Studies, Washington, D.C.
- **3.8** Hagia Sophia, interior: © Courtesy of Dumbarton Oaks, Center for Byzantine Studies, Washington, D.C.
- **3.9** Church of St. Mark, Venice, plan: © after Dehio
- **3.10** Church of Sant' Apollinare in Classe: © Foto Cielo, Rome
- **3.11** Church of Sant' Apollinare, nave: © Archivi Alinari, Florence
- **3.12** Church of S. Vitale, Ravenna, interior: © Bildarchiv Foto Marburg
- **3.13** Church of S. Vitale, Ravenna, plan: © after Dehio
- **3.14** Church of S. Vitale, Ravenna, exterior: © Marilyn Stokstad
- **3.15** S. Vitale, detail of Theodora's court mosaic: © Scala / Art Resource, NY
- **3.16** The Three Marys at the Tomb, Church of Sant' Apollinaire: © Scala / Art Resource, NY
- **3.17** S. Vitale, interior toward apse: © Scala / Art Resource, NY
- **3.18** The Court of Empress Theodora, S. Vitale: © Scala / Art Resource, NY
- 3.19 Apse mosaic of Sant' Appollinaire: © Church of Sant' Appollinaire: © Scala / Art Resource, NY
- 3.20 Mosaic, Monastery Church of St. Catherine, Mount Sinai: ⊚ reproduced through the courtesy of the Michigan-Princeton-Alexandria Expedition to Mount Sinai
- **3.21** Beth Alpha synagogue, plan: © Gabrielle Sed-Rajna
- **3.22** The Sacrifice of Isaac, Beth Alpha synagogue: © Gabrielle Sed-Rajna
- **3.23** Ivory diptych of St. Michael: © The British Museum, London. Museum photo
- 3.24 Justinian ivory: © The Louvre, Paris.
- **3.25** Dioscurides, *Materia Medica*, Constantinople: © Lichtbildwerkstatte, Alpenland
- **3.26** Rebecca at the well, Vienna Genesis, Constantinople: © Lichtbildwerkstatte, Alpenland
- **3.27** Ascension of Christ, from the Rabula Gospels: © Scala / Art Resource, NY
- 3.28 Crucifixion and The Women at the Tomb, from the Rabula Gospels: © Scala / Art Resource, NY

3.29 Icon of the Virgin and Child with saints and angels, Monastery of St.
Catherine, Mount Sinai: ⊚ reproduced through the courtesy of the Michigan-Princeton-Alexandria Expedition to Mount Sinai

CHAPTER 4

- 4.1 Celtic Sword: © The Metropolitan Museum of Art, Rogers Fund, 1999. (1999.94) Photograph © 1999 The Metropolitan Museum of Art, NY
- **4.2** Holcombe Mirror, illustration: © drawing by Philip Compton
- 4.3 Scythian birdman: © Institute of Archeology, National Ukrainian Academy of Sciences, Kiev
- **4.4** Vendel mount: © Antikvarisktopografiska Arkivet.
- **4.5** Bow fibula: © The Metropolitan Museum of Art, Fletcher Fund, 1947 (47.100.19) Photograph © The Metropolitan Museum of Art, NY
- **4.6** Eagle brooches: © Walters Art Museum, Baltimore
- **4.7** Votive crown of Recceswinth: © Archivio Fotográfico, Museo Arqueológico Nacional, Madrid
- **4.8** Gospel book cover of Theodolina: © Art Resource, Museo del Duomo, Monza
- 4.9 Santa Maria-in-Valle, Cividale: © Conway Library, Courtauld Institute of Art, London
- **4.10** Burgundian buckle: © Walters Art Museum, Baltimore
- **4.11** Medallion with bust of Christ: © The Cleveland Museum of Art, purchase from the J. H. Wade Fund. Museum photo
- **4.12** Crypt of St. Paul, Abbey of Notre-Dame de Joaurre: © Erich Lessing / Art Resource, NY
- **4.13** Sacramentary of Gelasius, France: © Bildarchiv Foto Marburg
- **4.14** Gummersmark brooch: © Lennart Larsen, Nationalmuseet, Copenhagen
- 4.15 Vendel hawk: © The Metropolitan Museum of Art, Rogers Fund, 1991.Photograph © 1991 The Metropolitan Museum of Art, NY
- **4.16** Osenberg Ship: © University of Oslo, University Museum of Cultural Heritage
- **4.17** Osenberg Ship, prow: © University of Oslo, University Museum of Cultural Heritage
- **4.18** Sutton Hoo clasps: © The British Museum, London. Museum photo
- **4.19** Sutton Hoo buckle: © The British Museum, London. Museum photo

- **4.20** Cathac of St. Columba: © Royal Irish Academy, Dublin
- 4.21 Weyland the Smith and the Adoration of the Magi, the Franks Casket: © The British Museum, London. Museum photo
- **4.22** Cross of Muiredach, Monasterboice, Ireland: © Mary Ann Sutherland
- 4.23 Papil Stone: © Papil Burra (Shetland)
- **4.24** Book of Durrow, lion (MS 57, fol. 191v): © The Board of Trinity College Dublin
- 4.25 Book of Durrow, man (MS 57, fol. 21v): © The Board of Trinity College Dublin
- **4.26** Ardagh Chalice: © National Museum of Ireland, Dublin
- 4.27 Lindesfarne Gospel, St. Matthew, manuscript illumination: © by permission of the British Library
- 4.28 Codex Amiatinus, manuscript illumination: © Firenze, Biblioteeca Medicea Laureziana, ms. Amiatino 1, c. Vr. Su concessione del Ministero per I Beni Culturali e le Attività Culturali
- **4.29** Lindesfarne Gospel, St. Matthew, carpet page (MS Nero D. iv, fol. 26v.): © by permission of the British Library
- 4.30 Book of Kells, monogram of Christ (MS 58, fol. 7v): © The Board of Trinity College Dublin
- 4.31 Book of Kells, Virgin and Child (MS 58, fol. 34r): © The Board of Trinity College Dublin

CHAPTER 5

- 5.1 Aachen, Palatine chapel, interior: © Institut Royal du Patrimoine Artistique, Brussels
- 5.2 Aachen, palace and chapel, model of complex: © model: Leo Hugot, photo: Robert G. Calkins
- **5.3** Aachen, city and chapel, plan: © Leo Hugot
- 5.4 Fulda, plan: © after Lehmann
- **5.5** Centula Abbey: © Giraudon / Art Resource, NY
- **5.6** St. Gall, plan: © Monastery Library of St. Gall, Switzerland
- **5.7** St. Gall, model: © Model by Walter Horn
- **5.8** Crypt at St. Germain, Auxerre, The Stoning of St. Stephen: © Johnson/Blum
- 5.9 Godescalc Gospels, Christ Enthroned:
 © Cliché Bibliothèque nationale de France, Paris
- 5.10 Godescalc Gospels, Fountain of Life:
 © Cliché Bibliothèque nationale de France, Paris

- **5.11** Ada Gospels, St. Mark: © D. Thomassin
- **5.12** Coronation Gospels, St. John: © Kunsthistorisches Meseum, Vienna
- 5.13 Lorsch Gospels, Virgin and Child with Zacharias and John the Baptist: © courtesy of the Board of Trustees, the Victoria and Albert Museum, London
- **5.14** Ebbo Gospels, St. Mark: © Giraudon / Art Resource, NY
- **5.15** Utrecht Psalter, Psalm 88: © University Library, Utrecht
- **5.16** Pericopes of Henry II, Crucifixion: © Bayerische Staatsbibliothek München
- 5.17 Drogo Sacramentary, letter C: © Cliché Bibliothèque nationale de France, Paris
- 5.18 Drogo Sacramentary, Te Igitur: © Cliché Bibliothèque nationale de France, Paris
- **5.19** Grandval Bible, Scenes from Genesis: © by permission of the British Library
- 5.20 First Bible of Charles the Bald, Charles: © Cliché Bibliothèque nationale de France, Paris
- 5.21 First Bible of Charles the Bald, David: © Cliché Bibliothèque nationale de France, Paris
- 5.22 Codex Aureus, Adoration of the Lamb of God:

 Bayerische Staatsbibliothek, München
- 5.23 Lindau Gospels, cover, Christ on the Cross: © The Pierpont Morgan Library, New York. MS M.1.

- **6.1** Hagia Sophia, lunette, Emperor Leo VI kneeling before Christ, Art Resource, NY
- **6.2** Hagia Sophia, interior: © Erich Lessing / Art Resource, NY
- **6.3** Hagia Sophia, apse mosaic: © courtesy of Dumbarton Oaks, Center for Byzantine Studies, Washington, D.C.
- **6.4** Joshua Roll, Joshua with the Angel: © courtesy of the Vatican Library
- **6.5** Paris Psalter, David the Harpist: © Foto Marburg / Art Resource, NY
- **6.6** Virgin and Child, ivory statuette: © courtesy of the Board of Trustees, the Victoria and Albert Museum, London
- 6.7 Processional cross: © The Metropolitan Museum of Art, Rodgers Fund, 1993. (1993.163) Photograph © 1993 The Metropolitan Museum of Art, NY
- 6.8 Textile, Monastery of Santa Maria de l'Estay: © Cooper-Hewitt, National Design Museum, Smithsonian Institution, Washington, D.C.

- **6.9** Diagram of Byzantine church types: © drawing by Leland M. Roth
- 6.10 Hosios Loukas, vaults: © Josephine Powell photograph, courtesy of Historic Photographs, Fine Arts Library, Harvard College Library, Cambridge, MA
- 6.11 Hosios Loukas, plan
- 6.12 Hosios Loukas, interior: © Photograph © 1997 The Metropolitan Museum of Art, NY. Photograph by Bruce White
- **6.13** Hosios Loukas, exterior: © American School of Classical Studies, Athens
- **6.14** Daphni, dome mosaic, Christ the Almighty: © courtesy of Dumbarton Oaks, Center for Byzantine Studies, Washington, D.C.
- **6.15** Daphni, mosaic, The Crucifixion: © courtesy of Dumbarton Oaks, Center for Byzantine Studies, Washington, D.C.
- 6.16 Kiev, Hagia Sophia, interior: © Photograph © 1997 The Metropolitan Museum of Art, NY. Photograph by Bruce White
- 6.17 Kiev, Hagia Sophia, plan
- **6.18** Vladimir Mother of God: © Tretyakov Gallery, Moscow
- **6.19** San Marco, Venice, interior: © Cameraphoto Arte, Venice
- **6.20** Great Mosque, Cordoba, interior: © Bildarchiv Foto Marburg
- 6.21 Great Mosque, Cordoba, bays in front of mihrab:

 Bildarchiv Foto Marburg
- **6.22** Rabat, Gate: © Josephine Powell photograph, courtesy of Historic Photographs, Fine Arts Library, Harvard College Library, Cambridge, MA
- **6.23** Cappella Palatine, Palermo, ceiling of nave: © Archivi Alinari, Firenze
- **6.24** Calligraphy, Kufic script: © The Nelson-Atkins Museum of Art, Kansas City
- 6.25 Lidded Bowl: © The Metropolitan Museum of Art, NY, Lila Acheson Wallase Gift, Harvey and Elizabeth Plontick Gift, and Louis E. and Theresa S. Seley Purchase Fund of Islamic Art
- **6.26** Ewer, metal inlay: © Freer Gallery of Art
- 6.27 Cefalù, apse mosaic, Christ the Lord: © courtesy of Dumbarton Oaks, Center for Byzantine Studies, Washington, D.C.
- **6.28** Cappella Palatina, Palermo, interior view to the west: © Archivi Alinari, Firenze
- **6.29** Cappella Palatina, Palermo, plan: © after Serradifalco

- **6.30** Cappella Palatina, Palermo, mosaic: © Chester Brummel
- **6.31** Norman Palace, Palermo: © Scala / Art Resource, NY

- 7.1 Gospels of Otto III, Otto III seated in majesty: © Bayerische Staatsbibliothek München
- **7.2** Map: © Meridian Mapping, Philip Schwartzberg
- 7.3 Church of Sta. Maria de Naranco: © Marilyn Stokstad
- **7.4** Diagram of groin vault: © drawing by Leland M. Roth
- **7.5** Church of St. Michael, Escalada, interior: © Hirmer Fotoarchiv
- 7.6 Tabara Apocalypse, Emeritus and Senior at Work: © Archivo Historico Nacional, Madrid, photo: Archivo Mas
- 7.7 Morgan Beatus, Woman Clothed with the Sun Escaping from the Dragon: © The Pierpont Morgan Library, New York, MS M.644 f. 152v−153.
- **7.8** Monastery of St. Martin, Canigou, distant view: © Gustav Kunstler
- **7.9** Church of St. Martin, Canigou, nave, upper church: © Foto Mas. 273
- 7.10 Church of S. Vincete, Cardona, nave:© Archivo Mas
- 7.11 Church of St. Genis-des-Fontaines, Christ and the Apostles:

 Marilyn Stokstad
- **7.12** Cluny II, plan of the early monastery: © Kenneth J. Conant
- **7.13** St. Philibert, Tournus, plan: © after Dehio
- **7.14** St. Philibert, Tournus, interior narthex: © Bildarchiv Foto Marburg
- **7.15** St. Philibert, Tournus, interior nave: © Rolf Achilles
- 7.16 Farmstead showing traditional building types:

 Norwegain Folk Museum, photo: Marilyn Stokstad
- 7.17 Urnes, stave church, carved portal and wall planks: © Universitetes Oldsaksamling, Olso
- 7.18 New Minster Charter, King Edgar Presenting the charter to Christ: © by permission of the British Library
- 7.19 Benedictional of St. Ethelwold, The Marys at the Tomb: © by permission of the British Library
- 7.20 Unfinished page of Benedictional: © Bishop Blessing the Congregation: © by permission of the British Library
- 7.21 Liber Vitae of New Minster, Heaven and Hell: © by permission of the British Library

- 7.22 Liber Vitae of New Minster, Dedication page:

 by permission of the British Library
- 7.23 Magdeburg Ivory, Otto I Presenting Magdeburg Cathedral to Christ: © The Metropolitan Museum of Art, Bequest of George Blumenthal, 1941. (41.100.157) Photograph © The Metropolitan Museum of Art, NY
- 7.24 Lorsch Gospels, Aachen, Christ in Glory:

 Biblioteca Centrala de Stat a RPR, Bucharest
- 7.25 Gero Codex, Christ in Glory: © Hessischelandesbibliothek, Darmstadt, photo: Bildarchiv Foto Marburg
- 7.26 Letters of St. Gregory, author portrait: © Trier Stadtbibliothek, MS 171/1626
- **7.27** Gospels of Otto III, St. Luke: © Bayerische Staatsbibliothek, München
- 7.28 Gospels of Abbess Hitda and St.
 Walpurga, presentation page: ©
 Hessische Landes und Hochshul
 Bibliothek, Darmstadt (Hs 1640, fol.6r)
- 7.29 Cologne Catherdal, Gero Crucifix: © Rheinisches Bildarchiv, Cologne, Germany
- 7.30 Diptych with Moses and Thomas: © Staatliche Museen zu Berlin Preussischer Kulturbesitz Skulpturensammlung
- **7.31** Covent of the Holy Trinity, Essen, interior: © Bildarchiv Foto Marburg
- 7.32 Monastery of St. Michael, Hildesheim, exterior:

 A.F. Kersting, London
- **7.33** Church of St. Michael, Hildesheim, plan: © drawing by Leland M. Roth
- 7.34 Church of St. Michael, Hildesheim, interior: © Centrum Kunstistorische Documentatie, katholike Universiteit, Nijmegen
- 7.35 Church of St. Michael, Hildesheim, doors, Old and New Testament Scenes:© Bildarchiv Foto Marburg
- 7.36 Cathedral of Hildesheim, spiral column with scenes from the Life of Christ:

 Bildarchiv Foto Marburg
- **7.37** Cathedral of Speyer, crypt: © Rolf Achilles
- **7.38** Cathedral of Speyer, interior of nave: © F. Klimm

- 8.1 Bayeux Tapestry, Harold's Oath: © Centre Guillaume le Conquérant, Bayeux, by permission of the city of Bayeux
- 8.2 Avila, view of the city: © Marilyn Stokstad

- 8.3 Mayeux Tapestry, Surrender of Dinan:© Centre Guillaume le Conquérant, Bayeux, by permission of the city of Bayeux
- 8.4 St. Barthélémy Church, Liège, Baptismal font: © Paul M.R. Maeyaert
- 8.5 Sant' Angelo in Formis, Desiderius Offering of the Church to Christ: © Scala / Art Resource, NY
- **8.6** Church of San Clemente, interior: © Archivi Alinari, Firenze
- **8.7** Church of San Clemente, mosaic: © Alinari / Art Resource, NY
- 8.8 San Miniato al Monte, Florence, façade:

 © Marvin Trachtenberg Archives, courtesy of the Photographic Archives, National Gallery of Art, Washington, D.C.
- **8.9** Cathedral and Campanile, Pisa, Bapistry: © Scala / Art Resource, NY
- **8.10** Cathedral, Modena, west façade: © Alinari / Art Resource, NY
- **8.11** Cathedral, Modena, relief, Death of Cain: © Alinari / Art Resource, NY
- **8.12** Church of San Ambrogio, exterior: © Marilyn Stokstad
- **8.13** Church of San Ambrogio, interior: © Archivi Alinari, Firenze
- 8.14 Church of San Clemente, painting in apse, Christ in Glory: © Museu Nacional D'Art de Catalunya, Barcelona, photo: Archivo Mas
- **8.15** Santo Domingo, Silos, Christ on the Way to Emmaus: © Paul M.R. Maeyaert
- **8.16** Santiago de Compostela, cathedral: © Kenneth J. Conant
- **8.17** Santiago de Compostela, plan: © after Dehio
- **8.18** Santiago de Compostela, south transept: © Archivo Mas
- 8.19 Santiago de Compostela and Cluny III, alternative structural forms, cross sections: © Kenneth J. Conant
- **8.20** Santiago de Compostela, Puerta de las Platerias: © Marilyn Stokstad
- **8.21** Church of St. Sernin, Toulouse, Christ in Glory: © Bildarchiv Foto Marburg
- **8.22** Church of St. Sernin, Toulouse, Miégeville door: © Bildarchive Foto Marburg
- **8.23** Cluny III, plan: © Kenneth J. Conant
- **8.24** Cluny III, as reconstructed by Kenneth J. Conant, drawn by Turpin Bannister: © Bildarchiv Foto Marburg
- **8.25** Autun Cathedral, nave: © Paul M.R. Maeyaert
- **8.26** Autun Cathedral, capital, Suicide of Judas: © Musée Lapidaire

- **8.27** Autun Cathedral, tympanum, Last Judgement: © Paul M.R. Maeyaert
- **8.28** Church of the Madeleine, Vézelay, nave: © Zodiaque, St. Leger Vauban
- **8.29** Church of the Madeleine, Vézelay, detail of piers and aisle capitals: © Clarence Ward Archive, courtesy of the Photographic Archives, National Gallery of Art, Washington, D.C.
- **8.30** Church of the Madeleine, Vézelay, tympanum: © Paul M.R. Maeyaert
- **8.31** Berze-la-ville, painting in apse: © Paul M.R. Maeyaert
- **8.32** Durandus, Moissac, cloister pier: © Bildarchiv Foto Marburg
- 8.33 Church of St. Peter, Moissac, tympanum, detail: © Marilyn Stokstad
- **8.34** Church of St. Peter, Moissac, tympanum: © Marilyn Stokstad
- **8.35** Church of St. Peter, Moissac, trumeau: © Marilyn Stokstad
- **8.36** Abbey Church, Fontenay, plan: © Bildarchiv Foto Marburg
- **8.37** Abbey Chruch, Fontenay, nave: © Robert G. Calkins
- 8.38 Cistercian Manuscript, Tree of Jesse:
 © Collection Bibliothèque municipale de Dijon. Ms. 129 f° 4v 5, cliché (François Perrodin)
- **8.39** Abbey Church, Fontervault, nave: © Johnson
- **8.40** Church of Notre-Dame-la-Grande, Poiters, west façade: © Johnson
- **8.41** Saint-Savin-sur-Gartempe, nave: © Achim Bednorz, Cologne
- 8.42 Abbey Church of St. Etienne, Caen, west façade: © Clarence Ward Archive, courtesy of the Photographic Archives, National Gallery of Art, Washington, D.C.
- 8.43 Abbey Church of St. Etienne, Caen, nave: © Clarence Ward Archive, courtesy of the Photographic Archives, National Gallery of Art, Washington, D.C.
- 8.44 Cathedral of Durham, nave: © Clarence Ward Archive, courtesy of the Photographic Archives, National Gallery of Art, Washington, D.C.
- **8.45** Cathedral of Durham, plan: © after Dehio
- **8.46** Gloucester candlestick: © By courtesy of the Board of Trustees, the Victoria and Albert Museum, London

- **9.1** Cathedral, Poiters, The Crucifixion and the Ascension: © Bridgeman Giraudon
- 9.2 Chateau Gaillard: © Johnson

- 9.3 House of Cluny, façade:

 Marilyn Stokstad
- **9.4** Merchant's house, Cluny, plan: © drawing by Leland M. Roth
- **9.5** Abbey Church of St. Denis, west façade: © Bildarchiv Foto Marburg
- **9.6** Church of St. Denis, plan: © drawing by Leland M. Roth
- **9.7** Church of St. Denis, head of king: © The Walters Art Museum, Baltimore
- 9.8 Abbey Church of St. Denis, interior of choir: © Clarence Ward Archive, courtesy of the Photographic Archives, National Gallery of Art, Washington, D.C.
- **9.9** Cathedral of Sens, nave: © Clarence Ward Archive, courtesy of the Photographic Archives, National Gallery of Art, Washington, D.C.
- 9.10 Chartres Cathedral, west façade, Scenes from the Life of Christ: © Wim Swaan
- 9.11 Chartres Cathedral, west façade, Tree of Jesse: © Jacques Nestigen, Éditions Flammarion
- 9.12 Chartres Cathedral, entire west façade: © Centre des monuments nationaux, Paris
- 9.13 Chartres Cathedral, west façade, Royal Portal: © Bildarchiv Foto Marburg / Art Resource, NY
- 9.14 Chartres Cathedral, west façade, Virgin Portal: © Pierre Devinoy
- **9.15** Chartes Cathedral, west façade, Ancestors of Christ: © Pierre Devinoy
- 9.16 Cathedral of Laon, exterior: © Jean Roubier, Paris
- **9.17** Cathedral of Laon, nave: © Clarence Ward Archive, courtesy of the Photographic Archives, National Gallery of Art, Washington, D.C.
- **9.18** Comparison of nave elevations, Laon and Paris: © after Grodecki
- 9.19 Cathedral of Notre-Dame, Paris, nave: © Clarence Ward Archive, courtesy of the Photographic Archives, National Gallery of Art, Washington, D.C.
- **9.20** Cathedral of Notre-Dame, Paris, plan: © after Dehio
- 9.21 Notre-Dame de Amiens, cross section through the nave: © drawing by Leland M. Roth
- **9.22** Cathedral of Notre-Dame, Paris, west façade: © Marilyn Stokstad
- 9.23 Cathedral of Notre-Dame, Paris, Head of David: © The Metropolitan Museum of Art, Harris Brisbane Dick Fund, 1938. Photograph © The Metropolitan Museum of Art, NY

- 9.24 Cathedral of St. Pierre, Poiters, nave:© Johnson
- 9.25 Grandmont Alter, Limoges, Christ on the Cross: © The Cleveland Art Museum, gift from J.H. Wade
- 9.26 Canterbury Cathedral, plan: © after Dehio
- 9.27 Canterbury Cathedral, choir interior:© Anthony Scibilia / Art Resource, NY
- 9.28 Winchester Bible, Morgan Leaf, Scenes from the Life of David: © The Pierpont Morgan Library, New York. MS M.619 verso.
- 9.29 Flying Fish of Tyre: © The Pierpont Morgan Library, New York. MS M.81 f. 69.
- **9.30** Liber Scivias, Hildegard's Vision: © Brepols Publishers, Turnhout, Belgium
- 9.31 Hortus Deliciarum after Rosalie Green et. al., Herrad von Landsberg: © Warburg Institute, London, 1976.
- **9.32** Ingeborg Psalter, Pentecost: © Musée Condé, Chantilly, France
- 9.33 Cathedral of Senlis, west portal, detail of tympanum and lintel: © Bildarchiv Foto Marburg
- **9.34** Nicolas of Verdun, alterpiece: © Stiftsmuseum Klosterneuberg
- **9.35** Nicolas of Verdun, Crucifixion: © Stiftsmuseum Klosterneuberg
- **9.36** Church of San Trophime, Arles, portal, west façade: © Helmut Hell
- 9.37 Santiago de Compostela, Portico de la Gloria: © Institut Amatller D'Art Hispànic, Barcelona

- 10.1 Moralized Bible, page with Louis IX and Queen Blanche of Castile: © The Pierpont Morgan Library, New York. MS M.240 f. 8.
- 10.2 Chartres Cathedral, air view with town: © Bernard Beaujard, Martiguargues, France
- 10.3 Chartres Cathedral, nave and choir:© Bildarchiv Foto Marburg
- 10.4 Chartres Cathedral, Charlemagne Window: © Wim Swaan
- 10.5 Chartres Cathedral, north transept, rose and lancets: © Angelo Hornak, London
- 10.6 Chartres Cathedral, north transept:© Clarence Ward Archive, courtesy of the Photographic Archives, National Gallery of Art, Washington, D.C.
- **10.7** Chartres Cathedral, upper wall of nave: © Pierre Devinoy
- **10.8** Plans of French cathedrals: Chartres, Bourges, Reims, Amiens: © after Dehio

- **10.9** Elevations: Chartres, Reims, Amiens: © Rizzoli International Publications
- 10.10 Reims Cathedral, west façade: © H. Lewandowsko © Reunion des Musees Nationaux, Paris
- **10.11** Bourges Cathedral, interior: © Clarence Ward Archive, courtesy of the Photographic Archives, National Gallery of Art, Washington, D.C.
- 10.12 Reims Cathedral, chevet exterior: © Marilyn Stokstad
- 10.13 Reims Cathedral, interior, choir looking west: © Bildarchiv Foto Marburg
- 10.14 Reims Cathedral, nave: © Clarence Ward Archive, courtesy of the Photographic Archives, National Gallery of Art, Washington, D.C.
- **10.15** Ideal seven-towered cathedral: © after Viollet-le-duc
- 10.16 Amiens Cathedral, west façade: © Clarence Ward Archive, courtesy of the Photographic Archives, National Gallery of Art, Washington, D.C.
- 10.17 Amiens Cathedral, interior nave: © Clarence Ward Archive, courtesy of the Photographic Archives, National Gallery of Art, Washington, D.C.
- **10.18** Chartres cathedral, north transept, Ste. Anne: © Hirmer Fotoarchiv
- **10.19** Chartres Cathedral, south transept, St. Theodore: © Pierre Devinoy
- **10.20** Amiens Cathedral, west portal: © Hirmer Fotoarchiv
- 10.21 Amiens Cathedral, central portal, west façade:

 Bildarchiv Foto Marburg
- **10.22** Notre-Dame, Paris, west portal, Last Judgement: © Hirmer Fotoarchiv
- 10.23 Bourges Cathdral, Portada del Sarmental: © Bildarchiv Foto Marburg
- **10.24** Reims Cathedral, west portal, Coronation of the Virgin: © Hirmer Fotoarchiv
- 10.25 Villard de Honnecourt, drawing of figures: © Cliché Bibliothèque nationale de France, Paris
- 10.26 Reims Cathedral, west portal, Annunciation and Visitation: © Hirmer Fotoarchiv
- 10.27 Reims Cathedral, west portal,Presentation in the Temple, with Joseph:© Hirmer Fotoarchiv
- **10.28** Winchester Hall, interior: © Robert G. Calkins
- 10.29 Wells Cathedral, west façade: © Marilyn Stokstad
- 10.30 Wells Cathedral, nave and crossing:© Bildarchiv Foto Marburg

- **10.31** Wells Cathedral, capitals in south transept, Man with a Toothache: © F.H. Crossley
- **10.32** Salisbury Cathedral, exterior: © Foto Marburg / Art Resource, NY
- 10.33 Salisbury Cathedral and Wells Cathedral, plans: © after Dehio
- 10.34 Salisbury Cathedral, Lady Chapel:
 The Gramstorff Collection, courtesy of the Photographic Archives, National Gallery of Art, Washington, D.C.
- 10.35 Salisbury Cathedral, nave: © Stephen Addiss
- 10.36 Last Judgement, William de Brailes:Fitzwilliam Museum, Cambridge (MS 330 fol.3)
- 10.37 Church of St. Michael, Hildesheim, ceiling painting:

 Michael Jeiter, Morschenich, Germany
- **10.38** Church of St. Elizabeth, Marburg, nave: © Bildarchiv Foto Marburg
- 10.39 Church of St. Elizabeth, Marburg, exterior: © Foto Marburg / Art Resource, NV
- 10.40 Naumburg Cathedral, choir screen with the Crucifixion:

 Deutscher Kunstverlag, München
- 10.41 Naumburg Cathedral, west chapel sanctuary, figures of Uta and Ekkhard: © Erich Lessing
- **10.42** Church of St. Francis, Assisi, transverse section: © Scala / Art Resource, NY
- 10.43 Royal Palace with Ste. Chapelle, Tres Riches Heures:

 Bridgeman Giraudon
- **10.44** Abbey Church of St. Denis, nave: © Archives Photographiques, Paris
- **10.45** Sainte-Chapelle, Paris, interior: © Erich Lessing / Art Resource, NY
- **10.46** Psalter of St. Louis, Abraham and the Angels: © Cliché Bibliotheque nationale de France, Paris
- 10.47 Reims Cathedral, inner west façade:© Bridgeman Art Library, NY

CHAPTER II

- 11.1 Abbey Church of St. Denis, Virgin and Child: © The Taft Museum, Cincinnati
- 11.2 The Church of St. Urbain, Troyes, exterior: © Clarence Ward Archive, courtesy of the Photographic Archives, National Gallery of Art, Washington, D.C.
- **11.3** The Church of St. Urbain, Troyes, interior: © Bildarchiv Foto Marburg
- 11.4 The Church of St. Urbain, Troyes, interior of choir:

 Marvin Trachtenberg Archives, courtesy of the Photographic

- Archives, National Gallery of Art, Washington, D.C.
- 11.5 Abbey Church of Saint-Ouen, Rouen, Silver-glass window: © The Cloisters Collection, 1984 (1984–1991.1–11, and 48–183–2)
- 11.6 Abbey Church of Saint-Ouen, Rouen, The Annunciation and Visitation: © Institut Amatller D'Art Hispànic, Barcelona
- 11.7 Le Chatelaine de Vergi, ivory box: © Spenser Museum of Art, University of Kansas
- **11.8** The Virgin of Jeanne d'Evreux: © Reunion des musées nationaux, Paris
- 11.9 Westminster Abbey, the Book of Hours of Jeanne d'Evreux: © The Metropolitan Museum of Art, the Cloisters Collection, NY
- 11.10 Lincoln Cathedral, Angel Choir: © The Gramstorff Collection, courtesy of the Photographic Archives, National Gallery of Art, Washington, D.C.
- **11.11** Lincoln Cathedral, the Triforium of the Angel © Marilyn Stokstad
- **11.12** Exeter Cathedral, bishop's throne © Marilyn Stokstad
- **11.13** Exeter Cathedral, choir and bishop's throne: © Bildarchiv Foto Marburg
- **11.14** Ely Cathedral, lantern: © British Tourist Authority
- 11.15 Gloucester Cathedral, Tomb of Edward II: © Angelo Hornak, London
- 11.16 Windmill Psalter, Beatus vir qui no abiit: © The Pierpont Morgan Library, New York. (MS M.102 f. 1v–2)
- 11.17 Queen Mary Psalter, Christ in the Temple: © by permission of the British Library
- 11.18 Chichester-Constable Chasuble, Life of the Virgin: © The Metropolitan Museum of Art, Fletcher Fund, 1927. (27.162.1) Photograph © 1981 The Metropolitan Museum of Art, NY
- 11.19 Strasbourg Cathedral, west façade:© Bildarchiv Foto Marburg
- **11.20** Strasbourg Cathedral, Satan and the Foolish Virgins: © Jean Roubier, Paris
- **11.21** Christ and St. John the Evangelist: © The Cleveland Museum of Art
- 11.22 Church of the Holy Cross, interior:© Bildarchiv Foto Marburg
- **11.23** Church of the Holy Cross, plan: © after Dehio
- **11.24** Altneuschul Synagogue, Prague, interior. Engraving from Das

- Historisches Prag in 25 Stahlstichen, 1864: © Avery Architectural and Fine Arts Library, Columbia University, NY
- **11.25** Altneuschul Synagogue, Prague, plan: © public domain
- 11.26 Synagogue of the Transito, Toledo:© Institut Amatller D'Art Hispànic, Barcelona
- **11.27** Cathedral of Sta. Eulalia, Barcelona, interior: © Archivo Mas
- **11.28** Cathedral of Sta. Eulalia, Barcelona, plan: © after Dehio
- **11.29** Church of St. Mary, Padralbes, Barcelona, interior: © Archivo Mas
- 11.30 Chapel of St. Michael, Padralbes, Barcelona, Ferrer Bassa:

 Archivo Mas
- 11.31 Church of St. Francis, Assisi, Miracle of the Crib at Greccio: © Scala / Art Resource, NY
- 11.32 Sta. Bona Cross, Crucifixion of the Christus Triumphans type: © The Cleveland Museum of Art
- **11.33** Nicola Pisano, pulpit, baptistery, Pisa: © Canali Photobank, Italy
- 11.34 Giovanni Pisano, Pistoia Pulpit: © Archivi Alinari, Firenze
- 11.35 Baptistery of San Giovanni, Andrea Pisano, Life of John the Baptist: © Archivi Alinari, Firenze
- 11.36 Arena Chapel, Padua, Giotto di Bondone, Last Judgement:

 Art Resource, NY
- 11.37 Arena Chapel, Padua, Giotto di Bondone, Kiss of Judas:

 Alinari / Art Resource, NY
- 11.38 Siena Cathedral, Maesta alterpiece, The Annunciation, The Prophets and Ezekiel: © Andrew Mellon Collection, National Gallery of Art, Washington, D.C.
- 11.39 Palazzo Publico, Siena, Allegory of Good Government in the City and Allegory of Good Government in the Country: © Scala / Art Resource, NY

- 12.1 St. George and the Dragon, Flanders:Alisa Mellon Bruce Fund, National Gallery of Art, Washington, D.C.
- **12.2** Christine Presenting Her Book to the Queen of France: © by permission of the British Library
- 12.3 The Holy Family, Flanders: © The Nelson-Atkins Museum of Art, Kansas City

- **12.4** Gloucester Cathedral, choir: © Achim Bednorz
- 12.5 Gloucester Cathedral, east window:Sonia Halliday Photographs, Weston Turville
- **12.6** Gloucester Cathedral, cloister: © Clarence Ward Archive, courtesy of the Photographic Archives, National Gallery of Art, Washington, D.C.
- **12.7** King's College Chapel, Cambridge, interior: © Wim Swaan
- 12.8 Westminster Abbey, Henry VII chapel:
 © The Gramstorff Collection, courtesy of the Photographic Archives, National Gallery of Art, Washington, D.C.
- **12.9** Church of San Juan de los Reyes, Toledo, Spain, interior: © Archivo Mas
- **12.10** Church of San Juan de los Reyes, Toledo, Spain, plan: © after Dehio
- **12.11** Hradcany Castle, Vladislav Hall, Prague: © Robert G. Calkins
- **12.12** Albrechtsburg Cathedral, Meissen, cloister vaults: © Robert G. Calkins
- **12.13** Church of St. Lorenz, Nuremberg, interior: © Bildarchiv Foto Marburg
- **12.14** Church of St. Lorenz, Nuremberg, The Annunciation: © Wim Swaan
- **12.15** Angers Apocalypse tapestries: © Centre des monuments nationaux, Paris
- 12.16 Concerning Famous Women, page with Thamyris: © Cliché Bibliothèque nationale de France, Paris
- 12.17 Carthusian monastery of Champmol, Dijion, The Well of Moses: Marilyn Stokstad
- 12.18 The Mater Dolorosa: © The Metropolitan Museum of Art, The Cloisters Collection, 1998. (1998.215b) Photograph © 1998 The Metropolitan Museum of Art, NY
- 12.19 Statues, Virgin and Child, Nuremberg: © The Metropolitan Museum of Art, Gift of Ilse C. Hesslein, in memory of Hans G. Hesslein and the Hesslein family, 1986 (1986.340) Photograph © 1998 The Metropolitan Museum of Art, NY
- 12.20 St. Dorothy wood cut: © Rosenwald Collection, National Gallery of Art, Washington, D.C.

All efforts were employed to research and secure permission and source credit information for the above images. Should information exist beyond these efforts, please write to Westview Press.

INDEX

Note: Illustrations appear on pages in **boldface** type.

Aachen: palace and chapel complex, 101, 103, 104, 105, 183, 359 Abbey, defined, 365 Abd er-Rahman, 143-144 Abgar, 72 Abraham, 62, 119, 299 binding of Isaac, 62, 65, 66, 119 Abstraction in Byzantine art, 50, 59-60, 63, 65, 72–73, 130 in early Christian period, 15, 16, 20 in Gothic art, 285 in late Roman art, 7, 8, 20 Ada Gospels, 111, 112 Adam and Eve, 15, 121, 186, 187 - 188Adoptionism, 160, 365, 371 Adoration of the Magi image, 92, 93 Aedicule, 365 Aerial perspective, 375 Agathies, 73 Agilbert, sarcophagus of, 84 Agilulf, 81 Agincourt, Battle of, 336 Agnus Dei, defined, 365. See also Lamb of God image Aidan, St., 91, 358 Aisle, defined, 365 Alan of Walsingham, 315 Alaric I, 12, 33, 78 Alb, defined, 365 Alcuin of York, 102, 113, 121 Aldred, 96

Alexander II, Pope, 191, 360 Alexander III, Pope, 233, 362 Alfonso II, 157 Alfonso III, 157 Alfonso VI, 158, 192, 208 Alfred the Great, 359 Alp Arslan, Sultan, 129 Alpha and omega, defined, 365 Altar frontal, defined, 365 Altneuschul (Prague), 321, 322 Ambo, defined, 365 Ambrose, St., 12, 32, 356, 370 Ambulatory, defined, 365 Amice, defined, 365 Amiens Cathedral, 273-275, 276, 278, 362 flying buttresses, 244 nave elevation, 268 ogee arches, 345 plan, 267 sculpture, 278, 279-280 west façade, 274 Anachtshild, defined, 365 Anastasis, defined, 365 Anastasis Rotunda (Church of the Holy Sepulchre), 29 Anchor, symbolic meaning of, 16, 18 Andrew, St., 365. See also Wells Cathedral Angels angel as symbol of Matthew, 97, archangels listed, 368

defined, 365

Gothic manuscript illumination, 309 Gothic sculpture, 278, 310 hierarchy of, 137, 367 Angers Apocalypse, 347, 348, 363 Angers Cathedral, 347, 348 Angilbert, St., 102, 106, 115 Angles, 79, 89 Anglo-Saxon Chronicle, 88 Anglo-Saxons chronology of events, 359-360 gems and jewelry, 89-90 manuscript illumination, 170 - 173riddles, 92 See also England and British Isles Animals in Anglo-Saxon art, 89 beakhead, 368 bestiaries, 250 in Gothic tapestries, 348 in Isabellan Gothic sculpture, 343 in Merovingian manuscript illumination, 85 rampant, 376 in Scandinavian art, 76-77, 87-89, 169-170 in Scythian art, 76 symbolic meanings of, 18, 79, 94-95, 178, 373 See also Birds; Monsters and fabulous beasts; specific animals Anne, St., 263, 264, 275, 277 Annular, defined, 365

Annunciation image	Arches	Augustinian Canons, defined, 366
Byzantine mosaics, 130	catenary, 368	Augustinians, 120
Gothic manuscript illumination,	diaphragm, 369	Autun, Church of (St. Lazare),
309	haunch, 371	210–212 , 361
Gothic painting, 330 , 331	horseshoe, 143 , 144, 158, 159 ,	Auxerre: Crypt of St. Germaine,
Gothic sculpture, 282, 283, 284 ,	165, 371	109 , 359
347	keystone, 372	Avars, 102
Gothic stained glass, 306	nodding ogee arch, 374	Avignon, 363
Ottonian bronze casting, 186,	ogee arch, 312, 345–346, 374	Avila, 192, 193
187–188	pointed, 240	Azulejos, defined, 366
Antelami, Benedetto, 256, 258	relieving arches, 376	
Antependium. See Altar frontal,	respond, 376	Babylonian Captivity, 303, 363
defined	spandrel, 376	Bacchus, 6, 16, 19
Anthemius, 48, 50–52	springers, 376	Bacon, Roger, 295, 363
Anthony, St., 65, 356	strainer arch, 377	Bailey, defined, 193-194, 366. See
Apocalypse imagery, 40, 43	triumphal, 24 , 377	also Motte-and-bailey castles
Byzantine manuscript illumination,	voussoir, 143, 144, 212, 369, 378	Baldachino, 24, 31, 366
70, 71	Architecture. See Sculpture; specific	Baldwin of Flanders, 297
Carolingian manuscript	types, such as Byzantine	Ball flower, defined, 312, 366
illumination, 124	architecture, and specific	Baluster, defined, 366
early Christian mosaics, 39, 40,	architectural elements	Bamberg Cathedral, 258
43, 43	Architrave, defined, 366	Baptism, 5, 18, 41
Gothic sculpture, 239, 256, 281	Archivolt, defined, 366	Baptistery, defined, 366
Gothic tapestries, 347, 348	Arcuated lintel, defined, 366	Baptistery of San Giovanni
Lombard-Catalan sculpture, 165	Ardagh Chalice, 95 , 96	(Florence), 329
Romanesque mural painting, 202,	Arena Chapel (Padua), 329,	Baptistery of the Orthodox
203	330–331 , 363	(Ravenna), 40, 41–42 , 43, 357
Romanesque sculpture, 217	Arianism, 11, 35, 60, 78, 81, 356,	Baptistery, pulpit (Pisa), 327, 328,
Apocryphal images, 34, 371	366	362
Apollinare, St See San Apollinare	Ark of the Covenant image, 65	Bar tracery, 366, 377
Nuovo, Church of; San	Arles: Church of St. Trophime, 256,	Barbarian art, 75-100
Apollinare, Church of	361	animal images, 76–77
Apollo, 13, 118	Armature, defined, 366	British Isles, 89-100
Apostles	Aron, 323	Goths and Langobards, 79–82
images of, 63 , 64 , 165 , 197, 198 ,	Arthur, King of the Britons, 220	Merovingian Franks, 82–89
279	Round Table of, 286	Vendels and Vikings, 86-89
list of, 365	Articulated, defined, 366	Barbarians, history of, 78-79. See
See also specific apostles	Ascension image, 19, 20, 34, 70, 71,	also specific groups
Apostoleion, defined, 365	120	Barberini Ivory, 68
Apse, defined, 365	Ashlar masonry, defined, 366	Barbican, defined, 366
Aquamanile, defined, 365	Assisi: Church of St. Francis, 295,	Barcelona
Aquinas, Thomas, 295, 363, 369	296, 326, 327 , 362	Cathedral of Sta. Eulalia,
Arcade, defined, 366	Assumption image, 253, 254 , 366	324–325 , 363
blind, 221	Asturian art, 157–161	Convent Church of Sta. Maria
spandrel, 376	Athanasius, St., 11, 370	Pedralbes, 325
Arch of Constantine, 7, 8 , 9–10,	Atmospheric perspective, 375	Barnes, Carl F., Jr., 283
356	Atrium, defined, 24, 366	Barrel vault, 163, 165, 167
Arch of Titus, 6, 7, 183, 356	Attila the Hun, 357	defined, 366, 377
Archangels, defined, 366	Audradus Modicus, 121	Bas-de-page, 309, 317, 366
Archbishop, defined, 366	Augustine of Hippo, St., 6, 91, 218,	Basil, St., 65, 72, 129, 139, 373
Arched corbel table. See Corbel table	356, 357, 358, 370	Basilica, 23–25, 55–56, 366

Basilisk, 373 Bassa, Ferrer, 325-326 Basse-taille, 308 Bataille, Nicolas, 347-348 Bay, defined, 366 Bayeux Tapestry, 191, 192, 193, 194, 226, 360 Beakhead, defined, 366 Beatrice of Swabia, 280 Beatus of Liébana, 160, 366 Beatus manuscript, 160-161, 216, 366 Beauce, Jehan de, 346 Beau Dieu, 278, 280 Becket, Thomas á, 247, 362 Belgium. See Franks; Mosan, Belgium Bema, defined, 366 Benedetto Antelami, 256, 258 Benedict of Aniane, St., 102 Benedict Biscop, 92 Benedict of Nursia, St., 65, 357, 366 Benedictine monasticism, 357, 366 Anglo-Saxons and, 170-173 Benedictine plan, 166, 167, 195-196 Catalonia and, 161 Charlemagne and, 102 Escalada monastery, 158 Louis the Pious and, 120 origins of, 65 power of, 156 See also Cluny, Congregation of; Suger, Abbot Benedictional, defined, 366 Benedictional of St. Ethelwold, 171 Berengar, 124 Berenguela of León, 280 Bernard, St., 212, 216, 218-219, 233, 361 aversion to ostentatious decoration, 219, 226 Bernward, Archbishop, 183, 187 Berry, Jean de, 349 Berze-la-Ville chapel, 215 Bestiaries, 250 Beth Alpha Synagogue (Galilee), 65, 66, 378 Bible: Vulgate, 121, 356, 366. See

also specific bibles, such as Vivian

Bible

Billet molding, defined, 366 Bimah, 322, 323 Binding of Isaac. See Isaac, binding of Birds eagle as symbol for St. John, 79, peacock as symbol of immortality, rooster as symbol for St. Peter, 375 in Scandinavian art, 87 Scythian Birdman, 76 symbolic meanings of doves, 17, 18, 197, **198**, **309** as symbols of paradise, 63, 64, 111 Black Death, 313, 333-336, 363 Black Friars. See Dominicans Blanche, Queen, 259, 261, 280 Blind arcade, defined, 366 Bobbio, monastery at, 81 Boccaccio, Giovanni, 349, 363 Bondol, Jean, 347-348 Boniface, St., 105-106, 358 Bony, Jean, 300 Book of Durrow, 94, 95, 358 Book of Hours, 251, 308, 309, 310, 363, 366 Book of Kells, 96-97, 98, 99, 359 Books. See Manuscript illumination; specific books Boss, defined, 366 Bourgos Cathedral, 234, 267, 268, **269**, 362 Brailes, William de, 290, 291 Braine, Henri de, 270 Brandea, 26 Branner, Robert, 296, 297 Breviary, defined, 366 British Isles. See England and British Bronze casting, 186, 187, 201. See also Metalwork Bruno, St., 361, 367 Bubble foliage, 312 Bulgars, 139 Bull, as symbol for St. Luke, 370 Burgos, Cathedral of, 280, 281, 362 Burgundy and Burgundians, 78 Byzantine influence, 141 metalwork, 83

Philip the Bold and, 349

Romanesque architecture, 208-216 See also Cluny, Congregation of Buttress, 367 flying buttress, 225, 234, 243, **244**, 346, 367 pinnacle, 375 strip buttress, 163, 165, 183, 201 Byzantine architecture, 48–58, 133-138 characteristics of, 135-136 domes, 50-52, 54-55, 135 light and color, 52 naos, 52, 378 pendentives, 50, 51 prothesis, 24, 38, 375 Byzantine art abstraction and, 59-60, 63, 65, 72 - 73early period, 45–73 East-West differences, 3, 258 enamels, 3, 132-133 icons and iconoclasm, 72-74 influence on Book of Kells, 99 influence on Carolingian art, 113-114, 141 influence on Gothic art, 141, 158, 253, 290, 293 influence on Lombard art, 82 influence on Ottonian art, 174-176 influence on Romanesque art, 195, 202, 226 influence on Western art, 141-143 ivories, 67–68, 132 light and color in, 48, 52, 63, 130, manuscript illumination, 68-72, 130 - 132metalwork, 132, 133 middle period, 129-133 mosaics, 58-67, 128-130, 138, 149-150, 151 Neoplatonic aesthetics and, 54, Norman kingdom in Sicily, 148-153 outside the empire, 139-141 Stavelot Triptych, 1-3, 133 symbolic mode of, 3 textiles, 133, 134

Byzantine Empire, 45–48, 129–133 chronology of events, 356-362 Crusades and, 128, 260, 361-362 icons and iconoclasm, 72-74, 129 See also Eastern Orthodox Church Byzantium. See Constantinople Cabochon, defined, 367 Caen: Abbey Church of St. Étienne, 223, 224-225, 360 Caesaropapism, 367 Calligraphy, 146, 367 Cambridge University, 341-342, 364 Came, defined, 367 Campanile, defined, 367 Canon of the Mass, 367 Canon table, defined, 367 Canons, defined, 120, 366 Canterbury Cathedral, 234, 247, **248**, 286, 362 The Canterbury Tales (Chaucer), 247, 353, 364 Canute the Great, 156, 168, 173, 360 Capet, Hugh, 227, 360 Capetian dynasty, 227–228, 303 Capital, defined, 189, 367 Cappella Palatina. See Palace Chapel (Palermo) Cardona: Church of S. Vincente, **164**, 165 Carlief, William de, 224 Carloman, Mayor of the Palace, 102 Carolingian architecture, 103-109, 231 westworks, 107, 183, 378 Carolingian art, 101-126 Byzantine influence, 113-114, 141 frescoes, 109-110 influence on Ottonian art, 181, 183 influence on Romanesque art, 195 ivories, 110, 113, 114, 118 manuscript illumination, 110-113, 115-125, 170 Carolingian dynasty, 101-103, 231 Carolingian minuscule, 110 Carpet page, defined, 367 Carthusians, 349-350, 361, 367

Cartoon, defined, 367

Castles bailey, 193-194, 366 Château Gaillard (early Gothic), 228-229 crenelation, 368 curtain wall, 369 Hradcany Castle, 344, 345, 364 keep, 193, 372 machicolation, 372 moat, 373 motte-and-bailey, 193, 373-374 Romanesque, 193–194 Catacomb in the Villa Torlonia, 16 Catacomb of Domitilla, 22, 23 Catacomb of Priscilla, 16, 17-18, 19 Catacombs, 356, 367 cubicula, 369 early Christian period, 15-19 loculi, 15, 376 Catalonia Gothic architecture, 324–325 Lombard-Catalan style, 161–166, 201 Romanesque style, 201–202 Catechumen, defined, 367 Catenary arch, 367 Catenary (chain) vault, 209, 367 Cathach, 91 Cathedra, defined, 367 Cathedrals defined, 367 naming conventions, 233 See also Sculpture; Stained glass; specific cathedrals and types of architecture Caxton, William, 353, 364 Cefalú, Cathedral at (Sicily), 137, 149 Cell, defined, 367 Cell vault, 344, 345 Celtic Christianity, 90-91, 95 Celtic cross, **93**, 368 Celts, 75–76, 79 Cenotaph, defined, 367 Cense, censer, 367 Centering, defined, 367 Centula, monastery at, 106, 107, 359 Ceramics, 146, 147 Chalcedon, Council of, 38 Chalice, defined, 367

Champlevé enamel, 3, **247**, 254, 367, 369 Chancel. See Choir, defined Chantry chapel, defined, 367 Charger, defined, 367 Charioteer image, 19-20 Charlemagne, 101-103, 175, 261, 262, 359 Charles IV, 303, 308, 344 Charles VII, 336 Charles of Anjou, 325 Charles the Bald, 114, 120, 121, 359 Charles the Fat, 115 Charles Martel, 102, 115, 358 Charles the Simple, 88, 115, 360 Chartres Cathedral, 238, 260, 261, 264, **265**, 274, 361, 362, 364 influence on Reims Cathedral, 268, 270 nave elevation, 268 plan, 267 sculpture, 236, 238, 239, 240, 275, 277, 278 stained glass, 234, 235, 237, 261, **262–263**, 264, **266** tracery, 346 Chartreuse, 367 Chartreuse de Champmol (monastery), 349, 350, 364 Châsse, defined, 367 Chasuble, 316, 318, 367 Château Gaillard, 228, 229, 362 Chaucer, Geoffrey, 247, 353, 364 Cherubim, 137, 367 Chevet, defined, 367 Chi Rho monogram, 2, 14, 22–23, 98, 373 Chichester-Constable Chasuble, 316, 318 Chidelee, John de, 318 Chip-carving, 86 Chivalry, 336 Choir, defined, 367 Choir screen, defined, 367 Christ, images of Ascension image, 19, 20, 34, 70, 71, 120 Beau Dieu image, 278, 280 Charioteer image, 19-20

Chamfer, defined, 367

Christ as friend of St. John, 321 Christ as King. See Christ in Glory/Majesty image Christ as Pilgrim image, 204 Christus patiens, defined, 367 Christus triumphans, defined, 367 Fisher of Souls image, 16, 18 Good Shepherd image, 13-17, 39 Lamb of God image, 124, Light of the World image, 20 Mother and child image. See Mother and child image Nativity images. See Nativity image Passion cycle. See Passion cycle Pantokrator image, 138-139, 149, 151, 152, 217. See also Christ in Glory/Majesty image Presentation in the Temple image, 186, 188, 282, 285 Resurrection image, 20, 22-23, **60**, 61, **198** Salvation image, 15, 17 Second Coming image, 37, 39, 43, 239, 278 Transfiguration image, 63, 64, 65 See also Christ in Glory/Majesty image; Cross; Crucifixion image Christ in Glory/Majesty image Byzantine mosaics, 130, 138 Carolingian manuscript illumination, 110 defined/described, 370 early Christian period, 19-20, 23 Lombard-Catalan sculpture, 165 Ottonian manuscript illumination, 176 Romanesque mural painting, 202, 203, 215 Romanesque sculpture, 207, 216, 217 See also Pantokrator image Christ, monograms and symbols for, 377 Christian architecture (early period), 23-32, 38-44 Christian art (early period), 13-44 Constantine and, 10-11, 21-23 symbols in. See Symbols in Christian art themes for, 4

Theodosius I and, 11–12 types and typology, 22 Christianity Adoptionism, 160, 367 Arianism, 11, 35, 60, 78, 81, 356, Babylonian Captivity, 303, 363 Celtic Christianity, 90-91 Charlemagne and, 102 chronology of events, 356-365 Constantine and, 10-11 Council of Chalcedon, 38, 377 Council of Constance, 335, 364 Council of Constantinople, 359 Council of Nicaea (first), 11 Council of Nicaea (second), 74 Council of Whitby, 91-92, 95, 358 East-West split, 3, 129, 191, 356 Edict of Milan, 10, 11, 356 Franks and, 82-83 Great Schism (rival Popes), 335, 364 history of early church, 3-6 icons and iconoclasm, 72-74, 129, 358 Monophysites, 33-34, 38, 48 mysticism in the 13th century, 319, 321 Neoplatonic One and, 54 Scandinavia and, 168-169 See also Eastern Orthodox Church: Roman Church Christus patiens, defined, 367 Christus, Petrus, 338, 351, 364 Christus triumphans, defined, 367 Chronology, 356-365 Ciborium (baldachino), 24, 31, 368 Cinquefoil, defined, 368 Cistercians, 120, 216-219, 361, 368 City of God (Augustine), 357 Clare, St., 327 Classe: Church of S. Apollinare, 56, **63**, 64, 357 Classical art, 8, 67, 70, 73, 251-256. See also Romanesque Clerestory, defined, 368 Cloisonné, 3, 83, 132-133, 368,

Cloister, defined, 368

345, 368 Close, defined, 288 Clotilda, St., 79, 82 Clovis, 79, 82-83, 101-102, 357 Cluny, Congregation of, 120, 166-168, 208-210, 368 Bishop Oliba and, 161 Church of St. Peter (Moissac), 214 Cluny II, 166, 167, 360 Cluny III, 206, 208, 209, 210, 361 founding of, 360 manuscript illumination and, 141 power of, 156, 191 Cluny, merchant's house, 230 Codex Amiatinus, 97 Codex Aureus, 124 Codex form for books, 69, 368 Collects, defined, 368 Collegiate churches, defined, 368 Colobium, defined, 368 Cologne Cathedral, 180 Colonette, defined, 368 Colophon, defined, 159, 368 Byzantine art and, 52, 58, 63, 130, early Christian art and, 20, 37 flashed glass, 306 Frankish cloisonné, 83 Gothic architecture and, 334 Gothic painting and, 333 grisaille glass and, 305-306 grisaille painting and, 308-309 heraldic alternation, 235 Mozarabic art and, 202 perspective and, 375 polychromy, 375 purple vellum for books, 69 Romanesque mural painting and, See also Stained glass Columban, St., 81 Column, defined, 368 Column-figure, defined, 368 Column of the flagellation, 72 Compound pier, defined, 165, 368 Conch, defined, 368 Confessio, defined, 368 Confessor saints, defined, 368

Cloister vault (domical vault), 344,

Connachtach, 98 Crécy, Battle of, 336 Romanesque mosaic, 197, 198 Conques: Church of St. Faith (Foy), Crenelation, defined, 368 See also Cross 204, 205 Crocket, defined, 368 Crucks, defined, 369 Constance, Cathedral of, 351 Crosby, Sumner, 233 Crusades, 361-362 Constance, Council of, 335, 364 Crosier, crozier, defined, 368 Constance, Queen, 208 Cross Constantina, 26–27 Byzantine processional cross, 132, end of, 336, 363 Constantine 133 Arch of Constantine, 7, 8, 9–10, Cross-standard, 368 356 Franciscan, 326, 327 baptism of, 6 Greek-cross plan for churches, 28, 260 Christian art under, 21-23 55, 106, 135 Suger and, 233 Vézelay and, 212 Christianity and, 10-11 images in paintings and mosaics. Crypt, defined, 371 chronology of events, 356 See Cross, images of churches built by, 23, 25, 28 Limoges cross (enamel), 246, 247 Constantinople and, 45-46 relics of the True Cross, 1-3, 18, 109, 359 East-West dichotomy and, 3 28, 133, 297 Head of Constantine, 9, 10 rood, 376 official art under, 9-10 Stations of the Cross, 376 Old St. Peter's and, 29-32 stone crosses of the British Isles, 93-94, 360 True Cross and, 2 17 Constantine V, 74 types of, 368 Constantine VII, 129, 131 See also Crucifixion image Constantinian cross, 368 Cross, images of Cusp, defined, 369 Constantinople Byzantine mosaics, 63, 64 Cuthbert, St., 96 Church of the Holy Apostles, 28, Chi Rho monogram, 2, 14, 22-23, Cybele, 6 55, 357 Crusades and, 128, 260, 361-362 Cross as Tree of Life (Romanesque (Prague) founding of, 11, 45-46 mosaic), 198 history of, 129-135, 356-363 early Christian period, 14, 18 Nika Revolt, 48 first use of symbol, 18 Turks and, 336 See also Crucifixion image Damascus, fall of, 143 walls of, 46, 47, 357 Cross of Muiredach, 93, 359 Crossing, defined, 368 Cope, defined, 368 Corbel table, 163, 165, 183, 201, Crucifix, defined, 371 368 Crucifixion image 138 Byzantine manuscript illumination, Córdoba David, King Great Mosque, 143, 144, 145, 359 71 St. Ferdinand and, 290 Byzantine mosaic, 138, 139 131 Corinthian capital, defined, 367 Carolingian gem and metalwork, Cormont, Regnault de, 274 124, 125 Cormont, Thomas de, 273, 297 Carolingian ivory, 118 Cornice, defined, 368 change from triumphant to 248, 249, 316 Coronation Gospels, 113, 175, 359 emaciated figure, 321 Christus patiens, defined, 367 Coronation of the Virgin image, 253, 254, 281, 282, 300 Christus triumphans, defined, 367 Corpus Christi, defined, 368 Gothic enamel, 246, 247, 255 Cosmati work, 197, 198, 326, 368 Gothic painting, 321, 327 da Vinci, Leonardo, 364 Couching, defined, 368 Gothic sculpture, 294 Deacon, defined, 372 Coucy, Robert de, 270 Gothic stained glass, 227, 246 Decorated style, 310-319, 345

Ottonian sculpture, 180, 181

Court style. See Rayonnant style

Château Gaillard and, 228 Constantinople and, 128, 260, 362 military architecture and, 194 origins of, 129, 192, 361 spread of Byzantine art and, 141, Crypt of St. Germaine (Auxerre), Crypt of St. Paul (Jouarre), 84, 358 Crypt, Speyer Cathedral, 188, 189 Cubiculum, defined, 15, 369 Cubiculum of the Veiled Lady, 16, Curtain wall, defined, 3769 Cushion capital, defined, 367 Czech Republic. See Altneuschul Dalmatic, defined, 369 Damascening, 147-148 Damp-fold drapery, 351, 369 Danes, 156, 170, 359, 360 Daphni: Church of the Dormition, Byzantine manuscript illumination, Carolingian manuscript illumination, 122, 123, 124 Gothic manuscript illumination, Gothic sculpture, 244, 246 Gothic stained glass, 263, 264 Ottonian manuscript illumination,

Deësis, defined, 372

Demeter, 5	in Gothic painting, 290, 291, 335,	Patriarch, defined, 375
Demetrius Presbyter, 113	336, 351	split with Rome, 3, 129, 191
Denmark, 168–169. See also Danes;	in Romanesque metalwork, 225	See also Byzantine art; Christianity
Scandinavian art	in Scandinavian art, 88, 169, 170	Ebbo, Archbishop, 115
Descent into Limbo, 374	Drapery	Ebbo Gospels, 115, 116 , 359
Desiderius, Abbot, 156, 192, 195,	British Isles manuscript	Ecclesius, Bishop, 56
196	illumination, 99, 172	Eckhardt, Meister, 352
Diaconicum, defined, 24, 38, 369	Carolingian ivory, 114	Economy of Europe, 192, 336
Diana, 118	damp-fold style, 251, 369	Ecumenical council, defined, 369
Diaper, defined, 369	Gothic manuscript illumination,	Edgar, King, 170, 171
Diaphragm arch, defined, 369	251, 253, 310	Edict of Milan, 10, 11, 356
Dietrich II, 293	Gothic sculpture, 275, 278, 281,	Edward I, 310
Diocese, defined, 369	284, 295, 304–305, 328, 345,	Edward II, 310
Diocletian, 7, 9, 356	350, 352	tomb of, 315 , 316, 338, 363
Dionysius the Pseudo-Areopagite,	Muldenstil, defined, 374	Edward III, 303, 310, 315
54, 236	multiple-fold, 374	Edward the Confessor, 310
Dionysus, 6	nested V-fold, 328, 374	Egbert of Trier, Archbishop, 177
Dioscorides, 68–69, 357	plate drapery, 375	Egypt. See St. Catherine, Church of
Diptych, defined, 369	Rayonnant manuscript	(Mount Sinai)
Ditmar, 294	illumination, 310	Einhard, 102, 113
Divine Office, defined, 366, 369	Romanesque metalwork, 195	Ekkehard, 293, 294
Dog-tooth moldings, 287, 369	Romanesque mural painting, 213	Eleanor of Aquitaine, 228, 231
Domes, 50, 51 , 52, 54–55, 135 ,	Romanesque sculpture, 204, 207,	Eleanor of Castile, 310 Elevation, defined, 369
369	212–214, 216	
drum, 369	Sluter's style, 350, 352	Elizabeth, St., 282. <i>See also</i> Visitation image
pendentives, 50, 51, 375	Zackenstil, defined, 378	Ely Cathedral, 225, 313, 314 , 315,
single- vs. multi-domed buildings,	Drogo, Archbishop, 102, 115, 119 Drogo Sacrementary, 119, 120 , 359	364
55 Domical vault. <i>See</i> Cloister vault	Drôleries, defined, 369	Ely, Regionald, 341–342
Dominations (order of angels), 137	Drum, defined, 369	Embroidery, 226, 316–319, 348. See
Dominic, St., 362	Duccio di Buoninsegna, 332–333,	also Bayeux Tapestry
Dominicans, 295, 345, 362, 369	363	Emeterius, 159–160
Domus, defined, 369	Dunstan, St., 170	Enamels
Donjon, defined, 369	Dura-Europos, house-church at, 15,	altarpiece (Nicholas of Verdun),
Doors, bronze, 186 , 201	356	253–254, 255
Dormition, Church of the (Daphni),	Dura-Europos, synagogue at, 14, 15,	basse-taille, 308
138	356	British Isles, 89
Dorothy, St., 353	Durandus, Abbot, 214, 216	Byzantine, 132–133
Dorte, defined, 369	Durham Cathedral, 224, 225, 361	champlevé, 3, 247, 254, 367, 369
Dosseret, defined, 190	Durrow, Book of, 94, 95 , 358	cloisonné, 3, 83, 132-133, 368,
Douay Bible, 366		369
Double-shelled octagon plan for	Eadfrith, 96	Limoges cross, 246, 247
churches, 369	Eadwine, 91	millefiori, 373
Doubting Thomas, 181, 182	Eagle	niello enamel, 254, 374
Dove	in art of the Goths, 79	Rayonnant Gothic, 306–307, 308
as apostle symbol, 197, 198	as symbol for St. John, 79, 370	reserved, 376
as Holy Ghost symbol, 17, 18, 309	Eastern Orthodox Church	St. Denis Abbey Church and, 232
Dowel, defined, 369	Hagia Sophia and, 48–55	Stavelot Triptych, 1 , 2 , 3, 133
Dragons, 373	iconoclasm and, 72–74	vermicule, 378
in Anglo-Saxon art, 89–90	liturgical cycle, 4	Enceinte, defined, 369
Anglo-Saxon Chronicle and, 88	middle Byzantine period, 133–138	Ende, 159–160

England and British Isles Eyck, Jan, 351 van Lombard-Catalan style, 161–166 chronology of events, 356-365 Ezekiel. See Apocalypse imagery Merovingian Franks, 82-89, 101 Decorated style, 310-319, 345 Ezra, scribe, 97 Rayonnant style, 275, 296-300, early art, 89-100 303-310 gems and jewelry, 89-90 Fabre, Jaime, 324 Romanesque style in Aquitaine, Gothic architecture, 285-290, Façade, defined, 370 219-222 310-316, 338-344, 341-342 Fald-stool, defined, 370 Vikings and, 359, 360 Gothic art, 247-250, 316-319 Fan vault, 341, 342, 370 See also Burgundy and Hundred Years War, 303, Fathers of the Church, 4, 370 Burgundians; Carolingian 335-336, 363 Feasts of the Church, 373, 370 architecture; Carolingian art; influence of English painting on Ferdinand and Isabella of Spain, 35, Catalonia; Franks; specific cities, Rayonnant Gothic style, 309 336, 364 churches, and cathedrals manuscript illumination, 94-99, Isabellan Gothic architecture, Francis, St., 295, 362, 370 170 - 173342-343 Franciscans, 295, 362, 370 millenial art, 168-173 Ferdinand, St., 280, 290 Stations of the Cross, 376 Normans in, 222-226, 360-361 Feudalism, 192 wooden painted crosses, 326, 327 Perpendicular style, 315-316, 338, Fibulae, 77, 79, 86, 87, 370 Frankl, Paul, 300 341-342 Filigree, defined, 370 Franks, 78, 82-89, 357 riddles, 92 Finial, defined, 370 Franks Casket, 92, 93, 358 Romanesque embroidery, 226 Fish Frederick II, 290, 362 stone crosses, 93-94 flying fish of Tyre, 250 Frederick Barbarossa, 3, 195, 361 Wars of the Roses, 336, 364 loaves and fishes image, 18 Fresco, 109, 110, 333, 370 See also Anglo-Saxons; specific symbolic meaning of, 18 Friar, defined, 370 cathedrals Fisher of Souls image, 16, 18 Frieze, 343, 370 Entablature, defined, 369 Flamboyant style, 345 Froggy in the Middle, 309 Epigraphy, defined, 369 Flashed glass, 306 Frontal. See Altar frontal, defined Epinoia, 69 Flêche, defined, 370 Fulda, Abbey Church of, 105, 106 Epiphany, defined, 369 Flemish masters, 350-351 Funerary art Epistles, defined, 370 Fleur-de-lis, 308, 347, 348, 370 in the age of Constantine, 21–22 Escalada, monastery at, 158, 159 Florence, 197-199 in the British Isles, 89-90 Essen: Convent of the Holy Trinity, Baptistery of San Giovanni, 329 cenotaph, 367 183 San Miniato al Monte, 199 Jewish and Christian funerary art Ethelwald, Bishop, 170, 171 Flying buttress, 234, 243, 244, 367 before Constantine, 14-19 Etrog (citron), 65, 66 Flamboyant style and, 346 mausoleum, defined, 373 Etymologies (Isidore of Seville), 80 precursors to, 225 Mausoleum of Galla Placidia Eucharist Flying ribs, 322 (Ravenna), 13-14, 39-40, 357 Carolingian manuscript Focillon, Henri, 206, 300 Mausoleum of the Julii (Rome), illumination, 119 Foil, defined, 370 19 - 20ceremony under Justinian, 54 Foliage. See Plants Scandinavian ship burials, 86-88 defined/described, 5, 370 Font, defined, 370 stone crosses of the British Isles, Fontenay, Abbey Church of, 218, early Christian images, 16, 18, 19 93-94 Eucharist procession in middle Byzantine period, 50 Fontevrault: Church of Notre-Dame, Gabriel, Archangel, 137, 309, 345, Eudokia, 72 220, 221 347, 366 Eusebius of Caesarea, 28, 29 Fouilloy, Evrard de, 273 Gaia, 118 Evangeliary, defined, 370 Fountain of Life image, 111 Galilee (architectural term), 166, Evangelists, defined, 370 France, 363 d'Evreux, Jeanne, 307-308, 363 Capetian dynasty, 227-228, 303 Galilee: Beth Alpha Synagogue, 65, Exarchate, defined, 370 Flamboyant style, 345 66 Exedra, defined, 370 Goths and, 356 Galla Placidia, 32, 33, 38 Exeter Cathedral, 312, 313, 363 Hundred Years War, 303, 335-336 Mausoleum of, **13**, 14, **39–40**, 357

Gallienus, 7
Games, symbolic meaning of, 309
Gargoyle, defined, 370
Garth, defined, 371
Gelduin, Bernard, 205, 207
Genesis images, 19, 121, 200. See
also Adam and Eve
George, St., 335, 336-337, 351
Gepids, 77
Gerald of Wales, 100
Gerbert of Aurillac, 161, 175
Germanic tribes. See Barbarians
Germany
chronology of events, 359–365
Gothic art and architecture,
290–295, 319–322, 338,
344–346
Ottonian art and architecture,
173–190
Parler style, 321–322, 344–346
Romanesque architecture,
194–201
See also Carolingian architecture;
Carolingian art; Franks; <i>specific</i>
cities, churches, and cathedrals
Gero, Archbishop, 180–181
Gero Codex, 176 , 177
Gero Crucifix, 180 , 181
Gervase of Canterbury, 247–248
Gesso, defined, 371
Ghibelline party, 194
Giotto di Bondone, 326, 329–332,
363
Gisant, defined, 371
Gisela, Queen, 174
Gislebertus, 210–212
Glory, defined, 371
Gloss, defined, 371
Gloucester Candelstick, 225, 226,
361
Gloucester Cathedral, 339-341, 363
stained glass, 340
tomb of Edward II, 315 , 316, 338
Godescalc Gospels, 110–111, 359
Godoman, 171
Gold tesserae, 37, 43, 58, 64, 130
Golgotha, 28-29, 247, 371
Good Shepherd image, 13-17, 39
Gorm the Old, 89, 168–169
Gorze, Abbey of, 191
Gospels, defined, 371
Coopers, demises, o/ 1

Gospels of Otto III, 155, 178, 179, Gospels of Theodelinda, 81 Gothic architecture, see also specific cathedrals, 264-275, 296-300 in Catalonia, 324-325 characteristics of, 240, 264-267, 322, 334 "creation by division," 275 Decorated style, 310-319, 345 in England, 285-290, 310-316, 338-344, 341-342 first cathedrals, 233-234, 240-247 first churches, 229-234 flying buttresses, 244 in France (Flamboyant style), 345 in France (Rayonnant style), 296-300 in Germany, 290-295, 319-322, 338, 344-346 Gothic aesthetics, 275, 338 Isabellan Gothic, 342–343 in Italy, 295-296 Mudejar architecture, 323–324, 342-343 Parler style, 321-322, 338, 344-346 Perpendicular style, 315-316, 338, 341-342 phases of Rayonnant style, 304-305 Romanesque influence, 245 secular, 229-230, 336-338 seven-spire church, 274 in Spain, 342-343 synagogues, 322-324 Gothic art art of the year 1200, 251-256 books for women, 250-251 Byzantine influence, 141, 253, 258, 290, 293 characteristics of, 236, 334 embroidery, 316-319, 348 enamels, 246-247, 253-255 in England, 247-250, 316-319 Flemish masters, 350-351 in France (Rayonnant style), 275, 296-300, 303-310 in Germany, 290-295, 319-322 "Gothic" term, 229 heraldry, 338, 348

in Italy, 295-296, 326-334 late style, 335-353 luxury arts, 306-307 manuscript illumination, 248–253, 307, 308–310, 316–317, 348-349 mature style, 259-301 metalwork, 307-308, 329 Neoplatonic aesthetics and, 236 origins of, 227-258 painting, 321, 335, 337-338, 350-351 Rayonnant style, 303-334 sculpture, 236-240, 246, 254, 256-257, 303-305, 319-321, 327-328, 350, 352 spread of, 256-258 stained glass, 227, 234-237, 246, 261-264, 304-306 tapestries, 347-348 Goths art of, 77, 79-82 history of, 78, 356-357, 366 sack of Rome (410), 32, 357 Gozbert, Abbot, 108 Gradual, defined, 371 Granada, 290, 336, 365 Grandval Bible, 121, 121 Grapes, baskets of (paradise symbol), 63, 64. See also Vineyards Great Britain. See England and British Isles Great Mosque (Córdoba), 143, 144, 145, 359 Greece Church of the Dormition, 138 Church of Hosios David, 43, 357 Greek cross, 368 Greek Fathers, 4, 373 Monastery of Hosios Loukas, 135, 136, 137 Greek-cross plan for churches, 28, 55, 106, 135, 371 Gregorian Reform, 192 Gregory I, Pope (the Great), 81, 91, 103, 177, 358 Gregory VII, Pope, 192, 199, 361 Gregory Master, 177-178 Gregory Nazianzus, St., 373 Gregory, St., 6, 373 Gregory of Tours, 82, 84

Grey Friars. See Franciscans Griffin, 373 "Gripping beast" motif, 89 Grisaille, 351, 374 glass, 305-306 painting, 308-309 Grodecki, Louis, 300 Groin, defined, 371 Groin vault, 163, 189-190, 344, 377 Guelfs, 194, 197 Guiford of Cerdana, 163 Guilloche, defined, 371 Gummersmark Brooch, 86 Gunzo, 208 Gutenberg Bible, 353 Guzmán, Domenico, 295, 396

Habit, defined, 371 Hadrian I, Pope, 104 Hagia Sophia (Constantinople), 46, **49-51**, **53**, 357 apse mosaic, 128, 359 destruction during Nika rebellion, dome, 50, **51**, 55, 357 icons restored to, 74, 129 Islamic discs, 128 rebuilt under Justinian, 48-55 refurbished after iconoclastic controversy, 129-130 Haito, Abbot, 108 Hakam II, 144 Hall church, 324, 344, 371 Halo, 176, 371 Hammerbeam, defined, 371 Hapsburgs, 319 Harald Bluetooth, 89, 169 Harpy, 373 Harrowing of Hell, 371 Haunch, defined, 371 Heaven and Hell. See also Descent into Limbo Heaven and Hell image, 173. See also Paradise Heinzelman, Konrad, 344 Helena, St., 2, 28 Helios image, 19-20, 65, 356 Hemicycle, defined, 371

Hemmel, Peter, 351

Henderson, George, 93

Henry I, 227, 228 Henry II, 181, 228, 247, 361 Pericopes of, 118 Henry III, 285, 310 Henry IV, 361, 364 Henry V, 364 Henry VII, 336, 342 Henry the Fowler, 173 Henry of Reynes, 310 Heraldry, 338, 342 heraldic alternation, 235 rampant, 376 tapestries and, 348 Heresies, 371. See also specific heresies Hermes, 16 Herod and Herodias, 300 Herrad of Landsberg, 250–251, 252 Hersfeld, monastery at, 182 Hetoimasia, defined, 371 Hezelo, 208 Hiberno-Saxon style of painting, 94, 110, 170 Hieratic, defined, 371 Hildebrand, 191-192, 361 Hildegard of Bingen, 250, 251 Hildesheim. See St. Michael, Church of (Hildesheim) Historiated, defined, 371 History of the Goths, Vandals, and Suevi (Isidore of Seville), 80 Hitda, Abbess, 179 Hitda Gospels, 179 Hodegetria, defined, 371 Hohenstaufens, 194 Holcombe Mirror, 76 Holy Apostles, Church of the (Constantinople), 28, 55, 358 Holy Cross, Church of the (Schwäbisch Gmünd), 321, 322, 363 Holy Ghost, 371 dove as symbol for, 17, 18, 309 The Holy Family (Petrus Christus), **338**, 364 Holy Roman Empire, 319 chronology of events, 356-365 Holy Sepulchre, Church of the (Jerusalem), 28, 29, 30, 356 Holy Trinity, Convent of the (Essen), 183

Holy Women at the Tomb image, 30, 60, 61, 71, 171 Homily, defined, 371 Honnecourt, Villard de, 240, 283 Honorius, 32 Hood molding, defined, 371 Horseshoe arch, 143, 144, 158, 159, 165, 371 Hortus deliciarum (Herrad of Landsberg), 250-251, 252 Hosios David, Church of (Thessalonika), 43, 357 Hosios Loukas, monastery of, 135, 136, 137 Hospice, defined, 371 Host, defined, 371 Hours, defined, 371 Hradcany Castle, 344, 345, 364 Hrolf, 88 Hugh of Semur, Abbot, 156, 166, 208 Hugh, St., 310 Humor, in English Gothic art, 287 - 288Hundred Years War, 303, 335-336, 363 Huns, 78-79, 356, 357 Hurley, William, 315 Hus, John, 335, 364 Hypatius of Ephesus, 54 Ichtus monogram, 373 Iconoclasm, 72-74, 103, 358, 376 Iconography, defined, 371. See also Symbols in Christian art Iconostasis, defined, 367, 371 Icons, 72, 73, 74, 140, 141, 141, 371 Idealism, 8 IHC, IHS monogram, 373 Immortality, peacock as symbol of, Impost block, defined, 371

Impost, defined, 371

Ingeborg Psalter, 251, 253

Inhabited initial or scroll, defined,

Ingeborg, 228, 251

Ink preparation, 119

INRI monogram, 373

Intaglio, defined, 371

371

Interpretation of Christian art, 16, 18, 22. See also Symbols in Christian art Iona, monastery at, 91, 357 Ireland St. Patrick and, 357 stone crosses of, 93, 359 Irene, Empress, 74 Isaac, binding of, 62, 65, 66, 119 Isabella of Hainault, 228 Isabellan Gothic architecture, 342-343 Isabelle of Angoulême, 228 Isidore of Seville, 80, 358 Isidorus of Miletus, 50-52 Isis, 5 Islamic architecture, 144-146, 212 Islamic art, 145-148. See also Mozarabic art Istanbul. See Constantinople Italy chronology of events, 356-365 Cosmati work, 197, 326, 371 Gothic art and architecture, 295-296, 325-334 Langobards (Lombards) and, 80-82, 358 Lombard-Catalan style, 161–166 Ostrogoths, 78-79, 357 Romanesque architecture, 194-201 See also Carolingian architecture; Carolingian art; Charlemagne; Ottonian art and architecture; specific cities and churches Ivories, 5 Byzantine, **67**, **68**, **132** Carolingian, 110, 113, 114, 118 early Christian period, 30, 34, 35 Ottonian, 175, 181, 182 Rayonnant Gothic, 303, 304, 307 Jacob of Voragine, 2

Jacob of Voragine, 2
Jamb, defined, 371
James, St., 157, 256
tomb of. See Santiago de
Compostela, Cathedral of
Jarrow, Monastery at, 92
Jarrow, monastery at, 92
Jeanne d'Evreux, Queen, 307–308,
363

Jerome, St., 356, 373 Ierusalem Church of the Holy Sepulchre, 28, 29, 30, 356 Crusades and, 192, 361 fall of, 143, 358 Saladin and, 362 Jesse, Tree of, 219, 220, 237, 256, **316**, 372 Jewelry and gems Anglo-Saxon, 89-90 Carolingian gem and metalwork, 124-125 Goths and, 77, 79-80 polychrome style (gem style), 77, Rayonnant Gothic, 307 Scandinavian art and, 86 torque, 377 See also Fibulae Iewish art and architecture Altneuschul (Prague), 322, 323, 363 Beth Alpha Synagogue (Galilee), building of synagogues banned, 67 Dura-Europos Synagogue (Syria), **14**, 15, 356 el Transito (Toledo), 323, 324, 363 Gothic period, 322-324 influence on early Christian art, 35 mosaics in early Byzantine period, 65, **66**, 67 pre-Constantine art, 14–16 Joan of Arc, 336, 364 Jocelin, Bishop, 286 John II, 129 John the Baptist, St. Carolingian ivory, 113, 114 Gothic metalwork, 329 Gothic sculpture, 300 Romanesque metalwork, 195 John of Damascus, St., 74 John the Evangelist, St., 40 Carolingian manuscript illumination, 113 eagle as symbol for, 79, 373 friendship with Christ, 321 Gothic sculpture, 294 lion image and, 94, 95

John, King, 285

Jonah, 18, 19 Joseph Master, 284-285, 321 Joseph, St., 285 Joshu Roll, 130, 131 Jouarre, monastery at, 84-85 Crypt of St. Paul, 84, 358 Judas, 211, 309, 331, 332 The Judgment of Jesus (play), 350 Iulianus Argentarius, 56 Junius Bassus, Sarcophagus of, 21, 22, 356 Jupiter, 22 Justinian, 47-55, 357 building program, 48–55 building of synagogues banned, 67 ivory image, 67, 68 mosaic images, 47, 62, 63 Nika Revolt, 48 Jutes, 79, 89 Kaiserdom, defined, 372

Katholikon, defined, 372

136, 137

Katholikon (Hosios Loukas), 135,

Keep, defined, 193, 372 Kells, Book of, 96-97, 98, 99, 359 Kerdyff, John de, 318 Keystone, defined, 372 Kiev: Cathedral of St. Sophia, 139, King's College Chapel (Cambridge), 341, **342**, 364 Klosterneuberg alter, 253-254, 255 Knights of the Garter, 336 Knop, defined, 375 Komnenian dynasty, 129-132 Komnenos, Alexios, 129, 192 Komnenos, Manuel, 3 Koran, 146, 372 Kraft, Adam, 344 Kufic script, 147, 372 Kunigunde, Queen, 181

La Tène Celts, 75–76 La Tène III, **75** Label, label-stops, 372 Lady Chapel, defined, 372 Lady Day, 375 Lamb of God image, **124** Lamech, **200** Lancet window, defined, 372 Landscapes, as symbols of paradise, Light of the World image, 20 See also Hosios Loukas, monastery Limbo, 374 Langlois, Jean, 304 Limbourg Brothers, 296, 337, 349 Lulav (palm frond), 65, 66 Langobards (Lombards), 79, 358 Limoges cross, 246, 247 Lunette, defined, 372 art of, 80-82 Lincoln Cathedral, 310, 311, 362 Lustre painted ware, 147, 372 Charlemagne and, 102 Lindau Gospels, 124, 125 Luzarches, Robert de, 273 Laon Cathedral, 240, 241, 242, 244 Lindisfarne Gospels, 96, 97, 98, 358 Lappet, defined, 372 Lindisfarne, monastery at, 91, 358, Mabel of Bury St. Edmonds, 318 Last Judgment imagery 359 Macedonian dynasty, 129 Gothic painting, 290, 291, 330 Linenfold, 338, 372 Machaut, Guillaume de, 307 Gothic sculpture, 256, 278, 280 Lintel, defined, 372 Machicolation, defined, 372 Madeleine, Church of the (Vézelay), Romanesque sculpture, 211 arcuated, 366 Lateran Baptistery, 111 Lion **212–214**, 361 Latin cross, 368 in Gothic sculpture, 278 Maestà alterpiece (Siena), 331, 332, Latin Fathers, 4, 370 as symbol of St. John, 94, 95 363 as symbol of St. Mark, 94, 370 Lauratron, defined, 372 Maestà, defined, 372 Lavabo, defined, 372 Liturgical cycles. See Feasts of the Magdeburg Church Lawrence, St., 33, 38, 38-41 Cathedral of, 182 Liturgy, defined, 372 Lazarus, St., 210 Magdeburg Ivories, 175 le Loup, Jean, 270 Liuthard, 124 monastery at, 174 Loculi, defined, 15, 372 Leaning Tower of Pisa, 199, 201, 362 Magi, defined, 372 Lectern, defined, 372 Loggia, defined, 372 Magistri comacini, defined, 163, 372 Lectionary, defined, 372 Lombard architecture, 81-82 Magnus, Albertus, 295, 363 Leo I, Pope (the Great), 32, 35, 38, Lombard-Catalan style art and Magyars, 115, 156, 174 architecture, 161-166, 183, 201 Mainz, Cathedral of, 182 357 Leo III, Emperor, 74 Maius of Escalada, 159-160 Lombards. See Langobards Leo III, Pope, 101, 104 (Lombards) Majuscule, defined, 372 Leo IX, Pope, 191, 212 London: Westminster Abbey, 197, Mâle, Émile, 300 Leo V, Emperor, 74 310, 342, **343**, 364 Malouel, Jean, 350 Leo VI, Emperor, 129, 130 Lorenzetti, Ambrogio, 333–334, 363 Man with a toothache, 288 Leo of Ostia, 196 Lorenzetti, Pietro, 333-334 Mandorla, 176, 178, 371 Letters of Gregory, 177, 178 Loros, 133 Mandyleon of Edessa, 72 Levi, Samuel, 323 Lorris, Guillaume de, 284 Manger scene, 326, 327 Liber Pontificalis, 372 Lorsch Gospels, 113, 114, 176, 359 Maniple, defined, 372 Liber Scivias (Hildegard of Bingen), Manuscript illumination, 160 Lothair I, 114 250, 251 Louis VI (the Fat), 227, 230 bas-de-page, 309, 317, 366 British Isles, 94-99, 170-173, Liber Vitae, 372 Louis VII, 227-228, 231, 361 Liber Vitae of New Minster, 172, Louis IX (St. Louis), 259, 260, 280, 288, 316-317 **173–174**, 360 296-299, 303-304, 310, 362 Byzantine, 68-72, 130-132 Liberal Arts educational system, 372 Louis X, 303 Byzantine influence, 141 Libri Carolini, 103 Louis XI, 336 Carolingian, 110-113, 115-125, Lierne, 310, **312**, 372 Louis the German, 114 170 Life of Charlemagne (Einhard), 102 Louis the Pious, 114, 115, 120, codex form, 69, 368 Light 359 colophon, 159, 368 Byzantine architecture and, 52, 54 Louis the Stammerer, 115 drôleries, 369 Byzantine mosaics and, 130 Luitprand, 81, 174 Gothic (early), 248-253, 299 Gothic architecture and, 232–233, Luke, St. Gothic (English), 288, 316-317 236, 344 bull as symbol for, 370 Gothic (late), 348-349 Neoplatonic aesthetics and, 54, icons painted by, 72, 140 Gothic (mature), 259, 299 58-59, 236 Ottonian manuscript illumination, Gothic (Rayonnant), 307, See also Stained glass 178 308-310

Hiberno-Saxon style, 94, 110, 170, 369 icons and, 141 ink preparation, 119 Kufic script, 147, 372 majuscule, 372 Merovingian, 85 miniscule, 110, 377 Mozarabic, 159–160	Matthew, St. Book of Durrow, 95 Lindisfarne manuscript illumination, 96, 97 man as symbol of, 94, 95, 370 angel as symbol of, 370 Maurice, Bishop, 280 Mausoleum, defined, 373 Mausoleum of Galla Placidia (Ravenna), 13, 14, 39–40, 357	Miter, defined, 373 Mithraism, 6, 17 Moat, defined, 373 Modena Cathedral, 200, 201, 361 Moissac: Church of St. Peter, 214, 216, 217 Molding billet molding, 369 defined, 373 dog-tooth molding, 287, 369
Ottonian, 155, 176–179 parchment, 378 purple vellum for, 69	Mausoleum of the Julii (Rome), 19, 20	hood molding, 371 roll molding, 376
Romanesque, 226	Maxentius, 9	string-course, 377 Monasterboice, cross at, 93
scriptoria, 159, 200, 372	Maximianus, Archbishop, 57, 62 Meander pattern, defined, 373	Monasteries, 373
Winchester style, 170–172 Marburg: Church of St. Elizabeth,	Medium, defined, 373	Benedictine plan, 166, 16 7
246, 293	Melchizedek, 119, 264, 300	Cluny III plan, 209 , 210
Maria Regina, defined, 372	Menorah, 65, 66 , 183	St. Gall plan, 108, 109, 359
Marian cycle, defined, 4	Merovingian Franks, 82-89, 101	See also specific locations or saints
Mark, St.	Metalwork	Monasticism, 65
Carolingian manuscript	British Isles, 95, 96	Augustinians, 120
illumination, 111, 112, 115, 116	bronze casting, 186 , 187, 201	Benedictines. See Benedictine
lion as symbol of, 94, 370	Byzantine, 132, 133	monasticism
Marquetry, defined, 372	Islamic, 147, 148	book production and, 121, 159,
Martini, Simone, 346	Ottonian, 186 , 187, 188 , 201	210 Carelanciana 240, 250, 361, 367
Martyria, 26, 373	Rayonnant Gothic, 307, 308 , 329	Carthusians, 349–350, 361, 367 Charlemagne and, 102
Martyrology, defined, 373	Romanesque, 194 , 225 , 226	chronology of events, 357–364
Marville, Jean de, 349	Michael, Archangel, 67 , 68, 137, 366	Cistercians, 120, 216–219, 361,
Mary, images of. See Virgin Mary,	Michael, St., 278. <i>See also</i> San	368
images of Mary Magdalen, St., 212. <i>See also</i>	Michael de Escalada, Church of	Clares, 327
Holy Women at the Tomb image	Michelangelo, 364	Congregation of Cluny. See Cluny,
Masonry, Ashlar, defined, 366	Miègeville door, 207, 208	Congregation of
Mass	Mihrab, 144, 373	Divine Office, 372
canon of the Mass, 367	Milan	Dominicans, 295, 345, 362, 372
collects, 370	Church of St. Ambrose, 201, 202,	Franciscans, 295, 326-327, 362,
defined, 373	361	374
origins of, 5	detroyed by Huns, 357	monks, canons, and lay abbots,
Master of the Antique Figures,	Millefiori, defined, 373	120
282–283, 284	Millefleur tapestry, 373	See also Manuscript illumination
Master of the Ingeborg Psalter, 283	Milvian Bridge, Battle of the, 356	Monkwearmouth, abbey at, 92
Master Matthew, 256	Minaret, 144, 373	Monograms and symbols of Christ,
Master of the Morgan Leaf, 248–249	Minbar, defined, 373	373 Manaphysites 33 34 38 48 373
Master Nicholas of Ely, 289	Miniature, defined, 373	Monophysites, 33–34, 38, 48, 373 Monotheistic cults and religions, 6,
Master of St. Denis, 297	Minster, defined, 373 Minuscule, defined, 373	373
Master of the Smiling Angels, 284		Monsters and fabulous beasts, 373
Materia Medica (Dioscorides), 68, 69 , 357	Misericord, defined, 373 Missal, defined, 373	in Gothic tapestries, 347, 348
Matilda, Abbess, 183	Missorium, defined, 373	in Romanesque metalwork, 225
Matilda, Abbess, 165 Matilda, Countess, 199	Missorium of Theodusius, 11, 12,	in Scandinavian art, 86–89, 169
Matroneum, defined, 24	356	See also Dragons; Serpents
	we to 10	~ .

Monte Cassino, monastery at, 115, 156, 195-196, 357 Montmartre, 231 Montreuil, Peter de, 297 Moors, 157, 290 Isabellan Gothic art and, 343-344 Mudejar architecture, 323–324, 342-343 See also Islamic architecture; Islamic art; Mozarabic art Moralized Bible, 259 Morgan Beatus, 160 Morgan Leaf, 248, 249 Morocco. See Rabat: Oudaia Gate Mosaics abstraction and, 20, 59, 59-60, 65, 130 Byzantine, 58–67, 128–130, **138**, **149**, **150**, 151 defined, 373 early Christian period, 13, 19-20, **27**, 35, **36**, **37**, 38–42 Jewish, 65-67 Romanesque, 198 Mosan, Belgium enamels, 232, 251, 253-255 metalwork, 194 Stavelot Triptych, 1, 2, 3 Moses, 35, 36, 350 Mosques, 144-146, 374 Great Mosque (Córdoba), 143, 144, **145**, 359 parts of, 144 Mother and child image Byzantine icons, 73 Byzantine ivory, 132 Byzantine mosaics, 128 Carolingian ivory, 113, 114 early British Isles, 99 early Christian period, 18, 19 Gothic manuscript illumination, Gothic painting, 337, 338 Gothic sculpture, **239**, **277**, 278, Gothic stained glass, 263, 264, Rayonnant Gothic ivory, 303, 304 Rayonnant Gothic metalwork, 307, 308

Romanesque manuscript illumination, 219, 220 See also Theotokos (Mother of God) image Motte-and-bailey castles, 193, 366, 373-374 Mouchettes, 345 Mount Sinai. See St. Catherine, Church of Mozarabic art, 157-161, 202, 204 Mudejar architecture, 323-324, 342-343 Muldenstil, defined, 374 Multiple-fold drapery, 374 Muqarnas (mukarnas) ceilings, 146, 152, 323, 373 Muslims, 115, 143-144 chronology of events, 358-365 Sicily and, 129 Spain and, 157-161, 358 See also Islamic architecture; Islamic art Naos, defined, 373 Narrative mode in Western art, 3, 50, 334 Narthex defined, 24, 374 Galilee porch, 166, 370 Nativity cycle, defined, 4 Nativity image Byzantine mosaic, 151, 152 Italian Gothic painting, 326, 327, Naumberg Cathedral, 293, 294, 362 Nave, defined, 31, 374

Necropolis, 374 Neoplatonic aesthetics, 54, 58-59, 130, 236 Neoplatonic One, 6 Nero, Emperor, 356 Neskhi, defined, 374 Nested V-fold drapery, 374 Nestorianism, 374 Net vault, 312, 322, 344, 374 New Minster Charter, 170, 171, 360 Nicaea, First Council of, 11, 359 Nicaea, Second Council of, 74 Nicholas of Ely, 289 Nicholas of Verdun, 282-283, 362 alterpiece, 253-254, 255

Nika Revolt, 48 Nimbus, defined, 371 Ninian, St., 90 Niphoros II, 129 Noah, 200 Nodding ogee arch, 312, 374 Nook shaft, defined, 374 Norman Palace (Palermo), 153 Normans Abbey Church of St. Denis and, 231 - 232conquest of England, 360 conquest of Sicily, 141, 148-153, Pope Gregory VII and, 192 Romanesque art and architecture of Normandy and England, 222-226 sack of Rome, 196, 361 Norway, 168-170. See also Scandinavian art Notre-Dame, Cathedral of (Chartres). See Chartres Cathedral Notre-Dame, Cathedral of (Paris), 242, 243, 244, 245, 246, 280, 297, 362 Rayonnant style changes, 297 sculpture, 244, 245, 246, 280 Notre-Dame, Church of (Fontevrault), 220, 221 Notre-Dame-la-Grande, Church of (Poitiers), 222 Nuremberg: Church of St. Lawrence, 344-345, 346, 347

Niello enamel, 254, 374

Octateuch, defined, 374 Oculus, defined, 374 Odo, Bishop of Bayeux, 226 Odo of Metz, 103, 104 Odovacar, 79 Ogee arch, 312, 345-346, 374 Oil painting, 350–351 Olaf, St., 169 Olga, Queen, 139 Oliba, Bishop, 161, 163 Oliba Cabreto, 161, 163 Omar, Caliph, 143, 358 On the Diverse Arts (Theophilus), 119, 225, 237

Italian Gothic, 326, 327, 329, One point linear perspective, 375 Opus alexandrium, 374 330-333 Romanesque, 202, 203, 213, 215, Opus anglicanum, 317-318, 374 Passion cycle Opus francigenum, 374 221, 222, 226 Opus reticulatum, 374 See also Fresco; Manuscript Orant, defined, 374 illumination Palace Chapel (Palermo), 146, 149, Oratory, defined, 374 Oratory of Sta. Maria-in-Valle, 81, 150, 151, 152 ceiling of nave, 146 22 - 2382 Orb, defined, 374 mosaics, 152 d'Orbais, Jean, 270 Palatine Chapel, defined, 374 Order (architectural), defined, 374 Paleography, defined, 369, 374 Order (ecclesiastical), defined, 374. Palermo See also Monasticism Muslim conquest of Sicily and, Order of the Golden Fleece, 336 144, 359 Order of the Star, 336 Norman kingdom in Sicily and, Orders (Holy Orders), defined, 374 148-153 Norman Palace, 153 Orpheus, 16 Oseberg ship, **87–88**, 89, 359 Palace Chapel, 146, 149, 150–152 Osiris, 5 Pallium, defined, 374 Palm Ostrogoths, 78-79, 357 Otto I (the Great), 156, 174, 175 palm fronds (lulav), 65, 66 Otto II, 174 symbolic meaning of, 17, 18 Otto III, 113, 155, 174-175, 360 Palmette, defined, 378 Paulinus, St., 91 Ottonian art and architecture, Panofsky, Erwin, 244, 300 173-190, 360 Pantokrator Peacock, 111 Byzantine mosaic, 138-139, 149, architecture, 182-190 Byzantine influence, 174-176 151, **152** Carolingian influence, 181, 183 Gothic sculpture, 239 Pedro III, 325 Romanesque sculpture, 217 church treasures, 180-182 Lombard-Catalan influence, 183 See also Christ in Glory/Majesty manuscript illumination, 176-179 image Papal States, 194, 290 sculpture, 186, 187, 188, 201 Papil Stone, 94 Oudaia Gate, Almohad (Rabat), 145 Oviedo: Church of Sta. Maria de Paradise, 374 symbols of, 63, 64, 111 Naranco, 157, 158 Ox, as symbol for St. Luke, 178, 370 Parapet, defined, 374 Oxford University, 341-342, 362 Paray-le-Monial, Church at, 210 Parchment, defined, 374 Padua: Arena Chapel, 329, 330-331 Paris Cathedral of Notre-Dame. See Pagan art. See specific peoples Pagan images in Christian art, 16, Notre-Dame, Cathedral of 341 - 34219-20, 26-27, 68, 118

Papil Stone, 94
Paradise, 374
symbols of, 63, 64, 111
Parapet, defined, 374
Paray-le-Monial, Church at, 210
Parchment, defined, 374
Paris
Cathedral of Notre-Dame. See
Notre-Dame, Cathedral of
city walls, 228–229
Sainte-Chapelle, 296, 297, 298, 299, 362
St. Denis. See St. Denis, Abbey
Church of
Paris Psalter, 130, 131
Parish, defined, 374
Parler, Heinrich, 321, 363
Parler, Peter, 321–322, 344, 363

Painting, 327

Anglo-Saxon, 172

Carolingian, 109-114

German Gothic, 321

Gothic, 335, 337, 338

English Gothic, 290, 291

Flemish masters, 350, 351

grisaille painting, 308–309, 351

Parler style, 321-322, 338 Pascal II, Pope, 192 Pasch, defined, 374 defined, 4, 374-375 early Byzantine manuscript illumination, 72 early Christian sarcogphagi, Gothc painting, 327 Gothic manuscript illumination, Gothic sculpture, 294 Ottonian bronze casting, 186, 187 See also Crucifixion image; Holy Women at the Tomb image; Resurrection image Passion Sarcophagus, 22, 23 Paten, defined, 375 Patriarch, defined, 375 Patrick, St., 90, 357 Paul the Deacon, 80, 102 Paul the Hermit, 84 Paul, St., 84, 152, 358 Pectoral cross, 375 Pediment, defined, 375 Pedro the Cruel, 323 Pendant vault, 375 Pendentive, 50, 51, 375 Penitential Psalms, 375 Pentateuch, defined, 375 Pentecost, defined, 375 Pepin II (of Herstal), 102, 359 Pepin the Short, 102, 111 Pericope, defined, 375 Pericopes of Henry II, 118 Peristyle, defined, 375 Perpendicular style, 315-316, 338, Perspective, 59, 333, 334 types of, 375 Peter, Abbot, 115, 225 Peter, St. Gothic painting, 290, 291

martyrdom of, 22

and plan for Cluny III, 208

rooster as symbol for, 375

See also Apostles, images of

Philip I (Philip Augustus), 227, 228,	Plate drapery, 375
251, 259, 285	Plate tracery, 377
Philip III (the Bold), 303	Platonic cosmology, 6
Philip IV (the Fair), 303	Plinth, defined, 377
Philip V, 303	Plotinus, 54, 58, 130. See also
Philip the Good, 364	Neoplatonic aesthetics
Philip of Valois, 303	Poitevin façade, 221
Photios, Patriarch, 129	Poitiers, Battle of, 336
Picts, 79, 90, 93, 94 Piers, defined, 375	Poitiers, Cathedral of (St. Pierre's),
	245, 246 , 362
compound pier, 165, 368	stained glass, 227 , 228, 236
paired cylindrical piers (first use), 234	Poitiers, Church of Notre-Dame-la- Grande, 222
<i>Pietà</i> image, 321, 375	Polychrome style (gem style), 77, 89
Pilaster, defined, 190, 375	Polychromy, defined, 377
Pilate, 188, 375	Poore, Richard, 288
Pilgrimages, 375	Porphyrogenitus, defined, 377
Christ as Pilgrim image, 204	Portraiture
"Pilgrimage style" Romanesque art	Constantine and, 9
and architecture, 202–208	early Byzantine, 63
sites of. See Gloucester Cathedral;	Gothic manuscript illumination,
Holy Sepulchre, Church of the	307
(Jerusalem); Santiago de	Gothic painting and, 334
Compostela, Cathedral of; St.	Gothic sculpture and, 283–285,
Peter, Basilica of (Rome)	304–305
The Pilgrim's Guide, 204, 206	iconoclasm and, 72-74
Pinnacle, defined, 375	Ottonian, 178–179
Piranesi, G. B., 31-32	representation of figures full face
Pisa	with profile legs and feet, 65, 66
cathedral complex at, 199, 201,	Powers (order of angels), 137
360	Prague
Leaning Tower, 199, 201, 362	Altneuschul, 321 , 322
Pisano baptistery, 327, 328 , 363	Precentor, defined, 375
Pisano, Andrea, 329	Predella, defined, 375
Pisano, Giovanni, 328–329, 363	Presbyters, defined, 375
Pisano, Nicola, 327–328, 363	Presentation in the Temple image,
Piscina, defined, 375	186 , 188, 282, 285
Pistoia: Church of Sant' Andrea,	Principalities (order of angels), 137
328–329	Priory, defined, 377
Pizan, Christine de, 33 7, 348, 364	Procopius, 47–48, 55
Plague, 313, 333–336	Propylaeum, defined, 377
Plants and foliage	Proskynesis, 130
acanthus leaves, 170	Prothesis, defined, 24, 38, 377
English Decorated style	Psalms, Penitential, 375
architecture, 310, 312	Psalters
palms and palm leaves, 17, 18, 65,	Cathach, 91
66	defined, 375
rinceau, 376	Ingeborg Psalter, 251, 253 Master of the Ingeborg Psalter, 283
as symbols of paradise, 63 , 64, 111 tapestries and, 348	Master of the Ingeborg Psalter, 283 Paris Psalter, 130, 131
vineyards, 19	Psalter of St. Louis, 299
,	

Queen Mary Psalter, 316, 317, 363 Utrecht Psalter, 115–116, 117, 118–119, 170–172, 188 Windmill Psalter, 316, 317 Pseudo-Dionysius the Areopagite, 54, 236 Public ministry cycle, defined, 4 Pucelle, Jean, 308–310, 333 Pulpits, 327, 328, 375 Pulpitum, defined, 375 Putti, defined, 375 Pyx, defined, 375

Qibla, 144, 375 Quadrant vault, 206 Quadripartite vault, 375 Quadruped, 373 Quatrefoil, 287, 329, 376 Queen Mary Psalter, 316, 317, 363 Queen of Heaven image, 37 Quincunx, 135, 376

Rabat: Oudaia Gate, 145
Rabbula Gospels, 70, 71, 72, 113, 358
Raedwald, 89
Ragnarok, 89
Rainier of Huy, 195
Ramiro I, 157
Rampant, defined, 376
Raphael, Archangel, 137, 366
Ratger, Abbot, 106
Ravenna
Baptistery of the Orthodox, 40, 41–42, 43, 357

41–42, 43, 357
Church of S. Apollinare Nuovo, 56, 59, 60, 61, 357
Church of S. Vitale, 47, 56, 57, 58, 59, 61, 62, 63, 104, 358
Church of Sta. Croce, 33, 38–39
early Christian architecture, 38–42
government moved to, 12, 32, 357
Mausoleum of Galla Placidia, 13, 14, 39–40, 357
Raymond of Burgundy, 192

Mausoleum of Galla Placidia, 13, 14, 39–40, 357
Raymond of Burgundy, 192
Rayonnant style, 296–300, 303–334
architectural phases, 304–305
in Catalonia, 324–325
English Decorated style, 310–319
in Germany, 319–322
in Italy, 325–334

luxury arts, 306–307	Rayonnant Gothic metalwork, 307,	Christian-Roman Empire of
manuscript illumination, 307,	308	Charlemagne, 101–103
308–310, 316–317	Stavelot Triptych, 1, 2, 3, 133	chronology of events, 356–365
origins of, 275	Repoussé, defined, 376	early Christianity and, 6
Perpendicular style and, 341–342	Reredos, defined, 376	See also Holy Roman Empire
sculpture, 327–328	Reserved, defined, 376	Romance of the Rose, 284
in Spain, 323–325	Respond, defined, 376	Romanesque architecture
stained glass, 304–306	Resurrection image, 20 , 22–23, 60 ,	"additive" nature of, 206, 300
Realism, 8, 278, 282, 334, 337	61, 198. See also Holy Women at	in Aquitaine, 219–222
Rebecca at the Well, 70	the Tomb image	Benedictine plan, 195–196
Reccared I, 79–80	Retablos, 325, 376	in Burgundy, 208–216
Recceswinth Crown, 80, 178, 358	Reverse perspective, 375	Cistercians and, 216–219
Recension, defined, 376	Rib, defined, 376	Cosmati work, 197–198, 326
Reconquista, defined, 157, 376	flying rib, 322	in Germany and Italy, 194–201
Refectory, defined, 376	tiercerone, 377	influence on Gothic architecture,
Regalia, defined, 376	Rib vault, 376, 377–378	245
Regensburg: Abbey of St. Emmeram,	Richard III, 336	Lombard-Catalan style and, 161
181	Richard the Lion-Hearted, 228, 362	Lombard influence, 81
Reginald, Bishop, 286	Riddles, Anglo-Saxon, 92	Order (architectural), defined, 374
Registrum Gregorii, 177 , 178	Rieth, Benedict, 344	"Pilgrimage style," 202–208
Reims Cathedral, 268, 270, 272,	Rinceau, defined, 376	secular, 193–194
273 , 301 , 345	Riquer, Bertrand, 324	Speyer Cathedral and, 188–189,
nave elevation, 268	Rite, defined, 376	194
plan, 26 7	Robert of Arbrissel, 220	Romanesque art, 191–226
Rayonnant style and, 299–300	Robert the Bruce, 315	"additive" nature of, 206, 300
rebuilt after fire of 1210, 362	Robert of Molesmes, 216, 361	Byzantine influence, 195, 202, 226
sculpture, 281, 284 , 285 ,	Robert the Pious, 227	Carolingian influence, 195
299–300	Roger I, 141, 148	in Catalonia, 201–202
stained glass, 300	Roger II, 141, 149–152	Cistercians and, 216–219
west façade, 271 , 282	Roger, Abbot, 216	East–West differences, 258
Reims, Gaucher de, 270	Roger of Helmarshausen, 225. See	influence on Gothic sculpture, 256
Rejas, 376	also Theophilus	manuscript illumination, 219–220,
Relics, 26	Roland, Count, 103, 261, 358	226
confessio, 368	Roll molding, 376	metalwork, 225–226
defined, 376	Rollo, 88	mural painting, 202–203, 213,
pilgrimages and, 205–206	Roman art	215, 221–222, 226
of Santa Bona, 327	abstraction in, 20	"Pilgrimage style," 202–208
of St. Anne, 264	5th century classical revival,	Romanesque aesthetics, 204, 206,
of St. Apollinaris, 56	33–38	219, 300
of St. Boniface, 105–106	traditional, 6–9	sculpture, 199–201, 204, 207–216
of St. Hugh, 310	Roman Church	Rome
of St. Lazarus, 210	Babylonian Captivity, 303, 364	Arch of Constantine, 7, 8 , 9–10,
of St. Mary Magdalen, 212	Celtic Christianity and, 91–92, 95	356
of St. Valerien, 16	Great Schism (rival Popes), 335,	Arch of Titus, 6, 7, 183, 356
tabernacle, 376	364	Basilica of St. Paul Outside the
of the True Cross, 1–3, 18, 28,	liturgical cycle, 4	Walls, 31, 32 , 33, 35, 38, 357
133, 297	split with Orthodox Church, 3,	Basilica of St. Peter. See St. Peter,
Relieving arches, 376	129, 191, 360	Basilica of (Rome)
Reliquary	See also Christianity	chronology of events, 356–357
châsse, 367	Roman Empire	Church of San Clemente, 196,
defined, 376	barbarians and, 78	197 , 198 , 361

Church of St. John Lateran, 25 San Apollinare Nuovo, Church of Scotus, Duns, 295 Church of Sta. Costanza, 26, 27, (Ravenna), 56, 59, 60, 61, 357 Scriptoria, 159, 210, 376 104, 356 San Clemente, Church of (Rome), Scrovengi, Enrico, 329, 331 Church of Sta. Maria Maggiore, 196, **197**, **198**, 361 Sculpture, 303-305 35, 36, 37, 38, 357 San Clemente, Church of (Tahull), Byzantine, **67**, **68** Church of Sta. Sabina, 24, 35, 202, 361 Carolingian, 109-113, 114 357 San Juan de los Reyes, Church of church façades, 221. See also cults, 5 (Toledo), 342, 343, 344, 364 specific churches and cathedrals fall of, 12 San Miguel de la Escalada, Church drapery. See Drapery funerary art (early Christian of, 158, 159 early Christian period, 9, 10, 19, period), 15-19 San Miniato al Monte (Florence), 21 - 23Mausoleum of the Julii, 19, 20 199 5th century, **34**, 35 sack of (410), 32, 33, 78 San Vincente, Church of (Cardona), first use of exterior decoration, 165 sack of (455), 32, 78 164, 165 Gothic (early), **231**, 236–237, sack of (1084), 196, 361 San Vitale, Church of (Ravenna), 56, 238–240, 246, 254, 256, 257 Sarcophagus of Junius Bassus, 21, **57**, 58, **61**, 104, 357 Gothic (late), 350, 352 22, 356 mosaics, 47, 59, 61, 62, 63 Gothic (mature), 275-285 Rood, defined, 376 Sanglier, Henri, 229, 233 Gothic (Rayonnant), 303, Rood screen, 367 Sant' Andrea, Church of (Pistoia), 304–305, 319, **320**, 321, 327, Rooster, as symbol for St. Peter, 375 328-329 328 Roriczer, Konrad, 344 Santa Bona Cross, 326 Greek, 143 Rosary, 345, 347 Santiago de Compostela, Cathedral Lombard-Catalan, 165 Round Table of King Arthur, 286 of, 157, 202, 205-207, 360 Ottonian, 175, 180, 181, 186, Rubble masonry, 376 first church at, 359 187, 188, 201 Rudolph of Hapsburg, 319 plan, 205 painted, 213 Rule, defined, 376 sculpture, 204, 256, 257 Romanesque, 199, 200, 201, 204, Rule of Benedict of Nursia, 65, 120 Sarah, 299 **207-208**, 209-213, **214**, Ruler of Heaven image. See Christ in Sarcophagus 216-217 Glory/Majesty image; defined, 376 tracery, 377 Pentokrator image early Christian period, 21-23, 356 traditional Roman, 6, 7 Rune, defined, 376 Merovingian, 84, 85 Scythian Birdman, 76 Rune stone, defined, 376 Sarcophagus of Agilbert, 84 Second Coming, images of, 37, 39, Russia and Russian art, 129, Sarcophagus of Junius Bassus, 21, 43, 239, 278 139-140 22, 356 Sedilla, defined, 376 Russian Orthodox Church, 139 Sarcophagus of Theodochilde, 84, Sedlmayr, Hans, 300 See, defined, 376 Sacramentary, defined, 376 Satan and the Foolish Virgins, 320, Senlis, Cathedral of, 251, 253, 254, Sacraments, defined, 376 362 Savin-sur-Gartempe, St., 245 Sacrifice, defined, 376 Sens Cathedral, 229, 233, 234, 240, Sacristry, defined, 38, 376 Saxons, 79, 89, 102 Sainte-Chapelle (Paris), 296, 297, Scallop shell, as badge of pilgrimage, Septimius Severus, 7 298, 299, 362 157, 204 Seraphim, 137, 376 Salisbury Cathedral, 246, 286, Scandinavia, 156, 360 Sergius, Pope, 85 **288–290**, 313–314, 362 Scandinavian architecture, 169 Serpents plan, 289 Scandinavian art, 86-89 in Anglo-Saxon art, 89 Salvation image, 15, 17. See also animal images, 76–77 basilisk, 377 Fisher of Souls image millenial art, 168-173 in Gothic sculpture, 278 San Ambrogio, Church of (Milan), Scholastica, St., 65 in Scandinavian art, 87-88, 201, 202, 361 Schwäbisch Gmünd: Church of the 169-170

Holy Cross, 321, 322, 363

Scots, 79, 90

Sexpartite vault, 376

Shetland Islands, 94

San Apollinare, Church of (Classe),

56, **63**, 64, 357

Ships, as burial vessels, 86–89, 359 Shofar, 65, **66** Sicily

Byzantine art and, 140–141 Cathedral at Cefalú, **137**, **149** Muslim conquest of, 129, 144, 359 Norman conquest of, 141, 148–153, 360 See also Palermo

Siena

mural paintings in City Hall, **333**, 334

Siena Cathedral, 328, **331**, 332, 363

Simson, Otto von, 300 Sistine Chapel, 365

Sixtus III, Pope, 32, 34–35, 37–38

Slavs, 139

Sluter, Claus, 349-350, 364

Soffit, defined, 376

Sol Invictus, 6, 20

Solar, defined, 376

Solomon, 263, 264, 316, 317

The Song of Roland, 103, 204

Soufflets, 345

Spain

Asturian and Mozarabic art, 157–161

Christian re-conquest of, 158, 192, 290, 361

chronology of events, 356–365 Isabellan Gothic architecture, 342–343

Islamic art and architecture in, 143–145

Mudejar architecture, 323–324, 342–343

Muslim conquest of, 157–161, 358

See also Catalonia; Ferdinand and Isabella of Spain; Visigoths; specific cities and churches

Spandrel, defined, 376

Speyer, Cathedral of, 188, **189**, 190, 194, 201, 360

Spire, defined, 376

Springers, defined, 376

Squinches, defined, 377, 376

St. Andrew's cross, 371

St. Catherine, Monastery of (Mount Sinai), 63, **64**, 65, 72, **73**, 357

apse mosaic, **64**, 65 icons, 72, **73**

St. Denis, Abbey Church of, 115, 229, **231**, **233**, 296, **297**

influence on Chartres Cathedral, 267

sculpture, 232

stained glass, 234

Suger's additions to, 231–233, 361

St. Elizabeth, Church of (Marburg), 246, **293**

St. Emmeram, Abbey of (Regensburg), 181

St. Étienne, Abbey Church of (Caen), **223**, 224–225, 360

St. Faith (Foy), Church of (Conques), 204, 205

St. Francis, Church of (Assisi), **295**, 296, 326, **327**, 362

St. Gall plan for ideal monastery, **108**, 109, 359

St. Genis-des-Fontaines, Church of, **165**

St. George and the Dragon (van der Weyden), 335, 351, 364

St. Germaine, Church of (Auxerre), 359

frescoes, 109

St. John, Church of (Ephasus), 357

St. John Lateran, Church of (Rome), 25

St. John, Monastery of (Zagba, Syria), 70

St. Lawrence, Church of (Nuremberg), 344–345, **346**, **347**

St. Lazare, Church of (Autun), **210–212**, 361

St. Mark, Cathedral of (Venice), **55**, 141, **142**, 360

St. Martin-du-Canigou, monastery and church at, **162**, **163**

St. Martin, monastery and church of (Tours), 84, 115, 121

St. Maximin, Abbey of (Trier), 177, 182

St. Michael, Church of (Hildesheim), 183, **184–185**, 186–187, 360 bronze doors, **186**, 201, 360

ceiling painting, 290, **292**, 293 plan, **184**

St. Ouen, Abbey Church of (Rouen), **306**

St. Paul, Cathedral of (Exeter), 312, 313

St. Paul Outside the Walls, Basilica of (Rome), 31, **32**, 33, 35, 38, 356

St. Peter, Abbey of (Gloucester). See Gloucester Cathedral

St. Peter, Basilica of (Rome), 19, **20**, **29–31**, 38, 356 founding of, 356

Leo I (Pope) and, 38

Mausoleum of the Julii (mosaic), 19, **20**

St. Peter, Church of (Moissac), 214, **216**, **217**

St. Philibert, Church of (Tournus), 166–167, **168**

St. Pierre's (Poitiers). *See* Poitiers, Cathedral of

St. Riquier, Abbey Church of (Centula), 106, **107**

St. Savin-sur-Gartempe, Abbey Church of, 221, **222**, 361

St. Sernin, Church of (Toulouse), 204, 205, **207–208**

St. Sophia, Cathedral of (Kiev), 139, 140

St. Trophime, Church of (Arles), **256**, 361

St. Urbain, Church of (Troyes), **304–305**, 363

St. Vitus, Cathedral of (Hradcany Castle), 344, **345**

Sta. Costanza, Church of (Rome), 26, **27**, 104, 356

Sta. Croce, Church of (Ravenna), 33, 38–39

Sta. Eulalia, Cathedral of (Barcelona), **324–325**

Sta. Maria de Naranco, Church of (Oveido), **157**, 158

Sta. Maria Maggiore, Church of (Rome), 35, **36**, **37**, 38, 357

Sta. María Pedralbes, Convent Church of (Barcelona), **325**

Sta. Sabina, Church of (Rome), **24**, 35, 357

C - : - 1 - 1	S = 1 = - : C :	
Stained glass	See also specific images	missorium of, 11, 12 , 356
construction of, 237	Synagogue of Dura-Europus, Syria,	official art under, 11–12
flashed glass, 306	14 , 15	Theodosius II, 29, 45–47, 72
Gothic (early), 227 , 228, 234, 235 ,	Synagogues	Theodulf of Orléans, 102, 103
236–237, 246	Altneuschul (Prague), 322, 323	Theolinda, 358
Gothic (late), 340	banned, 67	Theophano, Abbess, 183, 360
Gothic (mature), 261, 262–263 ,	Beth Alpha Synagogue (Galilee),	Theophanu, Empress, 174, 175
264, 272–273	65, 66	Theophany, defined, 43, 377
Gothic (Rayonnant), 304-305,	Dura-Europos (Syria), 14, 15, 356	Theophilus, 119, 225, 237
306	el Transito (Toledo), 323, 324, 363	Theotokos (Mother of God) image,
grisaille, 305-306, 351	Synod, defined, 377	377
heraldic alternation, 235	Synod of Whitby, 91–92, 95, 358	Byzantine manuscript illumination,
St. Bernard's aversion to narrative	Syria	70, 71
stained glass, 219	ceramics, 147	Byzantine mosaic, 129
Stalactite corbels, 343	Crusades and, 192	early Christian period, 37
Stalactite vault. See Muqarnas	metalwork, 148	Romanesque manuscript
(mukarnas) ceilings	Monastery of St. John (Zagba), 70	illumination, 219, 220
Star vault, 312 , 376	Rabbula Gospels, 70, 71 , 72, 113,	Thessalonika: Church of Hosios
Stations of the Cross, 376	358	David, 43 , 357
Stave church, 169, 170 , 377	synagogue and house-church of	Thimo, 294
Stavelot Triptych, 1, 2, 3, 133	Dura-Europos, 14–15 , 356	Thomas, St., 181, 182
Steinbach, Erwin von, 319	1	Thrones (order of angels), 137
Stele, defined, 377	Tábara Apocalypse, 159	Tiercerone, defined, 310, 312 , 377
Stephen II, Pope, 102	Tabernacle, defined, 377	Timber-framed buildings, 169, 371,
Stephen, King, 174	Tahull: Church of San Clemente,	377
Stephen, St., 109 , 110	202, 361	Titus, Emperor, 356
Stole, defined, 377	Tapestries, 347, 348	Toledo
Stoss, Veit, 344, 347, 364	Tau cross, 368, 377	Church of San Juan de los Reyes,
Strainer arch, 377	Tempietto (Valle), 81, 82	342, 343 , 344 , 364
Strasbourg Cathedral, 319–320, 322,	Teodomiro, Bishop, 157	recaptured by Alfonso VI, 158, 192
363	Terracota, defined, 377	El Transito, 323, 324 , 363
String-course, defined, 377	Tesserae, defined, 377. See also Gold	Toothache, man with, 288
Strip buttress, 163, 165, 183, 201	tesserae	Torque, defined, 377
Stucco, defined, 377	Tetraconch, defined, 377	Toucy, Hugues de, 233
Suger, Abbot, 229–236, 253, 361	Tetrarchy, defined, 377	Toulouse: Church of St. Sernin, 204,
Sully, Maurice de, 242-243	Textiles	205, 207–208
Sutton Hoo site, 89–90, 358	Bayeux Tapestry, 191, 192, 193,	Tournus: Church of St. Philibert,
Sweden, 169. See also Scandinavian	226	166–167, 168
art	Byzantine, 133, 134	Tours: Monastery and Church of St.
Sylvester II, Pope, 161, 175	embroidery, 226, 316-319, 348	Martin, 84, 115, 121
"Symbolic geometry," 234	Gothic tapestries, 347, 348	Tracery
Symbols in Christian art, 13, 17-20,	Islamic, 148	defined, 377
22–23, 43	Thamyris, 349	English Decorated style, 310
badges of pilgrimage, 157, 204	Theodelinda, 80–81	Flamboyant style, 345, 346
barbarians and, 79	Theodochilde, sarcophagus of, 84, 85	German Gothic, 322
games, 309	Theodora, 47, 48, 59	late Gothic, 338, 344
instruments of the Passion, 375	iconoclasm and, 74	Trajan, Column of, 356
monograms and symbols for	mosaic image, 62, 63	Transept
Christ, 373	Theodore, St., 277	defined, 377
symbolic vs. narrative mode, 3	Theodoric the Great, 357	first use of, 31
symbols for the four evangelists,	Theodosius I, 356	Transfiguration image, 63, 64, 65,
370	churches built by, 32	377

"Transitional Style," 251–256 El Transito (Toledo), 323, 324, 363 Transom, defined, 377 Treaty of Verdun, 114, 115 Tree of Jesse image, 219, 220, 237, 256, 316, 372 Trefoil, defined, 377 Très Riches Heures (Limbourg brothers), 337, 349 Tribune, defined, 377 Triclinium, defined, 377 Trier: Abbey of St. Maximin, 177, 182 Triforium, defined, 24, 275, 377 Triptych, defined, 377 Triquetra, defined, 377 Triskele, defined, 377 Triumphal arch, 24, 377 Tronzo, William, 151, 152 Troubadours, 219-220 Troyes: Church of St. Urbain, **304–305**, 363 True Cross. See Cross Trumeau, defined, 377 Truss, defined, 377 Tudors, 336, 342 Turkey. See Constantinople; Ephasus Tympanum, defined, 377 Types and typology, 22, 377

Ukrainian art, 139 Umayyad dynasty, 143 Uncial, defined, 377 Unicorn, 373 Universities, 341–342, 362 Urban II, Pope, 129–132, 192, 205, 208, 361 Urban IV, Pope, 304 Uriel, Archangel, 366 Urnes style, 169–170 Uta, 294, 295 Utrecht Psalter, 115–116, 117, 118–119, 170–172, 188

Valentinian III, 33, 357 Valerian, St., 16 Valle: Oratory of Sta. Maria, 81, **82** Vandals, 32, 78 Vasari, Giorgio, 329 Vaults, 377–378 barrel vault, 163, 165, 167, 366, 377 boss, 369

catenary (chain) vault, 209, 367 cell vault, 344, 345 cloister vault, 344, 345, 367 fan vault, 341, 342, 370 groin, 371 groin vault, 163, 189–190, 344, 377 haunch, 371 keystone, 372 liern ribs, 310, 312, 376 mukarnas vault, 146, 374 net vault, 312, 322, 344, 374 pendant vault, 342 quadrant (half-barrel) vault, 206 quadripartite vault, 385 rib, defined, 376 rib vault, 376, 377-378 sexpartite vault, 376 star vault, 312, 376 tiercerone, 310, 312, 377 See also Domes Vellum, defined, 378 Vendel art, 76-77, 86-87, 89 Venice Byzantine art and, 140-141 Cathedral of St. Mark, 55, 141, 142, 360 Vermicule, defined, 378 Vertue, William, 342 Vesperbild image, 321, 365, 378 Vestments, 316-319, 365, 373, 374 Vestry, defined, 378 Vézelay: Church of the Madeleine, 212-214, 361 Vices, defined, 378 Victor III, Pope, 192, 195 Victory (personification), 378 Vienna Dioscorides, 68, 69 Vienna Genesis, 69, 70 Viking art, 87-89 Vikings, 114–115, 129, 156, 168–169, 174, 359–360 Villa Torlonia, catacomb in, 16 Vincent of Beauvais, 295 Vineyards, 19 Viollet-le-Duc, Eugène Emmanuel, 243, 274, 300 Virgin Mary, images of Annunciation image. See Annunciation image Assumption image, 253, 254

change from joyous to sorrowing figure, 321 Coronation of the Virgin image, 253, **254**, 281, 282, 300 icons and, 72 Maestà image, 331, 332, 372 Mater Dolorosa, 351 Mother and child image. See Mother and child image Nativity image, 151, 152, 326, 327, 331, 332 *pietà* image, 321, 375 Queen of Heaven image, 37 Theotokos (Mother of God) image. See Theotokos (Mother of God) image Visitation image, 282, 284, 306, Virgin of Vladimir icon, 140, 141 Virtues (order of angels), 137 Virtues (theological), 378 Visigoths, 78-79, 356 art of, 79-80 sack of Rome (410), 12, 33, 78 Visitation image, 282, 284, 306, 378 Vitalis, St., 56-57. See also San Vitale, Church of (Ravenna) Vivian Bible, 121, 122-123, 124, 359 Vivian, Count, 120, 121 Vladimir II, 129 Vladimir, Prince of Kiev, 139 Vladislav Hall, 344, 365 Volute, defined, 378 Voussoirs, 143, 144, 212, 366, 378 Vulgate, 121, 356, 369, 378

Wars of the Roses, 336, 364 Wastell, John, 341 Wattle and daub, 378 Welfs, 194 Well of Moses, 350, 364 Wells Cathedral, 286, 287, 288, 312-313, 338, 341, 362 plan, 289 west façade, 286 Westminster Abbey Cosmati work, 197 Lady Chapel, 342, 343, 365 rebuilt by Henry III, 310 Westworks, 107, 183, 378 Weyden, Rogier van der, 336, 337, 351, 364

Westfalen, Arnold van, 344
Weyland the Smith, 92, 93
Wheel cross, 93, 368
Whitby, Council at, 91–92, 95, 358
Wibald, Abbot, 3, 195
Wiligelmo, 200, 361
William I (son of Roger), 152, 153, 368
William II (the Good), 149, 152
William IX, Count, 219
William the Conqueror, 222–223, 360
William the Englishman, 247, 286
William of Sens, 247–248, 286

William of Wynford, 341
Winchester Bible, 248, 249
Winchester Hall, 286, 362
Winchester style of painting, 170–172
Windmill Psalter, 316, 317
Windows
lancet, 375
oculus, 378
tracery, 377
transom, 377
Women, books for, 250–251
Woodwork, 323

Muqarnas (mukarnas) ceilings,

146, 152, 323, 374

Ottonian, **180**, 181 timber-framed buildings, 169, 371, 377 Urnes style (Norway), 169, **170** Worms, Cathedral of, 290 Wycliffe, John, 335 Wyvern, 373

XP. See Chi Rho monogram

Zacharias, 113, 114 Zackenstil, defined, 378 Zodiac, defined, 378 Zoomorphic, defined, 378 Zoroastrianism, 6, 17, 37

N 5970 , 575